Over the Line

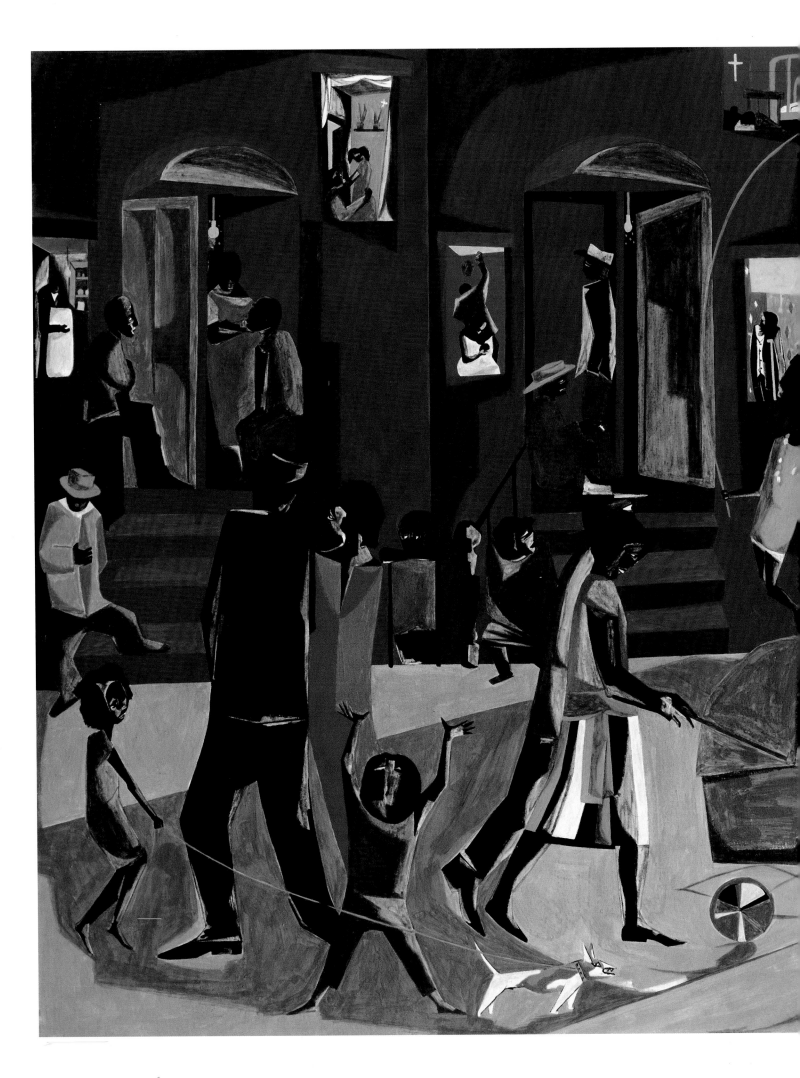

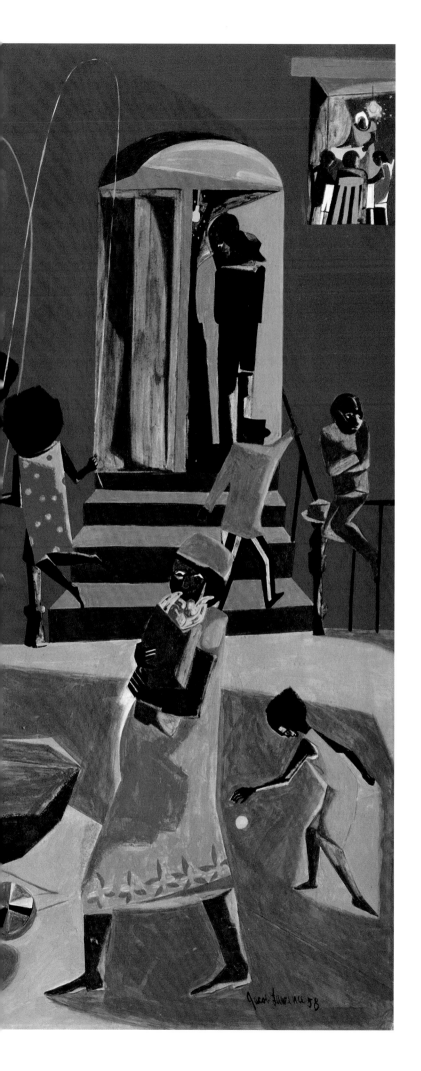

Over the Line
THE ART AND LIFE OF JACOB LAWRENCE

EDITED WITH AN INTRODUCTION BY

Peter T. Nesbett

Michelle DuBois

ESSAYS BY

Patricia Hills

Paul J. Karlstrom

Leslie King-Hammond

Lizzetta LeFalle-Collins

Richard J. Powell

Lowery Stokes Sims

Elizabeth Steele

Elizabeth Hutton Turner

University of Washington Press,
Seattle and London
in association with
Jacob and Gwendolyn Lawrence Foundation,
Seattle and New York

Dedicated to
Gwendolyn Knight Lawrence

This edition of this book is published on the occasion of a major retrospective, *Over the Line: The Art of Jacob Lawrence*, organized by The Phillips Collection, Washington, D.C., and includes information about the exhibition (pages 287–336) that was not included in the original printing. *Over the Line* was originally published in 2000 as part of a two-volume set titled *The Complete Jacob Lawrence.*

EXHIBITION ITINERARY

The Phillips Collection, Washington, D.C.
May 27–August 19, 2001

Whitney Museum of American Art, New York
November 8, 2001–February 3, 2002

The Detroit Institute of Arts
February 24–May 19, 2002

Los Angeles County Museum of Art
June 16–September 8, 2002

Museum of Fine Arts, Houston
October 5, 2002–January 5, 2003

Partial support for this book has been provided by the National Endowment for the Humanities, Washington, D.C., a federal agency, and the J. Paul Getty Trust, Los Angeles.

Published by University of Washington Press, Seattle and London, in association with the Jacob and Gwendolyn Lawrence Foundation, Seattle and New York.

Library of Congress Cataloging-in-Publication Data
Over the line : the art and life of Jacob Lawrence / edited with an introduction by Peter T. Nesbett, Michelle DuBois ; essays by Patricia Hills . . . [et al.].
 p. cm.
 Includes bibliographical references and index.
 ISBN 0-295-97964-x (cloth : alk. paper) —
ISBN 0-295-97965-8 (pbk. : alk. paper)
 1. Lawrence, Jacob, 1917–2000—Criticism and interpretation. 2. Painters—United states—Biography. 3. Afro-American painters—Biography. I. Nesbett, Peter T. II. DuBois, Michelle. III. Hills, Patricia.
 ND237.094 2000
 759.13—dc21
 [B] 00-56409

Frontispiece: *Brownstones,* 1958, egg tempera on hardboard, 31½ × 37¼ in. Clark Atlanta University Art Collections. Gift of Chauncey and Catherine Waddell.
Page 8: *Play Street,* 1942, gouache on paper, 30⅞ × 22⅜ in. Collection of Mrs. Stacey Clarfield Newman and Dr. Fredric Newman.

Edited by Fronia W. Simpson
Proofread by Sharon Vonasch
Indexed by Frances Bowles
Designed by John Hubbard
Image scanning by Jason Wiley
Color management by Gary Hawkey
Typeset by Christina Gimlin
Produced by Marquand Books, Inc., Seattle
 www.marquand.com
Printed and bound by CS Graphics Pte., Ltd., Singapore

Contents

In memory of Jacob Lawrence (1917–2000).

Jacob Lawrence passed away as *Over the Line* was going to press.
Present tense has been retained in the book to reflect his gracious and
encouraging involvement throughout its preparation.

Foreword

IN 1994 A MAJOR UNDERTAKING was initiated to document the art of Jacob Lawrence, those works he made from 1935 to the present. The goals were to catalogue and publish his entire lifework in a manner that was guided by the highest standards of scholarship and to make the results of research available to the public in a manner that provided the greatest benefit to a wide array of users. The two goals—sound scholarship and broad-based accessibility—were not viewed as mutually exclusive.

To achieve this, I conceived of the project as having several parts, each directed at different audiences and intricately related to the others. The core component would be a comprehensive reference book—a catalogue raisonné—that would include textual documentation and high-quality color reproductions of all the artist's paintings, drawings, and murals. Research from that project would then inform three other projects: a multiauthor interpretive monograph, an on-line visual archive and education center (www.jacoblawrence.org), and a retrospective exhibition that would highlight works discovered during research for the catalogue raisonné. The J. Paul Getty Trust assisted the project in developing the web site; the Phillips Collection, Washington, D.C., organizers of the well-received *Migration Series* exhibition in 1993, committed enthusiastically to organizing the retrospective. I am grateful to both for their tremendous cooperation.

This book offers a distinct contribution that the companion catalogue raisonné, the web-site, and the exhibition do not. It is the first multiauthor, in-depth probe of the artist's entire career: the nature of his work, his education, the critical climate in which he worked, and his use of materials and techniques. It also reproduces, in full color, more than one hundred works, most of which have not been published in color, or at all, in other books on the artist.

The book was a substantial undertaking that required a great degree of agility, perseverance, patience, and intellect. Michelle DuBois can be credited for having all those qualities. As the managing editor for this volume—and associate director for the Jacob Lawrence Catalogue Raisonné Project—she worked tirelessly to develop and refine the initial concept, selected and approached the writers, coordinated two writers' conferences, and worked closely with each writer, the copy editor, and the proofreader, in addition to working on the catalogue raisonné. When we both felt overburdened by the various demands of catalogue raisonné research and fundraising, Michelle was unfaltering in her dedication to seeing this book through to completion. We both hope that it will fuel further inquiry into the artist's work, stimulate debate, and contribute to the evolving understanding of twentieth-century modern art.

This book, and the catalogue raisonné to which it relates, has been copublished by the Jacob Lawrence Catalogue Raisonné Project and the University of Washington Press, both of which are nonprofit organizations. Partial proceeds from all sales will benefit the newly established Jacob and Gwendolyn Lawrence Foundation for the study of American, particularly African American, art. That this book will, in effect, support other projects is consistent with the compassionate spirit of the art and the artist that are its subject.

Peter T. Nesbett, Founder and Director
Jacob Lawrence Catalogue Raisonné Project
New York and Seattle

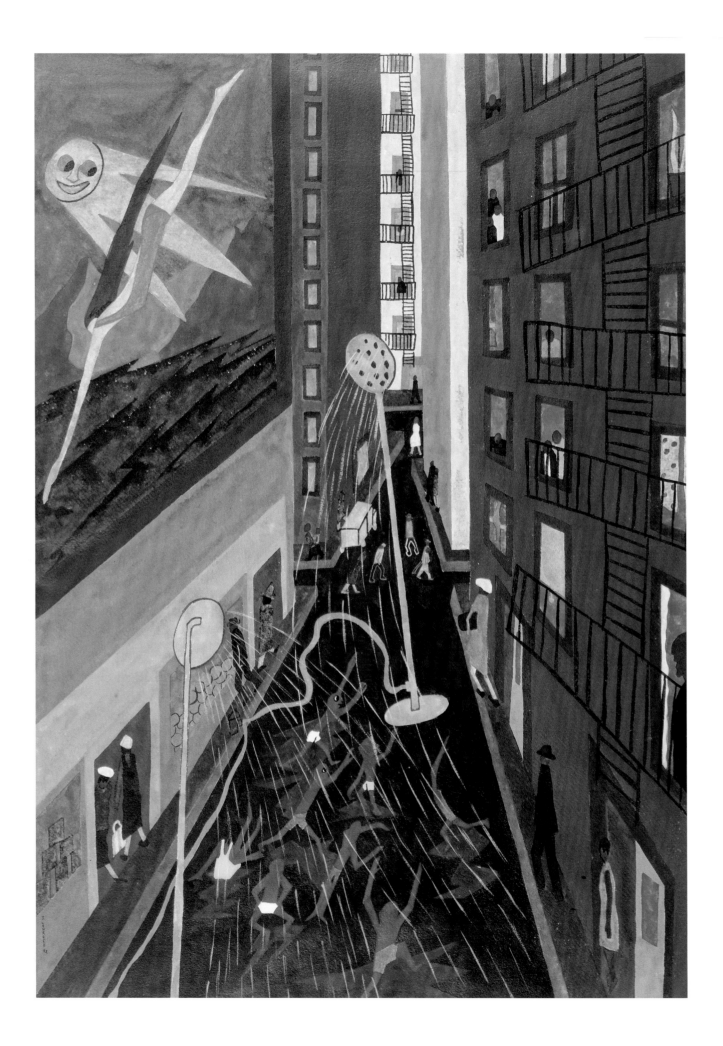

Acknowledgments

THIS COLLECTION OF ESSAYS is the result of more than three years of work and required the dedication of many people. It is meant to build significantly on the existing scholarship on the artist's art and life, and serve as a foundation for further, more extensive studies. It is also our hope that those with a general interest in the artist's work will gain a better understanding of its breadth and depth, its particular character, and the artist's unique contributions to twentieth-century art and culture.

Jacob and Gwendolyn Knight Lawrence are extraordinary individuals and artists, and working with them closely on this project has been for us both an honor and a pleasure. They have responded graciously to the many demands asked of them, providing access to their own letters and archives, participating in grueling interviews, and repeatedly fielding research questions at inopportune times. The Lawrences had no fiscal or managerial involvement with either this collection of essays or the accompanying catalogue raisonné, and their unstinting trust in our efforts has been a great source of encouragement. Additionally, the Jacob Lawrence Catalogue Raisonné Project's board of directors—Dr. Thaddeus H. Spratlen, Seattle; Dr. Walter O. Evans, Detroit; and Dr. Leslie King-Hammond, Baltimore—provided invaluable assistance throughout the process and we are thankful for their involvement. Dr. Evans, a preeminent collector of African American art, letters, and first-edition manuscripts, provided exceptional support, reflecting his passionate interest in the artist's work.

A special thank-you to the eight writers who contributed essays to this volume: Patricia Hills, Paul J. Karlstrom, Leslie King-Hammond, Lizzetta LeFalle-Collins, Richard Powell, Lowery Stokes Sims, Elizabeth Steele, and Elizabeth Hutton Turner. Their work adds considerable insight into Lawrence's career. Additionally, Stephanie Ellis-Smith coordinated photography, scanning, and rights and permissions for this publication and did so with great assiduousness, not to mention humor and grace under pressure. Jim Huffman and Antony Toussaint, Prints and Photographs Division, Schomburg Center for Research in Black Culture, assisted us in securing photographs for the timeline.

The Getty Conservation Institute assisted us tremendously with research, and we are grateful for their generous commitment to this project. We would especially like to thank Dr. Barry Munitz, CEO, The J. Paul Getty Trust, as well as the staff of the Conservation Institute and the Getty Museum, particularly Michael R. Schilling, Narayan Khandekar, Joy Keeney, Herant P. Khanjian, James Druzik, Erin O'Toole, Rona Sebasstian, and Alberto Tagle. Elizabeth Steele's analysis of the artist's materials and techniques that appears in this volume was greatly informed by her own experience in working closely with the Getty's accomplished staff. Additionally, we would like to thank others who assisted us with research, including Amy Ross, Boston, and Sydelle Rubin, New York, who helped compile the bibliography, as well as the staffs of the Francine Seders Gallery, Seattle, and the DC Moore Gallery, New York, particularly Francine Seders, Alison Stamey, Bridget Moore, Ed DeLuca, and Heide Lange.

We owe special gratitude to the Phillips Collection, Washington, D.C., for their tremendous support. Jay Gates, Director, enthusiastically embraced our proposal to organize a comprehensive traveling exhibition to complement this publication and offered to host one of two writers conferences during this book's development. Two of his staff, Elizabeth Steele, Conservator, and Elizabeth Hutton Turner, this exhibition's curator, in addition to contributing two of the essays, provided wise counsel from the

book's conceptualization. Other staff members, including Thora Colot and Elsa M. Smithgall, also made significant contributions.

Many institutions and individuals contributed to this effort financially. We received important support from The National Endowment for the Humanities, Division of Preservation and Access; The Tides Foundation, San Francisco; The Allen Foundation for the Arts, Seattle; and the University of Washington Press Development Advisory Board. Several corporations provided valuable assistance: Citibank, N.A., New York; Ford Motor Company, Dearborn, Michigan; Masco Corporation, Detroit; Microsoft Corporation, Redmond, Washington; and the Francine Seders Gallery, Seattle; as did The Detroit Institute of Arts; University of Michigan, Dearborn; and Hampton University Museum, Virginia. But a large portion of the research costs was generously provided by individuals, among them: Clarence and Jacqueline Avant, Drs. James A. Banks and Cherry McGee Banks, Janet and John W. Creighton, Walter and Linda Evans, Drs. Herbert J. Kayden and Gabrielle H. Reem, Larry and Vernita McNiel, Paul and Dolly Marshall, Jackie Mullins, Alan and Susan Patricof, John Whitney Payson, Thaddeus and Lois Price Spratlen, Brian and Diane Weck, George and Joyce Wein, Julia B. Williams, Jr., Mary McLellan Williams, and Edward Wilson, Jr. Others who should be singled out are David R. Jones, CEO, and Randreta Ward-Evans, Community Service Society, New York; Dr. James C. Renick, Chancellor, North Carolina A & T, Greensboro, N.C.; Nettie Seabrooks, Detroit; Dr. Lorna Thomas, Detroit; The Friends of African American Art at The Detroit Institute of Arts; Pari Stave, The AXA Gallery, New York; Michael Findlay, formerly with Christie, Manson & Woods, New York; William Weigand and Chris Pesce, Davis Wright Tremaine, Seattle; Leonard Weber, Merrill Lynch, Seattle; and Howard Donkin, Morrison, Donkin & McAlister, Bellevue, Washington.

We are grateful for the support of the advisory board to the Jacob Lawrence Catalogue Raisonné Project whose members provided counsel throughout the process. They are David C. Driskell, University of Maryland, Baltimore; Edmund Barry Gaither, Museum of the Center of Afro-American Artists, Roxbury, Massachusetts; Bruce Guenther, Portland Museum of Art, Oregon; Barbara Haskell, Whitney Museum of American Art, New York; Harry Henderson, New York; Patricia Hills, Boston University; Barbara Johns, Pilchuck Glass School, Seattle; Dr. Paul J. Karlstrom, Archives of American Art, San Marino, California; Drs. Herbert J. Kayden and Gabrielle H. Reem; Bridget Moore, DC Moore Gallery, New York; John Whitney Payson, Midtown Payson Galleries, Hobe Sound, Florida; Francine Seders, Francine Seders Gallery, Seattle; Lowery Stokes Sims, The Studio Museum in Harlem, New York; Governor Carlton Skinner, Marblehead, Massachusetts; Charles F. Stuckey, Kimbell Art Museum, Fort Worth; Elizabeth Hutton Turner, The Phillips Collection, Washington, D.C.; and Jeanne Zeidler, Hampton University Museum, Hampton, Virginia.

Those involved with the editing, design, and production of this book have made extraordinary contributions. We would like to thank Fronia W. Simpson for her keen editing and advice; Sharon Vonasch, Seattle, who proofread the manuscript and offered additional suggestions that improved it considerably; and Petra Siemion, Flight of Hand, Seattle, for entering the manuscript edits in the disk files. Jason Wiley scanned and color-managed the digital images, and Gary Hawkey provided valuable, hands-on counsel regarding digital imaging and printing. John Hubbard and Christina Gimlin of Marquand Books, Seattle, are responsible, respectively, for the excellent design and careful typesetting of this book; we also extend our appreciation to Ed Marquand and Marie Weiler of Marquand Books. Pat Soden, director, Donald R. Ellegood, director emeritus, Nina McGuinness, Mary Anderson, Alice Herbig, and the rest of the staff at University of Washington Press, Seattle, have shown their unstinting commitment to this effort from the early stages, and their encouragement is tremendously appreciated.

Finally, a special note of appreciation to Shelly Bancroft and David Gambill. They, too, have provided invaluable counsel and editorial advice, and we are grateful for their patience and loving support.

Peter T. Nesbett Michelle DuBois
New York Boston

Peter T. Nesbett and
Michelle DuBois

Introduction

JACOB LAWRENCE OCCUPIES an unusual position in the history of American art. He is an iconic figure, one of the great modern painters of the twentieth century, a distinction he earned early in his career when he gained widespread recognition for the narrative painting series *The Migration of the Negro* in 1941. In a century that equated the evolution of modern art with the will toward abstraction, Lawrence's early success and his sustained visibility are remarkable. He has walked a careful line between abstract and figurative art, using aesthetic values for social ends. His success at balancing such seemingly irreconcilable aspects of art is a fundamental characteristic of his long and distinguished career.

Lawrence is one of the first American artists trained in and by the black community in Harlem, and it is from the people of Harlem that he initially obtained professional recognition. He was also the first African American artist to receive sustained support from mainstream art museums and patronage outside of the black community during an era of legalized and institutionalized segregation. In 1941, at the age of twenty-four, Lawrence joined the Downtown Gallery, becoming the first artist of African descent to be represented by a major commercial art gallery. There he exhibited alongside such established modernists as Stuart Davis, John Marin, Charles Sheeler, and Ben Shahn, all of whom later became close friends. Although African American artists living uptown in Harlem and successful white artists living and exhibiting downtown were beginning to interact, at that time professional contact between the two groups was still rare. Lawrence's unique position—his widespread visibility both "uptown" and "downtown"—provided him with professional privileges as well as emotional challenges.

From this solitary position Lawrence developed a philosophy regarding art and the role that it can play in addressing social issues, particularly as they pertain to race. Though much of his career coincides with a period in which artists attempted to strip all narrative and literary references from their work, he has always maintained that art, as one of the highest forms of human endeavor, is too significant a communicative medium to be reduced simply to formal experimentation. For over sixty years and with intentionally limited means (water-based paints on boards or paper), he has harnessed the seductive power of semi-abstract forms to address many of the great social and philosophical themes of the twentieth century, especially as they pertain to the lives and histories of African Americans: migration, manual labor, war, family values, education, mental health, and creativity. He made visible a side of American history that includes the contributions of African Americans; has presented scenes of daily life that provide a compassionate counterpoint to stereotypical images of African Americans; and painted poignant social commentary on the effects of racism and bigotry in American culture. His ability to distill the essence of these subjects into elemental shapes is unparalleled and one of the defining aspects of his work.

This collection of essays is published in conjunction with a catalogue raisonné that documents and illustrates all the known paintings, drawings, and murals produced by Jacob Lawrence between 1935 and 1999. In surveying these works, many of which had remained unpublished until now, we realized that the artist's singular position in twentieth-century art is more nuanced than previous publications have indicated. Furthermore, many important aspects of Lawrence's career have not been dealt with adequately, indeed, some have not been treated at all. The reasons for this are complicated and are still being debated.

Perhaps the most important reason is one that usually remains unarticulated. His work often deals directly with or alludes to the status of race relations at different times in the twentieth century, and the attempt to address these issues in an unambiguous manner is a thorny endeavor.

It is our intention that this book replace a simplified, unified understanding of the artist's work, career, and life with a more textured and differentiated one. To this end, we also introduce the reader to a greater range of Lawrence's art than has previously been available. This book does not claim to be comprehensive or definitive. Instead, it offers multiple perspectives onto a multifaceted and complex career with the expectation that more questions will be raised and more discussions generated.

As editors of the catalogue raisonné, we had always intended that this monograph be a multiauthored volume. We are aware that there are many possible points of view about Lawrence's career, many methods for assessing it, not to mention varying opinions on what to emphasize. What confluence of factors and events joined to produce Lawrence's vision? How did Lawrence's art and career intersect with the cultural and social contexts in which he worked? The array of topics and perspectives represented by these essayists—male and female, black and white—was eminently appropriate for this artist, whose work is appreciated by different people for radically different reasons.

To map out the contents of this book, we convened two all-day writers' conferences, held nine months apart. We invited writers who had already published on the artist's work or were familiar with his artistic output. When we first contacted them, we found that they all had well-formed ideas about Lawrence and his art but had not found the right forum in which to express them. The first conference resulted in a series of lively discussions that easily could have extended beyond the eight hours we had scheduled. Of the sheer number of possible subjects regarding Lawrence's art, we had to decide what to present now and what to leave for further study: much remains in the latter category. At the second conference, the writers presented and critiqued each other's completed papers. This book, then, represents the individual authors' thinking augmented by group response and suggestions. We expect that topics that the essayists were unable to explore here will be published elsewhere in the future.

Six of the eight essays contained in this book deal with a specific era or body of work and roughly follow Lawrence's artistic development (the reader may also consult a detailed life and reception chronology immediately following this introduction). Leslie King-Hammond paints a broad picture of his environment during the 1930s, when he was becoming conscious of his artistic talents. She addresses how a historically and spatially restricted constellation of individuals with a certain philosophy and ethos informed the sensibilities of the young artist. Elizabeth Hutton Turner considers the facts of his education in terms of formal pedagogy as it was shaped by a white, mainstream educational system that filtered into the community through professional art teachers. Lizzetta LeFalle-Collins poses a difficult question: what did early critics of Lawrence's work mean when they referred to him as a "modern primitive"? Richard Powell writes on an unexplored period in Lawrence's career—the 1950s—a period that does not correspond readily to the standard characterization of the artist as a painter of socially pertinent subject matter. Patricia Hills analyzes Lawrence's paintings of the turbulent 1960s, addressing the artist's use of civil rights themes in his work. Lowery Stokes Sims considers the Builders theme as emblematic of his success in balancing and even establishing a symbiosis between form and content. This essay also provides the most in-depth discussion of the formal qualities of Lawrence's work that has been published to date.

The two concluding essays deal with topics pertaining to Lawrence's entire career. Paul Karlstrom explores issues faced by all successful artists: artistic vision and agency. How does an artist who is well known or successful for a given style and content grow? This problem was compounded for Lawrence because both blacks and whites projected onto him their conception of what an African American artist should do and what African American art should look like. The essay explores his approach to dealing with the constant pressure of these sometimes countervailing demands while remaining true to himself. Elizabeth Steele explores another constant in Lawrence's career that is fundamental and thus far had gone without in-depth analysis: how the artist's techniques and materials have affected the style of his work. An understanding of Lawrence's oeuvre has been hampered by a larger confusion regarding twentieth-century water-based materials. Steele, a paintings conservator, worked closely with the Getty Conservation Institute to collect and ana-

lyze paint samples from several dozen paintings executed over a forty-year period. The results of this groundbreaking research are analyzed and published here for the first time.

Of historical interest for present and future scholars is the fact that all of the writers, as well as we the editors, know Jacob Lawrence personally. Some of us know him very well while others less so, but every contributor to this volume of essays has had, at the very least, an interaction with him. A personal connection with an artist influences the manner in which a scholar approaches his or her work and life, and the reader should keep this caveat in mind. Lawrence as a person is very much present in the following pages, not only as the maker of the art being discussed but also as the subject of numerous interviews, the transcripts of which have been mined for his thoughts on a variety of topics. The writers have tried to strike a balance between respecting the artist's words and pursuing their own intellectual agendas. These essays form an intrinsic and pivotal component of the historiography of Jacob Lawrence.

Certain inconsistencies in the writers' use of terminology and points of view have been maintained in this volume as an indication of the range of complex responses to the artist's work. In many ways, the contradictions simply extend the varied responses to his work from the past to the present. Critics have described it as both grounded in the particularities of race or ethnicity and transcending race to address universal themes and subjects. Some have touted the work as sophisticated, exemplifying the tenets of progressive modern art, while others have discussed it as naïve and primitive. Almost all of these essays in some way touch on these dualities—particular/universal, black/white, modern/primitive, and sophisticated/naïve. Indeed, living with the sense of duality has been described as the essence of the African American experience.

Jacob Lawrence, as an artist in a highly unusual position in the world of twentieth-century American art, found himself in a web of contradictions and sets of dialectics. Perhaps what Lawrence and his art exemplify is that seemingly mutually exclusive positions may not be that after all; that it is quite possible to embrace, simultaneously, all of the above dualities. This belief informed our selection of the title for this book, *Over the Line*, which derives from one of his paintings in the *Harriet and the Promised Land* series of 1967 (fig. 1). The painting depicts Harriet Tubman crossing the border into Canada. Like the birds sur-

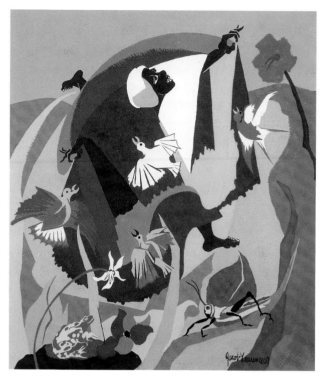

FIG. 1 *Over the Line*, 1967, gouache on paper, 14 × 13 in. Collection of Mr. and Mrs. Richard H. Markowitz.

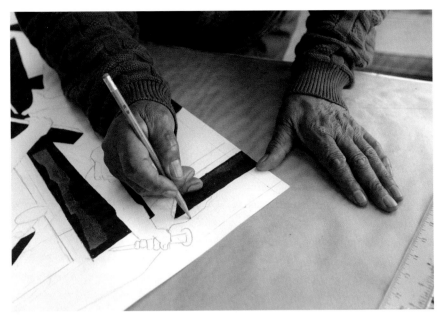

FIG. 2 Jacob Lawrence working at his drafting board, 1998. Photograph courtesy of Harley Soltes/*Seattle Times*.

FIG. 3 *The Migration of the Negro, No. 49: They also found discrimination in the North although it was much different from that which they had known in the South,* 1941, casein tempera on hardboard, 18 × 12 in. The Phillips Collection, Washington, D.C.

rounding her, she is not actually touching the ground. Literally, Tubman is both *above* and *beyond* the line—"over the line" in both senses of the term. The painting depicts a dynamic moment of transition and transgression.

In a concrete sense, our use of the title *Over the Line* refers to a technique employed by the artist throughout his career: in preparation for all of his paintings, he first makes a detailed underdrawing, which he covers up as he paints (fig. 2). Our use of the title, however, is meant to be evocative and allusive, utilizing both senses of the word *over* and implying that Lawrence and his art occupy a transitional, undefined, or liminal place in American culture. By alluding to a border (fig. 3) through the use of the word *line,* the title acknowledges the artistic and social climate in which the artist spent most of his professional life—in a culture that categorized difference in binary terms and attempted to clearly delineate between the two. But it is also meant to imply that in his art and life he attempted to transcend this situation, to negate and go beyond such limitations, and to deal with the fundamental complexities of modern life. Just as Harriet Tubman crossed the American-Canadian border many times, back and forth, so did Lawrence cross borders time and again. This transgression is not unidirectional; instead, it is an oscillation between situations, circumstances, and styles, in an effort to find common ground while not denying difference. For over sixty-five years, he has remained committed to this humanistic goal, surely a remarkable achievement.

The Homecoming, 1936, tempera on brown paper,
35 × 22 in. Collection of Mrs. Daniel Cowin.

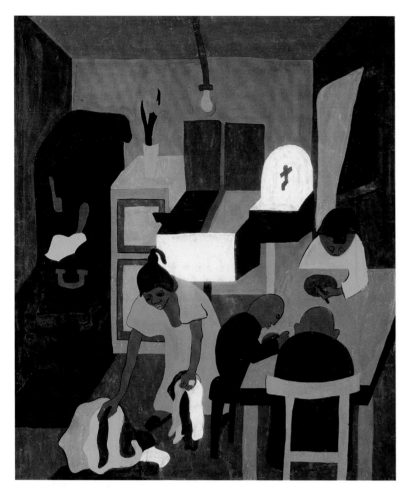

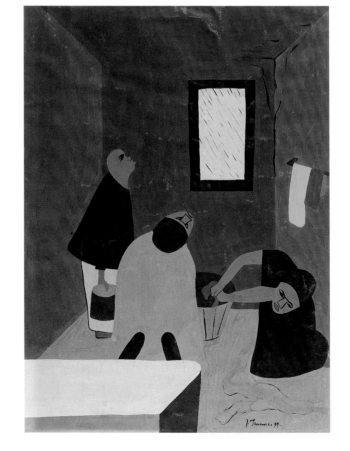

PL. 2 *Interior (Family)*, 1937, tempera on paper, 30⅜ × 25½ in. Collection of AXA Financial.

PL. 3 *Rain No. 1*, 1937, tempera on paper, image: 28½ × 20¾ in. Wadsworth Atheneum, Hartford, Connecticut. The Ella Gallup Sumner and Mary Catlin Sumner Collection Fund.

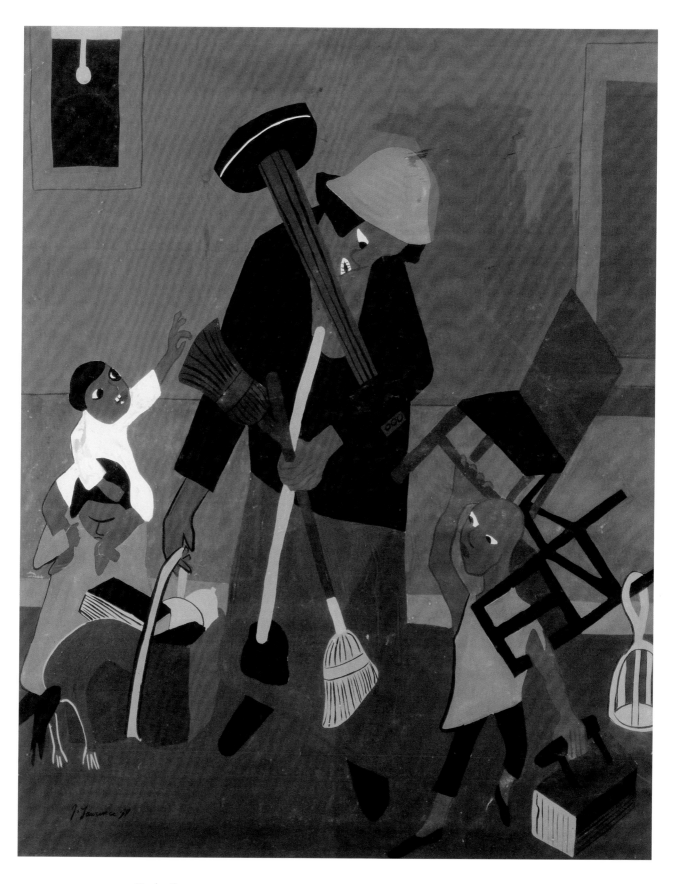

PL. 4 *Moving Day*, 1937, tempera on paper,
sight: 30 × 24¾ in. Private collection.

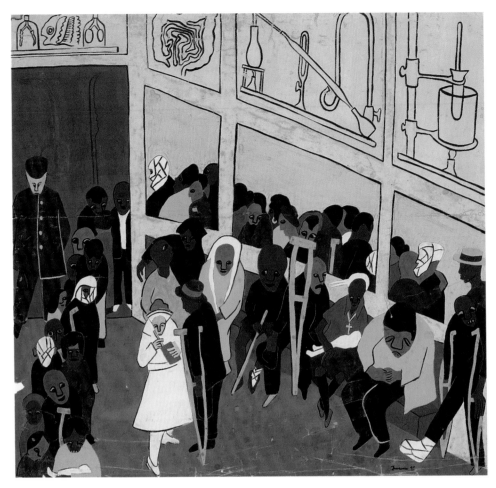

PL. 5 *Free Clinic*, 1937, tempera on paper,
28 × 29½ in. The Art Institute of
Chicago.

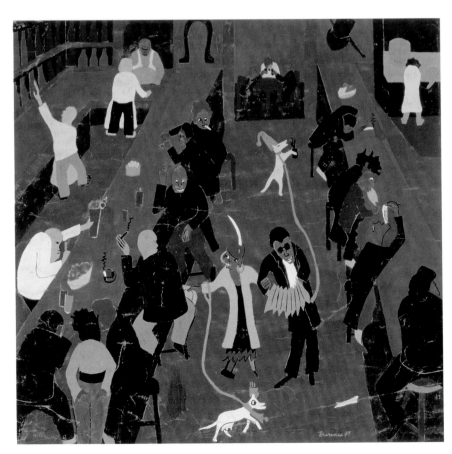

PL. 6 *Bar and Grill*, 1937, tempera on brown paper,
sight: 22½ × 23¾ in. San Antonio Museum
of Art, San Antonio, Texas. Purchased with
funds provided by Mr. and Mrs. Hugh Halff
by exchange, Dr. and Mrs. Harmon Kelley
and Dr. Leo Edwards.

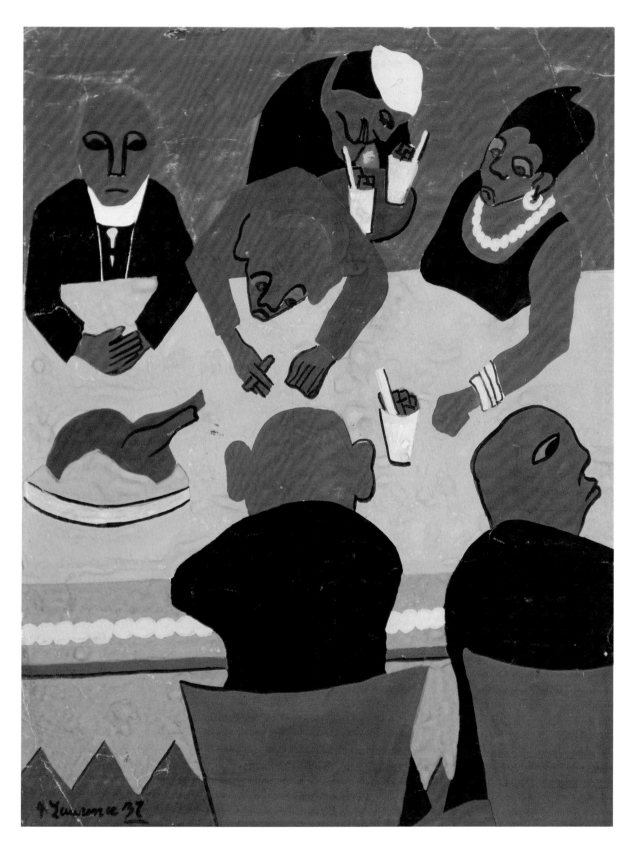

PL. 7 *Dining Out*, 1937, tempera on paper, 11½ ×
9 in. Collection of the Madison Art Center,
Madison, Wisconsin. Gift of the Estate of
Janet Ela.

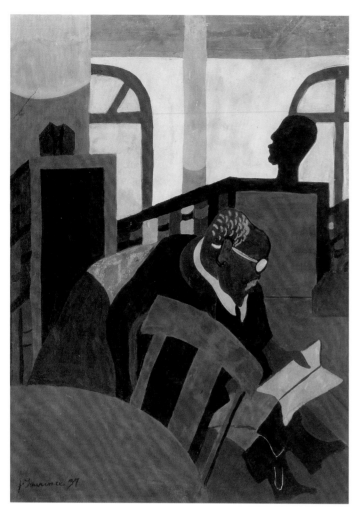

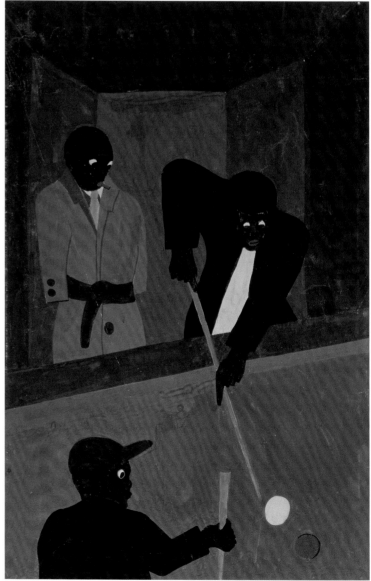

PL. 8 *Library* (also *The Curator*), 1937, tempera on
paper, sight: 11½ × 8½ in. Schomburg Center
for Research in Black Culture, New York Public
Library, Astor, Lenox & Tilden Foundations.

PL. 9 *Pool Players*, 1938, tempera on brown
paper, image: 17¾ × 11¾ in. Collection
of AXA Financial.

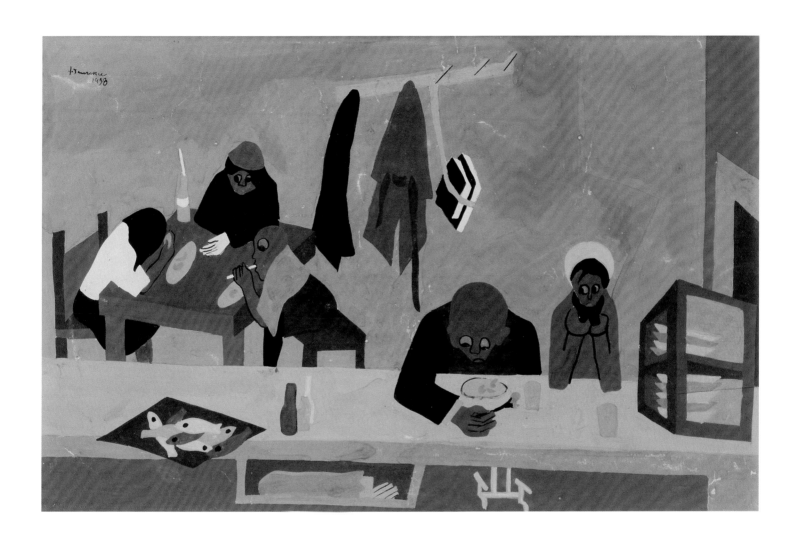

Harlem Diner, 1938, tempera on paper,
12⅝ × 19⅛ in. Collection of Mr. and
Mrs. Elie Hirschfeld, New York.

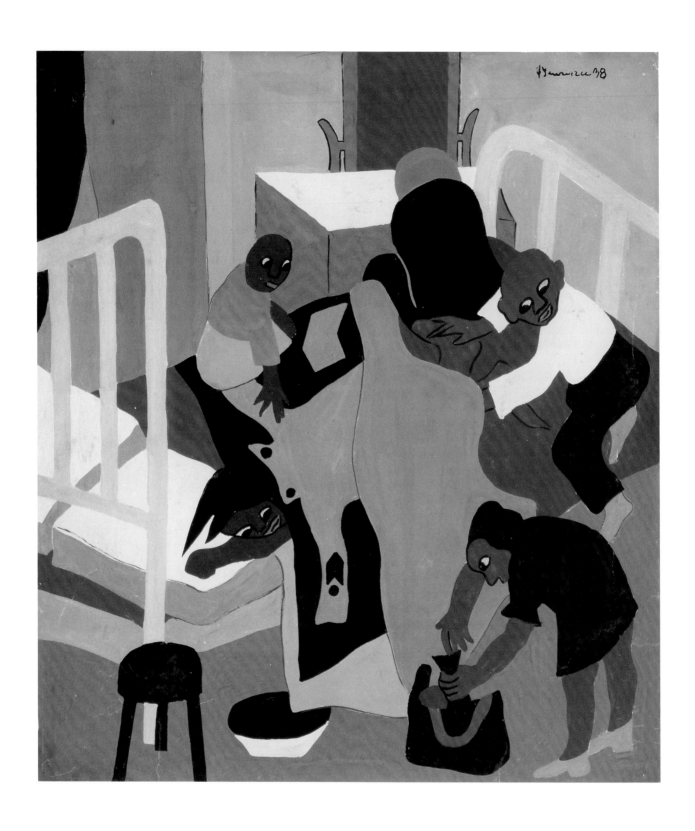

PL. 11 *Untitled* [*Pickpockets*], 1938, tempera on paper,
12¾ × 12½ in. Collection of Tarin M. Fuller.

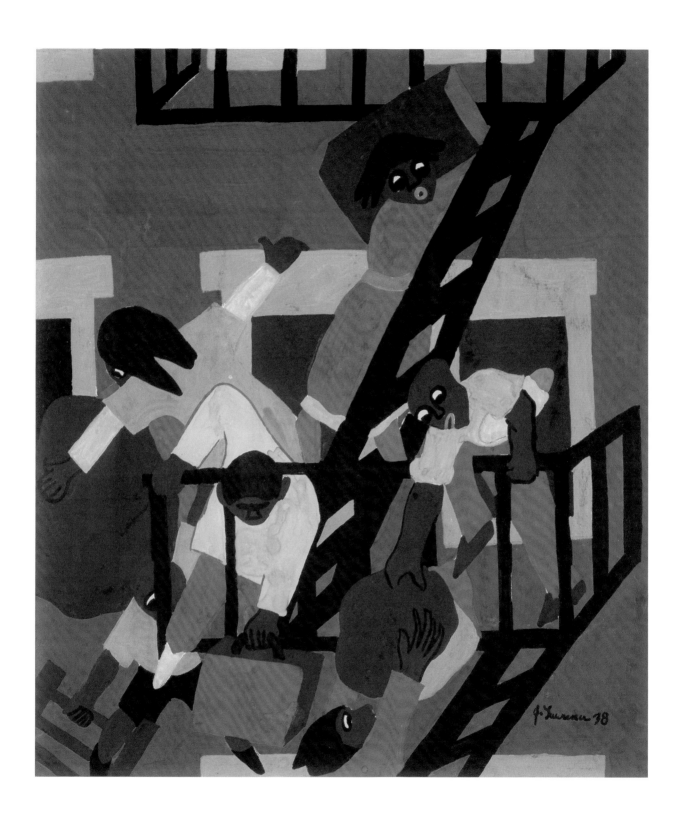

PL. 12 *Fire Escape,* 1938, tempera on paper, 12¼ ×
10⅞ in. Collection of Jules and Connie Kay.

Chronology

LIFE

1917
SEPTEMBER 7: Jacob Armstead Lawrence born in Atlantic City, New Jersey; parents are Jacob and Rosa Lee Lawrence.

1919
Family moves to Easton, Pennsylvania, where daughter, Geraldine, is born.

1924
Parents separate. Rosa Lee Lawrence moves the children to Philadelphia where another son, William, is born.

1927
Rosa Lee Lawrence moves to New York City. Jacob and his siblings remain in foster homes in Philadelphia until 1930.

1930
Rosa Lee Lawrence moves family to Harlem, where they live in an apartment at 142 West 143rd Street. Lawrence attends grammar school at P.S. 68 and Frederick Douglass Junior High School (P.S. 139). After school hours, attends day-care program at Utopia Children's House (also called Utopia Children's Center) at 170 West 130th Street, where he studies arts and crafts with Charles Alston. Paints nonfigurative geometric designs and makes papier-mâché masks and three-dimensional stagelike tableaux in small boxes.

1931
Attends church services and Sunday school at Abyssinian Baptist Church, where he hears Adam Clayton Powell, Jr., deliver sermons (early 1930s).

1932
Attends the High School of Commerce (until 1934) while continuing to study with Charles Alston, this time at the WPA Harlem Art Workshop, in the New York Public Library's 135th Street branch. The classes are sponsored by the College Art Association.

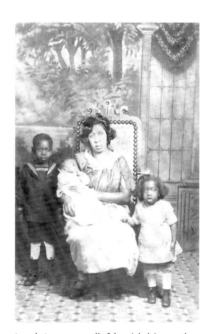

Jacob Lawrence (left), with his mother, brother William, and sister Geraldine, in 1923.
Courtesy of Jacob and Gwendolyn Knight Lawrence.

(left) Jacob Lawrence, ca. 1950s.
Photograph by William Grigsby.
Courtesy of Jacob and Gwendolyn Knight Lawrence.

LIFE

1934

Continues to study with Charles Alston and Henry Bannarn at the WPA Harlem Art Workshop, relocated to 306 West 141st Street (a.k.a. Alston-Bannarn Studios or Studio 306). Rents space in corner of Alston's studio until 1940.

Drops out of high school when his mother loses her job. Holds several part-time jobs including delivering newspapers and liquor and working for a printing shop.

Reads Thomas Craven's *Modern Art: The Men, the Movements, the Meaning.*

1935

Meets "Professor" Charles Seifert, a lecturer and historian who has a large library of African and African American literature. Seifert offers Lawrence use of his library and encourages him to make use of Arthur Schomburg's collection at the New York Public Library. Participates in bus trips organized by Seifert to museum exhibitions, including *African Negro Art* at the Museum of Modern Art.

Begins painting scenes of life in Harlem, using commercial tempera (poster) paints on lightweight brown paper. Several early paintings depict his immediate environment, including his studio and life at home with his family. Other early works offer a biting, satirical view of life in Harlem, highlighting poverty, crime, racial tensions, and police brutality.

1936

Works for six months in the Civilian Conservation Corps (CCC) near Middletown, New York; makes drawings of life in the CCC.

Watches Charles Alston paint WPA mural *Magic and Medicine*, which is installed in 1937 at the Harlem Hospital.

Sees W. E. B. Du Bois's play *Haiti* at the Lafayette Theater. Begins research on Haiti in the Division of Negro History, Literature, and Prints at the 135th Street branch of the New York Public Library in preparation for his first series—*The Life of Toussaint L'Ouverture*. The series is completed in 1938 and consists of 41 paintings depicting L'Ouverture's role in establishing the first black republic in the Western Hemisphere.

1937

With the assistance of Harry Gottlieb, secures two-year scholarship to American Artists School (organized by the John Reed Club, a Communist organization) at 131 West 14th Street. Studies with Gottlieb, Eugene Morley, Anton Refregier, Philip Reisman, and Sol Wilson.

Reception
Selected Exhibitions, Publications, Honors, and Awards

1933
Wins prize in Sunday school at the Abyssinian Baptist Church for drawing map illustrating the travels of the apostle Peter.

1935
Exhibits his work in group exhibitions at the Alston-Bannarn Studios at 306 West 141st Street (also in 1937).

1936
Addison Bates, a cabinetmaker with a workshop at the Alston-Bannarn Studios, gives Lawrence a solo exhibition in his studio.

1937
April–May: Exhibits six pencil drawings in a group show of the Harlem Artists Guild at the 115th Street branch of the New York Public Library.

Exhibits in a group exhibition at the American Artists School, where he is a student.

LIFE

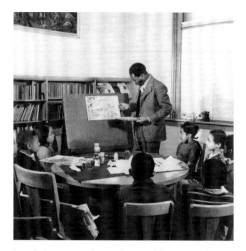

Jacob Lawrence lecturing on his art at Lincoln School, New Rochelle, New York, on February 28, 1941.
Photograph by Ray Garner.
Courtesy of the National Archives, Washington, D.C.

1937 (CONTINUED)
Sees solo exhibition of William Edmonson's sculpture at the Museum of Modern Art.

Applies to WPA Federal Art Project (WPA/FAP). Rejected because of age requirement (artists had to be at least 21 years old).

1938
Begins research for a series of paintings on the life of Frederick Douglass, the Maryland slave turned abolitionist, speaker, and writer.

SEPTEMBER: With the assistance of Augusta Savage, a sculptor and teacher at the Harlem Art Workshop whom Lawrence met earlier at the Savage Studio of Arts and Crafts, is hired by the WPA/FAP easel division. Employed for 18 months, submitting to the division two paintings every six weeks.

Continues to paint genre scenes of life in Harlem. Makes frequent visits to museums and modern art galleries.

1939
Completes series of 32 panels entitled *The Life of Frederick Douglass*, which he gives to the Harmon Foundation as collateral against a loan of approximately $100.

Begins research for a series on Harriet Tubman, the former slave who became an abolitionist and important figure in the Underground Railroad.

1940
Moves temporarily to 292 West 147th Street.

Completes series of 31 panels entitled *The Life of Harriet Tubman*, which he also provides as collateral to the Harmon Foundation in exchange for a second loan of approximately $100.

RECEPTION

Jacob Lawrence, 1940s.
Photograph by Glenn Carrington.
Courtesy of Jacob and Gwendolyn Knight Lawrence.

1938

FEBRUARY: Has solo exhibition at the Harlem YMCA, sponsored by the James Weldon Johnson Literary Guild. Also exhibits in *Twenty-one NYC Negro Artists* at the Harlem Community Center.

Exhibits at Dillard University, New Orleans, Fisk University, Nashville, and Brooklyn College.

1939

FEBRUARY: Exhibits in two-person show with Samuel Wechsler at the American Artists School. Exhibition receives positive review in *ARTnews*, which notes that his "style . . . is easy to call primitive . . . but closer inspection reveals draughtsmanship too accomplished to be called naïve."

The Life of Toussaint L'Ouverture (1938) is exhibited in a room of its own as part of *Contemporary Negro Art* at the Baltimore Museum of Art, which is organized with the assistance of the Harmon Foundation. A writer for *Newsweek* singles out Lawrence as "a discovery."

Exhibits in group show at the Labor Club, New York.

MARCH: Paintings reproduced in *Survey Graphic*, "First Generation of Negro Artists."

MAY: Through the efforts of Claude McKay, *The Life of Toussaint L'Ouverture* is exhibited at the De Porres Interracial Council headquarters on Vesey Street, New York. Alain Locke praises Lawrence's work in an important essay, "Advance on the Art Front," published in *Opportunity* magazine, noting that he is an "intuitive genius" and that his work exhibits a "modernistic" sensibility. Locke uses Lawrence's work to underscore his argument that there is "no essential conflict between racial or national traits and universal human values."

1940

JULY: Wins second prize at *Exhibition of the Art of the American Negro, 1851–1940* at the American Negro Exhibition in Chicago.

NOVEMBER: *The Life of Toussaint L'Ouverture* exhibited at Columbia University, New York, concurrent with an exhibition of woodblock prints by Hokusai.

LIFE

1940 (CONTINUED)

APRIL 17: Secures $1,500 fellowship from the Julius Rosenwald Fund to complete a series of paintings on "the great Negro migration during the World War." His application states his desire to have the work shown in "a series of exhibitions in art galleries, schools, and public buildings" and "to try to have this work published in book form." Lawrence's Rosenwald application is accompanied by recommendations from Alain Locke, Lincoln Kirstein, Helen Grayson, and Carl Zigrosser.

Moves to 33 West 125th Street, where he rents an unheated loft for $8.00 a month. Other artists and writers with studios in the building include Romare Bearden, Robert Blackburn, Ronald Joseph, Claude McKay, and William Attaway. He remains there for 18 months.

Meets Jay Leyda, assistant film curator at the Museum of Modern Art. Leyda introduces him to Mexican artist José Clemente Orozco while he is working on *Dive Bomber and Tank* mural at the museum. Leyda, who becomes a close friend, also acts temporarily as an agent and introduces Lawrence to documentary filmmaker Irving Jacoby, who becomes an early patron.

Begins research for *The Migration of the Negro* series at the Schomburg Collection, 135th Street branch, New York Public Library.

1941

SPRING: Works on 60 panels of *The Migration of the Negro* simultaneously, completing them with the assistance of Gwendolyn Knight, an artist who prepares the gesso panels and helps write the captions. Also secures a $1,200 renewal of his Rosenwald fellowship to paint a series on the life of the abolitionist John Brown. In an undated letter of intent, Lawrence writes, "with the remainder of my Rosenwald Year I plan to go to Virginia to live on a farm and make a study in the form of paintings of the life of the Negro in rural communities. If I receive another Rosenwald Grant, I plan to make a composite study of the Negro in Harlem, after which I plan to try to have these published in book form."

JULY 24: Marries Gwendolyn Knight in New York. They travel to New Orleans, their first trip to the South, living in a rooming house at 2430 Bienville Avenue through the end of the year. While in New Orleans, he paints *The Life of John Brown*, a series of 22 images, as well as individual paintings depicting life and segregation in the South.

DECEMBER: Still in New Orleans, joins the Downtown Gallery, New York, at the encouragement of Alain Locke, becoming the first African American artist to be represented by a major New York commercial gallery. Exhibits there regularly in solo and group exhibitions until 1953. Gallery represents Stuart Davis, John Marin, Ben Shahn, Charles Sheeler, and others.

RECEPTION

1940 (CONTINUED)

DECEMBER: Included in *Afro-American Art* at Fisk University, Nashville.

The Life of Frederick Douglass (1939) and *The Life of Harriet Tubman* (1940) exhibited at the Library of Congress, Washington, D.C., in commemoration of the 75th anniversary of the Thirteenth Amendment. *The Life of Harriet Tubman* is also exhibited at the Southside Community Art Center in Chicago.

Alain Locke's *The Negro in Art: A Pictorial Record of the Negro Artist and the Negro Theme in Art* is published, including reproductions of selected paintings from *The Life of Toussaint L'Ouverture.*

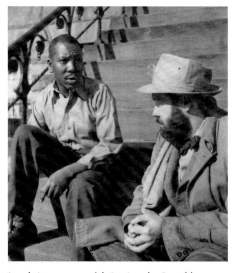

Jacob Lawrence with Jay Leyda, Brooklyn, 1941.
Courtesy of the Schomburg Center for Research in Black Culture, New York Public Library.

1941

JUNE–JULY: Edith Halpert of the Downtown Gallery and Alain Locke correspond regarding a comprehensive exhibition of African American art at her gallery that is to take place in December. Locke introduces Lawrence's work to Halpert, who introduces it to Deborah Calkins, an assistant art editor at *Fortune* magazine.

AUGUST 13: Halpert writes Lawrence in New Orleans to express her interest in representing him.

NOVEMBER: *Fortune* publishes a color portfolio of 26 panels of *The Migration of the Negro*, with text. The Downtown Gallery commemorates the event by exhibiting the series in the main gallery.

DECEMBER 9: *American Negro Art: Nineteenth and Twentieth Centuries*, the exhibition planned by Halpert and Locke and sponsored, in part, by Adele Rosenwald Levy, opens at the Downtown Gallery. It includes *The Migration of the Negro.*

LIFE

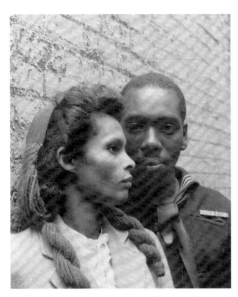

Jacob Lawrence and Gwendolyn Knight Lawrence, 1944.
Photograph by Arnold Newman.
Courtesy of Jacob and Gwendolyn Knight Lawrence.

1942
FEBRUARY–MAY: Visits relatives of his mother in Lenexa, Virginia, where he paints bleak scenes of rural life, labor, and poverty. Also experiments with oil paint, which he abandons.

APRIL 18: Secures $1,200 renewal of his Julius Rosenwald fellowship, which he plans to use to paint a group of paintings on life in Harlem when he returns to New York.

JUNE: Returns to New York and resides temporarily on Striver's Row before leaving to work as a summer art instructor at Wo-Chi-Ca (Workers Children's Camp) in Port Murray, New Jersey. While there, paints at least six theater backdrops for campers' plays including *Spring Plow*, a play about Thomas Jefferson; a French street for a play about Bastille Day; three for a play about Puerto Rico; and one for a Chinese play. The camp is loosely affiliated with the IWO (International Workers Organization), a Communist organization. Lawrence is recruited to join the Communist Party but never does.

FALL: Moves to an apartment at 72 Hamilton Terrace in Harlem, where he and Knight Lawrence remain for a year.

1943
SEPTEMBER: Moves from Harlem to 385 Decatur Street, Brooklyn, in the Bedford-Stuyvesant neighborhood, near Knight Lawrence's family.

OCTOBER: Inducted into U.S. Coast Guard as steward's mate; attends boot camp at Curtis Bay, Maryland. Stationed with an African American contingent at Ponce Training Station, St. Augustine, Florida, where he works as a steward at the officers' training camp and lives in an apartment above his commanding officer's garage. Writes to his dealer, Edith Halpert, of the horrible conditions for blacks in the South and notes that he plans to complete a group of drawings entitled *How the Negro Views the South*, which he hopes she can arrange to have published.

1944
Assigned to USS *Sea Cloud*, Boston, a weather patrol boat and the first racially integrated ship in U.S. naval history. The ship is commanded by Captain Carlton Skinner who promotes Lawrence to petty officer, 3rd Class, with public relations status that allows him to paint Coast Guard life full-time. Chooses atypical subjects for a combat artist, depicting scenes of daily life, rather than portraits of the officers, the ship, or images of war. When the USS *Sea Cloud* is decommissioned, Lawrence is reassigned to the USS *General Wilds P. Richardson*, a troop transport ship stationed in Boston that travels to England, Italy, Spain, Gibraltar, Port Said (Egypt), and Karachi (in present-day Pakistan). Completes sketches of his travels in spiralbound notebook.

Reception

1942

February: Adele Rosenwald Levy purchases the even-numbered works in *The Migration of the Negro* for the Museum of Modern Art, and Duncan Phillips agrees to exhibit the entire series at the Phillips Memorial Gallery in Washington, D.C. During the exhibition, Phillips purchases the remaining 30 panels.

April: Exhibits in group exhibition at the Downtown Gallery.

October: The Museum of Modern Art organizes a 15-venue national tour of *The Migration of the Negro* that ends at the museum in October 1944. The showing of the exhibition at the Portland Art Museum in Oregon coincides with racial unrest at the Kaiser Shipyards, and a public forum on race relations is held at the museum.

November: Four paintings are published in *Survey Graphic* as "How We Live in the South and North." The issue is edited by Alain Locke.

December: Awarded sixth purchase prize at *Artists for Victory: An Exhibition of Contemporary American Art* at the Metropolitan Museum of Art.

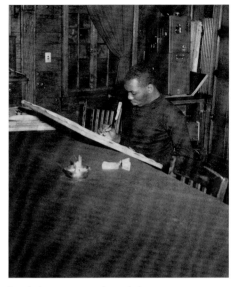

Jacob Lawrence on board the
USS *Sea Cloud,* ca. 1944.
Photograph by Harvey C. Russell, Jr.
Courtesy of Jacob and Gwendolyn Knight Lawrence.

1943

May: Solo exhibition of the Harlem paintings at the Downtown Gallery receives favorable reviews in a variety of publications. *Newsweek* compares Lawrence's talents with those of Paul Robeson, Richard Wright, and W. C. Handy. *ARTnews* comments that the paintings are even better than those in *The Migration of the Negro,* for which Lawrence has become widely known.

Included in the Brooklyn Museum's watercolor biennial and the University of Nebraska's annual and in *Paintings and Sculpture by American Negro Artists* at the Institute for Modern Art, Boston.

Publication of James A. Porter's *Modern Negro Art,* which includes the work of Lawrence, Horace Pippin, and William Edmondson in a chapter entitled "Naïve and Popular Painting and Sculpture."

1944

April: Included in *American Negro Art: Contemporary Painting and Sculpture* at the Newark Museum, New Jersey.

October: Solo exhibition at the Museum of Modern Art, *Paintings by Jacob Lawrence: Migration of the Negro and Works Made in U.S. Coast Guard,* which receives positive reviews. *Art Digest* notes of the *Migration* series that "no professional sociologist could have stated the case with more clarity or dignity" and that the Coast Guard paintings are "handsome in their simplified yet somehow sophisticated design."

LIFE

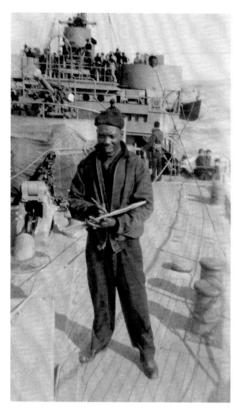

Jacob Lawrence on deck of the
USS *Richardson*, ca. 1945.
Photographer unknown.
Courtesy of Jacob and Gwendolyn Knight Lawrence.

1944 (CONTINUED)
Sister, Geraldine, dies of tuberculosis.

1945
Decides to paint series depicting experience of war. Applies for a John Simon Guggenheim Post Service fellowship. Alfred Barr, Francis Henry Taylor (director, The Metropolitan Museum of Art), and Robert Tyler Davis (director, Portland Museum of Art, Oregon) write letters of recommendation. Receives fellowship notification of award in October while still in the service.

DECEMBER 6: Discharged from U.S. Coast Guard and returns to Brooklyn, where he begins paintings of laborers: shoeshine boys, domestic servants, seamstresses, and carpenters.

1946
Begins work on the *War* series, painting the panels individually and signing them as they are completed rather than working on them simultaneously as he did with his earlier series.

JULY 2–AUGUST 28: Teaches in the summer session at Black Mountain College in Asheville, North Carolina, at the invitation of Josef Albers. Albers hires a private train car to transport the Lawrences to and from Asheville so they need not move to the "colored" section of the train at the Mason-Dixon Line. The Lawrences never leave the school's campus during their ten-week stay.

RECEPTION

1944 (CONTINUED)
Included in the Museum of Modern Art exhibition *Twelve Contemporary Painters*, which travels to 12 venues. Included in annuals at the Art Institute of Chicago, Atlanta University, the University of Nebraska, and the City Art Museum, Saint Louis.

1945
JANUARY: Included in *The Negro Artist Comes of Age* at the Albany Institute of History and Art.

MARCH: Included in *Four Modern American Painters: Peter Blume, Stuart Davis, Marsden Hartley, Jacob Lawrence* at the Institute for Modern Art, Boston.

NOVEMBER: Included in *1945: New Painting and Sculpture by Leading American Artists* at the Downtown Gallery.

DECEMBER: *The Life of John Brown* (1941) is exhibited for the first time at the Downtown Gallery and begins a 15-venue United States tour, sponsored by the American Federation of Arts. The series receives positive reviews in the mainstream art press. *Art Digest* notes that Lawrence "has made of this saga a powerful and compelling series. Simplified in approach, and, in several instances, highly abstract, they are never obscure in their import and their message is amplified through the technique employed."

Included in annuals at the Whitney Museum of American Art, the California Palace of the Legion of Honor, and the City Art Museum, St. Louis. Included in biennials at the Brooklyn Museum and the Los Angeles County Museum of Art.

1946
JANUARY: Receives achievement award from *New Masses* at a dinner "honoring Negro and white Americans whose achievements in the arts, sciences, and public life are major contributions toward greater racial understanding." Other award recipients include Mary McLeod Bethune, Alain Locke, W. E. B. Du Bois, and Paul Robeson.

MAY: Included in *Six Artists out of Uniform* at the Downtown Gallery.

Included in annuals at the Whitney Museum of American Art, the Art Institute of Chicago, and the University of Nebraska.

JUNE: Included in *American Painting, from the Eighteenth Century to the Present Day* at the Tate Gallery, London.

NOVEMBER: Included in *Exposition internationale d'art moderne* at the Musée d'Art Moderne, Paris.

DECEMBER: Included in *Three Negro Artists: Horace Pippin, Jacob Lawrence, Richmond Barthé* at the Phillips Memorial Gallery, Washington, D.C.

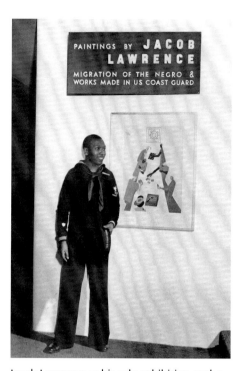

Jacob Lawrence at his solo exhibition at the Museum of Modern Art, 1944.
Photographer unknown.
Courtesy of Jacob and Gwendolyn Knight Lawrence.

LIFE

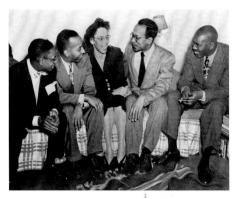

Send-off party for artist Charles White at home of Dorothy Spencer, 409 Edgecomb Avenue, Harlem, February 15, 1947.
Courtesy of the Schomburg Center for Research in Black Culture, New York Public Library.

1947

Commissioned by Walker Evans, then an editor at *Fortune* magazine, to execute paintings of Negro life in the Southern "Black Belt." Travels to Vicksburg, Mississippi, Tuskegee, Alabama, New Orleans, and Memphis. Three of the ten paintings are published in August 1948, with commentary by Evans.

FALL: Completes 14 paintings for the *War* series.

1948

Commissioned to create illustrations for Langston Hughes's *One-Way Ticket*, a collection of poems. Executes brush and ink drawings that differ significantly from earlier drawings in an attempt to find a style more compatible with printing technologies. Six drawings are included in the publication.

Completes commissions for *New Republic* and *Masses and Mainstream* (also 1949).

1949

Conceives of idea of painting series on "a history of the Negro people in the United States." Begins project five years later (1954) as *Struggle . . . From the History of the American People.*

JULY: Voluntarily enters Hillside Hospital, Queens, New York, for treatment of depression. Edith Halpert contributes to his medical expenses, helps Knight Lawrence find employment, and provides Lawrence with art supplies, which he uses to paint images of life in the hospital. He remains at Hillside Hospital for four months, leaving on November 12.

1950

JANUARY 16: Returns to Hillside for a seven-month stay. Continues to paint images of hospital life with a focus on modern forms of therapy. Remains a resident until August 4.

RECEPTION

1947

NOVEMBER: *War* series (1946–7) exhibited for the first time at the New Jersey State Museum, Trenton, and then in December at the Downtown Gallery. *Time* magazine notes that the series is "by far his best work yet." *ARTnews* remarks that Lawrence "is one of the few painters who can make stylization and design function beyond decorative ends."

Included in annuals at the Whitney Museum of American Art, the Carnegie Institute, and the University of Iowa. Included in the Brooklyn Museum's watercolor biennial.

1948

APRIL: Wins first place purchase award in *Seventh Annual Exhibition of Paintings, Sculptures, Prints by Negro Artists* at Atlanta University.

SUMMER: Exhibits for first time at the Venice Biennale.

Included in annuals at the Brooklyn Museum, the Art Institute of Chicago (wins Norman Wait Harris medal), the Carnegie Institute, the Pennsylvania Academy of the Fine Arts, the California Palace of the Legion of Honor, the Butler Institute of American Art, the University of Iowa, the University of Nebraska, and the Whitney Museum of American Art.

Receives certificate of recognition from *Opportunity* magazine.

1949

SEPTEMBER: Included in the Whitney Museum of American Art's exhibition *Juliana Force and American Art: A Memorial.*

Included in annuals at the Whitney Museum of American Art, the Carnegie Institute, the Art Institute of Chicago, the Pennsylvania Academy of the Fine Arts, and the University of Nebraska. Included in the Brooklyn Museum's watercolor biennial.

1950

JANUARY: Included in two-person exhibition, *Little Show of Work in Progress: Paintings by Robert Gwathmey and Jacob Lawrence,* at the Detroit Institute of Arts.

OCTOBER 15: *New York Times Magazine* includes feature article on Lawrence's stay at Hillside Hospital—"An Artist Reports on the Troubled Mind." Exhibition of hospital paintings opens at the Downtown Gallery one week later to positive reviews in mainstream art press. A reviewer for *Art Digest* comments that "clearly nothing can destroy this artist's objectively discerning eye."

Publication of Oliver Larkin's seminal *Art and Life in America.* Larkin characterizes Lawrence as a social painter and writes that to "praise Lawrence for his ingenious

Jacob Lawrence at work on painting *Recreational Therapy* at Hillside Hospital, 1949. Photograph by Sid Bernstein, Riordan Studios. Courtesy of Jacob and Gwendolyn Knight Lawrence.

LIFE

Jacob Lawrence and cat, ca. 1950s.
Photograph by Dena.
Courtesy of Jacob and Gwendolyn Knight Lawrence.

1951

Attends numerous theatrical performances with Charles Alan, associate director
of the Downtown Gallery, and begins work on a group of paintings on this theme
inspired, in part, by productions at the Apollo Theater in Harlem.

1952

DECEMBER: Invited by the United States Information Agency to participate in an
international travel and lecture program with the goal, according to the agency's
letter, of "counteracting the widespread ignorance that exists abroad regarding the
United States." Declines invitation.

1953

Executes paintings depicting people playing games—checkers, chess, dominoes, and
cards (through 1958).

Edith Halpert and Charles Alan, a long-time employee of the Downtown Gallery,
agree to create a new gallery—the Alan Gallery—that will represent the work of the
younger artists from the Downtown Gallery stable, including Lawrence and Jack
Levine. The Downtown Gallery continues to represent only the artists who have
been with the gallery for 30 years or more, including Stuart Davis, Charles Sheeler,
and John Marin. Lawrence is unhappy with the new arrangement.

1954

Begins research at the Schomburg Library for a series of 60 paintings on the history
of the United States. Completes five study drawings by May.

MAY–JULY: Works as a fellow at the Yaddo Foundation, Saratoga Springs, New York,
where he continues work on the series, completing six paintings by the end of the
year.

DECEMBER 16: Applies for a Chapelbrook Foundation fellowship for $2,000 to con-
tinue work on a "pictorial history of the United States." Jay Leyda acts as a reference.
Lawrence projects that with the fellowship he will complete the series in two years.

1955

Begins teaching at Five Towns Music and Art Foundation, Cedarhurst, Long Island
(until 1962, and again 1966–8), and at Pratt Institute, New York.

RECEPTION

1950 (CONTINUED)

patterns was to belittle their meaning as the shapes of tortured and congested living, the arabesques of white brutality."

Included in annuals at the Whitney Museum of American Art, the Pennsylvania Academy of the Fine Arts, and the Virginia Museum of Fine Arts.

1951

MAY: Receives honorary award from the Committee for the Negro in the Arts.

Exhibits in the São Paulo Bienal.

Included in annual at the Whitney Museum of American Art and the Brooklyn Museum's watercolor biennial.

1952

APRIL: Wins award in the Brooklyn Museum's biennial of the Society of Brooklyn Artists.

Included in annuals at the Whitney Museum of American Art and the University of Illinois.

1953

JANUARY: Solo exhibition, *Performance: A Series of New Paintings in Tempera by Jacob Lawrence*, at the Downtown Gallery. Mainstream press is positive but less exuberant than for previous exhibitions. *Art Digest* notes that Lawrence has abandoned social content, addressing instead problems of "expression and technique."

Included in annual at the Whitney Museum of American Art and biennial at the Brooklyn Museum.

1954

OCTOBER: Included in *Twenty-Fifth Anniversary Exhibition* at the Museum of Modern Art.

Included in annuals at the Pennsylvania Academy of the Fine Arts and the Virginia Museum of Fine Arts.

Jacob Lawrence, 1950s.
Photographs by William Grigsby.
Courtesy of Jacob and Gwendolyn
Knight Lawrence.

1955

JANUARY: Exhibits in two-person show, *Reuben Tam and Jacob Lawrence,* at the Philadelphia Art Alliance.

Jacob Lawrence and Gwendolyn Knight Lawrence, Brooklyn, 1947.
Photograph by Irving Penn.
Courtesy of Jacob and Gwendolyn Knight Lawrence.

Jacob Lawrence, 1957.
Photograph by Budd.
Courtesy of Jacob and Gwendolyn Knight Lawrence.

LIFE

Jacob Lawrence and Gwendolyn Knight
Lawrence, 1958.
Photograph by Peter Fink.
Courtesy of Jacob and Gwendolyn Knight Lawrence.

1955 (CONTINUED)

MAY: Invited to enter mural competition for the United Nations Building in New York. During summer, completes study for the mural, which is exhibited in the fall with the five other finalists at the Whitney Museum of American Art. Shares first prize with Stuart Davis, but the mural is never executed owing to a lack of funding.

SEPTEMBER–NOVEMBER: Visits Yaddo Foundation on his second fellowship. Continues work on the new series, *Struggle . . . From the History of the American People*, completing an additional ten panels by the end of the year.

DECEMBER: Purchases an apartment at 130 Edwards Street, in downtown Brooklyn.

1956

Completes first 30 panels of *Struggle . . . From the History of the American People* series.

1957

Charles Alan, Lawrence's dealer, restructures his business, deciding to reduce his stable of artists from twenty to six and to buy works wholesale from other artists rather than sell them on a consignment basis. Lawrence is not one of the six artists to be represented by Alan.

Decides not to complete the remaining 30 panels of *Struggle . . . From the History of the American People* series.

Serves as president of the New York chapter of the National Institute of Arts and Letters.

1958

OCTOBER: Joins faculty at Pratt Institute, New York (until 1970).

In a letter to Jay Leyda, writes: "As you probably know, things here are very exciting —the big issues at this time are whether or not to have integration in the public schools . . . and trying to reach the moon. Both seem to be a little time off still. I think the moon problem will be solved before the one on integration."

Reception

1955 (CONTINUED)

OCTOBER: Included in *Mural Sketches and Sculpture Models* at the Whitney Museum of American Art.

Included in annual at the University of Illinois.

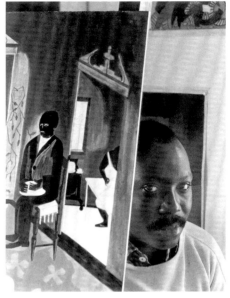

Jacob Lawrence with *The Visitors*, 1959.
Photograph by Arnold Newman.
Courtesy of Jacob and Gwendolyn Knight Lawrence.

1956

DECEMBER: *Struggle . . . From the History of the American People* (1954–6) exhibited at the Alan Gallery. Exhibition is favorably reviewed in *Time* magazine, which notes that "the fluid balance between abstraction and realist rendering is the most interesting . . . facet of this suite of illustrations." Art press coverage is widespread but mostly descriptive, on several occasions comparing the works with murals of the 1930s.

Exhibits in the Venice Biennale.

Included in annual at the Virginia Museum of Fine Arts and biennial at the Brooklyn Museum.

1957

OCTOBER: Receives the Pyramid Club Award for achievement in painting.

Included in annual at the Whitney Museum of American Art.

Selden Rodman, an authority on Haitian and American folk art, describes Lawrence as "the ablest painter the Negro race has so far produced in America—perhaps anywhere."

1958

MAY: *Struggle . . . From the History of the American People* is exhibited again at the Alan Gallery. Series is sold intact to a collector who breaks it up and sells panels individually over a 30-year period.

Included in annuals at the Des Moines Art Center and the Whitney Museum of American Art.

1959

APRIL: Included in *Art: USA: 59, A Force, A Language, A Frontier*, organized by Lee Nordness at the New York Coliseum.

LIFE

1960

Completes paintings on library theme.

1961

Decides to travel to Africa, but visa is denied by State Department. Writes to Edith Halpert for assistance. Gwendolyn Knight Lawrence applies for U.S. passport and is denied; later able to obtain British passport because she was born in Barbados and could claim dual citizenship.

Begins paintings on contemporary civil rights and the themes of interracial marriage, integrated education, and nonviolent protest.

1962

Becomes associated with the gallery Terry Dintenfass Inc., New York, through the encouragement of the painters Robert Gwathmey and Philip Evergood who also show there.

OCTOBER 31–NOVEMBER 4: Is granted visa and travels to Nigeria, accompanying an exhibition of his work. Lectures on the influence of African sculpture on European and American modernist art, particularly Cubism.

1963

Serves as president of the artists' committee of Student Non-Violence Coordinating Committee (SNCC); Ad Reinhardt serves as vice-president.

Reception

1959 (CONTINUED)

JULY: Included in *American Sculpture and Painting: American National Exhibition in Moscow*, which is later exhibited at the Whitney Museum of American Art.

DECEMBER: Selected by the Ford Foundation for a nationally touring retrospective to be circulated by the American Federation of Arts in 1960.

Included in annual at the University of Illinois.

1960

MAY: Solo retrospective opens at Brooklyn Museum and tours nationally to 16 other venues, mostly galleries and libraries at historically black colleges. Exhibition is accompanied by a catalogue containing an essay by Aline Louchheim Saarinen. Saarinen characterizes Lawrence as a narrative painter and "an artistic anomaly." She defends his work against the label of "primitive" by noting "the greater dimension of his experience and perception" but also "his conscious sensitivity to and control over his artistic means." Critical response to the exhibition in *Time* magazine and the mainstream art press is overwhelmingly positive. *ARTnews* notes that Lawrence is "undoubtedly one of the few painters who can handle a social message and painting simultaneously."

Cedric Dover's *American Negro Art* is published, which refers to Lawrence as a "unique episodic painter" and describes him as a "primitive by intention."

1961

OCTOBER: Solo exhibition, *Jacob Lawrence: Painting Exhibition*, at the Washington Federal Savings and Loan Association of Miami Beach, Florida.

DECEMBER: Exhibits in group show at the American Society of African Culture (AMSAC) offices in Lagos, Nigeria.

Included in annuals at the Whitney Museum of American Art and the University of Illinois.

1962

OCTOBER: Solo exhibition in Lagos and Ibadan, Nigeria, organized by the AMSAC and the Mbari Artists' and Writers' Club Cultural Center, which includes selections from *The Migration of the Negro* (1941) and *War* (1946–7), at Lawrence's recommendation.

DECEMBER: *The Migration of the Negro* exhibited at the Phillips Collection, Washington, D.C.

1963

MARCH: Solo exhibition at Terry Dintenfass Inc., New York, of paintings pertaining to the civil rights struggles in the United States. Press is positive. *Arts* magazine states that "his skill at expressing his feelings in dense, well-composed patterns continues

LIFE

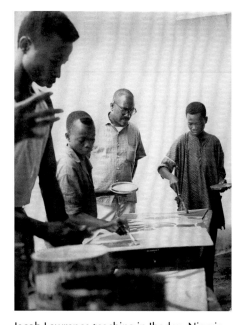

Jacob Lawrence teaching in Ibadan, Nigeria, 1964.
Photographer unknown.
Courtesy of Jacob and Gwendolyn Knight Lawrence.

1963 (CONTINUED)

Completes his first limited-edition print, an image of a black protestor being carried away by two white police officers (*Two Rebels*). The print is also published as a poster for his first exhibition at Terry Dintenfass Inc.

Serves on the advisory board for the founding of the Museum of African Art in Washington, D.C., and on the coordinating committee for an exhibition of contemporary African art that is sponsored by the American Society of African Culture (AMSAC) and exhibited in Nigeria in 1964. Among other committee members are James A. Porter, Ulli Beier, and J. Newton Hill.

1964

APRIL–NOVEMBER: Sells apartment in New York and returns to Nigeria with Knight Lawrence to teach and to "steep myself in Nigerian culture so that my paintings, if I'm fortunate, might show the influence of the great African artistic tradition." They are blacklisted on their arrival in Lagos and are unable to secure housing because, as Lawrence wrote to Jay Leyda, "of my so-called background." Aware that they are under constant surveillance by U.S. intelligence, they plan to leave Nigeria for Italy and then return to the U.S., where they promise to pursue a high-visibility lawsuit through the ACLU. They are encouraged to stay and are provided a car and driver. They remain in Lagos for a total of four months, then move to Ibadan for four months before returning to the United States. While in Nigeria, Lawrence completes paintings and drawings of African life and experiments with new painting techniques.

1965

FEBRUARY–MAY: At the invitation of Mitchell Siporin, an artist with whom Lawrence exhibited at the Downtown Gallery in the 1940s, works as artist-in-residence at Brandeis University, Waltham, Massachusetts. Executes drawings of student protests and police brutality as well as the first known self-portraits. Also continues to paint scenes of Nigeria (through 1966). Commutes to campus from an apartment on Brattle Street in Cambridge.

Returns to New York, moving into an apartment at 211 West 106th Street.

Helps organize an exhibition of work by black artists residing in the United States to be shown in Dakar, Senegal. Other members of the committee include Charles Alston, Henry Geldzahler, William Lieberman, Roy Moyer, James A. Porter, Charles White, and Hale Woodruff.

Serves as a member of the National Screening Committee for the Fulbright-Hays scholarship program (until 1967).

RECEPTION

1963 (CONTINUED)

to be impressive." *Newsweek* notes that "the force of Lawrence's paintings depends on his being a Negro as much as the force of James Baldwin's writing depends on his being a Negro. He has always painted his own world, as any artist does, and it happens that his world is that of the American Negro at mid-century."

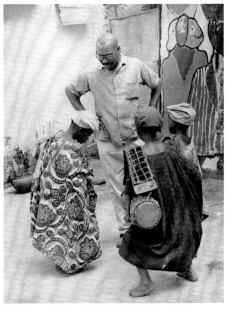

Jacob Lawrence in Ibadan, Nigeria, 1964.
Photographer unknown.
Courtesy of Jacob and Gwendolyn Knight Lawrence.

1964

MAY: Included in *The Portrayal of the Negro in American Painting* at Bowdoin College, Brunswick, Maine.

NOVEMBER: Two-person exhibition, *Jacob Lawrence and Gwendolyn Lawrence*, opens at the AMSAC offices in Lagos, Nigeria.

Exhibits in annuals at the Pennsylvania Academy of the Fine Arts and the Whitney Museum of American Art.

1965

JANUARY: Solo exhibition of paintings and drawings created in Nigeria at Terry Dintenfass Inc. Exhibition receives mixed reviews by mainstream art press, which critiques the work for being decorative and minutely patterned.

MARCH: Solo exhibitions at Brandeis University, Waltham, Massachusetts, and Morgan State College, Baltimore.

Exhibits in annual at the Whitney Museum of American Art.

Elected into the American Academy of Arts and Letters.

Life

1966

Begins teaching at the New School for Social Research, New York (until 1969).

Brother, William, dies in New York of drug overdose.

Commissioned by *Time* magazine to paint a portrait of Stokely Carmichael. Travels to Atlanta to meet Carmichael at SNCC headquarters shortly before Carmichael steps down as chairman.

1967

Teaches Life Drawing, Painting, and Composition course at the Art Students League, New York (through 1969; on leave of absence 1969–71), where former mentor Charles Alston has taught since the 1950s.

Creates paintings for *Harriet and the Promised Land*, which is published in 1968 by Windmill Books, a division of Simon & Schuster. Several paintings are not included in the final publication, including one that depicts Harriet Tubman with a gun.

1968

SUMMER: Teaches at Skowhegan School of Painting and Sculpture in Maine.

SEPTEMBER 12: Participates in symposium "The Black Artist in America" at the Metropolitan Museum of Art. Is referred to by moderator Romare Bearden as "America's foremost Negro painter" but is challenged by Tom Lloyd, fellow panelist and an active participant in the black arts movement.

Begins regularly incorporating images of builders, carpenters, and cabinetmakers into his paintings. The builders motif becomes a primary element in his work over the next 30 years. Begins dozens of pencil studies based on the woodcuts of Andreas Vesalius, a sixteenth-century Italian doctor who made elaborate drawings of cadavers.

1969

Commissioned by Windmill Books, Simon & Schuster to illustrate *Aesop's Fables*. Completes 23 ink drawings.

SUMMER: Teaches at Skowhegan School of Painting and Sculpture. Declines invitations to teach at State University College in Buffalo and at Harvard University.

SEPTEMBER: Mother dies.

Reception

1966

FEBRUARY: 21 panels from *Struggle . . . From the History of the American People* exhibited at the Martin Gallery, New York.

APRIL: Included in *Ten Negro Artists from the United States* at the First World Festival of Negro Arts, Dakar, Senegal. Also in ACA Galleries exhibition *Protest Paintings— USA: 1930–1945.*

SEPTEMBER: Included in *The Negro in American Art* at UCLA and *Art of the United States: 1670–1966* at the Whitney Museum of American Art.

Included in annual at the Pennsylvania Academy of the Fine Arts.

1967

SEPTEMBER: Included in *The Portrayal of Negroes in American Painting: United Negro College Fund Exhibition* at the Forum Gallery, New York.

OCTOBER: Included in *The Evolution of Afro-American Artists: 1800–1950* at City College of New York, organized by the Harlem Cultural Council.

Included in annuals at the Carnegie Institute and the Pennsylvania Academy of the Fine Arts.

1968

JANUARY: Solo exhibition of *Paintings for Harriet and the Promised Land* (1967) at Terry Dintenfass Inc. Reviews in mainstream art press are positive but largely descriptive. *Arts* notes that "Lawrence undeniably understands how illustrations should work—not as a repetition of text but as its natural complement to accelerate the action." Included in *Six Black Artists* at Dartmouth College, Hanover, New Hampshire.

OCTOBER: Included in *Thirty Contemporary Black Artists* at the Minneapolis Institute of Arts. Travels to 12 additional venues.

DECEMBER: Solo exhibition of *The Life of Toussaint L'Ouverture* at Fisk University, Nashville.

Carroll Greene, Jr., begins research for a major monograph on Lawrence to be published by Harry N. Abrams. Completes interview with Lawrence for the Archives of American Art Oral History Program.

1969

FEBRUARY: Included in *American Art of the Depression Era* at Amherst College, Massachusetts.

NOVEMBER: *The Life of Toussaint L'Ouverture* exhibited at the Studio Museum in Harlem. *The Migration of the Negro* exhibited at Saint Paul's School, Concord, New Hampshire.

Included in annual at the Whitney Museum of American Art.

LIFE

1969 (CONTINUED)

SEPTEMBER–MARCH 1970: Visiting artist at California State College, Hayward, at invitation of the painter Raymond Saunders with whom he and Knight Lawrence live.

1970

MARCH: Nominated for membership in the National Academy of Design but is not elected.

MARCH–JUNE: Visiting artist, University of Washington, Seattle.

SUMMER: Teaches at Skowhegan School of Painting and Sculpture in Maine.

SEPTEMBER: University of Washington offers Lawrence a full professorship, which he accepts. Pratt Institute counters by appointing him full professor, coordinator of the arts, and assistant to the dean.

1971

Moves with Knight Lawrence to suburban neighborhood in Seattle near the University of Washington, residing at 4316 37th Street NE. Sets up studio in his attic, where he works until 1995.

SEPTEMBER: Travels to London, Paris, and Munich.

Commissioned by Edition Olympia to create a silk-screen print for the 1972 Munich Olympic Games. Creates image of five black runners with obvious references to Jesse Owens's triumphant victory in Berlin in 1936.

Jacob Lawrence at Skowhegan School of Painting and Sculpture, 1969. Left to right: Eugene Tellez, Al Blaustein, Lawrence, Ezio Martinelli, Bob Goodnough, Jim Weeks. Photographer unknown. Courtesy of Francine Seders Gallery.

1972

SUMMER: Spends six weeks in New York, creating limited-edition prints and working with Carroll Greene, Jr., on forthcoming monograph.

Travels to Munich Olympics as a guest of the Olympic Games Committee.

Commissioned by the Washington State Capitol Museum to create "one or more paintings" based on the story of George Washington Bush, an African American

Reception

1970

FEBRUARY: Included in *Dimensions of Black* at La Jolla Museum of Art, California.

Included in *Five Famous Black Artists*, organized by Edmund Barry Gaither at the Museum of the National Center of Afro-American Artists in Roxbury, Massachusetts.

MAY: Included in *Afro-American Artists, New York and Boston* at the Museum of the National Center of Afro-American Artists; solo exhibition, *Jacob Lawrence: Work in Progress*, at the Henry Art Gallery, University of Washington, Seattle.

Becomes the first visual artist to receive the Spingarn Medal, the NAACP's highest award.

1971

APRIL: Included in *Contemporary Black Artists in America* at the Whitney Museum of American Art.

MAY: Included in *Black Artists: Two Generations* at the Newark Museum, New Jersey. *The Life of John Brown* (1941) exhibited at the Detroit Institute of Arts.

JULY: Included in *The Artist As Adversary* at the Museum of Modern Art.

OCTOBER: Included in *Art by Black Americans: 1930–1950* at the Smithsonian Institution.

NOVEMBER: Carroll Greene, Jr., visits Seattle for several days to interview Lawrence for forthcoming book.

Publication of Elton Fax's *Seventeen Black Artists*, which includes Lawrence. Fax discusses work from the 1940s and 1960s but not the 1950s and states that "not a single trace of irritation, anger, and bitterness that motivated his type of art expression ever invaded Lawrence's public oral statements. He reserved them, instead, for his paintings."

1972

NOVEMBER: Charles Alan, who was Lawrence's dealer in the 1950s, joins staff at Terry Dintenfass Inc. and replaces Carroll Greene, Jr., as author of the monograph to be published by Abrams.

Whitney Museum of American Art begins research for traveling retrospective of Lawrence's work, hiring Milton W. Brown, a noted authority on American art and social realism, to write the catalogue.

LIFE

1972 (CONTINUED)

pioneer who was one of the original settlers of Washington State. Proposes creating one painting and four finished drawings, but instead completes five paintings (in 1973).

1973

Travels to Barbados.

Jacob Lawrence in his studio at the University of Washington, 1971.
Photograph by Mary Randlett.

Jacob Lawrence, ca. 1974.
Photography by Anthony Barbozza. Courtesy of Jacob and Gwendolyn Knight Lawrence.

1974

The Detroit Institute of Arts, for reasons of conservation, refuses to lend the complete *John Brown* series to Lawrence's retrospective at the Whitney Museum of Art. The DIA approaches Lawrence about translating the paintings into silk-screen prints so they can accommodate requests for the series. Works with Ives-Silman, the New Haven–based workshop associated with Josef Albers. Project is completed in 1977.

Commissioned by Lorillard Tobacco company to create a limited-edition print to be included in a bicentennial portfolio that includes works by Robert Indiana, Larry Rivers, Alex Katz, Marisol, and others. Creates silk-screen print on the subject of black suffrage.

1975

Begins association with Francine Seders Gallery, Seattle. Gallery has long history of representing University of Washington professors and prominent Northwest modernists including Mark Tobey and Kenneth Callahan.

RECEPTION

1972 (CONTINUED)

Exhibits in annual at the Whitney Museum of American Art.

Romare Bearden and Harry Henderson's *Six Black Masters of American Art* is published, which includes Lawrence, Joshua Johnston, Robert Scott Duncanson, Henry Ossawa Tanner, Horace Pippin, and Augusta Savage.

Receives honorary doctorates from Pratt Institute, New York, and Denison University, Granville, Ohio.

1973

SEPTEMBER: Included in *Blacks: USA: 1973* at the New York Cultural Center.

OCTOBER: Paintings of builders exhibited for the first time at Terry Dintenfass Inc.

Elsa Honig Fine's *The Afro-American Artist: A Search for Identity* is published. Fine writes that "Lawrence seemed to fulfill all that Alain Locke had hoped for in the Black artist. He painted his people with warmth and humor but without sentimentality, utilizing the rhythms and patterns derived from his African heritage." In her opinion, eventually Lawrence became an "illustrator of the first order, but he thereby failed to fulfill his early promise as a leader of a school of Afro-American artists."

Charles Alan completes draft of the monograph. Abrams secures photographs and permissions but puts publication on hold because of Alan's death.

1974

MAY: The Whitney Museum of American Art opens retrospective of Lawrence's paintings that travels to five other U.S. venues. Milton Brown's essay characterizes Lawrence as a social painter who "addresses universal concerns from the vantage of his particular experience as a black person." States that Lawrence was "the first wholly authentic voice of the Black experience in the plastic arts." Discusses his work as an anomaly, as stylistically unique, noting that from the outset "he avoided the appearance of sophistication, though his use of 'expressionist' distortion would indicate an awareness of modern art forms." The exhibition receives positive reviews in the mainstream art press. *Art in America* describes the work as narrative and notes that Lawrence "has put back into painting everything that recent history has concentrated on removing." Also notes that "by an almost violent elimination of extraneous detail, he sums up the event or scene in a quintessential image that sticks in the mind long afterwards."

SEPTEMBER: Included in *Directions in Afro-American Art* at Cornell University, Ithaca, New York.

1975

OCTOBER: Included in *The Black Presence in Art* at the Saint Louis Art Museum.

NOVEMBER: Included in *Jubilee: Afro-American Artists on Afro-America* at the Museum of the National Center of Afro-American Artists in Roxbury, Massachusetts.

LIFE

1975 (CONTINUED)

Commissioned by Transworld Art to create a print for a bicentennial portfolio titled *An American Portrait*. Depicts a moment of confrontation between police dogs and marchers during the 1965 peace march from Selma, Alabama, to Montgomery.

1976

Cofounds the Rainbow Art Foundation in New York with Romare Bearden, Willem de Kooning, and Bill Caldwell to assist young printmakers in the production, exhibition, and marketing of their work. Foundation supports the work of artists whose art is seldom seen by the general public, including the work of "indians, eskimos, asians, hispanics, and blacks."

1977

Commissioned by the Presidential Inaugural Committee in Washington, D.C., to create a limited-edition print for a portfolio commemorating the inauguration of President Jimmy Carter. Rather than create a portrait of the president, he depicts an ethnically diverse crowd straining to see the event from a great distance.

Completes translation of *The Life of John Brown* to silk-screen print.

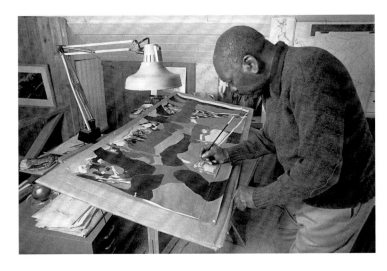

Jacob Lawrence working on maquette for *Games*, 1978.
Photograph by Mary Randlett.

1979

Completes first mural commission—*Games*—for Kingdome Stadium in Seattle, Washington. Completes six additional murals over the next 12 years.

Reception

1976

JUNE: Included in United States Information Agency exhibition *Two Hundred Years of American Painting, 1776–1976,* which travels to Europe.

SEPTEMBER: Included in David Driskell's exhibition *Two Centuries of Black American Art* at the Los Angeles County Museum of Art.

OCTOBER: Solo exhibition, *Graphics by Jacob Lawrence,* at the Francine Seders Gallery.

Appointed elector for Hall of Fame for Great Americans; receives honorary doctorate from Colby College, Waterville, Maine.

Harry N. Abrams resumes plans to publish Lawrence monograph, commissioning Lawrence to execute a limited-edition print that will be used as a fund-raiser to offset publication costs.

1977

NOVEMBER: Included in *New York/Chicago: WPA and the Black Artist* at the Studio Museum in Harlem.

1978

MARCH: Solo exhibitions at Terry Dintenfass Inc. and Spelman College, Atlanta.

OCTOBER: *The Life of John Brown* exhibited at the Detroit Institute of Arts.

DECEMBER: Included in *Representations of America* at the Pushkin Museum, Moscow.

Artist and art historian Samella Lewis, in *Art: Afro-American,* notes that "Lawrence represents with distinction the first generation of recognized artists nurtured by the Black experience: his community was Black, his early teachers were Black, and his first encouragement came from Blacks. . . . As important as the fact that Lawrence is probably the best known, most published, and most influential living Black American artist is the fact that he is a humble man of great personal stature."

Appointed commissioner of the National Council of Arts by President Jimmy Carter.

1979

OCTOBER: Solo exhibition, *Jacob Lawrence: Paintings and Graphics from 1936 to 1978,* at the Chrysler Museum of Art, Norfolk, Virginia.

LIFE

1980

Completes mural—*Explorations*—for Howard University, which depicts the 12 academic disciplines of the university, dedicated to the black educator Mary McLeod Bethune.

1981

In addition to executing paintings, prints, and murals for commissions, begins to concentrate on drawing. Completes a group of ten graphite drawings—images of labor and family life.

1982

Commissioned by the Limited Editions Club to complete original artwork for translation to silk-screen prints and inclusion in a limited-edition book. Chooses John Hersey's *Hiroshima* (1946), creating eight paintings that depict Hiroshima after the detonation of the atomic bomb.

Jacob Lawrence on the stairs to his attic studio, Seattle, 1983.
Photograph by Mary Randlett.

Worktable with paints, pigments, and brushes.
Photograph by Mary Randlett.

1983

Retires from teaching, becoming professor emeritus at the University of Washington.

1984

Completes second mural for Howard University entitled *Origins*, 12 images pertaining to African American life and history.

Reception

1980

January: Included in *Six Black Americans: Benny Andrews, Romare Bearden, Sam Gilliam, Richard Hunt, Jacob Lawrence, Betye Saar* at the New Jersey State Museum, Trenton.

1981

Receives honorary doctorate from Carnegie-Mellon University, Pittsburgh.

1982

January: Solo exhibition, *Jacob Lawrence: The Builder,* at the Mississippi Museum of Art, Jackson.

April: Solo exhibition at the Museum of African-American Art, Santa Monica College, California.

August: Solo exhibition of new drawings at the Francine Seders Gallery.

September–December: *The Life of Toussaint L'Ouverture* exhibited at the Conference for the Council of Churches, New York, and at the Lowe Art Museum, Coral Gables, Florida.

1983

January: Solo exhibition of new drawings at Terry Dintenfass Inc.

February: Solo exhibition at Stockton State College, Pomona, New Jersey.

March: Included in *Celebrating Contemporary American Black Artists* at the Fine Arts Museum of Long Island, Hempstead, New York.

October–December: *The Life of Toussaint L'Ouverture* exhibited at Howard University, Washington, D.C., and the Hampton University Museum, Virginia.

Elected to the National Institute of Arts and Letters.

1984

January: Included in *The Rhythm of Life: Selected Works by Bearden, Gwathmey, and Lawrence* at the Alexandria Museum of Art, Louisiana. Solo exhibition at the Massachusetts College of Art, Boston.

February: Included in *A Blossoming of New Promise: Art in the Spirit of the Harlem Renaissance* at Hofstra University, Hempstead, New York.

April: Included in *Since the Harlem Renaissance: Fifty Years of Afro-American Art,* which opens at Bucknell University, Lewisburg, Pennsylvania, and travels to five other venues.

LIFE

1985

Creates group of 18 colored-pencil drawings on builders theme.

Completes mural entitled *Theater* for University of Washington performance hall.

1986

Begins working with Lou Stovall Workshop, Inc., Washington, D.C., to re-create images from *The Life of Toussaint L'Ouverture* as silk-screen prints. Lawrence alters many of the images in the print format, heightening the drama of the original series.

1987

Commissioned by the Washington State Arts Commission Art in Public Places Program to design two murals for the rotunda of the Washington State Capitol. Completes the cartoons for the murals—*Debate I* and *Debate II*—but resigns from the project after the recently completed murals of Michael Spafford, a University of Washington colleague, are covered with a curtain.

1988

Completes two murals: *Community*, for the Joseph P. Addabbo Federal Building in Queens, New York; and *Space, Time, Energy* for the Orlando International Airport, Florida.

1989

Commissioned by the Limited Editions Club to create original artwork for translation to silk-screen prints and inclusion in an artist's book. Chooses to illustrate the Book of Genesis, creating eight paintings.

Reception

1984 (continued)

September: *The Life of Toussaint L'Ouverture* exhibited at the Portland Art Museum, Oregon.

December: Solo exhibition, *Jacob Lawrence: Fifty Years of His Work*, at the Jamaica Arts Center, New York.

Receives honorary doctorate from the State University of New York, and the Washington State Governor's Award.

1985

September: Included in *Hidden Heritage: Afro-American Art, 1800–1950*, which opens at the Bellevue Art Museum, Washington, and travels to nine other venues.

December: Solo exhibition of colored-pencil drawings at the Francine Seders Gallery.

Receives honorary doctorate from Howard University, Washington, D.C.

1986

July: Retrospective organized by the Seattle Art Museum tours nationally accompanied by the first major publication on the artist's work—Ellen Harkins Wheat's *Jacob Lawrence: American Painter*. Wheat characterizes Lawrence as a social painter whose sensibility was formed in Harlem during the depression. Book reproduces many formerly unpublished paintings, provides previously unpublished biographical detail, and addresses issues of artistic influence and the politics of being a successful African American artist in a predominately white art world.

Receives honorary doctorate from Yale University.

1987

January: Included in *Works by Artists Who Are Black* at the Arkansas Arts Center, Little Rock.

Receives honorary doctorate from Spelman College, Atlanta.

1988

October: Included in *Augusta Savage and the Art Schools of Harlem* at the Schomburg Center for Research in Black Culture, New York.

Receives the Artist Award from the College Art Association, the NAACP Third Annual Great Black Artists Award, and the Images Award for Outstanding Achievement in Art from the University of Pittsburgh.

1989

January: The artist and art historian Samella Lewis organizes two solo exhibitions—*Jacob Lawrence: Paintings and Drawings* and *Jacob Lawrence: Drawings and Prints*—which travel throughout the Caribbean and Africa, sponsored by the United States Information Agency.

LIFE

1990

Completes mosaic mural entitled *Events in the Life of Harold Washington* for new Harold Washington Library Center in Chicago.

1991

One of four artists commissioned by the New York City Metropolitan Transit Authority to design murals for a new subway complex at Times Square. Completes initial maquette in 1996; completes final maquette in 1997.

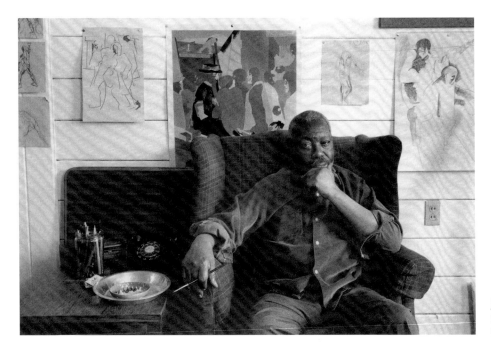

Jacob Lawrence in his studio, Seattle, 1991.
Photograph by Bruce W. Talaman.
Courtesy of Jacob and Gwendolyn Knight Lawrence.

Reception

1989 (CONTINUED)

FEBRUARY: Solo exhibitions, *Jacob Lawrence: The Washington Years*, at the Tacoma Art Museum, Washington, and *Jacob Lawrence: A Continuing Presence*, at Syracuse University.

SEPTEMBER: Included in *The Blues Aesthetic: Black Culture and Modernism*, which opens at the Washington Project for the Arts, Washington, D.C., and travels to four other venues.

Receives honorary doctorate from Tulane University.

1990

JANUARY: Included in *Facing History: The Black Image in American Art, 1710–1940*, organized by the Corcoran Gallery of Art, Washington, D.C. Solo exhibition at Arizona State University, Tempe.

Receives National Medal of Arts from President George Bush.

1991

FEBRUARY: *Jacob Lawrence: The Frederick Douglass and Harriet Tubman Series of 1938–40* begins its United States tour to 16 venues, accompanied by a catalogue by Ellen Harkins Wheat.

APRIL: Included in *American Abstraction at the Addison Gallery of American Art*, which travels nationally to eight venues.

Included in *Art of the Forties* at the Museum of Modern Art.

Peter Nesbett begins research on a catalogue raisonné of the artist's prints, which is sponsored by the Francine Seders Gallery, Seattle.

1992

JANUARY: Solo exhibition at the Whatcom Museum of History and Art, Bellingham, Washington.

FEBRUARY: Solo exhibition, *Jacob Lawrence: An American Master*, organized by East Carolina University, Greenville, North Carolina, travels nationally to seven other venues.

MARCH: Solo exhibition, *Jacob Lawrence: The Early Decades, 1935–1950* at the Katonah Museum of Art, New York.

NOVEMBER: Included in *Dream Singers, Storytellers: An African-American Presence*, which travels to Japan before it is exhibited at the New Jersey State Museum, Trenton. Rizzoli Publications publishes *Jacob Lawrence*, with an essay by Richard J. Powell, as part of its Art Series.

Receives honorary doctorates from New York University, Rochester University, and Bloomfield College. Receives the National Arts Award from Links, Inc.

LIFE

1993
Begins association with Midtown Payson Galleries, New York.

1994
Completes 12 paintings on the supermarket theme.

Jacob Lawrence, ca. 1993.
Photograph by Arnold Newman.
Courtesy of Jacob and Gwendolyn Knight Lawrence.

1995
NOVEMBER: Begins association with DC Moore Gallery, New York.

DECEMBER: Sells house and moves with Knight Lawrence to an apartment in downtown Seattle. Sets up a studio in an adjoining apartment.

Reception

1993

MAY: Solo exhibition, *Jacob Lawrence: An Exhibition Presented by the Black Alumni of Pratt Institute,* at Pratt Institute, Brooklyn, New York.

SEPTEMBER: *The Migration of the Negro* exhibited at the Phillips Collection in Washington, D.C. under the title *The Migration Series.* A two-year tour follows, accompanied by a multiauthor catalogue edited by Elizabeth Hutton Turner. Exhibition receives tremendous critical response nationwide. *Time* magazine critic Robert Hughes remarks that the paintings "constitute the first, and arguably the best treatment of black American historical experience by a black artist" and that "they are of far greater power than almost all the acreage of WPA murals that preceded them in the 1930s."

NOVEMBER: Solo exhibition, *Jacob Lawrence: Paintings, Drawings, and Prints,* at the Midtown Payson Galleries.

Receives Medal of Honor from the National Arts Club, New York.

1994

FEBRUARY: *Genesis* series (1989) exhibited at the University of Michigan, Dearborn.

APRIL: Solo exhibition, *Jacob Lawrence: Works on Paper,* at Shippensburg University of Pennsylvania.

SEPTEMBER: Catalogue raisonné of prints is published by the Francine Seders Gallery and accompanies a nationally traveling exhibition organized by the Bellevue Art Museum, Washington. Peter Nesbett begins preliminary research for a catalogue raisonné of paintings, drawings, and murals.

OCTOBER: Solo exhibitions, *Jacob Lawrence: Prints and Drawings,* at Shasta College, Redding, California, and *Jacob Lawrence: Paintings 1971–1994, Inaugural Exhibition,* at the University of Washington, Seattle.

DECEMBER: Solo exhibition of new paintings at the Francine Seders Gallery.

Receives the Charles White Lifetime Achievement Award in Los Angeles, and the Edwin T. Pratt Award from the Urban League of Metropolitan Seattle.

1995

JANUARY: Solo exhibition, *Jacob Lawrence, An Overview: Paintings from 1936–1994,* at the Midtown Payson Galleries. *War* series exhibited at the Whitney Museum of American Art at Phillip Morris, New York.

Jacob Lawrence Catalogue Raisonné Project is established as a nonprofit organization with an office in Seattle. Michelle DuBois joins staff of project. Stephanie Ellis-Smith begins working part-time in 1997.

Receives honorary doctorate from Harvard University and an award from the Skowhegan School of Painting and Sculpture. Inducted into the American Academy of Arts and Sciences.

LIFE

1996

Reworks group of study drawings from the late 1960s and 1970s based on the wood-cuts of Andreas Vesalius.

SPRING: Undergoes back surgery; spends two months recovering from the operation.

Jacob Lawrence with unfinished builders paintings, 1998.
Photograph by Mike Urban.
Courtesy of the *Seattle Post-Intelligencer*.

1998

SUMMER–FALL: Diagnosed with lung cancer. Undergoes radiation and chemotherapy.

SEPTEMBER: Completes 12 paintings on the builders theme.

1999

OCTOBER: Completes 12 paintings on the games theme.

DECEMBER: With Knight Lawrence, establishes the Jacob and Gwendolyn Lawrence Foundation to promote the creation, exhibition, and study of American Art.

2000

Begins paintings on university theme, though none are completed.

JUNE 9: Dies in his home at age 82.

RECEPTION

1996

MARCH: Solo exhibition, *Jacob Lawrence: An American Society in Transition,* at the San Antonio Museum of Art.

JULY: *Aesop's Fables* drawings (1969) exhibited at the Francine Seders Gallery.

OCTOBER: Solo exhibitions, *Jacob Lawrence: The Hiroshima Paintings,* at the Tyler Museum of Art, Texas, *After Vesalius: Drawings by Jacob Lawrence,* at Southern Methodist University, Dallas, and *Jacob Lawrence: Drawings, 1945 to 1996,* at DC Moore Gallery, New York.

Receives honorary doctorates from Amherst College, Amherst, Massachusetts, and Seattle University and the Algur H. Meadows Award from Southern Methodist University, Dallas.

1997

MARCH: Solo exhibition, *Jacob Lawrence, An American Vision: Paintings and Prints 1942–1996,* at the Museum of Northwest Art, La Conner, Washington.

JUNE: *The Life of Toussaint L'Ouverture* included in *Rhapsodies in Black: Art of the Harlem Renaissance,* which opens at the Hayward Gallery, London, and travels to five other venues in England and the United States.

Receives awards from the American Civil Liberties Union, the Pennsylvania Academy of the Fine Arts, the Cornish College of the Arts, Seattle, and New York Artists Equity.

1998

JANUARY: Drawings for *Aesop's Fables* travel nationally to five venues. Solo exhibition at Savannah College of Art and Design, Georgia.

JULY: Solo exhibitions, *Jacob Lawrence as Muralist,* at the Francine Seders Gallery, and *Jacob Lawrence: Painting Life,* at the University of Washington's Henry Art Gallery, Seattle.

NOVEMBER: Solo exhibition, *Jacob Lawrence: The Builders,* at DC Moore Gallery.

Receives honorary doctorate from the Universities of Illinois and Chicago, and Washington State Medal of Merit.

1999

Receives Lifetime Achievement Award from the Americans for the Arts and the 6th Annual Golden Umbrella Award and Mayor's Master Artist Award, Seattle.

2000

JANUARY: Solo exhibition, *Games,* at Francine Seders Gallery.

Receives 1st Annual PONCHO Artists Award, Seattle.

Jacob Lawrence and Ornette Coleman, American Academy of Arts and Letters Ceremonial, May 21, 1997.
Photograph by Dorothy Alexander.
Courtesy of Jacob and Gwendolyn Knight Lawrence.

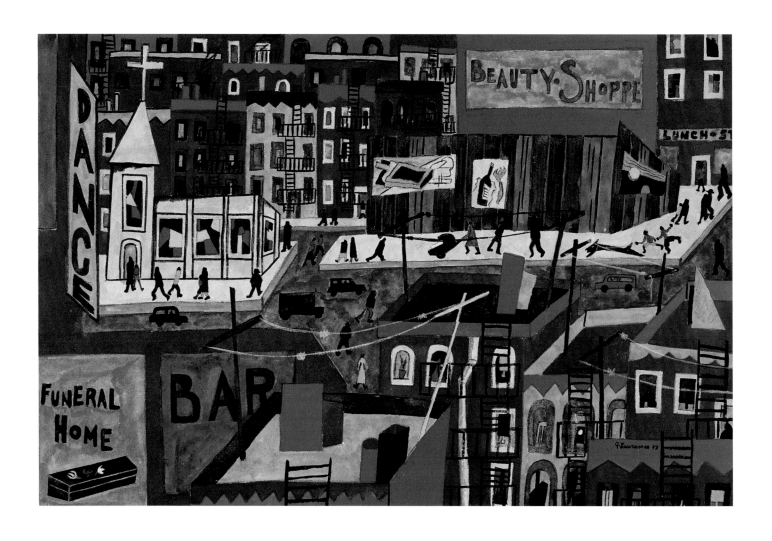

FIG. 4 *This Is Harlem*, 1943, gouache on paper,
15⅜ × 22¹¹⁄₁₆ in. Hirshhorn Museum and Sculpture
Garden, Smithsonian Institution. Gift of Joseph H.
Hirschhorn, 1966.

Leslie King-Hammond

Inside-Outside, Uptown-Downtown

JACOB LAWRENCE AND THE AESTHETIC ETHOS OF THE HARLEM WORKING-CLASS COMMUNITY

The gestures that make us conscious of security or freedom are rooted in a profound depth of being.

—GASTON BACHELARD, *The Poetics of Space*

THE EMERGENCE OF JACOB LAWRENCE and his sustained presence within the landscape of American art pose complex questions regarding the accepted conventions of an evolving modernist aesthetic. How could African American artists of the 1930s envision themselves in a modernist canon in a society that did not recognize them as part of the political, social, or human fabric of this country? Fortuitously, Lawrence found himself in Harlem, New York, that is, inside one of the most paradoxical cities of the 1920s and 1930s and outside the center of mainstream America. This new city within a city, with its New Negroes,[1] created its own sense and sensibility of modernism, very different from that of the downtown, primarily white, community. The experiences Lawrence had in Harlem became the bedrock of his character and identity. Harlem provided a place of security and offered him the freedom to express, in Bachelard's words, his "profound depth of being" and self-worth. Harlem was his universe and his university, and Lawrence would spend his entire life transforming his impressions of black working-class life into paintings, prints, and drawings (fig. 4). He developed an aesthetic style that both challenged and contributed to the tides of modernist categorization and philosophical thought.

Inside Harlem

Jacob Lawrence, Jr., was born in 1917 in Atlantic City, New Jersey. By 1919, the year of the "Red Summer" of racial violence,[2] his family had moved to Easton, Pennsylvania, and become part of the Great Migration of African Americans, West Indians, and Africans who relocated to the North from southern or rural, isolated communities and countries.[3] Originally from South Carolina and Virginia, the Lawrence family, like the tens of thousands of black migrants, hoped to find more promising economic opportunities, better jobs, housing, education, and freedom from tyranny, violence, and sexual abuse. African diaspora people were looking for a means to participate with full advantage and privilege in the democracy of the United States. In 1924, after his parents separated, Jacob's mother moved the family to Philadelphia. Rosa Lee Armstead Lawrence then left her children in foster care and migrated to Harlem, where she worked for several years until she had earned enough money to send for her family. Jacob Lawrence was thirteen years old when he arrived in Harlem in 1930.

The move north may not have been as wrenching for the Lawrence family as it was for many others. Life was very different in the North for black people accustomed to small-town lifestyles (fig. 5). The slower pace of rural life was replaced with the speed and accelerated movements common to developing urban centers dense with cars, taxis, buses, trolleys, trains, and crowds of people constantly moving through the streets. Instead of living in one- or two-story houses on a farm, the black migrants now lived in small apartments of densely compacted, vertically designed housing in tenements, which confined them to a life that was carried on more inside than outside. The pastoral sounds of nature were replaced with the urban din of people, traffic, radios, and modern machines moving across concrete sidewalks and cobblestone streets and above the ground on elevated tracks. The South, the Caribbean, and Africa are characterized by temperate to hot climates; by contrast, the

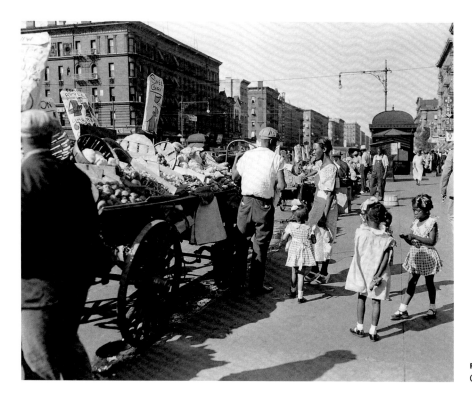

northern United States are cold, windy, and harsh in winter. Harlem was teeming with people trying to adjust to all of this. Young Jacob Lawrence, with his fertile, inquisitive, creative mind, arrived in the midst of a city that was unlike anything any African American migrant, much less this thirteen-year-old impressionable youth, could imagine. The hardships experienced by these new urban African Americans were further exacerbated by the inescapable fact of their social alienation and disenfranchisement from American society at large.

Historically, 1930 marks a shift in the flourishing New Negro movement, popularly recognized as the Harlem Renaissance, when the literary arts slowed and the visual arts began to evolve. This prolific flowering of creative black talent attracted and produced an unprecedented number of black politicians, businessmen, lawyers, intellectuals, writers, musicians, and artists. In spite of the economic difficulties, this new cultural and sociological enclave enjoyed a sense of optimism that was shared by many who entered the rarefied atmosphere of Harlem. James Weldon Johnson—lawyer, educator, songwriter, diplomat, as well as a fierce advocate for civil rights and black artistic expression—wrote in *Black Manhattan* (1930) that Harlem, "the greatest single community anywhere of people descended from age-old Africa appears at a thoughtless glance to be the climax of the incongruous. . . . It strikes the uninformed observer as a phenomenon, a miracle straight out of the skies."[4]

Harlem was such fertile ground for the imagination that writers, both black and white, had individualized, impassioned critical responses to it. Richard Wright was hired by the Works Progress Administration (WPA) to write about Harlem in the late 1930s. Wright's description of the community crystallizes the essence of Harlem's magnetism:

> Negro Harlem, into which are crowded more than a quarter of a million Negroes from southern states, the West Indies, and Africa has many different aspects. To whites seeking amusement, it is an exuberant, original, and unconventional entertainment center; to Negro college graduates it is an opportunity to practice a profession among their own people; to those aspiring to racial leadership it is a domain where they may advocate their theories unmolested; to artists, writers and sociologists it is a mine of rich material; to the mass of Negro people it is the spiritual capital of Black America.[5]

Claude McKay, one of the more highly lauded West Indian New Negro migrants, was a noted writer of the Harlem Renaissance. Not as optimistic or awed as Johnson, McKay's view of Harlem is circumscribed by the political, social, and economic urgencies of segregated life in the urban North combined with the devastating impact of the depression and its aftermath:

> Harlem is the queen of black belts, drawing Afroamericans together into a vast humming hive. They have swarmed from the different states, from the islands of the Caribbean and from Africa. And they still are com-

ing in spite of the grim misery that lurks behind the inviting facades. Over-crowded tenements, the harsh Northern climate and un-employment do not daunt them. Harlem remains the magnet.

Harlem is more than the Negro capital of the nation. It is the Negro capital of the world. And as New York is the most glorious experiment on earth of different races and diverse groups of humanity struggling and scrambling to live together, so Harlem is the most interesting sample of black humanity marching along with white humanity. Sometimes it lags behind, but nevertheless it is impelled and carried along by the irresistible strength of the movement of the white world.[6]

Johnson, McKay, and Wright, like numerous other "Harlem Literati"[7] of the period such as Langston Hughes, Countee Cullen, Zora Neale Hurston, and Jean Toomer as well as activists and intellectuals such as W. E. B. Du Bois, Marcus Garvey, Arthur A. Schomburg, and Alain Locke, sought to articulate a self-conscious African American identity. At the same time they debated what made Harlem Harlem. On the one hand, Harlem was grounded in African ancestral traditions, philosophies, folklore, music, dance, and religion as practiced and carried north by the new black migrants. On the other hand, Harlem was a new city caught in the flux of modernism, technology, and urbanity. Jacob Lawrence was a witness to the acculturated, innovative, and improvised lifestyles created by these confluences of the Great Migration, the depression, the jazz age, and the emergence of the New Negroes of the Harlem Renaissance. Looking back at this time, Lawrence remembers vividly that the 1930s "was actually a wonderful period in Harlem although we didn't know this at the time. Of course it wasn't wonderful for our parents. For them, it was a struggle, but for the younger people coming along like myself, there was a real vitality in the community."[8] There were no antecedents for this situation. Whether you were an insider, privileged as a descendant member of African ancestry, or a white Euro-American outsider, visiting as a tourist, voyeur, or patron, Harlem remained a place of wonder and mystery.

A vital aspect and particular fascination of the human landscape of Harlem was observed by Nancy Cunard from a downtown, white patronage perspective. In 1934 she edited a weighty anthology, *Negro*, whose essays echoed, in part, Alain Locke's 1925 anthology *The New Negro*, in which he formally announced "that a new spirit is awake in the masses."[9] Locke wrote from inside Harlem as the voice of reason and as the intellectual aesthetic architect of the New Negro art movement. Cunard, however, in her contribution to her anthology provides a telling outsider's observation of white America's fascination and preoccupation with race and racial mixes:

For in Harlem one can make an appreciation of a race. Walk down 7th Avenue—the different types are uncountable. Every diversity of bone-structure, of head-shape, of skin colour; mixes between Orientals and pure Negroes, Jews and Negroes, Red Indians and Negroes, mulattoes of all shades, yellow, "high yaller" girls, and Havana-coloured girls, and, exquisitely fine, the Spanish and Negro blends; the Negro bone, and the Negro fat too, are a joy to the eye.[10]

Cunard's description provides vivid, painterly detail of a community of black people who represented every aspect of the African diaspora. These observations were not lost to the black community but contributed to an internal infracultural antagonism arising from the issues of color, class, and caste consciousness rooted in the residual history of slave plantation societies and culture.

It was in this milieu that Jacob Lawrence found himself. The migration of people of African descent from other locations in the United States and the Caribbean, moving to this small geographical location in great numbers and then self-consciously restructuring their entire way of living and thinking, created a dynamic environment. Lawrence was immersed in this, and at his impressionable age, he was very much formed by these circumstances. He was obviously well aware that the time and place were unique, for he very much wanted to capture them in his art.

Art and Opportunity

Jacob Lawrence is the first major artist of the twentieth century who was technically trained and artistically educated within the art community of Harlem. Given the restrictions of segregation and the dire economic conditions for black Americans, training in professionally accredited and recognized art academies was

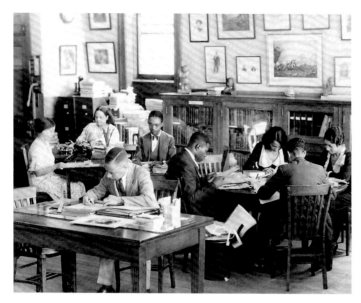

FIG. 6 Reading Room at the 135th Street library, ca. 1930. Schomburg Center for Research in Black Culture, New York Public Library.

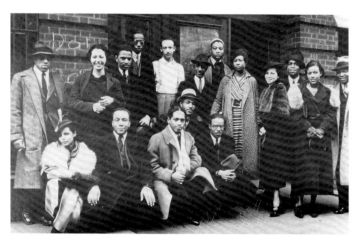

FIG. 7 "306" Group in front of 306 West 141st Street, aka Alston-Bannarn Studios and a gathering place for WPA artists, late 1930s. Standing left to right: Addison Bates, Grace Richardson, Edgar Evans, Vertis Hayes, Alston, Cecil Gaylord, John Glenn, Elba Lightfoot, Selma Day, Ronald Joseph, Georgette Seabrook (Powell), Richard Reed. Front row left to right: Gwendolyn Knight, James Yeargens, Francisco Lord, Richard Lindsey, and Frederick Coleman.

difficult, if not impossible, for the majority of black artists in America. Harlem provided the crucial aesthetic foundation and establishments to encourage the training and artistic education of its community as part of its philosophical movement of racial uplift. This was done by founding institutions to promote the history and culture of Africa and African Americans and by setting up art schools and workshops to teach the rudiments of artistic production. While many individuals participated in this process, several had a specific and direct impact on Lawrence as a young man.

Arthur Schomburg, a black Puerto Rican, noted historian, and bibliophile, was passionate in his support of the arts. In 1911 he founded the Negro Society for Historic Research, appointing William E. Braxton art director. Schomburg went on to sponsor numerous exhibitions of contemporary art by African Americans and of traditional African art, many at the Brooklyn YMCA. By 1921 Schomburg's efforts were rewarded with a new base at the 135th Street branch of the New York Public Library in Harlem (later to become the Schomburg Center for Research in Black Culture), housing one of the most distinguished collections of literature and artifacts on African and African American culture. Thwarted by lack of access to educational or cultural institutions downtown, Lawrence and numerous black artists found this library to be a natural haven in their quest to reclaim their historical legacy. With the additional resources from the YMCA located across the street, the 135th Street library made an ideal forum for exhibitions, social, cultural, and political events. Many photographs of African Americans reading were published in the black press of the period (fig. 6), stressing the importance of literacy as one of the newly found opportunities of the Great Migration.

Arts education was beginning to take form in Harlem at this time, and it was introduced to children at a young age. Arts and crafts classes were offered in community day-care programs such as Utopia Children's House, where Lawrence's mother sent him while she worked. It was here, in 1930, that Lawrence received his earliest art instruction from Charles "Spinky" Alston, a young painter and graduate student at Columbia University Teachers College. Lawrence continued his art studies in 1934 under Charles Alston at the Harlem Art Workshop and at his studio at 306 West 141st Street, which became a mecca for the artists in Harlem. During this time, Alston was also director of

the WPA Harlem Mural Project, and artists working on projects assigned to that area would sign up at Studio 306 (fig. 7). Unaware at the time of the magnitude of this historic experience, Lawrence later recalled meeting such notables as Alain Locke, Addison Bates, Langston Hughes, Ralph Ellison, William Aaron Douglas, Orson Wells, and, later, Ronald Joseph, Robert Blackburn, Georgette Seabrooke Powell, and Romare Bearden. Lawrence recalls that the conversations centered on "what they thought about their art. . . . It was like a school. . . . Socially, that was my whole life at that time, the '306' studio."[11]

The sculptor and political activist Augusta Savage (fig. 8) was another dynamic member of the Harlem community who had a profound affect on Lawrence's development as an artist. One of the most important teachers of the period, she had a strong influence on Lawrence. In 1932 she opened the Savage Studio of Arts and Crafts on 143rd Street. Everyone was welcome, and many young artists, including Norman Lewis, William Artis, Elton Fax, Ernest Crichlow, Elba Lightfoot, Marvin and Morgan Smith, and Gwendolyn Knight, came to study with her.[12] In 1933 she organized a group of young black intellectuals into the Vanguard, an activist group that met weekly to discuss issues of race and politics.[13] In 1936 Savage renovated a garage, which she called the Uptown Art Laboratory, for teaching art classes to children and young black artists seeking her guidance. Lawrence regularly attended Savage's classes (which must have been similar to the scene recorded in fig. 9) and formed an especially close friendship with Robert Blackburn, Ronald Joseph, and Gwendolyn Knight. They would regularly visit the 135th Street library, museums, galleries, and lectures both uptown and downtown, constantly discussing the art they saw, critical issues regarding modernism, and the aesthetic aspirations of African American artists. As the largest and most important school in Harlem, the Laboratory evolved in 1937 into the Harlem Community Art Center (fig. 10) and as such is still active today. The project was so successful that by 1938, with more than three thousand students enrolled, a second site had to be found to accommodate the demand for classes. That the laboratory became a model for later WPA art centers affirms the importance of community-based arts education.

The emergence of art centers and schools of art was the spiritual and aesthetic life force of the Harlem community, and because of them Lawrence benefited immensely. But equally

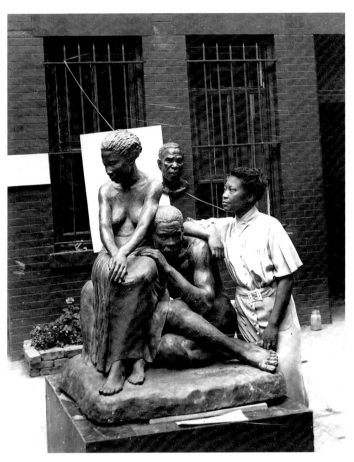

FIG. 8 Marvin and Morgan Smith, *Augusta Savage with* Realization, 1934. Schomburg Center for Research in Black Culture, New York Public Library.

FIG. 9 Jacob Lawrence (second from left) making block prints under the direction of Sarah West at the WPA Federal Art Project Workshop, Harlem, ca. 1933–4. National Archives, Harmon Foundation.

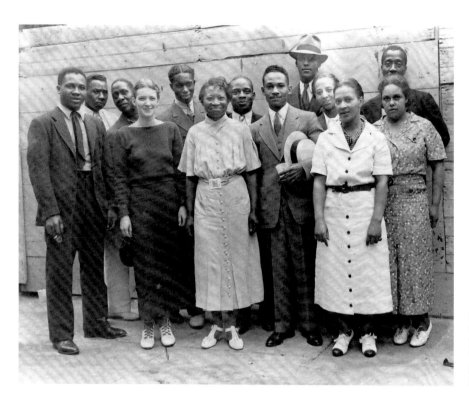

FIG. 10 WPA Harlem Community Art Center instructors, 1930s. Front row left to right: Zell Ingram, Pemberton West, Augusta Savage, Robert Pious, Sarah West, and Gwendolyn Bennett. Back row left to right: Elton Fax, Rex Gorleigh, Fred Perry, William Artis, Francisco Lord, Louise Jefferson, and Norman Lewis.

important was the presence in the community of practicing professional artists. Aaron Douglas was an influential example. Douglas arrived in New York at the onset of the Harlem Renaissance in 1924. A professionally trained artist, he soon became the principal visual artist of the Harlem Renaissance and provided a sense of stability and guidance to the younger black artists. In 1934 he completed six murals for the lecture hall of the New York Public Library at 135th Street. The series, *Aspects of Negro Life*, depicts the history of the Negro from Africa to America. The artist's formal devices—stylized, flat, cubist elements rendered in muted tones—reflect Douglas's assimilation of Egyptian-inspired aesthetics combined with his response to modernism. Douglas put into visual terms the ethos of the uptown Harlem working-class African American that was also to be found in all the black communities across America. Douglas recalled that "the field of plastic art was in a unique position in that there was almost no background; we had no tradition. Everything was done . . . almost for the first time . . . we were so hungry . . . as I look back at the things that I produced, it was so readily received and cheerfully received. . . . The Harlem Community never refused anything that I did. They accepted it; they put it forward."[14] Lawrence also was the beneficiary of this magnanimous spirit.

In addition to the impact of significant efforts from within the community, there were individuals and foundations outside of Harlem, some run by white people, that were also encouraging the cultural efforts of African Americans. In 1914 Joel E. Spingarn, then chairman of the National Association for the

Advancement of Colored People (NAACP), established the Spingarn Medal for "the highest and noblest achievement of an American Negro."[15] The creative and performing arts were among those disciplines recognized for meritorious achievement and often received critical attention in *Crisis*, the magazine published by the NAACP. The magazine's editor, W. E. B. Du Bois, one of the most important activist historians of the twentieth century, argued vociferously and eloquently for the intrinsic value of the African American artist as a vital contributor to his culture. Du Bois championed all the arts—drama, literature, music, and dance—and urged the black communities of America, which were also in a period of cultural florescence, albeit on a smaller scale than in Harlem, to "let us train ourselves to see beauty in black."[16]

The Harmon Foundation, established by the real estate developer William E. Harmon in 1922, granted the Distinguished Achievement among Negroes award from 1926 to 1933. From 1928 to 1933 over forty-five prizes and honorable mentions were granted and hundreds of works of art were exhibited in Harlem and across the United States. The Rosenwald Fund, established by Julius Rosenwald of Chicago, also played a significant role in the patronage of African American artists. Lawrence received loans from the Harmon Foundation and three fellowships from the Rosenwald Fund.

Lawrence was a product of the particular migration-depression culture of Harlem, within the larger context of America. Although these were difficult times economically, they were nonetheless optimistic and motivating for those in the artistic realm in Harlem. It was fortuitous for Lawrence that institutional and financial support systems were taking shape. Lawrence always looks back to the support he received from numerous individuals and institutions as being crucial to his artistic development and pursuit of art as a career.

"Finding His Own Way"

Charles Alston, as the director of the art program at Utopia Children's House, soon recognized that Lawrence had exceptional abilities; he would later reflect that "there was always something very simple and direct about his approach."[17] He felt strongly that "it would [have been] a mistake to try to teach Jake. He was teaching himself, finding his own way. All he needed was encouragement and technical information."[18] The first im-

ages that excited the young Lawrence were nonfigurative geometric shapes arranged in patterns of black and white and in bright primary colors. Lawrence describes "how I was playing with color; I always liked it."[19] Using crayons and then poster paints at Utopia House, he began to make compositions, no longer extant, inspired by his own home. Rosa Lee Armstead Lawrence had made a significant effort to create a beautiful home for her family in spite of the financial stress of the depression. The artist recalled:

> Our homes were very decorative, full of pattern, like inexpensive throw rugs, all around the house. It must have had some influence, all this color and everything. Because we were so poor the people used this as a means of brightening their life. I used to do bright patterns after these throw rugs; I got ideas from them, the arabesques, the movement and so on.[20]

At this early stage in his life Lawrence unwittingly was beginning to see, as Du Bois had urged, the "beauty in black," meaning black people and their lives. Lawrence began his own investigation inside his home as it was configured by his mother, doing the best she could to create a cheerful environment in her tenement apartment. Zora Neale Hurston identified this phenomenon in her seminal essay "Characteristics of Negro Expression," published in Nancy Cunard's *Negro*, as "the urge to adorn." Hurston, a woman far ahead of her time—an anthropologist, folklorist, writer, poet, actress—described the typical interior of the homes of many poor working-class black families who, migrating from the South, transplanted that aesthetic into their northern domiciles:

> On the walls of the homes of the average Negro one always finds a glut of gaudy calendars, wall pockets and advertising lithographs. The sophisticated white man or Negro would tolerate none of these, even if they bore a likeness to the Mona Lisa. No commercial art for decoration. Neither the calendar nor the advertisement spoils the picture for this lowly man. He sees the beauty in spite of the declaration of the Portland Cement Works or the butcher's announcement. I saw in Mobile a room in which there was an over-stuffed mohair living room suite, an imitation mahogany bed and chifferobe, a

console victrola. The walls were gaily papered with Sunday supplements of the Mobile Register. There were seven calendars and three wall pockets. One of them was decorated with a lace doily. The mantel shelf was covered with a scarf of deep home-made lace, looped up with a huge bow of pink crepe paper. Over the door was a huge lithograph showing the Treaty of Versailles being signed with a Waterman fountain pen.[21]

This penchant for decoration, springing from the poorer segments of the black population, was one facet of the quest for an aesthetic ideal in the black community in the 1930s. Du Bois's emphasis on the individual African American and personal concepts of self-worth, by contrast, was an elitist stance addressed to the "Talented Tenth."[22] Lawrence was not, by Du Bois's definition, a member of this group. He was, as Alston described him, a "poor kid," and consequently his sources of inspiration came from his working-class mother and the migration-depression culture that she embodied. Likewise, Hurston's assessments did not cater to the "Talented Tenth" but rather to the working class and the masses of African Americans who were too caught up in the struggle to survive to be able to participate in the formalist expressions of the New Negro movement. Yet the Renaissance never could have reached the visionary level of creativity it did had not the working-class people of Harlem provided, in Wright's words, a constant "mine of rich material" that inspired the artistic intellect of the New Negro literati. Douglas, when queried later in life about his aesthetic ideal and the contributions of the common man to the era of the New Negro, stated:

> As a matter of fact, if you had asked him about culture, he would have been hard-put to explain it at all, certainly to explain the black man's part in it. But, he was part of it, although he didn't understand this thing— he did not actually consciously make a contribution; he made his contribution in an unconscious way. He was the thing on which and around which this whole idea was developed. And from that standpoint it seems to me his contribution is greater than if he had attempted consciously to make a contribution.[23]

The working-class environment as decorated by Lawrence's mother and that inspired him to create his first abstract images of rug designs was no less important than the more fanciful interiors created by the "sophisticated" individuals who also sought to live in beauty. Hurston's analysis of African American interior domestic space was conflicted. She admitted, "It was grotesque, yes. But it indicated a desire for beauty . . . decorating a decoration. . . . The feeling back of such an act is there can never be enough beauty, let alone too much." What was important, Hurston declared, was the value such decoration assumed in people's lives. "Perhaps his idea of ornament does not meet conventional standards, but it satisfies the soul of its creator."[24] The most ordinary daily tasks, events, and routines, such as decorating one's home, would consume Lawrence's entire imagination. He would use what he saw around him every day to document the visual culture, beauty, and artistic spirit of Harlem.

As Lawrence became more skilled in the execution of his small compositional studies he became increasingly prolific in his production of images that captured the essence of Harlem's character, identity, and cultural ethos. His *Street Orator's Audience* (fig. 11), which echoes a photograph by Marvin and Morgan Smith entitled *Street-Corner Meeting, 125th Street* (fig. 12), is one example of his work from this period. Jacob and his colleagues from Savage's art schools capture an essential feature of the Harlem community at that time. In Lawrence's composition the audience, nearly transfixed by the orator's message, is viewed

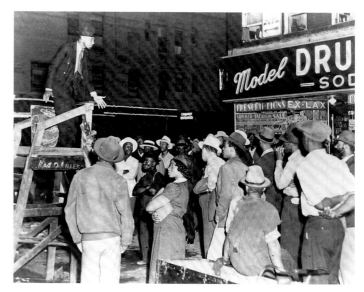

FIG. 12 Marvin and Morgan Smith, *Street-Corner Meeting, 125th Street*, ca. 1938. Schomburg Center for Research in Black Culture, New York Public Library.

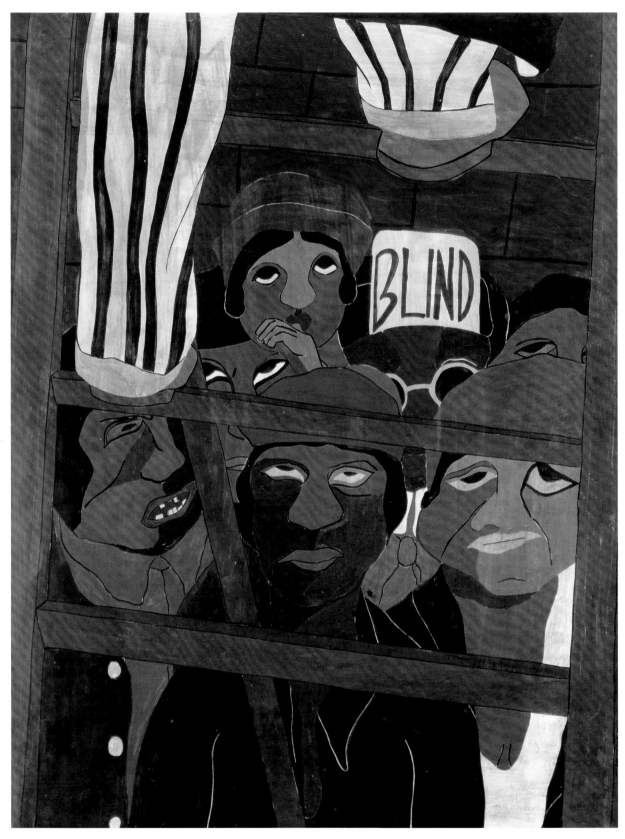

FIG. 11 *Street Orator's Audience*, 1936, tempera on paper, 24⅛ × 19⅛ in. Collection of Tacoma Art Museum. Gift of Mr. and Mrs. Roger W. Peck by exchange.

FIG. 13 Charles Alston, *Deserted House*, ca. 1938, lithograph. Collection of Reba and Dave Williams.

FIG. 15 Norman Lewis, *Umbrella*, 1938, lithograph. Collection of Reba and Dave Williams.

FIG. 14 Ernest Crichlow, *Lovers*, 1938, lithograph. Collection of Reba and Dave Williams.

from the perspective of the speaker. These "soap box" sessions became an important testing ground for political and social leaders to hone their verbal skills and transmit information quickly throughout the community.

The streets of Harlem—their movement, the people, the local color, and the sounds—became a bottomless source of visual and spiritual inspiration for Lawrence. His ability to tell the story of a community visually revealed his capacity for observation and acute attention to detail. The flatness of the forms allows the subject to move in a storyboard, cinematic style almost in anticipation of the next frame of action. Lawrence would not become just the storyteller, or visual griot, of Harlem, but in fact he would become the biographer of an extraordinary community and the autobiographer of the artist who evolved from it.

Lawrence's emphasis on Harlem as the primary subject matter in his nonserial paintings of the late 1930s and early 1940s is distinct from the art of many of his colleagues and mentors at the time. Whereas Lawrence drew thematic inspiration from his immediate environment, many other artists created images that strongly recalled their lives and experiences in the South. Alston's *Deserted House* (fig. 13) epitomizes what Hale Woodruff coined the "Out-House School."[25] The exhausted land on which the deteriorating house sits is a reminder of a lost era. Ernest Crichlow's *Lovers* (fig. 14) is an indictment of an insidious rape scene that records the abuses of the Ku Klux Klan that contributed to the black exodus north to freedom. Figurative imagery was important to African American artists and their communities who longed for a representation that would honor their likeness. However, the lure of abstraction and the question of modernism charged the intellect of artists like Norman Lewis, whose *Umbrella* (fig. 15) tests abstraction's potential to convey modernist interpretations of African American life. Alston, Crichlow, Lewis, and Lawrence worked closely during the years of the 1930s and acted as mutual catalytic forces on each other's lives and art. From this small sample of images—all produced in Harlem in the 1930s—it is clear that no two artists in Harlem worked in the same style. The diversity of styles and approaches available gave the artists freedom to express themselves individually while having the support and admiration of their peers.

Recognition of Lawrence's early paintings of Harlem came in February 1938 when, at the age of twenty, he had a solo exhibition at the 135th Street YMCA. Sponsored by the James Weldon Johnson Literary Guild, this was a remarkable moment of affirmation and celebration of an artist's youthful yet mature vision. Alston, in his introductory statement in the brochure that accompanied the exhibition, gives a perceptive critique of an achievement of this magnitude so early in the life of an artist:

> The place of Jacob Lawrence among younger painters is unique. Having thus far miraculously escaped the imprint of academic ideas and current vogues in art, to which young artists are most susceptible, he has followed a course of development dictated entirely by his own inner motivations.
>
> Any evaluation of his work to date is most difficult, a comparison impossible. Working in the very limited medium of flat tempera he achieved a richness and brilliance of color harmonies both remarkable and exciting.
>
> He is particularly sensitive to the life about him; the joy, the suffering, the weakness, the strength of the people he sees every day. This for the most part forms the subject matter of his interesting compositions.
>
> Still a very young painter, Lawrence symbolizes more than any one I know, the vitality, the seriousness and promise of a new and socially conscious generation of Negro artists.[26]

Attuned to modernism as it was evolving, Alston realized that it would be difficult if not impossible to find counterparts for Lawrence's work. Lawrence had already begun to define a new brand of modernism in part by using black subject matter as the prime vehicle of his expression. The exhibition at the 135th Street YMCA was a watershed moment for Jacob Lawrence and an endorsement of his work from within his community.

A "Peerless Delineator" Emerges

Lawrence painted not just what he saw, but also what he heard from the oral historians of Harlem. Lectures on aspects of African and African American history and culture given at the 135th Street library (history previously unknown to Lawrence since the topic was not part of the New York City public education curriculum) sparked his interest in these subjects. He, along with many other artists, heard lectures by Joel C. Rogers, Richard B. Moore, and the carpenter-cum-scholar "Professor" Charles C.

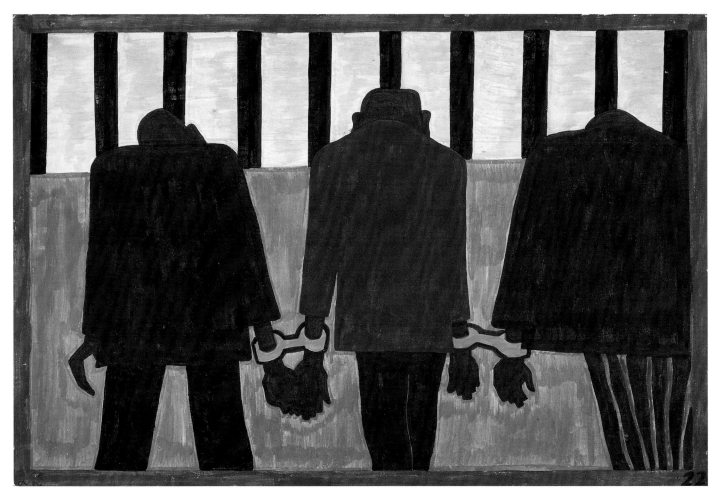

FIG. 16 *The Migration of the Negro, No. 22: Another of the social causes of the migrants' leaving was that at times they did not feel safe, or it was not the best thing to be found on the streets late at night. They were arrested on the slightest provocation,* 1941, casein tempera on hardboard, 12 × 18 in. The Museum of Modern Art, New York.

Seifert.[27] These lectures were part of a community-wide effort in Harlem to learn and value the history of African Americans and their contribution to American history. Lawrence was so impressed after having heard one of Seifert's lectures that he was inspired to research the history and political struggles of his people. Motivated by the courageous events he studied, he was compelled to create, in rapid succession, series of paintings on the important African American heroic narratives, *The Life of Toussaint L'Overture* (1938), *The Life of Frederick Douglass* (1939), and *The Life of Harriet Tubman* (1940). The stories and the struggles of these monumental freedom fighters became icons of survival and hope. In 1941 he painted *The Migration of the Negro,* based on his family's experience, the recollections of people in his community, and research completed at the New York Public Library.

Lawrence's intent for the series was nothing less than educational in the most profound sense. Pivotal to the success of the series were the complementary texts that accompanied each panel. Because looking at art was new to the New Negroes, Lawrence tried, through the text panels, to underscore the message of his art and to validate his viewers' newly found sense of literacy. Panel *No. 22* (fig. 16) of the series depicts the stark, bitter reality of unprovoked social injustice as it is dramatically played out in the backs of three black victims, handcuffed together facing the harsh vertical restraints of a prison cell. The composition is wrought with the pain of injustice, hopelessness, and the anonymity of the subjects, who represent anyone of African descent. The caption for the panel provides an explanation for the image: "Another of the social causes of the migrants' leaving was that at times they did not feel safe, or it was not the best thing to be found on the streets late at night. They were arrested on the slightest provocation." In this case, the panel and the text offer no hope of escape or redemption.

After Lawrence finished *The Migration of the Negro* series, the insularity of his artistic world was broken when Edith Halpert exhibited the series at her gallery, the Downtown Gallery—

the very name of which is significant. By her invitation, Lawrence became the first artist of African descent to be represented by a downtown gallery. As important as this event was to Lawrence, it did not sway him from his primary objective: to document the legacy of African American people in Harlem.

The experience of creating historical works in series format led Lawrence to think of images that functioned as thematic groupings. Between 1942 and 1943 Lawrence embarked on a group of thirty paintings that focused directly on life in Harlem. In *This Is Harlem* (fig. 4), the early lessons of creating patterns from the geometric and arabesque patterns of his mother's scatter rugs and the block prints he created at the Harlem Art Workshop reached new levels of virtuosity. Here the Harlem community is animated through the bold colors, repeating patterns, and the asymmetrical design of the composition. The sounds and music of the jazz age were not lost on

Lawrence as he incorporated the aural elements of rhythms, breaks, and changes into the visual polyphony of Harlem's environment, people, and culture. Technically, his work in the medium of gouache became more sophisticated through the assistance of Romare Bearden, who had a studio in the same building and who also shared a love of Harlem and jazz.[28]

Throughout the 1930s and well into the 1940s, Lawrence depicted some of the most fundamentally important issues for African Americans in post-depression Harlem. These include the desperate plight of black working women, the illness and disease that were the consequence of living in tight quarters and with inadequate health care, and the prominent role that religion and spirituality played in people's daily lives.

Though Lawrence's work at the time includes countless depictions of working-class labor, it exhibits a special sensitivity to the working women of Harlem, both socially and politically

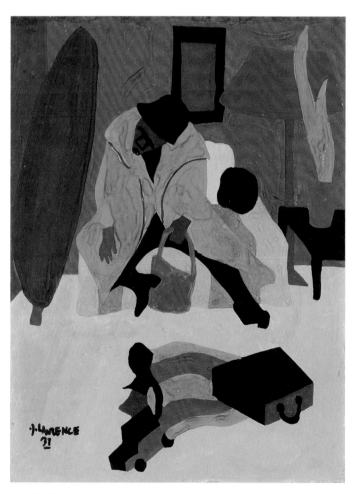

FIG. 17 *Woman*, 1938, tempera on paper, 11¾ × 9 in. Collection of Mrs. Suzanne Schwartz Cook.

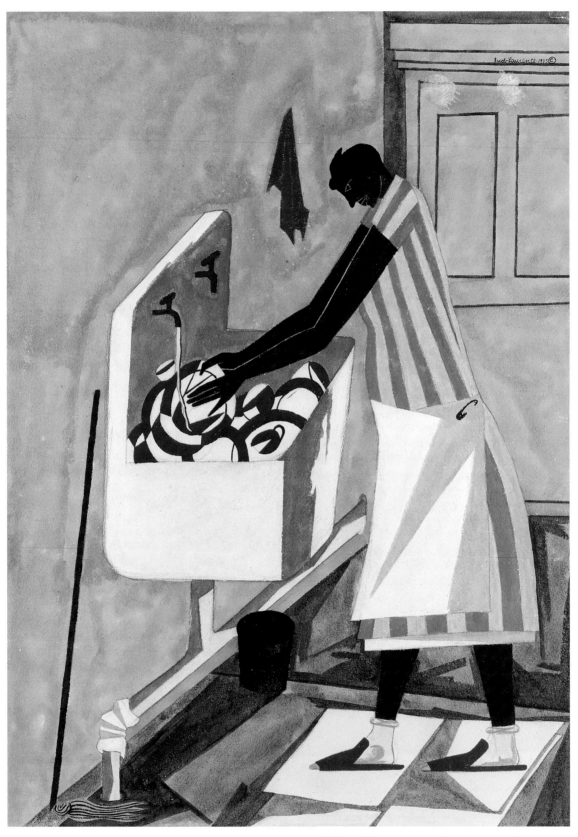

FIG. 18 *Home Chores*, 1945, gouache on paper, 29½ × 21⁄₁₆ in. The Nelson-Atkins Museum of Art, Kansas City, Missouri. Anonymous gift.

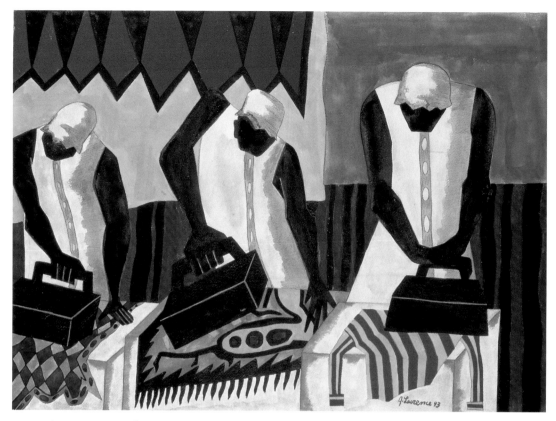

FIG. 19 *Ironers*, 1943, gouache on paper, 21½ × 29½ in.
Collection of Ann and Andrew Dintenfass.

(fig. 17). The dire employment conditions in America made the lives of African Americans particularly difficult, and Lawrence witnessed this firsthand, as his mother struggled to work as domestic help and then return home, tired, to raise three children single-handedly. Black women suffered the indignity and physical stress of having to work in domestic service regardless of their educational achievements (fig. 18). For example, despite Zora Neale Hurston's accomplishments, she was not spared the onus of working as a domestic simply to survive. In *Ironers* (fig. 19) Lawrence shows the female worker from several perspectives—that of the primary caretaker of her home, of an employed worker in service to a white family, and of a factory worker in the New York garment industry. The angular arms of the women ironing show strength. The bent heads indicate resignation to the repetitive, dulling, boring work. The anonymity of the subjects, shown in many of Lawrence's works, indicates the commonplaceness of this condition to all black women of that era. Lawrence's observations of life in Harlem were echoed in a 1937 study of the working conditions of black domestic workers. The study, sponsored by the federal government's New Deal programs, was condemnatory. "The problem of Negro domestic workers in the United States, affecting eighty-five percent of all Negro women workers, demands immediate action by the fed-

eral government. Their wages, hours, and standards of living, even lower than those for white workers in both rural and urban communities, offer a challenge to American ideals of social legislation."[29]

In addition to Lawrence's sympathy to the conditions of working-class black women, there was also great respect for their strength and perseverance, and this respect was fostered in part by his deep friendship and marriage, in 1941, to the artist Gwendolyn Clarine Knight. Born on the island of Barbados, she immigrated with her family to the United States, living in Saint Louis for a while and then settling in Brooklyn.[30] Her education at Howard University in the art department allowed her to study with the painter Lois Mailou Jones and the historian-painter James Porter. However, when the depression forced Knight to leave Howard, she returned to New York to continue her studies in the art schools of Harlem. Knight, a quietly focused woman of confidence, discipline, and elegance, deeply respected, supported, and protected Lawrence's talent and vision. Her strength of character owed much to her Barbadian heritage. From the time of slavery Barbadian women historically developed strong patterns of survival and resistance in response to extreme exploitation and abuse. The historian Hilary McD. Beckles maintains that, as a result, Barbadian women "did become, by

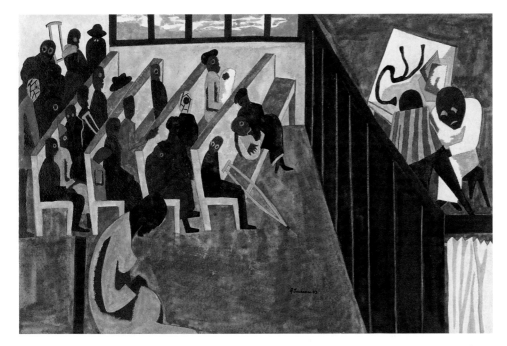

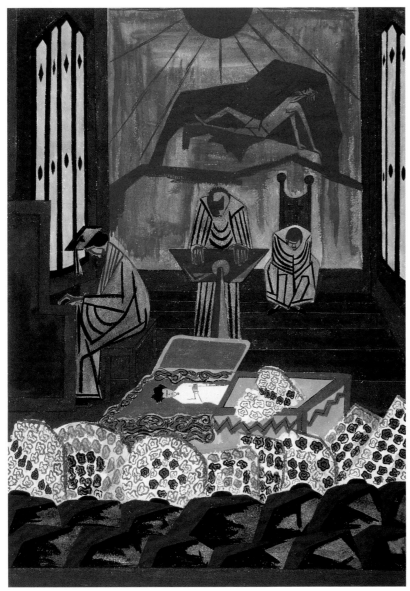

FIG. 20 *Harlem Hospital's Free Clinic Is Crowded with Patients Every Morning and Evening*, 1943, gouache on paper, 21³/₁₆ × 29⅛ in. Portland Art Museum, Portland, Oregon. Helen Thurston Ayer Fund.

FIG. 21 *Funeral Sermon*, 1946, gouache and watercolor on paper, 29⅜ × 21⅛ in. Brooklyn Museum of Art. Anonymous gift, 48.24.

the instinctive process of self-protection nothing less than natural rebels."[31] Gwendolyn Knight Lawrence channeled her rebellious nature, and in her partnered relationship with Lawrence, she formed a unique alliance with an artist equally matched to her own independence and intellect. Lawrence has always respected her opinions, philosophically and aesthetically.

Health concerns were predominant in post–depression era Harlem, not surprisingly, due to the density of the population following the Great Migration. Death, dying, illness, and physical and spiritual well-being were matters of constant urgency for black Americans. Limited access to health care and hospital facilities was one of segregation's greatest affronts to the tenets of democracy (fig. 20). In the face of such poor systemic conditions, the black church became a place of spiritual and psychological centering. As the migrants moved to the North from the South, the Caribbean, and Africa, they brought with them a myriad of religions grounded in African religions and philosophical belief systems. Charismatic figures like Father Devine and Daddy Grace drew huge followings. Black Jews and Muslims proliferated within the religious landscape of Harlem and added to the already innate sense of spirituality, great pageantry, elaborate rituals, lavish regalia, and stylized fashions.[32]

Lawrence's *Funeral Sermon* is one of many images that depicts spiritual life in Harlem (fig. 21). The black preacher stands off-center in the picture plane as he prepares the congregation for the deceased's passage to transmigrate from this mortal world to the final, otherworldly state of being. This is a beguiling representation of a funeral. For black people this is a passage of particular meaning and intensity. The act and actions of preaching take on special significance as articulated by the scholar Henry H. Mitchell:

> In its involvement of the entire person, Black preaching not only communicates gut level, sustaining core belief and motivation, it affirms the person and her/his culture, providing communion with God in the souls' "mother tongue." In other words, the preaching and worship traditions have survived amidst an alien majority culture precisely because they serve functions such as emotional support and affirmation of otherwise dehumanized personhood.[33]

Lawrence has not only captured the ritual of the funeral but references the entire cosmology of the African diasporic spiritual and religious activities of Harlem.

FIG. 22 Checkers on Lenox Avenue, 1935.
Copyright Bettman/CORBIS.

Everywhere Lawrence went, his eyes were a camera, and scene after scene fed his artistic appetite. He found material in the leisure time that was precious to the new working-class migrants—both young and old. Because downtown New York establishments such as clubs were off-limits for African Americans to patronize, people in Harlem made their own recreation. It took many forms, such as rent parties, shooting pool, dancing, singing, playing "numbers," cards, checkers, dominos, and telling "tall" stories (fig. 22). The children played stickball, jump rope, hide and seek, and hand-clapping and sidewalk chalk games.

Lawrence is not given to making long explanations about his work; when he does discuss it, he, like his creations, is always clear, focused, and concise. He has said: "Most of my work depicts events from the many Harlems which exist throughout the United States. This is my genre. My surroundings. The people I know . . . the happiness, tragedies, and the sorrows of mankind as realized in the teeming black ghetto."[34] Lawrence's commitment to his artistic vision was so strong that it inspired Claude McKay to inscribe a copy of his autobiography, *A Long Way from Home,* to the artist with these words: "For Jacob Lawrence, a peerless delineator of the Harlem scenes and types."[35]

Throughout his early work, Lawrence was relentless in his quest to preserve the Harlem ethos—its humanity and the heroic achievements of its common working-class people—by transforming it into art. He was himself one of the masses who worked and lived in Harlem, and he passionately believed in the community and its people. He later made the strong claim: "I am part of the Black community, so I am the Black community speaking."[36] Through his innovative figurative abstractions that mirrored the vast reservoir of culture and history of the jazz-depression-migration-era culture as it was expressed in Harlem, Lawrence gave visual affirmation and reality to a thoroughly authentic modernist style. That it can be directly attributed to the dynamics of an African American aesthetic moves Lawrence and all of black America from outside the edge to inside the center of modernist ideals.

NOTES

Epigraph: Gaston Bachelard, *The Poetics of Space* (Boston: Beacon Press, 1969), p. 224.

1. The New Negro was a manifestation of the Harlem Renaissance, that emergence and flourishing of black writers, artists, and poets who, with an assertive spirit, artistic determination, and self-conscious racial pride, crystallized their new sense of cultural identity. See Alain Locke's seminal anthology *The New Negro* (1925; reprint, New York: Atheneum, 1968).

2. In 1919 twenty-five race riots and other incidents occurred across the United States. Racial tension between blacks and whites just after World War I was high. Although the riots had common issues grounded in the negative treatment of African Americans, each riot had its own specific causes. James Weldon Johnson, who was an investigator for the National Association for the Advancement of Colored People, coined the term *Red Summer* for this period in history. See Alana J. Erikson, "Red Summer," *Encyclopedia of African American Culture and History*, ed. Jack Salzman, David Lionel Smith, and Cornel West (New York: Macmillan Library Reference USA, Simon & Schuster Macmillan), vol. 4, pp. 293–4; also William M. Tuttle, Jr., *Race Riot: Chicago in the Red Summer of 1919* (New York: Simon & Schuster, 1972).

3. The Great Migration was a very layered, complex, and self-determined African American phenomenon. The scholar Joe W. Trotter, Jr., asserts, "The Great Migration was by no means a simple move from southern agriculture to northern cities. It had specific regional and subregional components. It also had international ramifications for people in the Diaspora of the West Indies and Africa." Joe W. Trotter, Jr., "Migration/Population," in *Encyclopedia of African American Culture and History*, p. 1782.

4. James Weldon Johnson, *Black Manhattan* (New York: Arno Press, 1968), pp. 3–4.

5. Quoted in *The WPA Guide to New York City* (New York: Random House, 1982), p. 257.

6. Claude McKay, *Harlem: Negro Metropolis* (New York: Harcourt Brace Jovanovich, 1968), p. 16.

7. *Harlem Literati* was a term coined by Langston Hughes to describe the black literary intellectuals of the Harlem Renaissance. In his autobiography *The Big Sea*, Hughes devotes a special section to his compatriots. See Langston Hughes, "Harlem Literati," in David Levering Lewis, ed., *The Portable Harlem Renaissance Reader* (New York: Penguin Books, 1994), pp. 81–5.

8. Quoted in Jane Van Cleve, "The Human Views of Jacob Lawrence," *Stepping Out Northwest* 12 (winter 1982), pp. 33–7.

9. Alain Locke, "Enter the New Negro," *Survey Graphic* 6, 6 (March 1925), p. 631.

10. Nancy Cunard, ed., *Negro—An Anthology* (New York: Frederick Unger Publishing Company, 1934), pp. 53–4.

11. Quoted in Jacquelin Rocker Brown, "The Works Progress Administration and the Development of an Afro-American Artist, Jacob Lawrence, Jr.," unpublished paper, Howard University, Washington, D.C., 1974, p. 109.

12. Although it is now impossible to know what specific techniques and curricular pedagogy Savage used in her workshops, she was known to be a fierce activist, motivator, mentor, nurturer, friend, ally, and teacher to hundreds of African American artists and children in Harlem. Jacob Lawrence attributes Savage with remembering his birthday and taking him down to the WPA to sign up as an easel artist. See L. King-Hammond, "Quest for Freedom, Identity, and Beauty: New Negro Artists Prophet, Savage and Burke," in *Three Generations of African American Women Sculptors: A Study in Paradox* (Philadelphia: Afro-American Historical and Cultural Museum, 1996), pp. 26–37.

13. Juanita Marie Holland, "Augusta Christine Savage: A Chronology of Her Life, 1892–1962," in *Augusta Savage and the Art Schools of Harlem* (New York: Schomburg Center for Research in Black Culture, New York Public Library, 1988), pp. 12–9.

14. Leslie M. Collins, "Aaron Douglas Chats about the Harlem Renaissance," an oral history interview, Fisk University Library, Special Collections, quoted in Lewis, ed., *Portable Harlem Renaissance Reader*, pp. 120–1.

15. "Spingarn Medal," *Crisis* 8, 2 (June 1914), p. 88.

16. W. E. B. Du Bois, "Opinion of W. E. B. Du Bois: In Black," *Crisis* 20, 6 (October 1920), pp. 263–4.

17. See "Biographical Chronology," *Charles Alston: Artist and Teacher*, exh. cat. (New York: Kenkeleba Gallery, 1990), p. 20.

18. Quoted in Romare Bearden and Harry Henderson, *Six Black Masters of American Art* (Garden City, N.Y.: Doubleday, 1972), p. 102.

19. Jacob Lawrence, lecture, School of Art, University of Washington, Seattle, November 15, 1982.

20. Jacob Lawrence, interview by Ellen Harkins Wheat, February 15, 1983, in *Jacob Lawrence: American Painter*, exh. cat. (Seattle and London: University of Washington Press in association with the Seattle Art Museum, 1986), p. 29.

21. Zora Neal Hurston, "Characteristics of Negro Expression," in Cunard, ed., *Negro*, p. 25.

22. This was a concept espoused by black educator, philosopher, and author W. E. B. Du Bois, emphasizing the necessity for higher education to develop the leadership capacity among the most able 10 percent of African Americans. Du Bois was one of a number of black intellectuals who feared what he perceived was an overemphasis on industrial training. He believed this could result in the confinement of blacks to the ranks of second-class citizenship. To achieve political and civil equality, Du Bois stressed the importance of educating blacks so they could enter the professional ranks and then dedicate themselves to helping the masses.

23. "Aaron Douglas Chats about the Harlem Renaissance," quoted in Lewis, ed., *Portable Harlem Renaissance Reader*, p. 119.

24. Hurston, "Characteristics of Negro Expression," p. 26.

25. Quoted in Albert Murray, "An Interview with Hale Woodruff," in *Hale Woodruff: Fifty Years of His Art* (New York: Studio Museum in Harlem, 1979), p. 72.

26. Charles Alston, introduction to Lawrence's exhibition at the 135th Street YMCA, as quoted in Milton W. Brown, *Jacob Lawrence*, exh. cat. (New York: Whitney Museum of American Art, 1974), p. 9.

27. See Charles C. Seifert, *The Negro's or Ethiopian's Contribution to Art* (1938; reprint, Baltimore: Black Classic Press, 1986). The introduction contains an insightful description of the grand opening of the Harlem Art Workshop. This small publication contains nine topics in two chapters that were most probably presented at the 135th Street library lecture series. The publication also attests to the strong interest and involvement scholars had with the artistic community of Harlem. See also Elton Fax, *Seventeen Black Artists* (New York: Dodd, Mead, and Company, 1971), p. 152.

28. Fax, "Jacob Lawrence," in *Seventeen Black Artists*, pp. 158–9.

29. See Joe W. Trotter and Earl Lewis, eds., *African Americans in the Industrial Age: A Documentary History, 1915–1945* (Boston: Northeastern University Press, 1996), p. 181.

30. See Irma Watkins-Owens, *Blood Relations: Caribbean Immigrants and the Harlem Community, 1900–1930* (Bloomington and Indianapolis: Indiana University Press, 1966), pp. 20–1. Caribbean immigrants were under economic stresses similar to those of African Americans in the southern regions of the United States. Barbados's conditions were especially bleak and warranted relocation to survive.

31. Hilary McD. Beckles, *Natural Rebels: A Social History of Enslaved Black Women in Barbados* (New Brunswick, N.J.: Rutgers University Press, 1989), p. 177.

32. See Arthur Huff Fauset, *Black Gods of the Metropolis: Negro Religious Cults in the Urban North* (Philadelphia: University of Pennsylvania Press, 1944); C. Eric Lincoln, ed., *The Black Experience in Religion* (Garden City, N.Y.: Anchor Books, 1974); and Larry G. Murphy, J. Gordon Melton, and Gary L. Ward, eds., *Encyclopedia of African American Religions* (New York and London: Garland Publishing, 1993), p. 607. It must be noted that this is a field of scholarship that has grown considerably since the 1930s. These particular studies give a wealth of evidence to support the wide range of religious groups active in the North.

33. Henry H. Mitchell, "Preaching and the Preacher in African American Religion," in Murphy, Melton, and Ward, eds., *Encyclopedia of African American Religions*, p. 607.

34. Quoted in David Shapiro, ed., *Social Realism: Art As a Weapon* (New York: Frederick Unger Publishing Company, 1973), p. 217.

35. Jacob Lawrence and Gwendolyn Knight Lawrence, transcript of tape-recorded interview by Paul J. Karlstrom, November 18, 1998, Archives of American Art, Smithsonian Institution, Washington, D.C., p. 13.

36. Jessica B. Harris, "The Prolific Palette of Jacob Lawrence," *Encore* (November 1974), p. 52.

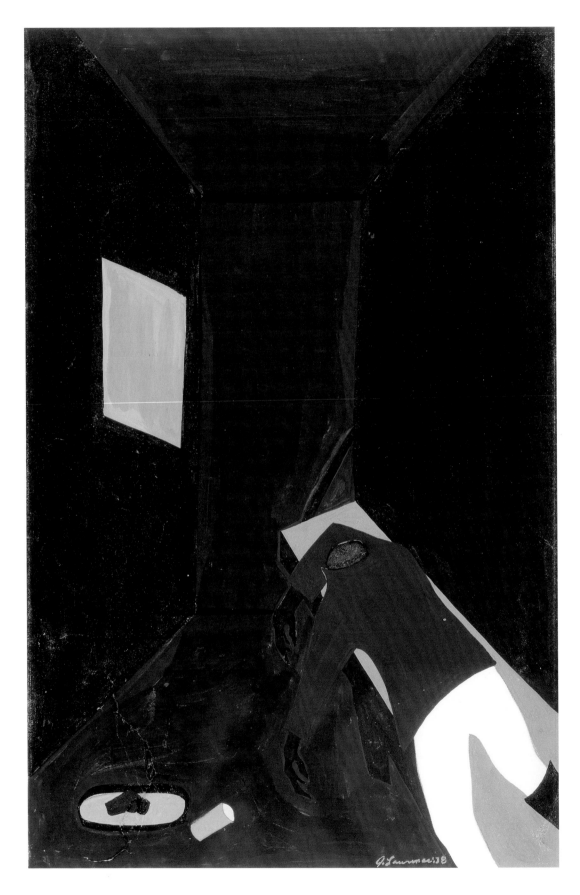

PL. 13 *The Life of Toussaint L'Ouverture, No. 39: The death of Toussaint L'Ouverture in the Prison of Le Joux, April, 1803. Imprisoned a year, Toussaint died of a broken heart,* 1938, tempera on paper, 19 × 11½ in. Amistad Research Center, Tulane University, New Orleans. Aaron Douglas Collection.

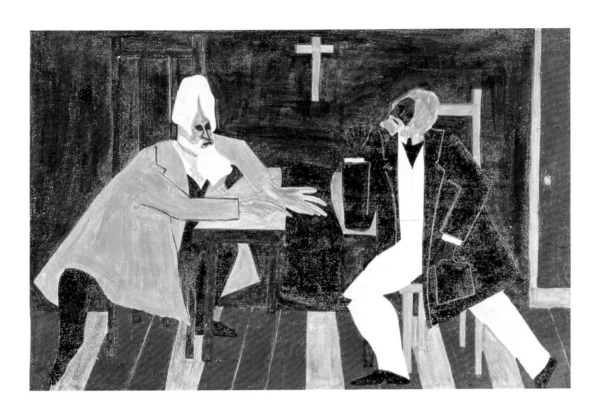

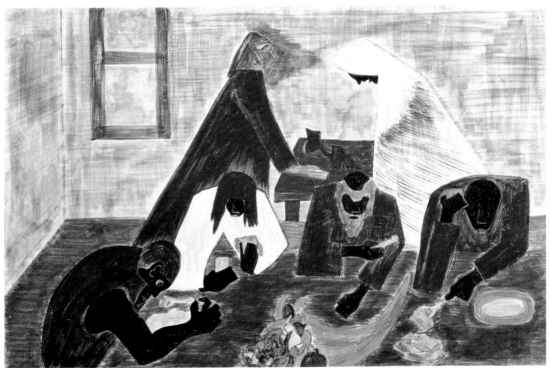

PL. 14 *The Life of Frederick Douglass, No. 24: John Brown discussed with Frederick Douglass his plan to attack Harper's Ferry, an arsenal of the United States Government. Brown's idea was to attack the arsenal and seize the guns. Douglass argued against this plan, his reason being that the abolishment of slavery should not occur through revolution,* 1939, casein tempera on hardboard, 12 × 17⅞ in. Hampton University Museum, Hampton, Virginia.

PL. 15 *The Life of Harriet Tubman, No. 22: Harriet Tubman, after a very trying trip North in which she had hidden her cargo by day and had traveled by boat, wagon, and foot at night, reached Wilmington, where she met Thomas Garrett, a Quaker who operated an Underground Railroad station. Here, she and the fugitives were fed and clothed and sent on their way,* 1940, casein tempera on hardboard, 12 × 17⅞ in. Hampton University Museum, Hampton, Virginia.

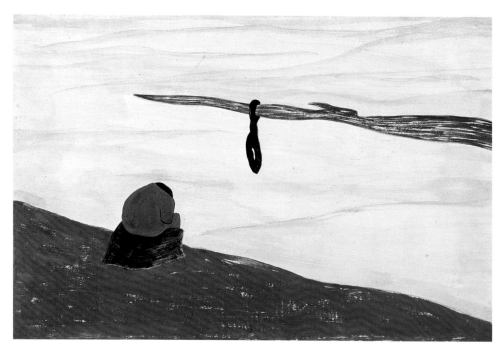

PL. 16 *The Migration of the Negro, No. 15: Another*
cause was lynching. It was found that where
there had been a lynching, the people who
were reluctant to leave at first left immedi-
ately after this, 1941, casein tempera on hard-
board, 12 × 18 in. The Phillips Collection,
Washington, D.C.

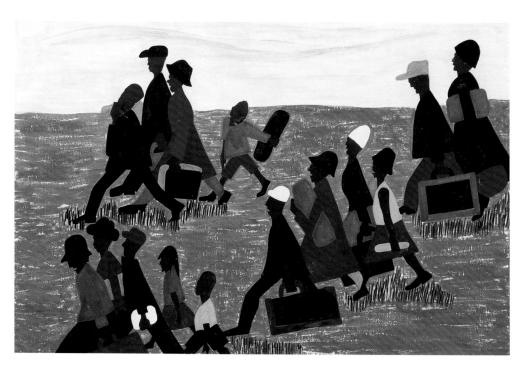

PL. 17 *The Migration of the Negro, No. 40: The mi-*
grants arrived in great numbers, 1941, casein
tempera on hardboard, 12 × 18 in. The Museum
of Modern Art, New York.

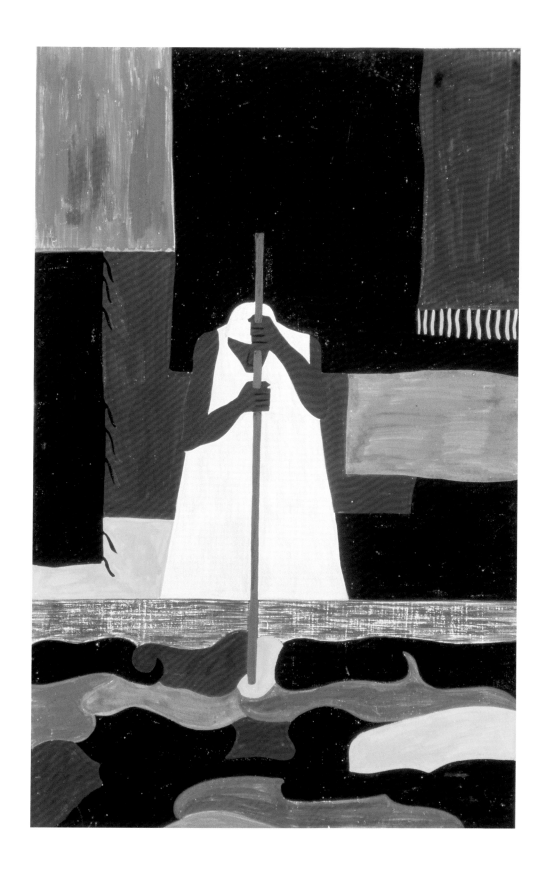

PL. 18 *The Migration of the Negro, No. 57: The female worker was also one of the last groups to leave the South,* 1941, casein tempera on hardboard, 18 × 12 in. The Phillips Collection, Washington, D.C.

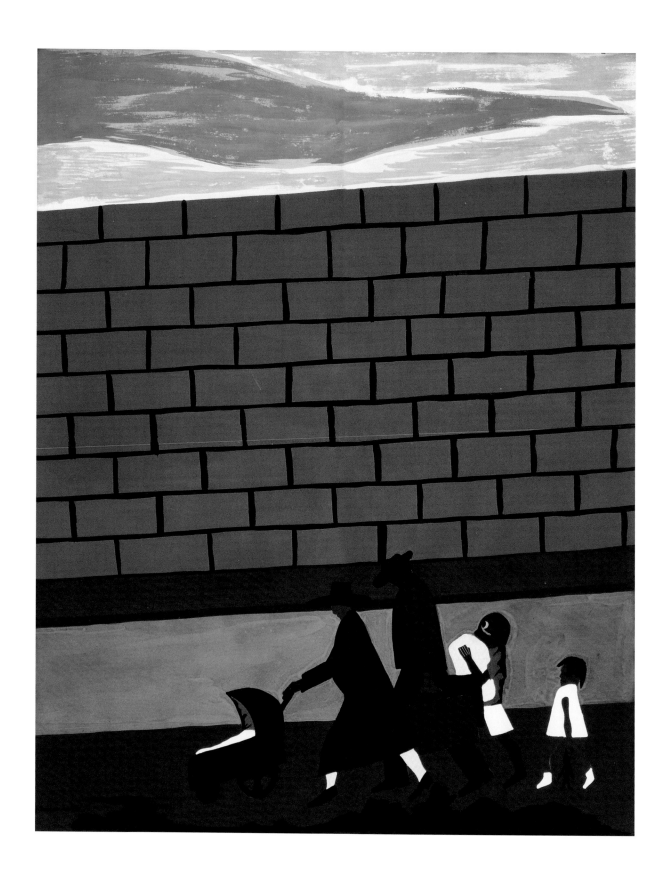

PL. 19 *The Wall*, 1941, tempera and gouache on paper, 22½ × 18 in. Private collection. Courtesy of Guggenheim, Asher Associates Inc., New York.

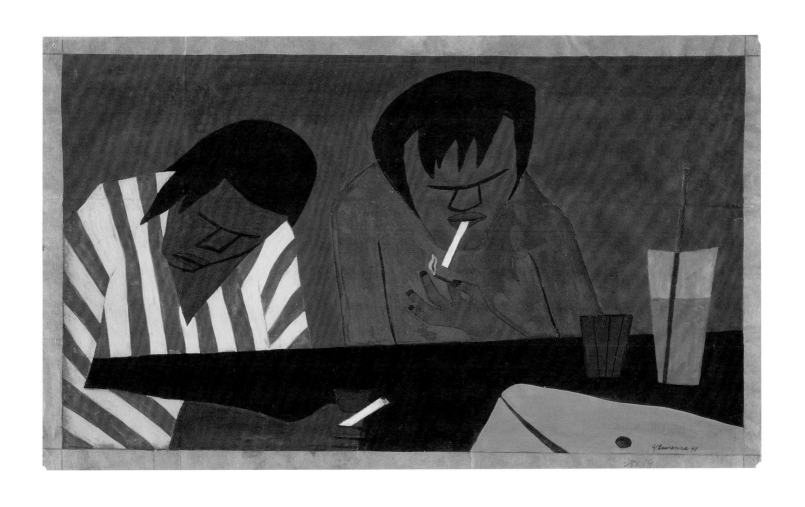

PL. 20 *Untitled* [*Two People in a Bar*], 1941,
tempera and gouache on brown paper,
14¾ × 25 in. Brooklyn Museum of Art.
Gift of Jay Leyda, 87.192.

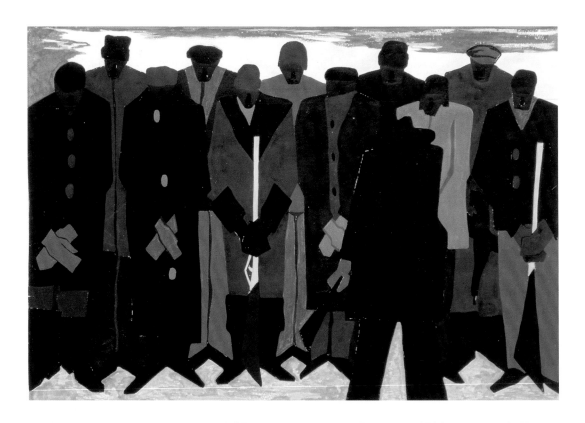

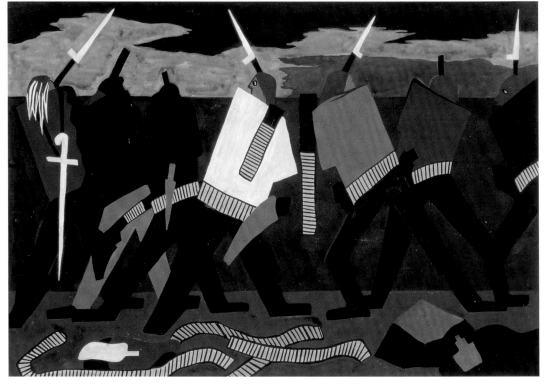

PL. 21 *The Life of John Brown, No. 17: John Brown re-*
mained a full winter in Canada, drilling Negroes
for his coming raid on Harpers Ferry, 1941, gouache
and tempera on paper, 13⅝ × 19⅞ in. The Detroit
Institute of Arts. Gift of Mr. and Mrs. Milton
Lowenthal.

PL. 22 *The Life of John Brown, No. 20: John Brown held*
Harpers Ferry for 12 hours. His defeat was a few
hours off, 1941, gouache and tempera on paper,
13⅝ × 19⅞ in. The Detroit Institute of Arts. Gift
of Mr. and Mrs. Milton Lowenthal.

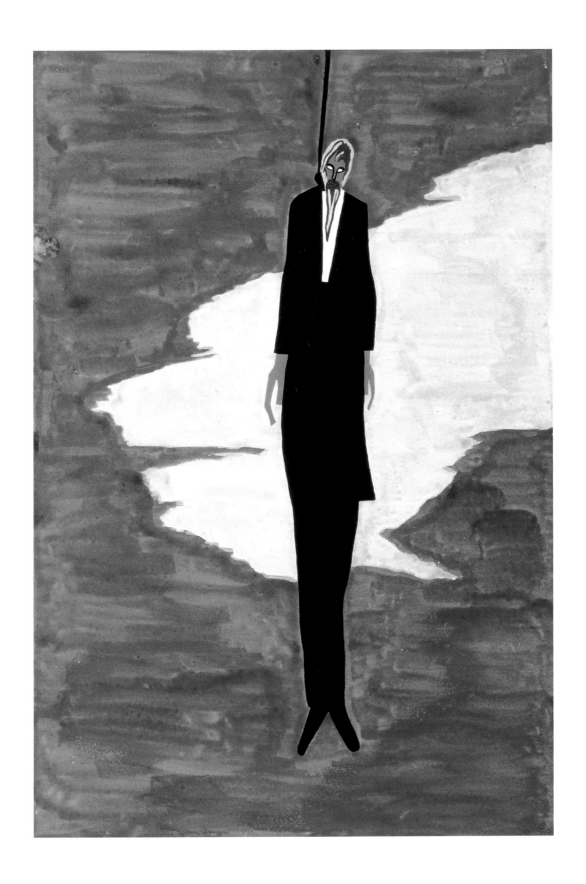

PL. 23 *The Life of John Brown, No. 22: John Brown was
found "guilty of treason and murder in the 1st
degree. He was hanged in Charles Town, Virginia
on December 2, 1859,"* 1941, gouache and tempera
on paper, 19⅞ × 13⅝ in. The Detroit Institute of
Arts. Gift of Mr. and Mrs. Milton Lowenthal.

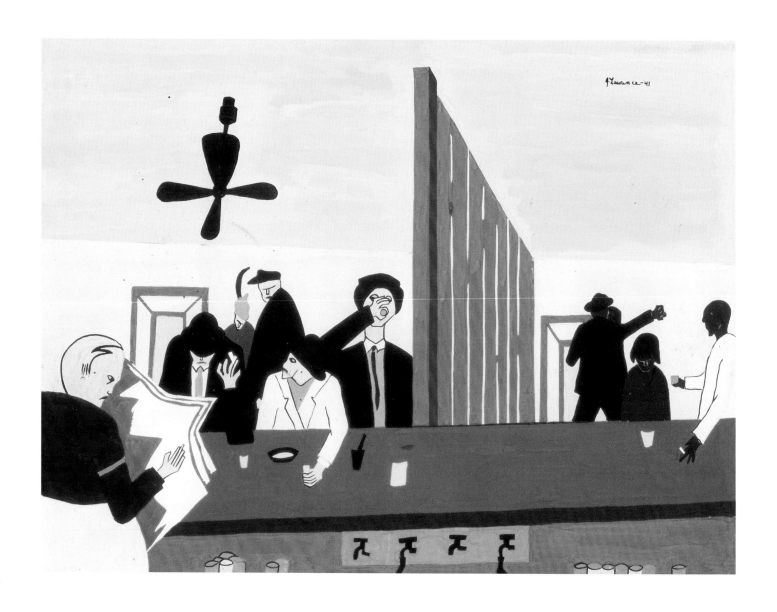

PL. 24 *Bar and Grill*, 1941, tempera and gouache on paper, 16¾ × 22¾ in. Delaware Art Museum. Gift of the National Academy of Design, Henry Ward Ranger Fund.

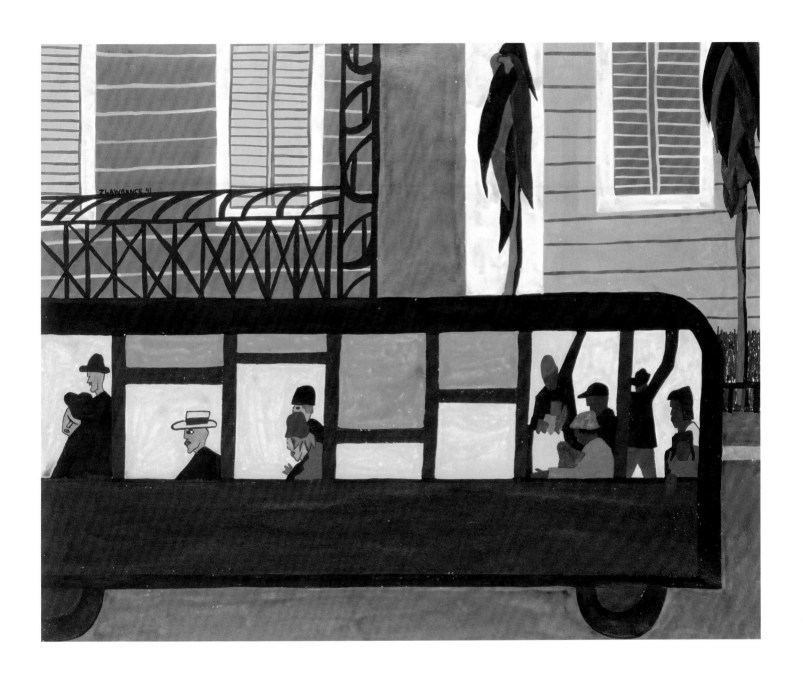

PL. 25 *Bus*, 1941, gouache on paper, 17 × 22 in. Collection of George and Joyce Wein, New York.

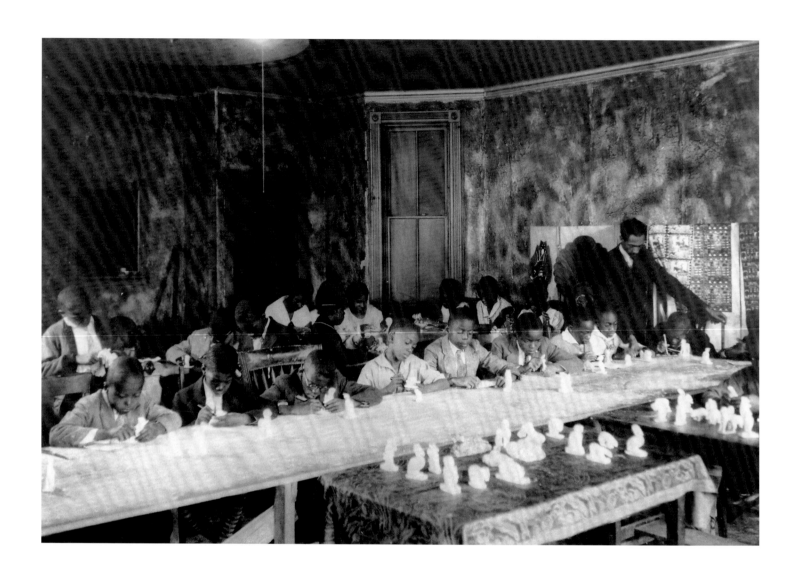

FIG. 23 James Wells instructing at the
Harlem Art Workshop, summer 1933.

Elizabeth Hutton Turner

The Education of Jacob Lawrence

But genius is nothing more nor less than childhood recovered at will—a childhood now equipped for self-expression with manhood's capacities and a power of analysis.

—BAUDELAIRE, *"The Painter of Modern Life"*

NOTIONS OF GENIUS have eclipsed the question of Jacob Lawrence's education since the start of his career. James Por-|ter's *Modern Negro Art* (1943) proclaimed Lawrence a virtuoso among popular painters. Porter credited Lawrence with childhood's gifts: "He sees the world anew for us. He has retained, from his age of innocence, that wholesomeness of comment that marks the effort of an unspoiled artist." Thus Lawrence was first described in a chapter along with Horace Pippin, a naïve artist who had invented his own way of painting. If this is an accurate characterization of Lawrence, it neatly deflects the question of his artistic education. According to Porter, "His teachers long ago agreed that he was an 'original' and not to be cramped with formal exercises in drawing and painting."[1] Charles Alston confirmed, "I decided it would be a mistake to try to teach him."[2] Lawrence has never second-guessed this decision. He has stated, as a matter of fact, "I was not trained as a professional artist."[3] But does that also mean that he was self-taught?

In telling his own story Lawrence emphasizes the lessons he learned from street preachers, Garveyites, Communists, and librarians, those people who fostered his view of the world and those who first bought and exhibited his work. He acknowledges the community in Harlem as an important source for his conviction to picture an untold story, for his desire to break through with his message that the life of his community was worthy of regard at a time when the commerce and acclaim of the New York art world itself was out of bounds to most African Americans.[4] Yet neither Lawrence's virtuosity nor his mandate as a popular artist can be completely reconciled with the facts of Lawrence's training, that is to say, how he learned to paint.

Lawrence was not a naïve artist, and in fact the story of his training is well known. His teacher was named Charles Alston. From 1934 to 1937 he attended Alston's Works Progress Administration (WPA) sponsored workshop at 306 West 141st Street, where he depicted street scenes on brown paper. Lawrence also received a scholarship to attend the American Artists School in 1937, the year he began work on his first history series. Last in this list of educational opportunities is the fact that Lawrence rented a corner in the studio shared by Alston and Henry Bannarn and there was open to mentoring until the time of his preparation to paint *The Migration of the Negro* series and his first Julius Rosenwald Fund Fellowship in 1940. Even though Alston said that he did not teach Lawrence, a bond developed between the younger artist and his teacher. Alston, in fact, considered Lawrence like "a son."[5] It was Alston who wrote the introduction for the brochure accompanying Lawrence's first one-man show at the YMCA and Alston who introduced him to Alain Locke, thereby paving the way to the dealer Edith Halpert and the larger New York art world. For his part, Lawrence must have felt he was gaining something from Alston's teaching methods to have allied himself with those particular workshops for the better part of a decade. This essay will explore what Lawrence learned.

Jacob Lawrence's modernism did not come with his acceptance by the modern museum or by way of his promotion by a modern dealer. It arrived instead by way of the modernity of his

education, even his proclaimed lack of professional training. Here an adage holds true: "Modern vision has two eyes."[6] One is the innocent eye that sees the world in a new way, à la Baudelaire. This quality of radical invention, which surely cannot be taught, corroborates Porter's and Alston's remarks and affirms the innate source of Lawrence's artistic genius. Yet we must look to the metaphysics of teaching (the values, beliefs, activities, examples, and choices to which Lawrence was exposed while he was learning to become an artist) to find out how he became an artist in the modern world. The theories and practices of modern pedagogy to which Lawrence was exposed assure the role of the second eye. This educated eye was trained to see the logic, the structure, the boundaries of the picture plane. This eye was strengthened by the principles of design, a grammar of gridded space embodying the language of vision. This eye surely enabled Lawrence to bridge the great currents of abstraction and representation with his powerfully expressive patterns.

In 1930 art was not contemplated as a career for the young Jacob Lawrence; art was an escape from the unwanted confinements of tenement and street in a poverty-stricken neighborhood, where the only playgrounds were sidewalks lined with speakeasies and gambling houses, pool rooms and dance halls.[7] As if joining the Cub Scouts or going on a hike, Lawrence chose art from among programs offered by the local settlement house. As Lawrence said, "It was something I just liked to do."[8] His earliest art experiences were informed by cutting-edge pedagogical theories recently espoused at Columbia University Teachers College. It was James Wells (B.A., Columbia, 1925), then a faculty member at Howard University, who established the arts and crafts program of Utopia Children's House, which Lawrence attended. Wells sought to make the art-making process less formidable. Picture the arts and crafts center as the Harmon Foundation photographer found it in 1933 (fig. 23). Wells is in the background, not positioned in the traditional academic orientation at the head of the class. It is not a studio but a workshop. There are tables and desks, not easels. The activities are not restricted to painting. Participation means play or experimentation with available materials.[9] Lawrence recalls that he tried soap carving, leatherwork, and woodwork as well as painting.[10] Of this initial exposure Lawrence has commented, "I didn't realize it was even art at the time."[11]

Lawrence remembers Charles Alston, not Wells, as his teacher.[12] Under Alston's supervision, the workshop functioned much as it had done under Wells. Alston considered Lawrence "not the usual mischievous, hell-raising kid. . . . Jake was always a grave little kid."[13] The seventeen-year-old Lawrence seemed mature, independent. He asked his teacher not what to do, but how to do it. "That's where I helped him," Alston said.[14] In this Alston was following the teachings of John Dewey, whose philosophy was widely read at Columbia, where he taught for many years. Dewey advocated that the student lead the way into an experience and that the teacher's lesson follow. Learning comes from seeing and doing, doing and undergoing.[15] Alston did not teach Lawrence to draw, but when he found Lawrence drawing masks, Alston showed him how to make life-size ones out of papier-mâché.[16] The exercise supplied more than materials and yielded more than masks. Fantasy assumed tangible form. Though the masks themselves have been lost—the papier-mâché long since faded and crumbled—the faces depicted in Lawrence's earliest known paintings retained the device as well as the intent of Alston's lesson: Art is not description; art comes from inside, from perception, from emotion, from imagination. This understanding provides the basis for what Columbia Professor Thomas Munro, a colleague of Dewey's, called "a selective and reconstructing eye."[17]

When the tempera paints on the workshop table carried Lawrence's inclinations further into painting, Alston next showed him how to take charge of the picture plane. Lawrence recalled the activity as "making designs with rugs." Such exercises in form and image structure were widely known, particularly at Columbia Teachers College, through a textbook entitled *Composition,* published in 1899 by Arthur Wesley Dow. Dow had been chairman of the Fine Arts program at Columbia University Teachers College from 1904 until his death in 1922. Dow's *Composition* had been the first text of its kind to provide popular access to ordinary artistic practices. Dow ignored traditional distinctions between fine art and decoration, finding the same principles of design in both categories. His examples put ideas of form and aesthetics within reach of everyday experience. *Composition* recommended, "Copying a part or the whole of some good rug—in line and color—is the best way to become acquainted with space, motives and quality. Then design a rug with border and centre, the shapes to be pure inventions or symbols."[18]

Following Dow's method, instead of teaching figure studies and other techniques of the academy, Alston taught objective or nonrepresentational drawing. Instead of passive description of the exterior world, Lawrence, following Alston, attended to the surface of the artwork. The preestablished compositions of rugs functioned as templates. By copying them Lawrence was plotting the rectangle, mapping the space, becoming aware of all pictures as compositional structures. As Dewey, once Dow's colleague at Columbia, said, "Art does not create the forms; it is their selection and organization in such ways as to enhance, prolong and purify the perceptual experience."[19] By reframing the designs, by recutting the space, by changing the orientation of the border, Lawrence's eye became attuned to visual relationships as well as his own predilections for certain shapes. Within the frame were experiences in pure pattern—using shapes he had liked or invented—seeing them in relation to each other—in repetition, alternation, and symmetry. "I think I like to put things against things and see them work. I think that's it. And seeing the entire picture plane as a whole and seeing one thing, how it reacts against something else, and the push, the pull of things," Lawrence has said.[20] Pattern had a powerful hold over the young Lawrence. Some say he was so obsessed that it led to his seeing pattern everywhere: doors, windows, fire escapes, subway tiles.[21] Such was the intent of Alston's lesson. And such was the experience of Frank Lloyd Wright who having been taught as a child first to draw geometric shapes remarked, "I soon became susceptible to constructive pattern evolving in everything I saw."[22] Wright himself recognized a connection with Lawrence, once telling the Downtown Gallery, "He would make a good architect."[23]

By equating design with decoration, Alston's lesson provided Lawrence with a broad definition of art, one that elided the question of class. Poverty was not a barrier to art if he could find it inside himself or somewhere in his neighborhood. Pride walked hand in hand with this idea. Once when asked whether there was talent in his family, Lawrence replied, "it expressed itself with colored rugs and pattern and that type of thing. You see? So I think the talent was expressed in that way, but not as painting, of course. As a way of living and decorating at home, I was surrounded by this as many of us were, and maybe this was a way that poor people have of getting some sort of beauty into their lives."[24] Later, when Lawrence had a studio of his own, he imposed on it a structured aesthetic similar to the one he found in patterns. "I have always liked a certain kind of structure that happens to be geometric. It's clean. To me, it has a cleanness about it, a neatness. Maybe that's it. A certain neatness. I keep my studio, try to keep my studio and home the same way. . . . And in teaching I emphasize this aspect."[25] Dewey would not have been surprised by Lawrence's delight in structure. As he explained, "It is not by accident that some objects and situations afford marked perceptual satisfactions; they do so because of their structural properties and relations . . . and an artist may utilize his deliberate awareness of them to create works of art that are more formal and abstract than those to which the public is accustomed."[26]

Alston, like most students at Teachers College, knew that yet another lesson lay within the idea of the art in the everyday, namely "Art as experience." Dewey said, "The work of art has a unique quality, . . . that of clarifying and concentrating meaning contained in scattered and wakened ways in the material of other experiences."[27] Sometime during his tenure at the neighborhood center Lawrence began making pictures inside cardboard shipping cartons. Lawrence did not keep the boxes, but he has described them. They were, as he said, "places where I had lived." He did not conceive of them as replicas—like ships in a bottle. Rather, they were arrangements. He said that he filled the boxes as one would design for the stage, though, in his words, "I didn't know about the theatre at the time." The idea of people on a platform posing or performing like players would be carried over to such paintings as Lawrence's migrants and builders themes. Lawrence has confirmed that he did indeed discover an analogue to painting while working within the preset geometry of the boxes. "They were just like any two-dimensional painting—only they were three-dimensional," he said.[28] The spaces of both, as they framed space, encapsulated Lawrence's growing awareness of "the world conceived and grasped as picture."[29] This awareness would compel him to make art, and eventually to call himself an artist.

When he was seventeen Lawrence quit Commerce High School, thus ending his mother's hopes for his securing his future as a postman. As he said, "I knew what I wanted to paint and I found that both my school work and painting were suffering and I had to give up one or the other so I left school."[30] Lawrence may have struck out on his own, but he also kept

Alston as a guide. His formal schooling ended in 1934, just when Alston left the 135th Street library and started a new workshop funded by the WPA at 306 West 141st Street.[31] Lawrence has always been clear about the importance of the 306 workshop. "It was responsible for those who may not have developed professionally as others to receive the experience of those who were professional, you see."[32]

Alston was not only the sole black artist with a master's degree in New York City, he was also the first salaried WPA art workshop director in Harlem.[33] Among Alston's first decisions was to hire Henry Bannarn, a personable artist with great technical virtuosity. Alston intended to handle the drawing and painting classes while Bannarn concentrated on the teaching of sculpture, but team teaching was more the rule.[34] Alston's workshop offered a new model of the artist's studio. It was not an isolated bohemian garret but rather a guildlike workshop for masters and a gathering place for their protégés—a bottega in the truest sense. Since the late 1920s the College Art Association had advocated the bottega as a place where the artist focused on teaching and useful production very similar to Lawrence's later description of 306.[35] "You were able to ask questions of people who had more experience than yourself about technical things in painting."[36] If the WPA workshop was, in Lawrence's words, "my education,"[37] what did he learn in the bottega at 306?

At 306 the exchanges involved more than just technical information because here the teacher was not only a skilled craftsman but a well-read, active voice in the community. At 306 art was not a solitary ritual; it both was conducted in the world and brought the world inside the artist. Lawrence's earliest accounts confirm this: "During my apprentice days (about seven years) I wasn't grounded so much in the technical side of painting as I was in the philosophy and subject I was attempting to approach. As a professional artist this philosophy has always taken precedence over technique."[38] This definition of the artist would send him out of the studio and back to the 125th Street library or to the Metropolitan Museum of Art or the Museum of Modern Art to find out more about who he was.

The struggle for self-portrayal by the African American community—indeed the desire to be born anew in the eyes of the world and to contribute powerfully to what it meant to be American—set the tone and direction of the Harlem

workshops. Intimations of this Holy Grail colored Alston's repeated requests for federal funds as well as his search for jobs and recognition for his students. This particular mix of racial pride and modern outlook would be reiterated by the artists and writers who came and went from 306. Among them were Claude McKay, Langston Hughes, Ralph Ellison, Aaron Douglas, and particularly Bannarn.

Looking back, Lawrence saw his goals shaped by the sequence of his workshop activities. As he said, "My first ambition was to design masks. Then I wanted to do stage sets, and I did build a few. . . . Then I wanted to do murals."[39] The execution of the mural at Harlem Hospital became the culminating event of the 306 workshop. Alston's mural, *Magic and Medicine* (fig. 24), connected images of tribal Africa, the point of origin for the great diaspora to the New World, with the faces and experiences of Harlem. According to Alston's mentor, the philosopher Alain Locke, Africa was the essential symbol of invention and strength for the New Negro in a modern culture unfettered by the academic tradition of the High Renaissance. This lesson would have been underscored by Lawrence's trips downtown to see West

FIG. 24 Charles Alston, *Magic and Medicine*, 1937, Harlem Hospital.

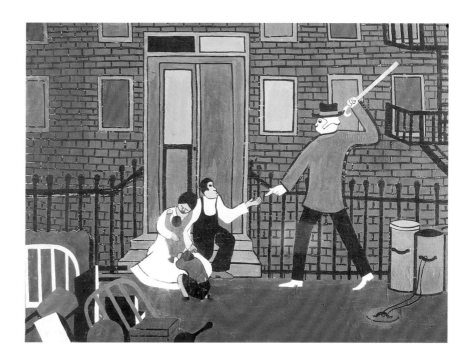

FIG. 25 *The Eviction*, 1935, tempera on brown paper, 28⁷⁄₁₆ × 38⅞ in. Jack S. Blanton Museum of Art, The University of Texas at Austin. Purchased through the generosity of Mari and James A. Michener, 1969.

African sculpture in the exhibition *African Negro Art* at the Museum of Modern Art.[40] Too young to join the some twenty-five young artists (including his future wife, Gwendolyn Knight) working with Alston (artists had to be twenty-one to work on WPA projects), Lawrence nevertheless witnessed Alston's struggle to paint the images of the New Negro as he wanted.[41] Alston said, "You see the faces of those Negroes in the sketch for the mural, he pointed to a fourteen foot white wall, [they] are angular, different from the conventional concept of beauty. But when you paint Negroes who look like Greek gods you're just faking."[42] For Lawrence the message was clear: To be an artist you must paint your race. But how?

Right from the start, the sensuous, musical appeal of Lawrence's tempera colors brought attention to Harlem subjects hitherto reserved for realist painters and poets as well as documentary writers and photographers. Lawrence's earliest surviving paintings take as their subjects rooms, facades, pedestrians, sidewalks, streets, and storefronts. The fast-drying, opaque poster paints on brown paper plied the faces of crowds and buildings with the immediacy of caricature. Lawrence's observations exposed hard truths and comic irony in *The Eviction* (fig. 25), *The Party* (fig. 26), and *Street Scene—Restaurant* (see p. 231, fig. 98). In this regard Lawrence's subjects shared much with the blunt humanism of the poet Claude McKay. McKay

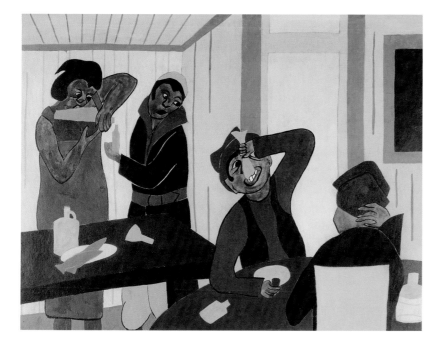

FIG. 26 *The Party*, 1935, tempera on paper, 17½ × 22½ in. Collection of Clarence and Jacqueline Avant, Beverly Hills.

was able to see and speak artistic truth in a way that the symbolism of the New Negro in Alston's Harlem Hospital murals did not. In *Home to Harlem* (1928) McKay's empirically detailed accounts had neither ignored nor apologized for the restricted and impoverished aspects of the African American working-class life. Like McKay, Lawrence balanced a certain playfulness of form with a heightened social conscience.[43] The action of angles within the picture plane, known to him from his earliest lessons, together with the flow of colors brushed over the carefully drawn shapes, conveyed immutable laws of ornament, of repetition, symmetry, and alternation. Here the language of pattern aspires to become as natural as speech, as rhythmic as poetry. Above all Lawrence prized this fluency.[44] As he said, "I want the idea to strike right away."[45]

Unlike his teachers—Alston and Bannarn, whom he called "college people"[46]—Lawrence adopted no named style, saw no need for oils, but continued with the simplest means of the children's workshops. He made this restriction the basis of his expression. Lawrence later explained, "Limiting yourself to these colors [available in poster paints] gives an experience you wouldn't get otherwise."[47] Lawrence's choice did not have its roots in what Dewey called a "discontent with existing technique,"[48] which led some artists to try to find meaning in new techniques. Lawrence, like most artists of conscience working during the depression, believed such experiments were for high modernists working in isolation.[49] Instead, Lawrence's passion to identify with his audience dictated his choices. "My work almost grew out of the way an unsophisticated person would work in a flat kind of pattern, color, but not academically. And they did encourage this." Who encouraged this thinking of medium and method in terms of education and class? Lawrence has said, "I think it was a period of this kind of encouragement in art—the country was very social minded—and I think the big influences were in art, the Mexican painters."[50]

The activities of Diego Rivera and José Clemente Orozco in New York in the 1930s indeed resonated in depression-era Harlem. Lawrence recalled, "I wanted to do murals. It was about this time I learned about Orozco and began to take note of outside well-known artists. He was the first."[51] Prior to doing the Harlem Hospital murals, Alston had watched Rivera paint his mural at Rockefeller Center and had talked to him in French because Rivera knew little English.[52] No longer a cubist, Rivera had

FIG. 27 *Chow*, 1936, graphite on paper, 9 × 6 in. Spelman College, Atlanta.

much to tell of his conversion to social realism—he even published an account of it. As a muralist he now highlighted objective reality. He immersed himself in the struggles of the working class as one preparing to voice a formerly suppressed idiom or dialect. Yet in concentrating on subject matter Rivera had not forgotten ultramodern technical means. He maintained that he was merely adapting his tools, his plastic form, his medium, even the method of his organization to a more accessible epic format. Dressed in coveralls, Rivera proudly spoke of his productivity. "It was first necessary for me to work night and day in order to arrive at a point where I could honestly call myself a workman. . . . I find my only justification in painting. Probably that is why I have been able to paint buoyantly, without fatigue, fifty easel pictures, any number of drawings, a quantity of water colors and 150 mural paintings in fresco."[53] This refrain would echo as Alston exhorted the Harlem Art Guild, "In the long run we will not be judged by emergencies but by achievements and these only. Production is very important."[54]

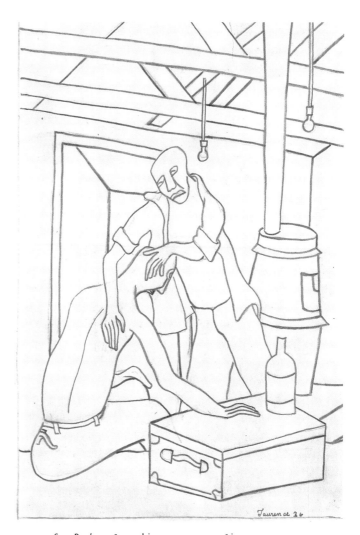

FIG. 28 *Infirmary*, 1936, graphite on paper, 9 × 6 in. Spelman College, Atlanta.

FIG. 29 *Sore Back*, 1936, graphite on paper, 9 × 6 in. Spelman College, Atlanta.

Rivera would have classified Lawrence a "workman." Until he was twenty-one, that is, until he was old enough for a paid position on the easel project of the WPA, Lawrence worked for a printer, delivered newspapers, and did construction labor for the Civilian Conservation Corps (CCC) to help support his family. Drawings depicting the CCC barracks such as *Chow* (fig. 27), *Infirmary* (fig. 28), and *Sore Back* (fig. 29) attest to the fact that, as he has said, "I was always thinking about art."[55] Like Ben Shahn's series of paintings based on the 1916 trial of the murder of the labor leader Tom Mooney, which was deemed praiseworthy by Rivera, Lawrence's CCC drawings aspire to constitute "a complete portrait of the social environment" in which the artist developed.[56] Lawrence ultimately became a tireless and assiduous researcher. He used his scholarship to the American Artists School in 1937, and beyond that for the next three years, until 1941, his Harmon Foundation and Rosenwald grants, to read voraciously at the Schomberg Library. Gwendolyn Knight Lawrence recalled, "No one worked harder than Jake."[57] Moreover,

he was productive. Between 1937 and 1941 Lawrence created more than 170 paintings in series depicting nearly two hundred years of history—or rather history as biography of the black race in America—*The Life of Toussaint L'Ouverture, The Life of Harriet Tubman, The Life of Frederick Douglass,* and *The Life of John Brown,* as well as the collective biography entitled *The Migration of the Negro.* An equally ambitious and inventive creative process matched the breathtaking scope of such narratives. To complete each cycle Lawrence made a system of painting as one would plan a city or build a skyscraper. As Orozco had said, "If new races have appeared upon the lands of the New World, such races have the unavoidable duty to produce a new Art in a new spiritual and physical medium. Any other road is plain cowardice. . . . The architecture of Manhattan is the first step. Painting and sculpture must certainly follow."[58]

In creating his earliest cycles, Lawrence first wrote captions and completed sketches (sometimes as many as ten to twenty) for each scene. Lawrence's first question, in fact, when

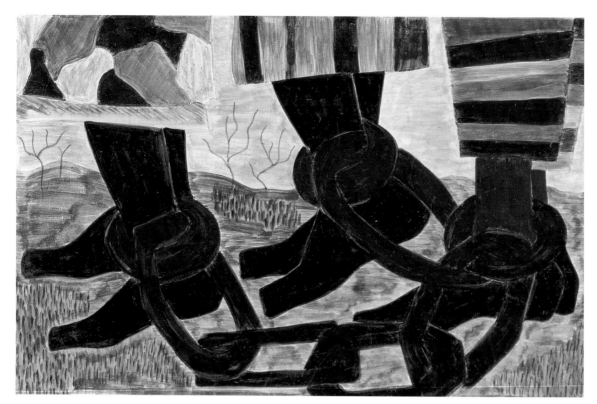

FIG. 30 *The Life of Harriet Tubman, No. 9: Harriet Tubman dreamt of freedom ("Arise! Flee for your life!"), and in the visions of the night she saw the horsemen coming. Beckoning hands were ever motioning her to come, and she seemed to see a line dividing the land of slavery from the land of freedom,* 1940, casein tempera on hardboard, 12 × 17⅞ in. Hampton University Museum, Hampton, Virginia.

he met Orozco making a mural in New York in 1940 was, "Where's your sketch, where's your detail?" Orozco told Lawrence that he did not need one.[59] By 1941 Lawrence would eliminate the separate step of sketching on paper by drawing directly on his same-sized gessoed panels of hardboard. He created rhythms of horizontal and vertical panels as he laid out the narrative sequence. As Rivera said, "The subject is to the painter what the rails are to a locomotive."[60] Set down like a track on his studio floor, the thirty to sixty panels of a given cycle could be seen together and, most important, painted all at once. Lawrence painted color by color, building up pattern and, in so doing, buttressing dark to light. His choice of colors—black and burnt umber moving to cadmium orange and yellow—achieves an overall decorative unity and consistency in *The Migration of the Negro* series, for example. Conceived as image and word, the poetry of Lawrence's cycles emerges from the repetition of certain shapes. The enlarged single spike or nail, the links of chains, of lattice, the hand and hammer serve as refrains in the lives, the decisions, the struggle of African Americans in the face of injustice (see *The Life of Harriet Tubman, No. 9* [fig. 30], *The Migration of the Negro, No. 4* [fig. 31]).

At this juncture Claude McKay again entered into Lawrence's education. In the early 1940s Lawrence and McKay lived in the same loft building on 125th Street. As Lawrence recalled, "He would wander into my studio, and I'd go to his place and talk. He was a very tough fellow, and very critical of our whole social environment, critical of whites, critical of blacks."[61] An immigrant from Jamaica to New York in 1912, McKay knew something about crossing boundaries. Sustained by an American literary tradition of dissent and social criticism, McKay became both a contributor and the only African American editor of the *Liberator* during the 1910s and 1920s. Langston Hughes recalled that back then McKay "wore a red shirt and mingled with the white radicals and writers of the town—a thing that shocked both Negroes and whites who were not used to seeing a big black boy breaking away from the color line."[62] In the summer of 1941, soon after Lawrence completed *The Migration of the Negro* series, McKay inscribed a copy of his autobiography, *A Long Way from Home* (1937), for Lawrence: "a peerless delineator of the Harlem scenes and types."

In 1946 Lawrence finally named his method and discovered a place on the modern "family tree," when Josef Albers invited him to teach, first as a counselor and later a full instructor, at Black Mountain College (fig. 32). "When I teach," Lawrence said, "I am definitely a descendant of the Bauhaus." Albers's desire to exhibit and study Lawrence's work at Black Mountain

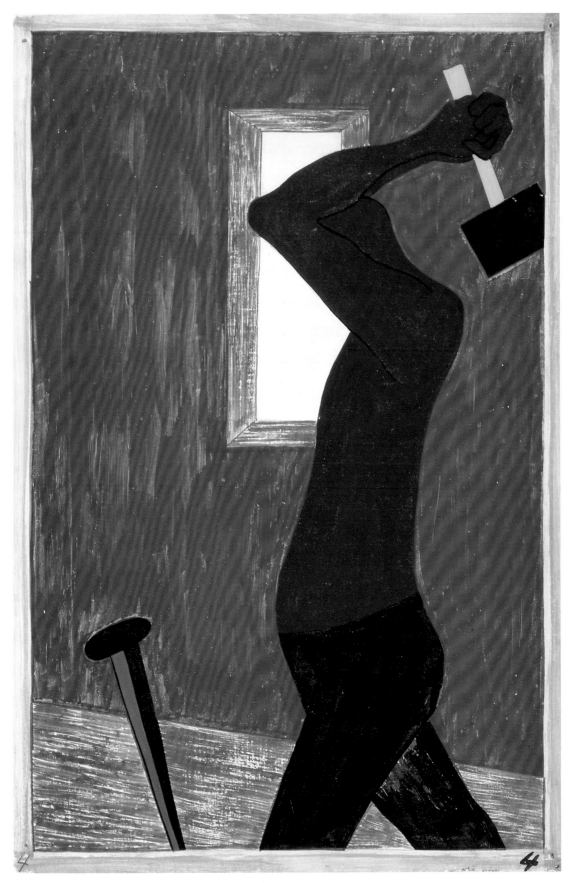

FIG. 31 *The Migration of the Negro, No. 4: The Negro was the largest source of labor to be found after all others had been exhausted*, 1941, casein tempera on hardboard, 18 × 12 in. The Museum of Modern Art, New York.

FIG. 32 Black Mountain College Summer Institute, 1946.

was matched by Lawrence's desire to observe him. "I noticed that each day he would sit in a different spot and observe a different painting." What did Albers show Lawrence? Most vivid in Lawrence's recollections is Albers's demonstration with a coat hanger to show the effect of line in space. Lawrence also saw "the magic working in the picture plane" when Albers simply changed one shape or altered just one color or revised the edge in a given composition.[63] Lawrence's perceptions—his wonder at Albers's performance of the picture plane was akin to his childhood wonder at trompe-l'oeil paintings at the Metropolitan[64]—inevitably led him to further investigation. Five years later, Lawrence performed his own demonstration. Two opposing performers, two weeping clowns from *Vaudeville* (fig. 33), face each other on the stage of the Apollo amid a dazzling array of color. The vibrations set in motion by the crisscross of legs, the dense pattern-against-pattern, the checkered overlap of circles and squares are interrupted by a single gesture. This large hand spreading wide alters the pattern of expectation and thereby captures the eye and affects the illusion. Its pantomime asks, "Can you follow?"

While watching Albers watch his paintings Lawrence came to recognize and analyze his own love of architectonic structure and economy of color. As with most artists whom he admired, Lawrence found more to like than technique. Here also was "a commitment to life."[65] In the bustling voices of students around tables working with their chosen craft at Black Mountain College

Lawrence may have also recognized and identified the means and merits of his earliest instruction, such as Alston's opening exercises of dividing lines according to Dow.[66] Albers's discussion of the economy of color ("Why use five colors when you can use three?"[67]) shared a mission with Utopia Children's House. Both Alston and Albers shared similar convictions about whom and how to teach. Both believed in art for everyone. Both offered a set of visual principles—an emphasis on arrangement, not representation; perception, not description—that broadened the definition of art. In demanding an art of everyday life, both used art as a tool for social reform.

We would do well to remember and value, as Lawrence certainly did, the early formats and media that he carried with him into adulthood. Lawrence's early résumé reveals his participation in what were then the new initiatives in art education—what James Porter hailed in 1939 as "a movement" in which "learning opportunities in the craft arts and the higher skills have increased more than fifty percent during the past twelve years."[68] These were well-orchestrated programs operating apart from the traditional atelier, including those run by Columbia University Teachers College graduates James Wells and Charles Alston. They suggest a different, more democratic audience for art. Their settings link child art to practices of modernism. In accordance with Dow's *Composition* and Dewey's philosophy, Alston's lessons of design—the rules of field and frame—empowered student decisions and thereby attached value to

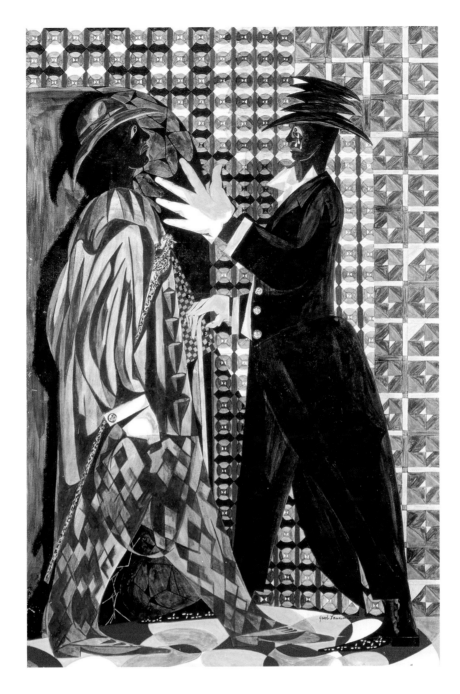

FIG. 33 *Vaudeville*, 1951, egg tempera on hardboard, 29⅞ × 19¹⁵⁄₁₆ in. Hirshhorn Museum and Sculpture Garden, Smithsonian Institution. Gift of Joseph H. Hirshhorn, 1966.

invention. Not surprisingly, in the fall of 1940 the Columbia University School of Architecture, Drawing, Painting, and Sculpture would want to hail the young Lawrence with an exhibition.[69] Lawrence's remarkable solutions to problems in materials and structure provided him the means by which to buttress the two great currents of the epic and the abstract that converged in his mature style. It was Lawrence's confidence in this invention that uniquely equipped him—unlike his professionally trained peers—for a dialogue with Orozco and Albers in the modern arena. "I have an assuredness of myself," he has said.[70] This, perhaps, is the greatest gift of education.

NOTES

I want to thank Michelle DuBois and Peter Nesbett and the team of scholars they put together to write this monograph for the Jacob Lawrence Catalogue Raisonné Project. I am particularly grateful for Fronia W. Simpson's editorial guidance and for Jobyl Boone's careful reading. I also want to thank Judy Throm and the staff of the Archives of American Art who assisted with my many research requests. I also am indebted to the staff of the Phillips Collection, particularly to Elsa Mezvinsky Smithgall, Assistant Curator, and interns Ricardo Harris Fuentes, Alex Marshall, and especially Jessica McMichael. Last and most important, I am grateful to Jacob Lawrence and Gwendolyn Knight Lawrence who have helped me to better recognize and value the educated decisions of artists.

Epigraph: Charles Baudelaire, *The Painter of Modern Life and Other Essays*, trans. and ed. Jonathan Mayne (New York: Phaidon, 1986), p. 8.

1. James Porter, *Modern Negro Art* (New York: Arno Press and the *New York Times*, 1969), p. 151.

2. Charles Alston, interview by Romare Bearden, May 1, 1969, quoted in Romare Bearden and Harry Henderson, *A History of African-American Artists from 1972 to Present* (New York: Pantheon Books, 1993), p. 294.

3. Jacob Lawrence, transcript of tape-recorded interview by Carroll Greene, Jr., October 26, 1968, Archives of American Art, Smithsonian Institution, Washington, D.C. (hereafter AAA), p. 10.

4. Jacob Lawrence, conversation with Henry Louis Gates, Jr., at the Phillips Collection consultant meeting for NEH planning for *The Migration of the Negro* series exhibition, June 3, 1992.

5. Bearden and Henderson, *A History of African-American Artists*, p. 261.

6. Howard Singerman, *Art Subjects: Making Artists in the American University* (Berkeley and Los Angeles: University of California Press, 1999), p. 97.

7. George Gregory, Jr., "The Harlem Children's Center," *Opportunity* 9–10 (November 1932), p. 341.

8. Lawrence, interview by Greene, p. 5.

9. Bearden and Henderson, *A History of African-American Artists*, p. 294.

10. Lawrence, interview by Greene, p. 5.

11. Ibid., p. 4.

12. Jacob Lawrence, conversation with author, June 5, 1999. Charles Alston, transcript of tape-recorded interview by Harlan Phillips, September 28, 1965, AAA, p. 5. "I came in on this thing not as the originator but to follow a man who later went to the art department in Howard University, a man by the name of James LaSeine Wells. He originated the workshop; so when I got there, the patterns were pretty well set."

13. Alston, interview by Phillips, p. 2.

14. Alston, interview by Bearden, May 1, 1969, quoted in Bearden and Henderson, *A History of African-American Artists*, p. 294.

15. Singerman, *Art Subjects*, p. 115.

16. Alston, interview by Phillips, p. 2.

17. Thomas Munroe, "The Dow Method and Public School Art," in *Art and Education* (New York: Barnes Foundation Press, 1929), p. 334.

18. Arthur Wesley Dow, *Composition: A Series of Exercises in Art Structure for the Use of Student and Teachers*, introduction by Joseph Mascheck (1913; reprint, Berkeley and Los Angeles: University of California Press, 1997), p. 127.

19. John Dewey, "Experience, Nature and Art," in *Art and Education*, p. 11.

20. Jacob Lawrence and Gwendolyn Knight Lawrence, transcript of tape-recorded interviews by Avis Berman, June 30 and August 4, 1982, AAA, p. 44, used with permission.

21. Bearden and Henderson, *A History of African-American Artists*, p. 294.

22. Frank Lloyd Wright, *A Testament* (New York: Horizon Press, 1957), pp. 19–20, quoted in Joseph Mascheck, "Dow's 'Way' to Modernity for Everybody," in *Composition*, p. 9.

23. Peter Pollack to Edith Halpert, n.d., copy, Jacob Lawrence Papers, roll 4571, frame 429, AAA.

24. Lawrence and Knight Lawrence, interviews by Berman, p. 7.

25. Ibid., p. 44.

26. Dewey, "Experience, Nature and Art," p. 11.

27. John Dewey, *Art As Experience* (New York: Minton, Balch, and Co., 1934), p. 38, quoted in Singerman, *Art Subjects*, p. 116.

28. Bearden and Henderson, *A History of African-American Artists*, p. 294.

29. Martin Heidegger, "The Age of the World Picture," in *The Question Concerning Technology and Other Essays*, trans. William Lovitt (New York: Garland Publishers, 1977), p. 129, quoted in Singerman, *Art Subjects*, p. 90.

30. Marvel Cooke, "Pictorial History of Haiti Set on Canvas," *New Amsterdam News*, June 3, 1939, clipping, Jacob Lawrence vertical files, National Museum of American Art Library.

31. The 306 workshop was funded through the Harlem Art Education Committee Workshop and Studio under the Federal Emergency Relief Act of May 12, 1933, with added support in November 1933 offered by the Civil Works Administration Act. For more information, see Jeff Richardson Donaldson, "Generation '306'—Harlem, New York" (Ph.D. diss., Northwestern University, Evanston, Illinois, 1974), pp. 110–1.

32. Lawrence, interview by Greene, p. 13.

33. Donaldson, "Generation '306'—Harlem, New York," p. 109.

34. Ibid., p. 114.

35. Singerman, *Art Subjects*, p. 36.

36. Lawrence, interview by Greene, p. 13.

37. Elizabeth McCausland, "Jacob Lawrence," *Magazine of Art* 38, 7 (November 1945), p. 253.

38. Black Mountain College Records, Faculty Files, 1946, roll 199, AAA, quoted in Ellen Harkins Wheat, *Jacob Lawrence: American Painter*, exh. cat. (Seattle and London: University of Washington Press in association with the Seattle Art Museum, 1986), p. 73.

39. McCausland, "Jacob Lawrence," p. 254.

40. Lawrence, interview by Greene, p. 85.

41. "Race Bias Charged by Negro Artists," *New York Times*, February 22, 1936.

42. "Creative Negroes; Harlem Has Its Artists, Working under Difficult Conditions," *Literary Digest*, no. 122 (August 1936), p. 22, quoted in Donaldson, "Generation '306'—Harlem, New York," p. 119.

43. George Hutchinson, *The Harlem Renaissance in Black and White* (Cambridge, Mass.: The Belknap Press of Harvard University, 1995), p. 254.

44. Lawrence and Knight Lawrence, interviews by Berman, p. 60. "It's like a language. You must be aware of this. . . . And if you're not aware of it, there's a tendency to be illustrative. If you are aware of these things you're creating, you're aware of the art in formalistic terms."

45. McCausland, "Jacob Lawrence," p. 251.

46. Lawrence, interview by Greene, p. 9.

47. Lawrence lecture, University of Washington, Seattle, November 15, 1982, quoted in Wheat, *Jacob Lawrence: American Painter*, p. 34.

48. Dewey, "Experience, Nature and Art," p. 6.

49. See Meyer Schapiro, "The Social Bases of Art," in *First American Artists' Congress* (New York: American Artists' Congress against War and Fascism, 1936), p. 33.

50. Lawrence, interview by Greene, p. 10.

51. McCausland, "Jacob Lawrence," p. 254.

52. Harry Henderson, "Remembering Charles Alston," in *Charles Alston: Artist and Teacher,* exh. cat. (New York: Kenkeleba Gallery, 1990), p. 7.

53. Diego Rivera, "The Revolution in Painting," *Creative Art* 4, 1 (January 1929), p. xxvii.

54. Minutes of the Harlem Art Guild, December 13, 1938, quoted in Bearden and Henderson, *A History of African-American Artists,* p. 294.

55. Samella Lewis and Lester Sullivan, "Jacob Lawrence," *Black Art* 5, 3 (The Jacob Lawrence Issue) (1982), p. 8.

56. Diego Rivera, foreword, in *The Tom Mooney Case,* exh. cat. (New York: Downtown Gallery, 1933), n.p., courtesy of the National Archives. Shahn's *Sacco and Vanzetti* and *Tom Mooney* series as well as his much publicized Jersey Homestead murals provided perhaps the closest precedents for Lawrence's own form of expression in tempera by the late 1930s. I want to thank Laura Katzman for bringing this reference to my attention.

57. Gwendolyn Knight Lawrence, conversation with author, June 5, 1999.

58. José Clemente Orozco, "New World, New Races and New Art," *Creative Art* 4, 1 (January 1929), p. xlvi.

59. Jacob Lawrence, conversation with Ellen Harkins Wheat, July 24, 1984, quoted in Wheat, *Jacob Lawrence: American Painter,* p. 61.

60. Rivera, "The Revolution in Painting," p. xxix.

61. Lawrence, conversation with Ellen Harkins Wheat, June 7, 1984, quoted in Wheat, *Jacob Lawrence: American Painter,* p. 59.

62. Langston Hughes, "Claude McKay: The Best," draft of an article for *American Negro Writers,* in Langston Hughes Papers, James Weldon Johnson Collection, Beinecke Rare Book and Manuscript Library, Yale University, quoted in Hutchinson, *The Harlem Renaissance in Black and White,* p. 264.

63. Avis Berman, "Jacob Lawrence and the Making of Americans," *ARTnews* 83, 2 (February 1984), p. 85.

64. Lawrence, conversation with Henry Louis Gates, Jr., at the Phillips Collection, June 3, 1992, p. 13.

65. Berman, "Jacob Lawrence and the Making of Americans," p. 83.

66. Dow, *Composition,* p. 74.

67. Lawrence's recollections of Albers often occurred while teaching. See Lawrence lecture, November 15, 1982, quoted in Wheat, *Jacob Lawrence: American Painter,* p. 34. "A teacher I once had said, 'Why use three colors when you can use two? Why use five colors when you can use three?' The idea is, it forces you to work with less, to work with a degree of economy, and out of that you could get a stronger work than you might get otherwise."

68. James Porter, "Art Reaches the People," *Opportunity* (December 1939), p. 375.

69. Franck Mechare to Jacob Lawrence, April 24, 1940, Lawrence Papers, Syracuse University, quoted in Wheat, *Jacob Lawrence: American Painter,* p. 196.

70. Lawrence, interview by Greene, p. 44.

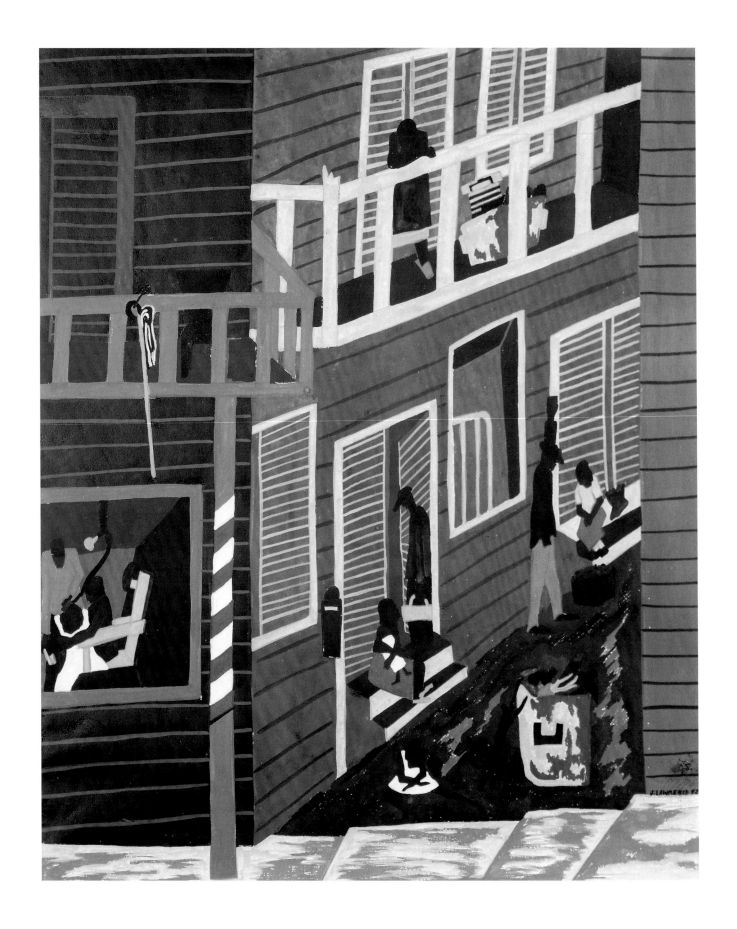

PL. 26 *Alley*, 1942, gouache on composition board,
27⅝ × 24 in. Clark Atlanta University Art
Collections. Gift of David Levy.

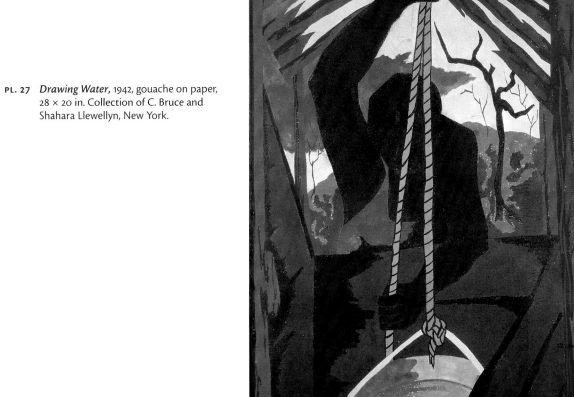

PL. 27 *Drawing Water,* 1942, gouache on paper, 28 × 20 in. Collection of C. Bruce and Shahara Llewellyn, New York.

PL. 28 *Firewood,* 1942, gouache, ink, and watercolor on paper, 22¾ × 31 in. National Museum of American Art, Smithsonian Institution. Transfer from United States Information Agency.

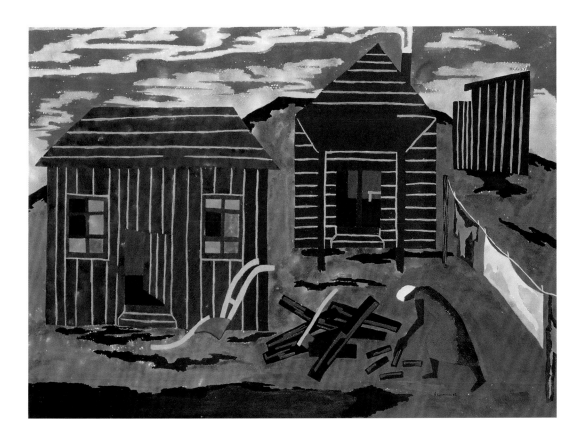

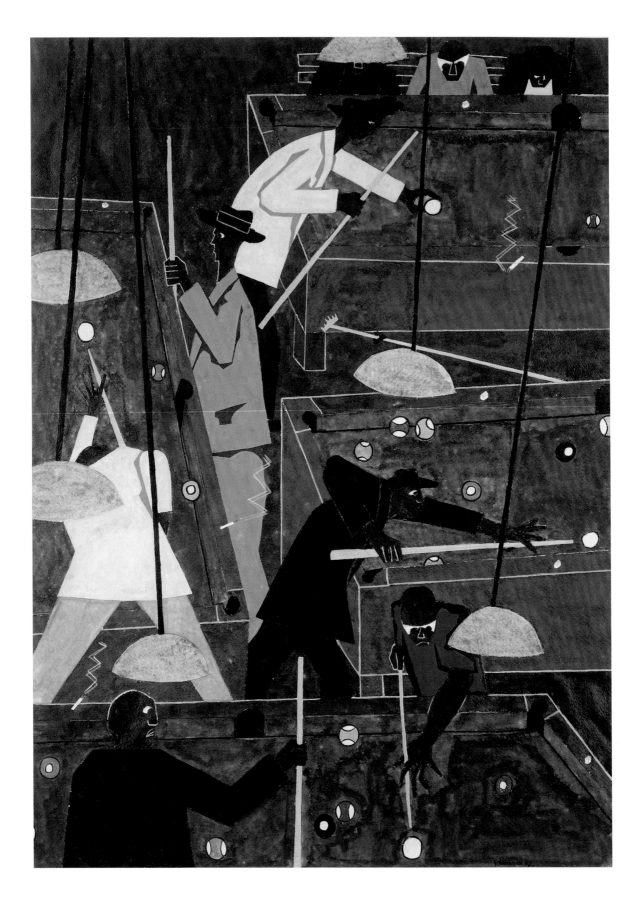

PL. 29 *Pool Parlor*, 1942, gouache and watercolor on paper, 31 × 22¾ in. The Metropolitan Museum of Art. Arthur Hoppock Hearn Fund, 1942, 42.167.

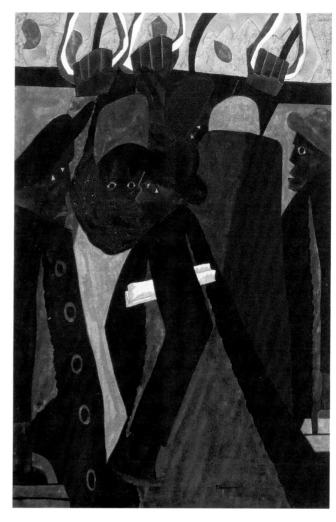

PL. 30 *The Mother and Father Go to Work,* 1943,
gouache on paper, image: 21½ × 14½ in.
Albright-Knox Art Gallery, Buffalo, New
York. Room of Contemporary Art Fund,
1944.

PL. 31 *Peddlers Reduce Their Prices in the Evening
to Get Rid of Their Perishables,* 1943, gouache
on paper, 15⅛ × 22⅝ in. Hampton University
Museum, Hampton, Virginia.

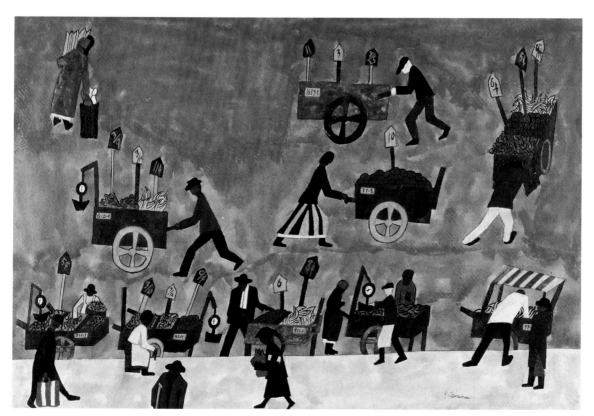

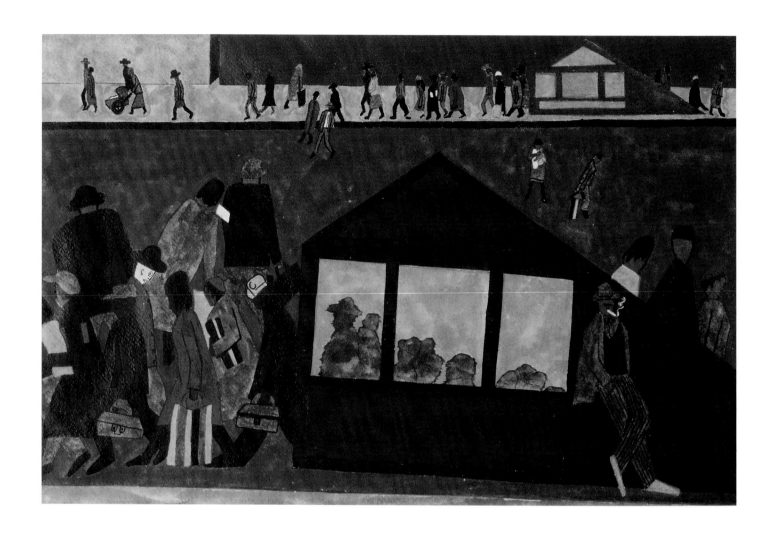

PL. 32 *In the Evening the Mother and Father Come Home from Work,* 1943, gouache on paper, 15⅜ × 22⅞ in. Virginia Museum of Fine Arts, Richmond. Gift of the Alexander Schilling Fund.

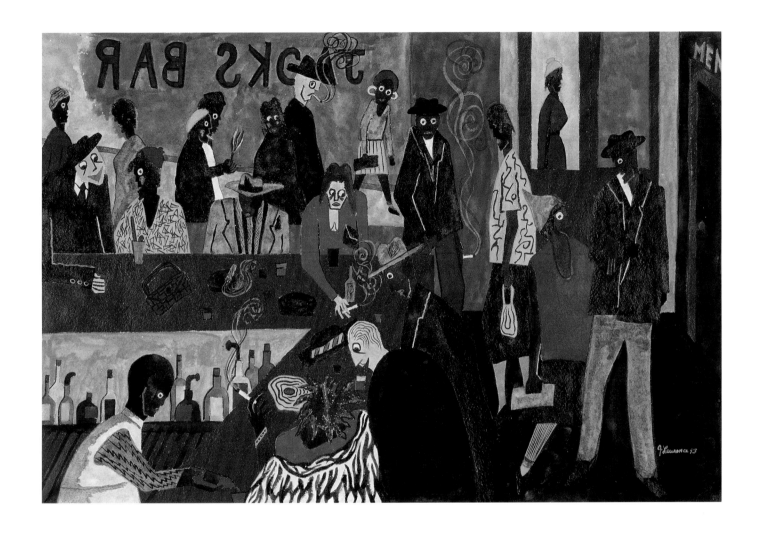

PL. 33 *There Is an Average of Four Bars to Every Block*, 1943, gouache on paper, 15⁹/₁₆ × 22½ in. Museum of Art, Rhode Island School of Design, Providence. Mary B. Jackson Fund, 43.565.

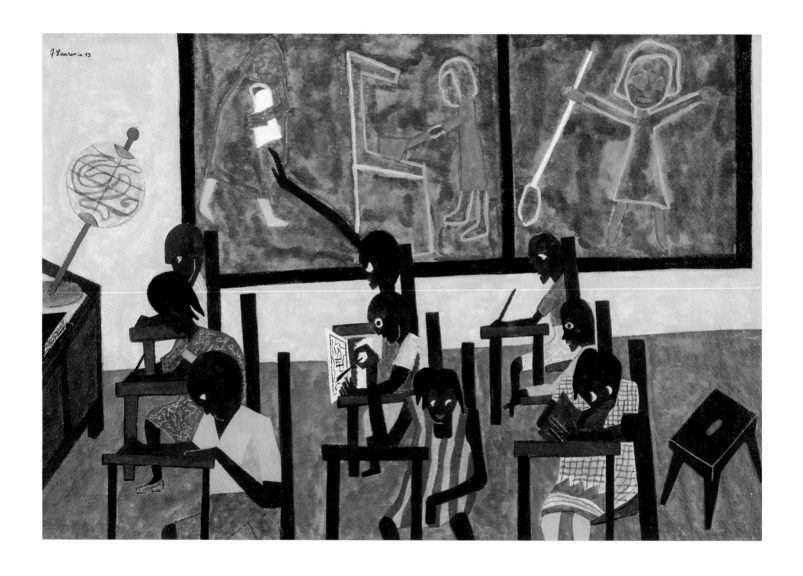

PL. 34 *The Children Go to School,* 1943, gouache on paper, 14¼ × 21¼ in. Collection of C. H. Tinsman, Kansas City, Kansas.

PL. 35 *They Live in Fire Traps,* 1943, gouache on paper, 22½ × 15⅜ in. Worcester Art Museum, Worcester, Massachusetts. Museum purchase.

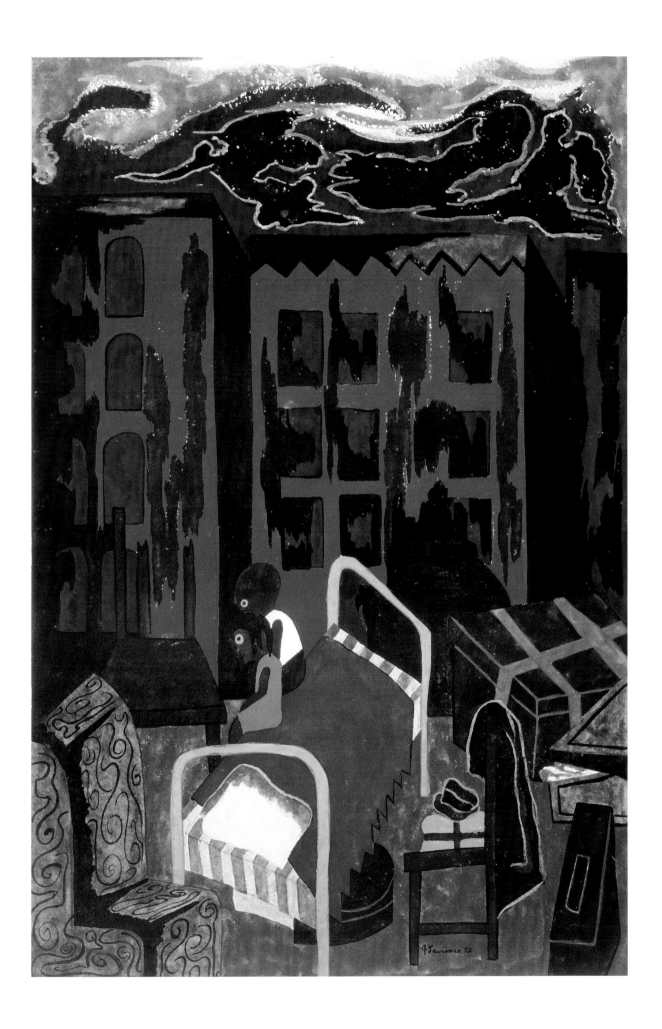

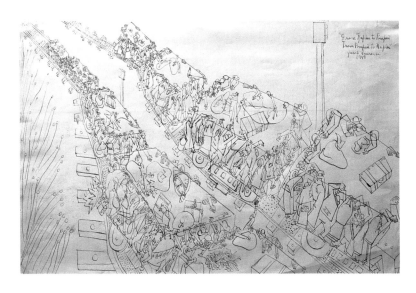

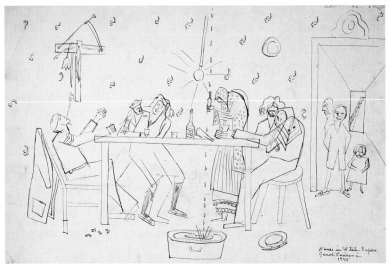

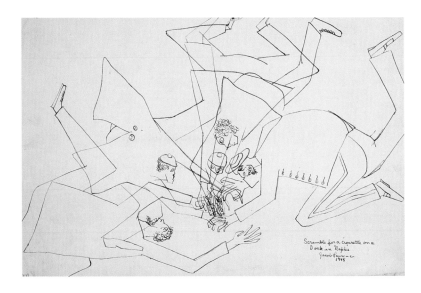

PL. 36 *From Naples to Pompeii, From Pompeii to Naples,* 1945, pen and ink on paper, 13 × 20 in. Private collection.

PL. 37 *House in Italy—Naples,* 1945, pen and ink on paper, 11⅞ × 18 in. Collection of Jacob and Gwendolyn Knight Lawrence. Courtesy of Francine Seders Gallery, Seattle.

PL. 38 *Scramble for a Cigarette on a Dock in Naples,* 1945, pen and ink on paper, 11⅞ × 18 in. Private collection.

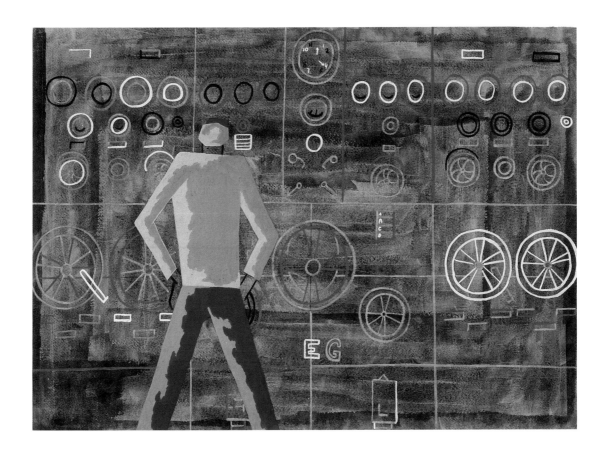

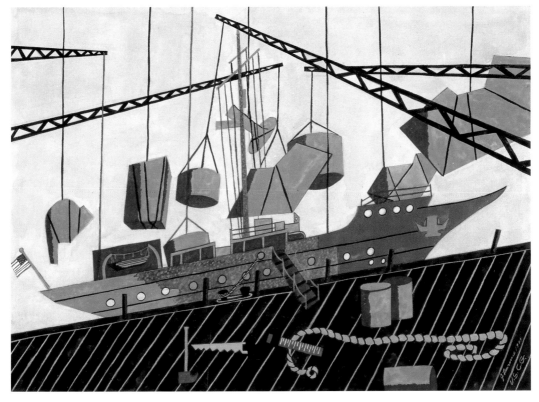

PL. 39 *No. 2, Main Control Panel, Nerve Center of Ship,* 1944, watercolor and gouache on paper, 20 × 24 in. United States Coast Guard Museum, New London, Connecticut.

PL. 40 *Decommissioning the* **Sea Cloud,** 1944, gouache on paper, 22¾ × 31 in. Santa Barbara Museum of Art. Gift of Mr. and Mrs. Burton Tremaine, Jr., 1947.14.

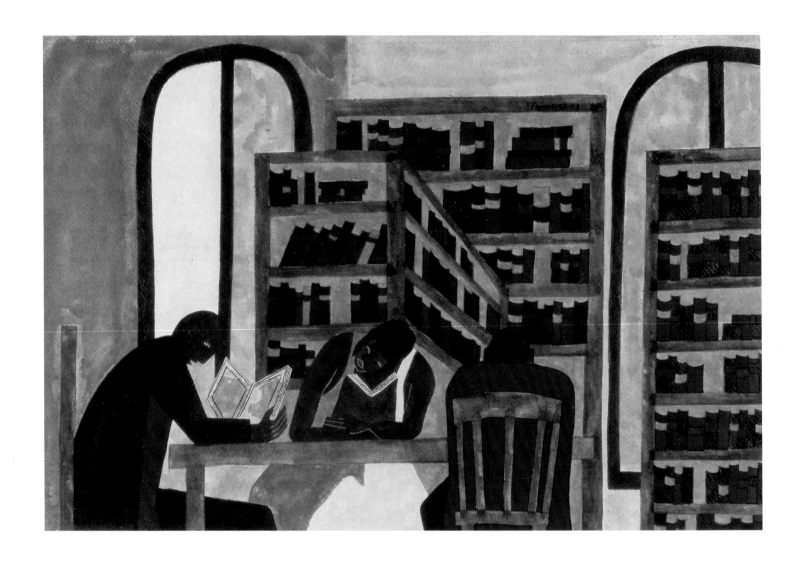

FIG. 34 *The Libraries Are Appreciated*, 1943, gouache on paper, 14¹¹⁄₁₆ × 21⅝ in. Philadelphia Museum of Art. The Louis E. Stern Collection.

Lizzetta LeFalle-Collins

The Critical Context of Jacob Lawrence's Early Works, 1938–1952

MODERN AND PRIMITIVE: these two complex, contradictory terms were used by critics in an attempt to define Jacob Lawrence's work during his early years as an artist. These words both characterized his ability as natural and untutored and celebrated his use of bright, unmodeled colors and strong, bold designs, reminiscent of the work of innovative modernist artists. This essay will examine the different uses of the terms *modern* and *primitive* as both black and white critics of Lawrence's work strove to contextualize him within or at the margins of a new and exciting American art.

Modern—a term brought into usage in the late nineteenth and early twentieth century by artists and intellectuals in western Europe—described an art that was about the present and the future. In the United States it described the changes in an energetic, machine-age, urban society that was becoming increasingly secularized and consumer-based. It also implied that viable artistic expressions could be born on American soil, distinct from European traditions. American art forms like jazz, rooted in African American culture, were integral to the sense of the modern and gave the movement its swing. Still, white mainstream critics, especially in the 1940s and 1950s, tended to emphasize formal invention over subject matter in their definitions of what made art modern. As Jeffrey C. Stewart has noted: "By privileging the artistic and literary rebellions of the late nineteenth and early twentieth century, modernist theorists usually validated the primacy of the art object as the center of any aesthetic interpretation and consider the social, political and economic underpinnings of cultural production as marginal."[1] In other words, unless a work was highly formalized—with no social, political, or even humanistic content—it was not valued within the modernist discourse.

Modern was also an attitude adopted by many African Americans as they tossed aside the legacy (and mannerisms) of slavery and moved North into the growing metropolises. The geographic change called for a corresponding psychological change. "New Negroes," as they called themselves, wanted to look different, act different, talk different, and be different from the ways they had left behind. New and modern, their personal and collective attitudes permeated their arts. So, as white artists and critics were designating new things as "modern," African Americans imbued the term with nuances distinct to their experiences and their ambitions.

Aside from its use to describe artwork coming into the United States from indigenous cultures in Africa, the Americas, and Oceania, the term *primitive* was used in the 1930s to describe art by self-taught and folk artists. The term also suggested a simplicity or a lack of sophistication frequently associated with the common man. When the so-called untutored qualities of the folk artist converged with the reductionist styles of abstract modernists, the artist was termed a *modern primitive*.[2] It was a term seemingly tailor-made for whites to discuss black artists. As the art historian Sharon Patton explains:

> Whites made blacks a symbol of personal freedom, which embodied modernism. . . . Primitivism, the cultural crucible for modernism, was for European and white American audiences available in American Negro culture, which was regarded as a subculture to mainstream America. Despite the fact that African Americans had lived in North America from the seventeenth century, there was a widespread belief that Africa pervaded Negro culture. As African descendants, the American Negro was the modern primitive.[3]

For many critics and curators, Lawrence was a modern primitive, an authentic voice. Prestigious art institutions such as the Baltimore Museum of Art, New York's Downtown Gallery, the Museum of Modern Art, and the Institute of Modern Art in Boston exhibited his work, but for the early part of his career, he remained in a curious position as a modern primitive, both within but also at the margins of the mainstream art world. As such, he was cast in the role as an unofficial spokesman for black people in the New York art scene, a spurious position for any artist to find himself in. Moreover, this designation is not accurate—Lawrence was not a spokesman; he simply interpreted life as he knew it.

Lawrence began his career during the waning years of the Harlem Renaissance, an outgrowth of modernism, when primitivism was current in the minds of an intellectual world that also included blacks. Harlem, and its performers and artists who utilized and visually portrayed black folk idioms, was perceived as exotic. Cabaret acts featuring black performers who performed a black popular repertoire and even sacred songs were sought as entertainment, in this country and abroad, for largely white audiences. Second only to American Indians, black people were valued in the white American consciousness and culture only for their so-called primitive qualities. Although Lawrence was too young to be considered an artist of the Harlem Renaissance, he and many black artists of the time were met by a critical reception that perpetuated such ideas. They faced a dilemma as they concentrated on representing their new modern black communities and especially nationalistic folk themes. If not modern—and they could not be that completely in the eyes of white modernists—the Negroness expressed in their literature and art was perceived as primitive by their white audiences. For members of an art world that delved into the primitive only as voyeurs, Lawrence perfectly fit the white notion of a black artist. He was not privileged but poor; he was not light-skinned like his mentors but very black; he was not university-trained but was characterized as self-taught.[4]

The critics chose to ignore the fact that Lawrence had been trained in the Harlem community, focusing instead on Lawrence's "natural talents" and his use of bright primary colors. Lawrence's work was frequently compared to posters and cartoons, and while some critics seemed complimentary, such phrases as "poster-like bright colored scenes" and "the cut-out kindergarten gaiety of his [Lawrence's] protest" diminished the seriousness of his work as an artist.[5] Writing about *The Migration of the Negro* series in the *New York Sun* in 1941, Henry McBride remarked, "There is little in Lawrence's work that departs from this saga of sadness. Its appeal lies in the fact that in his emotional reactions to it he has really gone native—has preserved the Negro's instinct for rhythm and love for crude brilliant colors which he handles with unfailing decorative felicity. At times, he strikes a poignant note, as in the simple aftermath of a lynching—an empty noose, and one bowed, mourning figure."[6] In calling Lawrence's work "natural," a reviewer stated, "realistic proportion and form would in no way help to tell his pictorial story better than he does in his own posteresque language of ungrammatical but dynamic art inventions."[7] In *Time* magazine, Lawrence's Coast Guard paintings were described as "patterned with the crude simplicity of a poster; his people angular, always distorted; his colors somber, often murky. But the moods he created were sure."[8]

Whites expected Lawrence, like other black artists of the period, to portray particular subjects. Patton states that "the New Gallery owner and director, George Hellman, urged Archibald Motley to paint the more exotic aspects of Negro life, scenes which should include the 'voo-doo' element as well as the cabaret element—But especially the latter for his solo show (1928)."[9] Black intellectuals were aware of white intellectuals' interest in the primitive and their view that black creative expression should well from a primitive past. White collectors such as Albert Barnes had become deeply committed to primitivism as a mode of modern art, and he also considered African art as a starting point for the development of a Negro art idiom.[10]

This presented a dilemma for the black middle class who, from the late nineteenth century, had rejected all things African except those from Egypt, which they viewed as a noble civilization removed from sub-Saharan Africa. Some black middle-class intellectuals accepted the interest on the part of white intellectuals in Africa and primitivism as a way for African Americans to be accepted. Alain Locke, a professor of philosophy at Howard University and a Rhodes scholar, promoted abstract symbolism and decorative designs in the arts of African Americans. He felt that African art provided "the mere knowledge of the skill and unique mastery of the arts of the ancestors, the valuable and stimulating realization that the Negro is not a cultural foundling

without his own inheritance."[11] Lawrence was aware that Locke recognized in his art a connection to their shared African past. In 1940 Lawrence asked Locke for a letter supporting his application for a fellowship to the Julius Rosenwald Foundation to complete a series of paintings on the migration of African Americans from the rural South to the urban North during World War I. Locke agreed to write the letter. In it he referred to one of Lawrence's earlier series and stated: "The Toussaint L'Ouverture Series has a dramatic force, a direct and original treatment and exciting naïve quality."[12] Locke was not immune to the art world's perception of the young Lawrence. By suggesting that the artist's works were naïve paintings (with all of the cultural implications that that term can suggest), Locke astutely ensured Lawrence's award of a scholarship. In 1943 the publication of James A. Porter's *Modern Negro Art* sealed the context for Lawrence's work by including it in a chapter entitled "Naïve and Popular Painting and Sculpture," alongside works by Horace Pippin, William Edmondson, and other equally nonacademic artists. Assumed at the time to be like these two named artists, Lawrence was championed for following his own course in his development as a painter, unbothered by any particular "ism."

Although Lawrence was not part of any stylistic movement, he nonetheless wished to be thought of as part of his time, as modern. In African American culture being modern meant being aware of one's intellectual history (fig. 34). This he conveyed in his earliest works by acknowledging the deeds of black heroes in paint. These heroes, both men and women, had already been lionized in the literature of the Harlem Renaissance, yet their stories were not taught in the schools. Lawrence had a point to make in painting their stories:

> I've always been interested in history, but they never taught Negro history in the public schools. . . . I don't see how a history of the United States can be written honestly without including the Negro. I didn't do it just as a historical thing, but because I believe these things tie up with the Negro today. We don't have a physical slavery, but an economic slavery. If these people, who were so much worse off than the people today, could conquer their slavery, we certainly can do the same thing.[13]

Between 1937 and 1941 Lawrence completed several groups of works on these themes, three illustrating the black cultural heroes: *The Life of Toussaint L'Ouverture* (1938), *The Life of Frederick Douglass* (1939), and *The Life of Harriet Tubman* (1940). Two others represented historic moments in black American life: *The Migration of the Negro* (1941) and *The Life of John Brown* (1941).

Lawrence chose specific modern formal devices to tell these crucial stories. When he produced the Tubman and Douglass series, these heroes were not yet well known outside African American communities. His introduction of these characters into art thus also introduced them to many Americans, and it called for a bold style. In the Tubman paintings, for instance, Lawrence shows Tubman's strength through her physical stature: broad, square shoulders, large blocklike hands (fig. 35), and arms that work like machines. The artist often stretched this figure beyond the confines of the frame, expanding the viewer's scope. Lawrence used this abstract pictorial device in other works, especially those that focused on manual labor, such as the gouache on paper *The Shoemaker* (fig. 36).

The compositional design of Lawrence's paintings frequently became so insistent that it fused figurative elements with their backgrounds, requiring a more discerning eye on the part of the viewer. This is especially evident in such works as *The Life of Toussaint L'Ouverture, No. 17: Toussaint captured Marmelade . . .* (fig. 37) and panels from *The Life of Harriet Tubman*. But the figurative element is not completely overwhelmed by compositional imperatives. Lawrence explained his concept of the abstraction process in a 1945 article in the *Magazine of Art*: "My work is abstract in the sense of having been designed and composed but it is not abstract in the sense of having no human content."[14] Abstraction of design and composition are fully realized in such works as the panel from *The Migration of the Negro, No. 50: Race riots were very numerous all over the North . . .* (fig. 38). The central riot figures stretch diagonally from the lower left to the top right of the composition, dynamically dividing the picture plane.

Another panel from *The Life of Harriet Tubman, No. 4* (fig. 39), however, exhibits how Lawrence used abstract, formal devices at times to heighten the gesture of the central figures. The picture plane is divided into two or three bands of color onto which the figures are placed; the figures seem to move while the background remains still. The carefree romp of these sticklike figures (of which Tubman is one) is in sharp contrast to the monumental figure of Tubman as an adult. In this panel

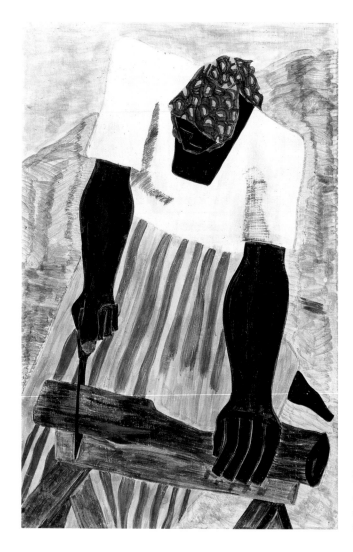

FIG. 35 *The Life of Harriet Tubman, No. 7: Harriet Tubman worked as water girl to field hands. She also worked at plowing, carting, and hauling logs*, 1940, casein tempera on hardboard, 17⅞ × 12 in. Hampton University Museum, Hampton, Virginia.

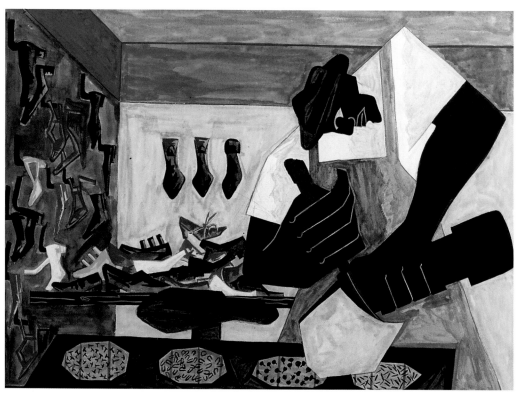

FIG. 36 *The Shoemaker*, 1945, gouache and watercolor on paper, 22⅝ × 30⅞ in. The Metropolitan Museum of Art. George A. Hearn Fund, 1946, 46.73.2.

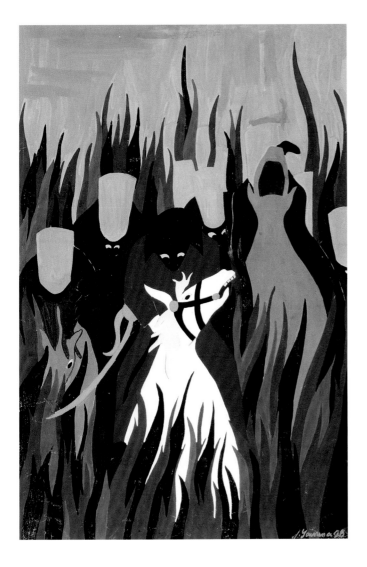

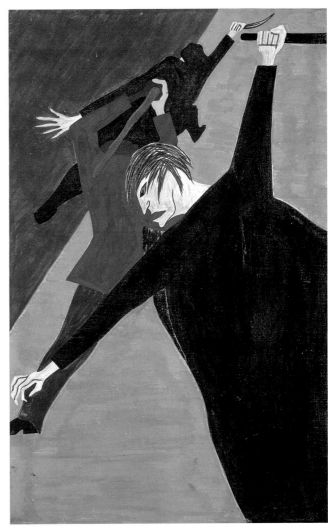

the space seems boundless and the children totally free. Their felt freedom of childhood is anomalous in the context of the reality of their enslaved condition. The intrusion of the creeping horizontal shape, perhaps a dark cloud or branch, looms over their play, a foreboding signifier of the restrictive limitations that they will soon know and share. This use of a foreboding abstract shape is present in other works, notably in *The Life of Harriet Tubman, No. 2: "I am no friend of slavery . . ."* (fig. 40), as a black body hangs in crucifix fashion (most likely a casualty of a flogging, judging from the whip marks across the back). Lawrence's form of abstraction was not lost on such critics as the *New York Times*'s Howard Devree, who stated, "A strong semi-abstract approach aids him in arriving at his basic or archetypal statements."[15]

The paintings in Lawrence's *The Life of John Brown* series (1941) are among his most compositionally successful works of the period. The heavy-lidded eyes in *No. 6* (fig. 41) suggest a clandestine activity in the making. When *The Life of John Brown* was first exhibited in 1945, however, Lawrence's work—often

FIG. 37 *The Life of Toussaint L'Ouverture, No. 17: Toussaint captured Marmelade, held by Vernet, a mulatto, 1795,* 1938, tempera on paper, 19 × 11½ in. Amistad Research Center, Tulane University, New Orleans. Aaron Douglas Collection.

FIG. 38 *The Migration of the Negro, No. 50: Race riots were very numerous all over the North because of the antagonism that was caused between the Negro and white workers. Many of these riots occurred because the Negro was used as a strike breaker in many of the Northern industries,* 1941, casein tempera on hardboard, 18 × 12 in. The Museum of Modern Art, New York.

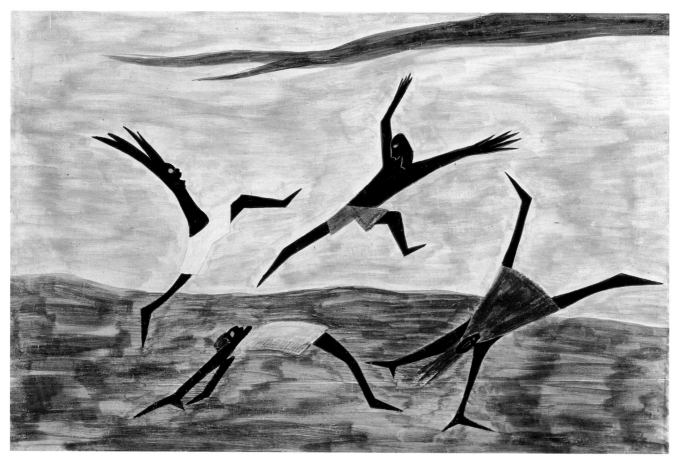

FIG. 39 *The Life of Harriet Tubman, No. 4: On a hot summer day about 1820, a group of slave children were tumbling in the sandy soil in the state of Maryland—and among them was one, Harriet Tubman. / Dorchester County, Maryland*, 1940, casein tempera on hardboard, 12 × 17⅞ in. Hampton University Museum, Hampton, Virginia.

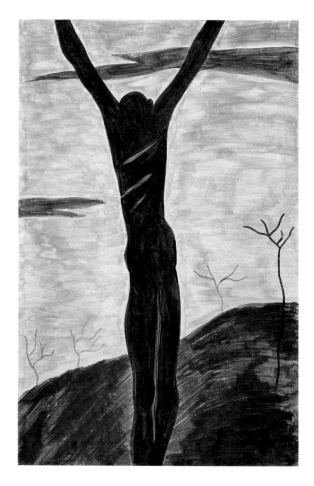

FIG. 40 *The Life of Harriet Tubman, No. 2: "I am no friend of slavery, but I prefer the liberty of my own country to that of another people, and the liberty of my own race to that of another race. The liberty of the descendants of Africa in the United States is incompatible with the safety and liberty of the European descendants. Their slavery forms an exception (resulting from a stern and inexorable necessity) to the general liberty in the United States."—Henry Clay*, 1940, casein tempera on hardboard, 17⅞ × 12 in. Hampton University Museum, Hampton, Virginia.

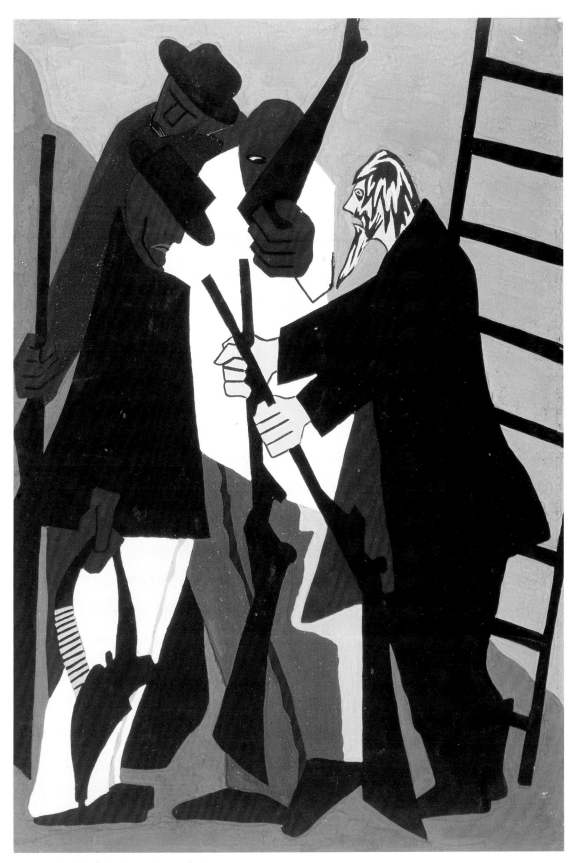

FIG. 41 *The Life of John Brown, No. 6: John Brown formed an organization among the colored people of the Adirondack woods to resist the capture of any fugitive slave,* 1941, gouache and tempera on paper, 19⅞ × 13⅝ in. The Detroit Institute of Arts. Gift of Mr. and Mrs. Milton Lowenthal.

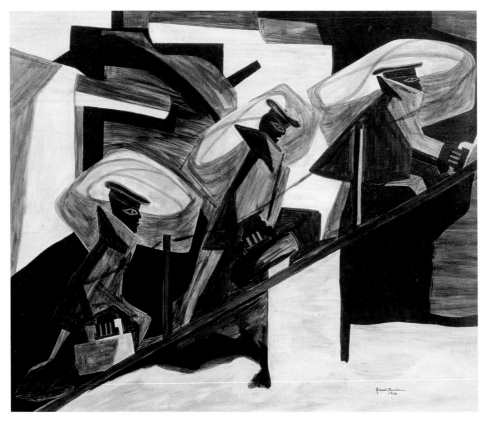

FIG. 42 *War, No. 3: Another Patrol*, 1946, egg tempera on hardboard, 16 × 20 in. Whitney Museum of American Art, New York. Gift of Mr. and Mrs. Roy R. Neuberger.

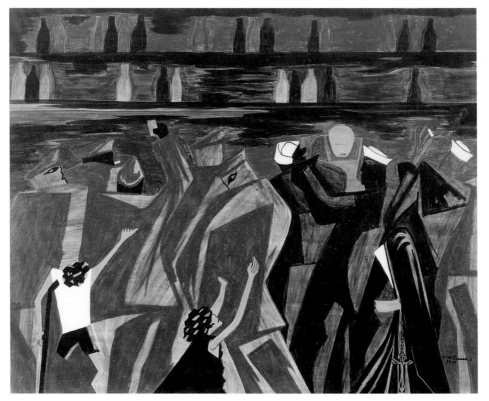

FIG. 43 *War, No. 7: On Leave*, 1947, egg tempera on hardboard, 16 × 20 in. Whitney Museum of American Art, New York. Gift of Mr. and Mrs. Roy R. Neuberger.

compared to cartoon and poster work—was viewed as stylistically similar to that of such other American artists as Milton Avery.[16] With this series critics began to cast a more critical eye on Lawrence's compositional designs.

By the time Lawrence created the *War* series (1946–7) (figs. 42, 43), some critics showed signs of reading his work outside the restricted framework they had constructed for him. In *Art Digest*, Jo Gibbs compared this new series with past works: "In these 14 temperas, the artist's consistent development over the past five years, already noted in his individual easel paintings, is particularly noticeable. Though still muted and dark, his color is richer, more subtle, and has greater range and luminosity. A few of the designs retain a certain primitive quality, but more of them are complex, sophisticated, and verge on the abstract."[17] In an article entitled "Jacob Lawrence's War Pictures" in the *Christian Science Monitor*, Dorothy Adlow called Lawrence "an artist with a remarkable capacity for imaginative projection . . . exceptional individuality." The article also discussed his style, saying that Lawrence "combines features of pictorial presentation that have evolved in the modern school. . . . There is some abstraction, some primitivistic mannerism, and much expressionistic vigor."[18] Adlow accepted the idea that Lawrence, while using his people as his subject matter, explored modernist concepts. Another writer, Gwendolyn Bennett, also attempted to view him and his work outside the inadequate primitive construct, in which he could at most be a modern primitive. A black writer, Bennett wrote in *Mainstream*:

> When critics first began to notice Lawrence's work many referred to it as "primitive." This characterization is inadequate and misleading. For here is an artist who has studied hard, worked ceaselessly, learned from many people, but who has always molded what he saw and learned into a form that was distinctly his own. The result is an art that is disciplined and refined in an adult sense, yet filled with a childlike clarity of pure colors, boldly juxtaposed.[19]

Bennett understood that by "primitive," critics meant untutored and unskilled. This was a category in which many African American artists of his period languished in the eyes of people who were eager to pigeonhole artists for the writers' own convenience.

Lawrence received acclaim as a very young man, acclaim far surpassing his teachers like Charles Alston and his contemporaries. Reflecting on that period, Lawrence has said that, with so much happening to him so fast, the experience was frightening. A quiet man, he reacted by remaining quiet. Lawrence spoke in a very guarded manner, like many other artists who have been thrust into the limelight. He rarely offered social, emotional, or stylistic interpretations of his work. In 1949 he voluntarily sought help for depression at Hillside Hospital in Queens, New York. While under doctors' care and removed from the fast-paced art world, Lawrence had time for reflection. The pictures he painted during this time were a marked departure from his other works: the characters are neither courageous nor hopeful for their futures but resigned; the colors are not pure and bright but mixed and subdued (fig. 44); the facial features do not suggest the pensive critical thought of his other characters but are agonized. Critics responded to the paintings by viewing Lawrence's mental anguish as a catalyst for an intellectual breakthrough. Many echoed the opinion of an *ARTnews* author who wrote about the Hillside paintings: "While his vivid patterning and dynamic actions are very much in evidence, there is one striking change: while formerly characterization was achieved by heightened gesture, the burden of expression is now shifted to a stylized facial expression."[20]

Other reviews of his hospital paintings discussed Lawrence's modernist consciousness. These included the type of psychoanalytical interpretation that would place Lawrence closer to the individualistic, self-absorbed, and self-reflective point of view associated with the abstract expressionists who were catching the eyes of critics and museum curators in the late 1940s. A writer for *Ebony* magazine compared Lawrence's situation with that of Vincent van Gogh. The lengthy article, published six months after Lawrence's release from Hillside Hospital, stated:

> He was conscious that he had one illustrious predecessor in Vincent Van Gogh who created works of enduring vitality during his confinement in the insane asylum in France. It was inevitable that an artist of Lawrence's integrity and courage should tackle the challenging theme offered by his experience in a mental institution. The result made art critics gasp and report excitedly on his new maturity and purpose.

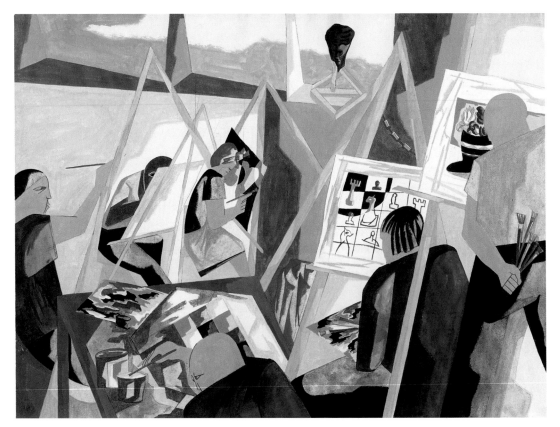

FIG. 44 *Creative Therapy*, 1949, casein tempera on paper, 22 × 30 in. The Cleveland Museum of Art. Delia E. Holden Fund, 1994.2.

There is general agreement among art experts that the new pictures are emotionally richer, technically more advanced, and socially more significant than Lawrence's previous work. The Hillside paintings are characterized by sharper personalization, keener insight, surer organization and a higher unity of substance and pattern.

There are many art critics who feel that the new paintings by Lawrence have projected him into the front ranks of America's foremost artists. . . . Dr. Emanuel Klein, Lawrence's doctor and friend, insists that the paintings cannot be credited to the painter's illness. "The paintings," Dr. Klein says, "express the healthiest portion of his personality."

This has not deterred many of Lawrence's warmest admirers from linking his new stylistic approach and purposeful mood to the therapy which he underwent at Hillside and making romantic observations on the role of neurosis in modern art.[21]

The suggestion was that as a result of mental anguish Lawrence had matured artistically, creating more emotionally riveting and intellectually challenging compositions. Charles Alan, one of Lawrence's dealers, wrote later that from the time of Lawrence's stay at Hillside:

> [He] composes more freely, but less instinctively, and with far more sophistication. He uses primary colors more sparingly, and introduces offbeat harmonies. Design becomes more linear and less formal as he draws with more sureness. But most significant, this increased technical authority seems merely a manifestation of the artist's desire to broaden the scope of his subject matter, his liberty to explore realms that combine fact and fantasy, to delve more penetratingly into subjects that he had already treated more cursorily and mainly for their decorative possibilities in earlier works.[22]

Aline B. Louchheim wrote in the *New York Times* of Lawrence's hospital paintings, "In artistic fact, too, [the paintings] represent a logical development from his previous work. . . . His style, with its brilliant color, abstract form and patterned surface, is wholly 'modern.'"[23] In general, critics writing about this body of work focused on its sophistication compared with earlier works. In *Art Digest*, James Fitzsimmons wrote, "Painting in casein, in

lighter tonalities than before, and employing a linear cartoon technique of abstraction-to-essentials, he [Lawrence] shows patients moving absorbedly in antiseptic worlds of cheerlessly bright color, sunlight and skylight exposing every gesture."[24] Howard Devree wrote in the *New York Times*, "In fact, Lawrence's people have emerged from a kind of mask-like anonymity into personalization, his color has become more subtle and his organizations are, if anything, surer than before. . . . There is a new lift in a number of the pictures and most of them may be definitely classed among his best work."[25]

After his eleven-month stay at Hillside, Lawrence was able to view with a fresh perspective his Harlem and the people and places that were the subject of many of his earlier paintings. With Charles Alan, an employee at the Downtown Gallery, he began visiting theatrical productions, and in 1951, he began a new body of work. The paintings on the theme of performance are highly decorative and more than any prior group display Lawrence's mode of abstraction with a heightened sense of emotionalism that makes for riveting and beautifully unsettling imagery. These works were produced from his memories of performances at the Apollo Theater on Harlem's 125th Street. Of *Vaudeville* (see p. 107, fig. 33) Lawrence said, "I wasn't thinking of any particular act. The decorated panel behind[,] I never saw it; I made it up. You can't just put together things you've seen. I wanted a staccato-type thing—raw, sharp, rough—that's what I tried to get."[26]

Critics praised Lawrence's exhibition of these paintings in the Downtown Gallery exhibition entitled *Performance*. Yet one must question Stuart Preston's choice of the word *savage* when he wrote in the *New York Times*, "What strange and savage presences are introduced into these performances! . . . Anyone who considers that the camera, as a recording agent, has ousted the artist had better look hard at these even if their point of view is not sympathetic."[27] Preston embraces a voyeuristic attitude of discovery, of penetrating something that is taboo or forbidden—the primitive. It is the same attitude that brought whites slumming into Harlem during the Renaissance and that continued to marginalize Lawrence and his work (figs. 45, 46).

Evolving notions of modernism combined with preconceptions about race and ethnicity in post-depression America informed the critical reception of Lawrence's work throughout the 1940s and into the 1950s. As a black modernist, he was curiously in a league by himself, both inside and outside the current American modernist mainstream. His work was compared with that of artists of previous generations such as Henri Matisse, because of his use of color and pattern. In 1945 Elizabeth McCausland wrote of Lawrence in the *Magazine of Art:* "In his work he has an extraordinary pattern, with the qualities of abstraction, insistence of idiomatic detail, and the harsh, high colours of Matisse."[28] The comparison with van Gogh was made because of his mental breakdown, but because Lawrence defied the formalist prescriptions of modernist discourse (because he chronicled the historic and contemporary oppression of his people), he remained at best a pseudo-modernist in the minds of many of his white patrons and supporters.

Lawrence emphasized the importance of the subject in his early works as well as later ones. But beyond the subject, he arranged angular colored shapes, creating dynamic contrast between occupied and empty spaces, and he enlarged central figures to stretch beyond the confines of the picture plane to enlarge our view of them. The dynamic juxtapositions of figure and ground relationships and the expression of emotion through sparse environments give strength to his compositions. In *The Life of Frederick Douglass, The Life of Harriet Tubman, The Migration of the Negro*, and *The Life of John Brown*, Lawrence was not only "telling the history of the Negro" but also introducing viewers to a new way of seeing objects and compositional relationships. He told stories by manipulating the planes in his compositions to expand the minds of his viewers. Yet the criticism that surrounds his work from 1938 to 1950 remains so tightly tied to his subject matter and personality that it informed the way many viewers and critics would interpret his paintings.

Discussing his own work, Lawrence often tried to reconcile the contemporary taste for formalism with the dramatic nature of his subject matter, characterizing his work as expressionist. He also noted that his work was "abstract in the sense of being designed and composed." His compositions were not just spontaneous reactions to what was going on around him but an intellectual process by which he consciously organized and placed shapes and colors into his picture planes to express the complex world of black people. As the cultural historian Nathan Irvin Huggins notes in *Harlem Renaissance*, his 1971 anthology:

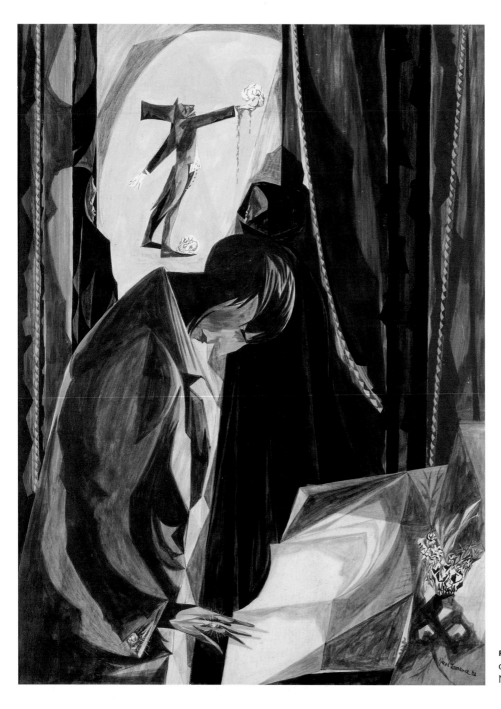

FIG. 45 *Night after Night*, 1952, egg tempera on hardboard, 24 × 18 in. Private collection, New York.

The Negro artist in the United States lives in a peculiar province—a spiritual geography. His art is self-consciously national while, at the same time, special—ethnically regional. It attempts to speak with two voices, one from the stage of national culture and the other from the soul of ethnic experience. Nor is this condition wholly a matter of the artist's will or intent. It is his ethnic fact. It is as if it were defined in the eternal constitution of things that to be a Negro artist in America one must, in some way, be a race-conscious artist.[29]

Most black people speak in these two voices, and Lawrence's two voices are so seamlessly merged in his paintings that subject and form present themselves equally on the "stage."

In many ways Lawrence's approach to figuration and subject matter can be compared to the writings of the poet Langston Hughes, who is noted for romanticizing the lower classes (or common man). In his 1926 essay "The Negro Artist and the Racial Mountain," Hughes wrote, "These common people are not afraid of spirituals . . . and jazz is their child. They furnish a wealth of colorful, distinctive material for any artist because they still hold their own individuality in the face of American standardizations."[30] Hughes felt that one part of the

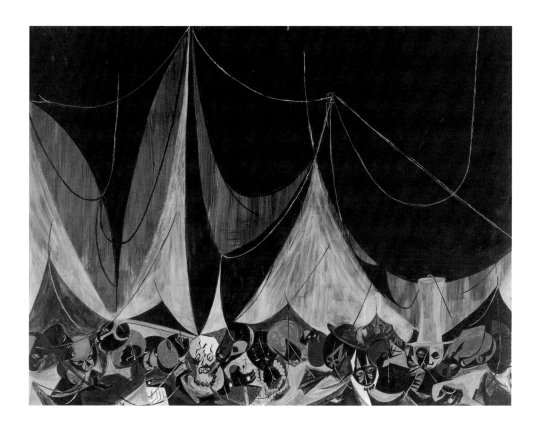

FIG. 46 *Marionettes*, 1952, egg tempera on hardboard, 18¼ × 24½ in. High Museum of Art, Atlanta. Purchase with funds from the National Endowment for the Arts and Edith G. and Philip A. Rhodes, 1980.224.

problem with art by black artists was the attitude of black middle and upper classes. In art as in life, he noted, they tended to identify with and patronize white culture. "In the North, they go to white theaters and white movies . . . [adopt] Nordic manners, Nordic faces, Nordic hair, Nordic art (if any), and an Episcopal heaven."[31] As true as this characterization was, the lower classes could neither sustain nor create the critical atmosphere an artist needed to define and redefine the art, leaving the artist who pursued folk themes no alternative but to depend on his white patrons. Huggins writes, "Sadly, all of Harlem—especially the entertainer, the artist, and the writer—was in some way, at one time or another, obliged to the white patron. The racial character of the relationship made it more damaging to the art and more galling to the artists."[32] Hughes reflected on his own experience with the stereotypical primitivist obsessions of white patrons, writing about one of his:

> She wanted me to be primitive and know and feel the intuitions of the primitive. But, unfortunately, I did not feel the rhythms of the primitives singing through me, and so I could not live and write as though I did. I was only an American Negro—who had loved the surface of Africa and the rhythms of Africa—but I was not Africa. I was Chicago and Kansas City and Broadway and Harlem.[33]

Lawrence is not apt to discuss his work in this context; rather, in most of the interviews he has granted, he has chosen to concentrate on his community-based art training in Harlem. Yet Lawrence felt helpless to do anything about his contextualization as a primitive, as illustrated many years later in a 1982 interview with Avis Berman. Berman asked Lawrence how he reacted to the label of primitive. Lawrence said, "I don't have a negative reaction to it if that's what you mean. I realize that when people write and when they talk about our work, they have to use certain references, and if they see it in those terms, . . . I don't think about it."[34] When Berman told Lawrence that she was not necessarily using the term in a negative manner, but wanted to know if he felt the term was accurate, he replied:

> Well, if they mean in terms of not having a formal, a formal kind of training at a certain state—and maybe that's what's meant by that—then, then if they're using it in that sense, then I would agree with that, I imagine, with what they had just said. I didn't approach things from an academic, you know, in an academic way, and . . . I guess that's what's meant by that.[35]

Lawrence was aware that the term had negative connotations for some black people. But he felt he could not stop what people said, that he had no control over what was said about him or the work he created. He also mentioned that for many

black artists the term suggests that they are not intellectual. But, he continued, "If they [critics] use the term 'primitive' in the sense of the early Italian painters, they use it like with Ben Shahn, it takes on a different meaning. . . . But if it's used for the early Renaissance, it's used as 'a first' in time and place. But when they use it for other peoples, they mean, sort of . . ." At this point in the interview, his wife, Gwendolyn Knight Lawrence, offers the word *naïve.* Lawrence agrees, saying *primitive* means a "naïve, nonintellectual kind of process. It's a nice, you know, it's a nice thing, but it's not a thought-out process and that kind of thing, see. I think that's why the term is. . . . So many, many of the minority artists resent the term. I wouldn't say many, but some resent the term for this reason."[36]

Both Lawrence and Hughes retreated from the "Negro-artist" dilemma by choosing to restrict themselves to investigating folk themes and not "high culture." Both possessed an anti-intellectual attitude (i.e., focusing on the working classes rather than the intellectually elite, and Lawrence especially for rejecting naturalism in favor of a brightly colored and unmodeled style of painting) toward their work, allowing them broad freedoms that some other black artists did not have. It helped Hughes legitimize people's voices in poetry and helped Lawrence legitimize their everyday lives.

Being thrust into the art world's limelight at such a young age was overwhelming for Lawrence, and he was clearly uncomfortable as the only widely recognized black artist in America during the end of the 1930s into the early 1950s. As it had been for Hughes, the pursuit of interpreting the folk expressions and lives of black people was at the center of his success as a professional artist. As Lawrence's career progressed, by the end of the 1940s some critics recognized that a complex sophistication in his work placed him "on the verge of [being] abstract."[37] Yet, even though Lawrence has enjoyed a successful artist's life by most standards, his early contextualization as a "primitive" by both white and black critics remained the most overarching and enormously complicated issue of his career.

NOTES

1. Jeffrey C. Stewart, "Paul Robeson and the Problem of Modernism," in *Rhapsodies in Black: Art of the Harlem Renaissance* (Berkeley and Los Angeles: University of California Press; London: Hayward Gallery and Institute of International Visual Arts, 1997), p. 92.

2. I am using "so-called untutored" here because "untutored" alone suggests that the artist did not have the benefit of a student-teacher relationship. It discounts apprenticeships, mentoring, passing down knowledge and skills generationally by family and community members.

3. Sharon F. Patton, *African-American Art* (Oxford and New York: Oxford University Press, 1998), p. 111.

4. See Wallace Thurman's novel *The Blacker the Berry* (1928) about a young black girl who struggles with her dark skin color among prejudiced blacks.

5. Maude Riley, "Effective Protests by Lawrence of Harlem," *Art Digest* 17, 16 (May 15, 1943), p. 7.

6. Henry McBride, review of *The Migration of the Negro* series, *New York Sun*, November 8, 1941, Jacob Lawrence Papers, Archives of American Art, Smithsonian Institution, Washington, D.C. (hereafter AAA).

7. "Combat Artist Now Painting War Story," *Louisville Defender*, June 17, 1944, AAA.

8. "Art: Strike Fast," *Time* 50 (December 22, 1947), p. 61.

9. Patton, *African-American Art,* pp. 111–2.

10. I have written about this before in my dissertation entitled "Sargent Johnson: The Intersection between a Double Consciousness and the Ideals of Modernism," University of California, Los Angeles, 1997, and in *Sargent Johnson: African American Modernist,* exh. cat. (San Francisco: San Francisco Museum of Modern Art, 1998). The passage on Albert Barnes in the dissertation reads: "Albert Barnes, the collector of modern and African art and founder and head of the Barnes Foundation, wrote in *The New Negro,* p. 19: 'The most important element to be considered is the psychological complexion of the New Negro as he inherited it from his primitive ancestors and which he maintains today. The outstanding characteristics are his tremendous emotional endowment, his luxuriant and free imagination and a truly great power of individual expression.' Barnes was also part of the New Negro debate due to his interest in African and modern art. Feeling that an art by black Americans was possible, Barnes supported the work of the self-taught artist Horace Pippin, who he felt was an 'authentic' African-American artist, whose work showed an absence of the 'sophisticated pretenders.' Barnes also wrote that 'The Negro has kept nearer to the ideal of man's harmony with nature and that, his blessing, has made him a vagrant in our arid, practical American life.' Barnes suggests that 'harmony with nature' is natural for blacks in the United States and is incompatible with the basic affairs of American life. This was Barnes' way to certify the legitimacy of the art he preferred. Barnes cites this incompatibility as the reason why blacks have not shared the wealth with whites and are vagrants in this modern land. Barnes, like many other whites, celebrated black spirituality and harmony with nature and even promoted these characteristics, as exemplified by his relationship with Pippin. This patronizing view by Barnes as well as some other supporters of primitivism seemed close to that of the white southerner who continually yearned for the good old plantation days of slavery. Both perceived progressive modes of behavior among blacks as opposite to their natural orientation" (pp. 88–90).

11. Alain Locke, ed., "The Legacy of the Ancestral Arts," in *The New Negro* (New York: Atheneum Books, 1992), p. 256.

12. Alain Locke Papers, January 23, 1940, box 164, Mooreland-Spingarn Research Center, Howard University, Washington, D.C. Alain Locke also introduced *The Migration of the Negro* series to Edith Halpert, founder of the Downtown Gallery, who, as Charles Alan stated, "created a profitable interest in American folk art." See Charles Alan, unpublished manuscript, ca. 1973, p. 5, courtesy Harry N. Abrams, New York. In 1941, encouraged by Locke and the publication of 26 panels of Lawrence's *The Migration of the Negro* series by *Fortune,* Halpert showed Lawrence's work at the Downtown Gallery, interestingly at about the same time that she showed paintings by Horace Pippin.

13. Lawrence, quoted in Ellen Harkins Wheat, *Jacob Lawrence: The Frederick Douglass and Harriet Tubman Series of 1938–40* (Hampton, Va., Seattle, and London: Hampton University Museum in association with University of Washington Press, Seattle, 1991), p. 14.

14. Lawrence, quoted in Elizabeth McCausland, "Jacob Lawrence," *Magazine of Art* 38, 7 (November 1945), p. 250.

15. Howard Devree, "From a Reviewer's Notebook: Brief Comment on Some Recently Opened Group and One-Man Shows—New Jersey Visitors, Jacob Lawrence's Harlem," *New York Times*, May 16, 1943, sec. 2, p. 12. Additional references to Lawrence's style of abstraction are in the Art Council's article "Art Today, Jacob Lawrence's Harlem," *Daily Worker*, May 29, 1943, p. 7, which states, "From the earliest showing of his work he utilized a simple, condensed, semi-abstract form. . . . Lawrence has grown in his use of rhythm as well as in sheer design and fluency." With particular reference to Lawrence's treatment of stained-glass windows of storefront churches in his Harlem theme paintings, the article continues, "This complete bit of abstraction seems to shout and exhort in a metaphysical hymn."

16. See Jane Watson Crane, "John Brown's Stirring," *Sunday Star*, October 5, 1946, p. B5: "The artist has made generous use of symbolism and has borrowed something from the poster technique, something from the animated cartoon."

17. Jo Gibbs, "Lawrence Uses War for New 'Sermon in Paint,'" *Art Digest* 22, 6 (December 15, 1947), p. 10.

18. Dorothy Adlow, "Jacob Lawrence's War Pictures," *Christian Science Monitor*, December 6, 1947, p. 18.

19. Gwendolyn Bennett, "Meet Jacob Lawrence, Harlem-born, Nationally Known," *Masses and Mainstream* 2, 1 (winter 1947), p. 97.

20. Dorothy Seckler, "Reviews and Previews: Jacob Lawrence," *ARTnews* 49, 7 (November 1950), p. 65.

21. "Jacob Lawrence: New Paintings Portraying Life in Insane Asylum Project Him into Top Ranks of U.S. Artists," *Ebony* (April 1951), p. 73.

22. Charles Alan, unpublished manuscript, ca. 1973, p. 50.

23. Aline B. Louchheim, "An Artist Reports on the Troubled Mind," *New York Times Magazine*, October 15, 1950, p. 15.

24. James Fitzsimmons, "Lawrence Documents," *Art Digest* 25, 3 (November 1, 1950), p. 16.

25. Howard Devree, "Modern Round-up: Record of Growth," *New York Times*, October 29, 1950, sec. 2, p. 9.

26. Lawrence, quoted in "Stories with Impact," *Time* 61 (February 2, 1953), p. 50.

27. Stuart Preston, "Recent Works by Stevens, David Smith, Lawrence," *New York Times*, February 1, 1953, sec. 2, p. 8.

28. McCausland, "Jacob Lawrence," p. 254.

29. Nathan Irvin Huggins, *Harlem Renaissance* (London, Oxford, and New York: Oxford University Press, 1971), p. 195.

30. Langston Hughes, "The Negro Artist and the Racial Mountain," *Nation* 122 (June 23, 1926), pp. 692–3.

31. Ibid.

32. Huggins, *Harlem Renaissance*, p. 127.

33. Hughes, quoted in ibid., p. 179. See Huggins's chap. 3, "Heart of Darkness," in which he very astutely discusses white patronage during the Harlem Renaissance and the impact of that patronage on the literary artists and their aesthetics. He refers to Hughes's patroness only as a very generous elderly Park Avenue matron.

34. Jacob Lawrence, transcript of tape-recorded interview by Avis Berman, February 6, 1982, Avis Berman Papers, AAA, p. 47, used with permission.

35. Ibid.

36. Ibid.

37. Gibbs, "Lawrence Uses War," p. 10.

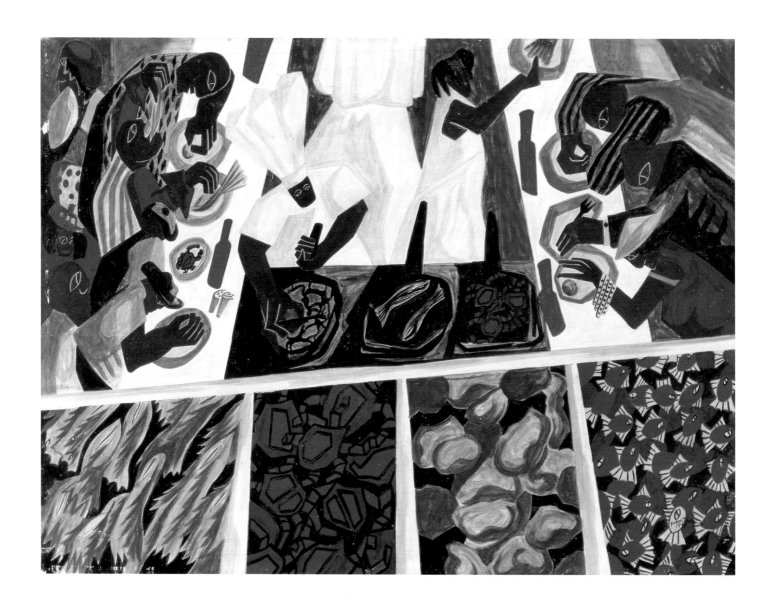

PL. 41 *Cat Fish Row,* 1947, egg tempera on hardboard, 18½ × 23½ in. Collection of Susie Ruth Powell and Franklin R. Anderson.

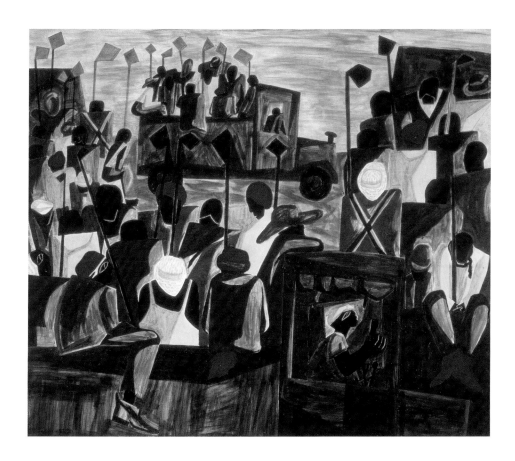

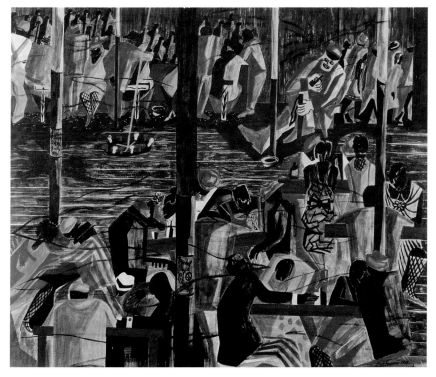

PL. 42 *In the Heart of the Black Belt,* 1947, egg tempera on hardboard, 20 × 24 in. Orange County Museum of Art, Newport Beach, California. Bequest of Betty Jane Cook.

PL. 43 *Beer Hall,* 1947, egg tempera on hardboard, 19½ × 23⅜ in. Collection of Lorraine Gordon, New York.

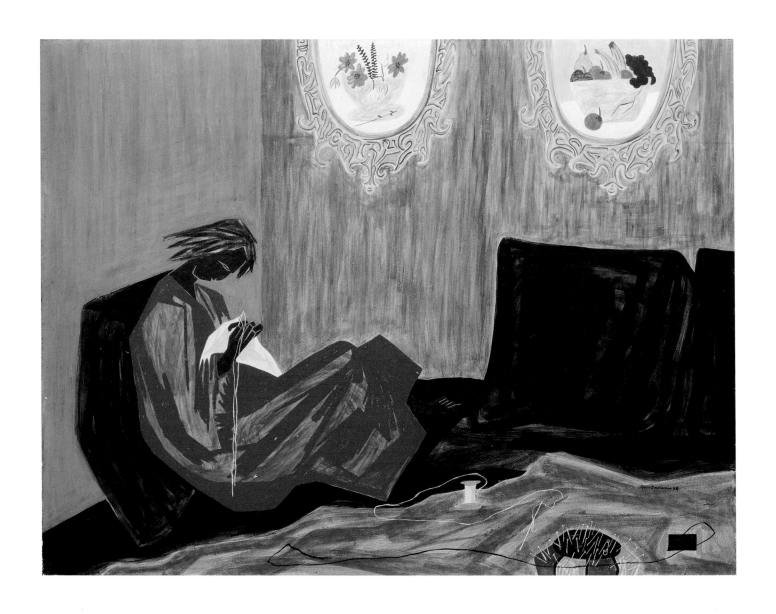

PL. 44 *Woman Sewing,* 1948, egg tempera on hard-
board, 17⅞ × 23⅞ in. Private collection.

PL. 45 *War, No. 6: The Letter,* 1946, egg tempera
on hardboard, 20 × 16 in. Whitney Museum
of American Art, New York. Gift of Mr. and
Mrs. Roy R. Neuberger.

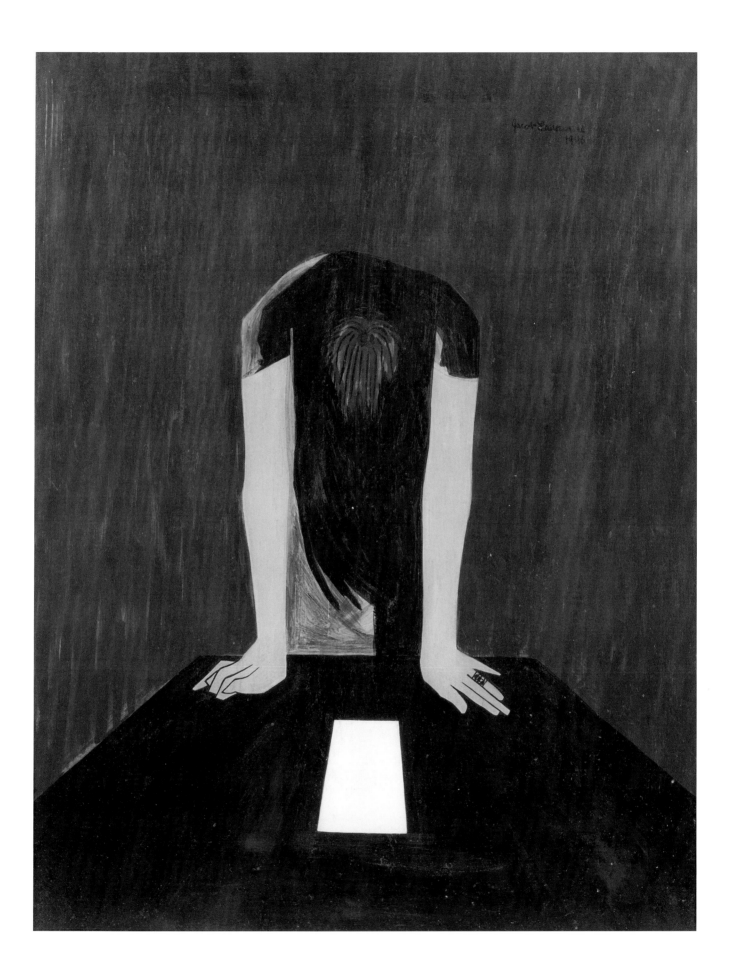

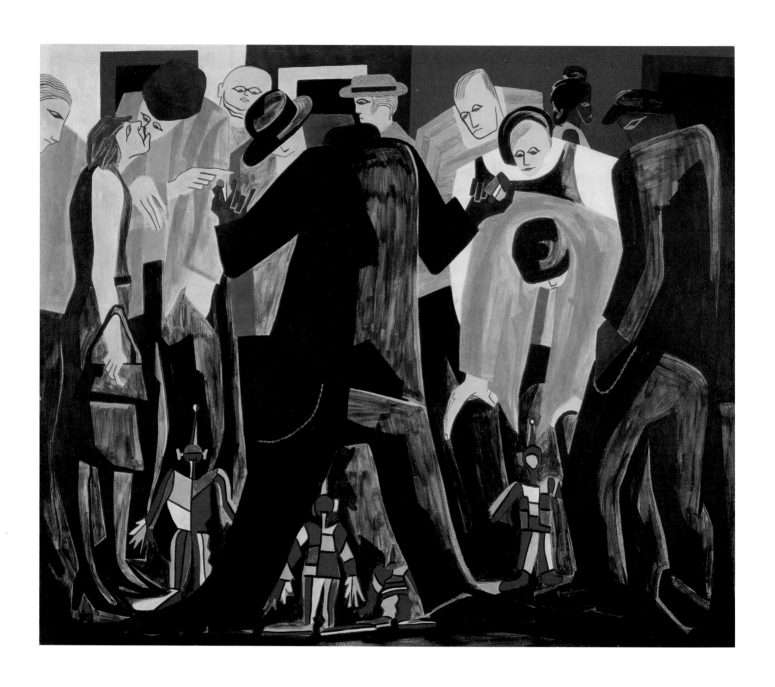

PL. 46 *Dancing Doll,* 1947, egg tempera
on hardboard, 20¼ × 24⅛ in. Frederick R. Weisman Art Museum
at the University of Minnesota.
Bequest of Hudson Walker from
the Ione and Hudson Walker
Collection.

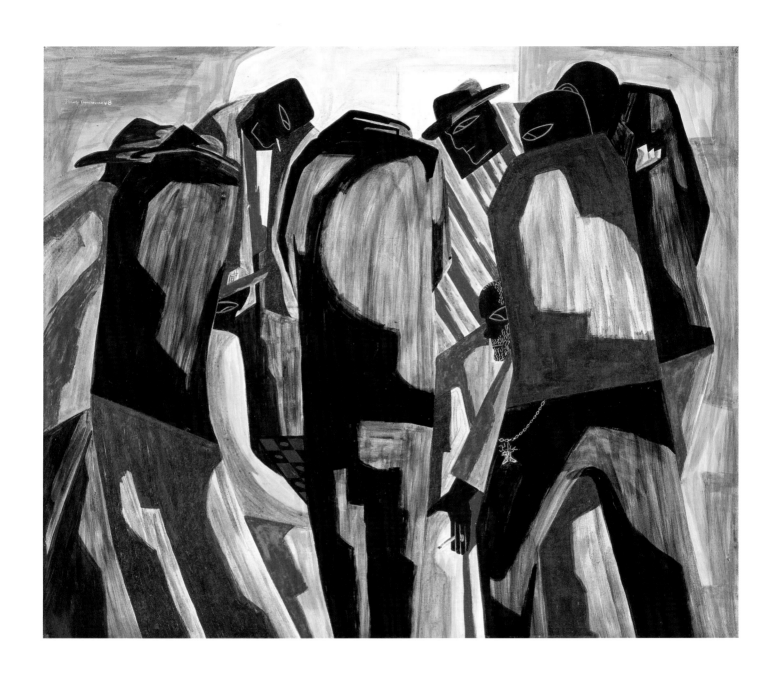

PL. 47 *Kibitzers*, 1948, egg tempera on hardboard,
20 × 24 in. Addison Gallery of American Art,
Phillips Academy, Andover, Massachusetts.
Gift of the Childe Hassam Fund of the
American Academy of Arts and Letters.

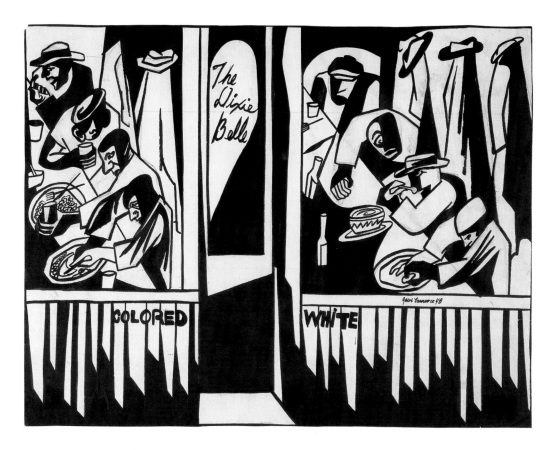

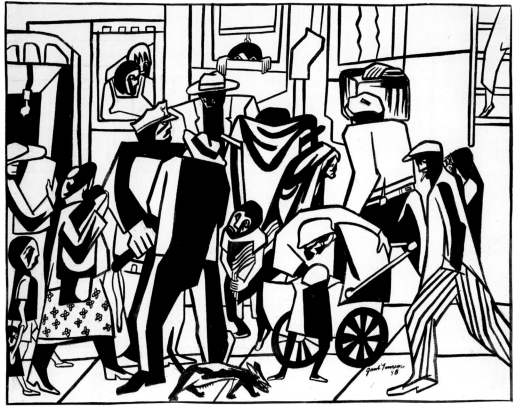

PL. 48 *Dixie Café*, 1948, brush and ink on paper, 17 × 22¼ in. Collection of Margaret and Michael Asch.

PL. 49 *New York Street Scene*, 1948, brush and ink on paper, 17¼ × 22¼ in. Courtesy of Michael Rosenfeld Gallery, New York.

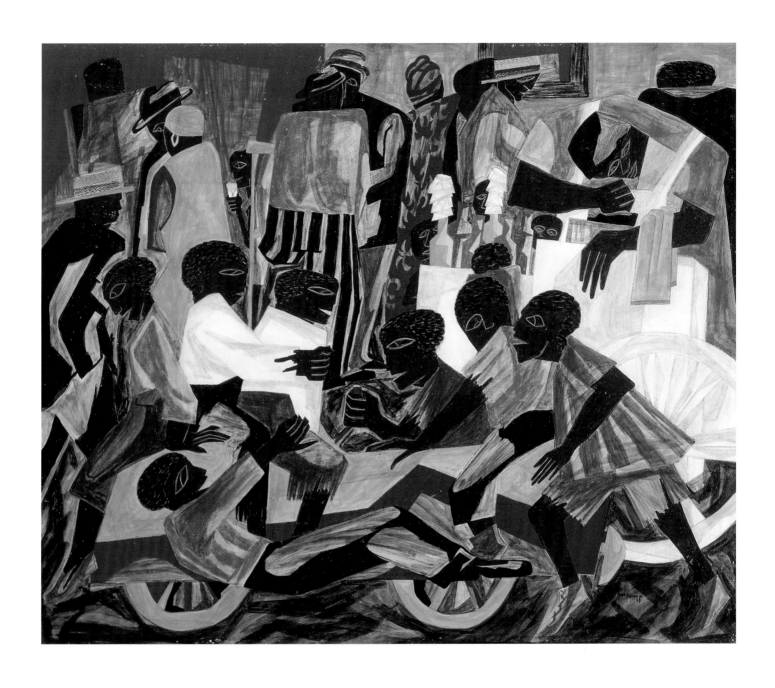

PL. 50 *Summer Street Scene,* 1948, egg
tempera on hardboard, 20⅜ ×
24¼ in. Memorial Art Gallery
of the University of Rochester.
Marion Stratton Gould Fund.

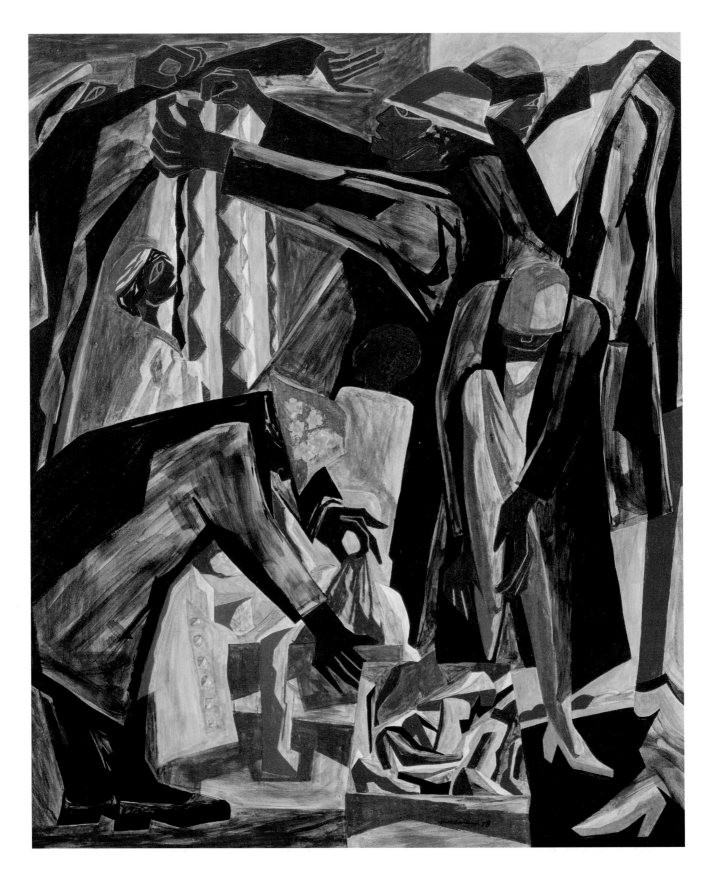

PL. 51 *Rummage Sale,* 1948, egg tempera on
hardboard, 24 × 20 in. Private collection.

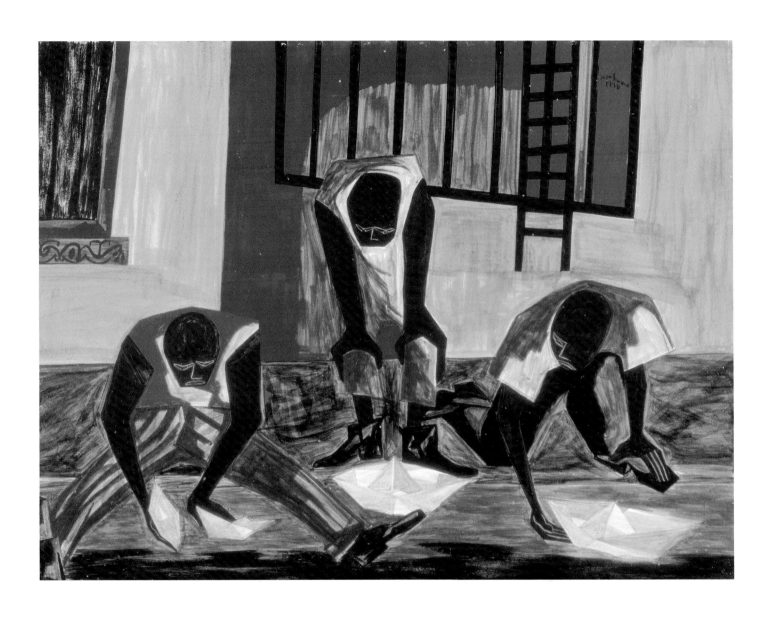

PL. 52 *Paper Boats*, 1949, egg tempera on hard-
board, 17⅞ × 23⅞ in. Sheldon Memorial Art
Gallery and Sculpture Garden, University
of Nebraska, Lincoln.

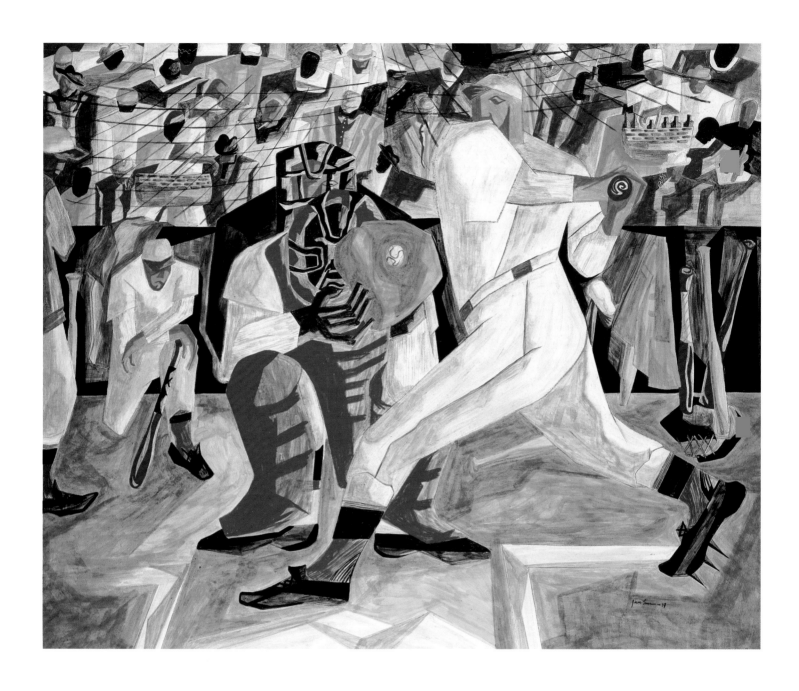

FIG. 47 *Strike*, 1949, egg tempera on hardboard, 20 × 24 in. Howard University Gallery of Art, Washington, D.C.

Richard J. Powell

Harmonizer of Chaos

JACOB LAWRENCE AT MIDCENTURY

EARLY IN 1949, just months before he voluntarily committed himself to a psychiatric hospital, Jacob Lawrence painted *Strike* (fig. 47), a scene from a crucial moment in the game of baseball. The painting's action revolves around a player at bat who, having just swung at the pitcher's ball and missed it, has had a strike called against him by the umpire. In evidence at this sporting event are racial differences in the stands and on the field, realized through tawny-colored Caucasians and obsidian-hued African Americans. Although camouflaged by a nondifferentiated space and the aforementioned people, one character—a black catcher—stands out in the mix. Having successfully intercepted the thrown ball, the black catcher nonetheless appears to be a lonesome, pathetic figure, with his surreal headgear, armorlike red apparel, and grasping hand, flanked on all sides by the umpire, spectators, and the opposing team.[1]

Looking at *Strike* and its lone black catcher in the context of Lawrence's subsequent hospitalization introduces the question of the artist's own sense of isolation, how he eventually overcame pressures from the world at large and from within, and how this state of affairs might have affected his work. While the standard histories simply tell us that Lawrence's "nervous difficulties"[2] were temporary, treatable, and in no way affected his art, *Strike* and other works of art in the years that immediately followed suggest a more nuanced explanation is in order. As described above, the black catcher in *Strike*, like the artist Jacob Lawrence himself, was surrounded at midcentury by critics both sympathetic and skeptical. The black catcher, like Lawrence, was successful in a profession where blacks hardly figured at all, and when they did, usually in a segregated context. With these parallels in mind, the notion that *Strike*'s black catcher (rather than simply representing the pioneering black

baseball great, the catcher Roy Campanella) might be a symbolic evocation of Lawrence himself is not a far-fetched idea.

Critics during the 1950s sometimes made analogies between Lawrence's emotional difficulties and his art, describing his troubled state of mind as manifested in paintings in which "too busy patterning, jagged, angry points, and razzle-dazzle sparkles run rampant."[3] Most critics, however, were dissuaded from making these analogies because of the sense that *any* comparisons between life and art were due just as much to the conclusions that one might draw from Lawrence's subject matter as to Lawrence's particular state of mind. Yet it is clear that beyond the subject and tenor of Lawrence's midcentury work, there is evidence of a new artistic point of view that, whether the result of his personal strategies for psychic healing, his creative interventions in an era of abstraction and national introspection, or both, transformed his previous narrativity into something nonlinear and manifold.

It is important to state at the outset that it is unnecessary to evoke Jacob Lawrence's illness and hospitalization to explain why he painted what he painted during the 1950s. Apart from an obvious impact on the subject matter for the pieces he painted while in the hospital, Lawrence's incapacitation accounts for very little. However, we must treat Lawrence's illness like any other major life event: significant but not the sole explanation for everything that was created. One should acknowledge Lawrence's temporary infirmity and, after situating it alongside his ongoing professional development, his aesthetic collision with New York abstraction, his reconciliation of cold war politics and civil rights era agitation, and his continuing artistic maturation, embrace these phenomena as part of his new, midcentury artistic identity.

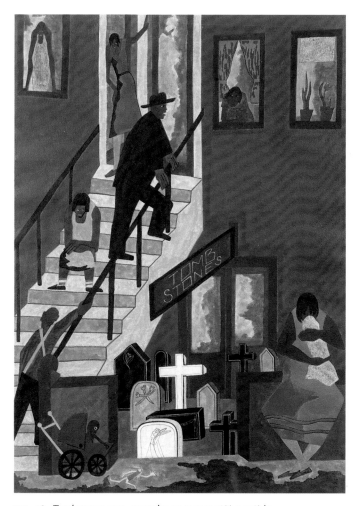

FIG. 48 *Tombstones*, 1942, gouache on paper, 28¾ × 22½ in. Whitney Museum of American Art, New York. Purchase.

No longer wedded to pictorial storytelling or sequential visual narration, by the 1950s Lawrence had introduced into his work a heightened compositional dynamism, bold geometries, and thematic ambiguity. This shift is important, for it removed him from the social realist painters and their emphasis on sociopolitical redress in art and, instead, pushed him closer to the abstractionists and their preoccupations with intellectual interiority and open-ended interpretations. Not abstract by any stretch of the imagination nor part of the roster of "modernist" art masterpieces as formulated by the critic Clement Greenberg, Lawrence's new paintings—figurative and anecdotal, but also decorative and frenetic—put him in league with many other midcentury American artists and intellectuals. These writers (e.g., William Burroughs and Allen Ginsberg), musicians (e.g., Ornette Coleman and John Cage), and visual artists (e.g., Larry Rivers and Jasper Johns) often sought refuge in intentionally vague, indeterminate art vocabularies: devices and languages that, although unresponsive to the particulars of a social reality, performed on the fringes of contemporary life

and employed elements of abstraction as a way, ironically, of restoring some semblance of meaning and order to a decidedly disaffected body politic. Although it is more the custom to view Jacob Lawrence's art as essentially humanitarian and stylistically conservative, a closer look at work he produced during the 1950s reveals abrupt stylistic departures from earlier formulas, subtle yet stinging observations about life, and a compositional armature that defied the standard, representational conventions.[4]

A comparison of *Tombstones* (fig. 48) with *Fulton and Nostrand* (fig. 49) underscores the artistic and ideological differences between these two moments in Lawrence's career. *Tombstones*—a painting that many agree is Lawrence's quintessential statement on the black urban experience—is distinctive for its bold color contrasts, evocative, silhouette-like figures, a none-too-subtle word/image symbolism, and, above all, visual economy. From a gritty meditation on birth, maturity, and death in Harlem to an ethereal sermon on spiritual ascendance, *Tombstones* arguably takes up the tools of social realist painting and puts them into service for a significant segment of the World War II–era art-viewing public. In contrast, *Fulton and Nostrand* takes the same racially tinged urban subject and, via Lawrence's unusual color palette and jagged, fractured forms, creates a more abstract, socially disengaged scene. In spite of the painting's emotional distance from the social concerns and racial sentimentality present in *Tombstones*, *Fulton and Nostrand* conjures less obvious but ever present social realities, having to do with group insularity, barriers to forming solid, interpersonal relationships based on gender, and a peculiar sense of foreboding and danger. Whereas in *Tombstones* Lawrence surveyed the cultural terrains of an idealized notion of the urban black community, in *Fulton and Nostrand* he first dissected and then reconstituted this community, so that what is left is a postcubist melange of architectonic markers, fragments of signage and marquees, and marionette-like figures, all reducible to two-dimensional ciphers were it not for Lawrence's inventive interplay of color, shape, and psychology.[5]

From the fiction of Ralph Ellison and James Baldwin—two writers who sought to free themselves from the "narrative straitjacket of realism and naturalism"[6]—to the subtle yet discernible sociocultural incursions into jazz during this same period by such musicians as Miles Davis, Charles Mingus, and Thelonius

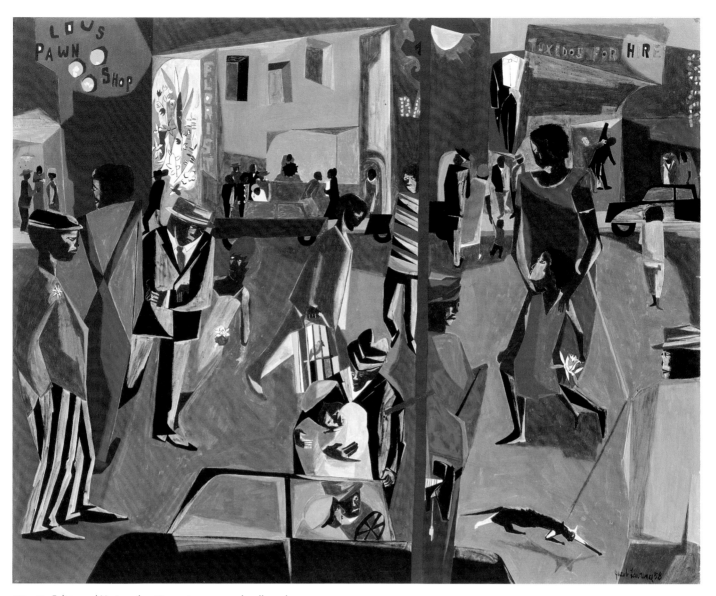

FIG. 49 *Fulton and Nostrand*, 1958, egg tempera on hardboard,
24 × 30 in. Collection of George and Joyce Wein, New York.

Monk, the decade of the 1950s was a watershed for many African American artists. The occasional references to the "universal," abstract paintings of Norman Lewis, Hale Woodruff, and Romare Bearden in art criticism also bore witness to an expanded cultural perspective, one in which "the Negro experience" and its sociological trappings were filtered through a seemingly raceless and timeless lens. With perhaps the exceptions of the 1950s figurative painters Eldzier Cortor and Charles White, some of the more prominent black artists of the period —including Jacob Lawrence—avoided an overt racial message in their work, if they did not circumvent black subject matter altogether. When black subject matter was present, the typical accouterments of a cultural rather than a racial blackness— mostly scenes of discrimination or acts of black cultural expressivity—were either nonexistent or pictorially drained of

their immediate sociopolitical import. In the case of Jacob Lawrence, his artistic presence at midcentury, rather than heralding race consciousness, conveyed an existential blackness that was incidentally "colored," yet unapologetically human and in the process of becoming. It is this artistic meditation on self and community in the midst of disorder—societal and psychological—that distinguishes Lawrence in the 1950s and frames the present examination of his work from this period.

Two works of art that date from the beginning of this "new creative phase" of Lawrence's, to use Aline B. Louchheim's phrase—*In the Garden* (fig. 50) and *Slums* (fig. 51)—illustrate his newfound interest in pictorial narratives that nevertheless allowed him to compose in a manner similar to that of many abstract painters. Of the eleven casein paintings that Lawrence made while hospitalized for eleven months at Hillside Hospital

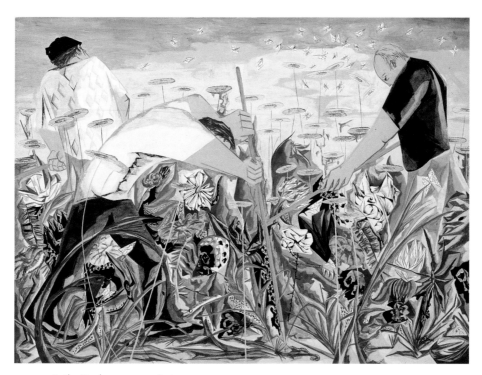

FIG. 50 *In the Garden*, 1950, casein tempera on paper, 22³⁄₁₆ × 30¹⁄₁₆ in. Private collection.

in Queens, New York, *In the Garden* stands apart as one of the most fascinating, intricately conceived works in the group. Three male patients, standing waist-high in a field of plants and flowers and actively engaged in gardening, are initially reminiscent of the bulky figures often seen in the paintings of the social realist Ben Shahn. However, as the eye begins to travel through the painting, it catches glimpses of plant and insect life and occasionally rests on strange, skull- and brainlike forms hidden amid the foliage.

The perceptual passageway through which Lawrence's *In the Garden* takes viewers—from social realist figures to scattered and partially obscured organic matter—suggests that, despite the artist's documented disdain for "abstract or nonobjective painting," one stylistic stream of painterly abstraction—specifically the investigation of anthropomorphic, glyphic, and "all-over" forms[7]—was of growing fascination to him. Couched within the painting's humanistic themes are swaying and bending plant stems, flying saucer–like blossoms, arabesque vegetation, and minuscule insects buzzing overhead and crawling underfoot, which collectively contribute to a discordant mood and the emotionally charged subject. More than just establishing *In the Garden*'s outdoor setting, these organic elements, rendered with equal measures of verisimilitude and license, impart a primordial energy and life force that, ironically, counters the painting's "work therapy" subject and an assumed drudgelike and/or institutional subtext. As with the works of many abstract artists, Lawrence's painted and drawn lines—at times undulating, at other times staccato—can be interpreted not solely in terms of what they represent but, rather, in terms of their implied dynamism and space/time expressivity: concepts that, in the context of the narrational concerns of the hospital pictures, shift the painting's emotional terrain from depression and convalescence to spiritedness and performance.

The visual eruptions and thematic departures that occur outside Lawrence's primary hospital narrative (i.e., the paintings he made with a hospital theme) and on the subterranean levels of *In the Garden* are, to a significant extent, also present in *Slums*. In both a contrastive and a comparative way, Lawrence magnified the actions of flies, cockroaches, and other vermin, instinctive to vermin, repulsive to humans, while simultaneously minimizing the painting's subject: crowded and substandard urban housing. The ultimate visual effects are an amazing blend of social documentary squalor, an almost surrealistic inversion of realistic scale and proportion and, most important, compositional overtures to diminutive, calligraphic- and grid-informed abstractions. Lawrence's decision in *Slums* to deemphasize human suffering and underscore the almost incidental presence of foraging insects denied spectators the assurances of relying on a classic, social realist "art script." Instead, *Slums* (like *In the Garden*) draws one's imagination away from reality and its attendant social agenda to a highly animated pictorial maelstrom that, though still grounded in figuration and signification, resonates

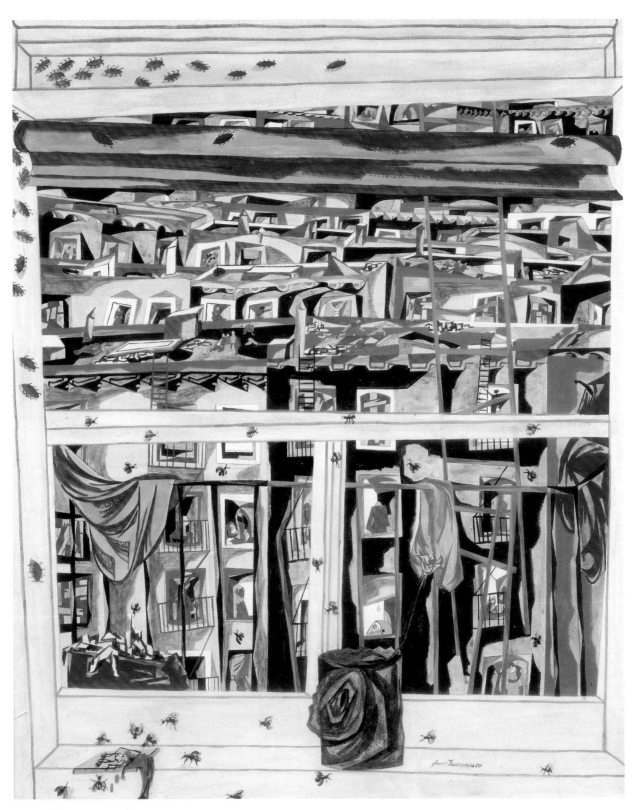

FIG. 51 *Slums*, 1950, casein tempera on paper,
25 × 21½ in. Collection of Elizabeth Marsteller
Gordon, San Francisco.

with abstract, value-free conceptualizations and an art of linear tracings, visionary markings, and arresting colors.

The manic, almost obsessive attention that Lawrence paid to small, seemingly inconsequential details in *Slums* and *In the Garden* (i.e., his renderings of crawling and flying insects, swirling outdoor vegetation, insistent patterns on clothing, etc.) might suggest for some the workings of a troubled, overly preoccupied mind. Ironically, it is this aspect of Lawrence's work that found communion with many of the abstract expressionist painters and their fascination with, in Cernuschi's words, "visualizing the unconscious." Lawrence's decision to position his gestural traceries and microscopic "action painting" within a recognizable set of social circumstances—the psychiatric hospital for *In the Garden* and black urban poverty for *Slums*—introduced a narrative element into these otherwise subconscious forays that undercuts their metaphysical nature, if not their overtures to abstraction.[8]

As has been argued in several recent studies of American art during the 1950s, the old battle lines that were drawn then between abstraction and figuration, although intractable and real for artists and their critics, collapse under close intellectual scrutiny and careful readings of the paintings and sculpture. What is revealed are murkier, more ambiguous positions around the definitions of "abstract" and "figurative": concepts that are not clarified by the mere presence (or absence) of recognizable forms from nature. Most scholars now agree that while the idea of abstraction is a valid one, such variables as narrational allusions, visual equivalents, and viewer-driven interpretations potentially interject figural or thematic references in an alleged abstract work, thus propelling what was once assumed to be purely nonobjective into the realm of suggestion, counterpart, and meaning.[9]

Although there are significantly fewer studies that argue for a perceived, omnipresent abstract element in many figurative works,[10] Jacob Lawrence's *In the Garden* and *Slums* suggest that this argument too has some measure of validity. Indeed, many figurative painters of the 1950s—social realists like Ben Shahn and Jack Levine, as well as figurative expressionists like Jan Müller and Richard Diebenkorn—frequently incorporated impromptu, non-narrational painted gestures, or pure color passages and other antinaturalistic elements into their works. These assorted ingredients of abstraction functioned for both the artist and the viewer on nonverbal levels of understanding, via their communication of emotions, moods, and dreams, rather than of specific ideas, accounts, or truths. Inextricably linked in several pictorial and thematic regards to the real world, *In the Garden* and *Slums* nonetheless manage to rise above their earthly circumstances, or at least they manage to conjure something in the viewer's imagination other than simply "work therapy" and "hardcore poverty," respectively. Illuminated in these two paintings (as a result of Lawrence's partial embrace of abstraction) are sensations, murmurs, and sounds: feelings and extrasensory communiqués that (as in the works of Jackson Pollock and Willem de Kooning) are attributable to implied movement, insinuating color, and a culture of interpretation.

It is no coincidence that Lawrence (like his abstract expressionist counterparts) situated these and other paintings in an allusive realm of human consciousness and comprehension, where either the subject matter or title of the work of art provided an interpretative starting point that, ideally, is supported by composition, color, and other formal elements. Aline B. Louchheim, who wrote about Lawrence's hospitalization for the *New York Times Magazine* in 1950, quoted him as saying that the brief period spent at Hillside Hospital greatly heightened his perception of himself and the world, allowing him to feel things "through his eyes." Indeed, *In the Garden* and *Slums*, like Jackson Pollock's pivotal *Eyes in the Heat* (1942), made Lawrence's own eyes vehicles not only for transmitting atmospheric effects but for conveying internal, conceptual phenomena.[11]

In the prologue to Ralph Ellison's novel *Invisible Man* (1952), the unnamed African American narrator writes eloquently on society's inability (largely because of racism) to fathom, discern, and essentially see him. "That invisibility to which I refer," states the narrator, "occurs because of a peculiar disposition of the eyes of those with whom I come in contact." "A matter," he continues, "of the construction of their inner eyes, those eyes with which they look through their physical eyes upon reality."[12] This socially constructed, reality-altering invisibility (which forms the ontological basis for Ellison's sweeping and profound novel) reminds contemporary audiences of just how fundamental the notions of visibility and its opposite were for many African Americans in the 1950s. Although African Americans were laborers, veterans, homemakers, churchgoers, and individual, ordinary citizens, they were noticeably absent

from the country's mediated view of itself. Just half a century ago, the overwhelming image of the African American in popular magazines, motion pictures, and on radio and television was as an object of burlesque entertainment, derision, or pity, if not absolute nonexistence. In *Invisible Man* Ellison considers these various images and reminds us that a reductive, depth-obliterating perception impedes understanding to such an extent that a virtual invisibility dominates racial and cultural intercourse. Of course, the African American response to this invisibility covered the gamut of reactions, from an insistence on being seen (as exemplified in such racially proactive, all-Negro periodicals as *Ebony*, *Jet*, and *Sepia*), protestations against a pervasive, benign neglect (as seen in the sit-ins and boycotts of the early civil rights movement), to vehement and, perhaps, exaggerated denials of invisibility (as articulated in assorted words and deeds of patriotism, idealism, and escapism by many African Americans).

Another response to social indiscernibleness, *Invisible Man* suggests, is for the subjects to turn this state of virtual nonbeing into an asset. Ellison's narrator, discussing the advantages of being invisible, argues that it "gives one a slightly different sense of time, you're never quite on the beat. Sometimes you're ahead and sometimes behind. Instead of the swift and imperceptible flowing of time, you are aware of its nodes, those points where time stands still or from which it leaps ahead." This passage submits that it is precisely this invisibility and cultural isolation that, ironically, fuels an off-kilter, extrasensory approach to art: a state of affairs that the narrator of *Invisible Man* likens to the genius of the jazz musician Louis Armstrong for "making poetry out of being invisible."[13]

Just before the 1952 publication of Ellison's *Invisible Man*, Jacob Lawrence also contended with questions of visibility and invisibility. Lawrence and his art had been regular fixtures on the New York art scene since his first important solo exhibition at the Downtown Gallery in 1941, and the early 1950s brought Lawrence and his work even more notoriety. As already discussed, his eleven-month stay at Hillside Hospital was the subject of a lengthy *New York Times Magazine* article in October 1950. And in March 1952 photographs of Lawrence and fourteen other artists affiliated with the Downtown Gallery were published in *Life* along with an article on New York's contemporary art scene (fig. 52).

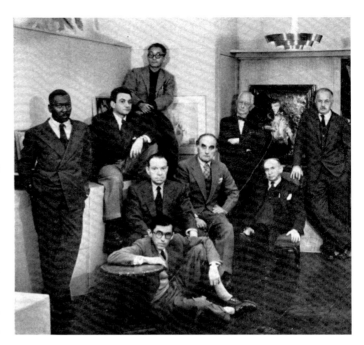

FIG. 52 Louis Faurer, *Artists Affiliated with the Downtown Gallery, New York,* 1952. *Life* (March 17, 1952).

Although reading this photograph is, admittedly, a highly subjective enterprise, it projected to the readers of *Life* a fascinating study in racial integration and, curiously, the art gallery as a form of the American corporation. The photographer Louis Faurer's self-conscious placement of Lawrence and his fellow Downtown Gallery stable mates—seemingly impromptu and casual, yet constrained by suits, ties, and the encroaching gallery walls—may have simply been what the editors at *Life* wanted. But what was communicated was a sense that these artists were serious-minded and professional, and their consortium was an idealized, if not warm and close-knit, racially integrated unit. Lawrence's persona and position in this photograph—proper, stoic, and marginal to the rest of the group—subliminally spoke to what life in a post–World War II, corporate, and racially integrated society might be like for African Americans.[14]

Like Ellison's *Invisible Man*, Lawrence examined in his work the realities of being black and invisible or, at best, the realities of being black and superficially perceived. After he made his paintings in the hospital Lawrence embarked on a series of works that explored the world of entertainment. On the surface these paintings are documentary: illuminations of memorable moments at Harlem's legendary Apollo Theater, as well as behind-the-scene observations of the not-so-memorable times in the lives of performers. However, beyond their documentary veneer, these paintings carefully interrogate the psychology

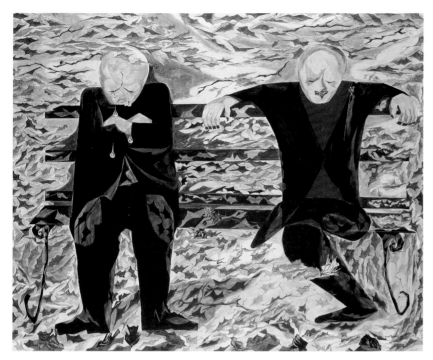

FIG. 53 *Tragedy and Comedy*, 1952, egg tempera on hardboard,
24 × 32 in. Collection of Michael and Elizabeth Rea, Connecticut.

of performance and self-presentation, demonstrating a firm grasp of the aforementioned racially charged invisibility/visibility debate.

In two of the most reproduced works from the paintings with the theater theme—*Tragedy and Comedy* (fig. 53) and *Vaudeville* (see p. 107, fig. 33)—Lawrence scrutinized this Ellisonian notion through bold parallelisms: paired representations set against pattern and color and anchored by a bioscopy of display. In *Tragedy and Comedy* the ancient personifications of the theatrical genres are transformed into two "white" men sitting on a park bench, idling their time away. Not so much white men as white-faced, zombielike incarnations of the dead, the paired figures act out their contrastive states, but not in the formats or evocations of olden times. Rather, these personifications exhibit countenances and gestures that touch ever so tangentially on the tragic and the comic. An alternative, more apropos title and theme would be *Atrophy and Combustion:* conditions that appositionally speak to a temperamental distance and emotional volatility, which, when imposed on Lawrence's ghostly duo, conjure a troubling, boundary-crossing theory of performance.[15]

Similarly, the two baggy suit–wearing comedians in *Vaudeville* are less corporeal than signlike: their vertical, open-legged stances function as enigmatic symbols set against an equally abstract field of colorful, intricate patterning. In the context of the other paintings by Lawrence that are preoccupied with masks,

masquerade, and illusion (e.g., *Magic on Broadway* and *Masks*), *Vaudeville* (like *Tragedy and Comedy*) takes the subject of the theater in a thematic direction having more to do with a social and/or racial identity than with the theater proper.

The two principal figures in *Vaudeville* are reminiscent of the legendary black comedians Dewey "Pigmeat" Markham and Tim Moore: both were "regulars" for many years at the Apollo Theater, and Tim Moore was a featured actor in the popular 1950s television series *Amos and Andy.* The two black comedians—frowning, crying, and confronting one another as if facing off in a dramatic, solemn *pas de deux*—digress from their expected comedic roles and, instead, offer a strange, unsettling image. Juxtaposing broad gestures and exaggerated, clownlike clothing with sorrowful faces and a fragmented background, Lawrence turned this world of slapstick humor, off-color jokes, and malapropisms into something introspective and serious. Recalling the second stanza of the poem "We Wear the Mask" (1895), Paul Laurence Dunbar's homage to black minstrelsy ("Why should the world be otherwise, in counting all of our tears and sighs? Nay, let them only see us, while we wear the mask"), *Vaudeville* uses abstraction and the tragic to critique, ironically, how the public perceives these black entertainers. Rather than presenting his black vaudevillians as shallow buffoons, Lawrence pictorially energized and humanized them, making them—and ultimately the entire black performance tradition of which they are a part—into vehicles of culture, truth, and, most significant, compassion.[16]

Paintings like *Vaudeville, Village Quartet* (fig. 54), and *Concert* (fig. 55) paid tribute not only to the existential fact of blackness but also to the captivating, often hypnotic effects of black entertainers. In related works Lawrence examined less explicit, though equally valid, representations of a black reality. In *Photos* (fig. 56), Lawrence portrayed his subjects in a manner that, without the fanfare or masklike qualities of many of his works, was comparable to mainstream images and identities. *Photos* countered black invisibility through depictions of African Americans experiencing life's many milestones (i.e., births, weddings, graduations, etc.) and through the idea of the photograph-as-irrefutable-evidence. These pictures of African American

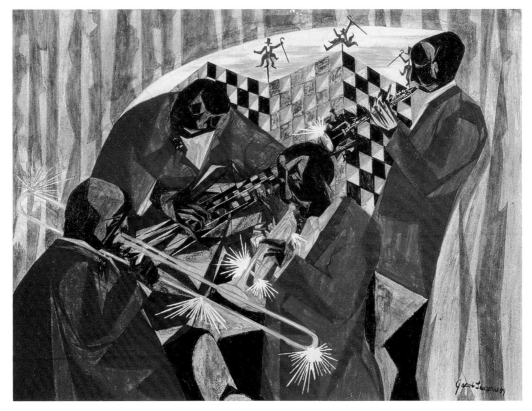

FIG. 54 *Village Quartet*, 1954, egg tempera on hardboard,
9 × 12 in. Private collection.

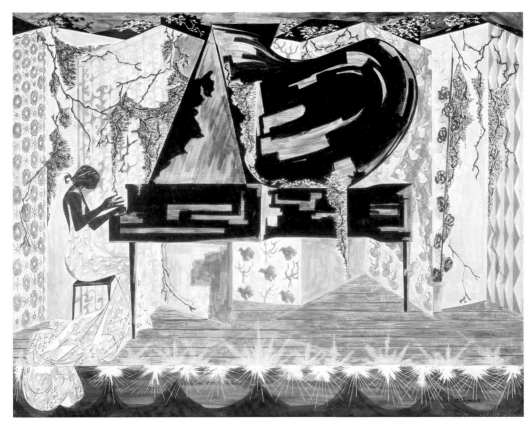

FIG. 55 *Concert*, 1952, egg tempera on hardboard, 22¾ × 31¾ in.
Herbert F. Johnson Museum, Cornell University, Ithaca, New York.
Gift of Dr. and Mrs. Emanuel Klein, Class of 1924.

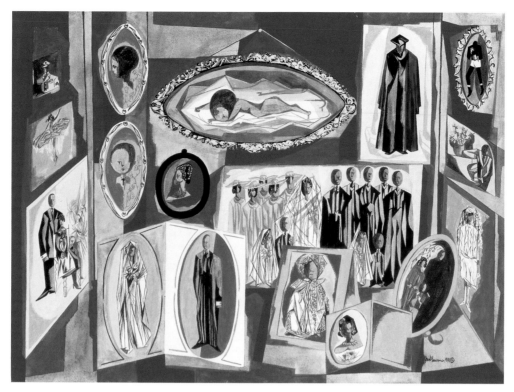

FIG. 56 *Photos*, 1951, casein tempera and gouache on paper, 23 × 32 in. Milwaukee Art Museum. Gift of Milprint, Inc., A Division of Philip Morris Industrial, M1971.1.

normalcy carried Lawrence's earlier inquests into community life to a higher, more challenging level of cultural representation.[17]

In a similar vein, Lawrence corresponded with the Chapelbrook Foundation in December 1954, requesting grant support for a "pictorial history of the United States." In Lawrence's proposal to the foundation, he explained:

> It was about five years ago that I first conceived the idea of doing a series of paintings relating the history of the Negro people in the United States. As this idea began to develope [sic] and take form, and as I read more of the history of the United States, I gradually began to appreciate not only the struggles and contributions of the Negro people, but also to appreciate the rich and exciting story of America and of all the peoples who emigrated [sic] to the "New World" and contributed to the creation of the United States.[18]

By 1956 (two years after receiving the Chapelbrook Foundation grant) Lawrence had completed thirty paintings for this project and exhibited them in New York's Alan Gallery under the collective title *Struggle . . . From the History of the American People.*

Lawrence had conceived of the sixty *Struggle* paintings as depicting "the struggles of a people to create a nation and their attempt to build a democracy." "This work," he continued, "will begin with the causes and events leading into the American Revolutionary War and end with the sailing of the American Fleet around the world in 1908. Between these two events will be depicted the great migration westward which occured [sic] during the greater part of the nineteenth century, and incidents leading up to and including the Civil War and the Industrial Revolution." A surviving page from a typed outline for the sixty *Struggle* paintings placed them in four historical categories: Part I: The Revolution and the Constitution; Part II: The Western Migration; Part III: The Civil War; and Part IV: The Industrial Revolution.[19] Despite Lawrence's plans, the series resulted in only thirty paintings (numbered consecutively 1 through 30), representing the Revolution, the Constitution, and the Western Migration.

An intimate look at the *Struggle* paintings points to the pre-Jacksonian era of United States history as Lawrence's primary source of inspiration. The titles of these paintings suggest a textual promenade through early American history, stopping at events or incidents that figured as important moments in the making of America. Some of these images addressed specific incidents, such as *No. 2: Massacre in Boston* (fig. 57), which depicts the bloody aftermath following a confrontation in 1770 between disgruntled American colonists and armed British soldiers. Others, like *No. 13: Victory and Defeat* (fig. 58), were less

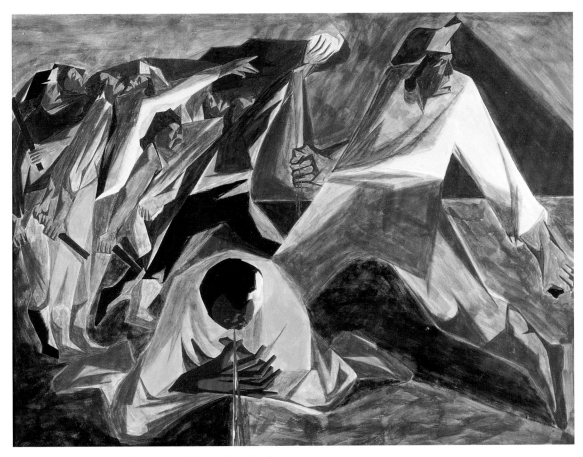

FIG. 57 *Struggle . . . From the History of the American People,
No. 2: Massacre in Boston,* 1955, egg tempera on hardboard,
12 × 16 in. Collection of Mr. and Mrs. Harvey Ross.

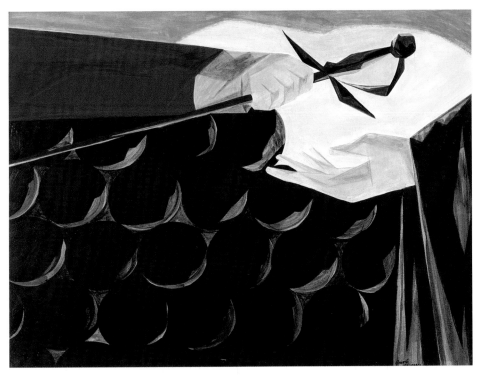

FIG. 58 *Struggle . . . From the History of the American
People, No. 13: Victory and Defeat,* 1955, egg tempera
on hardboard, 12 × 16 in. Private collection, Seattle.

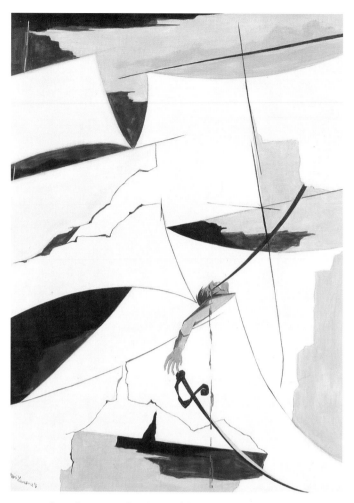

FIG. 59 *Struggle . . . From the History of the American People, No. 23: . . . if we fail, let us fail like men, and expire together in one common struggle . . . —Henry Clay, 1813,* 1956, egg tempera on hardboard, 16 × 12 in. Collection of Dr. Kenneth Clark.

descriptive (despite external references to Cornwallis's surrender to Washington at Yorktown, Virginia) and referred only obliquely to historic events.[20]

Whether they treat a particular incident or a more general theme, the *Struggle* paintings are unified by a compositional dynamism that suggests conflict instead of progress. In both *Massacre in Boston* and *Victory and Defeat,* Lawrence's placement of patterned and/or chromatically fragmented areas next to solid areas of color insinuated conflict, battle, and indeed, struggle: sensibilities that were at the core of Lawrence's interpretation of American history. In *Massacre in Boston* squats the bowed and bloody body of Crispus Attucks—a black man from Framingham, Massachusetts, and one of five Americans killed during this early Revolutionary skirmish—in marked contrast to a mob of white Bostonians, preoccupied with the battle beyond the picture frame and oblivious to this black-and-brown mound of a martyr. In *Victory and Defeat,* the uniformed arm and gloved hand of someone relinquishing his sword is visually countered by a sea of cannonballs, whose black uniformity and sheer numbers imply an omnipresent, insurmountable battalion. In both *Struggle* paintings, American advancements are framed by human and inanimate reminders of death, destruction, and social conflict.

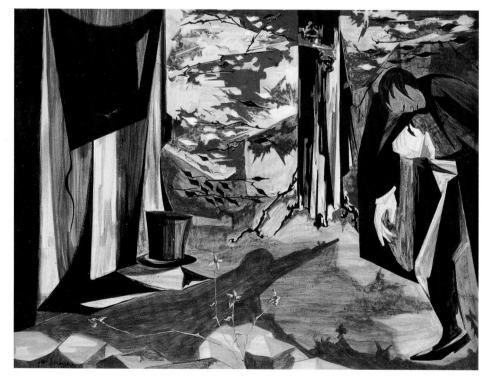

FIG. 60 *Struggle . . . From the History of the American People, No. 17: I shall hazard much and can possibly gain nothing by the issue of this interview . . . —Hamilton before his duel with Burr, 1804,* 1956, egg tempera on hardboard, 12 × 16 in. Collection of Mr. and Mrs. Harvey Ross.

Although the explicit narrative in *Struggle* painting *No. 23* (fig. 59) was America's military shortcomings during the War of 1812 (specifically, the high death toll that resulted from an 1813 clash with the British on Lake Erie), Lawrence's jagged "building blocks" and accents in black, white, gray, and red construct a pictorial space that, like paintings by the noted abstractionists Robert Motherwell and Franz Kline, can be interpreted as portraying something social and/or behavioral (i.e., aggression, confrontation, and resignation). The implicit narrative here is the universal, uphill "battle" with life, and the inevitable feelings of personal entrapment and loss that all human beings experience.

Even in those *Struggle* paintings where the abstract vision is subordinated to an illusionistic rendering (as in *No. 17*, which depicts the death of the U.S. Constitution's framer Alexander Hamilton [fig. 60]), a psychological state, rather than a historic perspective, is uppermost in Lawrence's agenda. Alexander Hamilton—shown defeated, bloodied, and mortally wounded after the 1804 duel with his shadowy political opponent, Aaron Burr—melodramatically sways and falls within this strange yet poignant setting of vegetation, architecture, and black drapery. By visually linking a legendary battle between two rivals during the early federalist period with a kind of vaudevillian mise en scène, Lawrence excavated the inner machinery of American democracy and, consequently, brought to the surface its histrionic, Shakespearean dimensions.

Struggle paintings *Nos. 5, 21,* and *27* (figs. 61, 62, see p. 236, fig. 107) all share the theme of peoples of color unified in their struggles against slavery and the annexation of Indian territories. Clutching weapons and gritting teeth, these fighting figures serve as constant reminders of a core American spirit of violence and antipathy. The captions for these paintings—

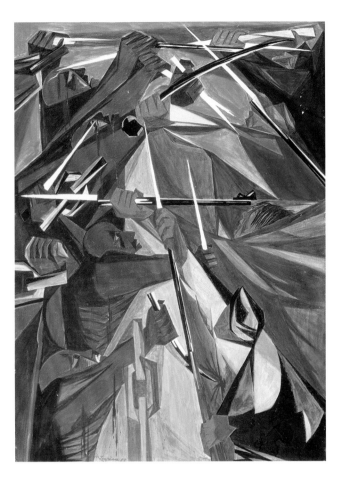

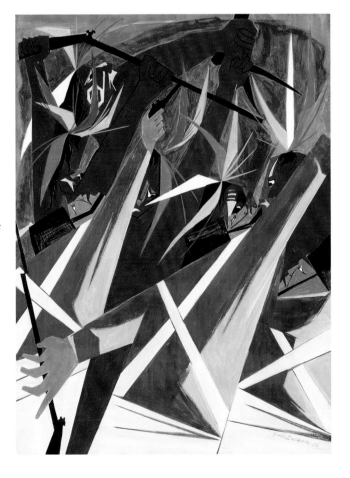

FIG. 61 *Struggle . . . From the History of the American People, No. 5: We have no property! We have no wives! No children! We have no city! No country! —Petition of many slaves, 1773,* 1955, egg tempera on hardboard, 16 × 12 in. The Thompson Collection.

FIG. 62 *Struggle . . . From the History of the American People, No. 21: Listen, Father! The Americans have not yet defeated us by land; neither are we sure they have done so by water—we therefore wish to remain here and fight our enemy . . . —Tecumseh to the British, Tippecanoe, 1811,* 1956, egg tempera on hardboard, 16 × 12 in. Collection of Mr. and Mrs. Harvey Ross.

always declarative and collective in tenor—argue that rebellion is the ultimate means for obtaining freedom.

Just when Lawrence was beginning to conceptualize the *Struggle* paintings, the radio and television airwaves were filled with talk about "the red scare": accusations that "certain people" were "Communist sympathizers," "foreign agents," or just plain "un-American." Senator Joseph McCarthy appeared in televised congressional hearings, asserting that the Army had been infiltrated by Communists. During this same period the legendary African American actor, singer, and "world ambassador" Paul Robeson was called before Senator McCarthy's House Committee on Un-American Activities and questioned about his alleged ties to the Communist Party and his past and present relationship with the Soviet Union.[21]

Lawrence, immersed in his chronicling of the American Revolution and westward expansion, could not have been unaware of Robeson's plight or the dilemmas of other Americans whose reputations and lives were ruined by similar accusations. It is perhaps more than coincidental that Lawrence's pictorial demolition of the myth of Americans as lovers of peace and defenders of the inalienable rights of the poor and dispossessed should appear precisely when loyalties were questioned and patriotism was tested. That these paintings emerged from the New York art scene during this contentious period in American history spoke volumes not only about Lawrence's sense of artistic understatement but of his career-long commitment to painting narratives about social progress and human striving.[22]

Lawrence was not alone among American artists in the 1950s in his exposé of the myths and illusions of American history. In 1953 Larry Rivers had created *Washington Crossing the Delaware* (The Museum of Modern Art, New York), a work that shared the same title as the famous Emanuel Leutze painting of 1851 but, with its sketchy treatment of the subject, undermined the textbook heroism of that alleged historic event. In his *Flag* of 1955 (The Museum of Modern Art, New York), Jasper Johns embraced a major American symbol, but with an unflinching precision that leaned toward the seditious. Also in 1955 the Swiss-born photographer Robert Frank began taking pictures of United States citizens, towns, and landscapes (eventually published in book form as *The Americans*) that, because of their bold, graphic quality and biting, critical perspective, represented Americans very differently from the Norman Rock-

well school of sentimental, patriotic illustrations which was then popular.

Like the *Struggle* paintings, these modernist works hardly concealed their ambivalence about America's heroes, symbols, and cultural representations. Unlike their depression-era predecessors who painted and wrote scathing diatribes against assorted forms of national hypocrisy, Rivers, Johns, Frank, *and* Lawrence concealed their contempt for American chauvinism and intolerance with more subtle tactics: by revealing the absurdity of certain American symbols via modernist painting techniques and by presenting the often complicated truths of their subjects within a nonliteral or theoretical framework. Although contained within a conceptual "red, white, and blue" mantle that even the gallery director Charles Alan perceived as "about the development of the democracy ideal," the *Struggle* paintings were unquestionably representations of a bloody, violent, and problematic democracy and struck a pessimistic chord in this period of political accusations, discrimination, social conformity, and cultural mythologizing.[23]

In spite of the omniscient and prophetic nature of Lawrence's *Struggle* paintings, critics have largely viewed the 1950s as a problematic period in Lawrence's artistic development. In her lengthy article on Lawrence for the February 1984 issue of *ARTnews*, Avis Berman described the hospital pictures as fraught with often "pointless" detail and "kaleidoscopic fragmentation," and the paintings with the theater theme as "strident and shrill, with artifice embraced for its own frenzied sake." Several decades earlier in the catalogue that accompanied Lawrence's first retrospective exhibition at the Brooklyn Museum, the art critic Aline B. Saarinen concluded that, as a result of Lawrence's being "more at peace with himself and the world," the "franticness and anxieties" in his paintings of the early 1950s had given way by the end of the decade to work that was "surer," that used color authoritatively, and that "returned to the bold simplicity of his early work, but . . . enhanced by new richness and resonance."[24]

What these critics failed to realize was that, at midcentury, Jacob Lawrence—mature, accomplished, and personally and professionally tested—was neither interested in repeating previously successful stylistic formulas nor comfortable with replicating his stock subjects from the past. Missing in these critiques was the capacity to think about this work in a manner that was

radically different from what audiences had come to expect from Lawrence. In retrospect the disregard by these and other critics for the theme of race in Lawrence's work during the 1950s seems to have prevented them from seeing his work in more subtle or discursive ways. While it is certainly true that Lawrence subordinated an explicit discourse of protest and race recognition in his work during the 1950s, that Lawrence was entirely disinterested in the burgeoning civil rights movement and that it had little or no impact on his imagination at the time are equally problematic propositions.[25]

In many of the paintings from the late 1950s, Lawrence focused on the decidedly nonpolitical experiences of black people. Street scenes, religious activities, and intimate pictures of black labor and leisure composed the bulk of Lawrence's work throughout the remainder of the decade. Thinking about these works in the context of a still racially segregated America, the innocuous and idyllic notions of neighborhood life that some critics persistently read into them are toppled and replaced with scenarios that, while not outwardly transgressive, simmered with a disquiet that is perhaps best characterized as the "strange fruit" of 1954.[26]

Of course, 1954 was the year that the U.S. Supreme Court ruled that racial segregation in public schools was unconstitutional. Rather than being a catalyst for hope and joy among black Americans, the decision precipitated what the historian Lerone Bennett has called "an era of bad faith." Most African Americans knew that such a ruling alone would not immediately change things and, if anything, was a harbinger of "skirmishes in schoolyards, of troops and tanks and despair."[27] If such works as *Palm Sunday* (fig. 63) appeared on the surface to be removed from the race question, then Lawrence's solemn gathering of parents, children, and a minister could not avoid being subliminally tied to contemporary images of these same principal actors in that period's highly publicized school desegregation cases. Despite the absence of a literal civil rights symbol, the submerged moods in *Palm Sunday* bubbled with a *Brown-v.-Board-of-Education-of-Topeka* dread and indirectly spewed out a bitter, race-infused bile.

Lawrence's ulterior motive for *Palm Sunday*—to situate black Americans inside everyday, ordinary American life and society—was clearly integrationist, and this perspective was frequently echoed by other African Americans, especially in

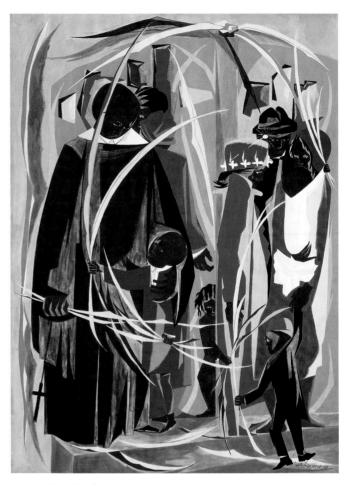

FIG. 63 *Palm Sunday*, 1956, casein tempera on paper, 30¼ × 22½ in. North Carolina Central University Art Museum, Durham. Friends of the Museum Fund and the National Endowment for the Arts.

contemporary editorials from the black press. "Those Negroes who are emotionally and economically alarmed over the changing times," observed a 1954 editorial in *Ebony* magazine, "must learn to adjust to an integrated society. . . . The elimination of a bi-racial system may cost them temporary displacement and discomfort, but by growing up in a racially-free community their children will be prepared to compete equally with white children for their place in a truly democratic society."[28]

In this and other editorials urging the Negro to "take inventory of himself and his position in relation to his fellow men," integration was based on a utopian ideal, which, when viewed next to a gnawing, persistent system of de facto segregation and a fearful atmosphere of racial violence, unfortunately veered toward the visionary and overly optimistic. Curiously, Lawrence, too, occasionally undermined his own positive view of integration, by exposing the roots of American violence (in the *Struggle* paintings) and by frequently representing a melancholy and chaotic world, untouched by governmental legislation (as seen in *Palm Sunday* and other paintings from the late 1950s).[29]

As discussed earlier, Lawrence's *Fulton and Nostrand* charted the artist's explorations of a sentimental black community into darker, more ambivalent territories. In this period of a professed sense of interracial cooperation, as well as painting "the pleasant story of neighborhood life" (Saarinen's words again), Lawrence envisioned the Brooklyn in *Fulton and Nostrand* as a segregated, fractured, and edgy place. While never explicitly emphasizing racial issues, Lawrence populated this Brooklyn neighborhood with little more than brown shards of humanity, flung and scattered against a red, ocher, and purplish blue background, thereby expressing doubts that made sense in light of that community's current decline. Furthermore, following Rosa Parks's arrest, Emmett Till's murder, Paul Robeson's being called before the House Committee on Un-American Activities, and President Eisenhower's sending paratroopers to help desegregate public schools in Little Rock, Arkansas, Lawrence, like many other black Americans, experienced a collective sense of apprehension that, as conveyed by works like *Fulton and Nostrand,* revealed Afro-America's introspective mind-set as it stood on the cusp of major social and cultural changes in the United States.[30]

The creative struggles that many black artists and intellectuals faced as they attempted to balance, on the one hand, their desire to participate in the larger American cultural enterprise with, on the other hand, a need to create something private, reflective, and, more important, idiosyncratically racial, often meant an end product that, like Lawrence's work of the 1950s, defied simple definitions. One is reminded of James Baldwin's narrator in "Sonny's Blues" (1957) who, while reflecting on his brother Sonny's extreme sense of alienation as a human being and artist, states:

> All I know about music is that not many people ever really hear it. And even then, on the rare occasions when something opens within, and the music enters, what we mainly hear, or hear corroborated, are personal, private, vanishing evocations. But the man who creates the music is hearing something else, is dealing with the roar rising from the void and imposing order on it as it hits the air. What is evoked in him, then, is of another order, more terrible because it has no words, and triumphant, too, for that same reason.[31]

If one extrapolates from this short passage by Baldwin his deft description of the jazz artist as someone who imposes an order that is both unspeakable (in terms of the terrible, hard choices made) and laudatory (vis-à-vis its triumphal stance), then Lawrence's work of the 1950s—with his subjects caught between a reality-based realm and a fractured, part contentious, part diaphanous atmosphere—is emblematic of the artist at a major crossroad in his career. What this closer look at Jacob Lawrence at midcentury suggests is that, like his fellow "harmonizers of chaos," Lawrence created a painted world that, while alternately viewed as either conservative or chaotic, kaleidoscopic or "kind of blue," skillfully rotates around satisfying an ever-changing marketplace of artistic ideas in the 1950s and satisfying a deliberative, forever questioning self.[32]

NOTES

1. Jacob Lawrence's stay at Hillside Hospital is discussed at length in Aline B. Louchheim, "An Artist Reports on the Troubled Mind," *New York Times Magazine,* October 15, 1950, pp. 15–6, 36, 38.

2. For comments by Jacob Lawrence's physician, Dr. Emanuel Klein, see ibid. For a general overview of Lawrence's life and career during the 1950s, see Ellen Harkins Wheat, "Mid-Career in New York: 1949 to 1968," in *Jacob Lawrence: American Painter,* exh. cat. (Seattle and London: University of Washington Press in association with the Seattle Art Museum, 1986), pp. 101–16.

3. Aline B. Saarinen, *Jacob Lawrence,* exh. cat. (New York: American Federation of Arts, 1960), p. 8.

4. Writing about the work Lawrence produced about 1950, Charles Alan noted that the artist "composes more freely, but less instinctively, and with far more sophistication. He uses primary colors more sparingly, and introduces offbeat harmonies. . . . But most significant, this increased technical authority seems merely a manifestation of the artist's desire to broaden the scope of his subject matter, his liberty to explore realms that combine fact and fantasy, to delve more penetratingly into subjects that he had already treated more cursorily . . . in earlier paintings." Charles Alan, unpublished manuscript, ca. 1973, courtesy Harry N. Abrams, New York. For a discussion of the cultural and political background behind this shift, see Leon F. Litwack, "The Nifty Fifties: Myth and Reality," in Taylor D. Littleton and Maltby Sykes, *Advancing American Art: Painting, Politics, and Cultural Confrontation at Mid-Century* (Tuscaloosa: University of Alabama Press, 1989), pp. 1–17.

5. For two very different descriptions of *Tombstones,* see Wheat, *Jacob Lawrence: American Painter,* p. 66, and Richard J. Powell, *Jacob Lawrence* (New York: Rizzoli Art Series, 1992), n.p.

6. In their discussion of African American literature at midcentury, Deborah E. McDowell and Hortense Spillers frame that period's aesthetic impulses under the collective title "Realism, Naturalism, Modernism, 1940–1960," in Henry Louis Gates, Jr., and Nellie Y. McKay, eds., *The Norton Anthology of African American Literature* (New York: W. W. Norton, 1997), pp. 1319–28. For a comparable discussion of the visual arts during this period, see Ann Eden Gibson, *Abstract Expressionism: Other Politics* (New Haven: Yale University Press, 1997). For related phenomena in music, see LeRoi Jones, "The Modern Scene," in *Blues People* (New York: Morrow Quill Paperbacks, 1963), pp. 175–236.

7. Lawrence makes emphatic his disdain for certain forms of abstraction in an interview published in Selden Rodman, *Conversations with Artists* (New York: Devin-Adair Co., 1957), pp. 204–7. For an analysis of how abstraction was critically received and comprehended, see Claude Cernuschi, *"Not an Illustration but the Equivalent": A Cognitive Approach to Abstract Expressionism* (Madison and Teaneck, N.J.: Fairleigh Dickinson University Press, 1997).

8. "He tried to give the feeling of the heat, the sunlight, the strenuous physical effort," wrote Charles Alan about Lawrence's *In the Garden.* "Therefore," he continued, "this painting is less literal than most of the others, but is a blend of precisely rendered minutiae and poetic hyperbole." Charles Alan, unpublished manuscript, ca. 1973.

9. In his review of John I. H. Baur's *New Art in America* (1957), the curator and critic Thomas B. Hess hardly conceals his sympathies in the abstraction/figuration debate when he acerbically writes that "history plods from 1900 to 1955 on the same old circuits, unaware of the jokes it perpetrates by making Gorky live with Kane and Tomlin with Jacob Lawrence." Thomas B. Hess, "For Spacious Skies, and All That," *ARTnews* 56, 7 (November 1957), p. 30. For a less trenchant discussion of Lawrence and his relationship to formal issues, see Ralph M. Pearson, *The Modern Renaissance in American Art* (New York: Harper and Brothers, 1954), pp. 163–9. For a more historical and theoretical view of Abstract Expressionism, see Michael Leja, *Reframing Abstract Expressionism* (New Haven: Yale University Press, 1993).

10. For a discussion of figurative art during this period, see Paul Schimmel and Judith E. Stein, *The Figurative Fifties: New York Figurative Expressionism,* exh. cat. (Newport Beach, Calif.: Newport Harbor Art Museum, 1988).

11. Louchheim, "An Artist Reports on the Troubled Mind," p. 16.

12. Ralph Ellison, *Invisible Man* (1952; reprint, New York: Vintage Books, 1972), p. 3.

13. Ibid., p. 8.

14. "New Crop of Painting Protégés," *Life* 32 (March 17, 1952), pp. 87–8.

15. Also see Victor Turner, *The Anthropology of Performance* (New York: PAJ Publications, 1988).

16. Paul Laurence Dunbar, "We Wear the Mask," in Gates and McKay, eds., *Norton Anthology of African American Literature,* p. 896.

17. For a philosopher's perspective on this concept, see Lewis R. Gordon, "Existential Dynamics of Theorizing Black Invisibility," in Lewis R. Gordon, ed., *Existence in Black: An Anthology of Black Existential Philosophy* (New York: Routledge, 1997), pp. 69–79.

18. Jacob Lawrence, letter to Mina Curtiss, December 16, 1954, Jacob Lawrence Papers, Archives of American Art, Smithsonian Institution, Washington, D.C. (hereafter AAA).

19. Jacob Lawrence, "Struggle . . . From the History of the American People," undated manuscript, Jacob Lawrence Papers, AAA.

20. Parts of this examination of the *Struggle* paintings are taken from a lecture, "Jacob Lawrence's *Struggle:* An Uneasy Freedom," given by the author at the Virginia Museum of Fine Arts, Richmond, December 7, 1996.

21. For historical and personal accounts of those years, see Griffin Fariello, *Red Scare: Memories of the American Inquisition, An Oral History* (New York: W. W. Norton, 1995).

22. Rick Stewart, currently director of the Amon Carter Museum in Fort Worth, Texas, has also linked the *Struggle* paintings with "the social tensions and hysteria of the McCarthy era." Stewart, "Jacob Lawrence Painting Acquired," *Dallas Museum of Art Bulletin* (summer 1985), pp. 10–2. Although Lawrence is his usual, reticent self on this and other controversial subjects, his documented refusal to accept a 1952 United States Information Agency invitation to lecture abroad for 3–4 months with the expressed charge of "counteracting the widespread ignorance that exists abroad regarding the United States" perhaps corroborates this sense that the *Struggle* paintings are, indeed, a veiled critique of American democracy, past and present, in praxis. I thank Michelle DuBois and Peter Nesbett of the Jacob Lawrence Catalogue Raisonné Project for bringing the USIA invitation and Lawrence's refusal to my attention.

23. Charles Alan, letter to Mrs. Windfohr, January 18, 1957, Charles Alan Papers, AAA.

24. Avis Berman, "Jacob Lawrence and the Making of Americans," *ARTnews* 83, 2 (February 1984), p. 86, and Saarinen, *Jacob Lawrence,* p. 9. Also see Jane Addams Allen, "Famed Artist Paints Niche in History," *Washington Times,* April 2, 1987, p. C2.

25. A contemporary exception to this critical myopia (in regards to Lawrence and race at midcentury) hails from the European art press: Clifford Wright, "Jacob Lawrence," *The Studio* (London) 161 (January 1961), pp. 26–8.

26. "Strange Fruit," of course, is the title of a song made famous by Billie Holiday. For evidence of a persistently saccharine, or uncomplicated view of mid-to-late 1950s works, see Saarinen, *Jacob Lawrence,* p. 9, and Wheat, *Jacob Lawrence: American Painter,* pp. 104–7.

27. Lerone Bennett, Jr., *The Negro Mood and Other Essays* (Chicago: Johnson Publishing Company, 1964), p. 17.

28. "Negro Diehards Die Hard," *Ebony* 9 (April 1954), pp. 76–7.

29. "Color Is Not a Crutch," *Ebony* 9 (June 1954), pp. 84–5. More than a decade after these rather optimistic views on integration, Lawrence spoke candidly about the actual impact of race in America and on him, observing that because of perceived racial differences among Americans, true integration "may never" [take place] and, therefore, "it can't help [but] influence . . . my thinking, . . . my work, and my whole being. . . ." Jacob Lawrence, transcript of tape-recorded interviews by Carroll Greene, Jr., October 25 and November 26, 1968, AAA.

30. For another view of African Americans during the 1950s, see Louis E. Lomax, "The Negro in the Fifties," in *The Negro Revolt* (New York: Signet Books, 1963), pp. 78–91.

31. James Baldwin, "Sonny's Blues," in *Going to Meet the Man* (New York: Dell Publishing Company, 1966), p. 119.

32. "Kind of Blue" is the title of Miles Davis's classic recording of about 1950. The phrase "harmonizers of chaos" is taken from Kimberly Benston's critical exegesis of the novelist Ralph Ellison and the cultural critic Albert Murray, in his book on the noted poet, playwright, and essayist Amiri Baraka. Kimberly W. Benston, *Baraka: The Renegade and the Mask* (New Haven: Yale University Press, 1976), p. 89. Also see Ralph Ellison, *Shadow and Act* (1964; reprint, New York: Vintage International, 1995), p. 257, and Albert Murray, *The Omni-Americans* (1970; reprint, New York: Vintage Books, 1983), p. 58.

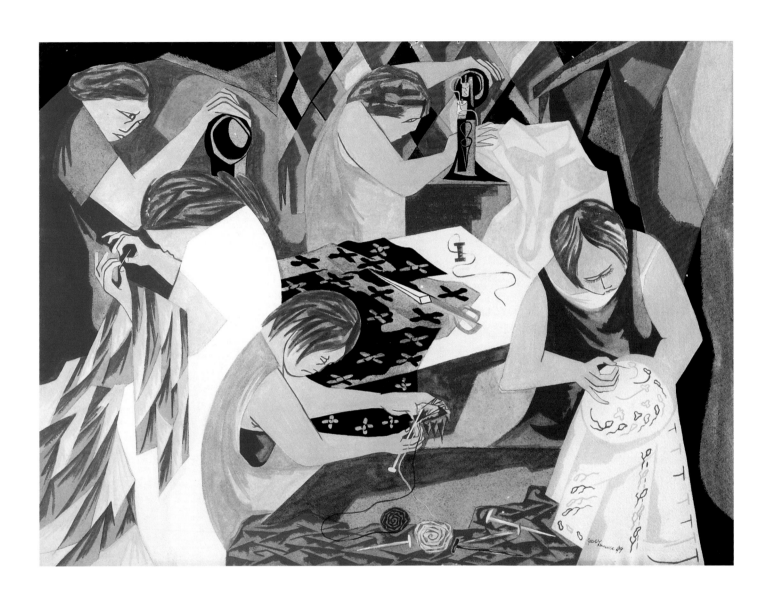

PL. 53 *Occupational Therapy No. 1*, 1949, casein tempera on paper, 23¾ × 31¾ in. Private collection.

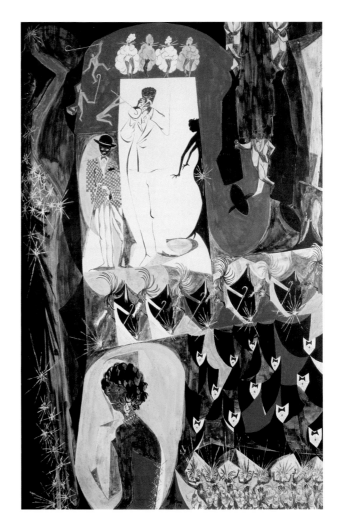

PL. 54 *Billboards*, 1952, egg tempera on hard-
board, 36 × 24 in. Private collection.

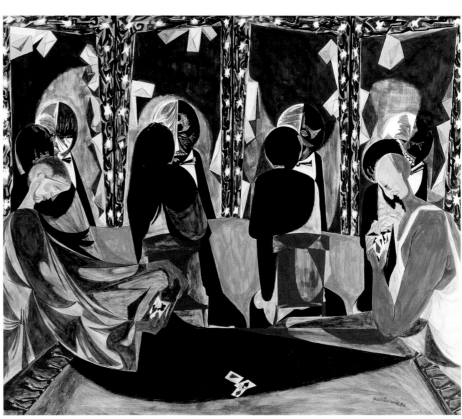

PL. 55 *Makeup*, 1952, egg tempera on hardboard,
20 × 24 in. Collection of Elisabeth and
William M. Landes, Chicago.

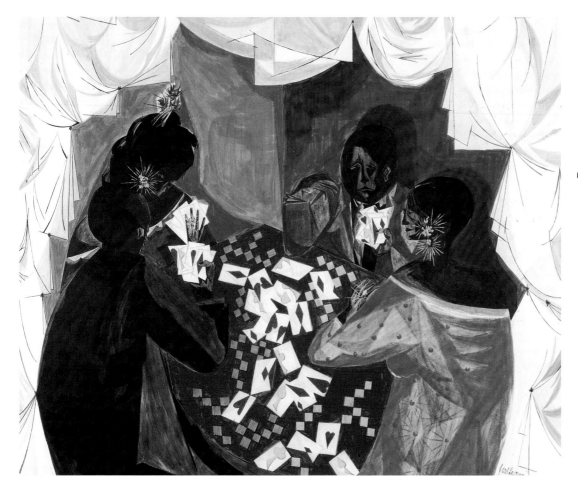

PL. 56 *Card Game,* 1953, egg tempera on hardboard, 19 × 23½ in. The Walter O. Evans Collection of African American Art.

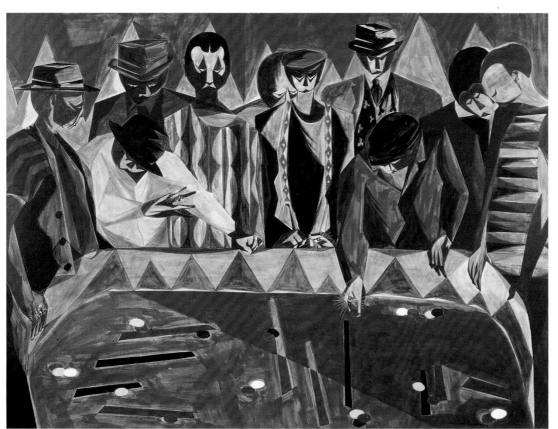

PL. 57 *A Game of Chance,* 1954, egg tempera on hardboard, 18 × 24 in. Private collection. Courtesy of Michael Rosenfeld Gallery, New York.

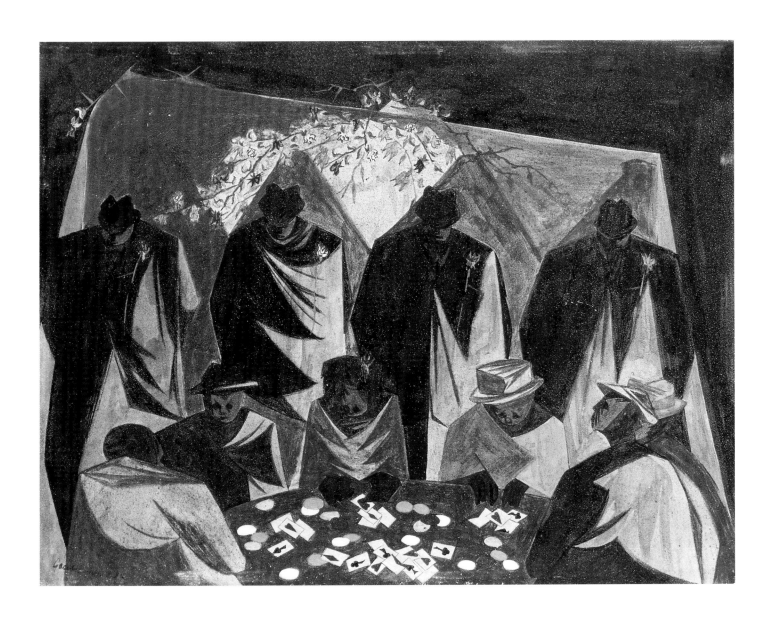

PL. 58 *Gamblers,* 1954, egg tempera on
hardboard, 9 × 12 in. Memorial Art
Gallery of the University of Rochester.
Marion Stratton Gould Fund.

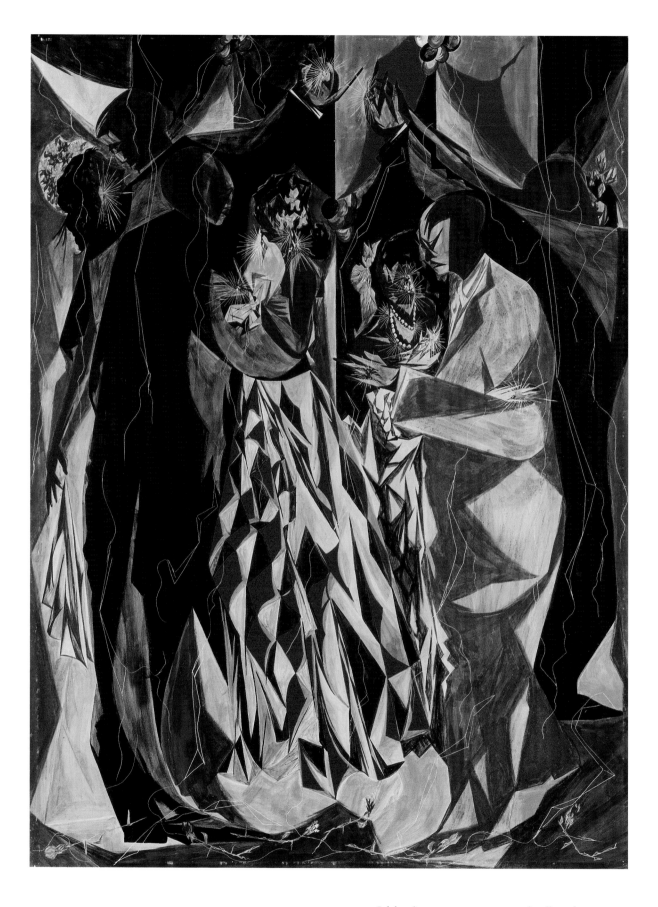

PL. 59 *Celebration,* 1954, egg tempera on hardboard, 23⅞ × 17⅛ in. Hirshhorn Museum and Sculpture Garden, Smithsonian Institution. Gift of Joseph H. Hirshhorn, 1966.

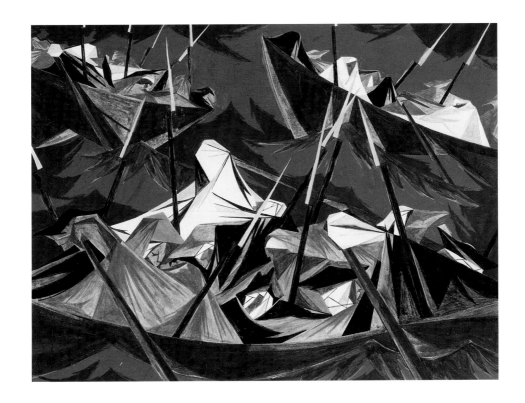

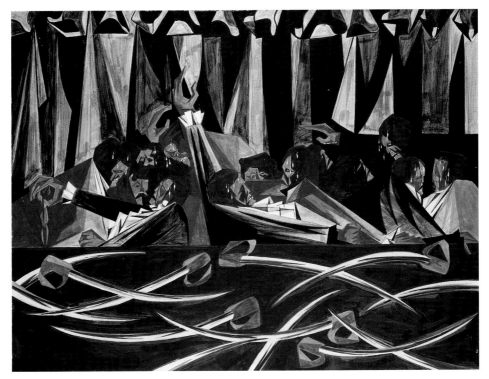

PL. 60 *Struggle . . . From the History of the American People, No. 10: We crossed the River at McKonkey's Ferry 9 miles above Trenton . . . the night was excessively severe . . . which the men bore without the least murmur . . . —Tench Tilghman, 27 December 1776*, 1954, egg tempera on hardboard, 12 × 16 in. Private collection.

PL. 61 *Struggle . . . From the History of the American People, No. 15: We, the people of the United States, in order to form a more perfect Union, establish justice, insure domestic tranquility . . . —17 September 1787*, 1955, egg tempera on hardboard, 12 × 16 in. Fogg Art Museum, Harvard University Art Museums. Anonymous fund in memory of Henry Berg, Henry George Berg Bequest, Richard Norton, and Alpheus Hyatt Fund.

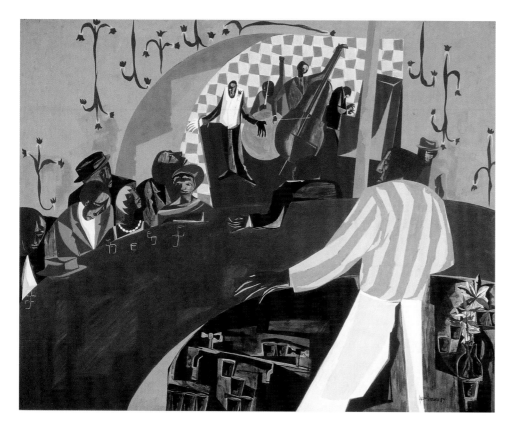

PL. 62 *Cafe Comedian,* 1957, casein tempera on paper, 23 × 29 in. Museum of Fine Arts, Boston. Gift of Mr. and Mrs. William H. Lane and Museum Purchase, 1990.378.

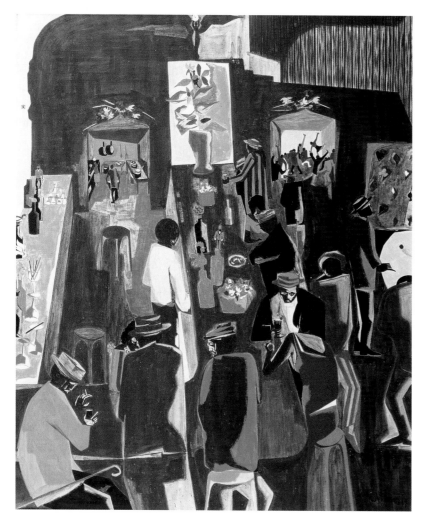

PL. 63 *The Brown Angel,* 1959, egg tempera on hardboard, 24 × 20 in. Private collection. Courtesy of F. B. Horowitz Fine Art, Hopkins, Minnesota.

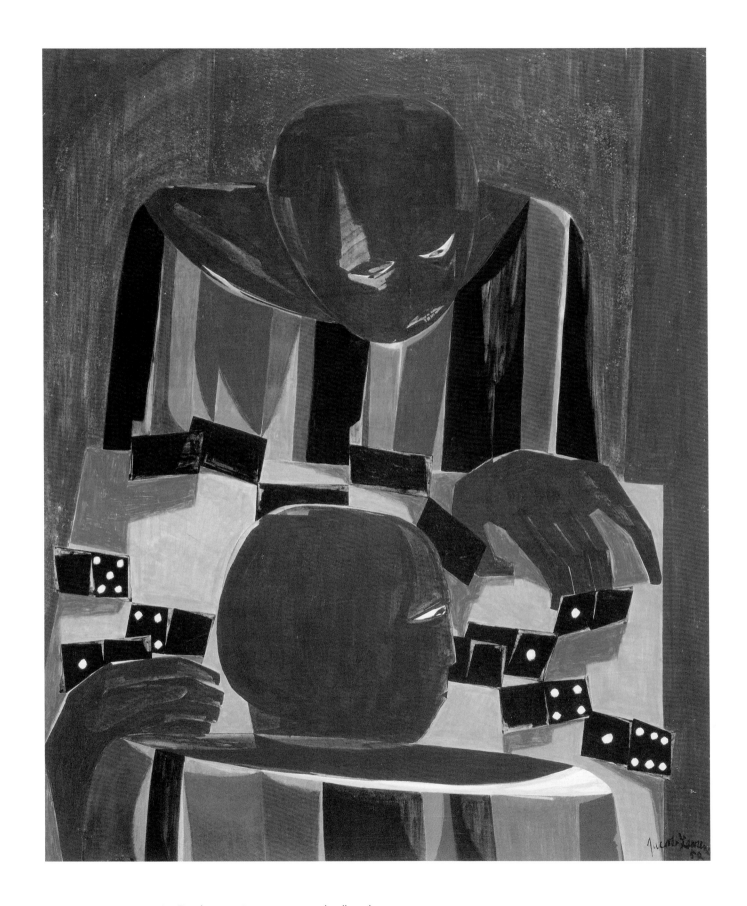

PL. 64 *Dominoes,* 1958, egg tempera on hardboard,
24½ × 19¾ in. Private collection.

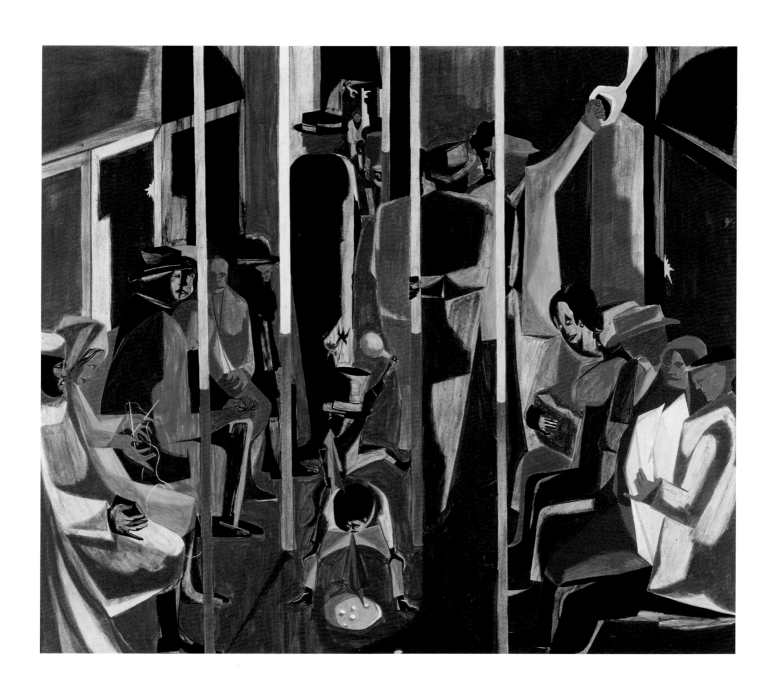

PL. 65 *Subway Acrobats,* 1959, egg tempera on hard-
board, 20 × 24 in. Private collection, New York.

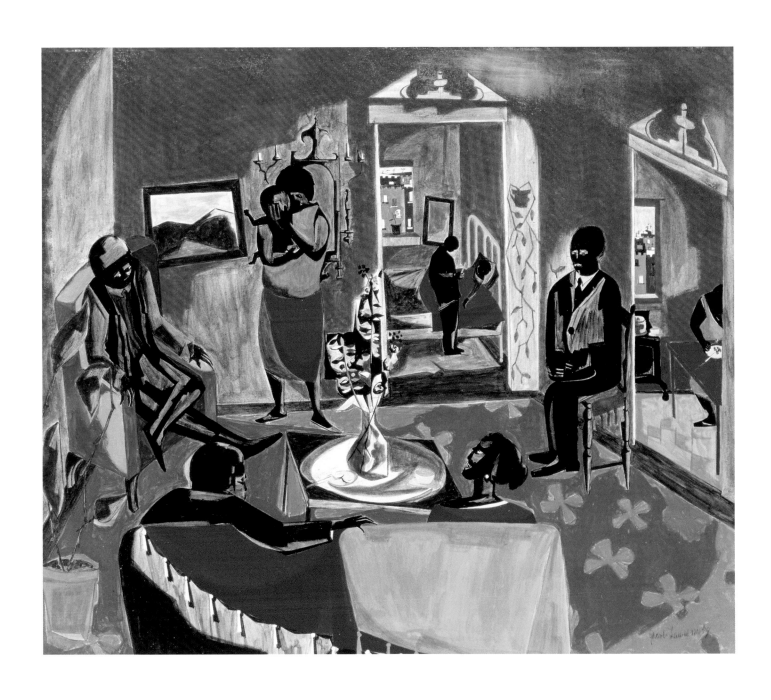

PL. 66 *The Visitors*, 1959, egg tempera on hardboard,
20 × 24 in. Dallas Museum of Art. General
Acquisitions Fund.

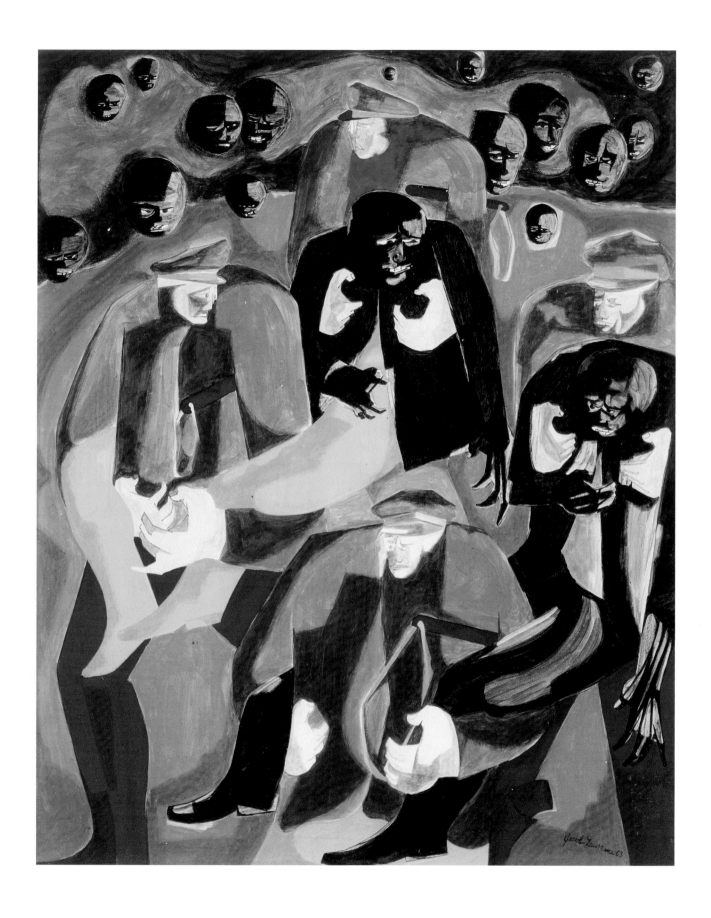

FIG. 64 *Two Rebels*, 1963, egg tempera on hardboard, 23¼ × 19¼ in. The Harmon and Harriet Kelley Foundation for the Arts.

Patricia Hills

Jacob Lawrence's Paintings during the Protest Years of the 1960s

MAY 3, 1963, BIRMINGHAM, ALABAMA: *Eugene "Bull" Connor, an ardent segregationist in charge of Birmingham's police and fire departments, called out eight K-9 units of police dogs to halt civil rights demonstrators from marching downtown and had firemen in readiness with high-powered water hoses.*[1]

The well-orchestrated campaign of the Southern Christian Leadership Conference (SCLC) to desegregate Birmingham's retail facilities had begun one month earlier, on April 3, with boycotts of stores, kneel-ins at churches, and sit-ins at lunch counters, followed by massive arrests. The strategy of nonviolent confrontation had been crafted by the Reverends Fred Shuttlesworth, Wyatt T. Walker, Martin Luther King, Jr., and Ralph Abernathy. Connor obtained an injunction to prevent King and others from marching, which the civil rights leaders defied on Good Friday, April 11. King, Abernathy, and Shuttlesworth were arrested and jailed, but the demonstrations continued. The entire African American community of Birmingham was united in its determination to expose racism in the South and Birmingham, in particular, through their actions.

At 1 p.m. on May 2 a phalanx of fifty teenagers left the SCLC staging area inside the Sixteenth Street Baptist Church singing "We Shall Overcome" and marched toward the white business district. Police immediately arrested them. More waves of children poured out of the church all afternoon and into the vans of the arresting police. By the end of the day, 959 children had been sent to jail.[2]

Hence, the next day photographers were on hand as more young people and adults continued to protest. Connor ordered the use of the dog units and the high-powered water hoses to stop the marchers. The most famous photograph, by Bill Hudson of William Gadsden being attacked by police dogs [fig. 65]*, was sent around the world by the wire services. Still the demonstrations continued in Birmingham, as well as across the country. According to a Department of Justice report, there were 1,412 demonstrations in three months of 1963.*[3]

Jacob and Gwendolyn Knight Lawrence must have watched with horror and disgust as news accounts like the above unfolded on television and in the newspapers and news magazines in April and May 1963, but they were hardly surprised.[4] Police brutality, vicious dogs, and repressive tactics were part of the collective experiences that African Americans had shared since the days of slavery. Dogs had been used during the era of slavery to track down runaway slaves and in the early years of the twentieth century by lynching mobs to hunt out African American men accused of alleged crimes against whites. While whites might talk about "the movement," as if it were something that had just begun in the mid-1950s when Rosa Parks refused to move to the back of a Montgomery bus, Lawrence and his friends had always known of the small and large, the individual and the collective, acts of resistance against racial injustice.[5]

At the time of the events in Birmingham, Lawrence, with the encouragement of his friends Robert Gwathmey and Philip Evergood, was having his first solo exhibition at Terry Dintenfass Inc., New York.[6] To publicize the exhibition at her gallery, Dintenfass had asked Lawrence to make a lithograph to be used as the design for a poster. Lawrence based the resulting design on one of the tempera paintings in the exhibition, *Two Rebels* (fig. 64), showing four white policemen carrying two black men. The heads of some fifteen witnesses crowd in. In the poster that number was reduced to ten heads that float like moons of light above a protester and his police handlers with their billy clubs dangling from their wrists.

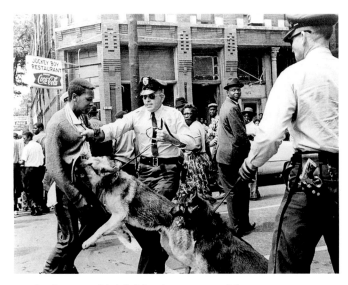

FIG. 65 A 17-year-old civil rights demonstrator, defying an antiparade ordinance of Birmingham, Alabama, is attacked by a police dog, May 3, 1963. (AP Photo/Bill Hudson)

FIG. 66 *Invisible Man among the Scholars*, 1963, egg tempera on hardboard, 24 × 35¼ in. Collection of Mr. and Mrs. Harold A. Sorgenti.

Although the poster would seem to announce the theme of social protest for the exhibition, the majority of the paintings did not focus on civil rights activities as subjects. Instead, as he had always done, Lawrence painted themes from the world around him: two of children (*Street Scene* [*Boy with Kite*] [1962] and *All Hallow's Eve* [1960]), one of entertainment (*Cabaret* [1962]), two on the migration theme (*The Travelers* [1961] and *Northbound* [1962]), two on the theme of the educational resources for blacks (*Library II* [1960] and *Library III* [1960]), and two indictments of racial prejudice that existed long before the civil rights movement of the 1950s and early 1960s (*Invisible Man among the Scholars* [fig. 66] and *Taboo* [fig. 67]).

In Lawrence's painting *Invisible Man among the Scholars*, the "invisible man"—explicitly so named in Ralph Ellison's 1952 novel—is removed to the left background. Isolated in a black cocoon, he is ignored by the white students sitting at a seminar table with their notebooks. The rhythms of the painting and the glances of the students pull our eyes toward the white professor draped in his colorful academic robes who, with his lecture notes, presides over the scene. When the artist painted this picture, he may have had in mind James Meredith, a former Air Force African American staff sergeant who decided to transfer

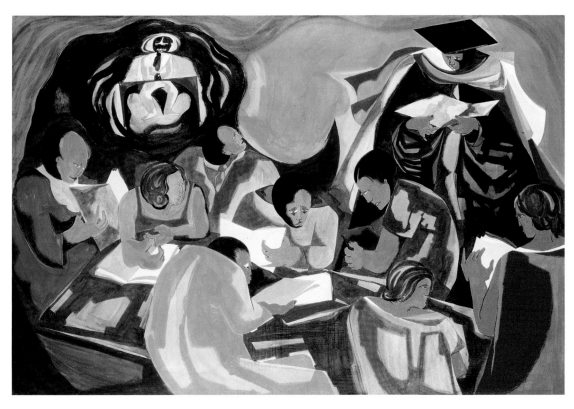

from an all-Negro college to the segregated University of Mississippi in September 1962. The courts ruled in his favor, but the governor of Mississippi resisted his enrollment and personally blocked his entrance. President John F. Kennedy finally called in the National Guard, and Meredith, accompanied by federal marshalls and state troopers, was allowed to register. Once enrolled, he found himself isolated and ignored by the white students, like the figure in *Invisible Man among the Scholars*, but he stayed the course and graduated in the summer of 1963.[7]

Taboo's image is more static with its two pairs of figures facing us like formal wedding portraits: a white groom and an elaborately attired black bride and a black groom with an equally richly dressed white bride. The painting's title, *Taboo*, alerts us to the social transgressiveness of the actions of the figures; in 1963 antimiscegenation statutes were still on the lawbooks of Southern states. And yet the fine attire and formal nature of the double wedding portraits also inform us of the calculated and preplanned nature of the decision of the two couples to marry outside their race.

It was, however, the five paintings on civil rights themes that attracted the attention of critics eager to have their say on

an issue of national importance. Vivien Raynor's reaction was typical:

> In his new paintings Lawrence is chiefly occupied with events in the South. . . . He translates the issues of racial dispute into condensed patterns that administer sharp jabs rather than knockout blows. *Praying Ministers* in their robes follow their mission surrounded by soldiers; *Ordeal of Alice* represents the Negro child in a white dress—she is riddled with arrows and beset by grimacing white female devils. If Lawrence's work has become less lyrical, his skill at expressing his feelings in dense, well-composed patterns continues to be impressive.[8]

Yet Lawrence saw those civil rights paintings as not different in kind from his other work. That is to say, he responded in his art to current events just as he responded in his art to all facets of contemporary African American life.

Praying Ministers (fig. 68) shows a number of black and white ministers and rabbis bending their heads and praying, while behind them protesting students raise their fists and wave a flag. A white and a black soldier flank the scene, prominently displaying their rifles and ammunition. Police or soldiers inhabit the three other paintings of this theme in the Dintenfass show: *Two Rebels* (fig. 64), *Soldiers and Students* (fig. 69), and *Four Students* (1961).[9] We can surmise that these paintings were triggered by news photographs and television images of the immediate events of 1960, 1961, and 1962. Sit-ins of segregated lunchrooms began in 1960, and later in the year Freedom Riders (blacks and whites riding together on interstate buses) journeyed to the South in defiance of local Jim Crow custom. In mid-1961 Freedom Riders, members of the Student Non-Violent Coordinating Committee, were jailed, yet the pressure continued. More Freedom Riders, voter-registration workers, and civil rights workers flooded the South and, even though committed to the principles of nonviolent civil disobedience, had frequent confrontations with the police and local racists.

Lawrence's painting *Ordeal of Alice* (fig. 70) raised the level of intensity in his paintings, and it

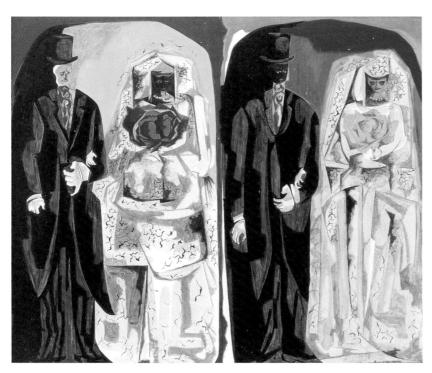

FIG. 67 *Taboo*, 1963, egg tempera on hardboard, 19⅞ × 23⅞ in. Collection of Mrs. Josef Jaffe.

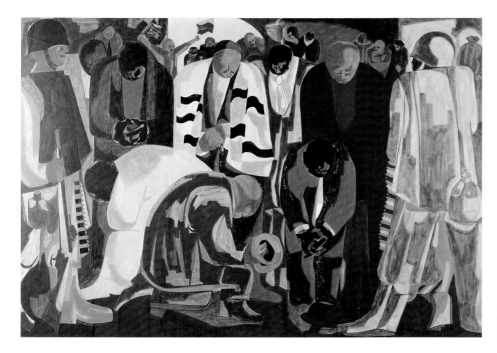

FIG. 68 *Praying Ministers*, 1962, egg tempera on hardboard, 23 × 38 in. Spelman College, Atlanta.

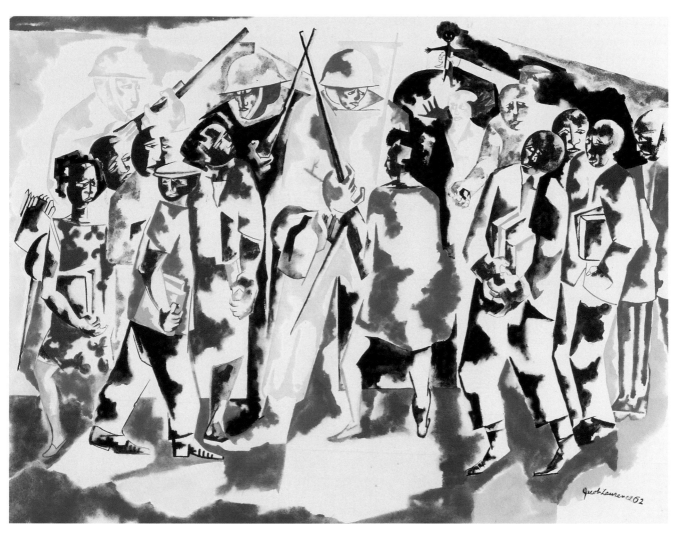

FIG. 69 *Soldiers and Students*, 1962, gouache on paper, 22½ × 30½ in. Hood Museum of Art, Dartmouth College, Hanover, New Hampshire. Bequest of Jay R. Wolf, Class of 1951.

drew the most comment from critics. Arrows pierce the white dress and stockings of the black schoolgirl carrying books and walking along a pathway bordered by small flowers. Bright red blood splashes across her clothing. The symbolism refers, of course, to the martyr Saint Sebastian who was sentenced by the Roman emperor to be shot with arrows when his Christian faith was discovered.[10] Alice's neat attire and her desire to take the path of education contrast with the six leering red, blue, and brown humanoids with their grinning ivory teeth, who taunt her. Such creatures were a new element in Lawrence's work. Their gyrations and menacing gestures press against her, creating an impenetrable barrier to her journey.

The desegregation of the schools had been much in the news. A landmark for civil rights occurred in 1954 when the Supreme Court, in *Brown v. Board of Education of Topeka*, judged that "separate but equal" public school systems were unconstitutional. Alice's "ordeal" should be seen in the light of the fact that since the Supreme Court decision nine years had passed with little progress being made to desegregate the schools. In fact, in 1957 confrontations occurred in Little Rock, Arkansas, between racists and nine African American teenagers attempting to desegregate the school system.[11] Governor Orville Faubus called out the National Guard to side with the segregationists.

One of the famous news photographs, by Pete Harris, depicts one of the nine children, Elizabeth Eckford, harassed by a mob of white women as she walked toward Central High in Little Rock on September 4, 1957 (fig. 71). She was stopped at the steps by a National Guardsman, who prevented her from entering. Lawrence's picture of Alice resonates with the photograph of the real-life schoolgirl, but the artist exaggerates that reality into a grim poetry.[12]

Lawrence knew that racism and racial tauntings leave long-lasting scars on black children. The many instances of such traumas have been recorded in the history and literature of black people and were part of every black person's personal experience. For example, W. E. B. Du Bois in *The Souls of Black Folk* (1903) meditated on the epiphanic moment when a classmate in Great Barrington, Massachusetts, refused his gesture of friendship because, he realized, he was "different from the others."[13] Du Bois's experience was not as ugly as some suffered by others, but the spiritual wounding was the same. Teasing and humiliations by ignorant and ranting people were part of what

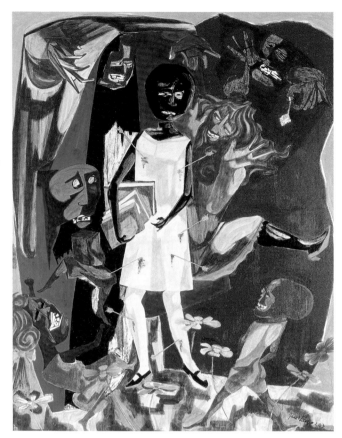

FIG. 70 *Ordeal of Alice*, 1963, egg tempera on hardboard, 24 × 20 in. Private collection, New York.

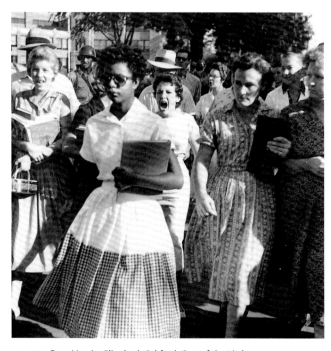

FIG. 71 Pete Harris, *Elizabeth Eckford, One of the Little Rock Nine, Pursued by the Mob outside Little Rock Central High School, September 4, 1957.* Reproduced in Steven Kasher, *The Civil Rights Movement: A Photographic History, 1954–1968* (New York: Abbeville Press, 1996).

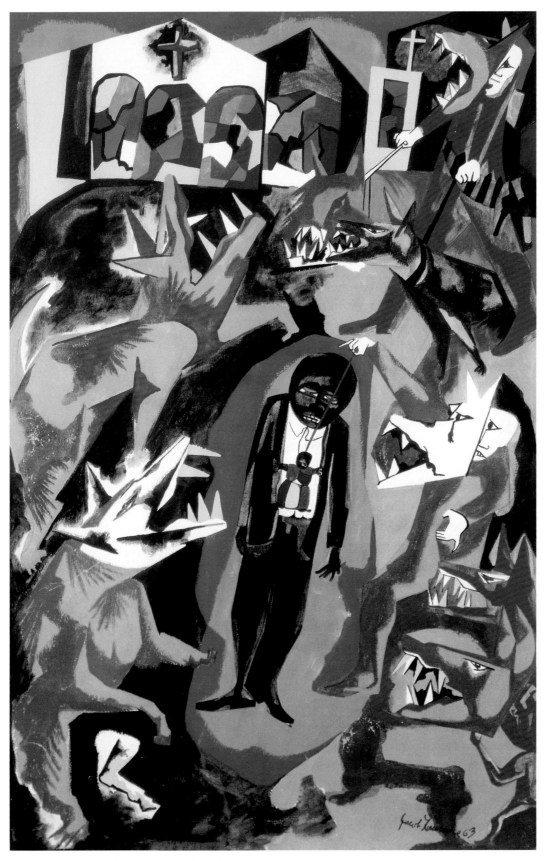

FIG. 72 *American Revolution*, 1963, gouache and tempera on paper, 23 × 15 in. Private collection. Courtesy of Peg Alston Fine Arts, New York.

Lawrence would call the collective "black experience." Hence, he called his young girl "Alice," the figure from Lewis Carroll's *Alice in Wonderland*, who must negotiate the bizarre world of irrational adults.[14]

When interviewed by the art critic from *Newsweek*, Lawrence admitted he was painting a nightmare and commented on the figures surrounding Alice: "It must be hellish . . . it must be like a dream—out of this world. You see they're human beings, and yet they're like animals." To these racists, Alice becomes the focus of their irrational hate. "The little girl becomes a symbol where they can get it [their hate] out. These people have no insight. It's sad that they're that way. They're worse off than the girl." The art critic noted that "Lawrence paints the nightmare, but with the natural unforced compassion of a man who is not at war with himself."[15] Discussing the figures in an interview in 1995, Lawrence reiterated that they were meant to represent "an ugly situation," which could only be expressed by distorting the characters.[16]

The editors of *Motive*, a magazine sponsored by the Methodist Student Movement, asked Lawrence to paint a picture for their October 1963 cover "to help underscore the urgency of our times and expose the raw face of hatred and evil and oppression."[17] With memories of James Meredith at the University of Mississippi in September 1962 and the police dogs of Birmingham in May still vivid in people's consciousnesses (see fig. 65), Lawrence submitted *American Revolution* (fig. 72), which draws on the imagery of police dogs and the endurance of people resisting injustice. In the middle of a composition crowded with snarling and lunging dogs and men wearing canine masks a black man stands erect. One dog-masked figure at the right manipulates a stick puppet of an Aunt Jemima–type figure in front of the protagonist. The bright primary colors with tints of the same hues shrilly scream at the viewer. Both Alice and the man in *American Revolution* endure the almost paralyzing effects of fear as they face the vicious beasts menacing them. When Anthony Lewis's book on the civil rights movement came out in 1964, the author called it *Portrait of a Decade: The Second American Revolution*. To Lewis, it was a "race-relations revolution . . . a unique effort to join a society rather than overthrow it."[18] Lawrence would have agreed.

The scope of the movement became clear to the nation when A. Philip Randolph, president of the Brotherhood of Sleeping Car Porters, and Bayard Rustin mobilized the March on Washington, D.C., staged for August 28, 1963. They were joined by other civil rights leaders: Roy Wilkins of the National Association for the Advancement of Colored People (NAACP), James Farmer of the Congress of Racial Equality (CORE), John Lewis of the Student Non-Violent Coordinating Committee (SNCC), Whitney Young, Jr., of the Urban League, and Martin Luther King of SCLC. The turnout numbered at least a quarter million demonstrators.[19] King's "I Have a Dream" speech electrified his audience, and souvenir pictures—reproductions of collages made from *Life* magazine news photos of the police dog and fire-hose attacks in Birmingham and other civil rights scenes—were sold for a dollar.[20] The backlash was equally clear, however, when a bomb went off in a Birmingham church on September 15, killing four black children.

To Lawrence, children meant family; family meant community. The future held uncertainties, and Lawrence was affected by such psychological tensions generated by the intense racism. In early 1964 Lawrence painted *The Family* (fig. 73), which represents an adult sitting at the end of a table facing the viewer, with two children on either side. They all bend over their plates. In the background hover two massive, cloaked figures; on the knobs of the chair backs are tiny, rounded, grimacing faces, like voudou charms. I asked Lawrence about the small demonlike faces and whether they held a connection to voudou, a folk religion practiced in the Brooklyn community in which the Lawrences then lived. Even today, in Caribbean communities, small hand-size cloth sculptures are used as personal amulets, to ward off evil and help one to control one's destiny. Lawrence seemed amused by the question and chuckled that perhaps they were part of his "racial memory." When pressed, he merely said that the picture related to the way he felt; it was "hard times" and he used the demons as a "symbol" of his subjective response. "They represent emotional intensity, hate. We are surrounded by it [hate]."[21] And yet the soaring plant stems with their bright green leaves and large red flower growing up from the large seeds placed at the bottom of the picture also symbolize Lawrence's enduring optimism and hope for the future.

Lawrence has never thought of himself as a political organizer, but because of his preeminence as an artist, particularly an African American artist, he was naturally called on to lend his name and support to groups raising funds for the civil rights

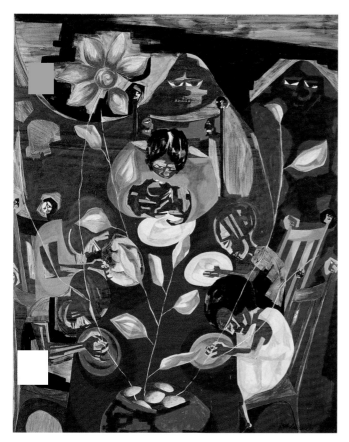

FIG. 73 *The Family*, 1964, egg tempera on hardboard,
24 × 20 in. Collection of Peggy and David Shiffrin.

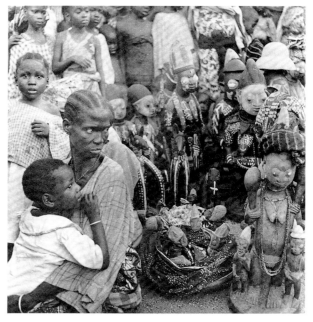

FIG. 74 *Festival of the Images, Ilobu,* in Ulli Beier, *Art in
Nigeria 1960* (Cambridge: Cambridge University Press, 1960).

movement. The magazine *Ebony*, in an article "Leading Negro Artists" (September 1963), stated that Lawrence "is hailed by many as the dean of current Negro painters."[22] Thus, Lawrence found himself in the fall of 1963 in the position of heading up an art committee to raise funds for SNCC. His friend Philip Evergood praised his work for SNCC, but perhaps the mounting pressure of events and the overwhelming responsibility of making a commitment to a cause that would take him away from his art making and his teaching led Lawrence to take stock and to plan a break from the numerous stressful situations.[23] With normal life disrupted by the civil rights tensions and the adventure of a previously planned African trip beckoning them, Lawrence and his wife, Gwendolyn Knight Lawrence, made arrangements to leave for Nigeria for an eight-month sojourn, from April to November 1964.

Lawrence had already briefly been in Africa. In late 1962, through an organization based in New York called the American Society of African Culture (AMSAC), Lawrence had been invited by the Mbari Artists' and Writers' Club Cultural Center to accompany an exhibition of his work to Nigeria. Lawrence himself selected part of *The Migration of the Negro* series for the tour, which was subsequently shown in both Lagos and Ibadan.[24] His

ten-day visit had opened his eyes to the visual spectacle of Nigeria and its creative arts (fig. 74). He returned to New York determined to plan a future, longer stay in Africa with his wife. At the time the State Department, working through the United States Information Agency, wanted artists to travel abroad as "ambassadors of good will" as part of the government's efforts in the cultural cold war with the Soviet Union.[25] Although the Lawrences were not part of an official mission, they sold their co-op apartment in Brooklyn and scheduled their trip abroad in the spring of 1964.

Because Lawrence and his wife were not sponsored by the State Department, they had to pay for their own travel and living expenses. In actual fact, the U.S. government made both the trip to Africa and their stay there difficult for them. Knight Lawrence was denied a visa and, because she was originally from Barbados, she had to invoke double citizenship to obtain a British passport. Once in Lagos, in April 1964, they were, in Knight Lawrence's words, "black-listed upon arrival, unable to secure housing, and under constant surveillance" by American government officials.[26] The contradictory responses from the U.S. officials in the early 1960s probably hinged on the fact that Lawrence had signed his name to petitions by organizations

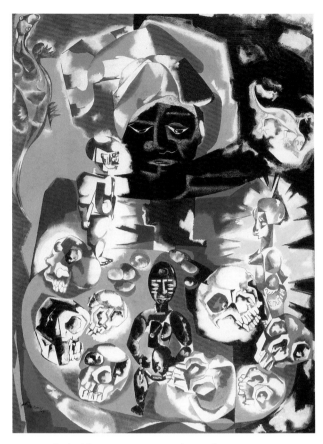

FIG. 75 *Antiquities*, 1964, tempera and gouache on paper, 30¾ × 22 in. The James E. Lewis Museum of Art, Morgan State University, Baltimore, Maryland.

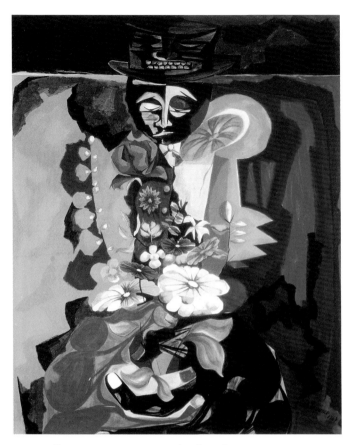

FIG. 76 *Clown*, 1963, egg tempera on hardboard, 24⁵⁄₁₆ × 20³⁄₁₆ in. The Newark Museum. Anonymous gift, 91.177.

considered subversive to the United States.[27] The Cuban missile crisis in the fall of 1962 had increased cold war tensions, and travel abroad was severely restricted. Moreover, many African Americans considered radical by the U.S. government, such as Malcolm X, had begun to travel to Africa, and the government was suspicious of their movements.[28]

The Lawrences, however, did finally set themselves up and found the Nigerian artists and civilians to be gracious hosts. Ulli Beier, a leading scholar on Nigerian art (see his *Art in Nigeria 1960*), introduced them to other artists and offered them the use of his house.[29] In Lagos, Lawrence gave informal weekly workshops to young Nigerian artists at the AMSAC center.[30] The government in one of its flipflops typical of the cold war period now encouraged the Lawrences to hold an exhibition of their work at the State Department's auditorium, following their exhibition at the Mbari Club in Lagos.[31] The work was also shown in Ibadan.

Lawrence produced at least eight tempera paintings and six drawings in Nigeria in 1964. Frequent motifs in Lawrence's paintings—skulls and statuettes of human forms—are repeated in one of the Nigerian paintings, *Antiquities* (fig. 75). It represents

a turbaned market woman presenting a tray of small African deities, amulets, and skulls. The frontality of the composition and the act of presentation recall *Clown* (fig. 76), a work Lawrence did before he left for Nigeria.

However, the majority of the Nigerian paintings, such as *Street to Mbari*, *Meat Market*, *Four Sheep*, and *Roosters*, emphasize the overall scene filled with objects typical of the marketplaces: vendors, purchasers, children, tables, foodstuffs, skulls, chickens, sheep, flies, roosters, statuettes, bolts of fabric, and the individual corrugated iron roofs of the stalls. The viewer is struck by the kaleidoscope of repetitive patterns that weave the elements together. Pattern has always been an important element in his compositions, as Lawrence explained in a 1968 interview: "I look around this room . . . and I see pattern. I don't see you. I see you as a form as it relates to your environment. I see that there's a plane, you see, I'm very conscious of these planes, patterns."[32] When asked in 1995 whether the patterns he saw in the marketplace were inspired by the African textiles he was seeing, Lawrence replied that his penchant to see pattern came from his earliest memories—of being conscious of patterns in his Harlem community.[33]

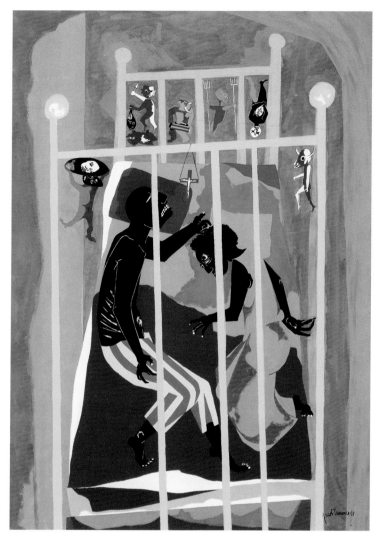

FIG. 77 *Dreams No. 1*, 1965, tempera and gouache on paper,
31 × 22½ in. New Britain Museum of American Art, New
Britain, Connecticut. Charles F. Smith Fund.

Back in the United States in late 1964, the Lawrences returned to the reality of the unfolding civil rights drama. During the time they had been in Africa riots had occurred in Harlem, Rochester, Jersey City, Paterson, Elizabeth, Philadelphia, and the Chicago suburb of Dirmor. As if the interlude in Africa had never happened, Lawrence made one painting, *Dreams No. 1* (fig. 77), that recalls those paintings of 1963. The painting represents a couple in a brass bed, on the rails of which hang small amulets of spirit forms and devils, visually related to voudou objects, but reminders of the nightmare of the riots that had occurred while the Lawrences were abroad. The painting relates directly to the iconographic and emotional intensity of *The Family*. The male figure in *Dreams No. 1* grits his teeth as he attempts to get some respite, but sleep cannot banish the small reminders of hate and bigotry that surround him.

In the few weeks before the Lawrences moved to the Boston area to begin Lawrence's visiting artist's appointment at Brandeis University, he began a series of large ink drawings with touches of red on the subject of the violent confrontations of the police with ordinary people, which he called *Struggle*. Executed in black and white, the drawings do not make clear the racial identity of either the police or their victims. Hence, oppression is not necessarily directed toward blacks only in such works as *Struggle II—Man on Horseback* (fig. 78), in which the mounted policeman beats down indiscriminately on the crowd of people. In *Struggle III—Assassination* (fig. 79) at least one of five figures is explicitly black—the crumpled-up man at the bottom of the pile. Violence continued to mark real life. On February 25, 1965, Malcolm X was assassinated—just about the time when the Lawrences were leaving the New York area. The month they arrived at Brandeis, March 1965, was the month of the march from Selma to Montgomery.

In 1965 the antiwar movement was also gaining momentum. Already in 1964 the War Resisters League had held a

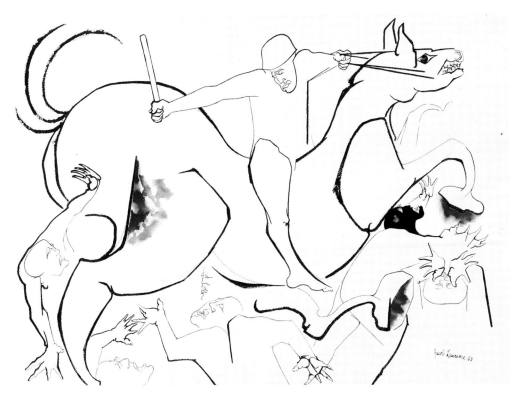

FIG. 78 *Struggle II—Man on Horseback*, 1965, brush and ink, and gouache on paper, 22¼ × 30¾ in. Seattle Art Museum. Gift of anonymous donors in honor of the Museum's fiftieth year.

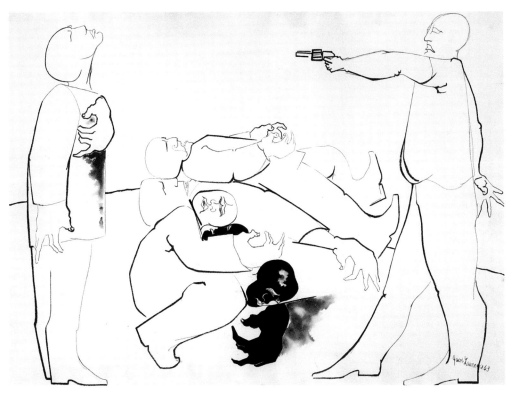

FIG. 79 *Struggle III—Assassination*, 1965, brush and ink, and gouache on paper, 22 × 30½ in. Collection of Jacob and Gwendolyn Knight Lawrence. Courtesy of Francine Seders Gallery, Seattle.

demonstration to protest the United States' military involvement in southeast Asia. Many New York artists friendly to Lawrence had also formed a group that called itself Artists and Writers Protest against the War in Vietnam.[34] It was clear that the escalation of the Vietnam War was underway. Although Lyndon B. Johnson won the presidential election in 1964 in part because a large segment of the citizenry rejected Republican candidate Barry Goldwater's "bomb Hanoi" rhetoric, Johnson himself was secretly planning such an offensive. The goals of the antiwar and the civil rights movements began to merge; both movements wanted the government to turn its attention to inequities and injustices on the home front. A drawing Lawrence did in 1965, *Struggle,* which shows one figure holding up his arms as a gesture of solidarity toward the other students who crowd the picture, thus resonates with both the civil rights and the antiwar movements.[35]

Events of the later years of Johnson's presidency—student protests against the war in Vietnam, the urban riots of 1966 and 1967, the assassination of Martin Luther King, Jr., the formation of such militant groups as the Black Panthers, and the demonstrations and arrests at the 1968 Democratic Party convention—kept up the pressure on artists of social conscience. Urban blacks demanded that colleges and universities incorporate black studies programs into their curricula. Artists and art students edged toward militancy, and books and articles appeared championing the new, militant black consciousness and the black power movement and analyzing the meaning of "black art" in contemporary society. Addison Gayle, Jr., writing the introduction to an anthology of essays, *The Black Aesthetic,* declared, "The serious black artist of today is at war with the American society as few have been throughout history."[36] Lawrence, however, did not feel himself at war with America. Like many others of his generation, he took the humanist view that men and women will endure and eventually conquer oppression.

Lawrence has recalled that the black students at Pratt Institute, where he had been teaching before his trip to Africa and to which he returned after Brandeis, often displayed antagonistically ambivalent feelings toward him. Lawrence was black, but as a teacher he also represented tradition and authority. In a 1982 interview Lawrence elaborated on his relationship with the black students:

> [T]hat was the time when all the black students would sit together in the cafeteria. If you didn't sit with these students, you were criticized, and if you did sit with the students, the attitude was "What are you doing here?" I had those kinds of problems, but they didn't bother me too much.
>
> Of course, I was a black but I was also in a position of authority, and those students were striking out in all directions. If you were seen as part of the Establishment, they didn't realize that your struggle had been as great as theirs. What I found is that you could accept the health of this rebellion intellectually, but emotionally you couldn't. You'd want to tell these people, "Look, I've been through some things, too, and so have the people before my generation, and they're the ones who made it possible for you to have this kind of protest."[37]

In a 1995 interview Lawrence elaborated on his view of the black students. He knew at the time that they were "very angry about our society" and was also aware that other black academics had not been sufficiently sensitive to the fact that black students wanted to address issues of racism and not just master academic disciplines.[38]

Most of these young black art students advocated separatism and black nationalism, while Lawrence believed that *the black experience* was inseparable from *the American experience.*[39] When questioned in 1968 by Carroll Greene, Jr., about his stand on these issues, Lawrence replied:

> I like to think I've expanded my interest to include not just the Negro theme but man generally and maybe if this speaks through the Negro I think this is valid also. . . . I would like to think of it as dealing with all people, the struggle of man to always better his condition and to move forward. . . . I think all people aspire, all people strive toward a better human condition, a better mental condition generally.[40]

And when Lawrence participated in a symposium held at the Metropolitan Museum of Art, along with black artists Romare Bearden, Sam Gilliam, Jr., Richard Hunt, Tom Lloyd, William Williams, and Hale Woodruff, he reiterated his beliefs that the struggles of African Americans had a universal significance.

The edited transcript of the symposium was published in the *Metropolitan Museum of Art Bulletin* at the time of the controversial exhibition *"Harlem on My Mind": The Cultural Capital of Black America*.[41] Lloyd, younger than the other artists and also a member of the Emergency Black Cultural Coalition, argued that black artists should create a "black art." Lawrence, with the concurrence of the other artists, argued that there is no "black art"—only "art," although artists may be black. As to his support for the civil rights movement, he said:

> I think you can relate in any number of ways, and the individual artist has to solve it in his own way. He may participate through the content of his work, or by donating [to civil rights fund-raising efforts] a piece that has no specifically relevant content. I know that we all relate to the civil rights movement, and we all make contributions. We give because we want to give. It's an obvious way of helping, not a spiritual one, but it's a way that has an immediate, definite benefit.[42]

Even if the stridency of the young radicals did not affect Lawrence, he did produce pictures that overtly made reference to the violence inherent in the struggle for freedom. In 1967 he returned to the life of Harriet Tubman and painted a set of pictures to illustrate a children's book, *Harriet and the Promised Land*. The individual tempera paintings were exhibited at Terry Dintenfass Inc. in January 1968 and reviewed by John Canaday for the *New York Times*. The critic called the exhibition "a soft-spoken show by any oratorical standard . . . superior to the 'protest' shows that, on several occasions last year, fell so embarrassingly flat. . . . I daresay that advocates of vehement statement will find these illustrations too gentle for their taste, but it was their reserve that attracted me."[43] The editors at Windmill Books, however, found at least one of the panels worrisome. They rejected for publication *Forward*, which shows Tubman carrying a gun as she pushes forward a man who appears to hesitate. The historical record indicates that once slaves had made the commitment to flee with Tubman, she would not allow them to turn back for fear of jeopardizing the whole group. Yet, as a whole, the new pictures on the theme of Tubman are lyrical and imaginative in both line and color, and wholly appropriate for a children's book.

Wounded Man (fig. 80) represents the effects of violence but indicates the determination to stay the course. A well-built young black man, partially obscured by the clapboards of a building, stands defiantly. Blood spurts from a chest wound, recalling the wound of Christ when his body was pierced by the centurion's spear while nailed on the cross at Calvary. Yet the tenseness of the black man's hands indicates his alertness and resistance. When composing the image in 1968, Lawrence may have recalled a poem by Claude McKay, "If We Must Die":

> If we must die, let it not be like hogs
> Hunted and penned in an inglorious spot,
> While round us bark the mad and hungry dogs,
> Making their mock at our accursed lot.
> If we must die, O let us nobly die,
> So that our precious blood may not be shed
> In vain; then even the monsters we defy
> Shall be constrained to honor us though dead!
>
> O kinsmen! we must meet the common foe!
> Though far outnumbered let us show us brave,
> And for their thousand blows deal one deathblow!
> What though before us lies the open grave?
> Like men we'll face the murderous, cowardly pack,
> Pressed to the wall, dying, but fighting back![44]

In his youth Lawrence admired McKay and would have known that McKay's poem spoke, not just about black people, but about all of oppressed humanity.[45] Lawrence used the wounded man image again in a black-and-white drawing that he contributed to *Freedomways*, a journal of opinion for the civil rights movement that vigorously spoke for integration rather than black nationalism.[46]

The "mad and hungry dogs" in McKay's poem and in Lawrence's 1963 painting *American Revolution* continued to function as a powerful symbol of the barbarism of the racists. The motif appears again in his 1975 print *Confrontation at the Bridge* that takes as its subject the 1955 civil rights march from Selma, Alabama, to Montgomery, some fifty miles.[47] Again and again the marchers were stopped at the Edmond Pettus Bridge just outside Selma. In *Confrontation* the dog is joined by menacing clouds with sharp points aimed at the crowd of people on the bridge. The people on the bridge, symbols of persistence and endurance, do not falter.

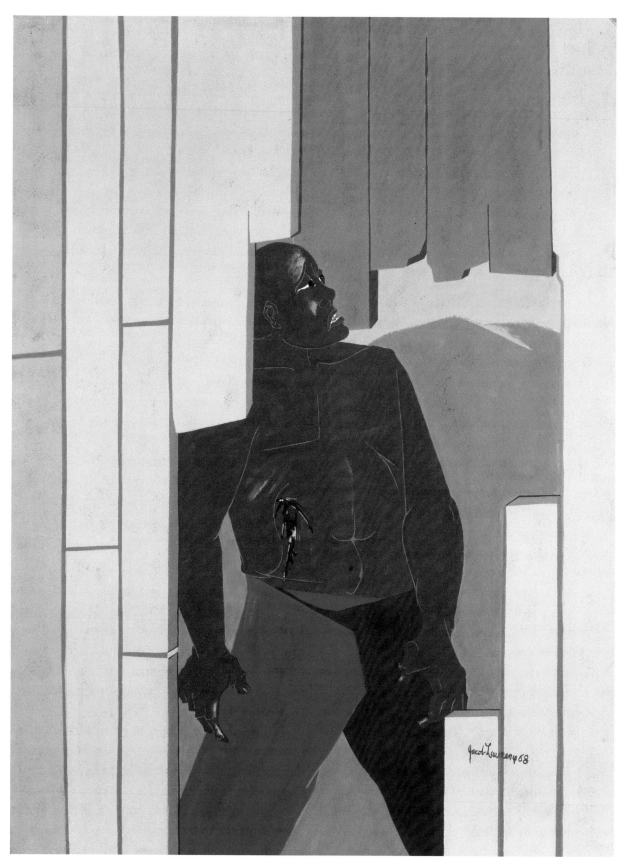

FIG. 80 *Wounded Man*, 1968, gouache on paper, 29½ × 22 in.
The Walter O. Evans Collection of African American Art.

In the summer of 1970 Lawrence was awarded the Spingarn Medal by the National Association for the Advancement of Colored People at a ceremony held in Cincinnati. Bayard Rustin, in presenting the award, delivered an address, "The Role of the Artist in the Freedom Struggle." Rustin made it clear that the concept of a "black art" did a "disservice to the artistic process":

> The black artist, whether or not he considers himself as such, is an essential member and a most important member of the freedom struggle. In saying this, I do not want to imply that the Negro artist should resemble in any way the social artist. The very concept of a social artist, an artist whose objective is to sell a cause or to sell a political party or even to sell Negroes, is a vulgarity and would be a misunderstanding of the nature of art and of the Negro struggle.

Rustin's point is that Lawrence differed from the "social artist" who made "protest art" as propaganda.[48] To Rustin, Lawrence was inside the struggle itself through his creative acts:

> What we have, therefore, is that the black artist is a part of the very struggle for justice and freedom by the fact that he paints or creates a poem because, by so doing, he is expressing the imaginative creativity and creation, and every time our recipient tonight paints a great picture, he automatically adorns the struggle.

Lawrence's art, to Rustin, is at one with other great art in that it "undergirds the movement and tends to create a consciousness amongst men." Rustin concluded by stating: "The black artist's role is to reveal to all the human core of the human experience as seen through the black experience. It is because Jacob Lawrence, with his beautiful canvases, has done precisely that, that we honor him."[49]

Lawrence responded by acknowledging that any "degree of success as a creative artist" that he had achieved was "mainly due to that black experience which is our heritage—an experience which gives inspiration, motivation, and stimulation."[50] Lawrence has consistently and repeatedly given verbal expression to these thoughts over the decades since then. He never forgets the "encouragement which came from the black community"—to convert the black experience into the human experience and in so doing to create a consciousness of all people's struggles for a better life.[51] Moreover, Lawrence always insists that his pictures are not "protest paintings." When invited to the White House in 1980 by President Jimmy Carter to be honored for painting pictures protesting racism, he declined and told a reporter: "I never use the term 'protest' in connection with my paintings. They just deal with the social scene. . . . They're how I feel about things."[52]

Indeed, throughout these years of protest, Lawrence painted many other pictures—of people studying in libraries, socializing in pool halls, and having social interchanges on the streets and stoops of New York, such as *Brooklyn Stoop* (1967; see p. 237, fig. 108), which shows a black child playing with her dolls and a white child. In 1968 he had already begun another set of pictures on the theme of builders—black and white workers erecting buildings together—a potent symbol of integration.[53] Like the West African griots, the storytellers who keep the histories of their communities vivid to future generations through the oral retelling of events, Lawrence aims to tell the story of working people's lives—their work, their struggles against oppression, their small pleasures, and their private moments—as he has known and observed them through the decades.[54] This remains the creative goal of Jacob Lawrence and his contribution to both our history and our art.

NOTES

This essay is dedicated to the memory of Nathan Irvin Huggins (1927–1989), whom I first met when I was a fellow at the Charles Warren Center at Harvard University during 1982–3 and he was director of the W. E. B. Du Bois Institute at Harvard. Long ago he read my earliest drafts on Lawrence's life and work and encouraged me in my studies of African American artists. I am also grateful to Henry Louis Gates, Jr., the current director of the W. E. B. Du Bois Institute, and Richard Newman, fellows officer at the W. E. B. Du Bois Institute. I want to thank the other authors of this volume for offering suggestions, and Michelle DuBois and Peter Nesbett for providing me with research materials in the files of the Jacob Lawrence Catalogue Raisonné Project and for continual support. Stephanie L. Taylor tracked down some obscure references for me, and Judy Throm continues to be extraordinarily helpful at the Washington, D.C., warehouse of the Archives of American Art. I want to thank Fronia W. Simpson for suggesting several deft sentences and for her superb editing. As always, I am grateful to Kevin Whitfield for reading the manuscript with care.

1. For brief histories of the Birmingham events of 1963, see Steven Kasher, *The Civil Rights Movement: A Photographic History, 1954–1968* (New York: Abbeville Press, 1996), pp. 88–113; Anthony Lewis and *The New York Times*, *Portrait of a Decade: The Second American Revolution* (New York: Random House, 1964), pp. 175–89; and Juan Williams, *Eyes on the Prize: America's Civil Rights Years, 1954–1965* (New York: Penguin Books, 1988), pp. 181–95.

2. Kasher, *The Civil Rights Movement*, p. 95.

3. Howard Zinn, *A People's History of the United States* (New York: Harper and Row, 1980), p. 447. Zinn's account of the civil rights movement is succinct and based on firsthand experience. Charles Moore's photographs of the attacks by police dogs and fire hoses were published in *Life* 54, 20 (May 17, 1963), pp. 26–36.

4. Speaking to Paul J. Karlstrom in November 1998, Lawrence recalled that he was not surprised or shocked by the events in the life of Bigger Thomas, Richard Wright's protagonist in his novel *Native Son* (1940): "it reinforced that condition which we existed [in] or we perceived to exist. . . . It's like saying, 'See? I told you so. There it is.'" See Jacob Lawrence and Gwendolyn Knight Lawrence, transcript of tape-recorded interview by Paul J. Karlstrom, November 18, 1998, Archives of American Art, Smithsonian Institution, Washington, D.C. (hereafter AAA), p. 66.

5. For a vivid description and analysis of ordinary African Americans defying the segregated buses, see Robin D. G. Kelley, *Race Rebels* (New York: The Free Press, 1996).

6. Since 1953 Lawrence had been showing at the Alan Gallery, run by Charles Alan, a former employee at Edith Halpert's Downtown Gallery, who, in arrangement with Halpert, had taken the younger Downtown artists to start his own gallery. Lawrence did not like the financial arrangements with Alan, however, and transferred to Dintenfass. See quotation from Lawrence on these reasons in Ellen Harkins Wheat, *Jacob Lawrence: American Painter*, exh. cat. (Seattle and London: University of Washington Press in association with the Seattle Art Museum, 1986), p. 108, based on Wheat's interviews of July 24, 1984, and May 3, 1985. Wheat's book remains the major monographic study of the artist.

7. See Lewis and *The New York Times*, *Portrait of a Decade*, pp. 214–24.

8. V[ivien] R[aynor], "In the Galleries," *Arts* 37, 9 (May 1963), p. 112.

9. *Four Students* had been shown at an Alan Gallery exhibition, September 12–30, 1961.

10. See Donald Attwater, *The Penguin Dictionary of Saints* (Baltimore: Penguin Books, 1965), p. 304. Sebastian's history is apparently not fully known. He had been an officer in the imperial guard in Rome. When his wounds were miraculously healed, Diocletian ordered him to be beaten to death, from which he did not recover.

11. See Lewis and *The New York Times*, *Portrait of a Decade*, pp. 46–69.

12. In her study of Norman Rockwell, the popular culture historian Karal Ann Marling brings to light the fact that Rockwell was deeply moved by the civil rights movement. When asked by the editors of *Look* to paint an illustration to accompany articles addressing "The Problem We All Live With," for the January 14, 1964, issue, he painted an African American girl accompanied by U.S. marshals. According to Marling, Rockwell was influenced by accounts of psychological studies on the effects of racism on black children. In his famous doll experiment, conducted in Clarendon County, South Carolina, the black psychologist Kenneth Clark gave black children both white and black dolls; the children rejected the black dolls in favor of the "good" white dolls. This evidence was used by the plaintiffs to argue the need for desegregation in the Supreme Court case *Brown v. Board of Education of Topeka*. Robert Coles, the Harvard child psychiatrist, also studied the effects of racial tauntings on six-year-old Ruby Bridges, who had integrated the New Orleans school system in 1960. Coles published his preliminary findings in 1963, in *The Desegregation of Southern Schools: A Psychiatric Study*. Marling maintains that Rockwell had little Ruby in mind when he conceived the picture in 1964. See Karal Ann Marling, *Norman Rockwell* (New York: Harry N. Abrams, 1997), pp. 135, 140–1.

13. See W. E. B. Du Bois, *The Souls of Black Folk*, introduction by Henry Louis Gates, Jr. (1903; reprint, New York: Bantam Books, 1989), p. 2.

14. Jacob Lawrence and Gwendolyn Knight Lawrence, tape-recorded interview by author, April 19, 1995; Lawrence admitted "Alice" was from Carroll's story.

15. "Art: Black Mirror," *Newsweek* 61, 5, April 15, 1963, p. 100.

16. Lawrence and Knight Lawrence, interview by author, April 19, 1995.

17. Brief comment following the caption for *American Revolution*, *Motive* 24, 1 (October 1963), cover. The issue was devoted to the arts and consisted of poetry, fiction, articles on art and topics of general interest, and book and movie reviews.

18. Lewis and *The New York Times*, *Portrait of a Decade*, p. 14.

19. The science of gathering statistics on crowds was not very precise. Kasher, *The Civil Rights Movement*, p. 118, states: "Estimates of the crowd size range from 200,000 to 500,000. It was unquestionably the largest political demonstration in the United States to date."

20. Ibid., p. 116.

21. Jacob Lawrence and Gwendolyn Knight Lawrence, tape-recorded interview by author, April 20, 1995.

22. "Leading Negro Artists: Talent Breaks Bias Band," *Ebony* 18, 11 (Special Issue) (September 1963), p. 131.

23. Lawrence's involvement with the civil rights movement prompted Philip Evergood to write him on October 21, 1963: "You are doing a wonderful job heading the Artists Committee of Snick [sic] [SNCC]," Jacob Lawrence Archives, The George Arents Research Library, Syracuse University Libraries, New York.

24. Lawrence and Knight Lawrence, interview by author, April 19, 1995. See also Wheat, *Jacob Lawrence: American Painter*, pp. 107–8.

25. In the United States, the organization was called USIA (United States Information Agency), but overseas it was called USIS (United States Information Service). The author found herself in the situation of working for the U.S. cold war effort when USIA sent her on a two-week tour to lecture on American art in the spring of 1974.

26. Gwendolyn Knight Lawrence observed, in Jacob Lawrence and Gwendolyn Knight Lawrence, transcript of tape-recorded interview by Michelle DuBois and Peter Nesbett, June 7, 1999, pp. 8 and 9: "We went on our own. We paid our own way to go, and we paid our own living expenses, but still they wanted control over our coming and going, they wanted to keep an eye out. . . . When we arrived it was really a hostile environment until I threatened them with filing a suit with the ACLS [sic; American Civil Liberties Union]." When DuBois pressed the Lawrences to describe the hostility, Knight Lawrence replied, "We could not get any services, we could not find a place to live, it was terrible. And the Africans were hostile to us and I think they were going along with the CIA because they were afraid of them, I guess." The Lawrences threatened to sue the U.S. government and eventually got the U.S. officials to relax their restrictions against them. Through businessmen friends, they were able to find housing.

27. This is Knight Lawrence's speculation; see ibid.

28. Elizabeth Catlett, living in Mexico in the mid-1950s, also found herself harassed by U.S. officials; Elizabeth Catlett, tape-recorded interview by author, June 3, 1995.

29. Ulli Beier, Art in Nigeria 1960 (Cambridge, Mass.: Harvard University Press, in collaboration with the Information Division Ministry of Home Affairs, Ibadan, Nigeria, 1960). Beier, in a September 14, 1964 letter to the Lawrences, offered them the use of the top floor of his house in Oshogbo; see Jacob Lawrence Papers, roll D-286, AAA.

30. "Artist Extraordinary," Interlink: The Nigerian American Quarterly Newsletter 2 (July 1964), p. 6; Jacob Lawrence Papers (not microfilmed), Box 4, Printed Material, AAA.

31. See letter of September 28, 1964, on the stationery of USIS, Lagos, to Lawrence; Jacob Lawrence Papers, roll D-286, frame 42, AAA. In 1965 USIA printed a special issue of its publication, Topic (no. 5), focused on "The Negro in the American Arts," which featured Lawrence; see unfilmed papers of Jacob Lawrence, Box 4, Printed Material, AAA.

32. Jacob Lawrence, transcript of tape-recorded interview by A. Jacobowitz, in "Listening to Pictures" program of the Brooklyn Museum, 1968, p. 15; Jacob Lawrence Papers, AAA, Gift of the Brooklyn Museum. I have corrected "plain" in the transcript to "plane," which the word plainly is.

33. Lawrence and Knight Lawrence, interview by author, April 19, 1995.

34. See Lucy R. Lippard, A Different War: Vietnam in Art, exh. cat., Whatcom Museum of History and Art (Seattle: The Real Comet Press, 1990), p. 12.

35. Lawrence received a major honor from the cultural world when he was inducted into the prestigious National Institute of Arts and Letters on May 19, 1965. His friend Ben Shahn gave a moving nomination speech, and other artists paid tribute to Lawrence through their congratulatory wishes and letters. After Lawrence wrapped up his visiting artist responsibilities at Brandeis, he and his wife moved back to New York—this time to West 106th Street. Philip Evergood wrote Lawrence on February 5, 1965, saying he was glad of the election and added: "[T]he Institute needs more painters with some guts and imagination. Shahn wrote a beautiful tribute to you I thought, when he proposed you"; Philip Evergood Papers, roll D-286, frame 55, AAA.

36. Addison Gayle, Jr., introduction to Gayle, The Black Aesthetic (Garden City, N.Y.: Doubleday and Company, 1971), pp. xvii–xviii.

37. Quoted in Jane Van Cleve, "The Human Views of Jacob Lawrence," Stepping Out Northwest 12 (winter 1982), pp. 33–7; quoted in Wheat, Jacob Lawrence: American Painter, p. 113. Lawrence reiterated this story to the author on April 20, 1995.

38. Lawrence and Knight Lawrence, interview by author, April 20, 1995. At this interview Knight Lawrence pointed out that the students at California State College, in Hayward, where Lawrence was visiting artist from September 1969 to March 1970, were even more militant because of the influence of the Black Panthers, whose headquarters were in Oakland, California.

It was characteristic of the times for black students to reject traditional techniques and research methods because such learning came from the middle-class white establishment and thus did not seem "relevant" to issues of racism. See Edward J. Barnes, "The Black Community and Black Students in White Colleges and Universities," in Black Students in White Schools, ed. Edgar A. Epps, National Society for the Study of Education, series on Contemporary Educational Issues, Kenneth J. Rehage, series ed. (Worthington, Ohio: Charles A. Jones Publishing Company, 1972), pp. 60–73.

39. The range of viewpoints can be found in Samella Lewis and Ruth G. Waddy, Black Artists on Art (Los Angeles: Contemporary Crafts Publishers, 1969), vol. 1.

40. See Jacob Lawrence, transcript of tape-recorded interview by Carroll Greene, Jr., October 26, 1968, AAA.

41. "The Black Artist in America: A Symposium," The Metropolitan Museum of Art Bulletin 27, 5 (January 1969), pp. 245–60. The actual date of the symposium was not noted in the bulletin.

42. Ibid., p. 259.

43. John Canaday, "The Quiet Anger of Jacob Lawrence," New York Times, January 6, 1968, p. 25.

44. According to Nathan Irvin Huggins, Harlem Renaissance (London, Oxford and New York: Oxford University Press, 1971), p. 313 n. 10, McKay first published his poem in Max Eastman's Liberator 2 (July 1919), p. 21, and it later appeared in Messenger 2 (September 1919), p. 4, and in McKay, Harlem Shadows (New York: Harcourt, Brace and World, 1922), p. 53. Huggins quotes the poem on p. 71.

45. Huggins, Harlem Renaissance, p. 72. McKay inscribed one of his books, A Long Way from Home (New York: Lee Fuhrman, 1937), to Lawrence. The inscription read, according to Lawrence's recollection: "For Jacob Lawrence, a peerless delineator of the Harlem scenes and types." See Lawrence and Knight Lawrence, interview by Karlstrom, p. 13.

46. Freedomways 9, 1 (winter 1969), cover.

47. Lawrence painted Confrontation at the Bridge when he was commissioned by Transworld Art, New York, to design an image to be included in one of three portfolios to accompany the ten-volume project An American Portrait, 1776–1976: see Peter Nesbett, Jacob Lawrence: Thirty Years of Prints (1963–1993): A Catalogue Raisonné (Seattle: Francine Seders Gallery, 1994), p. 32.

48. One needs to recall that W. E. B. Du Bois, a previous editor of Crisis, defended "propaganda" at the service of fighting racism.

49. These excerpts are from Bayard Rustin, "The Role of the Artist in the Freedom Struggle," Crisis 77, 7 (August–September 1970), pp. 260–3.

50. Jacob Lawrence, "The Artist Responds," Crisis 77, 7 (August–September 1970), p. 267.

51. Ibid.

52. Quoted by Stan Nast, "Painter Lawrence Is Honored for a 'Protest' That Was Life," Seattle Post-Intelligencer, April 5, 1980; quoted in Wheat, Jacob Lawrence: American Painter, p. 114.

53. These were brought together in an exhibition, Builders, held at Terry Dintenfass Inc., October 16–November 3, 1973.

54. For an elaboration of the griot analogy, see Patricia Hills, "Jacob Lawrence as Pictorial Griot: The Harriet Tubman Series," American Art 7, 1 (winter 1993), pp. 40–59. See Lawrence and Knight Lawrence, interview by Karlstrom, pp. 38–41, in which Lawrence concurs with the griot designation.

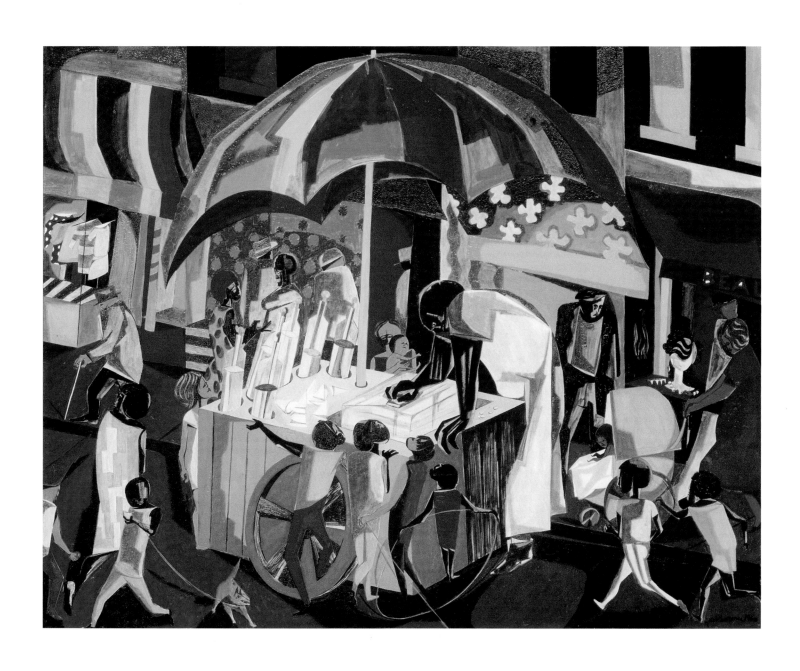

PL. 67 *Ices I,* 1960, egg tempera on hardboard,
24 × 30 in. The Walter O. Evans Collection
of African American Art.

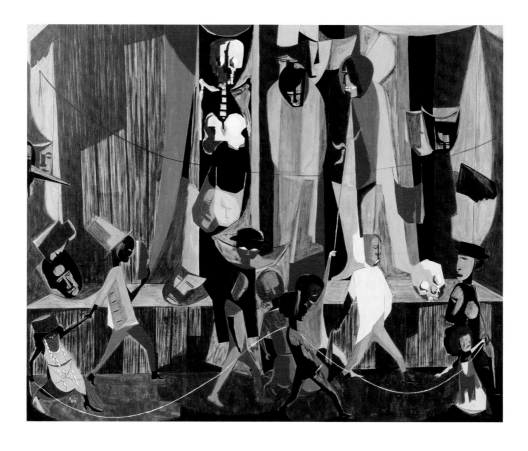

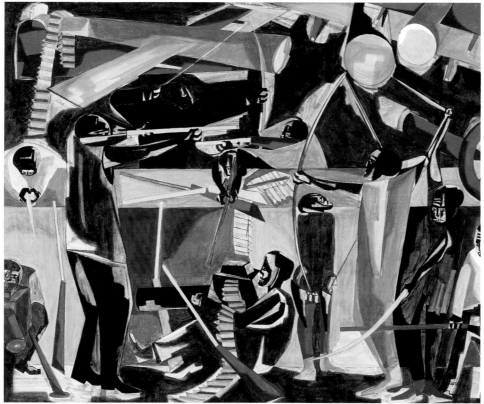

PL. 68 *All Hallow's Eve,* 1960, egg tempera on hardboard, 24 × 30 in. Collection of Ann and Walter Nathan, Chicago.

PL. 69 *Playthings,* 1961, egg tempera on hardboard, 16 × 20 in. Collection of Jules and Connie Kay.

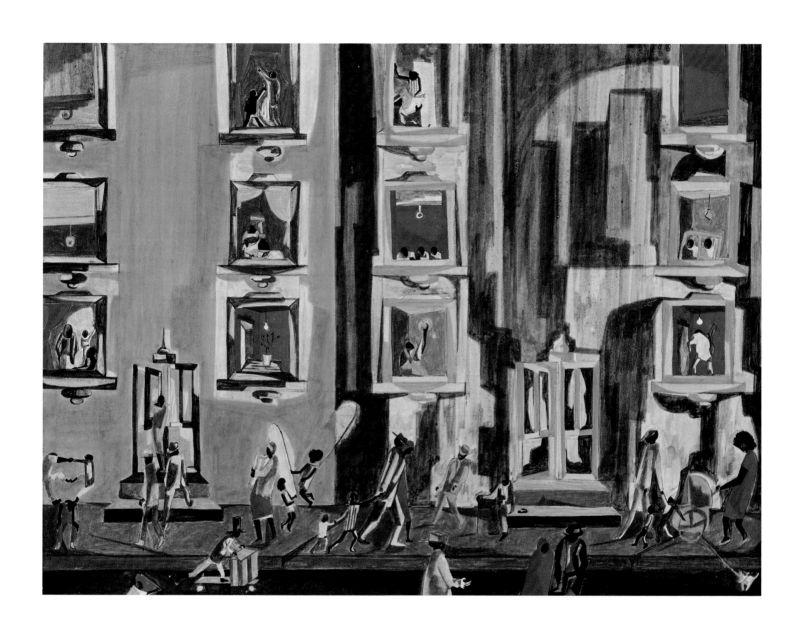

PL. 70 *Street Scene,* 1961, egg tempera on hardboard,
12 × 16 in. Private collection.

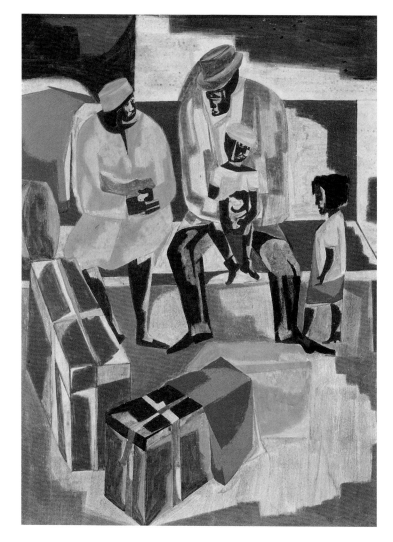

PL. 71 *The Travelers,* 1961, egg tempera on hardboard, 11½ × 8½ in. Collection of Professor and Mrs. David C. Driskell.

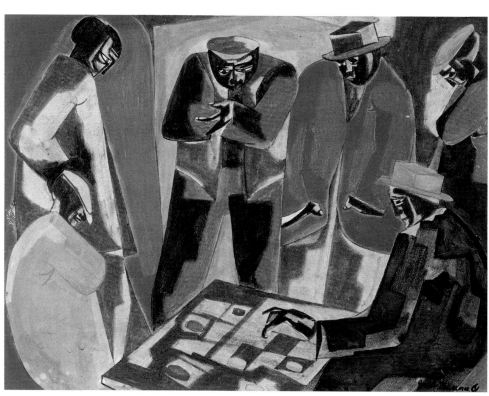

PL. 72 *Untitled [The Checker Players],* 1961, egg tempera on hardboard, 8¾ × 11⅝ in. Collection of Elizabeth and Steven Roose, Scarsdale, New York.

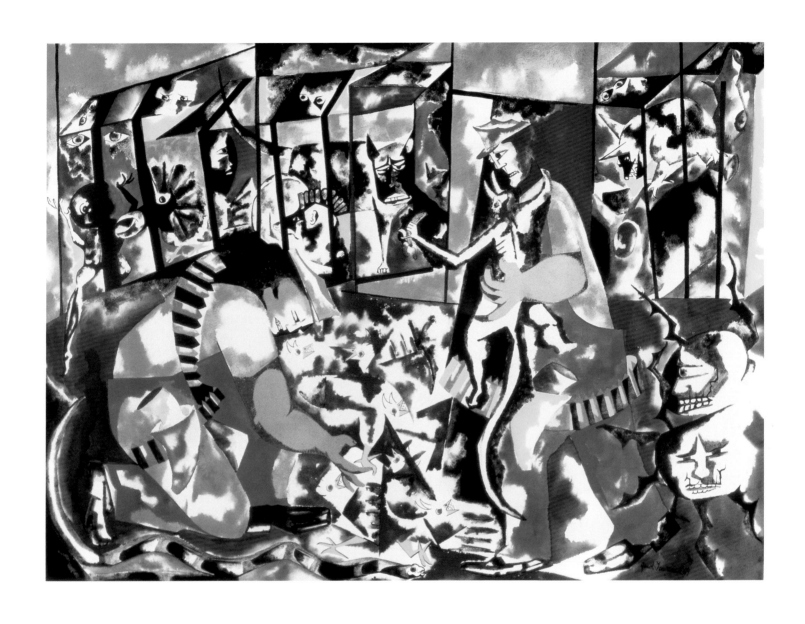

PL. 73 *Menagerie,* 1964, watercolor and gouache
on paper, 21½ × 30¼ in. Collection of
Emmanuel Schilling.

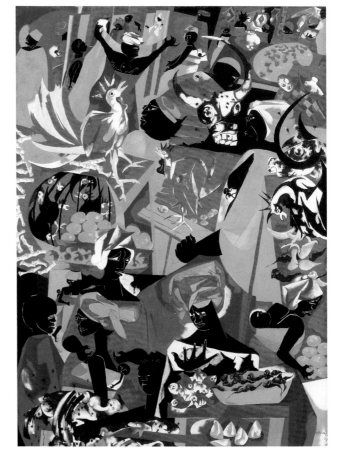

PL. 74 *Roosters,* 1964, tempera and gouache on paper, 30¾ × 22 in. Collection of Mr. and Mrs. Sherle Wagner.

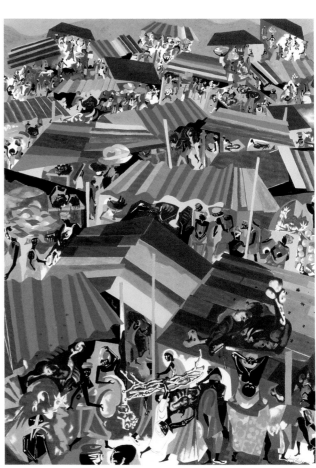

PL. 75 *Meat Market,* 1964, tempera and gouache on paper, 30¾ × 22 in. Collection of Judith Golden, New York.

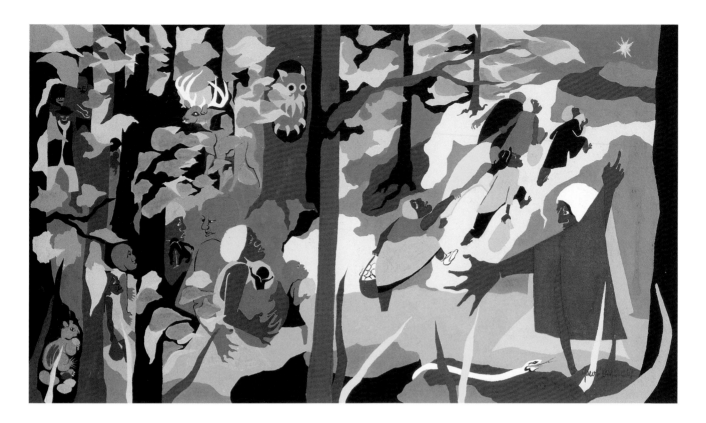

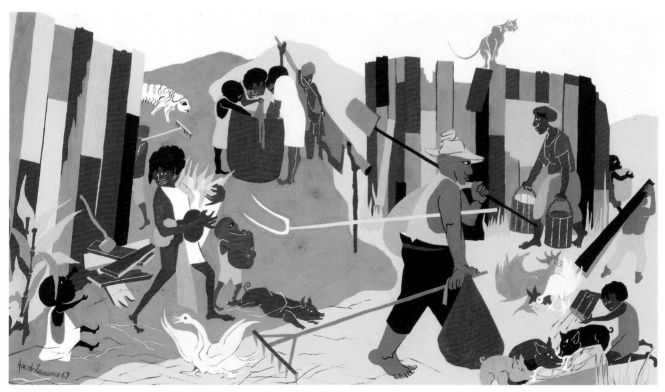

PL. 76 *Harriet and the Promised Land, No. 10: Through Forests, Through Rivers, Up Mountains,* 1967, gouache and tempera on paper, 15⅝ × 26¾ in. Hirshhorn Museum and Sculpture Garden, Smithsonian Institution. Bequest of Joseph H. Hirshhorn, 1986.

PL. 77 *Rural Scene,* 1967, tempera and gouache on paper, image: 14½ × 25¾ in. The Thompson Collection.

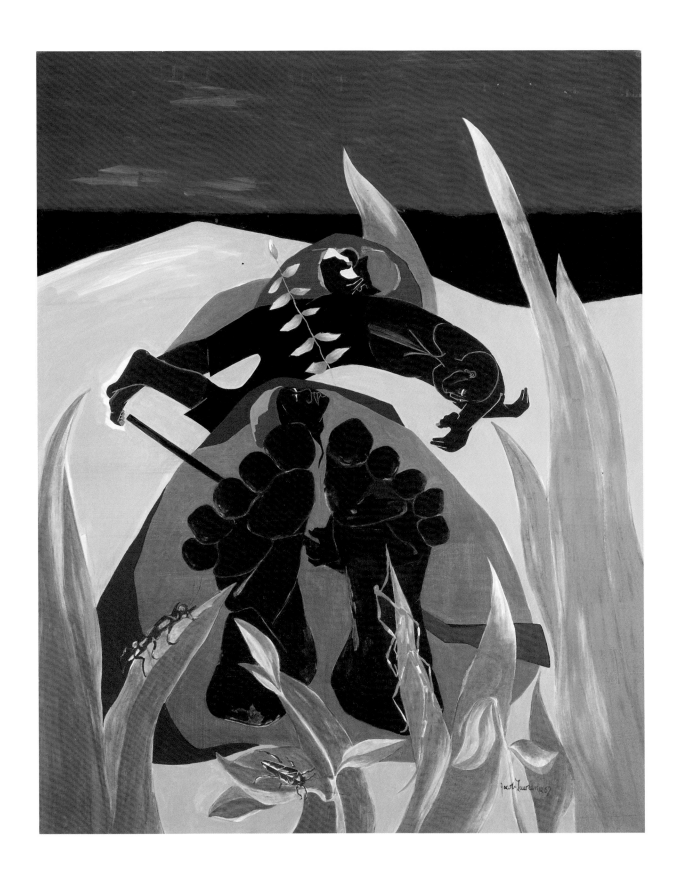

PL. 78 *Daybreak—A Time to Rest,* 1967, egg tempera
on hardboard, 31⅞ × 24⅞ in. National Gallery
of Art, Washington, D.C. Anonymous gift,
1973.8.1.

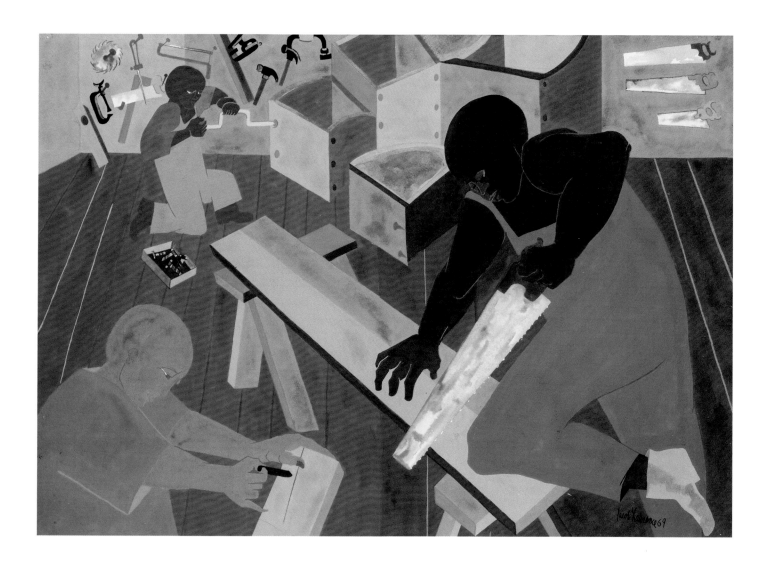

FIG. 81 *Builders No. 1*, 1969, gouache and tempera on paper, 22 × 30½ in. Collection of Ann and James Harithas.

Lowery Stokes Sims

The Structure of Narrative

FORM AND CONTENT IN JACOB LAWRENCE'S BUILDERS PAINTINGS, 1946–1998

I'VE ALWAYS BEEN INVOLVED WITH CONTENT . . . and form, I think form is just as important [as content]."[1] This statement by Jacob Lawrence from a 1968 interview poses a caveat to writers and critics of his work who inevitably focus on his subject matter. This is, however, understandable. Lawrence is foremost a storyteller, and, as if to emphasize this fact, he obliged us with texts for his early historical narratives on Frederick Douglass, Harriet Tubman, John Brown, *The Migration of the Negro, War,* and *Struggle . . . From the History of the American People* series, the last his version of the history of the United States. But while Lawrence has always been adamant about the content of his work, he has been equally adamant about the nature of the style with which it is presented. While this aspect of his work has been remarked on in the Lawrence literature, a more extensive explication of the sources and conceptualization of form in Lawrence's work has yet to have been done. This essay proposes to make a first attempt at this task, drawing on important statements and observations made by Lawrence over the course of his career.

Early on Lawrence used simplified forms and forthright color to highlight rhythmic patterns and draw attention to the abstraction and formal invention in his work. The particular sophistication of Lawrence's abstracted forms has always intrigued writers and critics who sought to pinpoint the origins of these elements. Yet because Lawrence defies the expected trajectory of vanguardist careers, these critical efforts have often been stymied. He was not associated with any vanguard circles during his early gestation as an artist, and his only artistic training occurred in the heart of the Harlem community. (See the essays by Leslie King-Hammond and Elizabeth Hutton Turner in this volume.) Lawrence was therefore first perceived as a remarkable autodidact who lacked the benefits of academic training. Henry McBride, writing in the *New York Sun,* offered a decidedly "primitivist" reading, noting that Lawrence's work exemplified "the Negro's instinct for rhythms and love for crude brilliant colors."[2] James Porter included Lawrence in his chapter "Naïve and Popular Painters" in his 1943 *Modern Negro Art.* Porter's observation that Lawrence worked in "two-dimensional patterns" making "little use of perspective," composing his pictures "more like children's illustrations than conventional adult paintings,"[3] highlighted modern art's appreciation of and appropriation of children's art, tribal art, and so-called folk or self-taught art to create alternatives to the academic tenets of Western art. It also demonstrated how formal conventions associated with those "alternative" art forms can be confused with their adaptations in modernist art.

Cubism is the stylistic paradigm most frequently brought to bear on Lawrence's work. By the time Lawrence was finding his artistic way, however, the term *cubist* had come to include a range of reductive strategies in terms of both form and space. Charles Alan astutely recognized the difference between classical French Cubism—characterized by stacked-block forms and shifted planes—and the flat shapes, articulated anatomies, and patternistic tendencies in Lawrence's work, which were more typical of the work of Henri Matisse or such late cubist compositions by Picasso as the 1921 *Three Musicians* (Philadelphia Museum of Art). But, writing before the postmodernist revision of the history of Cubism, Alan shortsightedly defined that difference as art-for-life's sake versus art-for-art's sake, postulating that the cubists were "almost exclusively concerned with the formal aspects of space and volume," while Lawrence was "primarily preoccupied with his subject matter."[4] In 1986 Patricia Hills

characterized Lawrence's work as "expressive cubism," comparing his work with that of Ben Shahn and Picasso as examples of artists who use "cubism as a vehicle for important social commentary."[5] The contemporary African American figural painter Robert Colescott would echo such sentiments in 1997, noting: "Cubism, the multiple realities created by geometry, is itself a theory in service of a two-dimensional art form. It affords us an experience in both time and place. Why not apply these techniques to the exploration of a contemporary complaint?"[6]

Alan says that Lawrence himself has observed that "the only real influence on his early work—and those were slight—were the Mexicans—chiefly Orozco whom he went to watch paint the New School murals."[7] The artist furthermore has noted that if he had been influenced by Cubism it would more likely have occurred through his exposure to African art. This makes sense within the context of the African American art community. In 1925 its chief magus, Alain Locke, exhorted African American artists to find a sense of "classic background," "discipline," "style," and "technical control" in their study of African art. "The African spirit," Locke wrote, "is at its best in abstract decorative forms."[8] Like several of his contemporaries—notably Norman Lewis and Romare Bearden—Lawrence was acquainted with "Professor" Charles Christopher Seifert, who introduced young Harlemites to African art. He saw the landmark 1935 exhibition of African art at the Museum of Modern Art with Seifert[9] and remembers that at the time: "Everybody was discovering African Art . . . [because of] . . . the Cubist influence and Picasso . . . Gris . . . and Braque."[10] Lawrence's wife, Gwendolyn Knight Lawrence, had also been exposed to African art as a student of James Porter at Howard University. She remembers, "we all . . . knew about Picasso, but . . . we thought about Picasso in terms of African sculpture."[11]

If Lawrence's work evidenced, in the words of Jeffrey Stewart, a "use of African design principles and ornamentation to create surface tensions,"[12] it is as much in his rendering of the proportions of the body as it is in the patterning in his work. As Lawrence observed to Avis Berman, his concern with proportion was always predicated on how it served the overall needs of his composition: "There are two kinds of proportion . . . natural proportion and artistic proportion . . . you want to consider the whole painting. . . . [I]s it the right proportion for that particular painting?"[13] Parallels to the conventions of African sculpture can be found in the lively facial articulation, strong torsos, and superattenuated arms, hands, and feet of Lawrence's figures. But he additionally moved beyond African sculpture's frontal formality to settle his figures into intensely articulated body postures to perform the task at hand.

Lawrence also revealed his interest in more expressionistic modes (especially as seen in the work of Käthe Kollwitz) in a 1998 interview with Paul J. Karlstrom.[14] His practical adaptations of the modalities of both Cubism and Expressionism are reflected in his appreciation of the work of Arthur Dove,[15] John Marin, Jacob Epstein, and Amedeo Modigliani.[16] Lawrence also singled out Aaron Douglas's 1934 murals, Aspects of Negro Life, at the Countee Cullen branch of the New York Public Library, in which the elegant, flatly articulated shapes certainly resonated with Lawrence's own art.[17] Having often noted the influence of theatrical sets on his compositions, Lawrence and Knight Lawrence also discussed with Karlstrom the influence of expressionist currents in Russian and German film on Lawrence's work. But, ultimately, Lawrence would attribute the development of abstraction in his work directly to his experiences in and observations of Harlem.

For Charles Alan he recalled the impact of the sights and sounds of Harlem when he first arrived there in 1930: the "endlessly fascinating patterns" of "cast-iron fire escapes and their shadows created across the brick walls." He remarked on the "variegated colors and shapes of pieces of laundry on lines stretched across the back yards . . . the patterns of letters on the huge billboards and the electric signs," the weekend and holiday parades organized by "all sorts of religious and fraternal organizations—the marchers wearing resplendent uniforms of all colors and lavishly trimmed with gold."[18] Learning to draw and color under the tutelage of Charles Alston at the Works Progress Administration (WPA) Harlem Art Workshop Lawrence again drew on this environment: "the . . . brightly colored 'Oriental' rugs covering the floors at home . . . their configurations and their repetitions, in their geometry, and the diversity of their colors."[19] Lawrence reminisced to Karlstrom that "people of my mother's generation would decorate their homes in all sorts of color. . . . So you'd think in terms of Matisse."[20] And Leslie King-Hammond reminds us that Lawrence also learned block printing on fabric from Sarah West at the workshop.[21] All of these experiences would have instructed Lawrence in the method of

simplifying form and becoming conscious of the visual potential for rhythmic repetition, and he would gradually become "aware of similar patterns in the cityscape around him."[22] He would even ascribe his use of gouache to his environment, noting that its physical qualities complement the "hard, bright, brittle" aspects of Harlem during the depression.[23]

For Charles Alan this awareness of the abstraction inherent in life allowed Lawrence to avoid the pitfalls of illustrative sentimentality and literalness that has daunted other contemporary artists working in narrative painting.[24] In an interview with Carroll Greene, Jr., in 1968 Lawrence noted that "[t]he content can be … figurative … or non-figurative. … [I]f you see … things only for what they are the chances are that you will become more illustrative and you will never develop from this."[25] He explained to A. Jacobowitz in 1968 that his use of "repetitive form" was "a part of … building the composition, the design, creating a certain tension. … [I]t's part of the structure, part of the building of the painting, part of the composition. [T]his is the way … I was told about design and composition, somehow this may have stuck with me and I developed it.[26] Certainly Lawrence's interest in math contributed to his special feeling for the rhythm and pattern that exists even in the more chaotic facets of life.[27] If critics tended to read this will to abstract form as a means to "remove it from the human experience," to suppress the impact of the subject matter, Lawrence would emphatically declare the importance of content in his work: "I'm very conscious of design and I realize if I want to say something, if I want to make some sort of statement that the forms must be equally as … resolved. … I have to be involved in form as well as content. … I don't think … you can pull, fragment the two things, after a while I think they become one."[28]

In this context it is important to note that while Lawrence, when pressed, would acquiesce to the label of "social realist"[29] he was keenly aware that his work was distinct from that of like-minded artists of his generation. For example, unlike Charles White and Elizabeth Catlett, he eschewed overt political polemic.[30] Unlike Reginald Marsh, he "never draws on the scene … never [goes] out with a sketch pad." His work is "all in [his] mind," and, as he said to Jacobowitz: "A scene doesn't inspire me as such. … It's the idea. … This is my content."[31] "More than just a reporter or an observer," he sees himself as a "critic," a term he considers as having "a broader meaning."[32] Following this logic

he described his work to Charles Alan as "reality rather than realism," and more "symbolic than meticulously descriptive."[33] "My work," he said, "is abstract in the sense of having been designed and composed, but it is not abstract in the sense of having no human content."[34]

Such characteristics are particularly evident in the builders paintings—a theme that has appeared in his work over the last fifty years starting in the mid-1940s (fig. 81).[35] Starting with *Cabinet Makers* (fig. 82), *The Builders* (fig. 83), and the single-figured *Cabinet Maker* (fig. 84), the paintings show men (and later women, white and black) hammering, sawing, planing, assembling, and installing planks of wood that literally transverse the compositions horizontally, vertically, and diagonally, effectively building the paintings before our eyes. The inspiration for the builders paintings was Lawrence's association with the Bates brothers, cabinetmakers in Harlem who were "close to the arts" and also worked at the WPA Harlem Art Workshop.[36] The prosaic nature of the subject is deceptive: as seen in *Tools* (fig. 85), Lawrence skillfully disrupts the expected visual conventions and our usual expectations of the situation to make us aware of the power of pictorial devices such as line, shape, color, and space to enhance—even predicate—our experience of the subject matter.

At first glance it is hard to discern exactly what is going on. Gradually the form of the carpenter, slumped at his worktable, reveals itself in the lower half of the composition. Above his head three shelves are stacked in the densely packed space. Their stable horizontality serves to offset the helter-skelter, almost sinister diagonal placement of the various tools, some of which perch precariously at the edge at one end (as observed in the two drills on the middle shelf). The feeling of disequilibrium is also conveyed by the angled thrusts of the gray-edged black wrench and black-edged red pliers at the bottom of the composition. Along with the black file at the extreme left and the various picks and awls on the tabletop, these tools seem to rise up to menace the unsuspecting carpenter. His eventual fate—in the event of some anthropomorphic metamorphosis of these tools—is symbolically enacted just above his head as the two brown and yellow four-by-four planks seem to be pierced on the left by the yellow-handled tool and the awl whose black twist leaves a jagged scar across their top edge. Lawrence's fascination with the abstract quality of tools, which he has always found

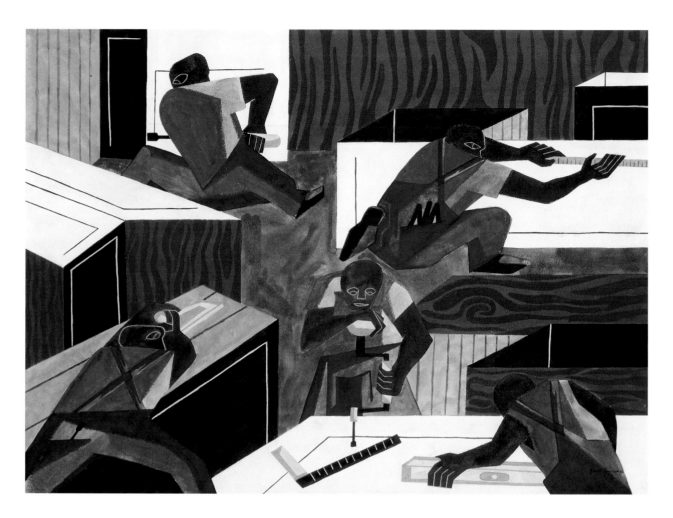

FIG. 82 *Cabinet Makers*, 1946, gouache on paper, 22 × 30¹⁄₁₆ in. Hirshhorn Museum and Sculpture Garden, Smithsonian Institution. Gift of Joseph H. Hirshhorn, 1966.

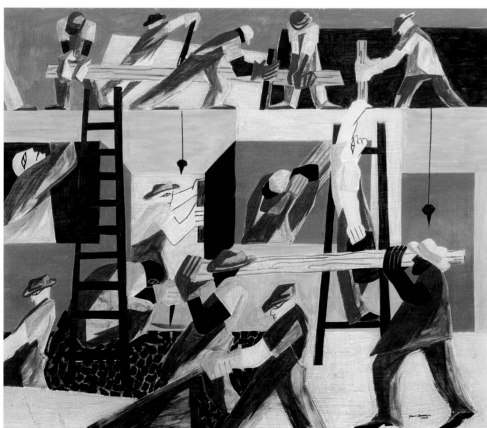

FIG. 83 *The Builders*, 1947, egg tempera on hardboard, 19¼ × 23½ in. Private collection.

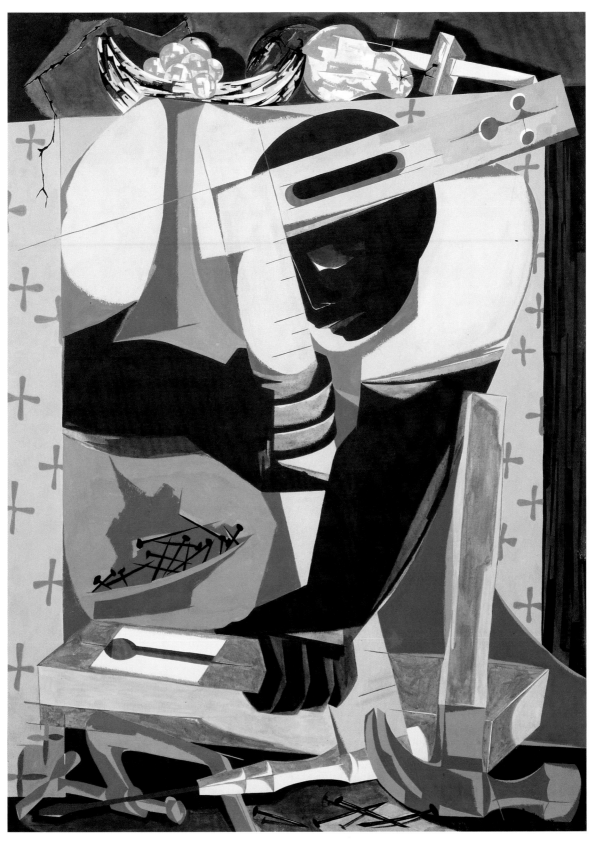

FIG. 84 *Cabinet Maker*, 1957, casein tempera on paper, 30½ × 22½ in. Hirshhorn Museum and Sculpture Garden, Smithsonian Institution. Gift of Joseph H. Hirshhorn, 1966.

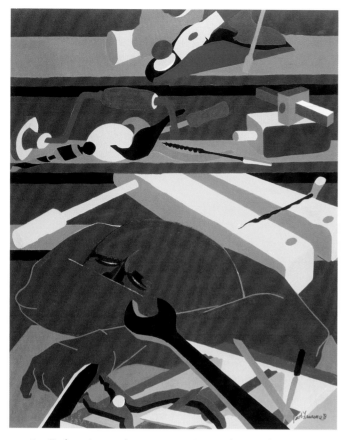

FIG. 85 *Tools*, 1978, gouache on paper, 21¾ × 18½ in. Detroit Institute of Arts. Founders Society Purchase with funds from the Friends of African and African American Art, Founders Junior Council, and the J. Lawrence Buell, Jr. Fund, Josephine and Ernest Kanzler Fund, Mr. and Mrs. Alvan Macauley, Jr. Fund, K. T. Keller Fund, Laura H. Murphy Fund.

FIG. 86 Stuart Davis, *Ana*, 1941, gouache on paper, 15⅝ × 15½ in. Collection of Max Ellenberg. © Estate of Stuart Davis/Licensed by VAGA, New York, NY.

to be "aesthetically beautiful like sculpture,"[37] is clear, for indeed the tools themselves become the center of attention.

At times the tools and pieces of wood seem to defy the area in which they have been placed: the red handle of one of the drills seems to be both beneath the top shelf and extending up to it as it intrudes on the black band that Lawrence has painted to denote the darkness at the back of the picture space. The two planes on the top shelf also fight visually with the delineations suggested by the two shades of brown to denote the perpendicular sides of the shelf space. Lawrence allows the horizontal bands of the shelves to run to the edge of the composition without providing complementary perpendicular elements to suggest the presumed boxlike configuration of the shelves. This use of color as fore- and background elements at the same time and the application of highly saturated colors throughout the composition enhance the sense of flatness. Such color and space manipulations call to mind those seen in the work of Stuart Davis—Lawrence's older contemporary who also showed at the Downtown Gallery in the 1940s. Davis developed a similar stylization of form and color that stresses the interaction, even interchangeability, between two-dimensional and three-dimensional form and space (see Davis's *Ana* [fig. 86]).

Davis called this method his color-space theory, and he fine-tuned its mechanics in his work during the 1930s and 1940s. This theory was based on the idea that through color the artist could create a planar relationship that established the way the spectator would read colors spatially on a two-dimensional plane.[38] Davis and Lawrence—as we have seen—subvert the usual perspectival reading of strong colors in the foreground and paler colors in the background, encasing each within a distinct form. They use fully saturated color on the figures and the background and allow the colors from each shape to run into one another, destroying the sense of an integral form. This method reaches a highly developed state in the latest builders paintings (1998) in which the blacks, blues, and grays in particular create spatial anomalies as they run off the figures into the background and vice versa. In *Builders—Builder with Pear* (fig. 87) the gray of the edge of the table, the plane, and the wall at the left creates a continuous visual flow with the facades of the buildings seen through the window on the right. The builder's blue coveralls flow into a jagged blue form on the wall, and the red of his shirt into the color of the wall at the right.

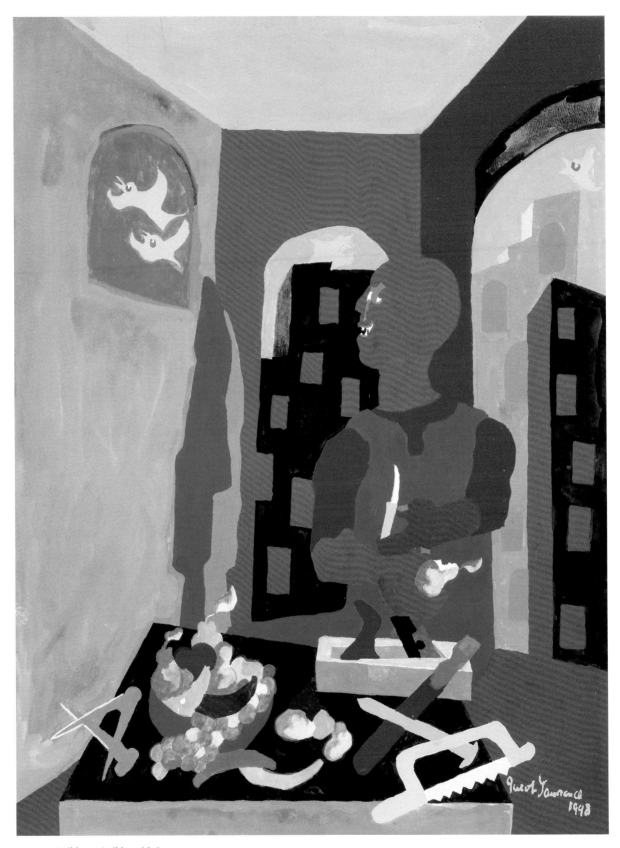

FIG. 87 *Builders—Builder with Pear*, 1998,
gouache on paper, 24 × 18 in. Collection of
Jacob and Gwendolyn Knight Lawrence.
Courtesy of DC Moore Gallery, New York.

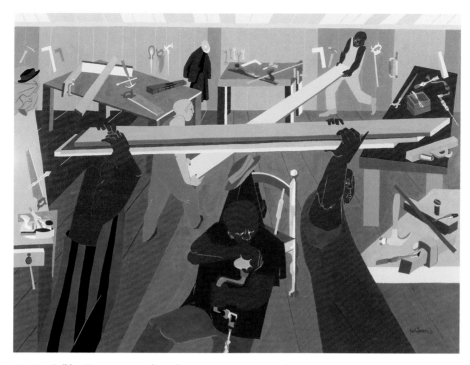

FIG. 88　*Builders No. 1*, 1970, gouache and tempera on paper, 22 × 30 in. Henry Art Gallery, University of Washington, Seattle. Gift of the Artist.

The olive green color of his right arm and especially his head joins with that of the far wall in the middle of the composition. Our reading is further complicated by the compression of the space (so that notions of inside and outside are disrupted), by the positioning of the builder at his table in relationship to the two windows and the skewed perspective of the wall/floor at the lower right.

Lawrence himself has not ascribed a direct relationship between his use of color with that of Stuart Davis. What he especially appreciated about Davis was the fact that although Davis's work "comes out of . . . a certain type of cubist tradition, there was also a very individual stamp there that was strong."[39] For Lawrence the example of Davis meant that he "could take a school or a tradition or a philosophy" and also put his individual stamp on it.[40] Lawrence did, on the other hand, acknowledge the impact of Josef Albers on his work. The two artists met when Albers invited Lawrence to teach at Black Mountain College in North Carolina in 1949.

According to Lawrence, Albers was the first person "outside the community" who had a significant impact on him as an artist. Through his exposure to Albers's work and teaching Lawrence began to understand more analytically the devices he already used, that is, "working on a two-dimensional picture plane and making it appear three-dimensional. Why you used three lines when you can use two." Albers also made Lawrence aware of "using an organic movement against the geometric

movement" to "create a tension there, a pull . . . [that] working with the edge of the picture plane . . . [was] . . . just as important as the inner part of the picture plane. Moving against the edge."[41] This also had an effect on Lawrence's awareness of color. He once admitted to Carroll Greene, Jr., that he had "never learned color in an academic way . . . in a formal way." This, he felt, "may have something to do with that of expressing myself in a very limited palette."[42] Now Lawrence also became aware of "[t]ension in color. Change as you move over the picture plane, in any of the elements with which you're working—the change of the texture, line, the warm color against a cool color, a shape. [How a color] in a round shape means something different if it's a square or a rectangle."[43]

Lawrence has postulated that Albers gravitated toward him because his work had already demonstrated traits valued in the Bauhaus tradition, that is, "Elements of design, color, texture, pattern; understanding the dynamics of the picture plane."[44] Like Albers, who spent most of his career exploring these precepts in the format of rectangles and squares, Lawrence has used as economical a means as possible for his own artistic investigations. He has always limited himself "mostly" to "the primary colors, plus black and white, and sometimes the secondary colors."[45] The builders paintings are distinctive in their use of the primaries. In *Builders No. 1* (fig. 88) the yellow planks of wood and tabletops create trapezoidal and diagonal elements that activate the beige and brown interior. The red shirts

of the carpenters and red and pink edges and legs of the table to the right lead the eye in an ovoid circuit, while the blues of their pants, coveralls, and the hat at the center set up a complementary movement on a more diagonal orientation.

By the 1980s Lawrence demonstrated an even freer organization of the composition. The tonalities are fewer now, and the arrangements of reds, yellows, and blues seem to follow their own logic and describe the forms only secondarily. In *Builders* (fig. 89) several visual devices, such as the serrated edge of the gray structure to the right (representing protruding struts) and the continuity of the reds in the upper half reaching from the floor to the plant to the facade of the building, create a lively "push and pull" (to borrow a concept from Hans Hofmann) between the figural elements and the several layers of background. Here Lawrence not only includes black and white male workers cooperating, but in an acknowledgment of the new

realities of the workplace he also features a white female builder at the right.

It has been noted that the builders paintings were always about more than depicting a construction site. They symbolize a variety of ideas about American worker culture, especially in the African American community. They come, Lawrence has said, from his "own observations of the human condition."[46] In the main the protagonists are actual construction workers and carpenters, but in several paintings he expands the idea of builder to the family, to artists as seen respectively in *Poster Design . . . Whitney Exhibition* (fig. 90) and in his 1981 design for the Pacific Northwest Arts and Crafts Fair. Lawrence has admitted to a more inclusive interpretation of the builders theme: "I like the symbolism [of the builder]. . . . I think of it as man's aspiration, as a constructive tool—man building."[47] He observed to Charles Alan that there was a "a thread between the 'library'

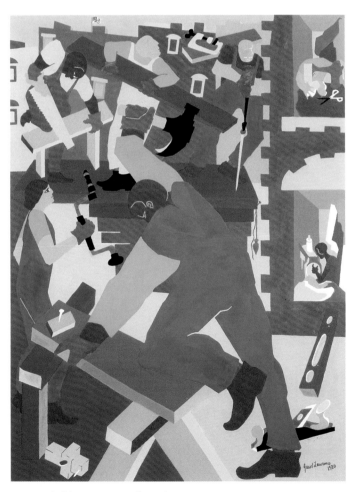

FIG. 89 *Builders*, 1980, gouache and tempera on paper, 34 × 25½ in. Collection of Safeco Corporation, Seattle.

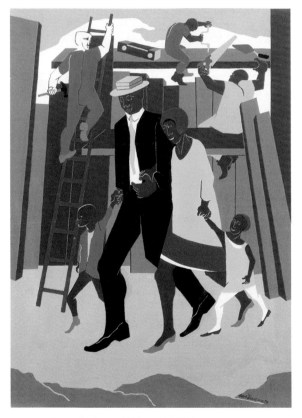

FIG. 90 *Poster Design . . . Whitney Exhibition*, 1974, gouache and tempera on paper, 30¹⁄₁₆ × 22¼ in. Private collection, New York.

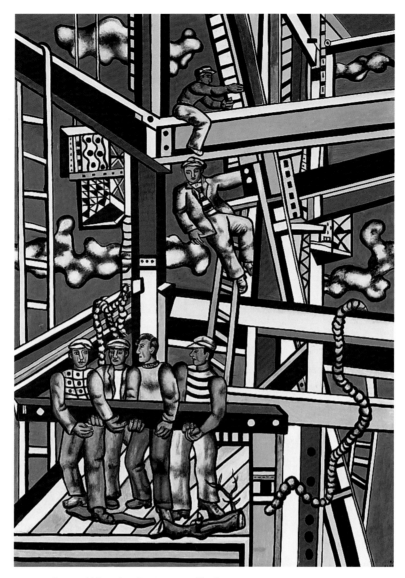

FIG. 91 Fernand Léger, *Les Constructeurs* (final state), 1950, oil on canvas, 118⅛ × 78¾ in. Musée national Fernand Léger, Biot.

paintings and the 'builders' theme," in that he was looking for symbols that "would show man's continuous aspiration to develop, to build."[48]

The peculiar tension between form and content in the builders paintings suggests affinities with this subject as it is found in contemporary works of art. The compressed, relieflike space and emphasis on geometric shapes in *The Builders* of 1947, for example, recall Lewis Hine's photographs of the builders of the Empire State Building. If Lawrence found a thematic and compositional and even political antecedent for the builders paintings in the murals of José Clemente Orozco at the New School for Social Research, we can also identify a corollary in Fernand Léger's painting *Les Constructeurs* (1950) (fig. 91). Here French *ouvriers* straddle and carry beams and hang from ladders amid red, black, white, and yellow structural elements set hori-

zontally, vertically, and diagonally in space. This grid activates and anchors the composition in a manner similar to that in Lawrence's work as seen in *Builders—Nine Windows* (fig. 92), where the grid is made of heavy, black architectural elements. They serve as scaffolding, support beams, and create at least three separate and distinct zones within which different scenes are enacted in different locales and on different scales.

The Léger is part of a series of paintings executed just after World War II that depict a veritable worker's paradise, indicating an elevation of the social and economic status of that class of society in the postwar boom. Lawrence's own paintings on the theme of builders also engage notions of construction of a more philosophical and social kind. The builders theme appeared in Lawrence's work in the later 1940s—at the conclusion of World War II—as one of several subjects dealing with labor. It is as if he

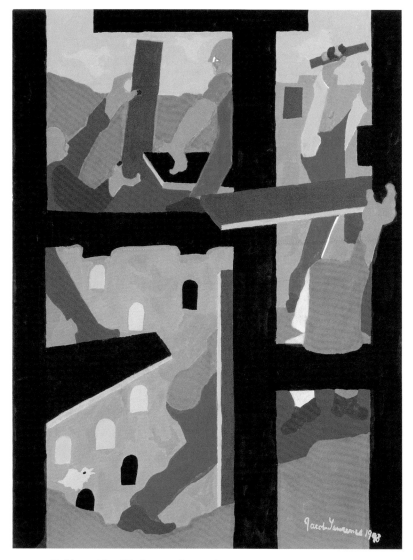

FIG. 92 *Builders—Nine Windows*, 1998, gouache on paper, 24 × 18 in. Collection of Jacob and Gwendolyn Knight Lawrence. Courtesy of DC Moore Gallery, New York.

is capturing the economic advancement that marked the war years for African Americans as well as the aspirations for greater advancement in American society, which would coalesce into the civil rights movement in the 1950s. In *The Shoemaker* (see p. 124, fig. 36), *Radio Repairs* (fig. 93), and *The Seamstress* (fig. 94), we see African Americans in tasks that go beyond factory work and domestic labor. Alan notes that in these paintings Lawrence "demonstrates . . . his absorption in the shapes of tool and implements . . . and he employs these shapes to create vibrant designs."[49] Later compositions such as *Typists* (fig. 95) acknowledge not only the presence of women in the workplace that escalated after World War II but also the growing professional class among African America.

The 1940s were a time of great opportunity for African Americans in the building trades. In *An American Dilemma,* Gunnar Myrdal's study of the situation of African Americans first published in 1947, he writes that this growth followed a period of decline after slavery when African Americans were the prime source of labor in the building trades. They lost ground following emancipation when they were forced to compete with a white working class augmented by successive waves of European immigration. As they did in other fields, African Americans found more opportunities as they moved North, particularly in the Great Migration, which was the subject of Lawrence's 1941 epic work. Myrdal observes that as a result "by 1930 almost half of the Negro building workers were in the North."[50]

Yet during the 1930s, as the building industry expanded, African Americans still found it difficult to compete with their white counterparts as the construction industry introduced new materials and techniques. They also had few opportunities

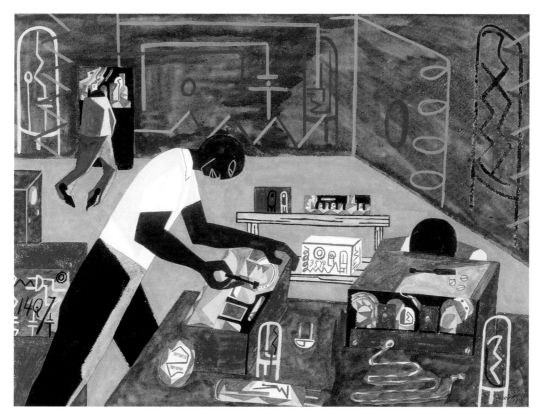

FIG. 93 *Radio Repairs*, 1946, gouache on paper,
21½ × 29½ in. Collection of Mr. and Mrs. Julius
Rosenwald.

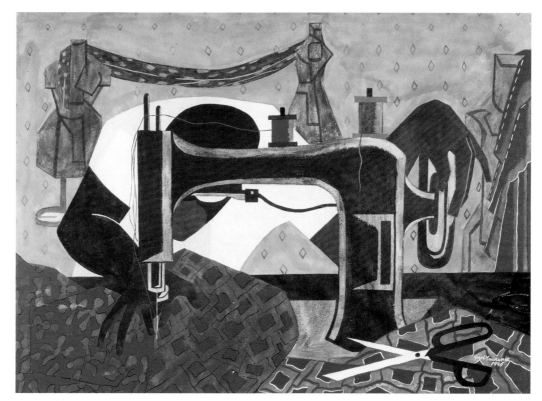

FIG. 94 *The Seamstress*, 1946, gouache on paper,
21⅝ × 29⅞ in. Southern Illinois University Mu-
seum at Carbondale.

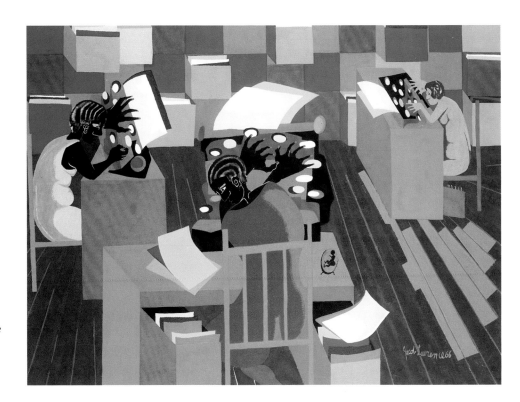

FIG. 95 *Typists*, 1966, tempera and gouache on paper, 22 × 29¼ in. Herbert F. Johnson Museum of Art, Cornell University. Gift of Isabel Berley, Class of 1945, and William Berley, Class of 1947.

to be trained in the newer trade areas such as electricity and plumbing and found themselves barred from many of the trade unions.[51] What few opportunities existed for them continued to be in the so-called trowel trades (bricklaying, plastering, and cement finishing) and in carpentry. Their participation in these jobs expanded during World War II and afterward. As well, at this time government regulations assured that the skilled craft unions also began to hire African Americans.[52] Myrdal reminded Americans as a whole of these facts, which Lawrence felt "historians have glossed over." He had intended to complete a series on the Industrial Revolution in America, which would highlight the role of African Americans as "the builders of America, how [they] tilled the fields, and picked cotton and helped build the cities." Lawrence felt this was important because "[a]ll we hear of the American Negro is that he picked cotton, and they don't even call it a contribution."[53] Lawrence never executed the paintings, and his resumption of the builders theme in the late 1960s may have been a replacement for that aborted series.

Charles Alan has noted that the "locales in most of the 'builders' pictures are very vague—often there is no indication of indoors or outdoors." Despite the representation of vigorous activity in these scenes, there is a calm purposeful determination, which emphasizes the commitment of the participants not only to complete the task at hand but, as has been noted, to build a sense of pride and a spirit of racial harmony in the process. This would seem to have particular resonance given the fact that, as Peter Nesbett has commented, the reappearance of

the builders theme in Lawrence's work in 1968 came when the momentum of the civil rights movement seemed to have reached a halt after the "assassinations of Robert Kennedy and Martin Luther King" and "the compromises in Civil Rights legislation and its enforcement, and the widespread urban riots," which "contributed to a profound sense of anger or despair for many in the country."[54] "There is," Charles Alan notes, "a solemnity about these paintings as if the artist were saying that the work depicted was a kind of devotional ritual."[55] In some, such as *Cabinet Makers* (1946) and *Builders No. 1* (1969), they are making various boxes and containers. In the original *Builders* of 1947 and in the versions of 1973, 1974, and 1980 they are engaged in constructing a building. The alternation between the intimate, interior, craft-oriented activity and the outdoor, grand-scale projects may perhaps reflect the artist's own sense of his ambitions for African Americans specifically and humanity in general. Lawrence has noted that he found himself criticized by his more militant students at the time because of his perceived accommodation of the establishment,[56] and, as expressed in his builders paintings, he did lack a vision of nation-building in the most literal sense. But as Alan proposes, Lawrence would see that the "only" way one could "improve a society" would be by "living totally within a society, not by being an outsider."[57]

To such a purpose, as we have seen, Lawrence brings the optimism of modernism, amply glimpsed in his geometricized forms and primary colors, recalling the protocols of art movements that sought to transform society in the first half of this

century, such as the Dutch De Stijl and the Russian Suprematism and Constructivism. But Lawrence never forgot the needs of the African American community for recognizable images in which they could see themselves reflected. What he has done so skillfully is to navigate that prescription while finding a highly personal style that introduced innovative techniques and media.[58] As Jeffrey C. Stewart writes, Alain Locke recognized this aspect of Lawrence's work when he stressed the compatibility between "racial and national traits and universal human values."[59] In his recommendation for Lawrence's Rosenwald Fund fellowship in 1940 Locke observed: "There is little or no hint of social propaganda in his pictures, and no slighting of the artistic problems involved, such as one finds in many of the contemporary social-theme painters. Yet his work has a stirring social and racial appeal."[60]

Jacob Lawrence has expressed his disinclination to experiment with new styles or new material once he had found his stride early in his career. As he observed to Jacobowitz, "My experimentation has really been with . . . the social statement dealing with people."[61] And while such an attitude may be disparaged by the art world, his dogged commitment to his task and his consistency in his output has triumphed over even the harshest of criticism. Robert Pincus-Witten would write in *Artforum* in 1974:

Striking is Lawrence's pragmatic acceptance of a once standard Cubist-Expressionist mode. Lawrence is sublimely unconcerned with the Kantian doubt that underlies the evolution of Modernist art history—of which the central paradigm is Analytical Cubism's transformation into Synthetic Cubism. Instead, Lawrence views Cubist-Expressionist representationalism in terms of a fundamental exploitation harnessed to straight narrative needs. In this, Lawrence demonstrated the vitality of a style which was long thought to be purely decorative. In Lawrence's hands that conceptual complex is transformed into Carpenter Cubism, as serviceable and as malleable as the situation warrants.[62]

This is ample praise indeed for an artist who has remained true to his artistic mission, never compromising his principles and his values. In his commitment to modernism and his commitment to the African American experience, Lawrence has created an oeuvre that bridges the gap between form and content which has been promoted by modernist criticism. In this he joins such artists as Wilfredo Lam, Romare Bearden, and Norman Lewis in highlighting the unique contribution of African American artists to twentieth-century art.

NOTES

1. Jacob Lawrence, transcript of tape-recorded interview by A. Jacobowitz, March 21, 1968, Archives of American Art, Smithsonian Institution, Washington, D.C. (hereafter AAA), part 1, p. 5.

2. Quoted in Charles Alan, unpublished manuscript, ca. 1973, p. 6, courtesy Harry N. Abrams, New York.

3. James Porter, *Modern Negro Art*, with a new introduction by David C. Driskell (1943; reprint, Washington, D.C.: Howard University Press, 1992), pp. 141–2.

4. Alan, unpublished manuscript, ca. 1973, p. 7.

5. Patricia Hills, "Jacob Lawrence's Expressive Cubism," in Ellen Harkins Wheat, *Jacob Lawrence: American Painter*, exh. cat. (Seattle and London: University of Washington Press in association with the Seattle Art Museum, 1986), p. 16.

6. Quoted in Miriam Roberts, *Robert Colescott: Recent Paintings*, exh. cat., with an essay by Lowery Stokes Sims (Santa Fe: SITE Santa Fe and the University of Arizona Museum of Art, 1997), p. 26.

7. Alan, unpublished manuscript, ca. 1973, pp. 6–7.

8. Alain Locke, ed., *The New Negro*, with an introduction by Arnold Rampersad (New York: Atheneum Books, 1992), pp. 256, 167.

9. Alan, unpublished manuscript, ca. 1973, p. 19.

10. Jacob Lawrence and Gwendolyn Knight Lawrence, transcript of tape-recorded interview by Paul J. Karlstrom, November 18, 1998, 28, AAA, pp. 23–4.

11. Ibid., p. 28.

12. Jeffrey Stewart, "(Un)Locke(ing) Jacob Lawrence's Migration Series," in Elizabeth Hutton Turner, ed., *Jacob Lawrence: The Migration Series*, exh. cat. (Washington, D.C.: Rappahannock Press in association with The Phillips Collection, 1993), p. 48.

13. Jacob Lawrence, transcripts of tape-recorded interviews by Avis Berman, July 20 and August 4, 1982, AAA, p. 41.

14. Lawrence and Knight Lawrence, interview by Karlstrom, pp. 16, 23.

15. Alan, unpublished manuscript, ca. 1973, p. 6.

16. Lawrence and Knight Lawrence, interview by Karlstrom, pp. 16, 23.

17. Ibid., pp. 34–5.

18. Alan, unpublished manuscript, ca. 1973, p. 12.

19. Ibid., p. 13.

20. Lawrence and Knight Lawrence, interview by Karlstrom, p. 77.

21. Leslie King-Hammond, comments at the Jacob Lawrence Catalogue Raisonné Project writers' conference (hereafter JLCRP writers' conference), The Phillips Collection, Washington, D.C., June 19, 1999. See also the photograph in Deborah Willis, "The Schomburg Collection: A Rich Resource for Jacob Lawrence," in Turner, *Jacob Lawrence: The Migration Series*, p. 37.

22. Alan, unpublished manuscript, ca. 1973, p. 13.

23. Lawrence, interview by Jacobowitz, part 1, p. 11.

24. Alan, unpublished manuscript, ca. 1973, p. 2.

25. Jacob Lawrence, transcripts of tape-recorded interviews by Carroll Greene, Jr., October 25 and November 26, 1968, AAA, quoted in Alan, unpublished manuscript, ca. 1973, p. 40.

26. Lawrence, interview by Jacobowitz, part 2, p. 14.

27. Ibid., part 1, p. 17.

28. Ibid., part 2, pp. 15–6.

29. Ibid., part 1, p. 12.

30. Lawrence and Knight Lawrence, interview by Karlstrom, p. 36.

31. Lawrence, interview by Jacobowitz, part 1, p. 13.

32. Ibid., part 2, p. 19.

33. Alan, unpublished manuscript, ca. 1973, p. 1.

34. Quoted in Elizabeth McCausland, "Jacob Lawrence," *Magazine of Art* 38, 7 (November 1945), pp. 250–4, quoted in Wheat, *Jacob Lawrence: American Painter*, p. 143.

35. In his distinction between a "series" and a "theme," Lawrence would describe the builders paintings as the latter in that they do not embody what Michelle DuBois describes as "a sequential narrative." Jacob Lawrence and Gwendolyn Knight Lawrence, transcript of tape-recorded interview by Peter Nesbett and Michelle DuBois, June 7, 1999, pp. 1–2.

36. Berman, quoted in Wheat, *Jacob Lawrence: American Painter*, p. 143.

37. Ibid.

38. See Lowery Stokes Sims, "Stuart Davis in the 1930s: A Search for Social Relevance in Abstract Art," in Lowery Stokes Sims et al., *Stuart Davis, American Painter*, exh. cat. (New York: The Metropolitan Museum of Art in association with Harry N. Abrams, 1991), p. 60.

39. Lawrence, interview by Berman, August 4, 1982, p. 107.

40. Ibid.

41. Ibid., p. 86.

42. Lawrence, interview by Greene, October 25, 1968, p. 36.

43. Lawrence, interview by Berman, August 4, 1982, p. 87.

44. Ibid., p. 93.

45. Elizabeth Steele ascribes Lawrence's color choices to the fact that he tended to use whatever water-based paints were available commercially straight from the bottle. Lawrence himself said that when he used the "full color" he might "gray that down with [a] complement." Lawrence, interview with Berman, August 4, 1982, p. 290. Leslie King-Hammond has suggested that the use of these colors indicates elements of African aesthetic feeling surviving in the African American community. JLCRP writers' conference, The Phillips Collection, Washington, D.C., June 19, 1999.

46. Bonne Hoppin, "Arts Interview: Jacob Lawrence," *Puget Soundings* (February 1977), p. 6, quoted in Wheat, *Jacob Lawrence: American Painter*, p. 143.

47. Ibid.

48. Alan, unpublished manuscript, ca. 1973, p. 68.

49. Ibid., p. 35.

50. Gunnar Myrdal, *An American Dilemma: The Negro in a White Nation* (1947; reprint, New York, Toronto, and London: McGraw Hill Book Company, 1964), vol. 1, p. 294.

51. Ibid., pp. 282–3.

52. Ibid., p. 412.

53. Lawrence, interview by Berman, July 20, 1982, pp. 74–5.

54. Peter T. Nesbett, "Jacob Lawrence: The Builder Paintings," in *Jacob Lawrence: The Builders, Recent Paintings*, exh. cat. (New York: DC Moore Gallery, 1998), p. 6.

55. Alan, unpublished manuscript, ca. 1973, p. 69.

56. Wheat, *Jacob Lawrence: American Painter*, p. 113.

57. Ibid., p. 17.

58. There has always been a certain bent toward figuration in the African American community. Although Alain Locke encouraged experimentation with African art and its abstract qualities, ultimately he would define the role of the African American artist as one who addressed the needs of his community. In 1939 he expressed his conviction that "after a pardonable and often profitable wandering afield for experience and freedom's sake . . . the Negro artist, like all good artists," would "eventually come home to the material he sees most and understands best." Locke's statement is admittedly ambiguous, not specifying a particular style for African American art. In the context of American art history, however, his description of a "wandering afield for experience and freedom's sake" would inevitably be interpreted as associating with modernist art historical movements in the mainstream art historical context, which in the 1930s and 1940s were proliferating in New York City in particular. Both Romare Bearden and Norman Lewis would wrestle with this issue in their own work. Lewis would end in the 1940s by writing that after having "struggled single-mindedly" for many years "to express social conflict" in his art, he "gradually . . . came to realize that . . . the development of one's aesthetic capabilities suffers" and that he had realized that his "own greatest effectiveness would not come by painting racial difficulties but by excelling as an artist first of all." Norman Lewis, quoted in Kellie Jones, "Norman Lewis: The Black Paintings," in *Norman Lewis, 1909–1979*, exh. cat. (Newark: Robeson Center Gallery, Rutgers, The State University of New Jersey, 1985), p. 8.

59. Stewart, "(Un)Locke(ing) Jacob Lawrence's Migration Series," p. 49.

60. Ibid., p. 42.

61. Lawrence, interview by Jacobowitz, part 1, p. 5.

62. Robert Pincus-Witten, "Jacob Lawrence: Carpenter Cubism," *Artforum* 13, 16 (September 1974), pp. 66–7, quoted in Wheat, *Jacob Lawrence: American Painter*, p. 144.

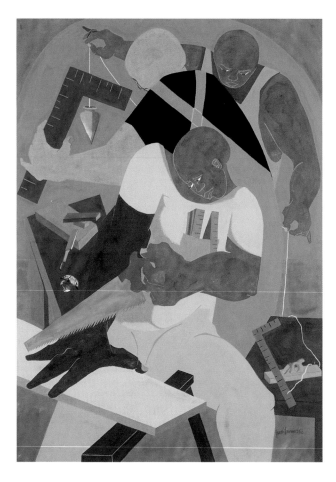

PL. 79 *Builders No. 1*, 1968, gouache and tempera on paper, 30½ × 22 in. Private collection.

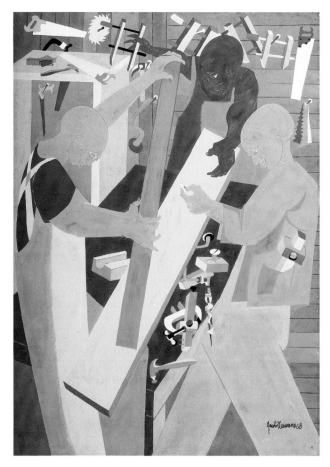

PL. 80 *Builders No. 2*, 1968, gouache and tempera on paper, 30 × 21¼ in. Reynolda House, Museum of American Art, Winston-Salem, North Carolina.

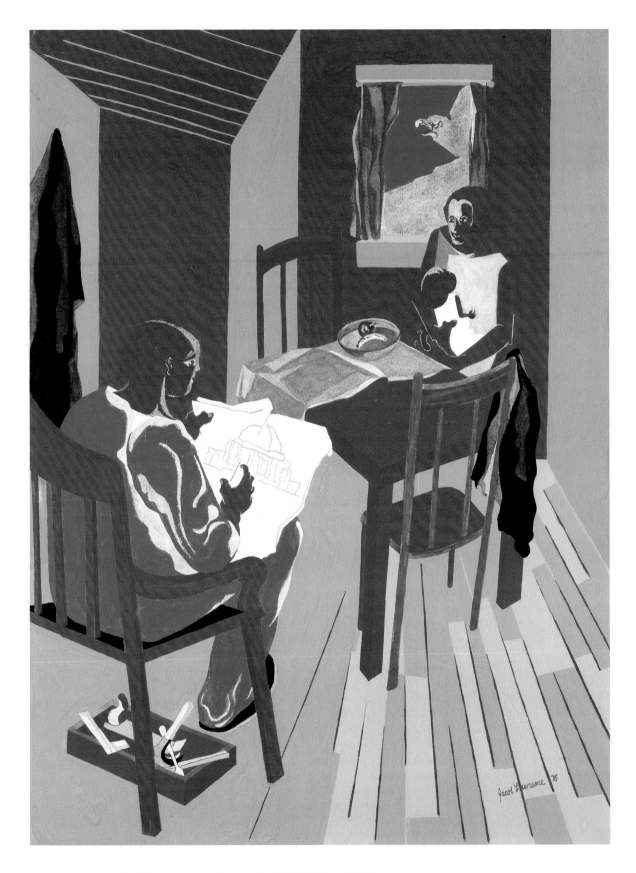

PL. 81 *In a free government, the security of civil rights must be the same*
as that for religious rights. It consists in the one case in the multi-
plicity of interests, and in the other, the multiplicity of sects.—
James Madison, 1788, 1976, gouache on paper, 30 × 22⅛ in.
National Museum of American Art, Smithsonian Institution.
Gift of the Container Corporation of America.

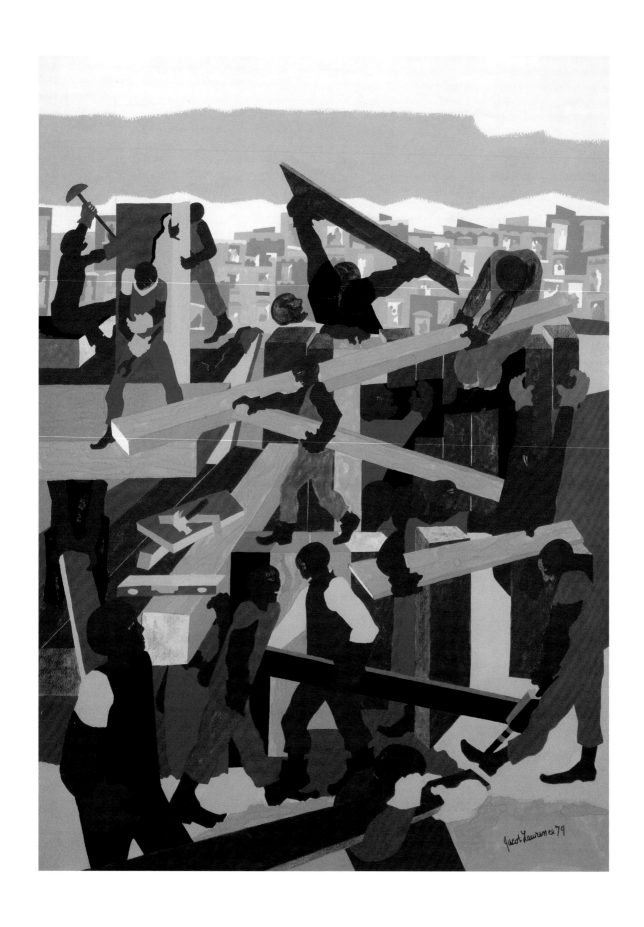

PL. 82 *Builders—19 Men,* 1979, gouache and tempera
on paper, 30 × 22 in. Private collection.

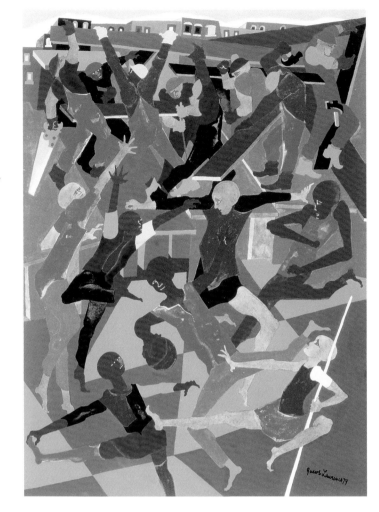

PL. 83 *Builders (Red and Green Ball),* 1979, gouache and tempera on paper, 30 × 22 in. New Jersey State Museum Collection. Purchase, FA1987.28.

PL. 84 *Eight Builders,* 1982, gouache and tempera on paper, 40 × 52 in. Seattle Arts Commission, Seattle City Light One Percent for Art Portable Works Collection.

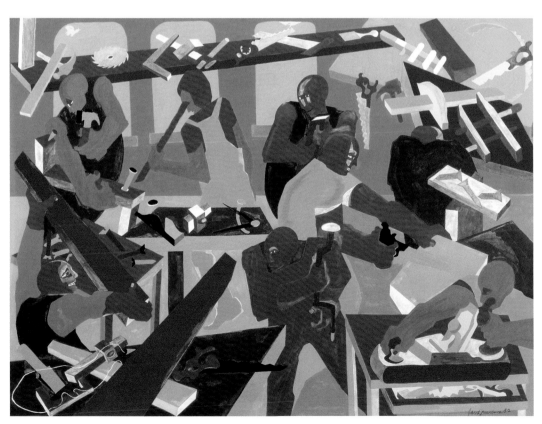

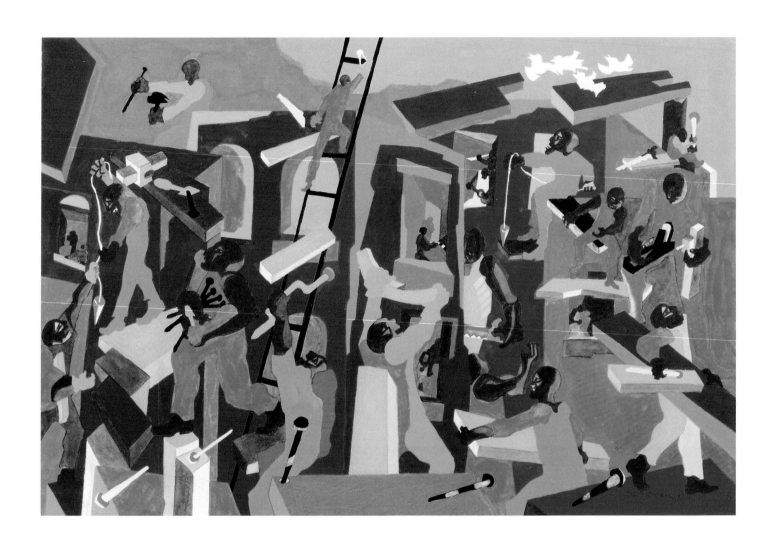

PL. 85 *Builders in the City,* 1993, gouache on paper, 19 × 28½ in. Courtesy of SBC Communications, Inc.

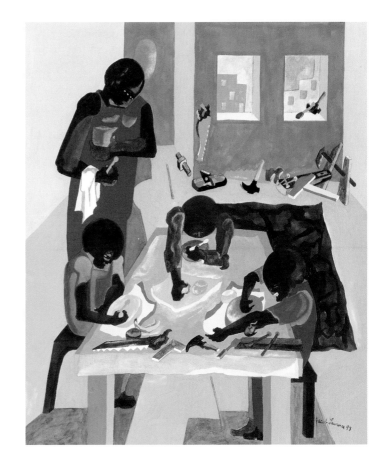

PL. 86 *The Builders Family,* 1993, gouache on paper, 26 × 22¼ in. Collection of Francie Bishop Good and David Horvitz, Fort Lauderdale.

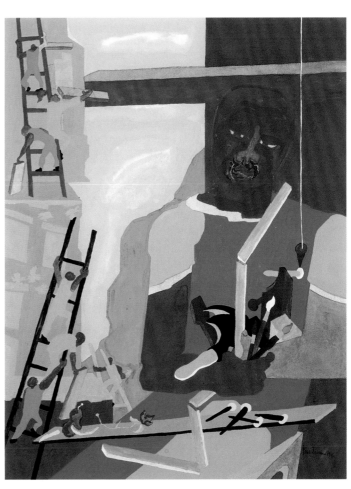

PL. 87 *Artist with Tools,* 1994, gouache on paper, 25¾ × 19⅝ in. Collection of Peter and Susan Tuteur, Saint Louis.

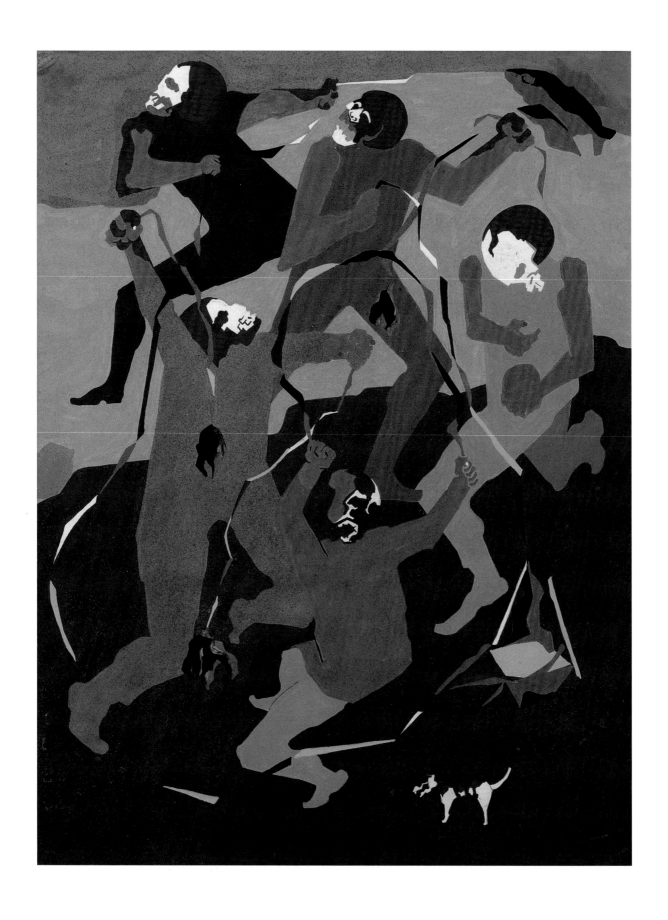

PL. 88 *Playground,* 1983, tempera and gouache
on paper, 23 × 17½ in. Collection of Jacob
and Gwendolyn Knight Lawrence. Courtesy
of Francine Seders Gallery, Seattle.

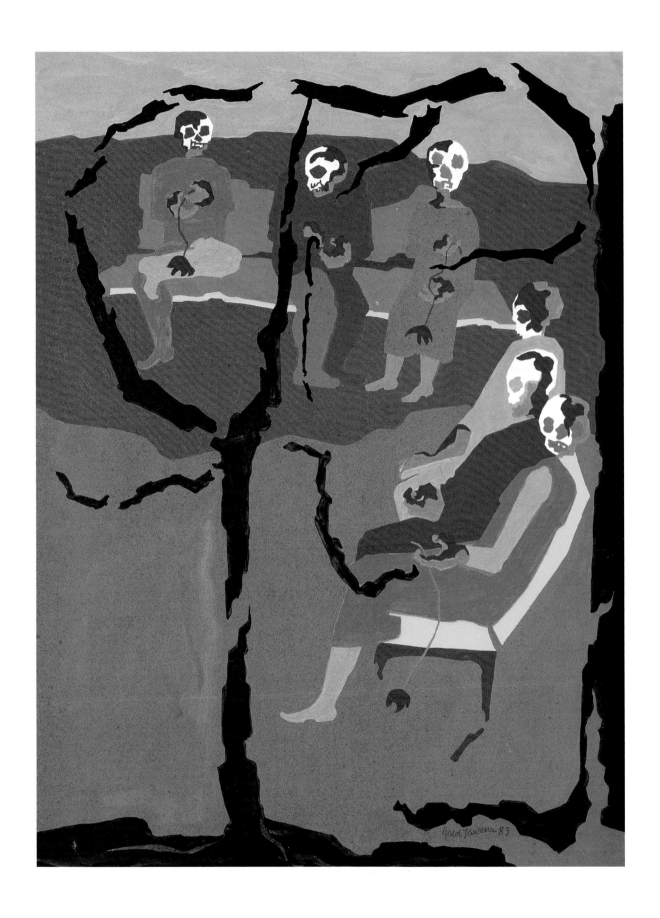

PL. 89 *People in the Park,* 1983, tempera and gouache
on paper, 23 × 17½ in. Collection of Jacob and
Gwendolyn Knight Lawrence. Courtesy of
Francine Seders Gallery, Seattle.

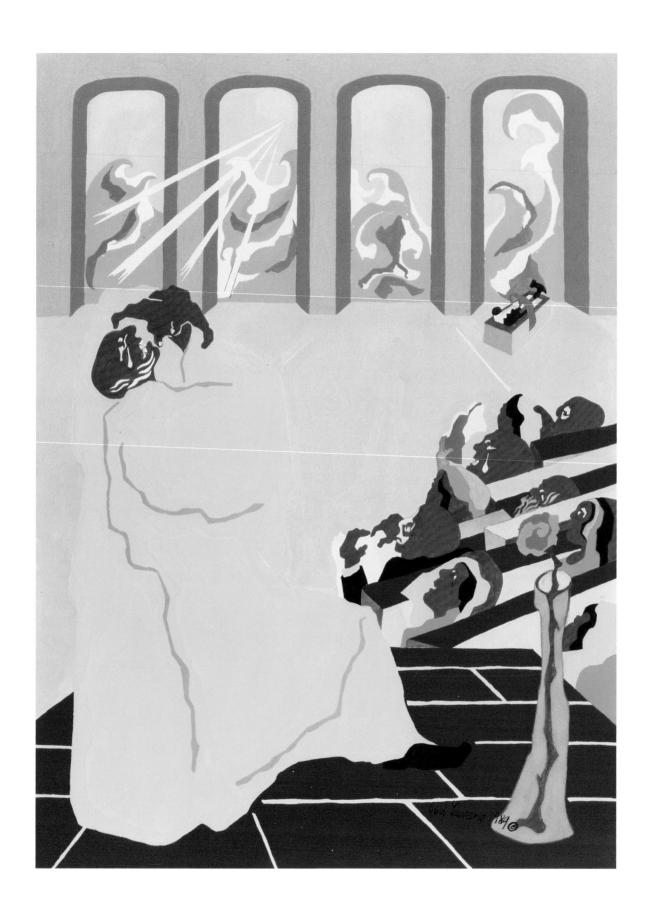

PL. 90 *Eight Studies for the Book of Genesis, No. 2: And God brought forth the firmament and the waters,* 1989, gouache on paper, 29¾ × 22 in. The Walter O. Evans Foundation for Art and Literature.

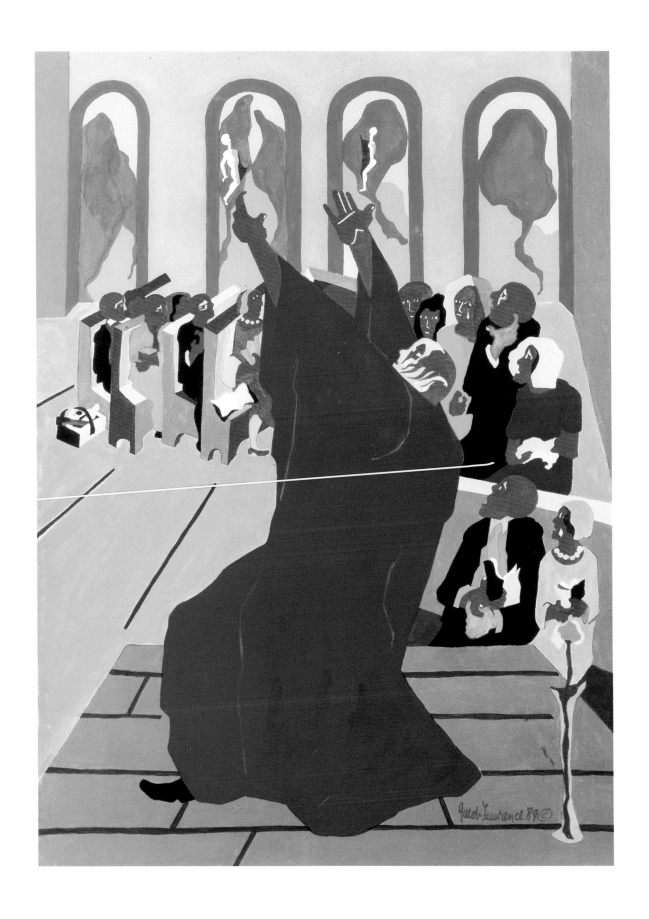

PL. 91 *Eight Studies for the Book of Genesis, No. 7: And God created man and woman,* 1989, gouache on paper, 29¾ × 22 in. The Walter O. Evans Foundation for Art and Literature.

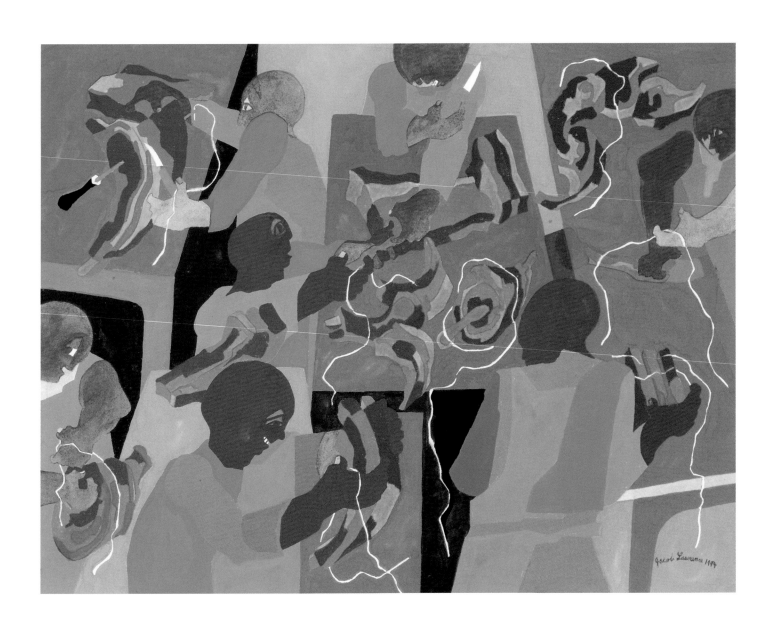

PL. 93 *Supermarket—Meats,* 1994, gouache on paper,
19½ × 25¾ in. Collection of Jeremy and Linda
Jaech, Seattle.

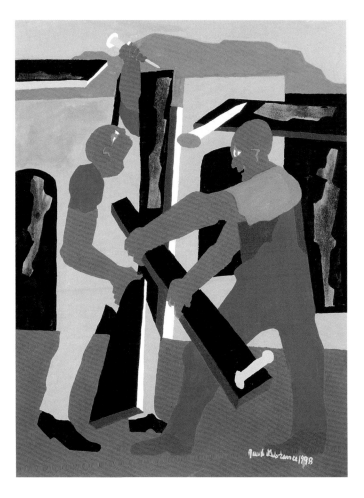

PL. 94 *Builders—Green Hills*, 1998, gouache on paper, 24 × 18 in. Private collection. Courtesy of DC Moore Gallery, New York.

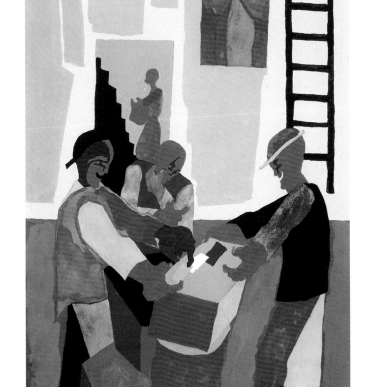

PL. 95 *Games—Three Card Monte*, 1999, gouache on paper, 24 × 18 in. Private collection. Courtesy of Francine Seders Gallery, Seattle.

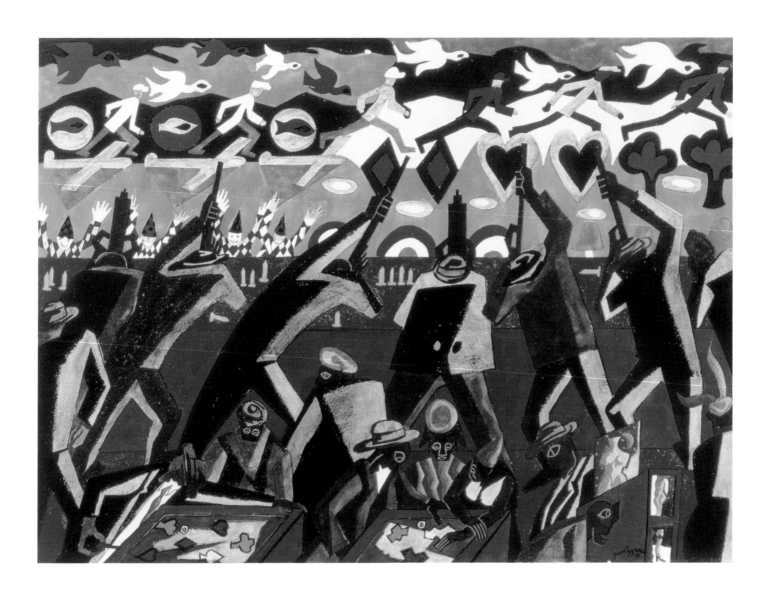

FIG. 96 *Shooting Gallery*, 1946, gouache, water-color and ink on paper, 21¾ × 29½ in. Walker Art Center, Minneapolis. Gift of Dr. and Mrs. Malcolm McCannel.

Paul J. Karlstrom

Jacob Lawrence
MODERNISM, RACE, AND COMMUNITY

IN 1970 JACOB LAWRENCE was awarded the Spingarn Medal for distinguished achievement by a black American. The presentation speech praised "the compelling power of his work, which has opened to the world beyond these shores a window on the Negro's condition in the United States; and . . . his unswerving commitment, not only to his art, but to his black brother within the context of society."[1] This tribute, along with the artist's acceptance comments, succinctly and completely states the major features—and the challenge—of Lawrence's long and distinguished career, one that spans more than six decades. By implication it also introduces the question of Lawrence's changing relationship to shifting notions of modernism as that term was defined at different points throughout his career. Indeed, Lawrence shared with other American artists of minority groups a central dilemma. They found themselves pulled between the poles of obligation to their communities and the demands of individual creative expression. These seemingly contradictory pressures produced an inescapable tension that may well define the special nature of their participation in the international modernist enterprise. It certainly did so in the case of Jacob Lawrence.

Throughout his career, Lawrence has emphasized the crucial role that the black community of Harlem played in his development as a young man and as an artist (discussed elsewhere in this volume). Of special significance to his developing thought was his exposure to the leading (or soon to be leading) black intellectuals and creative artists of the post–Harlem Renaissance period. Among them were Aaron Douglas, Ralph Ellison, Langston Hughes, Alain Locke, and Richard Wright. Each of these men represented different points of view—frequently conflicting, even diametrically opposed—about the position of the black man in American society and the responsibility of the artist in treating this topic. These ideas helped form Lawrence's own attitudes and were, I suspect, as important as any stylistic influence in determining his artistic direction and thinking.

In his acceptance speech for the Spingarn Medal, Lawrence reiterated, as he had so often before and has so often since, the role of community in his success: "If I have achieved a degree of success as a creative artist, it is mainly due to the black experience, which is our heritage—an experience that gives inspiration, motivation, and stimulation. We do not forget . . . that encouragement which came from the black community."[2] But exactly what this means, other than a gracious and appropriate acknowledgment of racial connection and shared experience, is not at all clear (fig. 96). The consequences of these circumstances, and Lawrence's somewhat ambivalent feelings about them from the perspective of a practicing artist, need to be more carefully identified and considered to suggest a comfortable resting place for the work within the broader sweeps of mainstream modernism and American art history. How does Jacob Lawrence fit in?

Probably the chief consideration in this question is the role ethnicity plays in circumscribing the activities of creative individuals. A minority artist is often expected to produce art on behalf of and in the interests of his or her group. Modernism, by contrast, has for decades been understood as a celebration of absolute artistic freedom. Since the nineteenth century creative activity has most often been individual in nature, and twentieth-century modernism especially encouraged and honored independence and innovation. At the same time, ideas of modernism attached themselves to social (as well as formal and stylistic) progress, incorporating the utopian belief of perfectibility

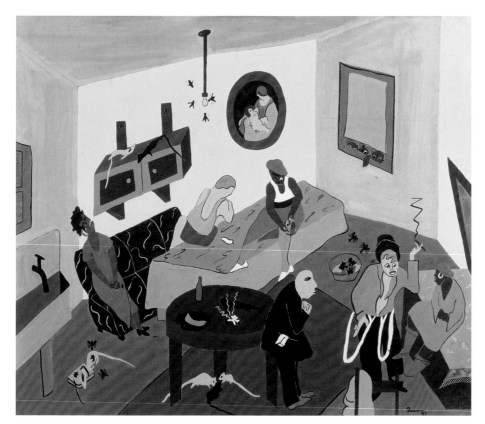

FIG. 97 *Interior Scene*, 1937, tempera on composition board, 28½ × 33¾ in. The Collection of Philip J. and Suzanne Schiller, American Social Commentary Art, 1930–1970.

through art and creative activity. By midcentury, critical thought, notably that of Clement Greenberg, considerably "downsized" that overly optimistic social ideal, applying the concept of progress exclusively to formal considerations and the primacy of abstraction. The idea of abstraction as a key feature of modernism was already well established by 1930 when the critic Henry McBride wrote, "There are other attributes to modern art but ability to feel the abstract is the real test."[3]

It would seem, especially to eyes and tastes conditioned by the compelling theories of Greenberg, that the social realism of Jacob Lawrence—deceptively naïve and decorative, even primitive, as the work appeared to many observers in the 1960s—had little or no connection to modernism. However, through a present-day postmodernist lens, works that once seemed thematically retrograde and overly indebted to principles of pictorial design may be rediscovered as an authentically modernist statement in the original sense. The question of Lawrence's simultaneous relationship to the black community—which provided his identity and his subjects—and to the compelling presence of modernism is a central consideration in any discussion of his art. The precarious balance he has maintained between these often conflicting demands is a defining characteristic of his career.

The degree of political content in Lawrence's work and his attitude toward its presence in his art are always open questions.

But, as I hope to demonstrate, the answer to these questions helps position Lawrence in terms of the relationship of his art to racial identity and, ultimately, to shifting notions of modernism. Lawrence's earliest and most memorable works, the Harlem genre paintings of about 1936–8, help provide the answer. The first efforts of a twenty year old, these small tempera on paper paintings are remarkably effective and original works of art. As Ellen Harkins Wheat and other writers have correctly observed, in the first few years of his career Lawrence "fixed the artistic patterns" that he has employed to the present day.[4]

Interior Scene (fig. 97) of 1937 is typical in its depiction of the artist's Harlem environment. An interest in the world of prostitutes is evident, raising the natural question whether the bordello was also a familiar part of the young artist's experience. In this focus on a particular ambience one is reminded of Henri de Toulouse-Lautrec. Did Lawrence see himself at any point as a latter-day impressionist, a painter of everyday (Harlem) life? It seems unlikely. Lawrence himself maintains that there was "no beginning to my awareness [of other artists and art, modernist or otherwise]; it was just *there* [emphasis mine]."[5] When pressed further on the subject of his influences, Lawrence invariably turns to the supportive Harlem community and the younger "professional" group (including his wife-to-be, Gwendolyn Knight, and their friends Ronald Joseph and Bob Blackburn) with which he associated. Even his mentors and teachers, chief

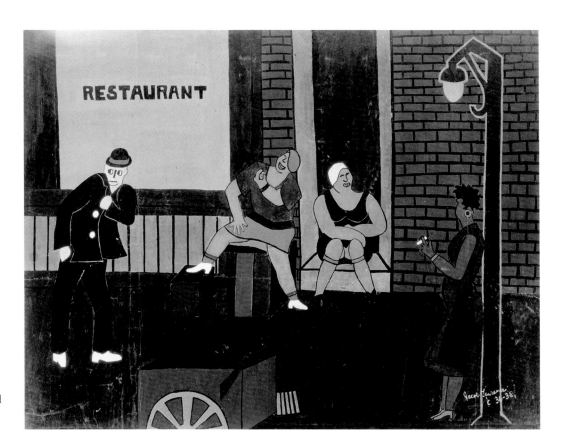

FIG. 98 *Street Scene—Restaurant*, ca. 1936, tempera on paper, 26¼ × 35 in. The Collection of Philip J. and Suzanne Schiller, American Social Commentary Art, 1930–1970.

among them the artists Charles Alston, Henry Bannarn, Augusta Savage, and the writer Claude McKay, are mentioned appreciatively for the support and encouragement provided, rather than any stylistic and aesthetic direction or influence. Lawrence recalls that they "encouraged me not to change, but to continue working the way I was working."[6] Or, more likely, was he familiar with such New York scene painters as John Sloan and several other members of the Eight, or such artists as Reginald Marsh, Raphael Soyer, and Ben Shahn who extended that tradition?[7] *Street Scene—Restaurant* (fig. 98)—another depiction of Harlem prostitutes—also presents an interesting racial mixture, perhaps more accurately described as a confrontation. A white man, looking furtively over his shoulder, approaches three black prostitutes waiting on the street for customers. Smiling reassuringly, the one on the left, legs spread provocatively, beckons "come hither" with the fingers of her left hand. In both pictures the client johns are white, the prostitutes black. Is this an overt comment on colonial exploitation, or is it simply a record of an aspect of life in Harlem? Lawrence himself acknowledges that they were at least in part the result of his being "sensitive to outsiders coming in to exploit the community."[8]

Interior Scene provides several formal clues about just how this important issue of political content might be pursued by examining individual works. The image is reductive and superficially flat, two standard characteristics of modernist style. The

radically tilted, spatially claustrophobic composition creates an indeterminate space of shifting angles and forms. Through these destabilizing devices movement and energy are injected into the work. The resulting tension may well be a pictorial analogue to the bordello atmosphere in general and an uneasy, uncomfortable confrontation between the races in particular.

A third and less familiar example on the same theme, *Woman with Veil* (fig. 99) of 1937, in its extreme simplicity is an even more strikingly sophisticated example of modernist design. Furthermore, its meaning is ambiguous, especially without reference to the other two works and without benefit of Lawrence's comments. Its anxious urban mood invokes the German Expressionism of Ernst Ludwig Kirchner and *Die Brücke* more than the Fauve flat-pattern design of Henri Matisse, and it is Lawrence's canny use of line and compressed space that gives the image its surprising emotional power and effectiveness.[9] The veiled woman in the foreground looks apprehensively over her shoulder as if she were being stalked, the psychological state of these street women in Harlem, so identified by the small figure leaning against the lamppost in the background, for whom Lawrence felt such sympathy. For the artist, these prostitutes literally embodied the invasive, exploitative treatment suffered by the black community. Other works of the period, such as *Street Orator* (1936), *Dust to Dust*, *Halloween Sand Bags*, *The Butcher Shop*, and *Untitled* [*Street Scene with Policemen*] (figs. 100–3), deal with

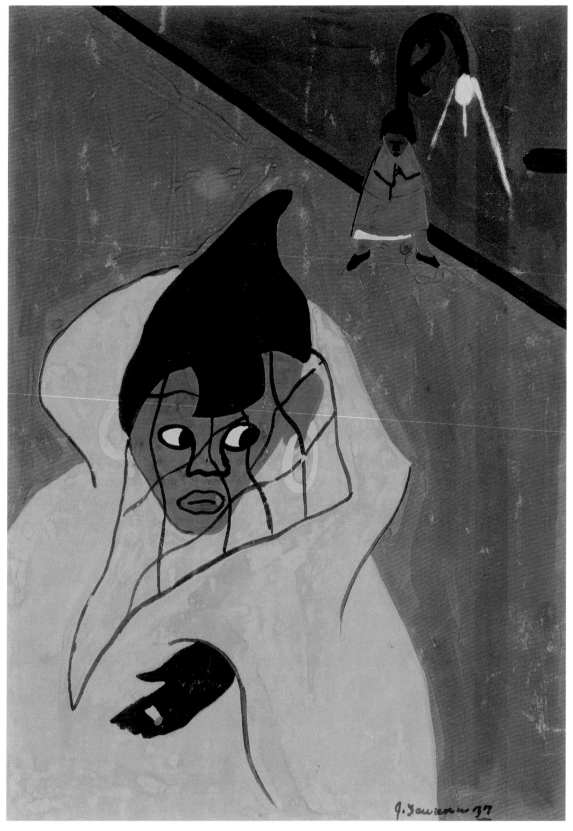

FIG. 99 *Woman with Veil*, 1937, tempera on brown paper, 17 × 13½ in. The Walter O. Evans Collection of African American Art.

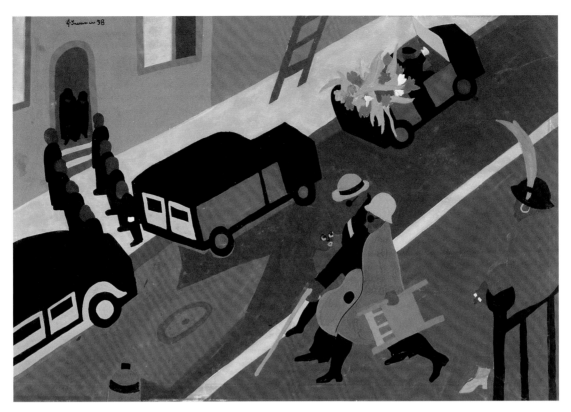

FIG. 100 *Dust to Dust*, 1938, tempera on paper, 12½ ×
18¼ in. Collection of Jacob and Gwendolyn Knight
Lawrence. Courtesy of Francine Seders Gallery, Seattle.

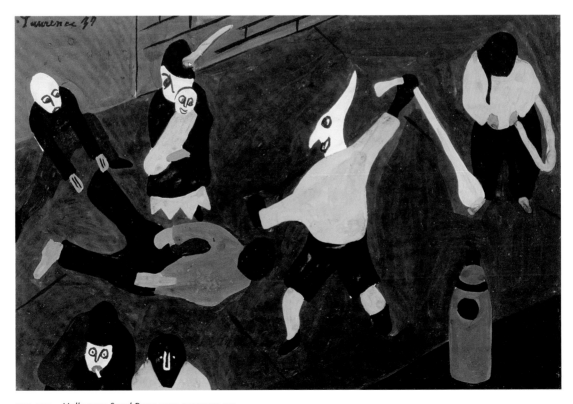

FIG. 101 *Halloween Sand Bags*, 1937, tempera on
paper, 8¾ × 12¾ in. The Harmon and Harriet Kelley
Foundation for the Arts.

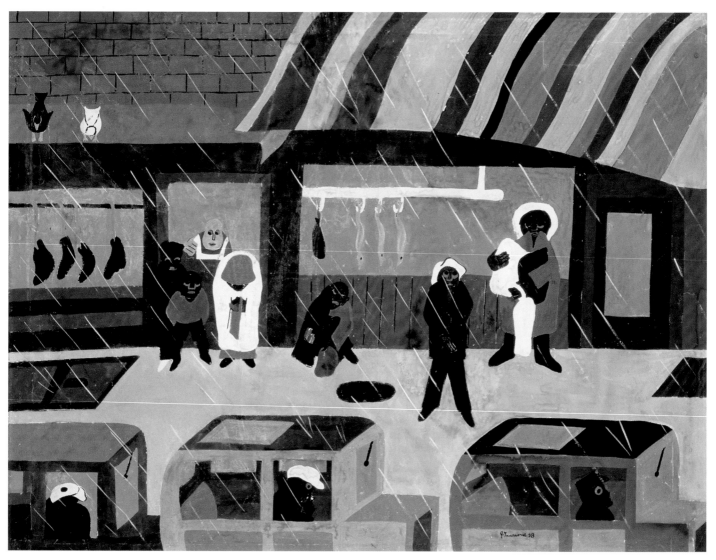

FIG. 102 *The Butcher Shop*, 1938, tempera on paper,
17½ × 24 in. Collection of Joan H. King, New York.

FIG. 103 *Untitled* [*Street Scene with Policemen*],
1938, tempera on paper, 11½ × 13 in. Private
collection, San Francisco.

234 PAUL J. KARLSTROM

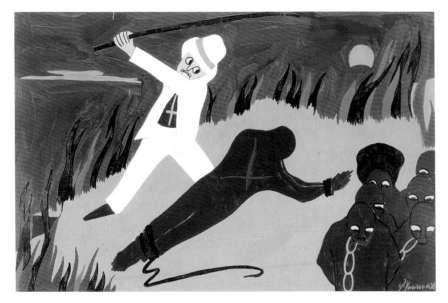

FIG. 104 *The Life of Toussaint L'Ouverture, No. 10: The cruelty of the planters towards the slaves drove the slaves to revolt, 1776. Those revolts, which kept cropping up from time to time, finally came to a head in the rebellion,* 1938, tempera on paper, 11½ × 19 in. Amistad Research Center, Tulane University, New Orleans. Aaron Douglas Collection.

similar themes of exploitation and displacement. Lawrence points especially to *Dust to Dust* as a statement of black American diaspora: typically when a person died in Harlem two funerals were held, one in the North and another in the South to where the body was taken "home."[10] From the beginning Lawrence's art was one of subtle protest, but he insists that he was unaware of the element of social commentary that was later recognized. By his account he was simply drawing his images from the life he knew. His work lent itself to social issues, and as a result he became an unwitting spokesman for portraying in the visual arts the black struggle and experience.[11]

Although one of the defining features of Lawrence's extended and remarkably consistent body of work is the attention he pays to race in America and the interaction between blacks and the dominant white society, he has generally been success-

ful in his acknowledged effort to avoid overt statements. Nonetheless, in the earliest works such as *Interior Scene*, or the great history series such as *The Life of Toussaint L'Ouverture*, whites are present only as agents of violent oppression (*Toussaint, No. 10* [fig. 104]) or exploitation (*Interior Scene*). As suggested earlier, the modernist devices employed in such works as the prostitute pictures contribute to the sense of an unsettled and uncomfortable interaction between the races. Still, if over the years Lawrence's point of view seems to vacillate between degrees of optimism and pessimism regarding race relations and the promise of integration, whites who were not violent and exploitative began to appear in Lawrence's work while he was at Hillside Hospital. Over the years whites have entered more frequently into his constructed black worlds in a positive way (see *Depression* [fig. 105]).

FIG. 105 *Depression,* 1950, casein tempera on paper, 22 × 30½ in. Whitney Museum of American Art, New York. Gift of David M. Solinger.

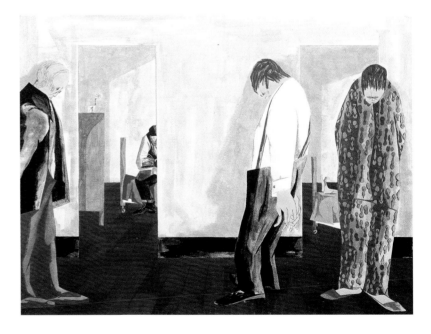

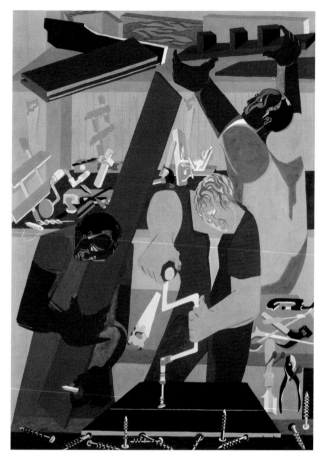

FIG. 106 *Builders No. 1*, 1974, gouache on paper, 30 × 22 in. Collection of The Vatican Museum, Vatican City, Italy.

This is particularly evident in the builders works begun in earnest in about 1968 and carried on throughout the 1990s. Done mostly in Seattle, where the Lawrences have lived since 1970, the builders paintings are indeed distinguished by the cooperative interaction between blacks and whites engaged in carpentry and related constructive projects.[12] *Builders No. 1* (fig. 106) of 1974 is typical with its two black men flanking a Caucasian working a drill and bit. What is perhaps most interesting is that the white builder occupies the central position in the composition, in no apparent conflict with his companions. This is true of numerous other treatments of the subject, and it seems to underline a basic optimism in Lawrence's personal philosophy about the capacity of the races in America to live in harmony.

It is tempting to conclude that, for Lawrence, the world of art permitted him to express ideals that represented hope rather than actual contemporary life. So, somewhat earlier than and even concurrently with the builders paintings, the artist was creating powerful images of protest in the numerous depictions of the struggle theme (1965), *Struggle . . . From the History of the American People* series (1954–6; fig. 107; *No. 27*), *Confrontation at the Bridge* (1975), and the horrific Hiroshima paintings of 1983. But it becomes evident in viewing these works that Lawrence's

FIG. 107 *Struggle . . . From the History of the American People, No. 27: . . . for freedom we want and will have, for we have served this cruel land long enuff . . . —A Georgia slave, 1810*, 1956, egg tempera on hardboard, 11¾ × 15⅝ in. Collection of Howard Phil Welt and Norma Crampton.

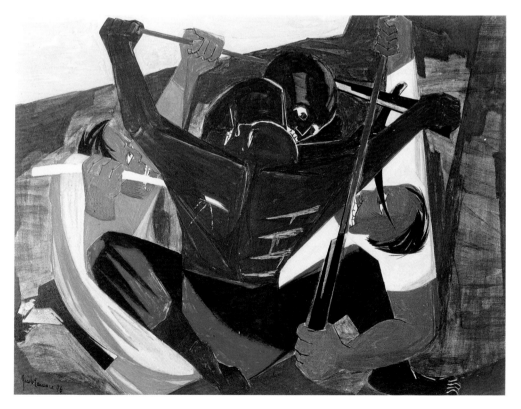

implicit attitude toward the issues they invoke was and is a humanist's insistence on the unity of humanity coupled with horror at mankind's historically demonstrated capacity to justify acts of denial of the humanity of other groups and individuals. Among the most eloquent of Lawrence's statements on this theme is *Ordeal of Alice* (see p. 179, fig. 70). Painted in 1963, the subject is the integration of a Southern school by a lone black girl who bravely faces and endures the arrows—piercing her body as they did that of the famous Christian martyr Saint Sebastian—of racism, hate, and prejudice. Lawrence's entire oeuvre is imbued with political content, emerging from an acute social conscience. What distinguishes his forays into 1960s activist protest art—and despite his own seeming disclaimers I believe that is exactly what these paintings represent[13]—is the increased intensity with which he engages the issues. But what separates them from much other political art of the time is their ability to depict alternative realities, as in *Brooklyn Stoop* (fig. 108), with the mixed-race girls playing with dolls in what can only be understood as an affirmation and celebration of the possibility of a new American society in which such things are not the exception but the rule, the norm. This reading of the picture, in which the shared doll is neither black nor white but blue, indicates—quite accurately in my view—Lawrence's ideological position in regard to race.

The use of modernist formal strategies to enhance emotional expressionism, notably in response to group experience and questions of race, is dramatically present in Lawrence's work. But it is exactly his combination of modernist stylistic devices—flatness, patterned shapes, repetition of forms, reduction and simplicity, arbitrary color—with group-specific subject matter—black American history—that makes it difficult to place him in the continuum of modernism. This enterprise depends on an expanded definition of modernism itself, from the standpoint of embracing what until the demise of formalist criticism (and unitary ideas of a modernism exempt from the limitations of individual/group specificity) had been suspect. On the one hand, political content had been viewed as subverting universal meaning; on the other hand was the assertion that art must be dedicated to social ends. In this situation, art for art's sake—the independence of aesthetic concerns—becomes a preoccupation that black artists simply could not afford. In 1926 W. E. B. Du Bois proclaimed, "'Truth in Art' be damned. I do

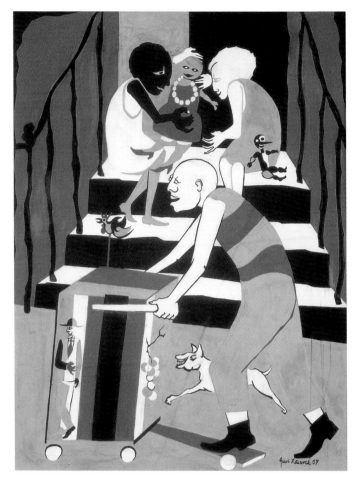

FIG. 108 *Brooklyn Stoop*, 1967, casein tempera on bristol board, 29⅛ × 20⅛ in. Collection of Tacoma Art Museum. Purchased with Acquisition Funds.

not care for any art that is not used as propaganda."[14] The ideological redemption of a race through struggle and creation of a unique culture drawing on origins and history becomes the artistic content, generally presented in the formal clothing of modernist styles.[15]

The dialogue between these two superficially antagonistic (at least incompatible) goals provides the conversational voice in the imagery of Jacob Lawrence. A pictorial and expressive reconciliation of two aspects of modernist art, often seen as contradictory, is achieved in the form of a continuum along which art may move while remaining modern. The same may be said of the tug-of-war between focus on artistic self and group service encountered in Lawrence's work and that of other minority artists. Tracking the fluctuating points on the scale provides insight into the artists' creative self-conception, view of the contemporary world, and relationship to the work. In my view, it is this constant negotiation, absent in the careers of most white male artists, that gives character to African American art, including that of Jacob Lawrence.

The Life of Toussaint L'Ouverture is a veritable marvel of sophisticated modernist design, all the more impressive because the series of forty-one small paintings was completed when the artist was not yet twenty-one years old. Despite the familiar efforts to explain the sophistication of these works in terms of available models provided by artists ranging from Arthur Dove to Diego Rivera and José Clemente Orozco,[16] these influences alone are simply not convincing as complete explanations for Lawrence's precocious achievement. It is true that the images are carefully composed and constructed, displaying surprisingly complex formal relationships considering the deceptive simplicity of the design. In this respect they resemble works by the Italian futurists and the French "primitive" Henri Rousseau. Regardless of the similarities between works of Lawrence and Orozco or Lawrence and Giacomo Balla,[17] I believe that many of these putative sources have been identified retrospectively and are actually indirect. The truth is that European modernism had already been absorbed into American art, illustration, and design, relevant examples of which would have been familiar to Lawrence and in which he no doubt found useful stylistic models.

Lawrence's use of flat-pattern color blocks puts the pictorial emphasis on design, and to a degree it is not unlike the typical illustrator's response to cubist and futurist devices. The decorative deployment of modernist lessons suggests a literally superficial treatment. However, whatever may be missing in an exploration of formal, spatial focus—the definition of modernist substance—is commensurately replaced by the narrative and its core meaning to the reality of human, specifically black, experience. In this respect, Lawrence's art may be viewed as a quest for a different modernist essentialism, one that embodies African American universal, humanist ideals and values. The key to modernity in this paradigm is the presence of a simultaneously held conception of art as an autonomous form of knowledge. As a means to uplift and restore his people, Lawrence's art seems purposefully to embrace and integrate both of these modernist ideals.

Art training and modernist forms are put to the service of a community-related ideal. But a complexity of method and strategy emerges, with Lawrence as a kind of "trickster" presenting concurrent multiple meanings, including shifting attitudes toward his subjects. Never entirely absent, however, nor far

beneath the flat surfaces, is the African American historical saga and contemporary experience. For Lawrence, the challenge was to fuse these concerns: modernist pictorial theory and form, and group identity. This was admirably achieved in *The Life of Toussaint L'Ouverture* and the series that followed immediately thereafter, including *The Life of Frederick Douglass* (1939), *The Life of Harriet Tubman* (1940), and especially *The Migration of the Negro* (1941), the series that brought Lawrence mainstream recognition. But along with that elevated position came the burden of almost single-handedly representing black art and culture in America, a far more sociopolitical than an aesthetic job assignment. Acting in this role, Lawrence takes his place as participant in a debate central to the African American experience: to what extent and in what ways does the black community have a claim on its creative members—the artists, writers, performers, and musicians who operate in the realm of culture and entertainment, admitting politics in widely varying degrees.

The most complicated, but at the same time most edifying, approach to the art of Jacob Lawrence is to consider it within the context of community, a term that functions as a veritable leitmotif in virtually all the artist's comments on his life and art. Any discussion of either requires an attempt to fix his position in the debate that has raged over the years about how best to serve the black community in America through art and creative activity. This is a critical subject for books, and indeed has been just that.[18] Nonetheless, it has been difficult to coax Lawrence into articulating his position regarding race and community. For the most part, in interviews and public statements, he tends to be cautious and conciliatory.

One of the most revealing documents in this respect is the transcript of a 1968 symposium held at the Metropolitan Museum of Art in conjunction with the *Harlem on My Mind* exhibition.[19] It contains what must be among his clearest public pronouncements on the relationship between art and community. In a debate with fellow panelist Tom Lloyd in which Lawrence seemed to have been drawn to reveal more than was his custom, he displays his own commitment to community by insisting on the black subject matter to which his audience could relate. Among a series of remarkable exchanges there is Lawrence's firm response to Lloyd's rather puzzling claim that because his own work was not accepted by the white community he was, perforce, a black artist. Lawrence disagreed:

Wait a minute. From what I've seen of your work—although you may be a terrific artist—there's no possible way that I can see anyone in the Black community *relating* to your work. They may respond to it aesthetically, they may feel that it's a terrific piece—but I can't see how anyone would *relate* to it, and I don't see why they should.[20]

Coming from a different set of observations and a body of work both more controversial and intentionally provocative, Robert Colescott made a related point in defense of his own position on the issue of art and community. His race-relations paintings, often attacked from both sides of the racial divide as caricature, provide members of the black community images to which they can relate—either negatively or positively. But his main point is that to serve the community one must *serve art first.* To do that the artist must be true to him- or herself.[21]

Although usually denying that pressure had been brought to bear regarding style or subject by the "community" or any other group or individual, Lawrence did comment on the importance of being independent as an artist: "This is what I am and this is what I must do. Yes, there is pressure, but it doesn't affect me." And on another occasion: "I would feel that the artist has a commitment to express himself or herself and let it go at that."[22] Lawrence's response when asked what he hopes his works will convey to the viewer further reinforces this independent, universalist approach to art, one in which the object somehow establishes a mystical form of communication beyond specific content: "I'd like for them to see a good painting . . . and that I had something to say about this particular theme. . . . That it's a successful statement, and . . . that it means just as much to a person in one culture as it does to someone of another."[23] These statements represent a view of art that transcends the needs or requirements of a specific group, society, nation, or even race. At such moments, Jacob Lawrence aligns himself with those who value art as a life-enhancing end in itself, without reference to political, social, and ideological concerns. Far from identity politics, this aesthetic stance is actually closer to traditional high modernism. It is precisely this conflict between competing creative goals that gives minority group art, or at least the challenges faced by those who produce it, its special character. And the artists are best understood and appreciated in rela-

tionship to community "obligation" when their chosen, and frequently shifting, positions on the sliding scale of engagement are taken into account.

This dialectic in African American intellectual and creative life is seen most clearly in the realm of letters, and a brief look at the key writers whose work is generally taken to define the polarities is helpful in considering Lawrence's relative position. The battle lines have generally been drawn on issues of opposition to white oppression and the struggle for true equality and/or black separatism. And the debate became more heated and dogmatic during the civil rights years and the rise of the black power movement. Black art increasingly was judged on the basis of its apparent commitment to race and the struggle to achieve political and social power. In such a climate, serious art came to have value only to the extent it could advance the cause. And African American artists and writers, especially prominent ones like Lawrence, were judged accordingly.

In the literary world Richard Wright came to represent the ideologically committed camp and Ralph Ellison the (elitist and modernist) insistence on the autonomy of art and its universal efficacy. In the novels and essays of these major American writers the cultural dilemma faced by black writers and artists is clearly and powerfully articulated, as it is in the work and career of Zora Neale Hurston, W. E. B. Du Bois, Langston Hughes, and James Baldwin. In each case the "Negro condition" (or problem) takes a central place and provides the pivot around which the art inevitably struggles to find an individual creative voice. Subjects and themes are, in effect, predetermined by the authors' race, limiting creative options.

In 1963 the critic Irving Howe initiated a famous debate with Ellison in the pages of *Dissent* and the *New Leader.*[24] Ellison was responding to Howe's "Black Boys and Native Sons" in which he and James Baldwin were criticized for not expressing the suffering of their people as consistently and effectively as did Wright. With eloquence and compelling reason, Ellison champions the right of the artist to function as an individual, true to himself and his calling. He above all objects to being categorized, limited by, and somehow responsible to the black experience. In a key passage, one that could be taken as a paradigm for Lawrence and his art, Ellison wrote:

I agree with Howe that protest is an element of all art, though it does not necessarily take the form of speaking for a political or social program. . . . If *Invisible Man* is even "apparently free from the ideological and emotional penalties suffered by Negroes in this country," it is because I tried to the best of my ability to transform these elements into art. My goal was . . . to transcend, as the blues transcend the painful conditions with which they deal. . . . If there is anything "miraculous" about the book it is the result of hard work undertaken in the belief that the work of art is important in itself, that it is a social action in itself.[25]

Lawrence echoes Ellison's words when he responds to questions about how he would like his so-called protest art to be received by the viewer. Having said elsewhere that he would like his art to make an effective "statement," recently he reflected on the importance of the work as an object: "I would like to think that . . . my work would stimulate, be provocative and appreciated, not only for its content but for its form, not only for the form but for the content which, I hope, [would be] appreciated on various levels."[26] With remarks such as these Lawrence declares himself unequivocally an artist, aligned with those—most prominently among African Americans, Ralph Ellison—who hold that the creative act is valid without recourse to social and political justification. Of course that is not to preclude social observation and comment with a point of view. But relationship to "community" then becomes negotiable if not actually ambivalent. His position as a black man making Black Art is called into question.[27]

Once again Ellison may be turned to for a clear statement of the dilemma and the choices facing the black artist in America. And his formulation draws directly on the famous and influential concept of double consciousness first articulated by Du Bois and subsequently incorporated into most thinking about the African American experience.[28] Elsewhere in his response to Howe, Ellison wrote of a double identity beyond that envisioned by Du Bois, the reconciliation of which is sought in art and not the political realm:

I would have said that it [the novel] is *always* a public gesture, though not necessarily a political one. I would

also have pointed out that the American Negro novelist is himself "inherently ambiguous." As he strains toward self-achievement as artist (and here he can only "integrate" and free himself), he moves towards fulfilling his dual potentialities as Negro and American.[29]

It seems to me that here Ellison is really describing a *triple* identity: black-American-artist. The order in which the identifying adjectival labels are arranged by the artist tell a great deal about worldview, understanding of individuals and society, relationship to art, and therefore the character and meaning of the work itself.

Zora Neale Hurston is the other writer who, along with Ellison and Wright, should be mentioned as a touchstone for the ideological debate to which black artists are unavoidably subjected. At one time a leading writer of the Harlem Renaissance and eventually placed into direct competition with Richard Wright, the other major and contrasting voice of black America, Hurston used myth, allegory, and fable to explore the African American experience. Her interests were universal, the conflicts and dilemmas shared with all other human beings. Her themes were the big ones: love, betrayal, and death, described by Henry Louis Gates, Jr., and Sieglinde Lemke as the "great themes of modernism."[30] What defines Hurston is not *if* she and her writing engage her people but rather *how* they do so. Her stories celebrate black qualities and virtues as cultural means of empowerment. Religion, imagination, rhythm, creativity, and memory sustain African Americans in the face of poverty and discrimination. This spiritual power is unseen by whites (another way to look at the invisibility, the "veil" described by Du Bois as the condition of being black in America, incorporated by Ellison in *Invisible Man*). For Hurston it comes down to materialistic/rational and subjective/emotional ways of confronting the world. In Hurston's anthropological and folkloric worldview, the classic reason-versus-spirit dichotomy provides a survival mechanism —almost a divine gift—for black America. This attitude, perceived as accepting of or at least accommodating white oppression, increasingly marginalized Hurston's writings with the rise of black activism and separatism in the late 1950s and 1960s.

Above all Hurston celebrated the power of storytelling in the black American tradition, reaching back to the griot, the African storyteller whose job it was to keep his people informed

of their tribal history. This is the point at which Hurston's writing and the images of Lawrence coincide. In fact, Lawrence sees himself as the storyteller, the griot.[31] And the nature and implications of this set of shared ideas about race, community, and art that unite the two is of the greatest significance to understanding their artistic vision. In both cases there is a keen and astute recognition that in the stories of black history (including folk tales) reside the strength and hope for community survival, an invisible form of black agency. Hurston placed her stories in the rural South and Lawrence drew his images from the urban North. His subjects were individuals within the Harlem community, participating alone in the universal human drama as did Janie in Hurston's masterpiece *Their Eyes Were Watching God* (1937). This awareness of self and individuality is one hallmark of modernity in the work of both. By their embrace of individual redemption and survival through a capacity to play, dream, and thereby create a secret world, a refuge unavailable to white America, Hurston and Lawrence chose to celebrate the spirit rather than the politics of black America as the battle for civil rights and dignity was joined in the public arena. The question for these and other black artists is to what extent were they engaged in the struggle through their work.

In the case of Jacob Lawrence *The Life of Toussaint L'Ouverture* series may be taken as a touchstone in this respect, as the historic subject was for Paul Robeson and others. The formal qualities of Lawrence's series have been discussed. But the way the theme is handled and understood, the way Toussaint is *used*, is also a key to determining the degree of political engagement of these artists. How did Lawrence understand this dramatic story of the struggle for Haitian independence from the French and liberation of the slave population under the leadership of General Toussaint L'Ouverture? Was it simply a colorful George Washington saga, a demonstration that black history is as distinguished and inspiring as that of white America? Or was the artist attracted by its historical significance to the birth of the black separatist movement, as an allegorical model for civil rights stirrings in twentieth-century United States, culminating in the events of the 1960s? What did the story of Toussaint mean to Jacob Lawrence?

On one level Toussaint may be seen, and was surely utilized by Lawrence, as a hero of mythic proportions, an inspiration and a source for the formation of black self-conception and identity. Black participation in history is, after all, one of Lawrence's favorite themes. In 1857 Toussaint was characterized by the Reverend James Theodore Holly, leader of the effort to establish Haiti as the focus of the black immigration movement, in the following terms:

> Now, with the illustrious traits of character of this brilliant negro before us, who will dare to say that the race who can produce such a noble specimen of a hero and statesman, is incapable of self-government? Let such a vile slanderer, if there any longer remains such, hide his diminutive head in the presence of his illustrious negro *superior.*[32] (emphasis mine)

This is certainly the way Lawrence presented his idealistic hero, as a positive role model for black people in the struggle for their human rights. However, did the artist understand the deeper implications of the story in connection with black separatism and immigration to the Caribbean from the United States? Although the series of small paintings was completed in 1938, a series of silkscreen prints on the theme was done between 1986 and 1993. Many of the images were reworked, and one could be forgiven for speculating to what extent the changes reflected an increased awareness of the political character of the story, as the artist looked back through a lens colored by the events of the 1960s.

Lawrence's relationship to his historical theme series becomes more clearly developed (or at least articulated) in such later works as the Hiroshima paintings of 1983 (fig. 109). The following year he described to Ellen Harkins Wheat his objective: "I used my own experience. . . . I don't think I could have executed the Japanese [features], and I don't think it was important either. I didn't want it to be an illustration of that sort; I wanted it to be in terms of man's inhumanity to man—a universal kind of statement."[33] Here we have a modernist essentialism that addresses moral and ethical issues at the core of human conscience. While grounded in Harlem and black heritage, Lawrence here declares his independence from group—indeed from community—and his participation in the broader humanist discourse. Comments such as these make it impossible to view Lawrence as simply a storyteller; he brings to his choices of subjects a philosophical basis and an ethical perspective. In a certain respect many of his works can be understood as cautionary tales or morality plays.

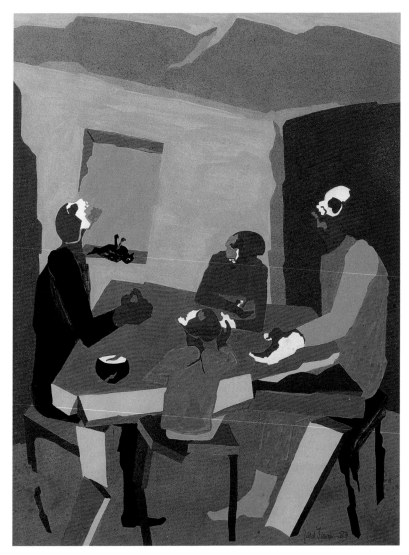

FIG. 109 *Family*, 1983, tempera and gouache on paper, 23 × 17½ in. Collection of Jacob and Gwendolyn Knight Lawrence. Courtesy of Francine Seders Gallery, Seattle.

With this in mind, it seems entirely appropriate to identify Lawrence as a humanist, placing him within that group of artists who employ a figurative style to investigate—to celebrate—aspects of history and the universal human condition. Two elements are fundamental to this approach. First, commitment to human presence and resistance to its disappearance in formal abstraction. Second, insistence on shared human experience despite difference. Lawrence would seem to qualify on both counts. In a speech delivered to artists and art students in the early 1950s he admonished the audience to avoid reducing humanity to the "sterility" of pure formalism: "And your work shall remain without depth for as long as you can only see and respect the beauty of the cube and not see and respect the beauty of man—every man."[34] On another occasion, in discussing *Struggle . . . From the History of the American People,* he explained, "Years ago, I was just interested in expressing the Negro in

American life, but a larger concern, an expression of humanity and of America, developed."[35] And, "The Negro struggle is a symbol of man's struggle, from my point of view."[36]

Lawrence's goals in his art are essentially humanistic and conciliatory, seeking reconciliation and mutual understanding. Like Hurston and Ellison—and unlike Paul Robeson, Richard Wright, and at one time Langston Hughes—Lawrence seems never to have abandoned hope for black progress toward equality within the framework of American democratic ideals. Theirs was a stubborn and lingering shared belief (against the evidence of history, many would say) in the principles on which American government and society were based. As Ellison powerfully wrote in the epilogue to *Invisible Man,* "Could he [the dying grandfather] have meant—hell, he *must* have meant the principle, that we were to affirm the principle on which the country was built and not the men, or at least not the men who did the violence."[37]

As for Lawrence's relationship to modernism, it seems clear that one need not look primarily to formal concerns and style, or even to sources and influences. Rather, it emerges in his sense of obligation to his art, his vocation as an artist, balanced against his identity as a member of the black community. Despite the omnipresence of Harlem and black history in the art of Jacob Lawrence, his cannot be adequately described as black art. It may be better understood, in one sense, as making art out of his own life experience, images constructed from the familiar. What matters is the artist's relationship to his subjects and the ways in which they incorporate a sense of self. This play between the individual—the artist—and the group, is where Lawrence's modernist identity should be sought. Robert Colescott has said that an artist cannot serve two masters, art and community.[38] But the ability to do so, consistently and simultaneously to acknowledge the demands of both, as Lawrence seemed able to do throughout his career, may represent a kind of modernist (or postmodernist) reconciliation.

Finally, in this search for the essential Lawrence, one would do well to turn again to his extraordinary deployment of shapes and colors in the creation of expressive design. Lawrence's contact with Josef Albers at Black Mountain College comes to mind in this connection.[39] Lawrence admired Albers's masterful use of the elements of design and counted him an important source for his own pictorial solutions. But in the end this influence seems to have been limited to certain formal, compositional lessons. Their art, and the nature of their modernism, could hardly be more different. A reading of Lawrence's work in terms of pictorial design (or worse still, as is sometimes the case, mere decoration) could not be more superficial and off the mark. Instead, it should be approached from the standpoint of ritual movement, dance, choreography, gesture.[40] Related to this interest is one of the earliest, most potent, and overlooked influences on Lawrence's visual imagination, cinema. The choice of the narrative series format, as in *The Life of Toussaint L'Ouverture,* is far from accidental: his fascination with movies during the depression years formed a basic idea of storytelling and the value of serial imagery to narrative. For him, the telling of stories through visual means involved a process not unrelated to the storyboards used to lay out film narrative.[41] Lawrence masterfully employs the expressive use of movement, to vitiate his surfaces in the service of theme and idea, and filmic serial narrative, to move the ideas and images across time as well as space. These are among the ways in which he ingeniously has drawn on the lessons of modernist form to serve his fundamentally humanist art.

Jacob Lawrence's imaginative gift was to create poetry of form, and his claim to modernism lies in his ability to animate and reify group history as a means to achieve identity. No elitist, Lawrence never ignored the struggle of his people to improve their lot in America. He deployed his art as a positive force on behalf of his community. At the same time, however, he respected himself and his art enough to resist allowing it to be taken captive by the politics of the various black freedom movements. As an artist, Lawrence understood, and to this day understands, that art has both a private and a public function—universal and inclusive—separate from and beyond the legitimate causes of political and social change. To whatever extent Jacob Lawrence's accomplishment was intuitive, the development of a personal style suitable for the depiction of familiar subjects, or strategic, the result of an artful synthesis of modernist sources, it remains one of the most forceful and compelling tributes to artistic integrity and independence in the history of American art.

NOTES

1. Published in the NAACP's magazine *Crisis* 77, 7 (August–September 1970), pp. 266–7.

2. Ibid.

3. Henry McBride, "Modern Art," *Creative Art* 6, 3 (March 1930), supplement 1; reprinted in Daniel Catton Rich, *The Flow of Art: Essays and Criticisms of Henry McBride* (New York: Atheneum, 1975), pp. 262–6.

4. Ellen Harkins Wheat, *Jacob Lawrence: American Painter*, exh. cat. (Seattle and London: University of Washington Press in association with the Seattle Art Museum, 1986), p. 48. While acknowledging the phenomenon of the almost fully formed birth of Lawrence's art, few writers have more than superficially investigated how that may have come about, beyond reciting the now canonical panoply of sources and influences that have become part of a legitimating effort to relate Lawrence to mainstream modernism.

5. Jacob Lawrence, transcript of tape-recorded interview by author, November 18, 1998, Archives of American Art, Smithsonian Institution, Washington, D.C. (hereafter AAA Interview 1), p. 24.

6. Ibid., pp. 14, 21. One could be forgiven for entertaining the possibility that Lawrence has been subjected to a form of résumé inflation that, in fact, is entirely gratuitous in light of his achievement. It could very well also occur to one that race played some role in this well-meaning but finally unnecessary art-historical elevation. Asked by interviewers about early influences on his work, Lawrence tends to be general and even vague when pressed on specifics. Nonetheless, those who have written about his work have actually made a great deal of what amounts to an artistic portfolio or curriculum vita heavily laden with references to old masters and leading contemporary figures, notably José Clement Orozco. Ellen Harkins Wheat's admirable study of Jacob Lawrence (see n. 4), the most comprehensive treatment of the work available until now, participates in this effort to legitimize Lawrence by emphasizing his participation, through influences, in established art history. There are fourteen references to Orozco, with six illustrations of the Mexican master's work. Among the other putative sources are Goya, Giotto, Posada, George Grosz, Picasso, Stuart Davis, Arthur Dove, John Marin, and even Pieter Breughel the Elder.

7. The New York scene painters, especially the so-called Ash Can group (the Eight) that exhibited together in 1908 at the Macbeth Gallery, seem to be an obvious but inadequately acknowledged source of precedent for Lawrence's Harlem genre scenes. When asked about possible influence Lawrence denied knowing the work of Sloan, Henri, and other members of the Eight when he began his own New York subjects, although he later came to know and admire their work and that of other urban scene painters: "Since I was going to museums and galleries, I probably did see their works but didn't associate their significance with a philosophy or period" (Jacob Lawrence, transcript of tape-recorded interview by author, May 4, 1999, Archives of American Art, Smithsonian Institution, Washington, D.C. [hereafter AAA Interview 2], p. 13). Nonetheless, it is difficult to think of a more relevant example in American art, one very close at hand, for Lawrence. George Bellows and Edward Hopper also come to mind in this regard.

8. Jacob Lawrence, telephone interview by author, May 17, 1999. According to the artist there were three prostitute paintings in a thematic group that addressed exploitation. He recalled that this was during the depression and black women were forced to sell their bodies, often (but not exclusively, Lawrence acknowledges) to white patrons. It seems clear that Lawrence's decision to divide roles and functions along racial lines was conscious and pointed, making these few works among the most direct social comment protest art from his early career.

9. Among the works of Kirchner that come to mind in this respect is *Portrait of a Woman* (1911) reproduced in Peter Selz, *German Expressionist Painting* (Berkeley and Los Angeles: University of California Press, 1957). Both the Kirchner and Lawrence's *Woman in Green* are what Selz describes as "aggressive" paintings, in contrast to Matisse's similar but more passive and pleasantly reassuring figures. In fact, the degree of tension and ambivalence that runs throughout much of Lawrence's oeuvre invites speculation about the presence of race as a central issue.

10. Lawrence, telephone interview by author, May 17, 1999.

11. Ibid. In this interview Lawrence described his protest as "unknowing." He went on to explain that he was not primarily interested in political and social programs; instead, these subjects provided vehicles for self-expression in a medium he could employ since, according to his own account, he could not sing or act. Music, dance, performance, and storytelling are in fact regularly cited by cultural historians and sociologists as strategies employed by American blacks as a means of group and individual survival in circumstances determined by slavery and its long aftermath.

The stories of Zora Neale Hurston are exemplary in this respect. The phenomenon is also noted by most contemporary writers on the black experience in America. However, according to one prominent authority there is much more to be done in establishing the crucial links between forms of plantation creative expression and African American modernism: "The part that their musical creativity has played since then, in making that confinement (slavery) endurable and negotiating ways out of it, has been less extensively commented upon." Paul Gilroy, "Modern Tones," in Richard J. Powell et al., *Rhapsodies in Black: Art of the Harlem Renaissance* (Berkeley, Los Angeles, and London: University of California Press, 1997), p. 14.

12. It is tempting to ascribe to the builders paintings and drawings ideas about carpentry and related building crafts as metaphors for bridging the gap between race. Shared cooperative endeavor, especially working with hands and tools, are at the heart of romantic notions of the redemptive power of labor. The influence of labor and even Marxist ideas—current from the 1930s on the left and a powerful force in the thinking and writing of many black intellectuals (among them Paul Robeson, Richard Wright, and Langston Hughes)—on Lawrence's iconography arises as a possibility. Many blacks viewed the Communist Party as the only organizational entity genuinely dedicated to their interests within the context of labor, and the only reasonable source of hope. However, it is typically difficult to ascertain Lawrence's own views regarding these specific political and ideological connections.

13. Wheat, *Jacob Lawrence: American Painter*, discusses Lawrence's relationship to art and politics (pp. 113–4). Lawrence himself maintained, "I never use the term 'protest' in connection with my paintings. They just deal with the social scene"; quoted in Stan Nast, "Painter Lawrence Is Honored for a 'Protest' That Was Life," *Seattle Post-Intelligencer*, April 5, 1980. See also n. 11.

14. W. E. B. Du Bois, "Criteria of Negro Art," *Crisis* 32 (October 1926), p. 296. Similar ethnocentric views of art are also encountered in the writings of Marcus Garvey and even Alain Locke. A mentor of Lawrence, Locke wrote *Negro Art: Past and Present* (Washington, D.C.: Associates of Negro Folk Education, 1936), the first history of African American art, in which he advocated a racial art.

15. The use of art to construct and retrieve racial, ethnic, national, or cultural identity within a recalcitrant dominant white society is perhaps most evident in the Chicano movement of the 1970s. The most influential modernist models were the great Mexican muralists, Los Tres Grandes, who worked in the United States in the 1930s. The acknowledged relationship between Lawrence and José Clemente Orozco has been frequently noted. Diego Rivera was especially important for the development of North American muralism, and the nativist sociopolitical content of his work pointed the direction for painters on the left as well as artists of color in search of group identity. Among several recent studies that demonstrate this connection, the most thorough and informative in regards to black American art is Lizzetta LeFalle-Collins, *In the Spirit of Resistance: African-American Modernists and the Mexican Muralist School*, exh. cat. (New York: American Federation of Arts, 1996). See also Paul J. Karlstrom, "Rivera, Mexico, and Modernism in California Art," in *Diego Rivera: Art and Revolution*, exh. cat. (Mexico City: Instituto Nacional de Bellas Artes with the Cleveland Museum of Art, 1999), pp. 219–33. For Rivera's impact in the San Francisco Bay area and the influential lessons he provided about dressing politics in quasi-modernist attire, see Anthony W. Lee, *Painting on the Left: Diego Rivera, Radical Politics, and San Francisco Public Murals* (Berkeley, Los Angeles, and London: University of California Press, 1999).

16. See n. 6 in connection with the most often cited sources, notably Orozco. In interviews Lawrence is more likely to cite in a manner both enthusiastic and convincing his admiration for the Italian "primitive" painters of the quattrocento. Among his favorites at the Metropolitan Museum of Art were the Dutch masters and, confirmed by Gwendolyn Knight Lawrence's memory, two paintings by (presumably Carlo) Crivelli (Venetian, active 1457–93) that they admired together during visits to the Met. What seemed to attract Lawrence was the verisimilitude, "making something appear where it's not." This trompe-l'oeil effect is described by Lawrence as "magic." AAA Interview 2, pp. 10–1.

17. When asked about his use of repetitive forms he responds in terms of creating a sense of tension through design (Jacob Lawrence, transcript of tape-recorded interview by A. Jacobowitz, for the "Listening to Pictures" program of the Brooklyn Museum, [day and month not given], 1968, Jacob Lawrence Papers, Archives of American Art, Smithsonian Institution, Washington, D.C. [hereafter AAA], p. 14). He also expresses an interest in movement that he attributes to early contact with the stage, performance, dance, and Harlem street or pool-hall activity. AAA Interview 2, pp. 16–7. Futurism is acknowledged almost as an afterthought, the result of direct questioning. In several interviews Lawrence has claimed early familiarity with the

futurists and suggested it may reach back to art books he saw in his youth. AAA Interview 1, pp. 76–7. However, there is no evidence that by 1937 he was aware of specific works that could have served as models for *The Life of Toussaint L'Ouverture* and stylistically related works.

18. Among the many sources for discussions of the absolutely central issues of double consciousness, race and community, black identity and self-conception, are: W. E. B. Du Bois, *The Souls of Black Folk* (New York: Penguin Books, 1989; first published in USA by A. C. McClurg & Co., 1903), Paul Gilroy, *The Black Atlantic: Modernity and Double Consciousness* (Cambridge, Mass.: Harvard University Press, 1993), and specifically directed to art and culture, Powell et al., *Rhapsodies in Black*. Du Bois's thinking is seminal, introducing the concepts of double consciousness (identity) and the veil, the central metaphor in *The Souls of Black Folk*.

19. The exhibition *"Harlem on My Mind": The Cultural Capital of Black America, 1900–1968* (January 18–April 2, 1969) is now seen as a historic event. That the Metropolitan Museum of Art intended it to be so is clear from the description in their museum bulletin (27, 5 [January 1969], p. 243): "On the eighteenth of this month The Metropolitan Museum of Art will open an exhibition that has *nothing to do with art in the narrow sense* [emphasis mine]—but everything to do with this Museum, its evolving role and purpose, what we hope is its emerging position as a positive, relevant, and regenerative force in modern society." What should be immediately recognizable here is the old modernist faith in social progress and change through art, a belief Lawrence held, but in a qualified sense. Also interesting is the seemingly defensive description of the show, as if excuses needed to be made. The whole, unpleasant question of affirmative action comes into play at this point. The symposium panelist Sam Gilliam even went so far as to raise the ever unpopular issue of "quality of aesthetic experiences" among blacks and the observation that few attend museums and cultural events (from "The Black Artist in America: A Symposium," transcript, *The Metropolitan Museum of Art Bulletin*, p. 251).

20. Jacob Lawrence responding to Tom Lloyd as recorded in "The Black Artist in America: A Symposium," p. 251. Lawrence's fundamentally populist approach echoes the views of Paul Robeson who insisted that ordinary black working folk, not the entrepreneurial or intellectual elite, were the source of true African American culture: "I will never forget that the ultimate freedom and the immediate progress of my people rest on [the workers]—the vast mass of Negro Americans from whom all talent and achievement rise in the first place"; address to the Annual Convention of the National Negro Labor Council, Cleveland, Ohio, November 21, 1952. This apparently shared attitude undoubtedly underlies the builders theme and related works of Lawrence.

21. Robert Colescott, transcript of tape-recorded interview by author, April 14, 1999, AAA, p. 16. Like Lawrence, Colescott takes the position that independent vision must be followed to make art truly effective: "They [some in the black community] want to have some kind of control over visual statements. Black artists should be free to express themselves . . . to do their own jobs, which is to be courageous citizens and artists." This fundamental view of the role of the artist serves to set them, despite commitment to race, apart from more polemical black artists.

22. AAA Interview 1, p. 46. AAA Interview 2, p. 20.

23. Lawrence, interview by Jacobowitz, pp. 20–1.

24. "The World and the Jug," in *Shadow and Act* (1953; reprint, New York: Quality Paperback Book Club, 1964), combines two essays in which Ellison responds to Howe's "Black Boys and Native Sons," a critique of Ellison and James Baldwin compared unfavorably with Richard Wright, in *Dissent* (fall 1963). Ellison's initial response appeared in the *New Leader;* the second essay, "A Rejoinder," followed Howe's reply, also published in the *New Leader.*

25. Ellison, *Shadow and Act*, p. 137.

26. AAA Interview 1, p. 54.

27. The debate about the nature of Black Art, as opposed to art by black Americans, implying an obligation placed on the artist, is discussed in most studies of African American art, including Wheat (*Jacob Lawrence: American Painter*, pp. 109–15) and Powell et al. (*Rhapsodies in Black*, pp. 14–33).

28. See n. 18.

29. Ellison, *Shadow and Act*, p. 110.

30. Henry Louis Gates, Jr., and Sieglinde Lemke, introduction to Zora Neale Hurston, *The Complete Stories* (New York: Harper Collins Publishers, 1995), p. xxiii.

31. Gwendolyn Knight Lawrence uses the term *griot* to describe Lawrence's function as an artist. The Lawrences agree with Patricia Hills's use of the term in connection

with Jacob's work in her introduction to Wheat's *Jacob Lawrence: American Painter.* AAA Interview 1, p. 40. Elsewhere in the interview (p. 42) the point is reinforced. According to Lawrence, "I loved to paint and I loved to tell a story."

32. James Theodore Holly, "A Vindication of the Capacity of the Negro Race for Self-Government and Civilized Progress," in *Black Separatism and the Caribbean, 1860,* ed. Howard H. Bell (Ann Arbor: The University of Michigan Press, 1970), p. 50.

33. Lawrence, in conversation with Ellen Harkins Wheat, July 2, 1984, quoted in Wheat, *Jacob Lawrence: American Painter*, p. 154.

34. Jacob Lawrence speech text, no date or title (ca. 1953), Jacob Lawrence Papers, Syracuse University, New York, quoted in Wheat, *Jacob Lawrence: American Painter*, p. 106.

35. Quoted in Bennett Schiff, "Closeup: The Artist as Man on the Street," *New York Post Magazine,* March 26, 1961, p. 2.

36. Jacob Lawrence, transcript of tape-recorded interview by Carroll Green, Jr., October 26, 1968, AAA, pp. 74–5. Standing in contrast to Lawrence's statement are the militantly separatist views of Marcus Garvey and implicitly ethnocentric theories of Alain Locke as expressed in Edmund Barry Gaither, introduction to *Afro-American Artists, New York and Boston* (Roxbury, Mass.: The Museum of the National Center of Afro-American Artists with Museum of Fine Arts and the School of the Museum of Fine Arts, 1970). See n. 14.

37. Ellison, *Invisible Man* (1952; reprint, New York: Modern Library Edition, 1994), p. 564. Although the Lawrences knew Ellison in Harlem, it remains an open question as to how directly Jacob was affected by the writer's ideas. Langston Hughes's contrasting, disaffected view was expressed by his very popular syndicated newspaper creation, Jesse B. Semple (a.k.a. Simple): "If I was to pray what is in my mind, I would pray for the Lord to wipe white folks off the face of the earth. Let 'em go! Let 'em go! *And let me rule awhile!*" From "Possum, Race, and Face" (1950), anthologized in Akiba Sullivan Harper, ed., and Arnold Rampersad, *The Return of Simple* (New York: Hill and Wang [A division of Farrar, Straus and Giroux], 1994), p. 95.

38. Colescott, interview by the author, p. 16.

39. Lawrence frequently cites Josef Albers as having had an important impact on him as an artist. But he denies any direct stylistic influence: "I didn't know a thing about Josef Albers until he invited me [in 1946] to Black Mountain [College Summer Institute] to teach." And elsewhere, "I would say I was less involved consciously with form than I was with content." AAA Interview 1, pp. 80 and 35.

40. For the importance of movement to Lawrence and its incorporation into his work, see AAA Interview 2. "I was around people in the theatre. I was around people who dealt with movement, who dealt with movement on the stage" (p. 16). Gwendolyn Knight Lawrence prefers to see the phenomenon in her husband's paintings as "gesture" (p. 17).

41. Throughout interviews and elsewhere and as recently as a telephone conversation with the author, October 21, 1999, both the Lawrences point to cinema as a major influence on Jacob's work. Their favorite movies in the 1930s included *The Thin Man* and the *Charlie Chan* series and movies with Shirley Temple, Ann Harding, Joan Crawford, and Bette Davis. According to Jacob, "the film might have played a very important part in . . . a certain kind of storytelling." AAA Interview 2, p. 3. He also made the connection between the movement in futurist painting and that of film. AAA Interview 1, p. 74. Knight Lawrence is quite explicit in locating a major source for Jacob's approach to his painting in the experience of cinema; she recalls how they saw Russian and German films, which she associates with expressionism. AAA Interview 1, p. 25. Both of them mention their friend Jay Leyda, an admirer of Lawrence's work who set up the film library at the Museum of Modern Art. Jacob remembers that Leyda "took a great interest in . . . what I was doing. I had just completed the [*Harriet Tubman* theme narrative] . . . and I was going into the *Migration* [*of the Negro*] series. So, both in form and content, he was greatly [interested]." AAA Interview 1, p. 27. *Two People in a Bar* (1941) is inscribed "for Jay Leyda," an indication of a close relationship that surely involved discussion of movies and perhaps cinematic elements shared with narrative painting. The Lawrences do not recall specifically having been introduced by Leyda to the use of storyboards in film narrative construction. Telephone interview, October 21, 1999. However, the general connection is reinforced by Lawrence's practice of drawing inspiration and formal lessons from his Harlem environment. He frequently mentions the Harlem Apollo Theatre, where he was impressed by the comedians and the chorus girls: "everything was jagged, bright, and brittle—kind of all the forms were people—so maybe my color and my shapes have this quality and developed out of that [experience]." Lawrence, interview by Jacobowitz, p. 17.

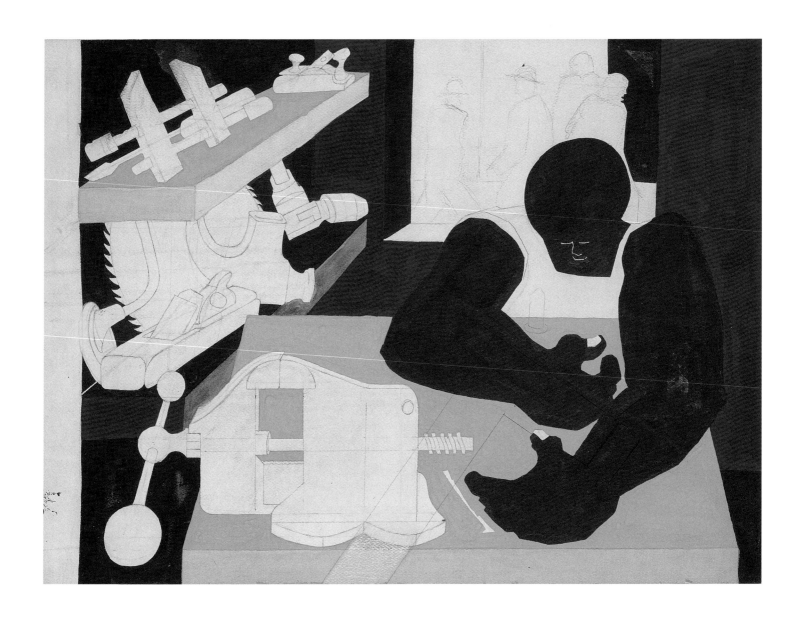

FIG. 110 Unfinished painting, 1977. A well-developed underdrawing lies beneath all of Lawrence's paintings. Collection of Jacob and Gwendolyn Knight Lawrence.

Elizabeth Steele

The Materials and Techniques of Jacob Lawrence

JACOB LAWRENCE'S EARLY TRAINING at the Utopia Children's House, the Harlem Art Workshop, and the Works Progress Administration introduced him to the materials that he would use throughout his career. It was in these depression-era centers that he became familiar with tempera paints, various papers, illustration board, and hardboard, and the appearance of his work is strongly influenced by his choice of media. Of great significance is his exclusive use of opaque, water-based paints, which dictates the techniques that he has developed for creating lively compositions from two-dimensional shapes. Of equal importance is his process, which is meticulous and consistent, so consistent, in fact, that the formula he follows for building a composition has changed little from the beginning of his career. Rather than change, his working method has matured over the years. This study seeks to document Lawrence's approach to his materials and techniques over a sixty-year period.

Lawrence is among the masters of tempera in the twentieth century, yet the identity of this medium with regards to his paintings and those of other contemporary artists has caused much confusion. Tempera comes from the Latin word *temperare*, meaning "to mix" or "to regulate." The classic recipe as recorded by Cennino Cennini in *Il libro dell'arte* in the late fourteenth century calls for emulsifying egg yolk with water and is considered by purists to be the only true definition of tempera.[1] However, in the first half of the twentieth century, many new water-based paints were developed to meet a demand from the growing advertising industry for fast-drying, opaque, matte paints. They were marketed by names such as showcard colors, poster colors, school colors, and mat [*sic*] watercolors in addition to the term *tempera*. Recipes changed in response to availability and cost for raw materials.[2] However, they were all classified by the paint manufacturers as "tempera," and it is from here that the confusion stems. While a shared characteristic was the ability to be thinned with water, the binding media may have included mixtures of gum and glue, starch and glue, glue and egg, egg and oil, egg, resin and oil, and so forth. Adding to this mélange, casein tempera was first introduced as a commercially prepared artist's paint after World War II, a medium known to the ancient world but in modern days associated primarily with house paint.[3] Max Doerner, the author of the popular handbook *The Materials of the Artist*, published in 1934, defines tempera paint as an emulsion. In his chapter on tempera painting he includes no fewer than eight tempera media: egg tempera, egg white tempera, casein tempera, gum tempera, animal glue tempera, vegetable glue tempera, soap tempera, and wax emulsion tempera.[4] Interestingly, the medieval recipe for tempera using egg yolk alone as the binder is mentioned only as historical interest. Ralph Mayer, the author of another well-read manual published in 1940, *The Artist's Handbook of Materials and Techniques*, describes tempera as follows: "In the modern usage of the term . . . a medium that may be freely diluted with water but which upon drying becomes sufficiently insoluble to allow overpainting with more tempera or with oil and varnish mediums."[5] He goes on to give instructions for making eight tempera paints including the egg-yolk-and-water recipe, three egg-and-oil recipes, a gum tempera, a wax-emulsion tempera, an oil tempera, and a casein tempera. From the above, it becomes evident that in the twentieth century the definition of tempera must take on a broader scope than a medium containing egg yolk alone as the binder. To better understand the aqueous media available to Lawrence, scientific analysis of paint samples taken from a representative group of his works was

conducted for this study. A summary of this analysis identifying the components of the media that he used can be found in the appendix at the end of this essay.

To understand Lawrence's painting method, one must first look at the underlying structure of his compositions. An unfinished work from 1977 sheds light on his technique (fig. 110). Lawrence began every painting with a well-developed underdrawing. With the exception of the series works and mural commissions, he does not make preparatory studies but rather conducts all editing and revisions in the drawing, which can be seen here. It is initially laid in with a tentative, light graphite sketch, as found, for example, in the figures seen through the window in the upper right. Lawrence then reworks the initial sketch, erasing some lines and reinforcing others with heavier, more emphatic marks on the paper until he arrives at his final composition. Such revisions in the drawing stage are apparent in the tools on the shelf. As a consequence, there are rarely large changes in his compositions once Lawrence begins to apply paint.

Because commercially produced temperas were made for illustrators and sign painters, manufacturers called them showcard colors or poster paints. They were sold in small jars that often bore several names and uses on the same label, such as the Rich Art No. 24 Poster Black, called a "moist water color" for "tempera, poster, airbrush" (fig. 111). Commercial artists demanded a fast-drying paint that was matte and opaque. They needed to be able to produce graphic works in a short amount of time and in a flat color that could be photographed for repro-

duction, qualities provided by tempera's body and covering power. They were applied in thin layers, two or three at the most, to achieve an opaque color.

The materials of the graphic artist suited Lawrence's painting process. He recalls that he was attracted by the low cost of poster paints and bought them at five-and-dime stores. More important, however, he was attracted to the tempera medium because, in his words, "I'm not the kind of person to drag things out. I work direct. So that's the reason, a simple reason, it's fast, it's just that, easy to use, for me."[6] Such a fast-drying medium does not allow modeling of forms to indicate volume and space or impastoed surfaces, and none are seen in *Beggar No. 1* of 1938 (fig. 112),[7] among the early works by Lawrence to be executed in commercially prepared tempera. Instead, the sharply skewed perspective of the red brick building is employed to promote a sense of three-dimensionality. Movement is suggested by the distorted angles in the figures' stances. Despite the limitations of a fast-drying medium, which once applied does not permit much manipulation, Lawrence is able to vividly capture the essence of the scene. His strong and expressive drawing ability allows the artist to distill the activity of the street and the dependence of the beggar leaning on his escort into flat, two-dimensional shapes rendered in opaque, matte colors.

The density of the paint and the way in which overlapping brushstrokes pool on the surface in a lighter tone distinguish the appearance of his tempera medium during the late 1930s and early 1940s. These inexpensive paints usually contained fillers that contributed to their opacity and matteness to the extent of

FIG. 111 Jar of Rich Art tempera paint. Photo courtesy of Clare Wilson, WilsonWorks Graphic Design.

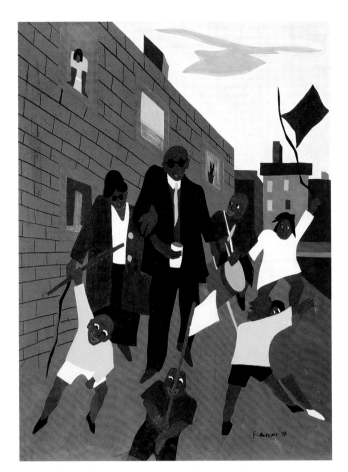

FIG. 112 *Beggar No. 1*, 1938, tempera on illustration board, 20 × 15 in. The Metropolitan Museum of Art. Gift of New York City WPA, 1943, 43.47.28. The medium is a commercial preparation that was called poster paint or showcard color by manufacturers. Its appearance is distinguished by its dense opaqueness and by matteness to the extent of appearing chalky.

FIG. 113 Showcard colors, exact date not known. Colors in the hand-painted swatches are remarkably similar to the palette employed by Lawrence in the late 1930s and early 1940s. Photography courtesy of Martin/F. Weber Co., Philadelphia.

seeming chalky. Analysis of the red paint used for the brickwork of the building in *Beggar No. 1* indicates that it is composed of a single pigment, iron oxide red, and a transparent mineral filler. The binding medium has been identified as a mixture of gum and glue.[8] The bold, bright hues present in this painting suggest that Lawrence used the paints unmixed, straight from the jar throughout the picture. The colors in *Beggar No. 1* are remarkably close to handpainted swatches of contemporary showcard colors from the F. Weber Co., a further indication that he rarely mixed the commercially prepared colors (fig. 113). Lawrence recalls that he had to stir the paints before using them. Indeed, the directions given on the jar label read, "Stir well. Ready for use with the Brush,"[9] because without the dispersants that would be added to later tempera paint recipes, the binder and pigment settled at the bottom of the jar. The lack of visible brushstrokes throughout most of the picture is striking in the extremely flat shapes, a consequence of the density of the paint as employed straight from the jar. This appearance conforms to the paint company's promise. Showcard colors were advertised as "ready

for use and are free flowing, leaving no brushstrokes, drying with a brilliant satiny mat finish; being opaque, they can be successfully applied one over the other, without disturbing the underlying color, similar to Tempera."[10]

Because of the artist's limited means, his early paintings were typically on very inexpensive, poor-quality papers. It is not uncommon to find brown wrapping or Kraft paper as the support for works at the beginning of his career. At the time that he painted *Beggar No. 1* on illustration board,[11] Lawrence was receiving higher-quality materials from the WPA.[12] However, a sense that the artist was still very concerned about the cost of his materials is apparent in their small size. This work measures only 20 by 15 inches, coincidentally the same size as *Subway* from the same year (fig. 114). A manufacturer's printed label, cut in half, is found on the reverse of each of these works. When put together, like two pieces of a puzzle, the identity of the supplier becomes apparent. Lawrence used Yankee Board, manufactured by Friedrich Co. of New York. The identical dimensions of *Beggar No. 1* and *Subway* may indicate that the supports were cut from

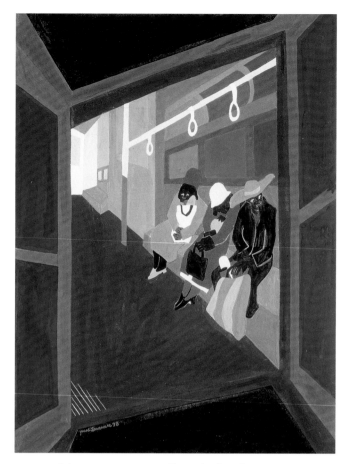

FIG. 114 *Subway*, 1938, tempera on illustration board,
20 × 15½ in. Schomburg Center for Research in Black
Culture, New York Public Library, Astor, Lenox & Tilden
Foundations.

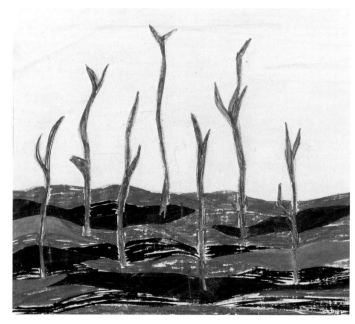

FIG. 115 Close-up of panel *No. 13* from *The Migration of the
Negro*, 1941. The Phillips Collection, Washington, D.C. The
artist-applied ground resulted in microscopic air bubbles in
the preparation layer. Lawrence exploits this texture in the
surface to depict the parched earth.

the same piece of illustration board. It is probable that by divid-
ing a single board in half to produce two paintings, Lawrence
was able to stretch his limited supplies. The artist has com-
mented that the small size of his works is attributable to reasons
of "economics."[13]

Lawrence completed the *Toussaint L'Ouverture* series in
1938. From 1938 through 1941 he completed three more series:
The Life of Frederick Douglass, The Life of Harriet Tubman, and *The
Migration of the Negro.*[14] For these ambitious works, he adopted
hardboard panels[15] and casein tempera paints. Together with his
soon-to-be wife, Gwendolyn Knight, he prepared the hard-
boards with a traditional ground layer made of rabbit-skin glue
and whiting. While using a conventional recipe for the prepara-
tion layer, the resulting surface is not the traditional smooth
ground surface that is indicated in artists' manuals. On the con-
trary, it is pitted and full of tiny air bubbles. The tiny white dots
that appear in the paint film, particularly noticeable in dark pas-
sages, visually unite these works. While it was not an intentional
device of the artist, it provided a surface with texture that
Lawrence exploited. Lawrence arrived at a convincing depiction
of the parched fields in the South on panel *No. 13* of *The Migra-
tion of the Negro* series by using a dry-brush technique that picks
up the microscopic-sized voids in the unusual preparation layer
(fig. 115). The barely wetted brush skips across the irregular sur-
face and the air bubbles in the ground help to describe the dis-
used and arid soil.

The series were conceived as single works, not as indi-
vidual paintings. In discussing *The Migration of the Negro* series,
Lawrence explained that he worked on all of the paintings at the
same time, "to hold it together, to unify it, because if I did one
panel and completed it, the next panel would probably be
different, you see" (fig. 116).[16] It was also important to keep his
colors uniform within the series. To this end, he bought dry pig-
ments from the well-known supplier Fedanzie and Sperrle, lo-
cated at 103 Lafayette Street in lower Manhattan (fig. 117) and
made his own casein tempera. He used the pigments unmixed
so that the colors would not vary from one panel to the next,
only adding white to obtain lighter shades of a hue. The strength
and vibrancy in his palette can be attributed to the use of pure,
unmixed colors. With all the prepared panels laid out, he sys-
tematically applied one color to each. He began with black and
then moved on to the lighter values, applying each color in

FIG. 116 Installation of *The Migration of the Negro*, 1941, in the 1999 exhibition of these works at The Phillips Collection, Washington, D.C.

FIG. 117 Dry pigments used by the artist in the preparation of casein paints used in *The Life of Frederick Douglass* (1939), *The Life of Harriet Tubman* (1940), and *The Migration of the Negro* (1941) series.

FIG. 118 *Trees*, 1942. Howard University Gallery of Art, Washington, D.C. While the trees and sky appear to be painted in gouache, the greens, earth reds, dark browns, and blacks in the lower portion of the painting have the density of a tempera (poster) paint.

FIG. 119 *There Are Many Churches in Harlem The People Are Very Religious*, 1943, watercolor and gouache on paper, 15½ × 22½ in. Amon Carter Museum, Fort Worth, Texas.

succession to every picture. Lawrence's homemade casein tempera resulted in a dry, matte surface that can be differentiated by its relative transparency and lack of body from the poster paint tempera used earlier.

In the 1940s Lawrence shifted from working in tempera media to gouache.[17] Gouache is defined as "opaque color and/or color mixed with white." Its principal ingredients are gums mixed with plasticizers and wetting agents plus pigment.[18] However, there are numerous works from the early 1940s in which both tempera and gouache seem to be present. One example is *Trees* (fig. 118) from 1942, painted during Lawrence's stay in Lenexa, Virginia. While the blue used in the sky and the browns used in the tree trunks have the appearance of a relatively transparent gouache medium, the greens, earth reds, dark browns, and blacks used elsewhere have more body and density, suggesting a tempera medium. An in-depth examination of *There Are Many Churches in Harlem The People Are Very Religious* (fig. 119) has revealed some paints that are completely water soluble and others that are completely water insoluble on the same work; additionally, some colors are glossy while others are matte. This strongly suggests that more than one medium was used on this work.[19] Given Lawrence's limited means, it is entirely probable that works from this time fall into a transitional period when he was using up his supply of tempera while

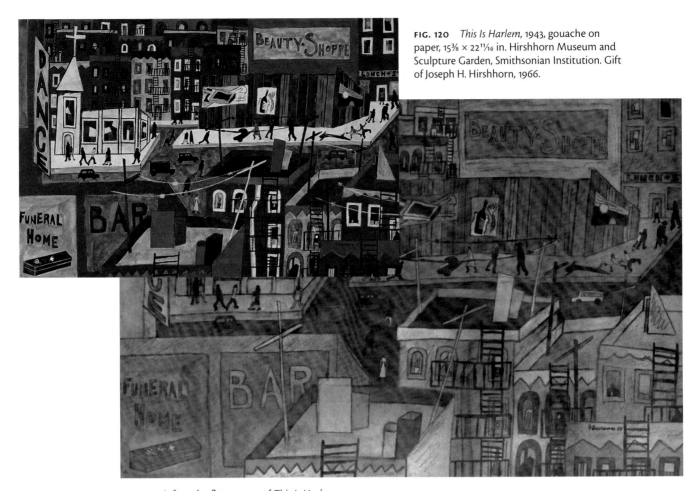

FIG. 120 *This Is Harlem*, 1943, gouache on paper, 15⅜ × 22¹¹⁄₁₆ in. Hirshhorn Museum and Sculpture Garden, Smithsonian Institution. Gift of Joseph H. Hirshhorn, 1966.

FIG. 121 Infrared reflectogram of *This Is Harlem*. Loosely drawn lines reinforced by darker, stronger lines are apparent in the drawing of the buildings in the lower right.

adopting gouache as a new aqueous paint. To Lawrence, the most important characteristic was that his paints be water-based, which allowed him to work in his fast, direct manner. Tempera, casein, gouache, and watercolor can be easily mistaken for one another, and as a consequence many of Lawrence's works throughout his career have incorrect media attributions. While gouache is less opaque than tempera or casein, it is more opaque than watercolor. It has less body than tempera but more body than watercolor. When any of these media are thinned to a wash consistency, it is difficult to differentiate them from transparent watercolor. Gouache, while generally matte, can be shiny in some colors as compared with poster paint temperas or casein, which are matte to the extent of appearing dry. Whether watercolor or thinned gouache is present in some works can never be fully resolved, but it is suspected that Lawrence generally used the latter since it is clear that he preferred opacity in his colors. Nonetheless, the important issue to understand about his use of aqueous media is that he did not build up forms with layers of transparent wash, as would a tra-

ditional watercolor painter, but instead juxtaposed flat colored shapes against one another.

An infrared reflectogram of *This Is Harlem* reveals that the strength of his composition is derived from the exceptionally complete graphite drawing that lies below this work (figs. 120, 121). Every detail of the composition can be found in the underdrawing. The lines are initially light and loosely formed. As the forms evolve, he goes over these lines with a heavier, darkly drawn mark. Squiggly pencil lines can be seen in the infrared reflectogram that are presumably a notation for color or tone, made in the process of working out the composition. In this work, the underdrawing serves as a dark outline for many shapes and, in some instances, Lawrence reinforced the underdrawing with graphite on top of the paint. By reworking his underdrawing many times, he refined the image to a level of completion so that when he proceeded to the next stage, that of applying color, there are few changes from the underdrawing. Next, Lawrence meticulously painted in and around the shapes of the underdrawing. He used the paint both diluted with water

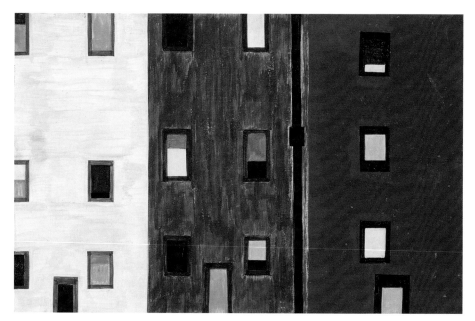

FIG. 122 *The Migration of the Negro, No. 31: After arriving North the Negroes had better housing conditions*, 1941, casein tempera on hardboard, 12 × 18 in. The Phillips Collection, Washington, D.C.

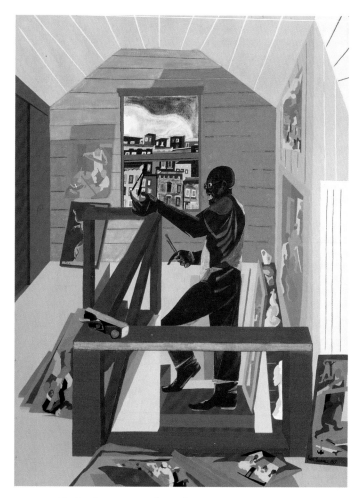

FIG. 123 *The Studio*, 1977, gouache and tempera on paper, 30 × 22 in. Seattle Art Museum. Partial gift of Gull Industries; John H. and Ann Hauberg; Links, Seattle; and gift by exchange from the estate of Mark Tobey.

in some places, so that the paint is mottled and transparent in some passages, and directly from the tube in others, rendering the color opaque and flat. *This Is Harlem* has been traditionally called a gouache on paper, but much of the palette is identical to that in *There Are Many Churches in Harlem* . . . so that a mixed aqueous media palette is more likely.[20]

This Is Harlem is a significant work because it captures the excitement Lawrence found in his community, in the activity on the streets and in the commerce of urban life. He has frequently acknowledged the tremendous impact that the vitality of Harlem had on him at an early age.[21] Repetition of the building facades, the windows, and the fire escapes epitomizes his love of the visual rhythms that he found in the big city. The alternating heights, colors, and widths of the apartment buildings move the eye around the picture plane in addition to creating the illusion of distance from the two-dimensional, flatly painted rectangles. Recurring pictorial motifs such as the windows can be found throughout his paintings. They are reduced to an abstract pattern in panel *No. 31* of *The Migration of the Negro* series (fig. 122) and are seen through the attic window of his Seattle house in the 1977 work *The Studio* (fig. 123).[22] When questioned about the anachronism of placing a New York vista in a Seattle suburb, he replied that he just "liked the pattern and the design" in these shapes. His predilection for certain shapes and patterns explains why so much repeated imagery from his youthful urban environment is found in his works.[23] Acute observation of his surroundings from his early, formative years is translated into the keen sense for composition that makes his images successful.

In the late 1940s Lawrence tried a different water-based paint, egg tempera. Many artists of the period championed a revival of this Renaissance medium, including Reginald Marsh, Ben Shahn, Isabel Bishop, Thomas Hart Benton, Paul Cadmus, and Andrew Wyeth. *The Checker Players* is an egg tempera on hardboard panel from this period (fig. 124).[24] The support is commercially prepared with a ground layer on both sides. This may be the "gesso board" manufactured by Leonard Bocour, which was advertised as primed on both sides for use.[25] Bocour was very

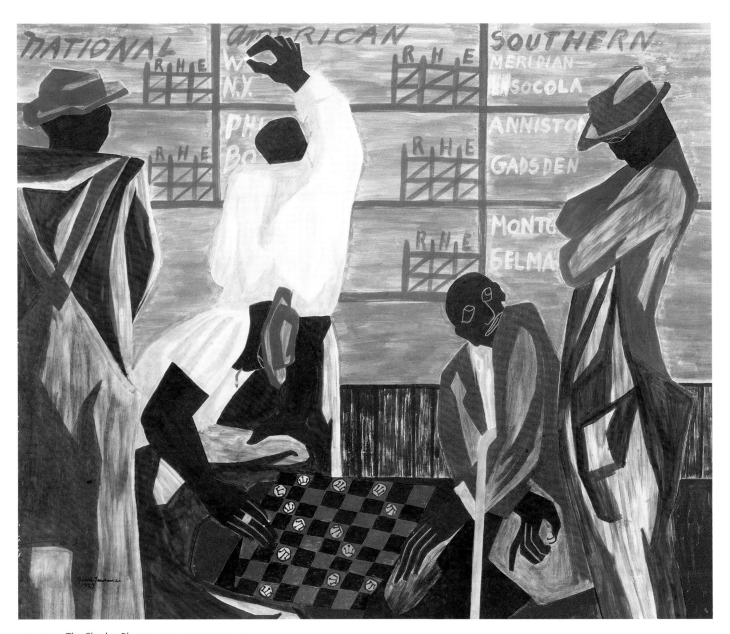

FIG. 124 *The Checker Players*, 1947, egg tempera on hardboard, 20 × 24 in. Worcester Art Museum, Worcester, Massachusetts. Gift of Saundra B. Lane in memory of her husband William H. Lane and purchase through the Stoddard Acquisition Fund. Abstract painting evolves within the elements of the composition, such as the back of the shirt of the figure writing on the chalkboard, as Lawrence moves away from flat shapes and begins to depict volume in the forms.

popular among artists for the special attention that he took to develop products to meet their needs, the gesso panel being a case in point. Lawrence remembers attending New Year's Eve parties at Bocour's apartment and the latter's encouraging him "to try my new gesso panels."[26] When Lawrence was buying the panels at art supply stores, in the late 1940s, he also seems to have been making his own paint. Analysis of the paint medium used on *The Checker Players* reveals it to be composed of pure egg.[27] Lawrence does not remember where he got his recipe, but thinks it was probably from a friend. It called for equal parts of egg yolk and water, to which he added a few drops of formaldehyde as a preservative; to further the shelf life, he kept the prepared emulsion in jars in the refrigerator.[28] The different handling qualities of egg tempera led Lawrence to alter his technique, which is apparent in this work. He acknowledges that he used egg tempera differently from other media, calling it "a glazing medium."[29] The paint was applied more thinly, and the readily visible brushstrokes play a textural role in depicting elements of the composition, such as the paneled wood wall below the chalkboard. Working within distinct passages, he used several thin coats of the same color to articulate the arch of an upraised arm or the slanted shift of a shoulder and to suggest folds and shadows in the men's clothing. In a departure from flat shapes, he thus begins to model the form. However, the modeling is only suggestive and not literal. Albeit an unintentional consequence, it is here that some of the most beautiful abstract

painting evolves within the forms of his representational images, such as in the shirt back of the man writing on the chalkboard and in the overalls of the standing figure with crossed arms. Reflecting on these shapes and brushwork, Lawrence says that this method of working was unself-conscious but that it made the painting process more interesting for him.[30]

Another technique he developed was to paint around details in the underdrawing, leaving the ground layer unpainted. In *The Checker Players*, the facial features and the spaces between the fingers are created in this manner. He painstakingly brushed the brown paint up to and just over the edges of the underdrawing, leaving a thin line in reserve to depict the eyes and other fine details. In this work, he then painted a transparent yellow over the reserved space (fig. 125). The artist refers to this method as "painting on either side of the line." He used this technique throughout the rest of his career and it became a hallmark of his style. Lawrence was enthusiastic about the unique character that these unpainted thin spaces had on his depictions of figures and objects. He liked "the feeling, the effect, [to] remain open to the possibilities of freedom of these lines."[31]

The eleven months that Lawrence spent at Hillside Hospital in 1949–50 mark a distinct period in his output and a departure into a new, commercially prepared medium, casein tempera.[32] *Sedation* (fig. 126)[33] is one of eleven paintings on paper from this period. The works from his eleven months of psychological counseling are the least flat, most three-dimensional

FIG. 125 Close-up of head of seated figure in lower right in *The Checker Players* (fig. 124). The facial features are created by a reserve technique where the paint is applied up to and just over the edge of the underdrawing, leaving a thin line of the preparation layer unpainted. Lawrence then brushes a transparent yellow over the white, exposed ground.

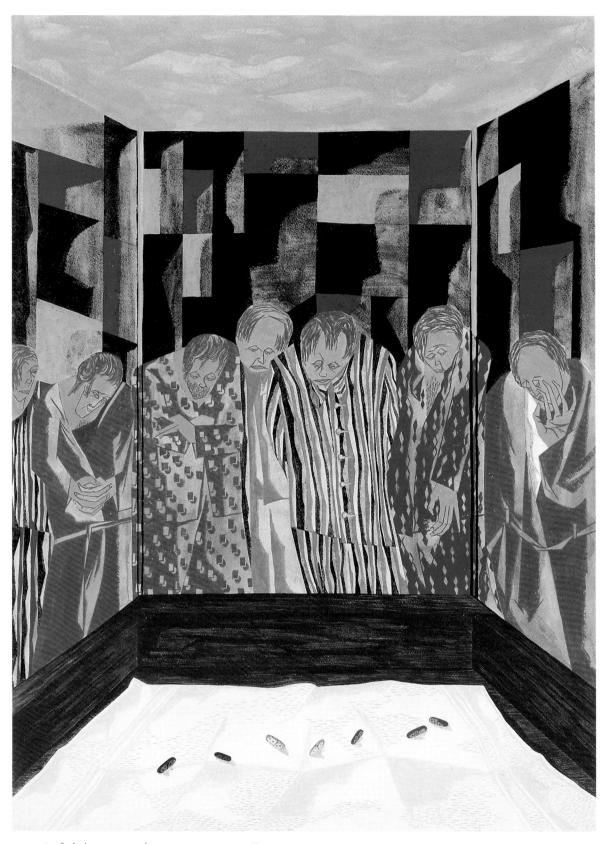

FIG. 126 *Sedation*, 1950, casein tempera on paper, 30⅞ ×
22¾ in. The Museum of Modern Art, New York. Gift of Mr. and
Mrs. Hugo Kastor, 1951. The palette of this work and others of
the period has a remarkable similarity to the hues found on
the "Bocour Casein Colors" brochure. It produces the driest
surface appearance of all the aqueous media employed by
the artist.

MANUFACTURED BY THE BOCOUR HAND GROUND ARTISTS COLOR COMPANY NEW YORK 11, NEW YORK

MAY BE THINNED WITH CASEIN EMULSION OR WATER
FOR: WATERCOLOR · GOUACHE · TEMPERA UNDER-PAINTING
MIXED TECHNIQUE · USED ON : ILLUSTRATION BOARD · PAPER
CANVAS · GESSO PANELS · · EXCELLENT FOR AIRBRUSH WORK

FIG. 127 Brochure with hand-painted swatches of "Bocour Casein Colors," date unknown. Photo courtesy of Leonard Bocour Papers and Business Records, 1947–92. Archives of American Art, Smithsonian Institution, Washington, D.C. The confusion regarding media identification is understandable when these paints were advertised as being able to be thinned with casein emulsion or water to make watercolor, gouache, or tempera.

of all his paintings. The perspective is not distorted, and volume in the figures is indicated. Hair, facial features, and hands are realistically delineated using a painted contour line not seen in earlier works. His love of abstract design is apparent in the meticulously observed patterns on the pajamas, the white cloth, and the rear wall, all faithfully reflecting popular design of the early 1950s. The paint is thinly applied, having been diluted with water, but the colors still appear to be unmixed from the tube. It is initially brushed onto the paper in washes, and, in a process similar to that used on *The Checker Players*, the forms are built up in less dilute, more opaque layers. His paintings from this time all have a remarkably similar palette. The somewhat muted hues of *Sedation* closely resemble the handpainted swatches on the Bocour Casein Colors brochure (fig. 127). Tube casein tempera produces the driest surface appearance of all the matte, opaque media that he employed. Analysis indicates that it is composed of casein with traces of sugar and glue.[34] Lawrence was enthusiastic about Bocour's paints, recalling that he was "the only one who sold casein at that time."[35] Bocour seems to have returned the enthusiasm, for Lawrence was among the artists with whom Bocour would trade materials for paintings. Two of his paintings found their way into the collection of Leonard Bocour, and in a brochure advertising Hand Ground Bocour Colors, Lawrence is listed among the artists who use his paints.[36]

The intricacy of the composition of *Vaudeville* (see p. 107, fig. 33) clearly required much planning. The amount of detail in the underdrawing that is revealed in the infrared reflectogram is representative of his meticulous working process (figs. 128, 129). Every line of the complex, geometric background, which, according to Lawrence, was inspired by the curtain at the Apollo Theater, was painstakingly drawn onto the ground layer. Nearly all the elements of the composition are found in the underdrawing. Evidence that Lawrence reworked the composition in the drawing phase is apparent from the visibly erased lines depicting rings on the upraised, white-gloved hand and in the white collar of the figure's shirt. However, in a daring departure for Lawrence, the abstract pattern of the green suit appears to have evolved in the painting process. Although the framework for the suit was established in the underdrawing with straight lines, the elaborate abstract design came during the application of color. Slight modification from the underdrawing to the painted image can also be found in the buttonholes of the suit and the

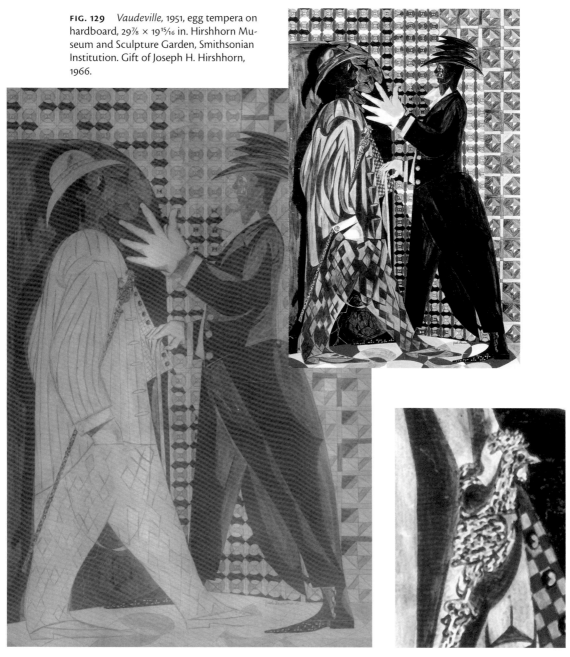

FIG. 129 *Vaudeville*, 1951, egg tempera on hardboard, 29⅞ × 19¹⁵⁄₁₆ in. Hirshhorn Museum and Sculpture Garden, Smithsonian Institution. Gift of Joseph H. Hirshhorn, 1966.

FIG. 128 Infrared reflectogram of *Vaudeville*. The entire composition is worked out in the drawing stage of creating the picture.

FIG. 130 Close-up of cane in *Vaudeville*. Lawrence scraped away yellow and black paint to create the white in the cane.

laces of both figures' shoes. More revisions by the artist can be found in the cane. The white lines are scratched out of the black and yellow paint, revealing the white ground layer, a technique frequently used by the artist when he edited after the paint was applied (fig. 130). Whites found elsewhere—in the gloves, shirt cuff, geometric shapes, and in the thin lines used to depict the noses, mouths, and chins—are also the unpainted preparation layer, a reserve technique that was standard for Lawrence by the 1950s. Since there is no white in the transparent watercolor palette, watercolorists since the beginning of the nineteenth century had evolved the method of leaving the paper unpainted to indicate this color.[37] However, Lawrence put a new twist on this technique. He used it to establish contours and fine details, painting around the lines of his extremely well developed underdrawings.

Analysis of the medium in *Vaudeville* has indicated that it is a commercially prepared egg tempera that incorporates oils and plasticizers into the paint formulation.[38] An efflorescence that is frequently found on the surface of Lawrence's pictures may be a characteristic that allows us to distinguish

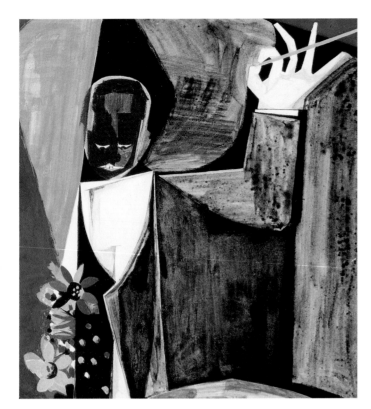

FIG. 131 Detail of *Magic Man*. A white efflorescence has developed in the darker colors, a sign of free fatty acids that form in egg tempera mediums.

egg temperas from other tempera paints available at the time. Efflorescence was present on the dark blue suit of the figure in *Vaudeville* (it has since been removed in a conservation treatment). Generally associated with blacks, browns, and other dark hues, a white crystalline substance has been noted on the surface of many works examined for this study. A sample of this white crystalline exudate was taken from *Magic Man* (1958) for analysis. It was identified to be a free fatty acid deposit, an aging phenomenon that is associated with egg media (fig. 131).[39]

An unusual aspect of *Vaudeville* is its wax coating.[40] Although Lawrence typically did not varnish his paintings, he occasionally was convinced to apply a surface coating to "preserve" the picture. Bocour recommended wax dissolved in turpentine in a "helpful hints" brochure that he distributed on casein painting, and commercially prepared wax varnishes were also available that Lawrence may have used.[41] An acrylic surface coating was identified on *Daybreak—A Time to Rest* (1967).[42] Lawrence acknowledged putting a varnish on this painting in an attempt to prevent the flaking paint that many works from the early 1960s were exhibiting.[43] He remembers using a commercially prepared Liquitex varnish for a brief time, but he did not like the glossy appearance it gave to the paints, preferring a matte surface.[44]

By midcareer, the artist was buying all of his materials from shops in and around Union Square in New York City, where most art suppliers were located to serve the downtown art community. The store that he patronized most frequently was Joseph Torch, at 29 West 15th Street. It was from such vendors that he bought his commercially prepared hardboards. One such gesso panel (as they were called) that Lawrence used often was made by the New York manufacturer Anjac. It was advertised as being excellent for "all temperas, oils and mixed media. Brilliant white coating is washable and permanent. Will NOT rub, crack, peel or change color. Surface has controlled absorbency for direct paint application. SIZING with shellac or varnish is UN-NECESSARY." The binder used in the preparation layers of several hardboards was identified to be casein, an innovation by manufacturers at the time in a departure from the more traditional animal glues.[45]

From the 1950s through the 1970s, Lawrence seems to have bought different types of water-based paints. Many medium lines from exhibition and sales receipts during this time state simply "tempera" while others have been mistakenly identified as gouache.[46] Given the marketing of aqueous media paints, it is little wonder that confusion as to their exact composition has arisen. In Bocour's brochure on casein painting, he misleadingly promotes the medium "as a watercolor, gouache (opaque watercolor) for commercial design, . . . designer's color, and . . . tempera."[47] Likewise, in a booklet published in 1958, Permanent Pigments describes casein as "a true tempera and is a form of gouache or opaque water color."[48] Art supply catalogues from the 1920s through the 1960s advertised tube paints that were simply marked "tempera" in addition to tubes marked "egg tempera." It is also probable that Lawrence continued to buy tempera (poster) paints in jars. The analysis of his paints has confirmed the presence of numerous binders and mixtures of binding media: gum; glue; egg; casein; gum and glue; egg and oil; egg, oil and rosin; and casein and glue.[49] In 1999 Lawrence's paint box contained primarily gouache, the medium correctly associated with his late works. However, one tube of Rowney Egg Tempera and one tube of Shiva Casein Tempera were found among the other paints. The two odd tubes were much older than the tubes of gouache, and Lawrence thought that he had not used them "in years."[50] It seems entirely probable that at many points in Lawrence's career, he simply had an aqueous media palette, not distinguishing between media but rather buying paints based on their colors.

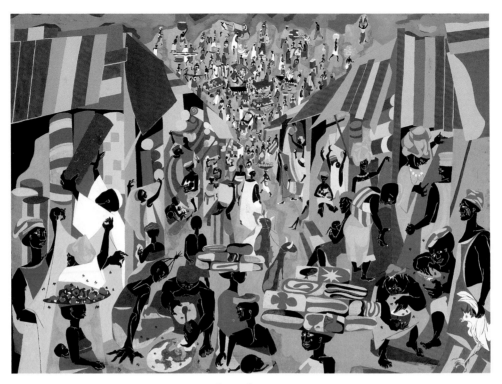

FIG. 132 *Street to Mbari*, 1964, tempera, gouache, and graphite on paper, 22¼ × 30⅞ in. National Gallery of Art, Washington, D.C. Gift of Mr. and Mrs. James T. Dyke.

A midcareer work on paper where mixed media may be present is *Street to Mbari* (fig. 132).[51] As with so many pictures dating from the 1960s onward, the medium has been identified as gouache. While the paint may be characterized as matte and opaque overall, a close inspection reveals a relative increase in the density and body of most colors as compared with those qualities in gouache. There is a dry quality to the surface, which easily registers scuff marks and suggests a binder other than gum. Samples of the blue and the ocher paint were taken from the upper edge of the picture, in which glue was identified as the principal binder, indicating a tempera medium.[52] However, other more transparent colors do exist in this work, such as the lighter blues in the bundles carried on the women's heads. These passages may be gouache or may simply be tempera paint thinned to the consistency of a wash so that they are visually indistinguishable from a gum arabic paint.

Thirty years into his career, Lawrence's mature working method was firmly developed, and all the hallmarks of the process and technique are present in *Street to Mbari*. This complex scene required an underdrawing that is worked out to the smallest detail. Evidence of reworking the underdrawing to capture the bustling spirit of the market is found in the erased graphite lines on the unpainted white paper that is held in reserve to depict the white tunic of the man with upraised arms on the left. The thin lines that give character to the eyes, ears, nostrils, eye-

brows, fingernails, and toenails are also white paper left unpainted. He used this technique of painting around his underdrawing to denote the sinuous contours of arms, legs, muscles, collarbones, and shoulder blades. As seen earlier in *The Checker Players*, the paint was brushed initially as a thin wash within a given passage, and the painted composition evolved with more opaque applications of the same hue. The compositional architecture of *Street to Mbari* shares many characteristics with *This Is Harlem*. The energy and movement of this cacophonous scene are emphasized by the seemingly endless repetition of colors and shapes. The distorted perspective draws the viewer into the picture, where there is so much activity that the eye is prohibited from resting on a single point.

Beginning in the early 1970s, Lawrence's compositions became less detailed and more streamlined. His ability to capture the essence of a story, however, remained as strong as ever. *Munich Olympic Games* (a study for a poster, 1971; fig. 133) is a superb example of Lawrence's distilling the impact of a moment into its most basic elements. The long strides of the figures and the distance involved in the track are expressed by the extreme foreshortening of the runners as they round the bend. The contorted facial features and strained necks convincingly convey the last bit of effort that the participants are putting into the race. Lawrence's many years of honing his draftsmanship enabled him to depict concisely the momentousness of reaching

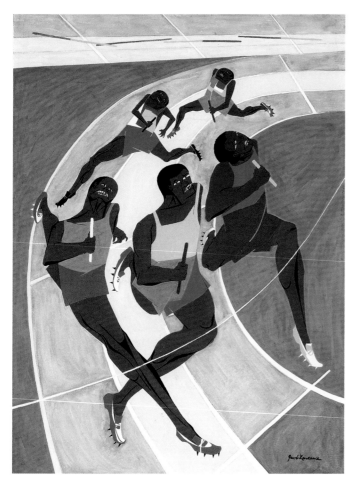

FIG. 133 *Munich Olympic Games*, 1971, tempera and gouache on paper, 39⅞ × 28¹⁵⁄₁₆ in. Seattle Art Museum. Purchased with funds from PONCHO.

FIG. 134 Detail from the study for *Explorations*, 1980, gouache and graphite on bristol board, 19¼ × 78 in. Howard University Gallery of Art, Washington, D.C.

the finish line. Interestingly, the white finish line is not white paper left in reserve or white paint applied to the surface but is scraped into the paint surface. By scraping into his painted surface, Lawrence achieved a hard edge, which may be intentional, to give this important element of the composition its strength, or it may be an indication that the finish line was an afterthought, a forgotten detail that he realized was necessary. Only five colors are used, green, red, brown, purple, and yellow, plus black, white, and gray, all undoubtedly straight from a tube or bottle judging from the intensity and purity of the hues. While the medium of this work has been recorded as gouache, the opacity and chalkiness of some colors, especially the green, would indicate a mixed-medium palette with temperas used for some passages and gouache used for others.

Throughout the late 1970s and early 1980s, Lawrence spent much of his time executing commissions. The studies for Howard University's murals, *Explorations* (1980) and *Origins* (1984), mark a return to the flat shapes that characterize his very early work.[53] The lack of modulation in most colors with little attempt to indicate volume is presumably in response to his anticipation that the studies would be transformed into the two-dimensional baked enamel medium that was envisioned for the murals (fig. 134). However, it also represents the continued simplification of his compositions characteristic of his later work. The medium has the appearance of gouache, the paint

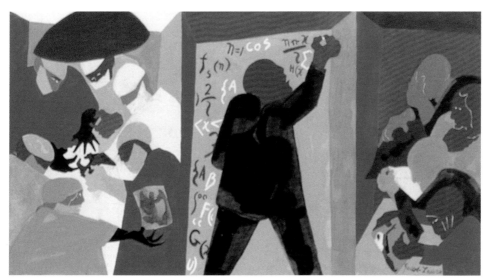

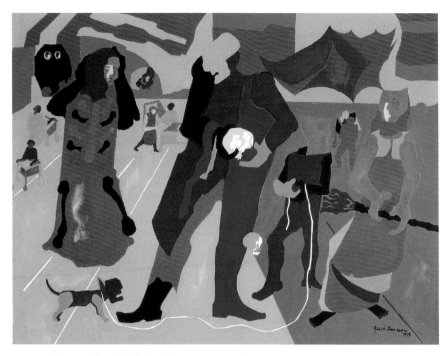

FIG. 135 *Supermarket—All Hallow's Eve*, 1994, gouache on paper,
19⅝ × 25⅝ in. Collection of Jacob and Gwendolyn Knight Lawrence.
Courtesy of Francine Seders Gallery, Seattle.

that is generally associated with his late work. Much of the free-hand graphite underdrawing is visible through many of the more transparent passages, and roughened paper fibers where the artist vigorously erased lines are evidence of much editing. In other places, it is clear that he has become less strict about adhering to his underdrawing from the many shapes that were conceived in the underdrawing but that were then painted over. Although Lawrence was becoming freer in his painting process, this does not mean that he abandoned meticulous planning of the work. In the unpainted border of *Explorations*, the colors to be used were indicated in the artist's handwriting: "raw umber, alizarin crimson, yellow ochre, burnt umber, grey no. 1, grey no. 2, cobalt blue, black, white."

A further loosening-up in his painting process is noted in his late work *Supermarket—All Hallow's Eve* (fig. 135). This mysterious and whimsical work is a gouache on paper. While the graphite underdrawing is still apparent in the more transparent passages, the irregularity of the forms suggests that he allowed the paint to flow onto the paper with less regard than previously to following a highly developed structure. This is particularly successful in the redheaded figure on the right dressed in a skeleton's costume. In the lower portion of the gray costume, an anomalous skip in the application of paint, revealing initial applications of wash, is allowed to remain visible. There is no distinction between the contour of the mask of the central figure

and the background, both painted in the same yellow ocher hue. In earlier paintings, a different color or a painted line would distinguish one shape from another. Here, however, eyes and other facial features are barely perceptible in the masks since these elements are depicted with the same hue. He continued to employ the reserve technique for the whites, a method that gives the thin white lines an appealing irregularity. While Lawrence remains a representational painter in his late years, a stronger feeling for the abstract emerges within his compositions as shapes melt together and lose their recognizable identity. This foray into abstraction is apparent in the skull shapes, in the bat image in the upper right, and in much of the background of *Supermarket—All Hallow's Eve*.

While Lawrence cannot be called a self-taught artist, neither is he an academic painter. If many other artists, from Giotto to Orozco, influenced him, his style is derivative of none. Throughout his career, he never strayed from the materials that first sparked his interest and ability to paint: water-based paints, paper, hardboard. His underdrawings remain critical to his process. When asked why he never ventured into other media, he laughed and responded that he was "a creature of habit."[54] Yet within these limited parameters, he developed a style that is unique and innovative. Working within an economy of means, his paintings are forceful, expressive, and to the point.

NOTES

I would like to thank Peter Nesbett and Michelle DuBois for their unending support and enthusiasm to conduct this study. I am deeply indebted to Michael Schilling, Narayan Khandekar, Herant Khanjian, and Joy Keeney from the Getty Conservation Institute for their strong interest and willingness to sample and conduct media analysis on over twenty paintings by Jacob Lawrence. Finally, I would like to acknowledge my many colleagues at the Hirshhorn Museum and Sculpture Garden, the National Museum of American Art, the National Gallery of Art, Howard University Art Gallery, The Museum of Modern Art, New York, the Whitney Museum of American Art, The Metropolitan Museum of Art, DC Moore Gallery, Tibor-Nagy Gallery, the Museum of Fine Arts, Boston, the Worcester Art Museum, the Seattle Art Museum, the Tacoma Museum of Art, and the Francine Seders Gallery for allowing me to examine the paintings by Jacob Lawrence in their collections.

1. Jane Turner, ed., *The Dictionary of Art* (London: Macmillan, 1996), vol. 30, pp. 425–8.

2. William Dukes, ed., *The Art Materials Industry, Art Material Trade News* (April 1978), Leonard Bocour papers and business records, 1947–92, Archives of American Art, Smithsonian Institution, Washington, D.C., which is a historical review of the art supply business in America (hereafter Leonard Bocour Papers). I gratefully acknowledge the assistance of several individuals in the art supply business who have provided valuable recollections and shared their personal archives of the trade. The first among these is Zora Pinney who passed on much insight into twentieth-century materials and opened the door to others who have been equally generous in providing information. I am indebted to Ed Flax, from the Martin/F. Weber Company (the name of this company changes at various times, often due to a change in ownership; the company names given here are taken from the brochure referenced and appear in various formats in this essay), Steve Steinberg from New York Central Art Supply, Ron Delese from Sargent Art Inc., Robert Auger from Van Aiken International, and Louis Rosenthal, owner of the former Rosenthals Art Supply in Union Square, New York.

3. Rutherford J. Gettens and George L. Stout, *Painting Materials: A Short Encyclopaedia* (New York: D. Van Nostrand Company, 1942), pp. 7–8. The most significant among the many art supply catalogues consulted for this essay are *Brushes and Artists' Materials*, Grumbacher, New York, 1933; *Colours the Masters Use*, price list no. 9, Winsor & Newton, New York, January 1930; *Artist and Drawing Materials*, Catalogue 700, 11th ed., F. Weber Co., Philadelphia, 1960; *Illustrated Catalogue, Artists' Materials, Drawing Materials, Drawing Instruments, Instruments of Precision for Draftsmen and Engineers, School Supplies*, F. Weber Co., Philadelphia, vol. 600, 1929, Warshaw Collection, National Museum of American Art, Smithsonian Institution, Washington, D.C. Paint recipes and catalogues from the F. Weber & Co. Archives, acc. no. 950018, Getty Research Institute, Research Library, were also consulted for this study.

4. Max Doerner, *The Materials of the Artist* (New York: Harcourt, Brace and Company, 1934), pp. 211–43.

5. Ralph Mayer, *The Artist's Handbook of Materials and Techniques* (New York: The Viking Press, 1940), p. 223.

6. Jacob Lawrence, video-recorded interview by the author, Susana Halpine, Shelly Wischhusen, and Elizabeth Chew, The Phillips Collection, Washington, D.C., June 4, 1992 (hereafter Interview, June 4, 1992).

7. I am indebted to Marjorie Shelley and Rachel Mustalish at the Metropolitan Museum of Art for their assistance in examining this work.

8. Michael R. Schilling, Narayan Khandekar, Joy Keeney, and Herant P. Khanjian, "Identification of Binding Media and Pigments in the Paintings of Jacob Lawrence"; see Appendix.

9. Jacob Lawrence, interview by author, Seattle, March 5, 1999 (hereafter Interview, March 5, 1999). Label from Sphinx Showcard color from the archives of Martin/F. Weber Company, Philadelphia.

10. *Illustrated Catalogue*, p. 97, Warshaw Collection, National Museum of American Art, Smithsonian Institution, Washington, D.C. It is interesting to note that with the advent of press-type vinyl letters and acrylic paint in the 1960s the poster paints employed by commercial artists and by Lawrence in the 1930s and 1940s went out of existence. Although a product called poster paint is still available, it is now made for the school market and has less body or covering power than the paint made for the commercial artists' market in the first half of the century.

11. Illustration board is a thin cardboard that is faced with paper on both sides. The paper on the front is of professional artist's quality, and the paper on the reverse carries the manufacturer's label.

12. Ellen Harkins Wheat, *Jacob Lawrence: American Painter*, exh. cat. (Seattle and London: University of Washington Press in association with the Seattle Art Museum, 1986), p. 44.

13. Interview, June 4, 1992.

14. See Elizabeth Steele and Susana M. Halpine, "Precision and Spontaneity: Jacob Lawrence's Materials and Techniques," in Elizabeth Hutton Turner, ed. *Jacob Lawrence: The Migration Series*, exh. cat. (Washington, D.C.: Rappahannock Press in association with The Phillips Collection, 1993), for an in-depth study of the materials and techniques of *The Migration of the Negro* series.

15. Hardboard is the generic name for a panel made from wood fibers fused under heat and pressure. It was originally made for the building industry in 1924 by the Masonite Corporation. The support is frequently termed Masonite, deriving its name from its first manufacturer. See R. Bruce Hoadley, *Understanding Wood: A Craftsman's Guide to Wood Technology* (Newtown, Conn.: The Taunton Press, 1980), p. 227. It was quickly adopted by painters as an inexpensive substitute for wood panels in the 1930s.

16. Interview, June 4, 1992.

17. In Wheat, *Jacob Lawrence: American Painter*, p. 66, the artist is said to have briefly made his own gouache in the early 1940s using rabbit-skin glue. Technically, such a paint should be classified as a tempera because of the binding medium; while rabbit-skin glue was not discovered among the samples analyzed from this period, the author has observed works from 1941–2 whose surface appearance is different from works executed in poster paints or gouache. Further study of this period is hoped for in the future.

18. Marjorie Cohn, *Wash and Gouache: A Study of the Development of the Materials of Watercolor* (Cambridge, Mass.: The Center for Conservation and Technical Studies, Fogg Art Museum and The Foundation of the American Institute for Conservation, 1977), p. 71. Wyndell Upchurch, telephone interview with the author, March 30, 1999. According to Upchurch, technical advisor to Colart, distributor of Winsor & Newton in the United States, the recipes for Winsor & Newton gouache are the same now as they were earlier in the century. Formulations for gouache include gum arabic, gum tragacanth, potato paste (another gum), sugars (honey, rock candy, treacle as plasticizers), arrowroot (a thickener), ox gall, and glycerin (wetting agents). Opaque watercolor, or gouache, has a higher pigment loading/lower binder level than in transparent watercolor. As a result, gouache has a lower refractive index, which accounts for its duller appearance. White pigments are not added to make Winsor & Newton gouache opaque. However, a translucent white, *blanc fixe*, is added to some pigments that are transparent and/or intense to render them more opaque and/or to lower their value. This is done so that all the colors will have an equal brilliance and opacity. Some pigments used in watercolor are too transparent to be used in gouache.

19. Examination and treatment record report by Holly Krueger for the Amon Carter Museum, May 21, 1999.

20. The support is a cream-colored, rough-textured, moderate-weight wove paper, a type that becomes his predominant choice for most of his works on paper. I am deeply indebted to Lawrence Hoffman, Susan Lake, Margaret Dong, Judith Zilcher, and Phyllis Rosenzweig at the Hirshhorn Museum and Sculpture Garden for facilitating my study of this painting and other works in this museum's collection.

21. Interview, March 5, 1999.

22. If literally depicted, the view from his studio window would be the side of his neighbor's house.

23. Interview, March 5, 1999.

24. My thanks to Rita Albertson, Phillip Klausmeyer, and Joan Wright at the Worcester Art Museum for assistance in the examination of this painting.

25. Leonard Bocour Papers.

26. Interview, March 5, 1999.

27. Appendix.

28. Interview, March 5, 1999. In a visit to the artist's studio, I found copies of several artists' handbooks on his shelves, including Doerner and Mayer, but none were worn from use. Lawrence's 1942 copy of Doerner appears untouched, despite the inscription inside the front cover, "With love from Gwen, Christmas, 1942." Also Interview, June 4, 1992. Lawrence stated that he did not use artists' handbooks often for himself, although he enjoyed reading them and would use them for teaching.

29. Interview, June 4, 1992. See also Wheat, *Jacob Lawrence: American Painter*, p. 73.

30. Interview, March 5, 1999.

31. Ibid.

32. Appendix.

33. I am appreciative of the support of Kirk Varnadoe, James Coddington, Anny Avarim, and Susanne Siano in examining Lawrence's paintings in the Museum of Modern Art.

34. Appendix.

35. Interview, March 5, 1999.

36. Jacob Lawrence, telephone interview by Peter Nesbett, July 16, 1998, confirms that he received paints from Bocour. The paintings that Bocour owned have since been dispersed to public institutions. See also Leonard Bocour Papers.

37. Cohn, *Wash and Gouache*, pp. 10–1, 44–5.

38. Appendix.

39. My sincere thanks to the Scientific Research Department at the National Gallery of Art, Washington, D.C., for conducting analysis on the efflorescence associated with *Magic Man*. For additional information, please contact Suzanne Lomax, Organic Chemist, at the National Gallery of Art.

40. Appendix.

41. Leonard Bocour Papers. In a brochure entitled *A Note on Casein Painting* (date unknown), Bocour recommended under "helpful hints": "Wax dissolved in turpentine will give gouache a 'wet look' and protect the surface from dirt." Note the erroneous interchangeability of the terms *gouache* and *casein* in this brochure. In the 1929 F. Weber Co., Inc., catalogue a Tempera Mat Varnish is advertised as "A solution of refined bleached pure wax. When applied over Oil or Tempera Paintings a dull finish is obtained which also somewhat subdues the color."

42. Appendix.

43. Jacob Lawrence, telephone interview by Nesbett. It is interesting to note that Lawrence abandoned the use of hardboard panels in the 1960s, perhaps in response to the deterioration suffered by many works from this period. *Street Scene (Boy with Kite)* (1962) was given as a study piece to the Conservation Institute at New York University by a collector because of recurring flaking paint. The cause for the instability of this work and other paintings from the early 1960s is not fully understood; however, it is suspected that the panels are tempered hardboards, which incorporate resins in their manufacture and thereby render the surface unsuitable for receiving a ground layer. I am most appreciative of Friederike Steckling and Jennifer Sherman for discussing this work with me.

44. Interview, June 4, 1992.

45. Anjac label found on reverse of *Wedding Party* (1953), Collection of Frederick C. Tobler. See also Appendix.

46. The Downtown Gallery Records and Alan Gallery Records, Archives of American Art, Smithsonian Institution, Washington, D.C.

47. See note 41.

48. Permanent Pigments, *Enduring Colors for the Artist: A Simplified Technical Treatise on Permanence in Paintings*, 1958, p. 36.

49. Appendix.

50. Jacob Lawrence, interview by Michelle DuBois, April 21, 1999.

51. I would like to acknowledge Shelly Fletcher and Judy Walsh from the National Gallery of Art, Washington, D.C., for facilitating the examination of this work. My appreciation also to Holly Krueger from the Library of Congress, Washington, D.C., for discussing this work and twentieth-century artists' materials with me.

52. Appendix.

53. I am grateful for the assistance of Trotobia H. Benjamin and Scott Baker at Howard University, Washington, D.C., in examining these pictures.

54. Interview, March 5, 1999.

Michael R. Schilling, Narayan Khandekar,
Joy Keeney, and Herant P. Khanjian
THE GETTY CONSERVATION INSTITUTE

Appendix

IDENTIFICATION OF BINDING MEDIA AND PIGMENTS IN THE PAINTINGS OF JACOB LAWRENCE

A COMPREHENSIVE ANALYTICAL SURVEY was undertaken to identify the painting materials used by Jacob Lawrence throughout his long career. Because paint consists of pigments, extenders, and binding media (materials that make the pigments stick to the painted surface), it was necessary to identify all of these materials in his paintings. It is clear that Lawrence would have had access to nearly the full range of twentieth-century commercial pigments and binding media.

One important goal of the survey was to identify the aqueous media that Lawrence used to distinguish between the various types of temperas found in his paintings and, furthermore, to differentiate them from gouache. This information contributes to a better understanding of his painting techniques and, ultimately, may aid conservators in their efforts to preserve his works. In light of the fact that modern tempera paints have never before been fully investigated, this study also reveals important information about the mixtures prepared by artists' colormen in the twentieth century.

From the previous article in this volume,[1] it is clear that Jacob Lawrence favored working in various water-based organic binding media. Interestingly, many water-soluble paint media contain common foodstuffs.[2] For example, plant gums, sugar, and starch are media based on carbohydrates. Casein (found in milk), glue (often obtained from animal hides), and egg are proteinaceous media. Moreover, Lawrence used commercially available tube colors in many of his later works. Manufacturers often add materials to tube colors, in addition to the binding media, to modify the working properties of the paints, stabilize the mixtures, and also for commercial reasons. These include glycerol, seed oils (linseed, poppy, and walnut), natural resins (dammar, rosin), plasticizers (dimethyl phthalate), and water.[3] From these lists, it is quite clear that Lawrence's paint media can be complicated mixtures of many substances.

The present study builds on the work of Steele and Halpine, who examined paintings in Lawrence's *The Migration of the Negro* series.[4] Twenty-one paintings that date from 1938 to 1976 were included in this survey. Samples of paint, most of which were smaller than a period on a printed page, were removed from each painting by scalpel and analyzed using extremely sophisticated scientific instrumentation.[5] Pigments were identified using polarized-light microscopy.[6] Organic binding media were identified with gas chromatography coupled with mass spectrometry (GC-MS)[7] following one experimental procedure for the analysis of proteins,[8] a second for natural resins,[9] and a third for plant gums.[10] For a few extremely small samples, Fourier-transform infrared microspectrometry (FTIR-microscopy) was used to preserve paint material.[11] It was seldom possible to use every scientific test on each paint sample because of the limited quantities of sample that were available. Fortunately, the appearance of the paint and its solubility in water gave indications as to the type of medium that was present, and so the tests for each sample were selected with that in mind. It should be noted that GC-MS tests occasionally yield inconclusive results due to interference by pigments and other components in paint.

The test results for pigment and binding medium analysis, listed in Table 1, show that Lawrence employed numerous paint formulations during his career. His pigments covered the full range of natural minerals, synthetic inorganic, and organic color-

TABLE 1 Results of Pigment and Binding Medium Analysis

Beggar No. 1, 1938, tempera on illustration board. The Metropolitan Museum of Art.
 Red: Iron red, minerals.[a] Casein, glue, glycerol[b]
 Blue: Ultramarine,[c] titanium white, iron red. Gum arabic

Painting the Bilges, 1944, gouache on paper. Hirshhorn Museum and Sculpture Garden.
 Blue: Ultramarine, clay, minerals. Gum arabic, glucose
 Red: Red lake. Medium not tested

African Gold Miners, 1946, gouache on paper. Hirshhorn Museum and Sculpture Garden.
 Blue: Ultramarine, cobalt blue, zinc white. Gum arabic
 Black: Lamp black. Gum arabic, glucose, sugar

New Jersey, 1946, gouache and watercolor on paper. National Museum of American Art.
 Red: Pigments not tested. Gum arabic, glucose

The Checker Players,* 1947, egg tempera on hardboard. Worcester Art Museum.
 Dark color: Titanium white, iron red, umber. Egg, casein
 Ground: Titanium white, minerals. Egg, casein, beeswax
 *Please refer to the discussion of these results, p. 267.

Sedation, 1950, casein tempera on paper. The Museum of Modern Art.
 Brown: Red lake, brown lake, charcoal. Protein results erratic[d]
 Green: Pigments not tested. Casein, sugar,[e] trace of glue

Vaudeville, 1951, egg tempera on hardboard. Hirshhorn Museum and Sculpture Garden.
 Blue: Pigments not tested. Egg, oil, DMP[f]
 Ground: Titanium white. Casein
 Verso ground: Zinc white, titanium white, iron red, gypsum, clay, minerals. Casein
 Coating: Beeswax

Struggle . . . From the History of the American People, No. 11: 120.9.14.286.9.33-ton 290.9.27 be at 153.9.28.110.8.17.255.9.29 evening 178.9.8 . . . —AN INFORMER'S CODED MESSAGE, 1955, egg tempera on hardboard. Private collection, New York.
 Brown: Bone black,[g] titanium white, iron red, minerals. Egg, oil, glycerol, gallic acid, rosin

The Cue and the Ball, 1956, casein tempera[h] on paper. Hirshhorn Museum and Sculpture Garden.
 Green: Chromium oxide. Glucose. Protein results erratic. Water-insoluble

Magic Man, 1958, egg tempera on hardboard. Hirshhorn Museum and Sculpture Garden.
 Black: Charcoal, yellow ocher, burnt umber, raw umber, iron red. Egg, oil, glycerol
 Light black: Charcoal, titanium white, gypsum. Egg, oil, glycerol
 Ground: Pigments not tested. No carbohydrates
 Verso ground: Titanium white, clay, gypsum, minerals. Protein results inconclusive[i]

Men exist for the sake of one another . . ., 1958, egg tempera on hardboard. National Museum of American Art.
 Blue: Ultramarine, charcoal, burnt umber, titanium white, iron red. Egg, glycerol
 Ground: Titanium white, charcoal, gypsum, minerals. Glycerol, no protein. Tests inconclusive

The Library, 1960, egg tempera on hardboard. National Museum of American Art.
 Ocher: Iron yellow, iron red, titanium white, gypsum, charcoal. Egg
 Brown: Raw umber, titanium white, burnt umber. Egg, oil, DMP

Parade, 1960, egg tempera on hardboard. Hirshhorn Museum and Sculpture Garden.
 Blue: Cobalt blue, ultramarine, burnt umber, titanium white, gypsum. Egg, glycerol
 Ground: Titanium white, gypsum, iron red, charcoal. Egg, glucose

Playing Card (Joker) and *Playing Card (King),* 1962, tempera on paper. Hirshhorn Museum and Sculpture Garden.
 King—Red: Iron red, titanium white, clay, minerals. Glue, no carbohydrates
 King—Black: Bone black, ultramarine, minerals, iron red. Glue
 Joker—Blue: Cobalt blue, clay, minerals. Glue
 Joker—Yellow: Protein results erratic

Ordeal of Alice, 1963, egg tempera on hardboard. Private collection, New York.
 Light brown: Titanium white, burnt umber. Egg, oil, glycerol

Street to Mbari, 1964, tempera, gouache, and graphite on paper. National Gallery of Art.
 Yellow: Yellow ocher, ultramarine. Glue, no carbohydrates
 Blue: Ultramarine, red lake, charcoal, raw umber. Glue, glucose

Students with Books, 1966, egg tempera on hardboard. Mr. Merril C. Berman, New York.
 Yellow: Yellow ocher, iron red, umber, minerals. Egg, oil, no carbohydrates
 Brown: Raw umber, gypsum, minerals. Egg, oil, rosin, DMP
 Purple: Iron red, cobalt blue, titanium white, charcoal. Egg, oil, rosin

Daybreak—A Time to Rest, 1967, egg tempera on hardboard. National Gallery of Art.
 Blue: Ultramarine, cerulean blue. Egg, oil, DMP, protein results inconclusive
 Light blue: Ultramarine, titanium white, iron red. Egg, oil, rosin, DMP
 Yellow: Yellow ocher. Egg, oil
 Ground: Titanium white. Protein results inconclusive
 Varnish: Acrylic resin

Harriet and the Promised Land, No. 10: Through Forests, Through Rivers, Up Mountains, 1967, gouache and tempera on paper. Hirshhorn Museum and Sculpture Garden.
 Black: Lamp black, clay. Glucose, but no oil or fats. Presumed to be glue due to appearance and slow solubility in water

*Other Rooms,** 1975, gouache and tempera on paper. Collection of Jacob and Gwendolyn Knight Lawrence.
 Glossy gray: Pigments not tested. Plant gum
 *Visual examination indicates the presence of tempera paint in addition to gouache.

In a free government . . . , 1976, gouache on paper. National Museum of American Art.
 Brown: Bone black, burnt umber. Plant gum, glucose, sugar

NOTES

a) "Minerals" in the pigment listing denotes an unknown transparent mineral material.

b) Glycerol is listed only when its concentration exceeded 1% by weight in the sample.

c) Synthetic ultramarine was the form of the pigment identified in all of the paints.

d) For three paint samples, the protein results showed no evidence for any amino acid or the internal standard. Accordingly, they were termed *protein results erratic*, and no conclusions could be drawn.

e) Sugar refers to cane sugar, which is composed of glucose and fructose.

f) DMP refers to dimethyl phthalate, a commonly used plasticizer.

g) It was not possible to differentiate between bone black and ivory black in this study because they possess identical optical properties. Hence, the term *bone black* refers to either pigment.

h) Binder is assumed to be casein because of surface appearance, palette, and complete insolubility in water.

i) In samples denoted with *protein results inconclusive*, the amino acid composition did not match any reference material.

ants. Moreover, he employed various mixtures of water-soluble binding media: gum and glue; casein; egg; egg and oil; egg, oil, and rosin; starch or dextrin (glucose); egg and starch; gum arabic and other plant gums.

Interpretation of the binding medium results should always be done carefully, and two examples serve to illustrate this point. On the painting *Beggars No. 1*, the red paint was tested for protein and carbohydrates, whereas the blue paint was tested solely for carbohydrates because the sample quantities were insufficient to perform both types of tests. Casein, glue, and gum arabic were detected in the red paint, and gum arabic was found in the blue paint. Assuming that the casein originated from the paper sizing, it is presumed that both paints were made with a traditional formulation of glue and gum arabic.[12] And in *The Checker Players,* both egg and casein were detected in both the ground and paint samples, although the ground sample tested much more strongly for casein than for egg. The difficulty of completely separating the thin paint film from the very thick ground layer in the sample preparation accounts for the presence of both proteins in the analytical results. Interpretation of analysis leads to the conclusion that egg is the binder for the paint, and casein is the binder for the ground. This conclusion is also consistent with both the artist's and art supply manufacturers' practices of the time.

Because the test procedures made it possible to detect various additives in the paint samples, this permits additional conjecture about the origin of the paints. For example, one may speculate that when a paint sample does not contain additives, Lawrence may have formulated it himself from traditional artists' recipes. Such is the case for the dark paint of *The Checker Players,* which contains the protein and fats characteristic of egg tempera and which Lawrence himself states that he made. In contrast, the brown egg tempera paint from *Struggle . . . From the History of the American People,* panel *No. 11,* also contains gallic acid preservative, in addition to rosin, oil, and glycerol modifiers, which is evidence for a tube color.

Oxalic acid, often noted as a marker for biological activity, was detected prominently in two paintings: the dark paint of *The Checker Players* and the yellow of *Street to Mbari.* Therefore, these paintings may have suffered more from microbial activity than the other paintings with similar media. This indicates that Lawrence could have formulated them himself, or, if they are tube colors, the preservatives were less effective than the other formulations Lawrence employed. It is also possible that the storage or display conditions over the lifetime of these two paintings were somewhat more favorable for microbial activity.

As mentioned earlier, a great deal of information about the composition of a painting may be obtained from a careful examination of the appearance of a paint and its water solubility, which can aid in interpreting the analytical results. For instance, the black paint of *Harriet and the Promised Land,* panel *No. 10,* showed no carbohydrates or oils; unfortunately, the protein test could not be performed on this paint. However, the appearance of the paint suggests that glue was used instead of gouache. For instance, the paint is more opaque and has more body than gouache, it is slowly soluble in water, and it did not test positively for gum. Also, clay is present among the pigments, which is a filler frequently used in temperas to give them more opacity.

This study amply illustrates the wealth of information that can be obtained by applying modern analytical procedures to the study of painted works of art. The scientific results were found to support much of the historical and anecdotal information, but in many instances it shed new light on the water-soluble media that Lawrence used so masterfully through his career.

NOTES

1. See Elizabeth Steele's article in this volume, "The Materials and Techniques of Jacob Lawrence."

2. John S. Mills and Raymond White, *The Organic Chemistry of Museum Objects*, 2nd ed. (London: Butterworths, 1994).

3. Ralph Mayer, *The Artist's Handbook of Materials and Techniques* (New York: The Viking Press, 1940).

4. Elizabeth Steele and Susana M. Halpine, "Precision and Spontaneity: Jacob Lawrence's Materials and Techniques," in Elizabeth Hutton Turner, ed., *Jacob Lawrence: The Migration Series* (Washington, D.C.: Rappahannock Press in association with The Phillips Collection, 1993).

5. The authors are grateful for the assistance of Elizabeth Steele, who assisted with many of the binding medium analyses and who contributed to the interpretation of the findings.

6. Pigment samples were ground and dispersed in Meltmount (from Cargille Laboratories, refractive index of 1.66) beneath a size 1 coverslip. Pigments were identified using polarized-light microscopy by comparing the optical properties of the samples to those of a set of pigment reference standards. For an excellent summary of the use of polarized-light microscopy, see Walter C. McCrone, "The Microscopical Identification of Artists' Pigments," *Journal of the International Institute for Conservation—Canadian Group* 7, 1–2 (1982), pp. 11–34.

7. Gas chromatography with mass spectrometry (GC-MS) is a technique that can be used to identify carbohydrates, proteins, and many paint additives. The samples must be treated with reactive chemicals prior to analysis, and each type of medium may require a specific pretreatment procedure.

8. In the GC-MS analysis of proteins and glycerol, samples are first degraded with $6N$ hydrochloric acid for 24 hours at 105° C to form free amino acids and glycerol. Afterward, the acid is evaporated and the residue is reacted with MTBSTFA (Pierce Chemical Company) in pyridine for five hours at 105° C to form the TBDMS derivatives, which are then separated on a 30M DB-5MS capillary column (J & W Scientific). Selected ion monitoring is used to obtain improved detection limits. The amino acid composition of the sample was compared to the compositions of standard casein, glue, and egg by correlation coefficients and other mathematical procedures to identify the protein. Data interpretation is discussed in detail in M. Schilling and H. Khanjian, "Gas Chromatographic Analysis of Amino Acids as Ethyl Chloroformate Derivatives III: Identification of Proteinaceous Binding Media by Interpretation of Amino Acid Composition Data," in *ICOM Committee for Conservation Preprints, 11th Triennial Meeting, Edinburgh, Scotland, 1–6 September 1996*, ed. J. Bridgland (London, 1996), pp. 220–7. The use of MTBSTFA is described in P. Simek, A. Heydová, and A. Jegorov, "High Resolution Capillary Gas Chromatography and Gas Chromatography–Mass Spectrometry of Protein and Non-Protein Amino Acids, Amino Alcohols, and Hydroxycarboxylic Acids as Their Tert-butyldimethylsilyl Derivatives," *Journal of High Resolution Chromatography* 17 (1994), pp. 145–52. A

manuscript that describes the complete GC-MS analysis procedure is currently in preparation.

9. Natural resins (such as rosin), additives (DMP, gallic acid, beeswax), fats and oils (egg fats, seed oils) were prepared for GC-MS analysis by treatment with a 40% solution of Meth Prep II (Alltech Associates, Inc.) in benzene at 60° C for one hour and allowed to react overnight. The methyl ester derivatives and other volatile components were separated on the same column used for protein analysis and identified by computer-aided matching to mass spectral reference data. Michael Schilling described the sample preparation procedure in a presentation at the annual meeting of the Western Association of Art Conservators held in Catalina, Calif., in 1990. A similar procedure is described in R. White and J. Pilc, "Media Analyses," *National Gallery Technical Bulletin* 17 (1996), pp. 91–103.

10. Carbohydrates were prepared for GC-MS analysis by degrading the paint samples in $1N$ trifluroacetic acid for one hour at 125° C. After evaporating the acid, the residue was reacted stepwise with methoxyamine hydrochloride and acetic anhydride in pyridine. The derivatives were dissolved in chloroform and separated on a 15M DB-WAX column (J & W Scientific), then analyzed by selected ion monitoring. Sample carbohydrate compositions were matched to data for standard plant gums, starch, glucose, and sugar by correlation coefficients. It should be noted that glucose is present in both starch and dextrin, so it is not possible to differentiate them. A manuscript that describes the procedure is in preparation.

11. Fourier-transform infrared microspectroscopy (FTIR) is a technique that has a number of advantages over GC-MS. FTIR can be used directly on a paint sample without requiring aggressive chemical pretreatment. Because samples may be recovered for subsequent analysis by other methods, it is termed a nondestructive technique. Furthermore, it can also identify pigments and other nonvolatile species (such as acrylic media) that cannot be detected by GC-MS. However, it can only detect components present in concentrations above five to ten weight percent, although many substances are well below that level in commercial paints. A representative sample particle was placed on a BaF_2 window, flattened by a stainless steel roller, and analyzed by transmitted infrared beam with an aperture of approximately 100 × 100 microns, using a 15X objective. Each spectrum was the sum of 200 scans at a resolution of 4 cm^{-1}. Based on the initial analysis results of bulk material, extraction was made by placing a microdroplet of solvent on the sample, and analysis was performed on the resultant extracted dry solvent ring. Infrared spectra of the samples contain bands that correspond to the paint components. To identify materials in a paint sample, the infrared spectrum may be matched to spectra for reference materials using a computer algorithm. Of course, other components may be present in the samples at concentrations below the 5% detection limit. For more details, see M. R. Derrick, *Practical Guide to Infrared Microspectroscopy*, ed. Howard J. Humecki (New York: Marcel Dekker, 1995).

12. Glue and gum mixtures were described in numerous recipes from the F. Weber & Company Archives, acc. no. 950018, Getty Research Institute, Research Library.

Bibliography

This bibliography is organized by publication type. Books illustrated by the artist, monographs, exhibition catalogues, and periodicals are ordered chronologically and are listed first. All other publications are listed alphabetically. This bibliography is selective. It contains sources with significant commentary but it is not exhaustive. For a more comprehensive listing, see the bibliography in the catalogue raisonné on the artist's work.

Books Illustrated by the Artist
(in chronological sequence)

Hughes, Langston. *One-Way Ticket,* with illustrations by Jacob Lawrence. New York: Alfred A. Knopf, 1948.

Lawrence, Jacob, with verses by Robert Kraus. *Harriet and the Promised Land.* New York: Windmill Books, Simon & Schuster, 1968; New York: Simon & Schuster, 1993.

Aesop's Fables, with illustrations by Jacob Lawrence. New York: Windmill Books, Simon & Schuster, 1970; Seattle: University of Washington Press, 1997.

Hersey, John, with silk-screen prints by Jacob Lawrence. *Hiroshima.* New York: The Limited Editions Club, 1983.

Genesis. [King James version of the book of Genesis, illustrated with eight screen prints by Jacob Lawrence.] New York: The Limited Editions Club, 1990.

Selected Solo Exhibition Catalogues and Monographs
(in chronological sequence)

[Alston, Charles]. *Jacob Lawrence.* Exh. cat. New York: James Weldon Johnson Literary Guild, 1938.

Saarinen, Aline B. *Jacob Lawrence.* Exh. cat. New York: American Federation of Arts, 1960.

The Toussaint L'Ouverture Series. Exh. cat. Nashville: Fisk University Art Gallery, 1968.

Brown, Jacquelin Rocker. "The Works Progress Administration and the Development of an Afro-American Artist, Jacob Lawrence, Jr." Unpublished paper, Howard University, Washington, D.C., 1974.

Brown, Milton W. *Jacob Lawrence.* Exh. cat. New York: Whitney Museum of American Art, 1974.

Sharp, Ellen. *The Legend of John Brown.* Exh. cat. Detroit: The Detroit Institute of Arts, 1978.

Jacob Lawrence: Paintings and Graphics from 1936 to 1978. Exh. cat. Norfolk, Va.: The Chrysler Museum of Art, 1979.

Buell, James M., with an introduction by Grant Spradling. *The Toussaint L'Ouverture Series: A Visual Narration of the Liberation of Haiti in 1804 under the Leadership of General Toussaint L'Ouverture.* Exh. cat. New York: United Church Board for Homeland Ministries, 1982.

Lewis, Samella, with Mary Jane Hewitt. *Jacob Lawrence.* Exh. cat. Santa Monica, Calif.: Santa Monica College, 1982.

Lemakis, Emmanuel. *Jacob Lawrence: An Exhibition of His Work.* Exh. cat. Pomona, N.J.: Art Gallery, Stockton State College, 1983.

Krane, Susan. *Jacob Lawrence: The Harriet Tubman Series.* Exh. cat. Buffalo: Albright-Knox Art Gallery, 1986.

Wheat, Ellen Harkins. *Jacob Lawrence: American Painter.* Exh. cat. Seattle and London: University of Washington Press in association with the Seattle Art Museum, 1986.

Lewis, Samella, with Mary Jane Hewitt. *Jacob Lawrence: Drawings and Prints.* Exh. cat. Claremont, Calif.: Scripps College of the Claremont Colleges, 1988.

Lewis, Samella, with Mary Jane Hewitt. *Jacob Lawrence: Paintings and Drawings.* Exh. cat. Claremont, Calif.: Scripps College of the Claremont Colleges, 1989.

Wheat, Ellen Harkins. *Jacob Lawrence: The Frederick Douglass and Harriet Tubman Series of 1938–40.* Exh. cat. Hampton, Va., Seattle, and London: Hampton University Museum in association with University of Washington Press, Seattle, 1991.

Powell, Richard J. *Jacob Lawrence.* New York: Rizzoli Art Series, 1992.

Sims, Patterson. *Jacob Lawrence: The Early Decades, 1935–1950.* Exh. brch. Katonah, N.Y.: The Katonah Museum of Art, 1992.

Jacob Lawrence: Paintings, Drawings, and Prints. Exh. cat. New York: Midtown Payson Galleries, 1993.

Turner, Elizabeth Hutton, ed. *Jacob Lawrence: The Migration Series.* Exh. cat. Washington, D.C.: Rappahannock Press in association with The Phillips Collection, 1993.

Nesbett, Peter, with an essay by Patricia Hills. *Jacob Lawrence: Thirty Years of Prints (1963–1993): A Catalogue Raisonné.* Seattle: Francine Seders Gallery in association with University of Washington Press, 1994.

King-Hammond, Leslie. *Jacob Lawrence, An Overview: Paintings from 1936–1994.* Exh. cat. New York: Midtown Payson Galleries, 1995.

Van Keuren, Philip. *After Vesalius, Drawings by Jacob Lawrence.* Exh. cat. Dallas: Division of Art, Southern Methodist University, 1996.

Wolfe, Townsend. *Jacob Lawrence: Drawings, 1945 to 1996.* Exh. cat. New York and Little Rock, Ark.: DC Moore Gallery and Arkansas Arts Center, 1996.

Benson, Cynda L. *Jacob Lawrence.* Exh. cat. Savannah, Ga.: Savannah College of Art and Design, 1998.

Nesbett, Peter T. *Jacob Lawrence: The Builders.* Exh. cat. New York: DC Moore Gallery, 1998.

Selected Group Exhibition Catalogues and Monographs

(in chronological sequence)

[Wilson, Sol]. *Jacob Lawrence and Samuel Wechsler.* Exh. cat. New York: American Artists School, 1939.

Locke, Alain. *The Negro Artist Comes of Age.* Exh. cat. New York: Albany Institute of History and Art, 1945.

Three Negro Artists: Horace Pippin, Jacob Lawrence, Richmond Barthé. Exh. cat. Washington, D.C.: The Phillips Memorial Gallery and the Catholic Inter-Racial Council, 1946.

Hale, Robert Beverly, ed. *One Hundred American Painters of the Twentieth Century.* Exh. cat. New York: The Metropolitan Museum of Art, 1950.

World at Work, 1930–1955: An Exhibition of Paintings and Drawings Commissioned by Fortune, *Presented on the Occasion of the Magazine's Twenty-Fifth Anniversary.* New York: Time, 1955.

Twenty-Eighth Venice Biennale: American Artists Paint the City. Exh. cat. Chicago: The Art Institute of Chicago, 1956.

Painting in America: The Story of Four Hundred Fifty Years. Exh. cat. Detroit: The Detroit Institute of Arts, 1957.

Twenty-Five Years of American Painting 1933–1958. Exh. cat. Sweden: Göteborgs Konstmuseum, 1959.

Contemporary American Painting: Selections from the Neuberger Collection. Exh. cat. Ann Arbor, Mich.: University of Michigan, 1962.

Nordness, Lee, ed. *Art: USA Now.* Exh. cat. Lucerne, Switzerland: C. J. Bucher, 1962.

Ingersoll, R. Sturgis. *The Louis E. Stern Collection.* Exh. cat. Philadelphia: Philadelphia Museum of Art, 1964.

Herbert A. Goldstone Collection of American Art. Exh. cat. Brooklyn: The Brooklyn Museum, 1965.

The Art of the American Negro: Exhibition of Paintings. New York: Harlem Cultural Council, 1966.

Goodrich, Lloyd. *Art of the United States: 1670–1966.* Exh. cat. New York: Whitney Museum of American Art, 1966.

Porter, James A. *The Negro in American Art.* Exh. cat. Los Angeles: UCLA Art Galleries, Dickson Art Center, 1966.

Two Hundred Years of Watercolor Painting in America. Exh. cat. New York: The Metropolitan Museum of Art, 1966.

Woodruff, Hale. *Ten Negro Artists from the United States (Dix artistes nègres des Etats-Unis).* Washington, D.C.: United States Commission for the First World Festival of Negro Arts, and National Collection of Fine Arts, Smithsonian Institution, 1966.

Bearden, Romare, and Carroll Greene, Jr. *The Evolution of Afro-American Artists: 1800–1950.* Exh. cat. New York: City University of New York in cooperation with Harlem Cultural Council and New York Urban League, 1967.

The Portrayal of Negroes in American Painting. New York: Exh. cat. Forum Gallery, 1967.

Protest and Hope: An Exhibition of Contemporary American Art. Exh. cat. New York: New School Art Center, 1967.

Walker, Lester C., Jr. *American Painting: The 1940s.* Exh. cat. New York: American Federation of Arts, 1967.

Edith Halpert and The Downtown Gallery. Exh. cat. Storrs, Conn.: Museum of Art, University of Connecticut, 1968.

Robbins, Daniel, ed. *The Neuberger Collection: An American Collection.* Exh. cat. Providence, R.I.: Museum of Art, Rhode Island School of Design, 1968.

Thirty Contemporary Black Artists. Exh. cat. Minneapolis and New York: Minneapolis Institute of Arts in association with Ruder & Finn Fine Arts, 1968. Reprint. *Contemporary Black Artists.* New York: Ruder & Finn Fine Arts, 1969.

Five Famous Black Artists: Romare Bearden, Jacob Lawrence, Horace Pippin, Charles White, Hale Woodruff. Exh. cat. Roxbury, Mass.: Museum of the National Center of Afro-American Artists, 1970.

Gaither, Edmund Barry. *Afro-American Artists, New York and Boston.* Exh. cat. Roxbury, Mass.: Museum of the National Center of Afro-American Artists with Museum of Fine Arts and the School of the Museum of Fine Arts, 1970.

Hope, Henry Radford. *The American Scene: 1900–1970.* Exh. cat. Bloomington, Ind.: Indiana University Museum of Art, 1970.

Lewis, James E. *Afro-American Artists Abroad.* Exh. cat. Austin, Tex.: The University of Texas, 1970.

Teihet, Jehanne, ed. *Dimensions of Black.* Exh. cat. La Jolla, Calif.: La Jolla Museum of Art, 1970.

Doty, Robert. *Contemporary Black Artists in America.* Exh. cat. New York: Whitney Museum of American Art, 1971.

Glauber, Robert H. *Black American Artists / 71.* Exh. cat. Chicago: Illinois Bell Telephone, 1971.

Kingsbury, Martha. *Art of the Thirties: The Pacific Northwest.* Exh. cat. Seattle: University of Washington Press, 1972.

Andrews, Benny. *Blacks: USA: 1973.* Exh. cat. New York: New York Cultural Center, 1973.

The Barnett-Aden Collection. Exh. cat. Washington, D.C.: Smithsonian Institution, 1974.

Bullard, E. John. *A Panorama of American Painting: The John J. McDonough Collection.* Exh. cat. New Orleans: New Orleans Museum of Art, 1975.

Driskell, David C. *Amistad II: Afro-American Art.* Exh. cat. Nashville: Department of Fine Art, Fisk University, 1975.

Gaither, Edmund Barry. *Jubilee: Afro-American Artists on Afro-America.* Exh. cat. Roxbury, Mass.: Museum of Fine Arts in cooperation with the Museum of the National Center of Afro-American Artists, 1975.

Morris, George North. *A Century and a Half of American Art.* Exh. cat. New York: National Academy of Design, 1975.

Black Artists of the WPA 1933–1943: An Exhibition of Drawings, Paintings and Sculpture. Exh. cat. Brooklyn: New Muse Community Museum, 1976.

Driskell, David C. *Two Centuries of Black American Art.* Exh. cat. Los Angeles: Los Angeles County Museum of Art, 1976.

Goodrich, Lloyd. *A Selection of American Art: The Skowhegan School 1946–1976.* Exh. cat. Boston: Institute of Contemporary Art, 1976.

McMichael, Norma. *Fourteen Afro-American Artists.* Exh. cat. Brooklyn: Pratt Institute Gallery, 1976.

Selected Work by Black Artists from the Collection of The Metropolitan Museum of Art. Exh. cat. New York: Bedford-Stuyvesant Restoration Corporation, 1976.

Two Hundred Years of the Visual Arts in North Carolina. Exh. cat. Raleigh, N.C.: North Carolina Museum of Art, 1976.

Willis, John Ralph. *Fragments of American Life, An Exhibition of Paintings: Romare Bearden, Joseph Delaney, Rex Gorleigh, Lois Mailou Jones, Jacob Lawrence, Hughie Lee-Smith, Hale Woodruff.* Exh. cat. Princeton, N.J.: The Art Museum, Princeton University, 1976.

American Watercolors, 1855–1955. Exh. cat. Ithaca, N.Y.: Herbert F. Johnson Museum of Art, Cornell University, 1977.

Black American Art from the Barnett-Aden Collection. Exh. cat. Pittsburgh: Frick Fine Arts Museum, University of Pittsburgh, 1977.

Dillenberger, Jane, and John Dillenberger. *Perceptions of the Spirit in Twentieth-Century American Art.* Exh. cat. Indianapolis: Indianapolis Museum of Art, 1977.

North, Percy. *Hudson D. Walker: Patron and Friend, Collector of Twentieth-Century American Art.* Exh. cat. Minneapolis: University Gallery, 1977.

Park, Marlene, and Gerald E. Markowitz. *New Deal for Art.* Exh. cat. New York: The Gallery Association of New York, 1977.

Stewart, Ruth Ann. *New York/Chicago: WPA and the Black Artist.* Exh. cat. New York: The Studio Museum in Harlem, 1977.

Gingold, Diane J. *American Art, 1934–1956: Selections from the Whitney Museum of American Art.* Exh. cat. Montgomery, Ala.: Montgomery Museum of Fine Arts, 1978.

Hills, Patricia, and Abigail Booth Gerdts. *The Working American.* Exh. cat. Washington, D.C.: Smithsonian Institution Traveling Exhibition Service, 1979.

Hills, Patricia, and Roberta K. Tarbell. *The Figurative Tradition and the Whitney Museum of American Art: Paintings and Sculpture from the Permanent Collection.* New York: Whitney Museum of American Art, 1980.

Six Black Americans: Benny Andrews, Romare Bearden, Sam Gilliam, Richard Hunt, Jacob Lawrence, Betye Saar. Exh. cat. Trenton, N.J.: New Jersey State Museum, 1980.

Styron, Thomas W. *American Figure Painting 1950–1980.* Exh. cat. Norfolk, Va.: The Chrysler Museum of Art, 1980.

Berman, Greta, and Jeffrey Wechsler. *Realism and Realities: The Other Side of American Painting, 1940–1960.* Exh. cat. New Brunswick, N.J.: Rutgers University Art Gallery, State University of New Jersey, 1982.

Flomenhaft, Eleanor. *Celebrating Contemporary American Black Artists.* Exh. cat. Hempstead, N.Y.: Fine Arts Museum of New York, 1983.

Hills, Patricia, with an essay by Raphael Soyer. *Social Concern and Urban Realism: American Painting of the 1930s.* Exh. cat. Boston: Boston University Art Gallery, 1983.

Ausfeld, Margaret Lynne, and Virginia M. Mecklenburg. *Advancing American Art: Politics and Aesthetics in the State Department Exhibition 1946–48.* Exh. cat. Montgomery, Ala.: Montgomery Museum of Fine Arts, 1984.

Gelburd, Gail. *A Blossoming of New Promise: Art in the Spirit of the Harlem Renaissance.* Exh. cat. Hempstead, N.Y.: Hofstra University, 1984.

The Rhythm of Life: Selected Works by Bearden, Gwathmey, and Lawrence. Exh. cat. Alexandria, La.: Alexandria Museum of Art, 1984.

Since the Harlem Renaissance: Fifty Years of Afro-American Art. Exh. cat. Lewisburg, Pa.: The Center Gallery of Bucknell University, 1984.

Driskell, David C. *Hidden Heritage: Afro-American Art, 1800–1950.* Exh. cat. San Francisco: Art Museums Association of America, 1985.

Rand, Harry. *The Martha Jackson Memorial Collection.* Exh. cat. Washington, D.C.: Smithsonian Institution Press, 1985.

Roudabush Norelli, Martina. *Art, Design, and the Modern Corporation: The Collection of the Container Corporation of America, A Gift to the National Museum of American Art.* Exh. cat. Washington, D.C.: Smithsonian Institution Press, 1985.

Selections from the Permanent Holdings: Nineteenth and Twentieth Century American Art. Exh. cat. Washington, D.C.: The Evans-Tibbs Collection, 1985.

Tradition and Conflict: Images of a Turbulent Decade, 1963–1973. Exh. cat. New York: The Studio Museum in Harlem, 1985.

Wooden, Howard E. *American Art and the Great Depression: Two Sides of the Coin.* Exh. cat. Wichita, Kans.: Wichita Art Museum, 1985.

Gordon, Peter H., ed., with Sydney Waller and Paul Weinman. *Diamonds Are Forever: Artists and Writers on Baseball.* Exh. cat. San Francisco: Chronicle Books, 1987.

Los Angeles Collects: Works by over Thirty Artists from Fifteen Private Collections. Exh. cat. Los Angeles: The Museum of African American Art, 1987.

The Studio Museum in Harlem. *Harlem Renaissance: Art of Black America.* Exh. cat. New York: Harry N. Abrams, 1987.

Bibby, Deirdre L. *Augusta Savage and the Art Schools of Harlem.* Exh. cat. New York: The Schomburg Center for Research in Black Culture, 1988.

Danly, Susan. *American Art from the Collection of Vivian and Meyer P. Potamkin.* Exh. cat. Philadelphia: Pennsylvania Academy of the Fine Arts, 1989.

McElroy, Guy C., Richard J. Powell, and Sharon F. Patton. *African-American Artists 1880–1987: Selections from the Evans-Tibbs Collection.* Exh. cat. Washington, D.C.: Smithsonian Institution Traveling Exhibition Service, 1989.

Powell, Richard J. *The Blues Aesthetic: Black Culture and Modernism.* Exh. cat. Washington, D.C.: Washington Project for the Arts, 1989.

Reynolds, Gary A., and Beryl J. Wright. *Against the Odds: African-American Artists and the Harmon Foundation.* Exh. cat. Newark: The Newark Museum, 1989.

McElroy, Guy C. *Facing History: The Black Image in American Art, 1710–1940.* Exh. cat. San Francisco: Bedford Arts Publishers in association with The Corcoran Gallery of Art, 1990.

Castleman, Riva. *Art of the Forties.* Exh. cat. New York: The Museum of Modern Art, 1991.

Adams, Henry, Margaret Stenz, Jan M. Marsh, et al. *American Drawings and Watercolors from the Kansas City Region.* Kansas City, Mo.: The Nelson-Atkins Museum of Art, 1992.

Perry, Regenia A. *Free within Ourselves: African-American Artists in the Collection of the National Museum of American Art.* Exh. cat. Washington, D.C.: National Museum of American Art, Smithsonian Institution, in association with Pomegranate Art Books, 1992.

Weld, Alison, and Sadao Serikawa. *Dream Singers, Storytellers: An African-American Presence.* Exh. cat. Trenton, N.J., and Fukui, Japan: New Jersey State Museum and Fukui Fine Arts Museum, 1992.

Nelson, Naomi. *First in the Heart Is the Dream—African American Artists in the Twentieth Century: The Philadelphia Connection.* Exh. cat. Philadelphia: The Philadelphia Art Alliance, 1993.

Roznoy, C. *Spheres of Influence: Artists and Their Students in the Permanent Collection of the Whitney Museum of American Art.* Exh. cat. Stamford, Conn.: Whitney Museum of Art at Champion Plaza, 1993.

Sandler, Irving. *Roy R. Neuberger: Patron of the Arts.* Exh. cat. Purchase, N.Y.: Neuberger Museum of Art, 1993.

Troyen, Carol, and Sue Welsh Reed. *Awash in Color: Homer, Sargent, and the Great American Watercolor.* Exh. cat. Boston: Museum of Fine Arts, 1993.

A Collector's Eye: Depression-Era Paintings from the Collection of John Horton. Exh. cat. Doylestown, Pa.: James A. Michener Art Museum, 1994.

Harmon and Harriet Kelley Collection of African American Art. Exh. cat. San Antonio: San Antonio Museum of Art, 1994.

Miller, Mark H., ed. *Louis Armstrong: A Cultural Legacy.* Exh. cat. New York: Queens Museum of Art, 1994.

Schwartz, Constance, and Franklin Hill Perrell. *American Realism between the Wars: 1919–1941.* Exh. cat. Roslyn Harbor, N.Y.: Nassau County Museum of Art, 1994.

American Federation of the Arts. *In the Eye of the Storm: An Art of Conscience, 1930–1970, Selections from the Collection of Philip J. and Suzanne Schiller.* Exh. cat. New York: Pomegranate Art Books, 1995.

Powell, Richard J. *African-American Art, Twentieth Century Masterworks II.* Exh. cat. New York: Michael Rosenfeld Gallery, 1995.

Venn, Beth. *American Art 1940–1965, Traditions Reconsidered: Selections from the Permanent Collection of the Whitney Museum.* Exh. brch. San Jose, Calif.: San Jose Museum of Art, 1995.

Flam, Jack. *Powerful Expressions: Recent American Drawings.* Exh. cat. New York: National Academy of Design, 1996.

Lefalle-Collins, Lizzetta. *In the Spirit of Resistance: African-American Modernists and the Mexican Muralist School.* New York: American Federation of Arts, 1996.

Powell, Richard J. *Rhapsodies in Black: Art of the Harlem Renaissance.* Exh. cat. Los Angeles: University of California Press, 1997.

Gips, Terry, ed. *Narratives of African-American Art and Identity: The David C. Driskell Collection.* Exh. cat. College Park, Md.: University of Maryland, 1998.

Masterworks by Twentieth Century African-American Artists. Exh. cat. Springfield, Ohio: Springfield Museum of Art, 1998.

Beyond the Veil: Art of African American Artists at Century's End. Exh. cat. Winter Park, Fla.: Cornell Fine Arts Museum, Rollins College, 1999.

Haskell, Barbara. *The American Century: Art and Culture, 1900–1950.* Exh. cat. New York: Whitney Museum of American Art, 1999.

Powell, Richard J., and Jock Reynolds. *To Conserve a Legacy: American Art from Historically Black Colleges and Universities.* Exh. cat. Andover, Mass.: Addison Gallery of American Art; New York: The Studio Museum in Harlem, 1999.

Selected Articles Published in Periodicals and Newspapers

(in chronological sequence)

Emmart, A. D. [Review of Toussaint L'Ouverture series.] *Baltimore Sun,* February 5, 1939.

Lowe, Jeannette. "The Negro Sympathetically Rendered by Lawrence, Wechsler." *ARTnews* (New York) 37, 21 (February 18, 1939), p. 15.

"First Generation of Negro Artists: Paintings by Archibald J. Motley, Malvin Gray Johnson, Elton Fax, Jacob Lawrence." *Survey Graphic* (East Stroudsburg, Pa.) 28, 3 (March 1939), pp. 224–5.

Locke, Alain. "Advance on the Art Front." *Opportunity* (New York) 17, 5 (May 1939), pp. 132–6.

"Art Exhibit Depicts Life of Ouverture." *Crisis* (New York) 46 (June 1939), p. 180.

"Life of Toussaint." *Art Digest* (New York) 15, 6 (December 15, 1940), p. 12.

Locke, Alain. "'. . . And The Migrants Kept Coming': A Negro Artist Paints the Story of the Great American Minority." *Fortune* 24 (November 1941), pp. 102–9.

"Art News of America: Picture Story of the Negro's Migration." *ARTnews* (New York) 40, 15 (November 15–30, 1941), pp. 8–9.

"And the Migrants Kept Coming." *South Today* (Atlanta) 7, 1 (spring 1942), pp. 5–6.

Locke, Alain, ed. "How We Live in South and North: Paintings by Jacob Lawrence." *Survey Graphic* (East Stroudsburg, Pa.) 31, 11 (November 1942), pp. 478–9.

Riley, Maude. "Effective Protests by Lawrence of Harlem." *Art Digest* (New York) 17, 16 (May 15, 1943), p. 7.

Devree, Howard. "From a Reviewer's Notebook: Brief Comment on Some Recently Opened Group and One-Man Shows—New Jersey Visitors, Jacob Lawrence's Harlem." *New York Times,* May 16, 1943, sec. 2, p. 12.

"Art Today, Jacob Lawrence's Harlem." *Daily Worker* (New York), May 29, 1943, p. 7.

Coates, Robert M. "In the Galleries." *The New Yorker* 19, 15 (May 29, 1943), p. 15.

"Art: Harlem in Color." *Newsweek* 21, 23 (June 7, 1943), p. 100.

Symason, Meyer. "Canvas and Film: The Young Negro Artist Jacob Lawrence Depicts Harlem in a Series of Paintings." *New Masses* (New York) 47, 10 (June 8, 1943), pp. 29–30.

"Exhibition of Paintings by Jacob Lawrence." *Opportunity* (New York) 21 (July 1943), p. 124.

Pacheco, Patrick. "Artist in Harlem." *Vogue* 102 (September 15, 1943), pp. 94–5.

"M.M.A. Program." *ARTnews* (New York) 43, 11 (September 1–30, 1944), p. 6.

L[ouchheim], A[line] B. "Brisk and Brighter: An October Opening." *ARTnews* (New York) 43, 12 (October 1, 1944), p. 24.

Genauer, Emily. "Navyman Lawrence's Works at Modern Art." *New York World-Telegram,* October 14, 1944, p. 9.

Louchheim, Aline B. "Lawrence: Quiet Spokesman." *ARTnews* (New York) 43, 13 (October 15–31, 1944), p. 15.

Catlett, Elizabeth. [Review of Lawrence exhibition at Museum of Modern Art.] *People's Voice* (New York), October 21, 1944.

"Jacob Lawrence." *Bulletin of The Museum of Modern Art* (New York) 12 (November 1944), p. 11.

Gibbs, Josephine. "Jacob Lawrence's Migrations." *Art Digest* (New York) 19, 3 (November 1, 1944), p. 7.

Greene, Marjorie E. "Jacob Lawrence." *Opportunity* (New York) 23, 1 (January–March 1945), pp. 26–7.

McCausland, Elizabeth. "Jacob Lawrence." *Magazine of Art* (Washington, D.C.) 38, 7 (November 1945), pp. 250–4.

Wolf, Ben. "The Saga of John Brown." *Art Digest* (New York) 20, 6 (December 15, 1945), p. 17.

"Art: John Brown's Body." *Newsweek* 26, 26 (December 24, 1945), p. 87.

Coates, Robert M. "The Art Galleries." *The New Yorker* (May 18, 1946), pp. 77–9.

"Art: The Lost and Found." *Newsweek* (May 20, 1946), p. 102.

Moon, Bucklin. "The Harlem Nobody Knows." *Glamour* (July 1946), p. 68.

Crane, Jane Watson. "John Brown's Stirring." *Sunday Star* (Washington, D.C.), October 5, 1946, p. B5.

Louchheim, Aline B. "One More Carnegie." *ARTnews* (New York) 45, 9 (November 1946), pp. 40–1, 53–4.

Breuning, Margaret. "Vernal Preview." *Art Digest* (New York) 21, 14 (April 15, 1947), p. 21.

Bennett, Gwendolyn. "Meet Jacob Lawrence, Harlem-Born, Nationally Known." *Masses and Mainstream* (New York) 2, 1 (winter 1947), p. 97.

"Reviews and Previews: Jacob Lawrence." *ARTnews* (New York) 46, 10 (December 1947), p. 44.

Valente, Alfredo. "Jacob Lawrence." *Promenade* (New York) (December 1947), p. 44.

Adlow, Dorothy. "Jacob Lawrence's War Pictures." *Christian Science Monitor* (Boston), December 6, 1947, p. 18.

Genauer, Emily. "Jacob Lawrence War Paintings Are Tragic." *New York World-Telegram,* December 6, 1947, p. 4.

Burrows, Carlyle. "In the Art Galleries." *New York Herald Tribune,* December 7, 1947, sec. 6, p. 4.

Devree, Howard. "An Annual Round-up: Jacob Lawrence." *New York Times,* December 7, 1947, p. 16.

Gibbs, Jo. "Lawrence Uses War for New 'Sermon in Paint.'" *Art Digest* (New York) 22, 6 (December 15, 1947), p. 10.

"Art: Strike Fast." *Time* 50 (December 22, 1947), p. 61.

Evans, Walker. "In the Heart of the Black Belt." *Fortune* 37, 2 (August 1948), pp. 88–9.

Adlow, Dorothy. "The Artist Speaks." *Christian Science Monitor* (Boston), April 9, 1949, p. 6.

"Art: Questions and Answers." *Time* 53 (April 11, 1949), p. 57.

Seckler, Dorothy. "Reviews and Previews: New Paintings." *ARTnews* (New York) 48, 6 (October 1949), pp. 44–5.

Louchheim, Aline B. "An Artist Reports on the Troubled Mind." *New York Times Magazine,* October 15, 1950, pp. 15–6, 36, 38. Reprint. "Art in an Insane Asylum." *Negro Digest* (Chicago) 9 (February 1951), pp. 14–9.

Seckler, Dorothy. "Reviews and Previews: Jacob Lawrence." *ARTnews* (New York) 49, 7 (November 1950), p. 65.

Fitzsimmons, James. "Lawrence Documents." *Art Digest* (New York) 25, 3 (November 1, 1950), p. 16.

"Jacob Lawrence: New Paintings Portraying Life in Insane Asylum Project Him into Top Ranks of U.S. Artists." *Ebony* (Chicago) (April 1951), pp. 73–8.

P[orter], F[airfield]. "Reviews and Previews: Jacob Lawrence." *ARTnews* (New York) 51, 10 (February 1953), p. 73.

Geist, Sidney. "Fifty-Seventh Street in Review: Jacob Lawrence." *Art Digest* (New York) 27, 9 (February 1, 1953), p. 17.

Preston, Stuart. "Recent Works by Stevens, David Smith, Lawrence." *New York Times,* February 1, 1953, sec. 2, p. 8.

"Stories with Impact." *Time* 61 (February 2, 1953), pp. 50–1.

"Lawrence and Tam in Joint Exhibit." *Philadelphia Art Alliance Bulletin* 33 (January 1955), p. 8.

"Exhibition at the Alan Gallery, New York." *Pictures on Exhibit* (New York) 20 (January 1957), p. 4.

J. R. M. "In the Galleries: Jacob Lawrence." *Arts* (New York) 31, 4 (January 1957), p. 53.

Newbill, Al. "Gallery Previews in New York." *Pictures on Exhibit* (New York) 20, 4 (January 1957), p. 23.

Tyler, Parker. "Reviews and Previews: Jacob Lawrence." *ARTnews* (New York) 55, 9 (January 1957), p. 24.

Devree, Howard. "Forceful Painting." *New York Times,* January 6, 1957, sec. 2, p. 15.

"Birth of a Nation." *Time* 69 (January 14, 1957), p. 82.

Genauer, Emily. "New Exhibit Proves Art Needn't Be Aloof." *New York Herald Tribune,* June 6, 1957, p. 10.

"American Struggle: Three Paintings." *Vogue* 130 (July 1957), pp. 66–7.

[Review of the Alan Gallery Exhibition.] *New York Herald Tribune,* September 15, 1957.

James, Milton M. "Jacob Lawrence." *Negro History Bulletin* (Washington, D.C.) 21, 1 (October 1957), p. 18.

"New Work at Alan Gallery." *Apollo* (London) 70, 106 (October 1959), p. 106.

Raynor, Vivien. "In the Galleries: Jacob Lawrence." *Arts* (New York) 35, 4 (January 1961), pp. 54–5.

Wright, Clifford. "Jacob Lawrence." *The Studio* (London) 161 (January 1961), pp. 26–8.

Smith, Clifford. "Bright Sorrow." *Time* 77 (February 24, 1961), pp. 60–3.

Schiff, Bennett. "Closeup: The Artist as Man in the Street." *New York Post Magazine,* March 26, 1961, p. 2.

Hayes, Richard. "Reviews and Previews: New Work." *ARTnews* (New York) 60, 4 (summer 1961), p. 54.

Rigg, Margaret. "Jacob Lawrence: Painter." *Motive* (Nashville) (April 1962), p. 20–1, 23.

Elliot Rago, Louise. "A Welcome for Jacob Lawrence." *School Arts* (Worcester, Mass.) (February 1963), pp. 31–2, 88–9.

Beck, James H. "Jacob Lawrence." *ARTnews* (New York) 62, 2 (April 1963), p. 13.

"Major, A. Hyatt. "Painters' Playing Cards." *Art in America* (New York) 51, 2 (April 1963), pp. 39–42.

"Art: Black Mirror." *Newsweek* 61, 15 (April 15, 1963), p. 100.

R[aynor], V[ivien]. "In the Galleries: Jacob Lawrence." *Arts* (New York) 37, 9 (May 1963), p. 112.

Kramer, Hilton. "In the Museums." *Art in America* (New York) 52, 2 (March 1964), pp. 36–47.

"Artist Extraordinary." *Interlink: The Nigerian American Quarterly Newsletter* (Lagos, Nigeria) 2 (July 1964), p. 4.

Barnitz, Jacqueline. "In the Galleries: Jacob Lawrence." *Arts* (New York) 39, 66 (February 1965).

Browne, Rosalind. "Reviews and Previews: Jacob Lawrence." *ARTnews* (New York) 63, 10 (February 1965), p. 17.

Kay, Jane H. "Lawrence Retrospective: Capsulating a Career." *Christian Science Monitor* (Boston), March 26, 1965, p. 4.

Pomeroy, Ralph. "Reviews and Previews: Jacob Lawrence." *ARTnews* (New York) 66, 9 (January 1968), p. 15.

Glueck, Grace. "New York Gallery Notes: Who's Minding the Easel?" *Art in America* (New York) 56, 1 (January–February 1968), pp. 110–3.

Canaday, John. "The Quiet Anger of Jacob Lawrence." *New York Times,* January 6, 1968, p. 25.

Willis, Clayton. "Jacob Lawrence's Paintings on Exhibit." *New York Amsterdam News,* January 20, 1968, p. 16.

Dorset, Gerald. "In the Galleries: Jacob Lawrence." *Arts* (New York) 42, 4 (February 1968), p. 65.

Bearden, Romare. "The Black Artist in America: A Symposium." *The Metropolitan Museum of Art Bulletin* (New York) 27, 5 (January 1969), pp. 245–60.

Greene, Carroll, Jr. "Jacob Lawrence: Story Teller." *American Way* (July–August 1969).

Lawrence, Jacob. "The Artist Responds." *Crisis* (New York) 77, 7 (August–September 1970), pp. 266–7.

"Jacob Lawrence." *Contact* (New York) (October 1970), pp. 20–1.

Kramer, Hilton. "Art: Lawrence Epic of Blacks." *New York Times,* May 18, 1974, p. 25.

Glueck, Grace. "Sharing Success Pleases Lawrence." *New York Times,* June 3, 1974, p. 38.

Loercher, Diana. "Jacob Lawrence—World's Painter of Black Experience." *Christian Science Monitor* (Boston), June 6, 1974, p. F6.

Glueck, Grace. "Praise for UW Artist." *Seattle Post-Intelligencer,* June 9, 1974.

Tarzan, Delores. "Seattle's Best Kept Secret." *Seattle Times,* June 14, 1974.

Mainardi, Pat. "Review of Exhibitions: Jacob Lawrence at the Whitney." *Art in America* (New York) 62, 4 (July–August 1974), p. 84.

Williams, Milton. "America's Top Black Artist." *Sepia* (Fort Worth) 23, 8 (August 1974), pp. 75–8.

Campbell, Lawrence. "Reviews: Jacob Lawrence." *ARTnews* (New York) 73, 7 (September 1974), p. 114.

Pincus-Witten, Robert. "Jacob Lawrence: Carpenter Cubism." *Artforum* (New York) 13, 66 (September 1974), pp. 66–7.

Harris, Jessica B. "The Prolific Palette of Jacob Lawrence." *Encore* (New York) (November 1974), pp. 52–3.

Watkins, Richard. "Jacob Lawrence: The Famous Artist Who Chronicles Major Black Events in American History Says He Is Motivated and Inspired by the Black Experience." *Black Enterprise* (New York) 6, 5 (December 1975), pp. 66–8.

Campbell, R. M. "The New Art of Jacob Lawrence." *Seattle Post-Intelligencer,* October 22, 1976.

Tarzan, Delores. "Great Paintings by Jacob Lawrence." *Seattle Times,* January 25, 1977, p. A11.

Hoppin, Bonnie. "Arts Interview: Jacob Lawrence." *Puget Soundings* (Seattle) (February 1977), p. 6.

Major, Clarence. "Clarence Major Interviews: Jacob Lawrence, The Expressionist." *The Black Scholar* (Oakland, Calif.) 9, 3 (November 1977), pp. 23–34.

"Dintenfass Gallery, New York." *ARTnews* (New York) 77, 5 (May 1978), p. 180.

Winn, Steven. "Prints and Paintings by Jacob Lawrence." *Seattle Weekly* (December 13–19, 1978), pp. 42–7.

Campbell, R. M. "Artist Who Stuck to His Story: Jacob Lawrence's John Brown." *Seattle Post-Intelligencer,* December 20, 1978, pp. A8–9.

Wilson, Judith. "Main Events: Art." *Essence* (New York) 10 (September 1979), pp. 12–4.

Nast, Stan. "Painter Lawrence Is Honored for a 'Protest' That Was Life." *Seattle Post-Intelligencer,* April 5, 1980.

Lewis, Samella, and Lester Sullivan. "Jacob Lawrence Issue." *Black Art* (New York) 5, 3 (1982).

Raynor, Vivien. "Forty-One Paintings Tell a Tale of Haitian Revolt." *New York Times,* April 18, 1982, sec. 2, p. 20.

Wilson, William. "Art Review: Lawrence, Folk Roots Grow Slick." *Los Angeles Times,* April 26, 1982, sec. 6, p. 1.

Hackett, Regina. "A Match of Form and Content." *Seattle Post-Intelligencer,* August 24, 1982, p. D3.

Van Cleve, Jane. "The Human Views of Jacob Lawrence." *Stepping Out Northwest* 12 (winter 1982), pp. 33–7.

Glowen, Ron. "Jacob Lawrence at Francine Seders." *Images and Issues* (Santa Monica, Calif.) (January–February 1983).

Smallwood, Lyn. "The Art and Life of Jacob Lawrence, Seattle's Old Master." *Seattle Weekly,* January 18–24, 1984, pp. 35–6.

Berman, Avis. "Jacob Lawrence and the Making of Americans." *ARTnews* (New York) 83, 2 (February 1984), pp. 78–86.

Jones, Glory. "Jacob Lawrence: The Master Nobody Knows." *Washington* (Bellevue, Wash.) 1, 3 (November–December 1984), pp. 54–8.

Stokes Oliver, Stephanie. "Jacob Lawrence: A Master in Our Midst." *Seattle Times,* October 27, 1985, Pacific magazine, pp. 14–7.

Hackett, Regina. "Jacob Lawrence's Latest Series Has Slowed to a Standstill." *Seattle Post-Intelligencer,* December 10, 1985, p. C5.

Wheat, Ellen Harkins. "Jacob Lawrence and the Legacy of Harlem." *Archives of American Art Journal* (Washington, D.C.) 26, 1 (1986), pp. 18–25.

Hackett, Regina. "Jacob Lawrence's Retrospective Show Celebrates Fifty Artistic Years." *Seattle Post-Intelligencer,* July 8, 1986, pp. C1–7.

Tarzan, Deloris. "SAM Celebrates Lawrence." *Seattle Times,* July 9, 1986, pp. C1–2.

Kangas, Matthew. "Looking Back at Jacob Lawrence." *Seattle Weekly,* July 16–22, 1986, pp. 35–6.

Turner, Wallace. "Painter Joins Seattle Art Lovers in Looking Back on His Career." *New York Times,* July 28, 1986, p. A6.

Berman, Avis. "Commitment on Canvas." *Modern Maturity* (Ojai, Calif.) (August–September 1986), pp. 68–75.

Stokes Oliver, Stephanie. "Jacob Lawrence." *Essence* (New York) (November 1986), pp. 89–91, 134.

Wheat, Ellen Harkins. "Jacob Lawrence: American Painter." *American Visions* (Washington, D.C.) (1987).

Wheat, Ellen Harkins. "Jacob Lawrence: Chronicler of the Black Experience." *American Visions* (Washington, D.C.) 2, 1 (February 1987), pp. 31–5.

Stone, TaRessa. "Jacob Lawrence Interview." *Art Papers* (Atlanta) 11, 2 (March–April 1987), pp. 35–6.

Tarzan, Deloris. "Proposed Mural Touches Off New Debate on Art in Capitol, Is Jacob Lawrence Too Contemporary?" *Seattle Times,* March 13, 1987.

Wernick, Robert. "Jacob Lawrence: Art As Seen through a People's History." *Smithsonian* (Washington, D.C.) 18, 3 (June 1987), pp. 56–67.

Johnson, Fridolf. "Art Books: Jacob Lawrence, American Painter." *American Artist* (New York) 51 (September 1987), pp. 28, 78–9.

Larson, Kay. "Museums: Jacob Lawrence." *New York* 20, 37 (September 21, 1987), pp. 66–7.

Solomon, Deborah. "The Book of Jacob." *New York Daily News Magazine,* September 27, 1987, pp. 18–21.

"Retrospective Exhibit on Afro-American Painter." *People's Daily World* (New York), September 30, 1987, p. A11.

Russell, John. "Art View: The Epic of a People Writ Large on Canvas." *New York Times,* October 11, 1987, sec. 2, p. 39.

Larson, Kay. "Bound for Glory." *New York* 20, 41 (October 19, 1987), p. 112.

Heartney, Eleanor. "Reviews: Jacob Lawrence." *ARTnews* (New York) 86, 10 (December 1987), p. 143.

Collins, Amy Fine. "Jacob Lawrence: Art Builder." *Art in America* (New York) 76, 2 (February 1988), pp. 130–5.

Mills, Pamela. "Always Reaching for a New Dimension Defines Lawrence's Fifty-Year Career." *People's Daily World* (New York), March 22, 1989.

Highwater, Jamake. "Stripping Art of Elitism." *Christian Science Monitor* (Boston), April 23, 1990, p. 16.

Raynor, Vivien. "The Theme Is Humanity (or Inhumanity)." *New York Times,* March 31, 1991, p. 6.

Kimmelman, Michael. "Art, Art, Everywhere Art." *New York Times,* September 20, 1991, p. C1.

Kimmelman, Michael. "Review/Art: Stark or Sweet Images Tell Black History's Tale." *New York Times,* September 20, 1991, p. C24.

Bass, Ruth. "Reviews: Jacob Lawrence, Studio Museum in Harlem," *ARTnews* (New York) 90, 10 (December 1991), pp. 120–1.

Zimmer, William. "A Painterly Storyteller Takes Black America as His Subject." *New York Times,* April 5, 1992, p. WC20.

"Jacob Lawrence: Greatest Living Black Painter." *Ebony* (Chicago) (September 1992), pp. 62, 64, 66.

Knight, Christopher. "Panels Take a Small Look at Large Lives." *Los Angeles Times,* June 14, 1993, pp. F1, F9.

Frank, Peter. "Jacob Lawrence." *L.A. Weekly,* August 6–12, 1993.

Turner, Elizabeth Hutton. "Jacob Lawrence, Black Migration Series." *American Art Review* (Los Angeles) 5, 5 (fall 1993), pp. 132–5.

Vincent, Steven. "Jacob Lawrence at Midtown Payson." *Art and Auction* (Doyleston, Pa.) (November 1993), pp. 78–80.

Kimmelman, Michael. "A Sense of the Epic, A Love of the Ordinary." *New York Times,* November 14, 1993, sec. 2, p. 39.

Hughes, Robert. "Stanzas from a Black Epic." *Time* 142, 22 (November 22, 1993), pp. 70–1.

Hills, Patricia. "Jacob Lawrence as Pictorial Griot: The *Harriet Tubman* Series." *American Art* (New York) 7, 1 (winter 1993), pp. 40–59.

Gibson, Eric. "Exhibition Notes: 'Jacob Lawrence—The Migration Series' at the Phillips Collection." *The New Criterion* (New York) 12, 4 (December 1993), p. 51.

Kaufman, Jason Edward. "The Saga of American Blacks According to Jacob Lawrence." *The Art Newspaper* (London) 33, 4 (December 1993), p. 14.

Wilkin, Karen. "At the Galleries." *Partisan Review* (New York), 1 (1994), pp. 132–49.

James, Curtia. "Reviews: Jacob Lawrence, Phillips Collection," *ARTnews* (New York) 93, 1 (January 1994), p. 169.

"Jacob Lawrence's Paintings Depict Negro Exodus." *The Economist* (London) 330 (January 8, 1994), p. 82.

Hollingsworth, Lt. Charles H., Jr. "Jacob Armstead Lawrence, Famous Artist Served on Active Duty as CG Reservist from '43–'45." *Coast Guard Reservist* (Washington, D.C.) (February 1994).

"Jacob Lawrence." *American Way* 27, 4 (February 15, 1994).

Margolies, Beth Anne. "Bibliographic Essay on Three African American Artists: William H. Johnson, Romare Bearden, and Jacob Lawrence." *Art Documentation* (Tucson, Ariz.) 13, 1 (spring 1994), pp. 13–7.

Hackett, Regina. "Lawrence's Early Works Say So Much with So Little." *Seattle Post-Intelligencer*, March 10, 1994.

Hackett, Regina. "True to Life, Jacob Lawrence's Art Honors the Real Lives of Real People." *Seattle Post-Intelligencer*, March 10, 1994, pp. C1, C4.

Updike, Robin. "Lives of Tubman, Douglass à la Jacob Lawrence." *Seattle Times*, March 17, 1994, pp. E1–2.

Turner, Elizabeth Hutton. "Jacob Lawrence: Chronicles of Color." *Southwest Art* (Houston) 23, 11 (April 1994), pp. 72–5.

Weinstein, Joel. "Profile: Jacob Lawrence." *Visions* (Los Angeles) (summer 1994), p. 47.

Hurwitz, Laurie S. "Exhibits: On Migration." *American Artist* (New York) 58 (August 1994), p. 8.

Wills, Gary. "The Real Thing." *New York Review of Books* 41, 14 (August 11, 1994), pp. 6–9.

Hackett, Regina. "Painter Jacob Lawrence Finds Supermarket Ripe with Images." *Seattle Post-Intelligencer*, December 9, 1994.

Updike, Robin. "Lawrence Exhibit Is This Month's Star at Galleries." *Seattle Times*, December 14, 1994, pp. F1, F3.

White, Michelle-Lee. "Common Directions, Epic Dimensions: Jacob Lawrence's Murals at Howard University." *International Review of African American Art* (Santa Monica, Calif.) 12, 4 (1995), pp. 30–7.

Wallach, Amei. "Northern Exposure." *New York Newsday*, January 8, 1995.

Smith, Roberta. "Art Review: The Migration from the South in Sixty Images." *New York Times*, January 13, 1995, pp. C1, C29.

Wilkin, Karen. "The Naïve and The Modern: Horace Pippin and Jacob Lawrence." *The New Criterion* (New York) 13, 7 (March 1995), pp. 33–8.

Fitzgerald, Sharon. "The Homecoming of Jacob Lawrence." *American Visions* (Washington, D.C.) 10 (April–May 1995), pp. 20–5.

Borum, Jennifer P. "Reviews: New York, Jacob Lawrence." *Artforum* (New York) 33, 9 (May 1995), pp. 101–2.

"Jacob Lawrence: The Migration Series." *Antiques and the Arts Weekly* (Atlanta) (May 5, 1995).

"Hampton University Lawrence Series." *International Review of African American Art* (Santa Monica, Calif.) 13, 4 (1996), p. 57.

Green, Roger. "Jacob Lawrence: Full Circle." *ARTnews* (New York) 95, 67 (March 1996), p. 67.

Schwabsky, Barry. "Black Exodus." *Art in America* (New York) 84, 3 (March 1996), pp. 88–93.

Kimmelman, Michael. "An Invigorating Homecoming: At the Met and Modern with Jacob Lawrence." *New York Times*, April 12, 1996, pp. C1, C4.

Lovelace, Carey. "Looking at Art: The Artist's Eye, Jacob Lawrence." *ARTnews* (New York) 95, 11 (December 1996), pp. 79–80.

Wallis, Stephen. "Jacob Lawrence: Portrait of a Serial Painter." *Art and Antiques* (New York) 19, 11 (December 1996), pp. 58–64.

Thompson Dodd, Jacci. "Jacob Lawrence: Recent Work." *International Review of African American Art* (Santa Monica, Calif.) 14, 1 (1997), pp. 10–3.

Updike, Robin. "A Modern Master." *Seattle Times*, June 28, 1998, *Pacific Northwest* magazine, pp. 14–22.

Hackett, Regina. "Jacob Lawrence: A Life in Art." *Seattle Post-Intelligencer*, July 2, 1998, pp. D1, D9.

Updike, Robin. "Jacob Lawrence." *Seattle Times*, July 2, 1998, pp. E1–2.

McTaggart, Tom. "'Life' Has Its Ups and Downs." *Seattle Weekly*, July 9, 1998, p. 22.

Hackett, Regina. "The Public Side of Jacob Lawrence." *Seattle Post-Intelligencer*, July 17, 1998, p. 21.

Updike, Robin. "Maquette Show Offers Taste of Jacob Lawrence's Large Works." *Seattle Times*, July 23, 1998.

Bell, Shaniece A. "Art of the African World, Jacob Lawrence: One of the World's Most Preeminent Artists." *The Black Collegian* (New Orleans) (October 1998), pp. 12–3.

Naves, Mario. "Five Painters." *The New Criterion* (New York) 17, 6 (February 1999), pp. 49–52.

Viveros-Faune, Christian. "New York: Jacob Lawrence at DC Moore." *Art in America* (New York) 87, 4 (April 1999), p. 143.

Selected Publications and Reference Works

(in alphabetical sequence by author's last name or by title if no author is cited)

Allan, Lois. *Contemporary Art in the Northwest.* North Ryden, Australia: Craftsman House Art Books, 1995.

Arnason, H. H., Marla F. Prather, and Daniel Wheeler. *History of Modern Art.* New York: Harry N. Abrams, 1998.

Atkinson, J. Edward. *Black Dimensions in Contemporary American Art.* New York: New American Library, 1971.

Baigell, Matthew. *The American Scene: American Painting of the 1930s.* New York: Praeger Publishers, 1974.

Bardolph, Richard. *The Negro Vanguard.* New York: Rinehart, 1959.

Barr, Alfred H., Jr. *Painting and Sculpture in The Museum of Modern Art.* New York: The Museum of Modern Art, 1942. Rev. eds. 1948, 1958, 1977.

Baur, John I. H., ed. *New Art in America: Fifty Painters of the Twentieth Century.* Greenwich, Conn.: New York Graphic Society, 1957.

Bearden, Romare, and Carl Holty. *The Painter's Mind.* New York: Crown Publishers, 1967.

Bearden, Romare, and Harry Henderson. *A History of African-American Artists from 1972 to Present.* New York: Pantheon Books, 1993.

Bearden, Romare, and Harry Henderson. *Six Black Masters of American Art.* Garden City, N.Y.: Doubleday, 1972.

Britton, Crystal. *African American Art: The Long Struggle.* New York: Todtri, 1996.

Brown, Milton W., Sam Hunter, John Jacobs, Naomi Rosenblum, and David M. Sokol. *American Art.* New York: Harry N. Abrams, 1979.

Brown, Milton W., with the assistance of Judith H. Lanius. *One Hundred Masterpieces of American Painting.* Washington, D.C.: Smithsonian Institution Press, 1983.

Carpenter, James M. *Visual Art: A Critical Introduction.* New York: Harcourt Brace Jovanovich, 1982.

Clapp, Jane. *Art in Life.* New York: Scarecrow, 1959.

Craven, Wayne. *American Art: History and Culture.* New York: Harry N. Abrams, 1994.

Davidson, Marshall B. *The Artist's America.* New York: American Heritage, 1973.

Davis, Lenwood G., and Janet L. Sims. *Black Artists in the United States: An Annotated Bibliography of Books, Articles, and Dissertations on Black Artists, 1779–1979.* Westport, Conn.: Greenwood Press, 1980.

Dover, Cedric. *American Negro Art.* Greenwich, Conn.: New York Graphic Society, 1960.

Eliot, Alexander. *Three Hundred Years of American Painting.* New York: Time, 1957.

———. *Art of Our Time, 1950–1960: Painting, Architecture, and Sculpture.* New York: Omicron, 1959.

Fax, Elton C. *Seventeen Black Artists.* New York: Dodd, Mead and Co., 1971.

———. *Black Artists of the New Generation.* New York: Dodd, Mead and Co., 1977.

Feldman, Edmund Burke. *Art as Image and Idea.* Englewood Cliffs, N.J.: Prentice-Hall, 1967.

———. *Becoming Human through Art.* Englewood Cliffs, N.J.: Prentice-Hall, 1970.

———. *Varieties of Visual Experience: Art as Image and Idea.* 2nd ed. Englewood Cliffs, N.J.: Prentice-Hall, 1972.

———. *Varieties of Visual Experience.* New York: Harry N. Abrams, 1980.

———. *The Artist.* Englewood Cliffs, N.J.: Prentice-Hall, 1982.

Feldman, Frances T. "American Painting during the Great Depression, 1929–1939." Ph.D. dissertation. New York: New York University, 1963.

Fine, Elsa Honig. *The Afro-American Artist: A Search for Identity.* New York: Hacker Art Books, 1973. Reprint, 1982.

Foner, Moe, ed. *Images of Labor.* New York: Pilgrim Press, 1981.

Freedgood, Lillian. *An Enduring Image: American Painting from 1665.* New York: Crowell, 1970.

Gardner, Albert Ten Eyck. *History of Water Color Painting in America.* New York: Reinhold Publishing, 1966.

Glubak, Shirley. *The Art of America since World War II.* New York: Macmillan, 1976.

Goodrich, Lloyd, and John I. H. Baur. *American Art of Our Century.* New York: Frederick A. Praeger, 1961.

Gruskin, Alan. *Painting in the U.S.A.* Garden City, N.Y.: Doubleday & Co., 1946.

Guenther, Bruce. *Fifty Northwest Artists: A Critical Selection of Painters and Sculptors Working in the Pacific Northwest.* San Francisco: Chronicle Books, 1983.

Hale, Robert Beverly. *One Hundred American Painters of the Twentieth Century.* New York: The Metropolitan Museum of Art, 1950.

Havlice, Patricia Pate. *Art in Time.* Metuchen, N.J.: Scarecrow, 1970.

hooks, bell. *Outlaw Culture: Resisting Representation.* New York: Routledge, 1994.

Hoopes, Donelson, Jr. *American Watercolor Painting.* New York: Watson-Guptill, 1977.

Huggins, Nathan Irvin. *Harlem Renaissance.* London, Oxford, and New York: Oxford University Press, 1971.

Igoe, Lynn Moody, with James Igoe. *Two Hundred Fifty Years of Afro-American Art: An Annotated Bibliography.* New York: R. R. Bowker Company, 1981.

Janson, H. W., and Anthony F. Janson. *History of Art.* New York: Harry N. Abrams, 1997.

Larkin, Oliver W. *Art and Life in America.* New York: Rinehart & Company, 1950. Rev. ed. New York: Holt, Rinehart and Winston, 1960.

Lewis, Samella. *African American Art and Artists.* Berkeley, Calif.: University of California Press, 1990.

Lewis, Samella, and Ruth G. Waddy. *Black Artists on Art.* Los Angeles: Contemporary Crafts Publishers, 1969.

Lindey, Christine. *Art in the Cold War from Vladivostok to Kalamazoo, 1945–1962.* New York: New Amsterdam Books, 1990.

Lipman, Jean. *What Is American in American Art?* New York: McGraw-Hill, 1963.

Lipman, Jean, and Helen M. Franc. *Bright Stars: American Painting and Sculpture since 1976.* New York: E. P. Dutton, 1976.

Locke, Alain. *The Negro in Art: A Pictorial Record of the Negro Artist and of the Negro Theme in Art.* Washington, D.C.: Associates in Negro Folk Education, 1940. Reprint. New York: Hacker Art Books, 1971.

Lucie-Smith, Edward. *Race, Sex, and Gender in Contemporary Art.* New York: Harry N. Abrams, 1994.

McCoubrey, John W. *American Painting 1900–1970.* New York: Time-Life Books, 1971.

McCurdy, Charles. *The American Tradition in the Arts.* New York: Harcourt, 1968.

McLanathan, Richard. *The American Tradition in the Arts.* New York: Harcourt, Brace & World, 1968.

Meltzer, Milton. *Violins and Shovels: The WPA Art Project.* New York: Delacorte Press, 1976.

Myers, Bernard S., ed. *Encyclopedia of Painting.* New York: Crown Publishers, 1955.

O'Connor, Francis V. *Federal Support for the Visual Arts: The New Deal Then and Now.* Greenwich, Conn.: New York Graphic Society, 1969.

———. *The New Deal Art Projects: An Anthology of Memories.* Washington, D.C.: Smithsonian Institution Press, 1972.

———, ed. *Art for the Millions: Essays from the 1930s by Artists and Administrators of the WPA Federal Art Project.* Greenwich, Conn.: New York Graphic Society, 1973.

Patton, Sharon F. *African-American Art.* Oxford and New York: Oxford University Press, 1998.

Pearson, Ralph M. *The Modern Renaissance in American Art: Presenting the Work and Philosophy of Fifty-Four Distinguished Artists.* New York: Harper & Brothers, 1954.

Porter, James A. *Modern Negro Art.* New York: The Dryden Press, 1943. Reprint. Washington, D.C.: Howard University Press, 1992.

Powell, Richard J. *Black Art and Culture in the Twentieth Century.* London: Thames and Hudson, 1997.

Puma, Fernando. *Modern Art Looks Ahead.* New York: Beechhurst Press, 1947.

Reynolds, Jock. *American Abstraction at the Addison.* Andover, Mass.: Addison Gallery of American Art, Phillips Academy, 1991.

Richardson, E. P. *Painting in America: The Story of Four Hundred Fifty Years.* New York: Crowell, 1956.

———. *A Short History of Painting in America: The Story of Four Hundred Fifty Years.* New York: Crowell, 1963.

Rodman, Selden. *Horace Pippin: A Negro Painter in America.* New York: Quadrangle Press, 1947.

———. *Conversations with Artists.* New York: Devin-Adair, 1957.

Rose, Barbara. *American Art since 1900: A Critical History.* New York: Frederic A. Praeger, 1968.

Sayre, Henry. *A World of Art.* Upper Saddle River, N.J.: Prentice-Hall, 1997.

Schapiro, David, ed. *Social Realism: Art as Weapon.* New York: Patrick Ungar Publishing Company, 1973.

Schneider Adams, Laurie. *A History of Western Art.* New York: Harry N. Abrams, 1994.

Schwartz, Barry. *The New Humanism: Art in a Time of Change.* New York: Praeger, 1974.

Selected Works: Outstanding Painting, Sculpture, and Decorative Art from the Permanent Collection. Atlanta: High Museum of Art, 1987.

Selz, Peter. *Art in Our Times: A Pictorial History 1890–1980.* New York: Harry N. Abrams, 1981.

Silver, Larry. *Art in History.* Englewood Cliffs, N.J.: Prentice-Hall, 1993.

Stebbins, Theodore E., Jr., and Carol Troyen. *The Lane Collection: Twentieth-Century Paintings in the American Tradition.* Boston: Museum of Fine Arts, 1983.

Steiner, Mary Ann, ed. *The Saint Louis Art Museum Handbook of the Collection.* Saint Louis: The Saint Louis Art Museum, 1991.

Stokstad, Marilyn. *Art History.* New York: Harry N. Abrams, 1999.

Strickler, Susan E. *The Toledo Museum of Art, American Paintings.* Toledo, Ohio: Museum of Art, 1979.

———, ed. *American Traditions in Watercolor: The Worcester Art Museum Collection.* New York: Abbeville Press, 1987.

Sweetkind, Irene S., ed. *Master Paintings from the Butler Institute of Art.* New York: Harry N. Abrams, 1994.

Tansey, Richard G., and Fred S. Kleiner. *Gardiner's Art through the Ages.* New York: Harcourt Brace College Publishers, 1996.

Taylor, Joshua C. *America as Art.* Washington, D.C.: Smithsonian Institution Press, 1976.

Tighe, Mary Ann, and Elizabeth Ewing Lang. *Art in America.* New York: McGraw-Hill, 1977.

The Twentieth-Century Art Book. London: Phaidon, 1999.

The University of Arizona Collection of American Art. Tucson, Ariz.: University of Arizona, 1947.

Von Blum, Paul. *The Art of Social Conscience.* New York: Universe Books, 1976.

———. *The Critical Vision: A History of Social and Political Art in the U.S.* Boston: South End Press, 1982.

Wilkins, David G., and Bernard Schultz. *Art Past, Art Present.* New York: Harry N. Abrams, 1990.

Wilmerding, John. *American Art.* New York: Penguin Books, 1976.

———. *American Masterpieces from the National Gallery.* New York: Hudson Hills Press, 1988.

Wolfe, Townsend. *Twentieth-Century American Drawings from the Arkansas Arts Center Foundation Collection.* Little Rock, Ark.: The Arkansas Arts Center, 1984.

Woodson, Shirley, ed. *The Walter O. Evans Collection of African-American Art.* Savannah, Ga.: King-Tisdell Foundation, 1991.

Index

Note: Page numbers in *italics* indicate illustrations.

Notes on Contributors

PATRICIA HILLS is a professor of art history at Boston University and writes extensively on both nineteenth- and twentieth-century American art. As both a scholar and a museum curator, she has written books and articles on genre and figure painting, portraiture, African American art, and the interrelationship of visual culture and political and social history. She has authored and contributed to such exhibition catalogues and books as *John Singer Sargent*, *Alice Neel*, and *Social Concern and Urban Realism: American Painting in the 1930s*.

PAUL J. KARLSTROM, West Coast Regional Director of the Archives of American Art in San Marino, California, is a specialist in modern and contemporary art and culture in the United States. His publications include *On the Edge of America: California Modernist Art, 1900–1950* and a contribution to the exhibition catalogue *Diego Rivera: Art & Revolution* (Museo de Arte Moderno, Mexico City). He is currently spearheading a major project to document the history and culture of Asian Americans.

LESLIE KING-HAMMOND, Dean of Graduate Studies at the Maryland Institute, College of Art, in Baltimore, was president of the College Art Association from 1996 to 1998, and is currently project director for Philip Morris Fellowships for Artists of Color. Her publications include *Celebrations: Myth and Ritual in African American Art*, *Art as a Verb*, and *Three Generations of African American Women Artists: A Study of Paradox*. Her forthcoming book is titled *Masks and Mirrors: African American Art (1750–Now)*.

LIZZETTA LEFALLE-COLLINS earned her Ph.D. in art history from the University of California, Los Angeles, and is an independent scholar and curator, living in California. She has curated the exhibitions *Sargent Johnson: African American Modernist* and *In the Spirit of Resistance: African-American Modernists and the Mexican Mural School*. LeFalle-Collins also represented the United States as the official curator at the 22nd International São Paolo Bienal (Brazil) in 1994.

RICHARD J. POWELL is John Spencer Bassett Professor of Art and Art History at Duke University. He is the author of numerous publications on African American art and artists, including *The Blues Aesthetic: Black Culture and Modernism*, *Homecoming: The Art and Life of William H. Johnson*, and *Black Art and Culture in the 20th Century*.

LOWERY STOKES SIMS, formerly curator of modern art at the Metropolitan Museum of Art, has recently been appointed director of the Studio Museum in Harlem. Sims has curated exhibitions on the work of such artists as John Marin, Stuart Davis, Richard Pousette-Dart, Hans Hofmann, and Wilfredo Lam. She has published extensively on twentieth-century art with a particular emphasis on African, Native, Latino, and Asian American artists.

ELIZABETH STEELE is the conservator for the Phillips Collection in Washington, D.C. She has a master of arts degree and a certificate of advanced study from the State University of New York, Oneonta, and has received advanced training at the National Gallery of Art and the Metropolitan Museum of Art. Her research interests are the materials and techniques of modern painters.

ELIZABETH HUTTON TURNER is a curator at the Phillips Collection in Washington, D.C., and a specialist in modern art. Turner has directed a series of traveling exhibitions, including *Two Lives: Georgia O'Keeffe and Alfred Stieglitz: A Conversation in Paintings and Photographs*, *Jacob Lawrence: The Migration Series*, *In the American Grain: Arthur Dove, John Marin, Georgia O'Keeffe, and Alfred Stieglitz, Americans in Paris*, and, most recently, *Georgia O'Keeffe: The Poetry of Things*.

Photography Acknowledgments

THE EDITORS AND THE PUBLISHERS would like to thank the owners of the pictures for providing photographs and/or permitting reproduction of photographs of their work in this book. The owners are credited under the reproductions. Additional credits are listed below. Every effort has been made to contact the copyright holders of both photographs and works. Any errors or omissions are inadvertent and will be corrected in subsequent editions and/or on-line.

David Allison, figs. 45, 70, 83, 90, pp. 318l, 331br; Dean Beasom, pl. 78, fig. 132; Benjamin Blackwell, p. 317tl; Ricardo Blanc, figs. 4, 120; Bliss Photography, pl. 42; E. Irving Blomstrann, fig. 77; Del Bogart, pl. 33; Eduardo Calderón, pl. 93, fig. 135; Simon Cherry, pls. 1, 4, 10, 43, 54, 82, figs. 49, 81, pp. 324l, 328bl, 330br; Geoffrey Clements, fig. 48; © The Detroit Institute of Arts, pls. 21, 22, 23, figs. 41, 85, pp. 314–16, 319tr; Dan Dragan, pls. 83, 87; Janet Dwyer, pl. 48; Chris Eden, pls. 63, 90, 91, fig. 89, pp. 334tr, 334br; Biff Heinrich, pl. 30, p. 319tl; Intermedia Services, University of Washington, figs. 54, 88; Ron Jennings, pl. 32; Mike Jensen, figs. 27, 28, 29; Kate Keller, pl. 17, figs. 31, 38, pp. 307–13, even-numbered panels; Tim Lee, fig. 57; Becket Logan, p. 326tl; Paul Macapia, pl. 6, figs. 53, 78, 88, 89, 94, 107, 109, 123, 133, pp. 333tl, 333bl, 333tr, 333br, 334bl; Spike Mafford, pls. 41, 73, 84, 85, 86, pp. 327r, 331tr; Dave Matthews, pl. 61; Melville McLean, pl. 79; © 1985 by The Metropolitan Museum of Art, fig. 36; © 1986 by The Metropolitan Museum of Art, pl. 29; © 1998 Museum of Modern Art, New York, pl. 17, figs. 31, 38, 126, pp. 307–13, even-numbered panels; © Board of Trustees, National Gallery of Art, Washington, pl. 78, fig. 132; Richard Nicol, pls. 2, 37, 38, figs. 79, 99, 101, 110, 117, pp. 330tl, 336tr, 336br; Edward Owen, pls. 16, 18, fig. 122, pp. 307–13, odd-numbered panels; Joe Painter, pls. 12, 60, 69, fig. 93, p. 319bl; Ian Reeves, p. 290; Harold Rhynie, fig. 68, p. 323bl; Ellen Rosenbery, fig. 26, p. 301; Clive Russ, pls. 36, 44; Kevin Ryan, pls. 70, 74, fig. 51, pp. 317tr, 323tl, 326r, 336tl, 336bl; Manu Sassoonian, fig. 114; E. G. Schempf, pl. 34; Marvin and Morgan Smith, figs. 8, 12; Michael J. Smith, fig. 64; R. Jackson Smith, pl. 80; Lee Stalsworth, pls. 51, 59, 64, 71, 76, figs. 33, 73, 84, 119, pp. 287, 296, 318br, 325l, 328tl; Tim Thayer, fig. 17, pp. 328br, 330tr; Jerry Thompson, pl. 11; Joe Thompson, p. 328tr; Saverio Truglia, pl. 55; Stephen Tucker, p. 335; David Ulmer, p. 329; Misha Van Boksner, pl. 72, fig. 59, pp. 8, 327tl, 330bl; CJ Walker, pl. 65; James Whitelaw, pp. 322bl, 322r, 323tr, 327bl; © 1999 Whitney Museum of American Art, pl. 45, figs. 42, 43, 48, 105, pp. 320–21; Scott Wolff, pls. 14, 15, 31, figs. 30, 35, 39, 40, pp. 303–6; Patrick J. Young, p. 331bl; Dorothy Zeidman, pl. 9.

The Exhibition

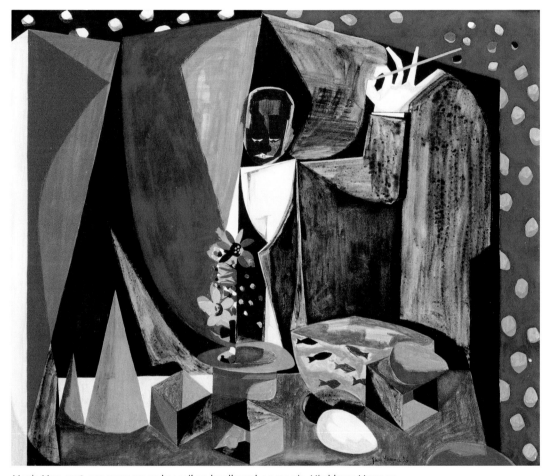

Magic Man, 1958, egg tempera and pencil on hardboard, 20 × 24 in. Hirshhorn Museum and Sculpture Garden, Smithsonian Institution. Gift of Mrs. Henry Folkerson, 1981.

Contents

Sponsors' Statements

As part of our ongoing support of excellence in the arts, ExxonMobil is honored to be the national sponsor of *Over the Line: The Art and Life of Jacob Lawrence.* This extraordinary exhibition chronicles the lives, struggles, and aspirations of African Americans during significant moments in American history. Jacob Lawrence's vision of the American epic speaks to us all. The exhibition will travel to five cities over two years and will bring his art to the largest audience to ever see his work.

Jacob Lawrence began painting in Harlem in the 1930s, encouraged by an after-school program and community mentors. Part artist and part historian, through his paintings, Lawrence offers a precise portrait of an era. His most famous work includes *The Migration of the Negro Series,* which depicts the mass migration of African Americans from the rural South to urban centers in the North. We are moved by Lawrence's simple and eloquent style. His storytelling allows us to see the dignity of everyday people living in their times and to better understand America's history and diverse culture.

Over the Line: The Art and Life of Jacob Lawrence is a comprehensive review of the style, technique, and methods of an American master. This exhibition and catalogue include many never-before-seen Lawrence works from private collections, as well as several complete narrative cycles, including *The Harriet Tubman Series* and *The Migration of the Negro Series.* The educational materials developed for the exhibition will assist students and educators in their study of American art and history.

Since 1943, ExxonMobil has supported the arts, museums, and historical associations in communities where we live and operate. Art is a language that crosses geographic, cultural, and national boundaries; it informs and unites. As a global corporate citizen, we recognize the strengths of our diverse workforce and the value of corporate giving and community investment. We are, therefore, especially pleased to sponsor this comprehensive exhibition and educational program of the art and life of Jacob Lawrence, which will reach such a broad audience. We are indebted to The Phillips Collection for their dedication in curating this exhibition and nurturing the legacy of Jacob Lawrence.

Lucio A. Noto
Vice Chairman
ExxonMobil

At AT&T, we believe communication means sharing ideas, whether over a network or through an artist's brush. Since the 1940s, AT&T has supported artistic expression and has helped bring diverse contemporary artists to a wider public.

We are pleased to join with ExxonMobil and the National Endowment for the Arts in supporting *Over the Line: The Art and Life of Jacob Lawrence*, originating at The Phillips Collection and continuing to New York, Detroit, Los Angeles, and Houston.

Lawrence's innovation within the tradition of American modernism, combined with his responsiveness to the African American voice in American history over the six decades of his prolific career, make him one of the finest artists of the twentieth century. His ability to communicate within the African American community and across differences of color, generation, and aesthetic value provides an important window into American culture.

We congratulate The Phillips Collection on its role in preserving Lawrence's work and in presenting this landmark exhibition. In supporting *Over the Line: The Art & Life of Jacob Lawrence*, AT&T is privileged to celebrate one of the visionaries of contemporary art.

C. Michael Armstrong
Chairman & CEO
AT&T

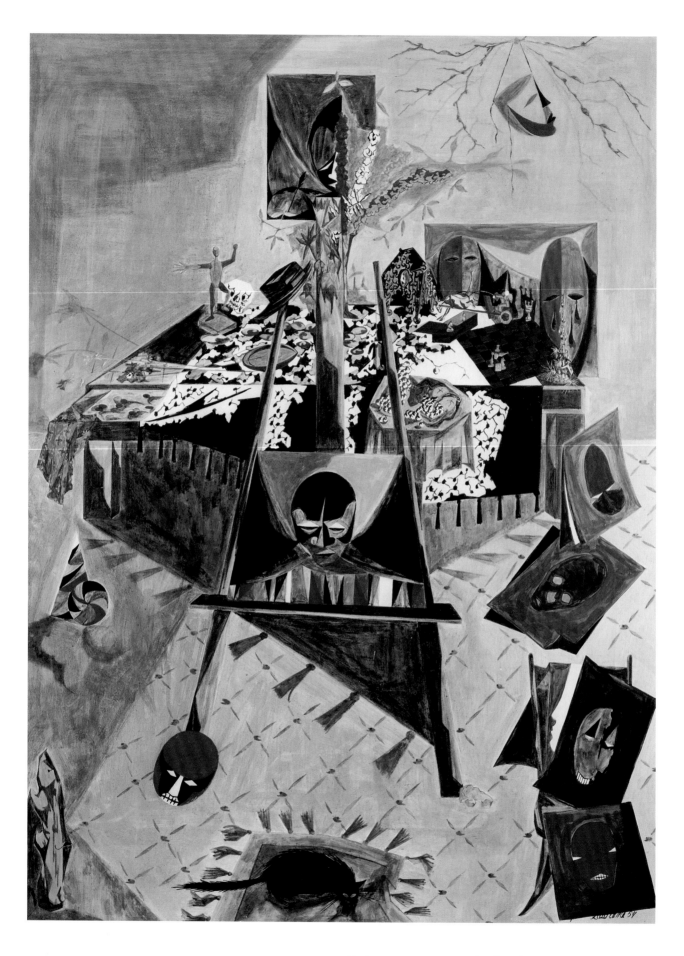

Masks, 1954, egg tempera on hardboard,
24 × 17¾ in. Elizabeth Marsteller Gordon.

Letter from the Director

My belief is that it is most important for an artist to develop an approach and philosophy about life— if he has developed this philosophy he does not put paint on canvas, he puts himself on canvas.

—*Jacob Lawrence to Josef Albers, 1946*

FOR MORE THAN SIXTY-FIVE YEARS Jacob Lawrence (1917–2000) was both an impassioned observer and storyteller whose gaze was firmly fixed upon the complexities of our American tumult from the Civil War period of the 1860s to the civil rights movement of the 1960s—to the end of the twentieth century. Lawrence's paintings made the realities of race and racial differences visible in the process of Americanization. Seized by the strength and beauty of his compositions, generations of viewers have embraced the triumphs and tragedies of America's struggle for freedom and justice. Yet while much attention has been given to Lawrence's changing subject matter, prior to the publication of the Jacob Lawrence Catalogue Raisonné and the opening of this retrospective, little time has been devoted to the evolution of his form. Ironically Jacob Lawrence did not see himself as a history painter or even a realist. In seeing and selecting this line or that color, in balancing this form with that pose or gesture, Lawrence, through his discipline of paint, espoused a philosophy, or rather constructed an approach to life. If, as he once said, painting was more like self-portraiture, then Lawrence's reflections upon American culture also bear closer examination for the ongoing narrative of his own creative struggle.

THE PHILLIPS COLLECTION is extremely honored to present the exhibition *Over the Line: The Art and Life of Jacob Lawrence*, organized on the occasion of the Jacob Lawrence Catalogue Raisonné publication released in the fall of 2000.

Countless individuals and institutions contributed to the successful realization of this exhibition, and we wish to acknowledge them for their generosity and goodwill.

First and foremost, we are profoundly thankful to the late Jacob Lawrence for his enthusiasm and vital support of this exhibition over the past two years. We also are extremely grateful for the warmth and good counsel provided by Gwendolyn Knight Lawrence throughout this entire project. For her keen artistic sensibility and firsthand insights into Jacob Lawrence's art and life, we owe a special gratitude.

This exhibition would not have been possible without the support and commitment of our funders. The Phillips Collection is immensely grateful to Exxon Mobil Corporation, whose strong financial support made this exhibition possible. We are also deeply grateful to AT&T for their important additional support. Special thanks is also due to the National Endowment for the Arts for their grant in support of the exhibition.

We offer our gratitude to The Phillips Collection's Senior Curator and Project Director, Elizabeth Hutton Turner, whose passion for Jacob Lawrence and unwavering enthusiasm, expertise, and commitment has been an ever-present guiding force behind the successful realization of this project.

The exhibition is indebted to the Jacob Lawrence Catalogue Raisonné Project. We have benefited considerably from their scholarship, counsel, enthusiasm, and strong support, under the direction of Peter T. Nesbett, Executive Director, and Michelle DuBois, Associate Director, who graciously provided untold assistance at every turn. Their comprehensive research and documentation of the artist's oeuvre based upon the latest discoveries concerning Lawrence's technique, medium, and narrative invention proved invaluable to our exhibition. The

Catalogue Raisonné's efforts brought to light many works in private collections that we have been most fortunate to bring together for the first time in an exhibition.

A special thanks is also due to the galleries and dealers representing Jacob Lawrence's work—Francine Seders of Francine Seders Gallery and Bridget Moore and Heidi Lange of DC Moore Gallery—for their constant support and cooperation in response to our numerous queries.

We are delighted that four museums are participating in the exhibition's national tour and want to acknowledge our colleagues and the dedicated staff at each institution for their interest in and commitment to this exhibition: At the Whitney Museum of American Art: Maxwell Anderson, Director, and Barbara Haskell, Curator, Prewar Art; at the Museum of Fine Arts, Houston: Peter Marzio, Director, and Alvia Wardlaw, Curator of Contemporary Art; at The Detroit Institute of Arts: Graham W. J. Beal, Director, and Ellen Sharp, Curator of Prints; at the Los Angeles County Museum of Art: Dr. Andrea Rich, President and Director, and Howard Fox, Curator of Contemporary Art.

This exhibition would never have come into being without the remarkable generosity and cooperation of all the lenders, whose tremendous sacrifice and good faith made it all possible.

The over eighty individuals, institutions, and organizations who were willing to loan important works are to be warmly thanked by name.

We are enormously grateful to the large numbers of private collectors—over forty in all—for their support and cooperation. We especially want to thank Dr. Walter O. Evans and Gwendolyn Knight Lawrence for graciously granting numerous key loans.

In addition, we want to express our thanks to Marylin Bender Altschul; Clifford A. Ames and E. Grant Spradling; Margaret and Michael Asch; James Banks; Ruth Bowman; Bette Crouse; Dr. Walter O. Evans; Linda Herget Fiebig and Craig Fiebig; Francine Seders, Francine Seders Gallery; Judith Golden, Brooklyn; Elizabeth Marsteller Gordon; The Harmon and Harriet Kelley Collection; Allan and Nenette Harvey; Abigail Kursheedt Hoffman and Jane Hoffman Paress; Jeremy and Linda Jaech, Seattle; Private Collection of Mrs. Josef Jaffe; Jules and Connie Kay; William H. Lane Collection; Ronald and Elizabeth Kanof Levine; Mrs. Norma Marin; Bill and Holly Marklyn; Mr. and Mrs. Richard H. Markowitz; Collection of Mrs. Harpo Marx; Nicholas Neubauer; Mrs. Stacey Clarfield Newman and Dr. Fredric Newman; Mr. and Mrs. James R. Palmer; Michael Rosenfeld and halley k harrisburg, New York; Mr. and Mrs. Harvey M. Ross; The Collection of Philip J. and Suzanne Schiller, American Social Commentary Art 1930–1970; Celeste Schmid; Shirley Seligman; Dr. Mildred Beatty Smith; Harold A. and Ann R. Sorgenti; The Thompson Collection; Susan and Peter Tuteur; and to nine private collectors who wish to remain anonymous.

Our special gratitude also goes to the institutional lenders for their enormous support. We appreciate the significant contributions from the Hirshhorn Museum and Sculpture Garden and the Spelman College Collection. Special thanks is due to the Museum of Modern Art for the loan of their 30 panels from *The Migration of the Negro* series, to Hampton University Museum for the loan of all 31 panels from *The Harriet Tubman* series, and to the Whitney Museum of American Art for the loan of their 14 panels from the *War* series.

We also want to thank: ADDISON GALLERY OF AMERICAN ART: Adam D. Weinberg, The Mary Stripp & R. Crosby Kemper Director; and Denise J. H. Johnson, Registrar; ALBRIGHT-KNOX ART GALLERY: Douglas Schultz, Director; and Laura Fleischmann, Senior Registrar; AMON CARTER MUSEUM: Richard Stewart, Director; Jane Myers, Chief Curator; and Melissa G. Thompson, Registrar; THE ART INSTITUTE OF CHICAGO: James N. Wood, Director and President; Daniel Schulman, Associate Curator of Modern and Contemporary Art; Martha Sharma, Assistant Registrar; and Kristin Lister, Conservator; CITIGROUP: Suzanne F. W. Lemakis, Art Curator; and Ellen Quinn, Art Manager; CLARK ATLANTA UNIVERSITY ART GALLERIES: Tina Dunkley, Director; and Stacey Savatsky (former Interim Registrar); THE CLEVELAND MUSEUM OF ART: Katharine Lee Reid, Director; Diane De Grazia, The Clara T. Rankin Chief Curator; Carter Foster, Assistant Curator of Drawings; and Mary Suzor, Chief Registrar; DALLAS MUSEUM OF ART: Jack Lane, Director; Eleanor Jones Harvey, Curator of American Art; Angie Morrow, Associate Registrar for Exhibitions and Permanent Collection; and Jeanne Chvosta, Associate Registrar for Rights and Reproductions; FREDERICK R. WEISMAN ART MUSEUM: Lyndel King, Director; Patricia McDonnell, Curator; Karen Duncan, Registrar; and Laura Muessig, Associate Registrar; HAMPTON UNIVERSITY MUSEUM: Jeanne Zeidler, Director and C.E.O.; and Mary Lou Hultgren, Curator of Collections; THE HARMON AND HARRIET KELLEY FOUNDATION FOR THE ARTS;

HERBERT F. JOHNSON MUSEUM OF ART: Franklin Robinson, Director; Nancy E. Green, Chief Curator; and Warren Bunn, Registrar; HIGH MUSEUM OF ART: Michael Shapiro, Director; Carrie Przybilla, Curator of Modern and Contemporary Art; and Jody Cohen, Associate Registrar; HIRSHHORN MUSEUM AND SCULPTURE GARDEN: James T. Demetrion, Director; Phyllis Rosenzweig, Associate Curator; Susan Lake, Conservator; Margaret Dong, Assistant Registrar for Loans; and Brian G. Kavanah, Registrar; HOOD MUSEUM OF ART: Margaret Dyer Chamberlain (former Acting Director); Barbara MacAdam, Curator of American Art ; Kellen G. Haak, Registrar; and Juliette Bianco, Exhibitions Manager; THE HUNTER MUSEUM OF AMERICAN ART: Cleve K. Scarbrough (former Director); and Ellen Simak, Curator of Collections; JOSLYN ART MUSEUM: John E. Schloder (former Director); Marsha V. Gallagher, Chief Curator; Theodore W. James, Collections and Exhibitions Manager; and Penelope Smith, Registrar; MAIER MUSEUM OF ART: Karol Lawson, Director; and Ellen Schall Agnew, Associate Director; THE METROPOLITAN MUSEUM OF ART: Philippe de Montebello, Director; William S. Lieberman, Chairman of the Department of Modern Art; Ida Balboul, Research Associate Modern Art; Rachel Mustalish, Conservator; and Lisa Yeung, Associate Loans Coordinator; MILWAUKEE ART MUSEUM: Russell Bowman, Director; Kristin Makholm, Curator Prints and Drawings; and Leigh Albritton, Registrar; MUSEUM OF FINE ARTS, BOSTON: Malcolm Rogers, Ann and Graham Gund Director; Sue Reed, Curator of Prints and Drawings; and Kim Pashko, Assistant Registrar—Loans; THE MUSEUM OF MODERN ART: Glenn Lowery, Director; Gary Garrels, Chief Curator, Department of Drawings; Kirk Varnedoe, Chief Curator, Department of Painting and Sculpture; Cora Rosevear, Associate Curator; Laura Rosentock, Assistant Curator; Kristin Helmick-Brunet, Curatorial Assistant; and Avril Peck, Painting and Sculpture Loan Assistant; NATIONAL ACADEMY OF DESIGN: Annette Blaugrund, Director; David B. Dearinger, Chief Curator; and Wendy Rogers, Registrar; NATIONAL GALLERY OF ART: Earl A. Powell, III, Director; Jeffrey Weiss, Curator, Modern and Contemporary Art; Mervin Richard, Deputy Chief of Conservation and Head of Department; Stephanie Belt, Head, Department of Loans and The National Lending Service; Alicia Thomas, Loans Officer; and Judy Cline, Registrar; THE NELSON-ATKINS MUSEUM OF ART: Marc F. Wilson, Director; Deborah Emont Scott, Chief Curator; and Ann Erbacher, Chief Registrar; THE NEWARK MUSEUM: Mary Sue Sweeney Price, Director; Joseph Jacobs, Curator of American Art; and Amber Woods Germano, Assistant Registrar; NORTH SHORE—LONG ISLAND JEWISH HEALTH SYSTEM: David R. Dantzker, M.D.; and Lory Gazzola, Executive Associate to the C.E.O.; THE REEM & KAYDEN FOUNDATION; SAFECO: Jim McDonald, Corporate Art Curator; SBC COMMUNICATIONS INC.: Julie Kinzelman, Vice President, Cary Ellis Company; SCHOMBURG CENTER FOR RESEARCH IN BLACK CULTURE, ART & ARTIFACTS DIVISION: Howard Dodson, Director; and Tammi Lawson, Curatorial Assistant; SEATTLE ART MUSEUM: Mimi Gardner Gates, Director; Trevor Fairbrother, Deputy Director of Art and the Jon and Mary Shirley Curator of Modern Art; and Lauren Tucker, Associate Registrar; SHELDON MEMORIAL ART GALLERY: Janice Driesbach, Director; Daniel Siedell, Curator; and Cynnamon Jones, Registrar; SMITHSONIAN AMERICAN ART MUSEUM: Elizabeth Broun, Margaret and Terry Stent Director; and Abigail Terrones, Associate Registrar; SPELMAN COLLEGE COLLECTION: Akua McDaniel, Director; THE STUDIO MUSEUM IN HARLEM: Lowery Stokes Sims, Director; and Ann Kovach, Registrar; TACOMA ART MUSEUM: Janeanne Upp, Executive Director; Barbara Johns (former Chief Curator); and Rosanna Sharpe, Registrar; UNIVERSITY OF CALIFORNIA, BERKELEY ART MUSEUM: Kevin Consey, Director; and Lisa Calden, Collection and Exhibition Administrator; THE UNIVERSITY OF MICHIGAN MUSEUM OF ART: James Steward, Director; and Lori A. Mott, Registrar; VATICAN MUSEUMS: Francesco Buranelli, Acting Director General; WALKER ART CENTER: Kathy Halbreich, Director; Joan Ratsis, Curator; and Heather Thimm, Assistant Registrar; WHITNEY MUSEUM OF AMERICAN ART: Maxwell Anderson, Director; Janie C. Lee, Curator; Barbara Haskell, Curator, Prewar Art; Marla Prather, Curator, Postwar Art; Shamim Momin, Assistant Curator; Ken Fernandez, Curatorial Assistant; Barbi Spieler, Senior Registrar; and Joelle LaFerrara, Assistant Registrar.

Over the course of working on this exhibition, the project was greatly enriched by the breadth and depth of expertise and advice from the eight essayists of the Catalogue Raisonné Project, among them: Patricia Hills, Professor of Art History at Boston University; Paul Karlstrom, West Coast Regional Director of the Archives of American Art; Leslie King-Hammond, Dean of Graduate Studies at the Maryland Institute; Lizzeta LeFalle-Collins, independent scholar and curator; Richard J. Powell, John Spencer Bassett Professor of Art and Art History, Duke University; Lowery Stokes Sims, Director, Studio Museum in Harlem;

Elizabeth Steele, Conservator, The Phillips Collection; as well as Elizabeth Hutton Turner, Senior Curator of The Phillips Collection, and the Project Director for this exhibition. Together, their groundbreaking research provided a critical foundation for our examination of the artist's work in this exhibition.

We would also like to thank the many kind and dedicated individuals who facilitated our research efforts at numerous libraries and archives. We are particularly grateful to Ted Dalziel, Art Information Specialist, National Gallery of Art; Pat Lynagh, Assistant Librarian, National Museum of American Art; and Judith E. Throm, Chief Reference, Archives of American Art.

The exhibition also benefited from the expertise and enthusiasm of talented consultants. We are grateful to Val Lewton and Robyn Kennedy for their creative and thoughtful installation of this exhibition and to Gibson Creative for their powerful graphic design. We thank Jackson Frost, Vincent Gancie, Chad Finelay, and Daniel J. Linnik. Deba Leach is also due thanks for her kind support and assistance. Thanks also to the conservation consultants who graciously performed condition reports of works in the exhibition. Particularly, we thank Martin J. Radecki and Claire L. Hoevel of the Indianapolis Museum of Art.

Our collaboration with University of Washington Press and Marquand Books has been especially fruitful. For their hard efforts and creative solutions to designing and publishing the catalogue material, we owe our thanks to Ed Marquand and John Hubbard of Marquand Books and Pat Soden and his staff at the University of Washington Press.

The entire staff of The Phillips Collection, who adopted this project with great enthusiasm, deserves our heartfelt thanks for their hard work and dedication to the project. Their collaboration made this a smooth and effective team effort. Laughlin Phillips, President of the Board of Directors of The Phillips Collection, and Eliza Rathbone, Chief Curator, deserve a special thanks for their unfailing support and guidance throughout this project.

For their special expertise and contributions, we are particularly grateful to: Barbara Benney, Director of Human Resources; Hanna Byers, Curatorial Assistant; Kate Clinton, Director of Development; Linda Clous, Assistant Registrar; Marla N. Curtis, Conservation Fellow; Vanessa Curtis, Education Project Assistant; Dan Datlow, Director of Facilities and Security; Tiffany De Santis, Human Resources Generalist; Faith Flanagan, Director of Graphic Communication; Sue Frank, Assistant Curator; Jennifer Greenhill, Curatorial Assistant; Meri Grube, Development Associate; Johanna Halford-MacLeod, Director of Programming and Publications; Jessica Hickox, Membership Associate; Joe Holbach, Chief Registrar; Elizabeth Holleman, Membership Manager; Bill Koberg, Installations Manager; Byron Luke, Director of Finance; Alec MacKaye, Assistant Preparator; Amy Mannarino, Public Relations and Marketing Officer; Shelly Marker, Education Project Assistant; Fran Marshall (former Payroll Clerk); Nathan Martin, Grants and Research Manager; Matt Moffett, Chief of Facilities and Security; April Molley, Bookkeeper; Mary Alice Nay, Manager of Special Events; Cherie Nichols, Accounting Manager; Laura Parham, Assistant to the Director; Ruth Perlin, Special Assistant to the Director for Interpretive and Technological Initiatives; Stephen Phillips, Associate Curator; Lynn Rossotti, Director of Public Relations; Joanna Rothman, Tour Coordinator; Rich Rutledge, Chief Operating Officer; Karen Schneider, Librarian; Eric Stensvaag, Corporate Membership Manager; Frampton Tolbert, Marketing and Programming Coordinator; Shelly Wischhusen, Chief Preparator; and Nancy Zabaloieff, Accounting Manager.

Over the years, a host of interns also contributed in vital ways to the success of the exhibition: Evelyn Braithwaite, Amanda Blumburg, Alexia DePottere Smith, Lucy Dinsmore, Ricardo Harris Fuentes, Meaghan Kent, Nicole Laurent, Alex Marshall, Jessica McMichaels, Sabrina Paige, and Maura Pilcher.

We are deeply indebted to Elsa M. Smithgall, Assistant Curator of the exhibition, for her skill, expertise, and tireless work, which has played a vital role in all aspects of the exhibition. We are grateful to Thora Colot, Director of Marketing and Business Activities, for her facilitation of exhibition publications and the Jacob Lawrence film. Our thanks also to Suzanne Wright, Director of Educational Programs. A special thanks to The Phillips Collection's Conservator, Elizabeth Steele, whose in-depth study of the materials and techniques of Jacob Lawrence contributed important new insights into the artist's work.

Jay Gates
Director, The Phillips Collection

Lenders to the Exhibition

Addison Gallery of American Art

Albright-Knox Art Gallery

Marylin Bender Altschul

Clifford A. Ames and E. Grant Spradling

Amon Carter Museum

The Art Institute of Chicago

Margaret and Michael Asch

James Banks

Ruth Bowman

Citigroup

Clark Atlanta University Art Galleries

The Cleveland Museum of Art

Bette Crouse

Dallas Museum of Art

The Detroit Institute of Arts

The Estate of Jacob Lawrence

Dr. Walter O. Evans

Linda Herget Fiebig and Craig Fiebig

Francine Seders Gallery

Frederick R. Weisman Art Museum

Judith Golden, Brooklyn

Elizabeth Marsteller Gordon

Hampton University Museum

The Harmon and Harriet Kelley
 Collection

The Harmon and Harriet Kelley
 Foundation for the Arts

Allan and Nenette Harvey

Herbert F. Johnson Museum of Art

High Museum of Art

Hirshhorn Museum and Sculpture
 Garden

Abigail Kursheedt Hoffman and
 Jane Hoffman Paress

Hood Museum of Art

The Hunter Museum of American Art

Jeremy and Linda Jaech, Seattle

Private Collection of Mrs. Josef Jaffe

Joslyn Art Museum

Jules and Connie Kay

William H. Lane Collection

Gwendolyn Knight Lawrence

Ronald and Elizabeth Kanof Levine

Maier Museum of Art

Mrs. Norma Marin

Bill and Holly Marklyn

Mr. and Mrs. Richard H. Markowitz

Collection of Mrs. Harpo Marx

The Metropolitan Museum of Art

Milwaukee Art Museum

Museum of Fine Arts, Boston

The Museum of Modern Art

National Academy of Design

National Gallery of Art, Washington

The Nelson-Atkins Museum of Art

Nicholas Neubauer

The Newark Museum

Mrs. Stacey Clarfield Newman and
 Dr. Fredric Newman

North Shore—Long Island Jewish
 Health System

Mr. and Mrs. James R. Palmer

The Phillips Collection

The Reem & Kayden Foundation

Michael Rosenfeld and halley k
 harrisburg, New York

Mr. and Mrs. Harvey M. Ross

SAFECO

SBC Communications Inc.

The Collection of Philip J. and Suzanne
 Schiller, American Social Commentary
 Art 1930–1970

Celeste Schmid

Schomburg Center for Research in Black
 Culture, Art & Artifacts Division

Seattle Art Museum

Shirley Seligman

Sheldon Memorial Art Gallery

Dr. Mildred Beatty Smith

Smithsonian American Art Museum

Harold A. and Ann R. Sorgenti

Spelman College Collection

The Studio Museum in Harlem

Tacoma Art Museum

The Thompson Collection

Susan and Peter Tuteur

University of California, Berkeley
 Art Museum

The University of Michigan Museum
 of Art

Vatican Museums

Walker Art Center

Whitney Museum of American Art

Nine Anonymous Lenders

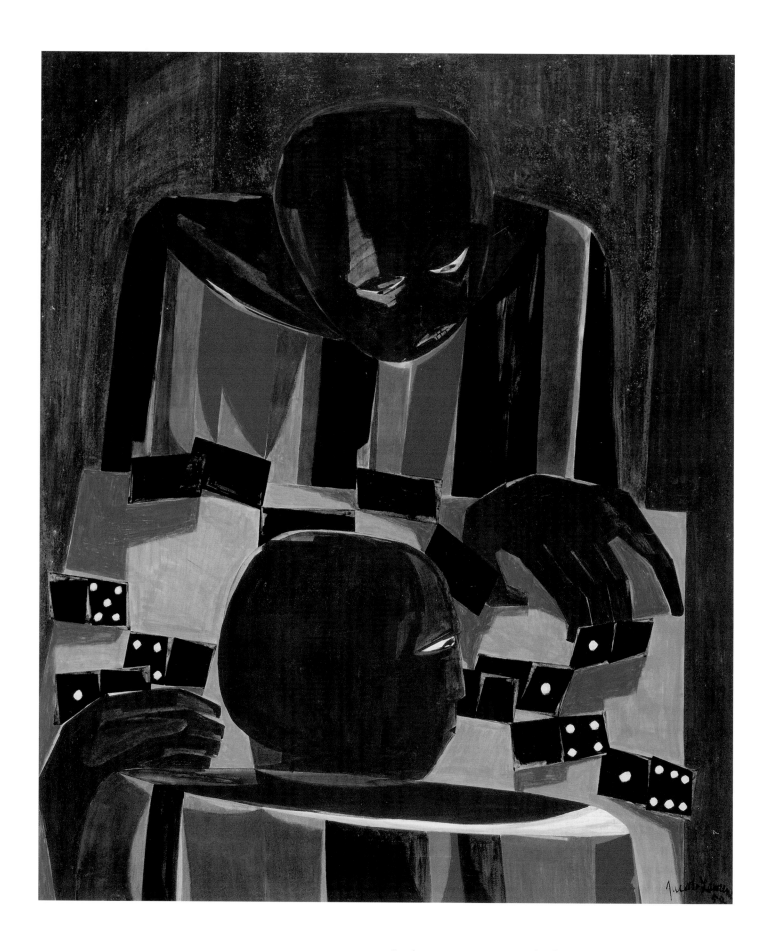

Dominoes, 1958, egg tempera on hardboard,
24½ × 19¾ in. Private collection.

Elizabeth Hutton Turner

Curator's Statement

JACOB LAWRENCE'S ART AND LIFE were lived and experienced, as the editors of this book have described, "Over the Line." Trained in the art workshops of the Harlem community in the 1930s, Lawrence was the first voice of the black experience to speak to a mainstream audience. At the age of 24, with the exhibition and joint purchase by The Museum of Modern Art and The Phillips Collection of his narrative entitled *The Migration of the Negro*, Jacob Lawrence became the first modern African American painter to break into an art world that was highly segregated and receive ongoing support from major institutions. To be sure these "firsts" launched Lawrence's career. It was nevertheless a lonely journey. As the sole African American within Edith Halpert's Downtown Gallery, and the sole African American teaching with Josef Albers at Black Mountain College, Lawrence, with his flat astringent color patterns of tempera, operated within overlapping imaginative worlds. But how? What happened to the artistic imagination of this black painter who was always conscious of representing his race? How did he choose to portray himself within a world of modern art that declared itself universal or race free?

When asked about what ignited and informed his imagination, Lawrence consistently spoke about three things: the magic of the picture plane, the architecture of experience, and the beauty of struggle. From the moment he first marveled at the sweat on a grape in a still life at the Metropolitan Museum, Lawrence remained convinced that painting had magic. Lawrence's mastery of this magic came not by copying the little Dutch masters, but by developing his own command of the rhythms and geometries of composition. He became the architect of his own observations, as well as a designer of experiences for others. Art and experience came together for Lawrence as he connected vision and symbol with a language of form extracted from his surroundings. A child of the workshops, taught to see pattern and given only poster paint, Lawrence ascribed meaning and value to his continued use of only three tempera colors. He believed fewer colors could make a stronger work. Changing one color, shifting one shape can produce the needed movement. Limitations of circumstance bring experience, he has said.

Too young for the mural projects of the Federal Art Project, Lawrence told his story in the alternating rhythms of hardboard panels, mining every aspect, every edge and angle of the continuum for its physical, social, historical, and economic significance. The series format also provided the consistency necessary for Lawrence's virtually ceaseless exploration of perceptual fact and improvisations with form. From Harlem to West Africa to his last studio among the high-rises of Seattle, Lawrence's art evolves from the deliberately race conscious epics to the seminarrative and part fantastic vision of his players, performers, and builders. No subject—not the Garveyite or the iceman, not the storefront church, the brothel, or the poolhall, not Harlem, not Nigeria, not racism, not poverty, not war, not interracial marriage, not even the mental hospital or the plights of aging—no aspect was too small or too large, or too overwhelming to escape his observation. Struggle brings a new dimension of meaning to human life, Lawrence has said. Much the same could be said of his paintings, where opposition and tension inform the beauty of every pattern.

Rarely do form and content conspire to create such a narrative genius. As Giotto was to the Renaissance, as Exekias was to the glory of Greece, so Lawrence shines with the clearest portrayal of our culture for the ages.

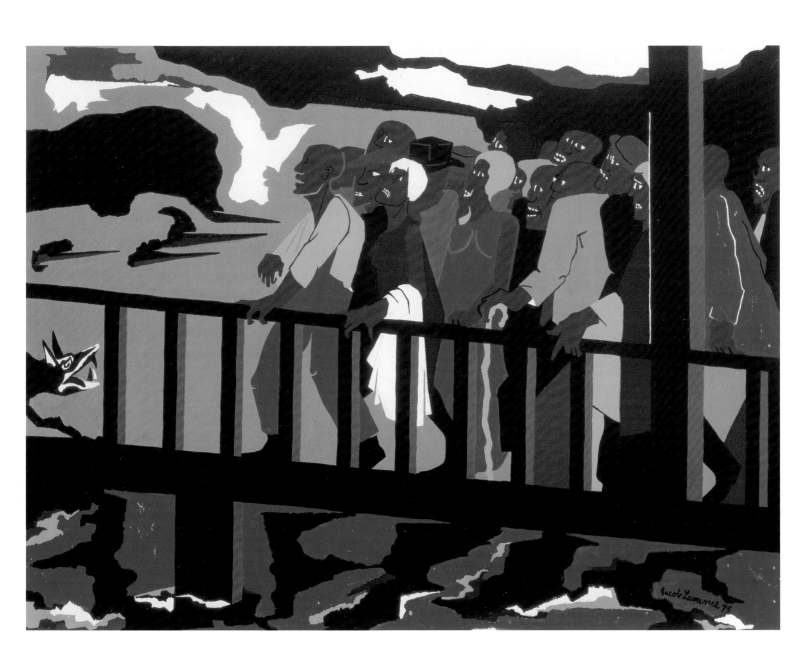

Confrontation at the Bridge, 1975, 22½ × 30¼ in.
Collection of Mr. and Mrs. James R. Palmer, Pennsylvania.

Notes to Works in the Exhibition

Title

Unless the lender has requested otherwise, the title used is the earliest known title for the work. Alternate titles are noted in brackets.

Dimensions

Dimensions are for the support only (i.e., hardboard, paper) and not the image unless otherwise indicated. Dimensions are given in inches; height precedes width.

Medium

Through physical examination of many works, the Jacob Lawrence Catalogue Raisonné Project found that the use of a graphite underdrawing and the preparation of hardboards with a white ground was a common practice for the artist. In keeping with these assumptions of the Catalogue Raisonné Project, the medium lines in this exhibition list do not include "over graphite" and all paintings on hardboard do not include "gesso" unless it is at the request of the lender.

Venue

Works on the checklist will be presented at each venue of the exhibition tour unless otherwise indicated. Partial venues are designated by the city location of the museum where the work is being exhibited (i.e., Washington, D.C. = The Phillips Collection; New York = Whitney Museum of American Art; Detroit = The Detroit Institute of Arts; Los Angeles = Los Angeles County Museum of Art; and Houston = The Museum of Fine Arts, Houston).

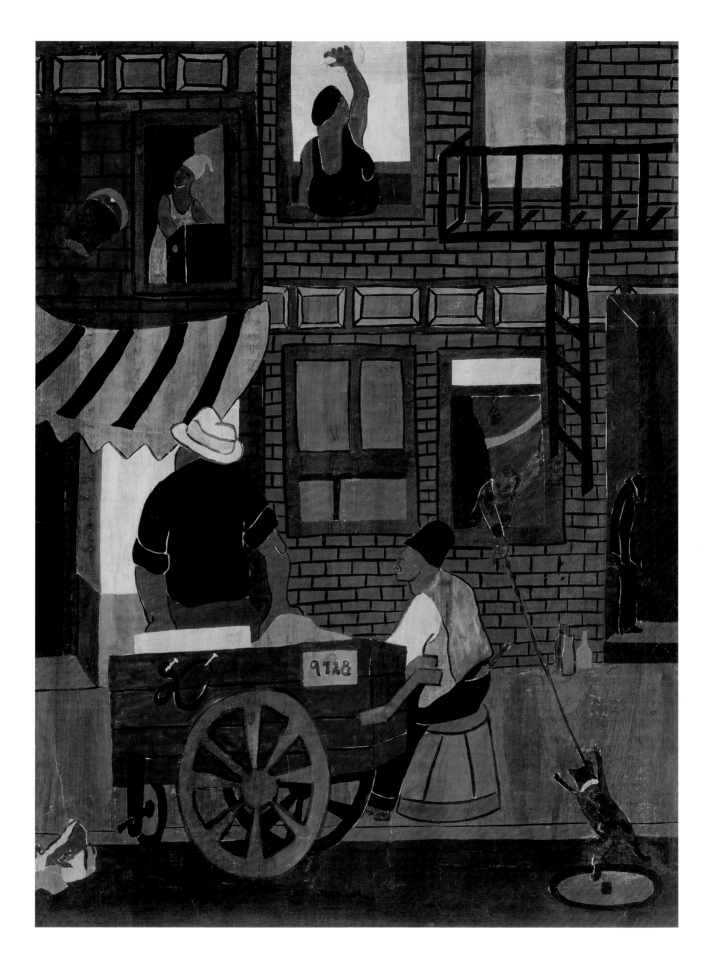

Ice Peddlers [Ice Man], 1936, tempera on paper, 26 × 19½ in.
The Walter O. Evans Collection of African American Art.

Works in the Exhibition

All works are by Jacob Lawrence and are listed in chronological order. Dimensions are for sheet size and are in inches; height precedes width.

1930s

Chow, 1936
graphite on paper
9 × 6 in.
Spelman College Collection, Atlanta, Georgia
[Fig. 27]

Ice Peddlers, 1936
[Ice Man]
tempera on paper
26 × 19½ in.
The Walter O. Evans Collection of African American Art

Infirmary, 1936
graphite on paper
9 × 6 in.
Spelman College Collection, Atlanta, Georgia
[Fig. 28]

Sore Back, 1936
graphite on paper
9 × 6 in.
Spelman College Collection, Atlanta, Georgia
[Fig. 29]

Street Orator's Audience, 1936
[Street Orator]
tempera on paper
24⅛ × 19⅛ in.
Tacoma Art Museum, gift of Mr. and Mrs. Roger W. Peck, by exchange
[Fig. 11]

Studio Corner, 1936
watercolor on paper
24¼ × 18¼ in.
Private collection

Street Scene—Restaurant, ca. 1936–38
tempera on paper
26¼ × 35 in.
The Collection of Philip J. and Suzanne Schiller, American
Social Commentary Art 1930–1970
[Fig. 98]

Halloween Sand Bags, 1937
[Street Scene]
tempera on paper
8¾ × 12¾ in.
The Harmon and Harriet Kelley Collection
[Fig. 101]

Interior Scene, 1937
tempera on illustration board
28½ × 33¾ in.
The Collection of Philip J. and Suzanne Schiller, American
School of Commentary Art 1930–1970
[Fig. 97]

Library, 1937
[The Curator; Portrait of Arthur Schomburg]
tempera on paper
11½ × 8½ in.
Schomburg Center for Research in Black Culture, Art &
Artifacts Division, The New York Public Library, Astor,
Lenox and Tilden Foundations
[Pl. 8]

Woman with Veil, 1937
tempera on brown paper
17 × 13½ in.
The Walter O. Evans Collection of African American Art
[Fig. 99]

Blind Beggars, 1938
[Beggar No. 1]
tempera on illustration board
20 × 15 in.
Lent by The Metropolitan Museum of Art.
Gift of New York City WPA, 1943, 43.47.28
Washington, D.C. and New York only
[Fig. 112]

The Butcher Shop, 1938
tempera on paper
17½ × 24 in.
Private collection, New York
Washington, D.C. and New York only
[Fig. 102]

Dust to Dust, 1938
[The Funeral]
tempera on paper
12½ × 18¼ in.
Courtesy of Gwendolyn Knight Lawrence
[Fig. 100]

Fire Escape, 1938
tempera on paper
12¼ × 10⅞ in.
Jules and Connie Kay
[Pl. 12]

Subway, 1938
tempera on illustration board
20 × 15½ in.
Schomburg Center for Research in Black Culture, Art &
Artifacts Division, The New York Public Library, Astor,
Lenox and Tilden Foundations
[Fig. 114]

Harriet Tubman Series (31 panels), 1939–40
[The Life of Harriet Tubman]
casein tempera on hardboard
12 × 17⅞ and 17⅞ × 12 in.
Gift of the Harmon Foundation, Hampton
University Museum, Hampton, Virginia
Washington, D.C. only

1. "With sweat and toil and ignorance he consumes his life, to pour the earnings into channels from which he does not drink."—Harriet Ward Beecher

2. "I am no friend of slavery, but I prefer the liberty of my own country to that of another people, and the liberty of my own race to that of another race. The liberty of the descendants of Africa in the United States is incompatible with the safety and liberty of the European descendants. Their slavery forms an exception (resulting from a stern and inexorable necessity) to the general liberty in the United States."—Henry Clay

3. "A house divided against itself cannot stand. I believe that this government cannot last permanently half slave and half free. I do not expect this union to be dissolved; I do not expect the house to fall, but I do expect it will cease to be divided. It will become all one thing or the other."—Abraham Lincoln

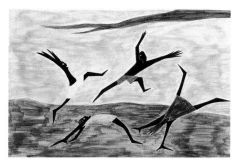

4. On a hot summer day about 1820, a group of slave children were tumbling in the sandy soil in the state of Maryland—and among them was one, Harriet Tubman. / Dorchester County, Maryland.

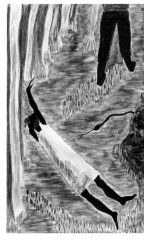

5. She felt the sting of slavery when as a young girl she was struck on the head with an iron bar by an enraged overseer.

6. Harriet heard the shrieks and cries of women who were being flogged in the Negro quarter. She listened to their groaned-out prayer, "Oh Lord, have mercy."

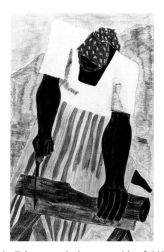

7. Harriet Tubman worked as water girl to field hands. She also worked at plowing, carting, and hauling logs.

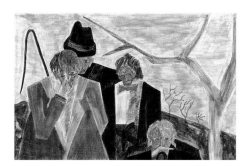

8. Whipped and half starved to death, Harriet Tubman's skull injury often caused her to fall faint while at work. Her master, not having any more use for her, auctioned her off to the highest bidder.

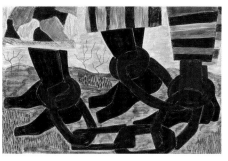

9. Harriet Tubman dreamt of freedom ("Arise! Flee for your life!"), and in the visions of the night she saw the horsemen coming. Beckoning hands were ever motioning her to come, and she seemed to see a line dividing the land of slavery from the land of freedom.

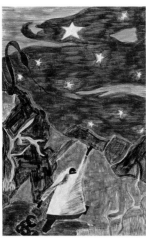

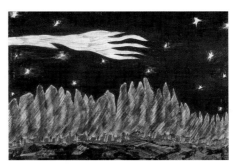

10. Harriet Tubman was between twenty and twenty-five years of age at the time of her escape. She was now alone. She turned her face toward the North, and fixing her eyes on the guiding star, she started on her long, lonely journey.

11. "$500 Reward! Runaway from subscriber on Thursday night, the 4th inst., from the neighborhood of Cambridge, my negro girl, Harriet, sometimes called Minty. Is dark chestnut color, rather stout build, but bright and handsome. Speaks rather deep and has a scar over the left temple. She wore a brown plaid shawl. I will give the above reward captured outside the county, and $300 if captured inside the county, in either case to be lodged in the Cambridge, Maryland, jail. / (Signed) George Carter / Broadacres, near Cambridge, Maryland, / September 24th, 1849"

12. Night after night, Harriet Tubman traveled, occasionally stopping to buy bread. She crouched behind trees or lay concealed in swamps by day until she reached the North.

13. "I had crossed the line of which I had been dreaming. I was free, but there was no one to welcome me to the land of freedom. Come to my help, Lord, for I am in trouble."

14. Seeking help, Harriet Tubman met a lady who ushered her to a haycock, and Harriet found herself in a strange room, round and tapering to a peak. Here she rested and was fed well, and she continued on her way. It was Harriet Tubman's first experience with the Underground Railroad.

15. In the North, Harriet Tubman worked hard. All her wages she laid away for the one purpose of liberating her people, and as soon as a sufficient amount was secured she disappeared from her Northern home, and as mysteriously appeared one dark night at the door of one of the cabins on the plantation, where a group of trembling fugitives was waiting. Then she piloted them North, traveling by night, hiding by day, scaling the mountains, wading the rivers, threading the forests—she, carrying the babies, drugged with paragoric. So she went, nineteen times, liberating over 300 pieces of living, breathing "property."

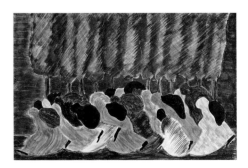

16. Harriet Tubman spent many hours at the office of William Still, the loft headquarters of the antislavery Vigilance Committee in Philadelphia. Here, she pored over maps and discussed plans with the keen, educated young secretary of that mysterious organization, the Underground Railroad, whose main branches stretched like a great network from the Mississippi River to the coast.

17. Like a half-crazed sibylline creature, she began to haunt the slave masters, stealing down in the night to lead a stricken people to freedom.

18. At one time during Harriet Tubman's expeditions into the South, the pursuit after her was very close and vigorous. The woods were scoured in all directions, and every person was stopped and asked: "Have you seen Harriet Tubman?"

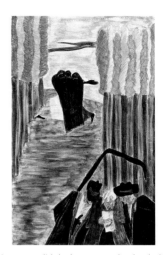

19. Such a terror did she become to the slaveholders that a reward of $40,000 was offered for her head, she was so bold, daring, and elusive.

22. Harriet Tubman, after a very trying trip North in which she had hidden her cargo by day and had traveled by boat, wagon, and foot at night, reached Wilmington, where she met Thomas Garrett, a Quaker who operated an Underground Railroad station. Here, she and the fugitives were fed and clothed and sent on their way.

20. In 1850, the Fugitive Slave Law was passed, which bound the people north of the Mason and Dixon Line to return to bondage any fugitives found in their territories—forcing Harriet Tubman to lead her escaped slaves into Canada.

21. Every antislavery convention held within 500 miles of Harriet Tubman found her at the meeting. She spoke in words that brought tears to the eyes and sorrow to the hearts of all who heard her speak of the suffering of her people.

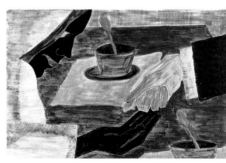

23. "The hounds are baying on my track, / Old master comes behind, / Resolved that he will bring me back, / Before I cross the line."

24. It was the year 1859, five years after Harriet Tubman's first trip to Boston. By this time, there was hardly an antislavery worker who did not know the name Harriet Tubman. She had spoken in a dozen cities. People from here and abroad filled her hand with money. And over and over again, she made her mysterious raids across the border into the South.

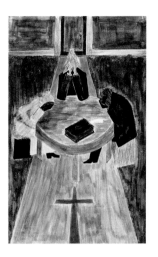

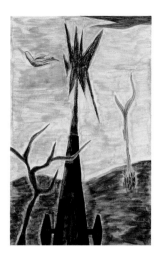

25. (left) Harriet Tubman was one of John Brown's friends. John Brown and Frederick Douglass crossed into Canada and arrived at the town of St. Catharines, a settlement of fugitive slaves, former "freight" of the Underground Railroad. Here, Douglass had arranged for a meeting with "Moses." She was Harriet Tubman: huge, deepest ebony, muscled as a giant, with a small close-curled head and anguished eyes—this was the woman John Brown came to for help. "I will help," she said.

26. (right) In 1861, the first gun was fired on Fort Sumter, and the war of the Rebellion was on.

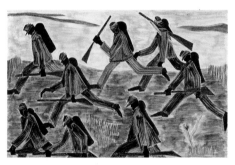

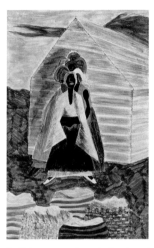

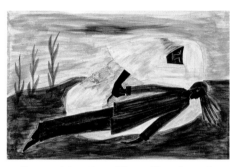

27. Governor John Andrew of Massachusetts, knowing well the brave, sagacious character of Harriet Tubman, sent for her and asked her if she could go at a moment's notice to act as a spy and scout for the Union Army and, if need be, to act as a hospital nurse. In short, to be ready for any required service for the Union cause.

28. Harriet Tubman went into the South and gained the confidence of the slaves by her cheerful words and sacred hymns. She obtained from them valuable information.

29. She nursed the Union soldiers and knew how, when they were dying by large numbers of some malignant disease, with cunning skill to extract a healing draught from roots and herbs that grew near the source of the disease, thus allaying the fever and restoring soldiers to health.

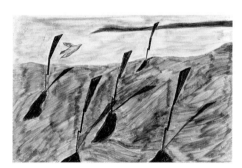

30. The war was over, men were being mustered out, and regiments melted away overnight. For Lincoln's words were now not paper words: they had been written in the travail and blood of the men whom Harriet Tubman had known.

31. Harriet Tubman spent the rest of her life in Auburn, New York. When she died, a large mass meeting was held in her honor. And on the outside of the county courthouse, a memorial tablet of bronze was erected.

The Migration of the Negro (even-numbered panels, 2–60), 1940–41
[The Migration Series]
casein tempera on hardboard
12 × 18 and 18 × 12 in.
The Museum of Modern Art, gift of Mrs. David M. Levy, 1942
Washington, D.C. and New York only

The Migration of the Negro (odd-numbered panels, 1–59), 1940–41
[The Migration Series]
casein tempera on hardboard
12 × 18 and 18 × 12 in.
The Phillips Collection, Washington, D.C.,
Acquired 1942

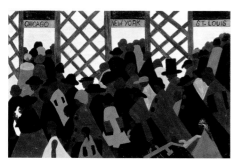

1. During the World War there was a great migration North by Southern Negroes.

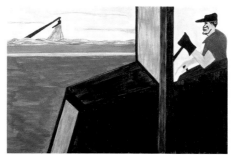

2. The World War had caused a great shortage in Northern industry and also citizens of foreign countries were returning home.

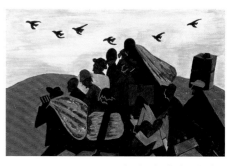

3. In every town Negroes were leaving by the hundreds to go North and enter into Northern industry.

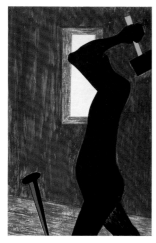

4. The Negro was the largest source of labor to be found after all others had been exhausted.

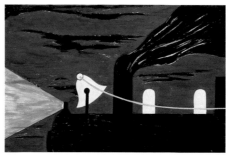

5. The Negroes were given free passage on the railroads which was paid back by Northern industry. It was an agreement that the people brought North on these railroads were to pay back their passage after they had received jobs.

6. The trains were packed continually with migrants.

7. The Negro, who had been part of the soil for many years, was now going into and living a new life in the urban centers.

8. They did not always leave because they were promised work in the North. Many of them left because of Southern conditions, one of them being great floods that ruined the crops, and therefore they were unable to make a living where they were.

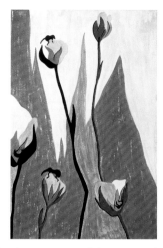

9. Another great ravager of the crops was the boll weevil.

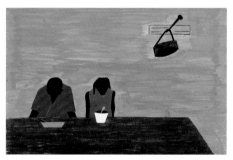

10. They were very poor.

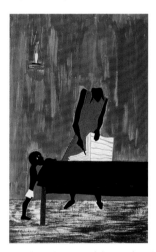

11. In many places, because of the war, food had doubled in price.

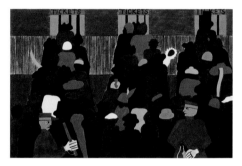

12. The railroad stations were at times so over-packed with people leaving that special guards had to be called in to keep order.

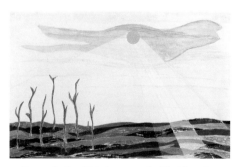

13. Due to the South's losing so much of its labor, the crops were left to dry and spoil.

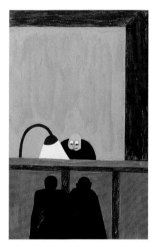

14. Among the social conditions that existed which was partly the cause of the migration was the injustice done to the Negroes in the courts.

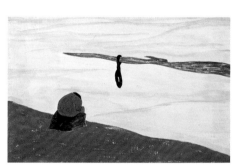

15. Another cause was lynching. It was found that where there had been a lynching, the people who were reluctant to leave at first left immediately after this.

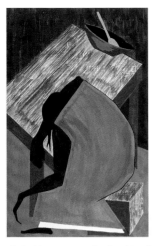

16. Although the Negro was used to lynching, he found this an opportune time for him to leave where one had occurred.

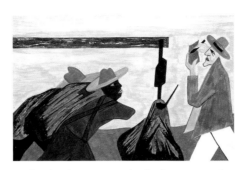

17. The migration was spurred on by the treatment of the tenant farmers by the planter.

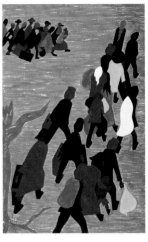

18. The migration gained in momentum.

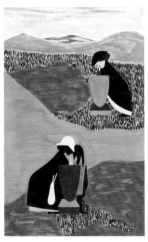

19. There had always been discrimination.

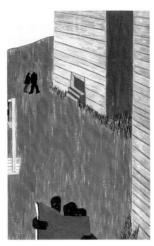

20. In many of the communities the Negro press was read continually because of its attitude and its encouragement of the movement.

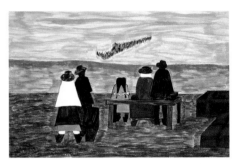

21. Families arrived at the station very early in order not to miss their train North.

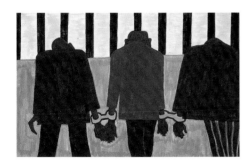

22. Another of the social causes of the migrants' leaving was that at times they did not feel safe, or it was not the best thing to be found on the streets late at night. They were arrested on the slightest provocation.

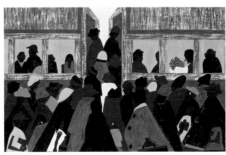

23. And the migration spread.

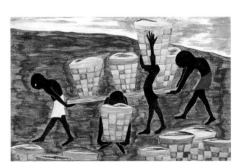

24. Child labor and a lack of education was one of the other reasons for people wishing to leave their homes.

25. After a while some communities were left almost bare.

26. And people all over the South began to discuss this great movement.

27. Many men stayed behind until they could bring their families North.

28. The labor agent who had been sent South by Northern industry was a very familiar person in the Negro counties.

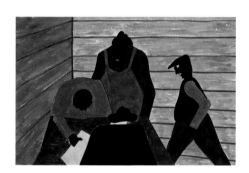

29. The labor agent also recruited laborers to break strikes which were occurring in the North.

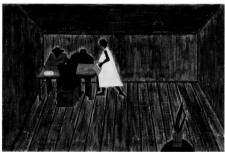

30. In every home people who had not gone North met and tried to decide if they should go North or not.

31. After arriving North the Negroes had better housing conditions.

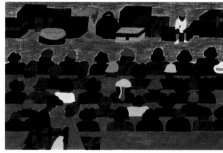

32. The railroad stations in the South were crowded with people leaving for the North.

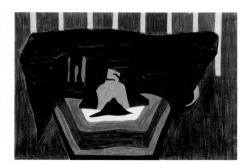

33. People who had not yet come North received letters from their relatives telling them of the better conditions that existed in the North.

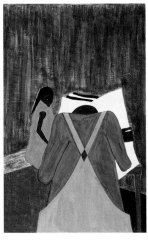

34. The Negro press was also influential in urging the people to leave the South.

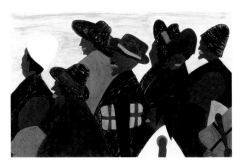

35. They left the South in large numbers and they arrived in the North in large numbers.

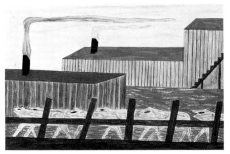

36. They arrived in great numbers into Chicago, the gateway of the West.

37. The Negroes that had been brought North worked in large numbers in one of the principal industries, which was steel.

38. They also worked in large numbers on the railroad.

39. Luggage crowded the railroad platforms.

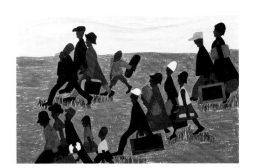

40. The migrants arrived in great numbers.

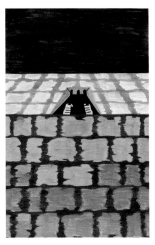

41. The South that was interested in keeping cheap labor was making it very difficult for labor agents recruiting Southern labor for Northern firms. In many instances, they were put in jail and were forced to operate incognito.

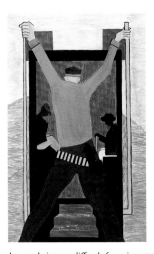

42. They also made it very difficult for migrants leaving the South. They often went to railroad stations and arrested the Negroes wholesale, which in turn made them miss their train.

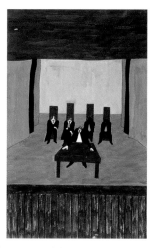

43. In a few sections of the South the leaders of both groups met and attempted to make conditions better for the Negro so that he would remain in the South.

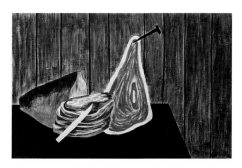

44. Living conditions were better in the North.

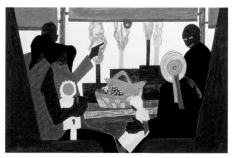

45. They arrived in Pittsburgh, one of the great industrial centers of the North, in large numbers.

46. Industries attempted to board their labor in quarters that were oftentimes very unhealthy. Labor camps were numerous.

47. As well as finding better housing conditions in the North, the migrants found very poor housing conditions in the North. They were forced into overcrowded and dilapidated tenement houses.

48. Housing for the Negroes was a very difficult problem.

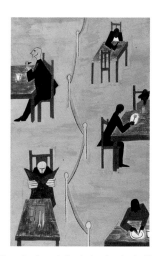

49. They also found discrimination in the North although it was much different from that which they had known in the South.

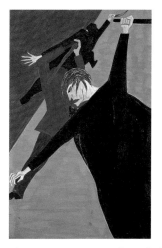

50. Race riots were very numerous all over the North because of the antagonism that was caused between the Negro and white workers. Many of these riots occurred because the Negro was used as a strike breaker in many of the Northern industries.

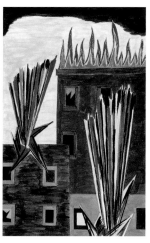

51. In many cities in the North where the Negroes had been overcrowded in their own living quarters they attempted to spread out. This resulted in many of the race riots and the bombing of Negro homes.

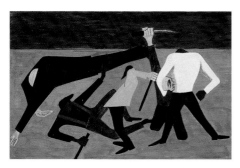

52. One of the largest race riots occurred in East St. Louis.

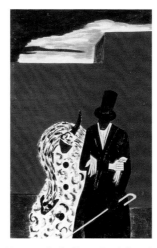

53. The Negroes who had been North for quite some time met their fellowmen with disgust and aloofness.

54. One of the main forms of social and recreational activities in which the migrants indulged occurred in the church.

55. The Negro being suddenly moved out of doors and cramped into urban life, contracted a great deal of tuberculosis. Because of this the death rate was high.

56. Among one of the last groups to leave the South was the Negro professional who was forced to follow his clientele to make a living.

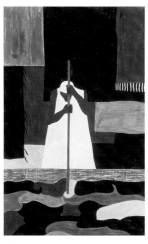

57. The female worker was also one of the last groups to leave the South.

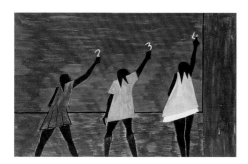

58. In the North the Negro had better educational facilities.

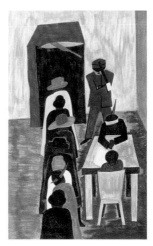

59. In the North the Negro had freedom to vote.

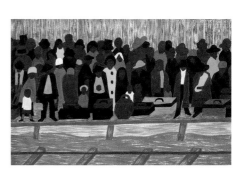

60. And the migrants kept coming.

The Life of John Brown (22 paintings), 1941
gouache and tempera on paper
13⅝ × 19⅞ and 19⅞ × 13⅝ in.
The Detroit Institute of Arts, Gift of Mr. and Mrs. Milton Lowenthal
Detroit only

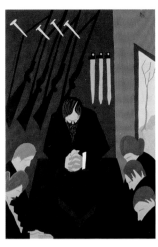

1. John Brown, a man who had a fanatical belief that he was chosen by God to overthrow black slavery in America.

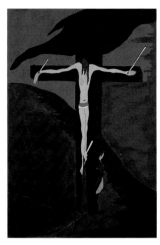

2. For 40 years, John Brown reflected on the hopeless and miserable condition of the slaves.

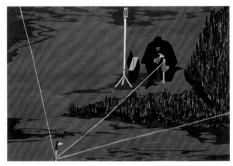

3. For 12 years, John Brown engaged in land speculations and wool merchandising. All this to make some money for his greater work which was the abolishment of slavery.

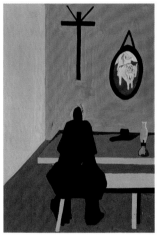

4. His ventures failing him, he accepted poverty.

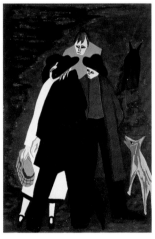

5. John Brown, while tending his flock in Ohio, first communicated with his sons and daughters his plans of attacking slavery by force.

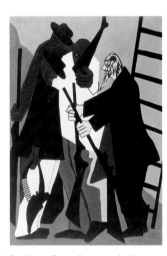

6. John Brown formed an organization among the colored people of the Adirondack woods to resist the capture of any fugitive slave.

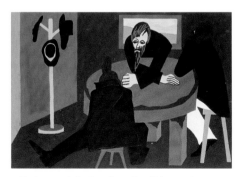

7. To the people he found worthy of his trust, he communicated his plans.

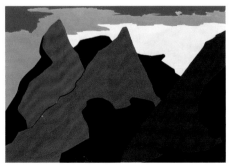

8. John Brown's first thought of the place where he would make his attack came to him while surveying land for Oberlin College in West Virginia, 1840.

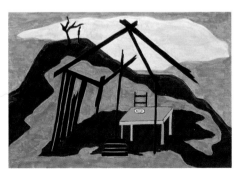

9. Kansas was now the skirmish ground of the Civil War.

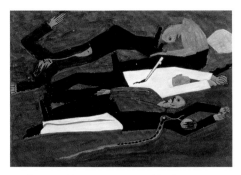

10. Those pro-slavery were murdered by those anti-slavery.

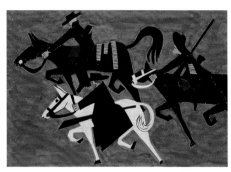

11. John Brown took to guerilla warfare.

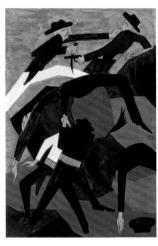

12. John Brown's victory at Black Jack drove those pro-slavery to new fury, and those who were anti-slavery to new efforts.

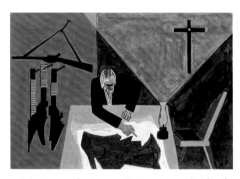

13. John Brown, after long meditation, planned to fortify himself somewhere in the mountains of Virginia or Tennessee and there make raids on the surrounding plantations, freeing slaves.

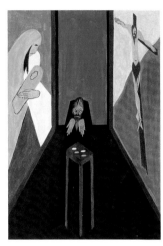

14. John Brown collected money from sympathizers and friends to carry out his plans.

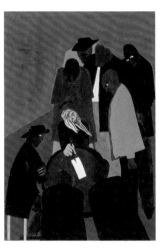

15. John Brown made many trips to Canada organizing for his assault on Harpers Ferry.

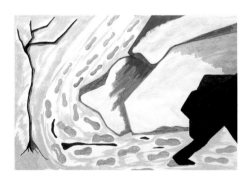

16. In spite of a price on his head, John Brown, in 1859, liberated 12 Negroes from a Missouri plantation.

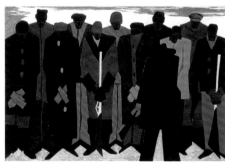

17. John Brown remained a full winter in Canada, drilling Negroes for his coming raid on Harpers Ferry.

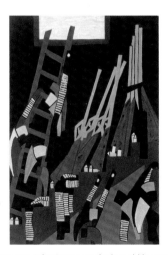

18. July 3, 1859, John Brown stocked an old barn with guns and ammunitions. He was ready to strike his first blow at slavery.

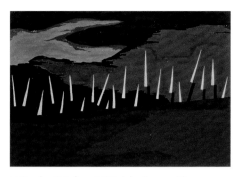

19. Sunday, October 16, 1859, John Brown with a company of 21 men, white and black, marched on Harpers Ferry.

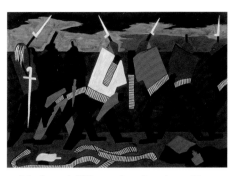

20. John Brown held Harpers Ferry for 12 hours. His defeat was a few hours off.

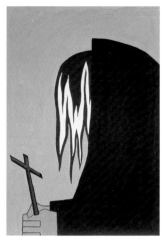

21. After John Brown's capture, he was put to trial for his life in Charles Town, Virginia.

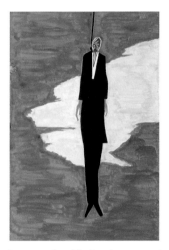

22. John Brown was found "guilty of treason and murder in the 1st degree. He was hanged in Charles Town, Virginia on December 2, 1859."

Catholic New Orleans, 1941
tempera on paper
17⅞ × 23¾ in.
University of California, Berkeley Art Museum, Purchased
with the aid of funds from the National Endowment for
the Arts

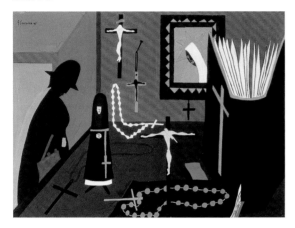

The Green Table, 1941
tempera and gouache on paper
23¾ × 18 in.
Norma Marin Collection—Promised Gift to Smith,
Mount Holyoke and Wellesley College Art Museums

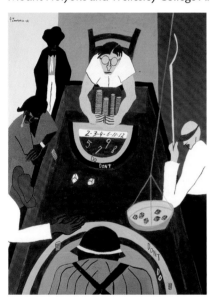

John Brown's Arsenal, 1941
gouache and tempera on paper
image sight 19¾ × 13½ in.
Maier Museum of Art, Randolph-Macon Woman's College,
Lynchburg, Virginia. Purchased with Centennial Campaign
funds donated by Suzanne Goodman Elson '59, 1997

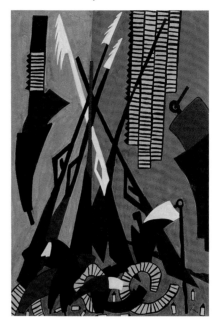

Play Street, 1942
gouache on paper
30⅞ × 22⅜ in.
Mrs. Stacey Clarfield Newman and Dr. Fredric Newman
[Page 8]

Tombstones, 1942
gouache on paper
28¾ × 22½ in.
Whitney Museum of American Art, New York; Purchase
Washington, D.C. and New York only
[Fig. 48]

The Apartment, 1943
gouache on paper
21¼ × 29¼ in.
Hunter Museum of American Art, Chattanooga, Tennessee,
Museum purchase with funds provided by the Benwood
Foundation and the 1982 Collectors' Group

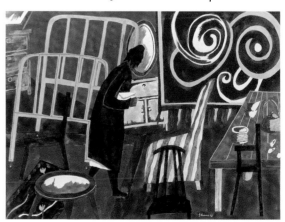

At Times It Is Hard to Get a Table in a Pool Room, 1943
[Pool Parlor]
gouache on paper
21½ × 14½ in.
The Reem and Kayden Foundation

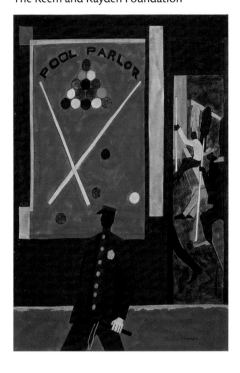

Ironers, 1943
gouache on paper
21⅜ × 29½ in.
Private collection
[Fig. 19]

Peddlers Reduce Their Prices in the Evening to Get Rid of Their Perishables, 1943
[Fruit and Vegetable Peddlers; Peddlers]
gouache on paper
15⅛ × 22⅝ in.
Countee Cullen Art Collection, Hampton University Museum, Hampton, Virginia
[Pl. 31]

Rooftops (No. 1, This is Harlem), 1943
gouache with pencil underdrawing on paper
15⅜ × 22¹¹⁄₁₆ in.
Hirshhorn Museum and Sculpture Garden, Smithsonian Institution. Gift of Joseph H. Hirshhorn, 1966.
Los Angeles and Houston only
[Figs. 4 and 120]

There Are Many Churches In Harlem. The People Are Very Religious, 1943
watercolor and gouache on paper
15½ × 22½ in.
Amon Carter Museum, Fort Worth, Texas, © 1943, Jacob Lawrence
Houston only
[Fig. 119]

Captain Skinner, 1944
gouache on paperboard
29⅛ × 21⅛ in.
Smithsonian American Art Museum, Gift of Carlton Skinner

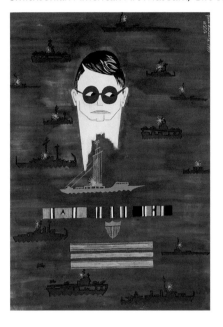

Painting the Bilges, 1944
gouache on paper
30⅞ × 22⅝ in.
Hirshhorn Museum and Sculpture Garden, Smithsonian Institution. Joseph H. Hirshhorn Bequest, 1981
Los Angeles and Houston only

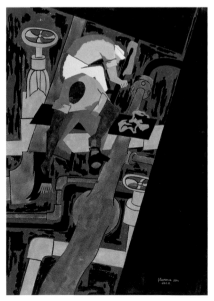

Home Chores, 1945
gouache on paper
29½ × 29¹⁄₁₆ in.
The Nelson-Atkins Museum of Art, Kansas City, Missouri
(Anonymous Gift) F69-6
[Fig. 18]

Seaman's Belt, 1945
gouache and watercolor on paper
image: 21 × 29 in.
The Martha Jackson Collection at the Albright-Knox
Art Gallery, 1974

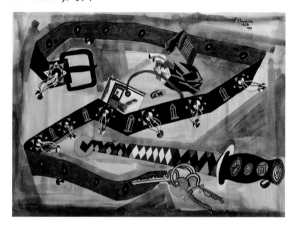

The Shoemaker, 1945
gouache and watercolor on paper
22⅝ × 30⅞ in.
Lent by The Metropolitan Museum of Art,
George A. Hearn Fund, 1946, 46.73.2
Washington, D.C. and New York only
[Fig. 36]

Going Home, 1946
gouache on paper
22 × 30¼ in.
Jules and Connie Kay

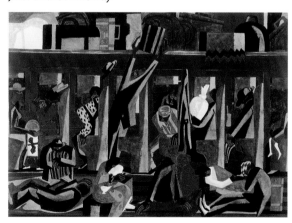

Juke Box, 1946
gouache and tempera on paper
image 29½ × 21⅛ in.
The Detroit Institute of Arts. Gift of Dr. D. T. Burton,
Dr. M. E. Fowler, Dr. J. B. Greene, and Mr. J. J. White
Detroit only

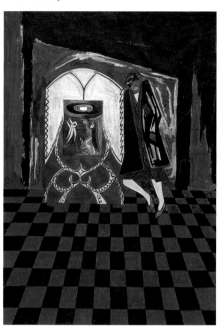

The Lovers, 1946
gouache on paper
21½ × 30 in.
Collection of Mrs. Harpo Marx

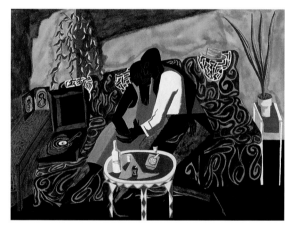

Shooting Gallery, 1946
ink, watercolor, and gouache on paper
23 × 31¼ in.
Collection Walker Art Center, Minneapolis.
Gift of Dr. and Mrs. Malcolm McCannel, 1953
[Fig. 96]

War (14 panels), 1946–47
egg tempera on hardboard
16 × 20 and 20 × 16 in.
Whitney Museum of American Art, New York.
Gift of Mr. and Mrs. Roy R. Neuberger
New York, Los Angeles, and Houston only

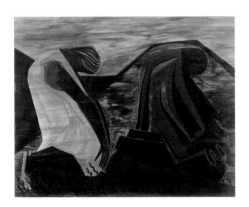

1. *Prayer*

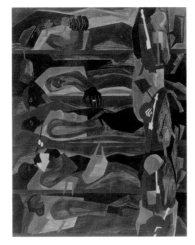

2. *Shipping Out*

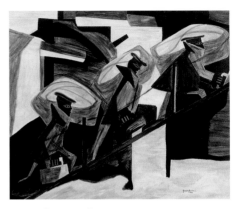

3. *Another Patrol*

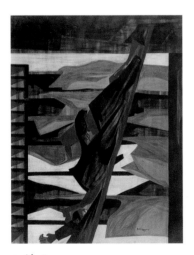

4. *Alert*

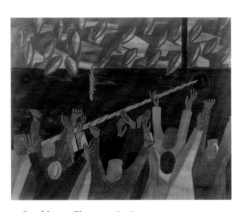

5. *Docking—Cigarette Joe?*

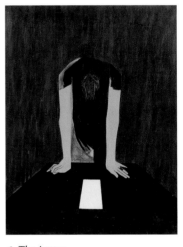

6. *The Letter*

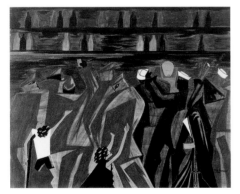

7. *On Leave*

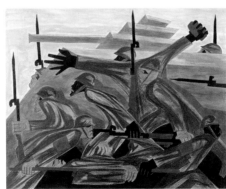

8. *Beachhead*

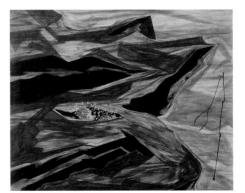

9. *How Long?*

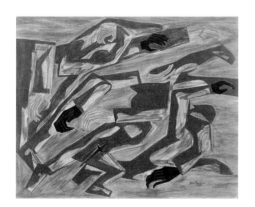

10. *Purple Hearts*

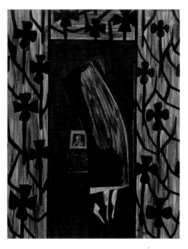

11. *Casualty—The Secretary of War Regrets*

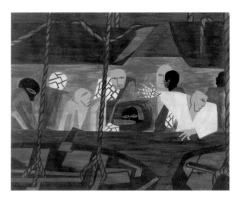

12. *Going Home*

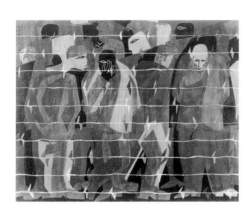

13. *Reported Missing*

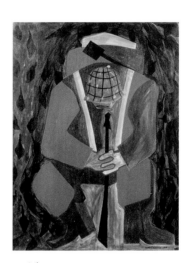

14. *Victory*

Dancing Doll, 1947
egg tempera on hardboard
20¼ × 24⅛ in.
Lent by the Frederick R. Weisman Art Museum, University of
Minnesota, Bequest of Hudson Walker from the Ione and
Hudson Walker Collection
[Pl. 46]

Red Earth—Georgia, 1947
egg tempera on hardboard
20 × 24 in.
James Banks

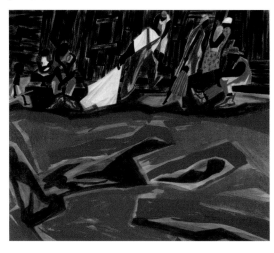

Dixie Café, 1948
brush and ink on paper
17 × 22¼ in.
Margaret and Michael Asch
[Pl. 48]

Flight, 1948
brush and ink on paper
24½ × 16 in.
Private collection, Connecticut

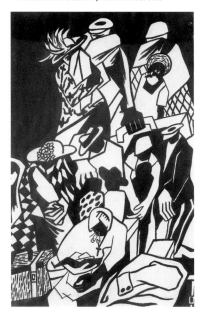

Kibitzers, 1948
egg tempera on hardboard
20 × 24 in.
Addison Gallery of American Art, Phillips Academy, Andover,
Massachusetts. Gift from the Childe Hassam Fund of the
American Academy of Arts and Letters
Washington, D.C., New York, Los Angeles, and Houston only
[Pl. 47]

New York Street Scene, 1948
brush and ink on paper
18 × 24 in.
Courtesy of Michael Rosenfeld and halley k harrisburg, New York
[Pl. 49]

One-Way Ticket, 1948
brush and ink on paper
24½ × 16 in.
Private collection, Connecticut

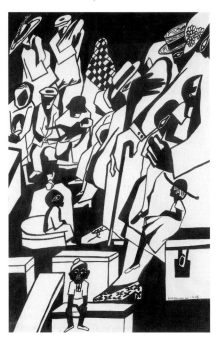

The Preacher, 1948
brush and ink on paper
21½ × 16¼ in.
Shirley Seligman, Brooklyn, New York

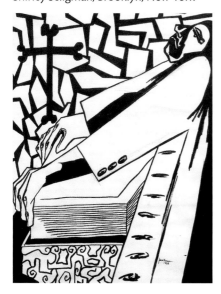

Saturday Night, 1948
egg tempera on hardboard
21¼ × 24¾ in.
Collection of Clark Atlanta University Art Galleries,
Gift of the Arts Fund of New York

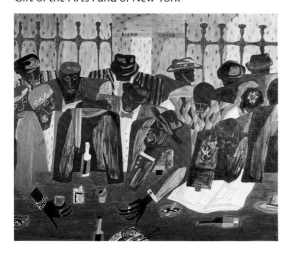

Silhouette (The Lynching), 1948
brush and ink on paper
24½ × 16½ in.
Private collection, Connecticut

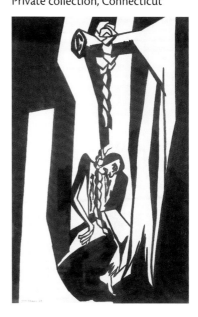

The Wedding, 1948
egg tempera on hardboard
20 × 24 in.
The Art Institute of Chicago. Gift of Mary P. Hines
in memory of her mother, Frances W. Pick, 1993.258
Detroit, Los Angeles, and Houston only

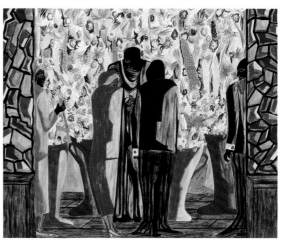

Creative Therapy, 1949
casein tempera on paper
22 × 30 in.
The Cleveland Museum of Art, Delia E. Holden Fund, 1994.2
Houston only
[Fig. 44]

Paper Boats, 1949
[Paper Sail Boats]
egg tempera on hardboard
17⅞ × 23⅞ in.
Sheldon Memorial Art Gallery and Sculpture Garden, University
of Nebraska-Lincoln. F. M. Hall Collection (1949.H-288)
[Pl. 52]

Psychiatric Therapy, 1949
casein tempera on paper
18⅜ × 23⅜ in.
North Shore–Long Island Jewish Health System

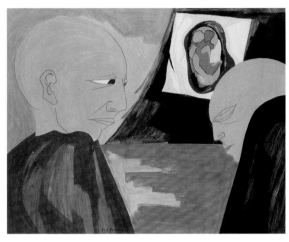

1950s

In the Garden, 1950
casein tempera on paper
21³⁄₁₆ × 30¹⁄₁₆ in.
Ronald and Elizabeth Kanof Levine
[Fig. 50]

Sedation, 1950
casein tempera on paper
30⅞ × 22¾ in.
The Museum of Modern Art, New York.
Gift of Mr. and Mrs. Hugo Kastor, 1951
[Fig. 126]

Slums, 1950
casein tempera on paper
25 × 21½ in.
Elizabeth Marsteller Gordon
[Fig. 51]

Photos, 1951
watercolor and gouache on paper
23 × 31⅝ in.
Milwaukee Art Museum, Gift of Milprint, Inc.,
a Division of Philip Morris Industrial
Washington, D.C. and New York only
[Fig. 56]

Tie Rack, 1951
egg tempera on hardboard
29¾ × 19¼ in.
The Thompson Collection

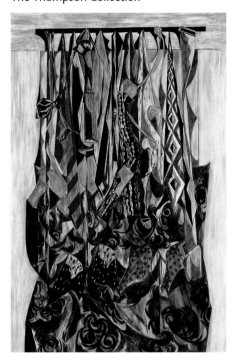

Vaudeville, 1951
egg tempera on hardboard with pencil
29⅞ × 19¹⁵⁄₁₆ in.
Hirshhorn Museum and Sculpture Garden, Smithsonian
Institution. Gift of Joseph H. Hirshhorn, 1966
[Figs. 33 and 129]

Marionettes, 1952
egg tempera on hardboard
18¼ × 24½ in.
High Museum of Art, Atlanta, Georgia. Purchase with
funds from the National Endowment for the Arts and
Edith G. and Philip A. Rhodes, 1980.224
[Fig. 46]

Card Game, 1953
egg tempera on hardboard
19 × 23½ in.
The Walter O. Evans Collection of African American Art
[Pl. 56]

Masks, 1954
egg tempera on hardboard
24 × 17¾ in.
Elizabeth Marsteller Gordon
[Page 290]

Struggle . . . From the History of the American People
No. 2: Massacre in Boston, 1955
egg tempera on hardboard
12 × 16 in.
Mr. and Mrs. Harvey M. Ross
[Fig. 57]

Struggle . . . From the History of the American People
No. 17: I shall hazard much and can possibly gain nothing by the issue of
this interview . . . —HAMILTON BEFORE HIS DUEL WITH BURR, 1804
1956
egg tempera on hardboard
12 × 16 in.
Mr. and Mrs. Harvey M. Ross
[Fig. 60]

Struggle . . . From the History of the American People
No. 27: . . . for freedom we want and will have, for we have served
this cruel land long enuff [sic] *. . . —A GEORGIA SLAVE, 1810,* 1956
egg tempera on hardboard
11¾ × 15⅝ in.
Private collection
[Fig. 107]

The Cue and the Ball, 1956
casein tempera with pencil underdrawing on paper
30½ × 22½ in.
Hirshhorn Museum and Sculpture Garden, Smithsonian
Institution. Gift of Joseph H. Hirshhorn, 1966
Washington, D.C. and Houston only

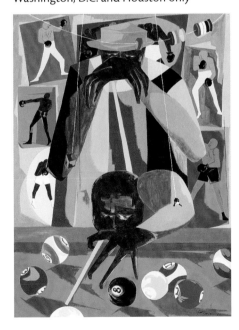

Playroom, 1957
egg tempera on hardboard
20 × 16 in.
The William H. Lane Collection

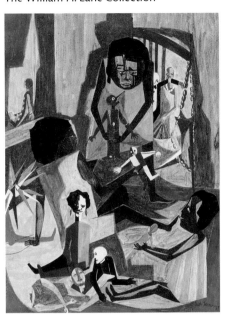

Brownstones, 1958
egg tempera on hardboard
31½ × 37¼ in.
Collection of Clark Atlanta University Art Galleries,
Gift of Chauncey and Catherine Waddell
Washington, D.C. and New York only
[frontispiece]

Dominoes, 1958
egg tempera on hardboard
24½ × 19¾ in.
Private collection
[Pl. 64; page 296]

Magic Man, 1958
egg tempera and pencil on hardboard
20 × 24 in.
Hirshhorn Museum and Sculpture Garden, Smithsonian
Institution. Gift of Mr. and Mrs. Henry Folkerson, 1981
[Fig. 131 (detail); page 287]

The Architect, 1959
egg tempera on hardboard
11¾ × 16 in.
Collection of The Studio Museum in Harlem,
Gift of Mr. and Mrs. James Harithas

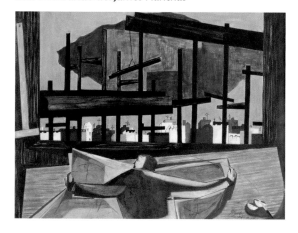

The Visitors, 1959
egg tempera on hardboard
20 × 24 in.
Dallas Museum of Art, General Acquisitions Fund
[Pl. 66]

1960s

Library III, 1960
egg tempera on hardboard
30 × 24 in.
Collection of Citigroup

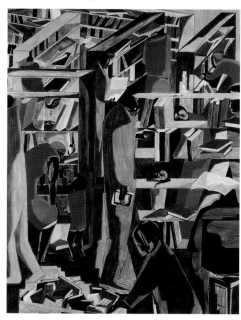

Street Scene, 1961
tempera on hardboard
12 × 16 in.
Private collection
[Pl. 70]

Praying Ministers, 1962
egg tempera on hardboard
23 × 38 in.
Spelman College Collection, Atlanta, Georgia
[Fig. 68]

American Revolution, 1963
gouache and tempera on paper
23 × 15 in.
Private collection. Courtesy Peg Alston Fine Arts, New York
Washington, D.C. only
[Fig. 72]

Clown, 1963
egg tempera on hardboard
24⁵⁄₁₆ × 20³⁄₁₆ in.
Collection of The Newark Museum, Anonymous Gift, 1991
[Fig. 76]

Invisible Man Among the Scholars, 1963
egg tempera on hardboard
24 × 35¼ in.
Harold A. and Ann R. Sorgenti, Haverford, PA
[Fig. 66]

Taboo, 1963
egg tempera on hardboard
19⅞ × 23⅞ in.
Private collection of Mrs. Josef Jaffe
Washington, D.C. only
[Fig. 67]

Two Rebels, 1963
egg tempera on hardboard
23¼ × 19¼ in.
The Harmon and Harriet Kelley Foundation for the Arts
[Fig. 64]

Iyo, 1964
gouache on paper
22½ × 30¼ in.
Joslyn Art Museum, Omaha, Nebraska; Museum purchase
(JAM 1966.478)

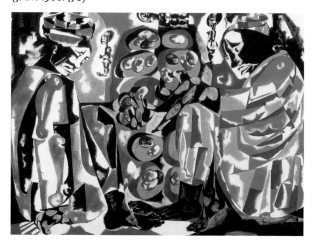

Meat Market, 1964
tempera and gouache on paper
30¾ × 22 in.
Judith Golden
[Pl. 75]

Three Red Hats, 1964
tempera and gouache on paper
22 × 30¾ in.
Mrs. Stacey Clarfield Newman and Dr. Fredric Newman

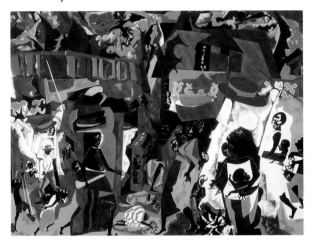

Confrontation, 1965
brush and ink on paper
24 × 17½ in.
Private collection, Connecticut. Courtesy DC Moore Gallery,
New York

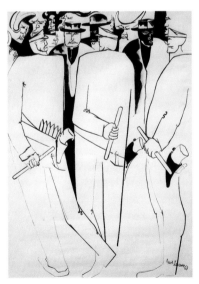

Self-Portrait, 1965
brush and ink
15¼ × 11⅝ in.
Courtesy of Gwendolyn Knight Lawrence

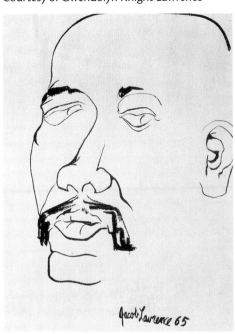

Typists, 1966
tempera and gouache on paper
22⅛ × 30 in.
Herbert F. Johnson Museum of Art, Cornell University.
Gift of Isabel Berley, Class of 1947, and William Berley, Class of 1945
[Fig. 95]

Daybreak—A Time to Rest, 1967
egg tempera on hardboard
30 × 24 in.
National Gallery of Art, Washington, D.C.
Anonymous Gift 1973.8.1
[Pl. 78]

Harriet and the Promised Land
1. *Birth 1822*, 1967
gouache and tempera on paper
13 × 12 in.
Collection of Bette Crouse

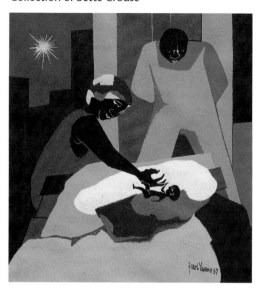

Harriet and the Promised Land
3. *Lullaby*, 1967
gouache and tempera on paper
12½ × 12½ in.
Nicholas Neubauer

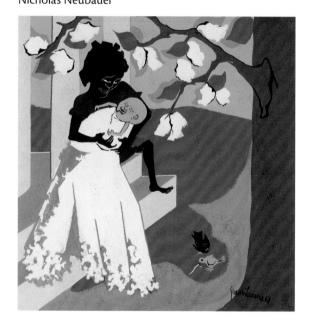

Harriet and the Promised Land
4. *A Mother Tells the Story of Moses*, 1967
gouache and tempera on paper
11½ × 11¼ in.
Abigail Kursheedt Hoffman and Jane Hoffman Paress

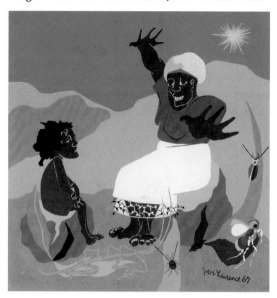

Harriet and the Promised Land
5. *Prayer*, 1967
gouache and tempera on paper
11½ × 11 in.
Dr. Mildred Beatty Smith

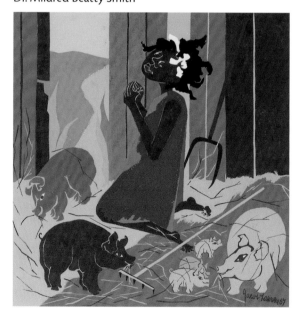

Harriet and the Promised Land

7. Labor, 1967
gouache and tempera on paper
11¼ × 11 in.
Celeste Schmid

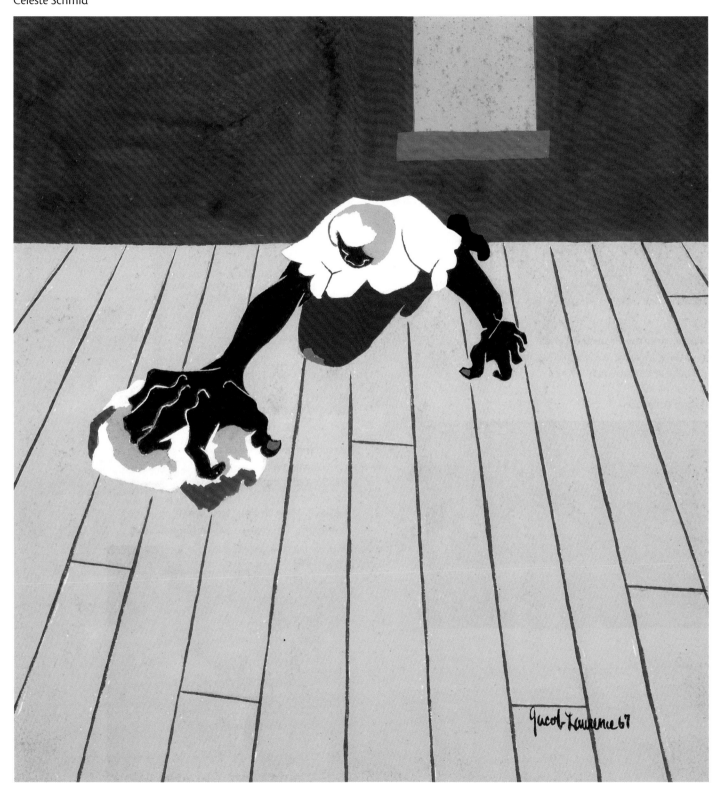

Harriet and the Promised Land

8. *A Plan to Escape,* 1967
gouache and tempera on paper
14¼ × 13 in.
Bill and Holly Marklyn

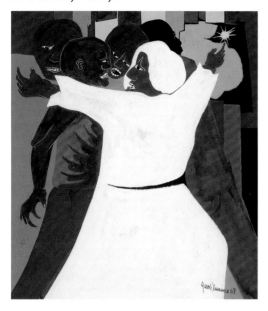

Harriet and the Promised Land

9. *Walking by Night, Sleeping by Day,* 1967
gouache and tempera on paper
16¼ × 23¼ in.
Private collection

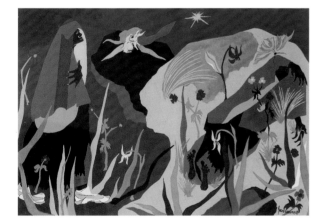

Harriet and the Promised Land

12. *Fugitives,* 1967
gouache and tempera on paper
17 × 9 in.
Dr. Mildred Beatty Smith

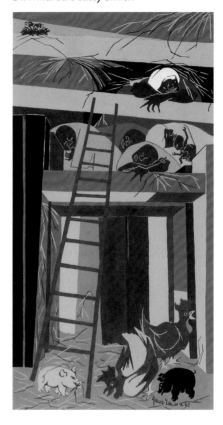

Harriet and the Promised Land

13. *An Underground Railroad,* 1967
gouache and tempera on paper
14¼ × 13 in.
Marylin Bender Altschul, New York
Washington, D.C., New York, and Detroit only

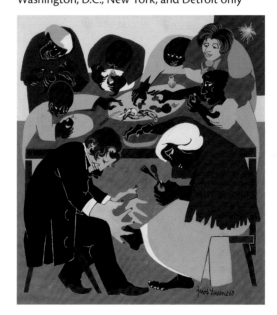

Harriet and the Promised Land

14. *Flight II*, 1967
gouache and tempera on paper
15½ × 13⅞ in.
Hood Museum of Art, Dartmouth College, Hanover, NH
Bequest of Jay R. Wolf, Class of 1951

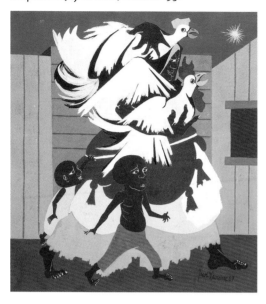

Harriet and the Promised Land

15. *Canada Bound*, 1967
gouache and tempera on paper
16½ × 28¼ in.
The University of Michigan Museum of Art,
Gift of Dr. James and Vivian Curtis

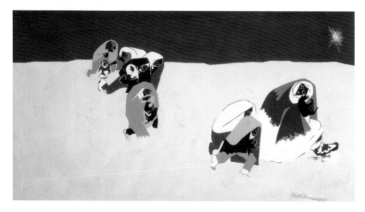

Harriet and the Promised Land

16. *Flight III*, 1967
gouache and tempera on paper
17 × 9 in.
Allan and Nenette Harvey

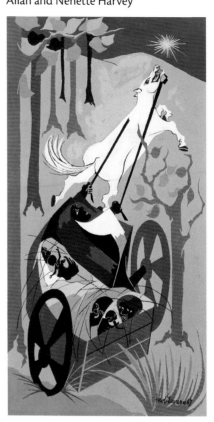

Harriet and the Promised Land

17. *The Last Journey*, 1967
gouache and tempera on paper
15⅝ × 26¾ in.
The Reem and Kayden Foundation

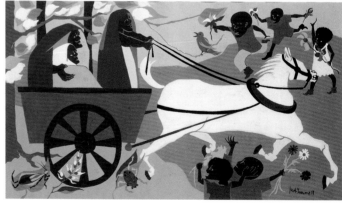

Over the Line, 1967
gouache on paper
14 × 13 in.
Mr. and Mrs. Richard H. Markowitz
[Fig. 1]

Rural Scene, 1967
tempera and gouache on paper
image: 14½ × 25¾ in.
The Thompson Collection
[Pl. 77]

Through Forest, Through Rivers, Up Mountains, 1967
tempera and gouache with pencil on paper
15¹¹⁄₁₆ × 26⅞ in.
Hirshhorn Museum and Sculpture Garden, Smithsonian
Institution. Joseph H. Hirshhorn Bequest, 1981.
Los Angeles and Houston only
[Pl. 76]

1970s

The Pool Game, 1970
gouache and tempera on paper
22 × 30 in.
Museum of Fine Arts, Boston. Courtesy of Emily L. Ainsley Fund
Washington, D.C. and New York only

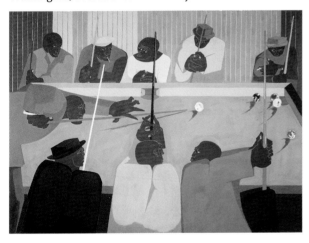

Munich Olympic Games, 1971
tempera and gouache on paper
39⅞ × 28¹⁵⁄₁₆ in.
Seattle Art Museum, purchased with funds from P.O.N.C.H.O.
[Fig. 133]

Builders No. 1, 1974
gouache on paper
30 × 21½ in.
Vatican Museums, Vatican City
Washington, D.C., New York, and Detroit only
[Fig. 106]

Confrontation at the Bridge, 1975
gouache on paper
22½ × 30¼ in.
Collection of Mr. and Mrs. James R. Palmer
[Page 298]

Self-Portrait, 1977
gouache and tempera on paper
23 × 31 in.
National Academy of Design, New York
Washington, D.C. and New York only

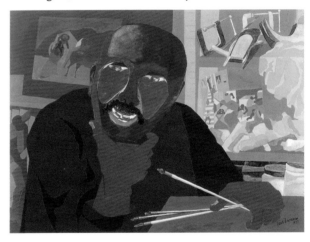

The Studio, 1977
gouache and tempera on paper
30 × 22 in.
Seattle Art Museum, partial gift of Gull Industries;
John H. and Ann Hauberg; Links, Seattle; and gift
by exchange from the estate of Mark Tobey
[Fig. 123]

1980s

Builders, 1980
gouache on paper
34 × 25½ in.
SAFECO
[Fig. 89]

Hiroshima
Boy with Kite, 1983
tempera and gouache on paper
23 × 17½ in.
Gwendolyn Knight Lawrence. Courtesy of Francine
Seders Gallery, Seattle

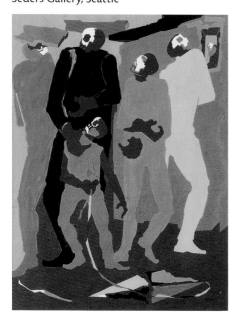

Hiroshima
Man with Birds, 1983
tempera and gouache on paper
23 × 17½ in.
Gwendolyn Knight Lawrence. Courtesy of Francine
Seders Gallery, Seattle

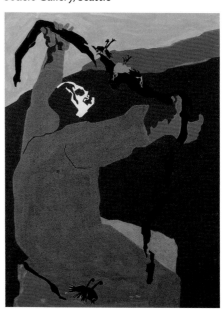

Hiroshima
Family, 1983
tempera and gouache on paper
23 × 17½ in.
Gwendolyn Knight Lawrence. Courtesy of Francine
Seders Gallery, Seattle
[Fig. 109]

Hiroshima
Farmers, 1983
tempera and gouache on paper
23 × 17½ in.
Gwendolyn Knight Lawrence. Courtesy of Francine
Seders Gallery, Seattle

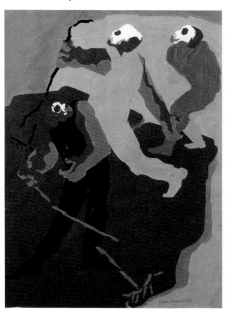

Hiroshima
Market, 1983
tempera and gouache on paper
23 × 17½ in.
Gwendolyn Knight Lawrence. Courtesy of Francine
Seders Gallery, Seattle

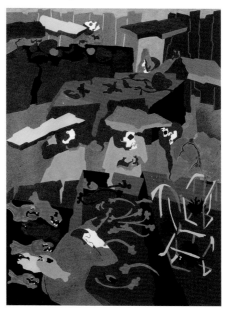

Hiroshima
People in the Park, 1983
tempera and gouache on paper
23 × 17½ in.
Gwendolyn Knight Lawrence. Courtesy of Francine
Seders Gallery, Seattle
[Pl. 89]

Hiroshima
Playground, 1983
tempera and gouache on paper
23 × 17½ in.
Gwendolyn Knight Lawrence. Courtesy of Francine
Seders Gallery, Seattle
[Pl. 88]

Hiroshima
Street Scene, 1983
tempera and gouache on paper
23 × 17½ in.
Gwendolyn Knight Lawrence. Courtesy of Francine
Seders Gallery, Seattle

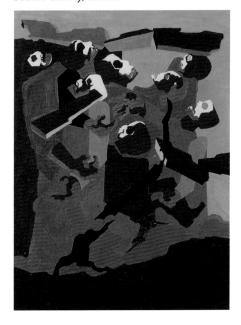

Eight Studies for the Book of Genesis, 1989
No. 5: *And God created all the fowls of the air and the fishes of the seas.*
gouache on paper
29¾ × 22 in.
The Walter O. Evans Foundation for Art and Literature

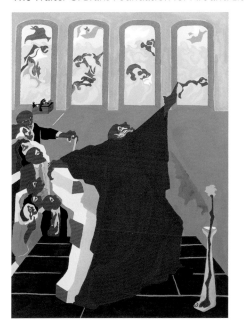

Eight Studies for the Book of Genesis, 1989
No. 6: *And God created all the beasts of the earth.*
gouache on paper
29¾ × 22 in.
The Walter O. Evans Foundation for Art and Literature

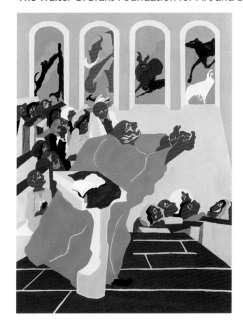

Eight Studies for the Book of Genesis, 1989
No. 7: *And God created man and woman.*
gouache on paper
29¾ × 22 in.
The Walter O. Evans Foundation for Art and Literature
[Pl. 91]

Builders in the City, 1993
gouache on paper
19 × 28⅝ in.
Courtesy of SBC Communications Inc.
[Pl. 85]

Self-Portrait, 1993
brush and ink on paper
11¼ × 9¾ in.
Ruth Bowman

Artist with Tools, 1994
gouache on paper
25¾ × 19⅝ in.
Susan and Peter Tuteur
[Pl. 87]

Supermarket—All Hallow's Eve, 1994
gouache on paper
19⅝ × 25⅝ in.
Courtesy of the estate of Jacob Lawrence
and Francine Seders Gallery, Seattle
[Fig. 135]

Supermarket—Meats, 1994
gouache on paper
19½ × 25¾ in.
Jeremy and Linda Jaech, Seattle
[Pl. 93]

Builders—Man in Blue Jacket, 1998
gouache on paper
24 × 18 in.
Private collection, Connecticut

Games—Chess, 1999
gouache on paper
24 × 18 in.
From the collection of Linda Herget Fiebig and Craig Fiebig

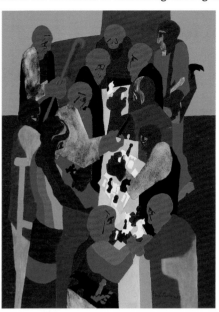

Builders—Man with Still Life, 1998
gouache on paper
24 × 18 in.
Private collection, courtesy DC Moore Gallery, New York

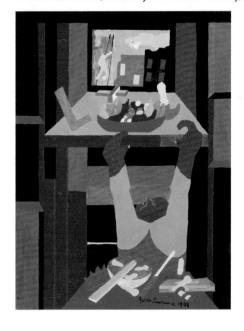

Games—Pocket Pool, 1999
gouache on paper
24 × 18 in.
Clifford A. Ames and E. Grant Spradling

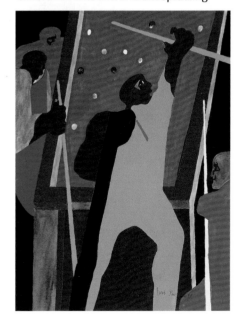